# ANDY WARHOL SCREEN TESTS

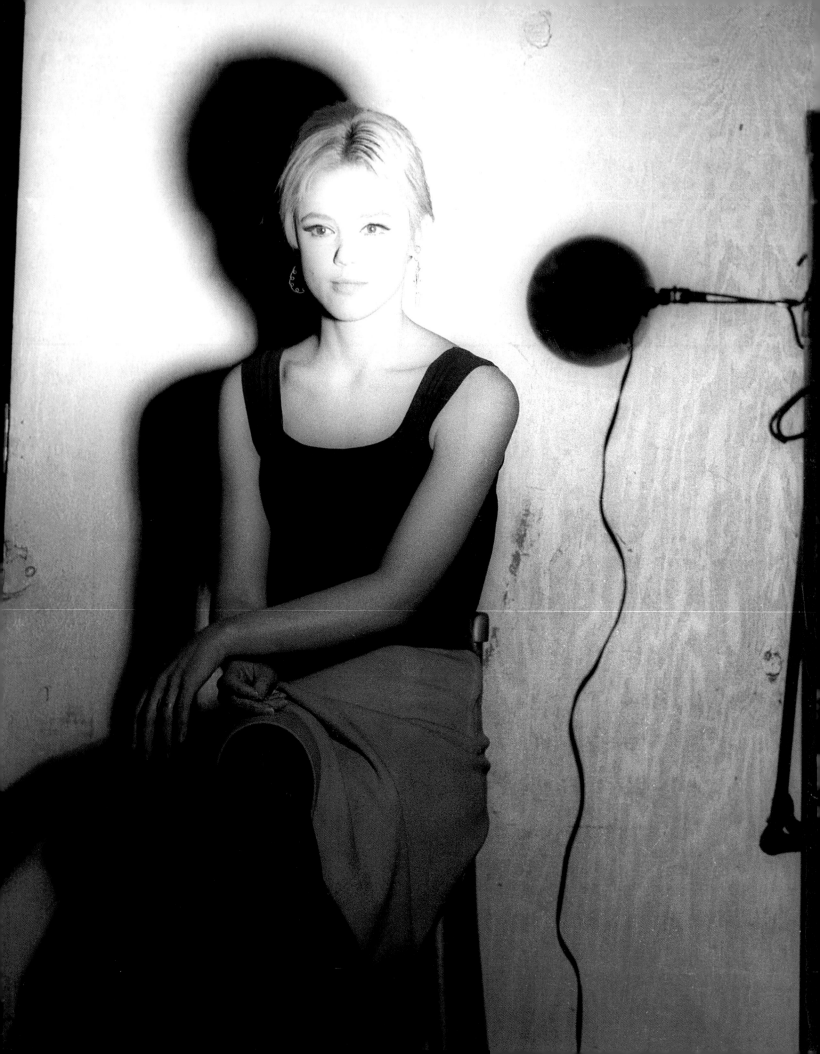

# ANDY WARHOL SCREEN TESTS
## THE FILMS OF ANDY WARHOL CATALOGUE RAISONNÉ
### VOLUME 1

**CALLIE ANGELL**

**ABRAMS, NEW YORK, IN ASSOCIATION WITH
WHITNEY MUSEUM OF AMERICAN ART, NEW YORK**

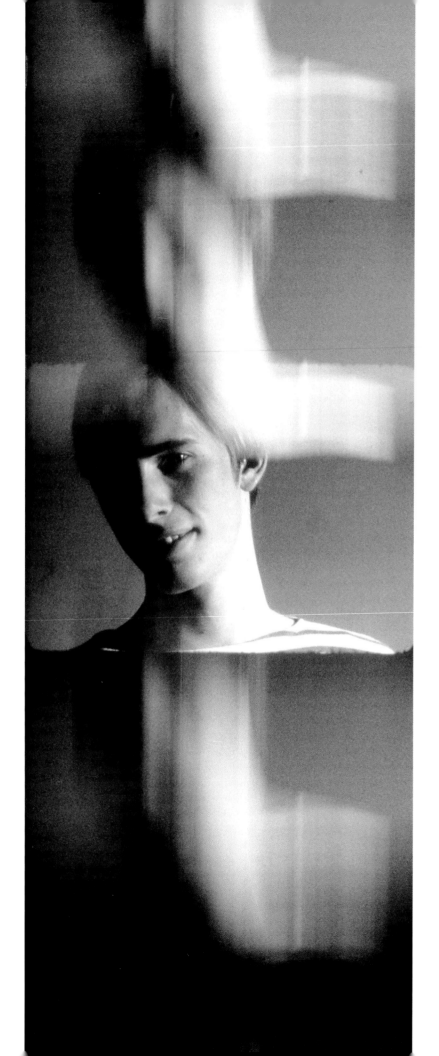

ST274. *Richard Rheem*, 1966.

# CONTENTS

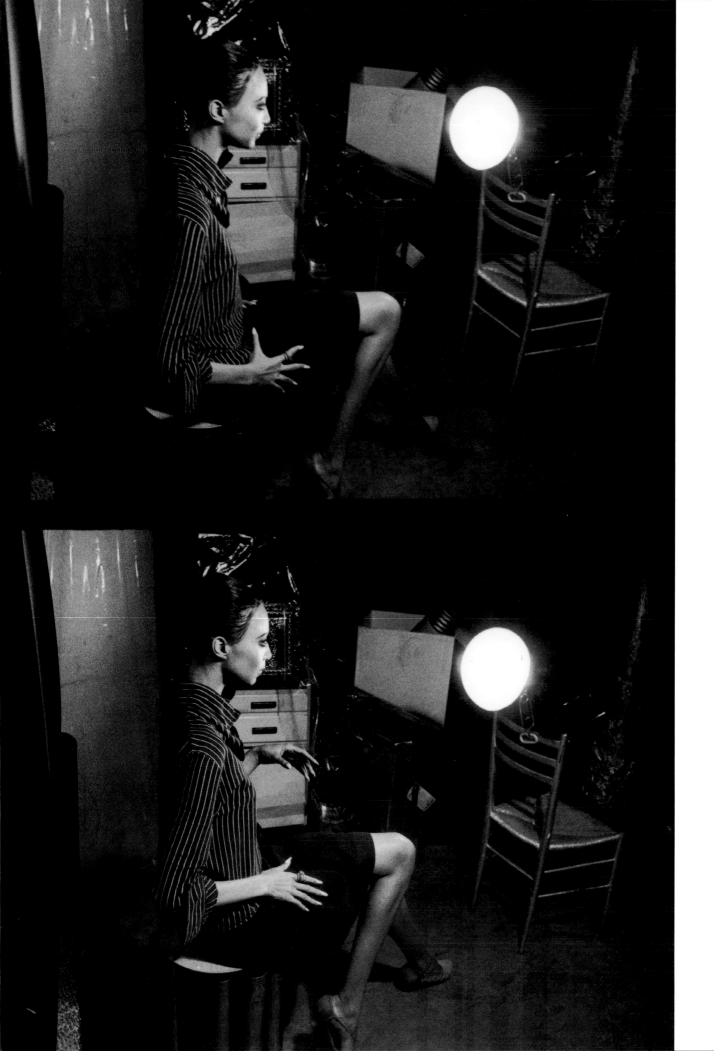

# Foreword

I came to New York in the mid-1960s, during the time that Andy Warhol was shooting his "stillies" and various other short and feature-length films, including the 472 films that have become known as the *Screen Tests*. Although I went to an event at the Factory I recall mostly the crowds, not the evening itself, and have no idea of whether or not I saw a film projection. I do recall more clearly going to The Museum of Modern Art and to various midtown art houses for Warhol's movies. *The Chelsea Girls* (1966) simply had to be seen, and I thought *Lonesome Cowboys*, which came to New York theaters in 1969, gave new meaning to the developing art form of the deadpan take on 1960s life, although it was set in an absurd West rather than on a New York street. The films starring Candy Darling and the gang—*Flesh* (1968), *Trash* (1970), and *Heat* (1972)—were not to be missed. I adored them.

In 1967 I found my place in the city as a junior editor at Harry N. Abrams, where the editor in chief, Milton Fox, and Harry himself provided many insights into modern art, including that of Warhol. I well remember my cubbyhole near the mailroom, next to Larry Rivers's wonderful *Dutch Masters*—his painted version of the popular cigar box with the Rembrandt group portrait. Twenty years later, in 1987, the year Warhol died, I was the director of the department of film at The Museum of Modern Art, and Warhol's films had become the stuff of legend.

MoMA is one of the few American museums that collect historical and contemporary films as well as other visual arts. A significant part of its collecting activities is the acquisition and restoration of "avant-garde" cinema, that is, films that are thought of as experimental, poetic, or personal, from the early days of twentieth-century filmmaking to the present day. The 1960s and 1970s brought new generations of brilliant filmmakers, and MoMA, the Pacific Film Archive, New York's Anthology Film Archives, and the Whitney Museum of American Art, as well as other venues, launched or expanded daily programs of new directions in cinema. The film and video department at the Whitney was headed by John G. Hanhardt, a good friend and colleague of mine, who contacted me several years before Warhol's death to propose a collaborative project: the Whitney would research and produce a catalogue raisonné of Warhol's films, and MoMA would deposit his work in our film archive, where the originals could be preserved, new negatives could be made, and prints could be made available to the public. The films were in Warhol's possession and in need of preservation.

I thought the idea was a brilliant one, since this major part of what, in both John's and my opinion, was Warhol's greatest art was unavailable to the public except in stray copies here and there. As early as 1970, Warhol had withdrawn his films of 1963–68 from distribution, so for nearly two decades they had only rarely been seen. His films and videos had not been collected in depth by individuals or museums, yet they were every bit as valuable (we believed) as his paintings, sculptures, and prints, and in some ways more celebrated, notorious, and influential. John was eager to get the films shown again, so he and I visited Fred Hughes at the Factory and proposed that the films come to MoMA, where we would care for them, and that the Whitney and MoMA would present the work, following preservation and cataloguing. John became the director of the project, Jon Gartenberg at MoMA assisted in the preparation of the films and filmography, and Callie Angell became a special consultant on the catalogue raisonné, and eventually adjunct curator of the Andy Warhol Film Project at the Whitney and consultant to MoMA on the preservation of the Warhol films. In 1988, the Whitney showed sixteen of Warhol's movies, including excerpts of *Sleep* (1963) and *Empire* (1964). In 1989, Kynaston McShine, then curator in the department of painting and sculpture at MoMA, mounted a retrospective of Warhol's entire work, including a selection of films.

Since then, each batch of restored films has been copied onto 16mm stock and distributed worldwide by MoMA and after 1994 by The Andy Warhol Museum in Pittsburgh. More than 4,000 reels of film have been identified, constituting some 150 films directed by

Donyale Luna posing for her *Screen Test* (ST195) at the Factory, 1965.
Photograph by Nat Finkelstein.

Warhol in 1963–68 and 472 *Screen Tests*. Many people have contributed to this effort. Early on, Vincent Fremont was most supportive, for he and Fred Hughes at the Andy Warhol Estate understood the importance of reintroducing Warhol's cinematic works, especially to new generations of artists. With an endowment from the Andy Warhol Estate, The Andy Warhol Foundation for the Visual Arts, Inc. was established in 1987 at the direction of Warhol's will. Soon after, the Warhol Foundation, MoMA, and the Whitney began their unique collaboration on research, cataloguing, and preservation efforts. In 1994 The Andy Warhol Museum opened in Pittsburgh, adding a new partner to the project. In 1997 the Warhol Foundation donated all original film elements and preservation funds to MoMA; gave copyrights to all titles and prints of preserved films to The Andy Warhol Museum; and renewed its grant to the Whitney Museum for the research and writing of a catalogue raisonné of the films. Generous support from the Warhol Foundation has enabled MoMA to preserve and restore most of the black-and-white shorts and feature films, various color features, and approximately 279 of the 472 *Screen Tests*.

Thus, within the past decade, a sizable number of Warhol's "stillies" have been returned to public exhibition, enabling artists and scholars, art lovers both serious and casual, the young and the old, and the curious everywhere to experience what I believe Warhol intended: he wanted us to be seduced, fascinated, mesmerized, puzzled, irritated, exasperated, or any combination of the above, but most of all to be delighted by the works' sheer beauty, daring, and wit. For the *Screen Tests* rank among modern art's most significant contributions to the great established genre of portrait painting. The ways in which these works were conceived and filmed, the fascinating details of styles of lighting and shooting, the films' relationship to Warhol's other types of portraits, the stories of the subjects themselves and of *their* relationships to Warhol and the Factory—all this is detailed in this splendid catalogue raisonné by Callie Angell in which the *Screen Tests* are identified and their preservation is described.

As film and video, or media arts, have flourished in the past several decades, Warhol's films have taken on the quality of old masterworks. They are to be studied carefully, to be revisited repeatedly, not simply copied or imitated. There is much to be mined here with an eye to the development of the portrait from the Renaissance and the pictures of the Van Eycks, Dürer, and Titian through contemporary photography and moving-image works. There is much to explore about Warhol's influence on generations of younger artists. Since their recent restoration and rerelease, the *Screen Tests* have circulated constantly in many countries around the world; I am curious indeed to know more about the sources of this steady demand. But none of this would have been possible without the painstaking work of colleagues such as Callie Angell; John Hanhardt; Peter Williamson, film conservator at MoMA; and Tom Sokolowski and Geralyn Huxley at the Warhol Museum.

Most important of all, the work will endure, thanks to the generous support that MoMA has received to maintain its film archives. In the steady and chilly storage provided for the "stillies" and features, the originals will survive and be available well into the future. Like oil on canvas, good old 16mm stock, properly cared for, will be with us for a long time, regardless of the comings and goings of new technologies and materials, and we can count on the films being there for scholars and filmmakers and audiences to discover in the years to come.

**Mary Lea Bandy**
**Celeste Bartos Chief Curator of Film and Media**
**The Museum of Modern Art, New York**

# Acknowledgments

The Warhol Film Project was the brainchild of John G. Hanhardt, formerly curator and head of film and video at the Whitney Museum of American Art and now chief curator of media at the Solomon R. Guggenheim Museum. I would like to express my personal gratitude to John Hanhardt for his vision and persistence during the initial years of this project, for his excellent advice, and for having given me one of the most interesting jobs in the world.

My colleagues at The Museum of Modern Art receive the greatest credit and congratulations for their work in preserving and restoring the Warhol films, as well as my deep appreciation for the unhesitating assistance and unprecedented access they have extended to the catalogue raisonné project over the years. I am indebted to Mary Lea Bandy, Celeste Bartos chief curator of film and media, for her decisive leadership and unwavering support. Peter Williamson, film conservator, has overseen the lab work on the restored titles; his technical expertise and his meticulousness have been real assets for Warhol's cinema, obvious in the beauty of the new prints. Jon Gartenberg, former assistant curator, handled the initial cataloguing of the Warhol Film Collection and has maintained an enthusiastic interest in the films ever since. I would like to thank Artie Wehrhahn, vault manager, as well as Mary Keene, John Weidner, Phyllis Monahan, Dave Freidman, and the entire staff of MoMA's Celeste Bartos Film Preservation Center for their kind assistance and hospitality during the months spent viewing, cataloguing, and photographing the Warhol Film Collection at their facility in Pennsylvania. I would also like to express my gratitude to a number of other MoMA colleagues for their help and facilitations: Stephen Higgins, curator, Anne Morra, assistant curator, Larry Kardish, senior curator, and Charles Silver, associate curator of research and collections; Kitty Cleary, Brian Coffey, and Bill Sloan of MoMA's Circulating Film Library, Greg Singer, projectionist, and Don Finnamore, archival editor. John Johnson, senior film cataloguer, was an avid fan of the Warhol films and a valued friend; this volume is dedicated to his memory.

This project would not have been possible without the support and cooperation of The Andy Warhol Foundation for the Visual Arts, Inc., which has generously funded both the catalogue raisonné project at the Whitney and the preservation of the films by MoMA. Archibald L. Gillies, former president of the Warhol Foundation, has been a wonderfully enthusiastic advocate for this project; the current president, Joel Wachs, has been no less supportive and encouraging. The late Frederick W. Hughes, chairman emeritus, was a key supporter of the Warhol Film Project. Vincent Fremont was also a great help during the research phase of this project, especially in facilitating access to Warhol's business papers. Pamela Clapp, program director, has been a steadfast source of encouragement for this book and its author; I would like to thank her personally for her level-headed guidance, her patience, and her support. I would also like to thank Eileen Clancy, former director of film and video at the Warhol Foundation, for her energetic work on behalf of the films and in support of this project; in 1997, Eileen organized the donation and transfer of all of Warhol's film materials to The Museum of Modern Art, as well as the donation of the film rights to The Andy Warhol Museum. The early inventories and cataloguing of the Warhol films initially held by the Warhol Foundation were conducted by Mirra Bank Brockman, Terry Irwin, and Adrian Marin; Paul Morrissey provided crucial assistance in identifying reels. Emily Todd, former program officer, Dara Meyers-Kingsley, former director of the film and video collections, and Jane Rubin, former administrator of the collections, also gave important assistance to this project. I would also like to thank Timothy Hunt, sales agent for prints and photography; Claudia Defendi, chief curator and curator of prints; Martin Cribbs, former licensing director; Yona Backer, program officer; K. C. Maurer, chief financial officer; Scott Ferguson, collections management; and Heloise Goodman, William Ganis, and Jim Hubbard for their collegiality and for the myriad acts of assistance, both large and small, they have given to the work of this project over the years.

I would like to express my personal appreciation to two valued colleagues at the Warhol Foundation, Neil Printz and Sally King-Nero, respectively editor and executive editor of the catalogue raisonné of Warhol's paintings and sculpture. Fellow Warholists, we have spent many hours in detailed discussions of Warhol's work and history, trading information and ideas, commiserating on the difficulties of our work, and sharing its pleasures. Neil Printz has been a particularly inspiring friend; he was the first to read the manuscript, for which he offered many helpful suggestions and corrections, and his influence can be found throughout this text.

The Warhol Film Project at the Whitney is immensely indebted to the staff of The Andy Warhol Museum in Pittsburgh for its assistance and support over many years of research. Matt Wrbican, assistant archivist, has been unfailingly accommodating and cheerful in providing access to the Warhol Time Capsules and other primary materials in the Archives Study Center at the Warhol Museum. Matt's amazingly detailed knowledge of Warhol's life, work, and papers is unsurpassed on this planet; both he and John Smith, archivist, have been great assets to me and to many other Warhol scholars as well. Geralyn Huxley, curator of film and video, and Greg Pierce, film and video technician, have been valued colleagues; I want to express my gratitude to them for their support and enthusiasm. I would also like to thank Tom Sokolowski, director of the Warhol Museum, for his graciousness and his advocacy, and give a special note of thanks to three former members of the museum's staff, Margery King, Mark Francis, and Richard Hellinger.

At the Warhol Film Project at the Whitney Museum, I have been fortunate to work with exceptionally gifted and dedicated assistants, to whom I owe a great debt. Matthew Buckingham, research assistant, helped to collect, collate, and organize large portions of primary research at both the Archives Study Center of The Andy Warhol Museum and MoMA's Celeste Bartos Film Preservation Center; he also designed and built the unique camera stand used to make the frame enlargements from the Warhol films, and then photographed most of the preserved films for the catalogue raisonné. Luke Sieczek, photography coordinator, completed the photography of Warhol's unrestored camera originals at MoMA's Film Preservation Center, developing an uncanny ability to extract beautiful frame enlargements from films he was able to see only on rewinds. Amy Herzog, curatorial assistant, created the database used to organize the Warhol film materials for the catalogue raisonné; she also researched the digital reproduction of the film images for publication, transformed vast quantities of cataloguing data into manuscript, completed exhibition histories for a number of the films, and read this manuscript in its early stages. Lauren Cornell, curatorial assistant, has continued Amy Herzog's work, including supervision of digital scanning, compilation of illustrations for the catalogue, fact-checking, proofreading, and seeing the manuscript through its final phases into publication. I have also been lucky to have a number of talented interns who generously volunteered their time to help with the work of this project; my grateful thanks go to Andrew Cappetta, Allison Chapas, Steven Freid, Roy Grundmann, Erin Kenny, Jean Yen-chun Ma, Eliot Nolen, Christiana Perella, and Gretchen Skogerson.

My valued colleagues, both current and former, at the Whitney Museum of American Art have assisted the Warhol Film Project through all its phases. I particularly want to thank the Alice Pratt Brown directors, David A. Ross, Maxwell L. Anderson, and especially Adam D. Weinberg, for their encouragement. Special thanks goes to Willard Holmes, former deputy director, for heroic assistance in the arena of administration. Chrissie Iles, curator and fellow Warhol fan, has been an enthusiastic champion of the catalogue raisonné project, as has Henriette Huldisch, assistant curator. The staff of the former film and video department have been indispensable allies as well; many thanks to Richard Bloes, Gary Carrion-Murayari, Nathalie Dubuque, Christopher Eamon, Lucinda Furlong, Mindy Krazmien, Tanya Leighton, Deborah Meehan, Glenn Phillips, Maria-Christina Villaseñor, and Matthew Yokobosky. Much appreciation goes to Mary DelMonico, Anita Duquette, Kate Norment, Sheila Schwartz, Dale Tucker, Makiko Ushiba, Nerissa Vales, Garrett White, Rachel Wixom, and all the staff in the museum's publications department for their encouragement and help. And I would like to acknowledge the following Whitney colleagues, past and present, for their expertise and their kind support: Randy Alexander, Hillary Blass, May Castleberry, Martha Coletar, Susan Courtemanche, Steve Dennin, Adrienne Edwards, Bridget Elias, Scott Elkins, Thelma Golden, Peter Guss, Barbara Haskell, Mary Haus, Nick Holmes, Sang Lee, Carol Mancusi-Ungaro, Dana Miller, Nelson Ortiz, Jane Otto, Kathryn Potts, Marla Prather, Suzanne Quigley, Veronica Roberts, Larry Rinder, Debbie Rowe, Carol Rusk, Paul Sharpe, Joan Simon, Stephen Soba, Susan Spencer-Crowe, Elisabeth Sussman, Elvin Topac, Eugenie Tsai, and Alexandra Wheeler.

Thanks also to the staff and librarians at Anthology Film Archives, the Avery Architectural and Fine Arts Library at Columbia University, the Billy Rose Theatre Collection at the New York Public Library for the Performing Arts, and the Mid-Manhattan Library.

Foremost among the many Warhol colleagues and contemporaries who assisted with the research into the *Screen Tests*, I want to thank Billy Name (Linich), whose generous spirit, steadfast support, and profound understanding of Warhol and his films have been a fount of wisdom and encouragement for this project for many years. Gerard Malanga was exceptionally helpful in delineating the history of this film series and identifying individual *Screen Tests*. Joe Campbell, Bibbe Hansen, Bob Heide, Allen Midgette, and Ronald Tavel have also been especially generous with their time and memories. A great many other people were kind enough to provide information or share their recollections of the 1960s with me at one point or another, and I want to thank all who contributed to this volume, including anyone inadvertently left off this list: Olga Adorno, Eric Andersen, Marty Andrews, Steve Balkin, Timothy Baum, Irving Blum, Randy Bourscheidt, John Cale, Katha Dees Casey, Lawrence Casey, Lucinda Childs, David Dalton, Walter De Maria, Isabel Eberstadt, Nicholas Ekstrom, Kenward Elmslie, Marisol Escobar, Rosebud Felieu-Pettet, Julie Finch, Nat Finkelstein, Eileen Ford, Megan Sermoneta Friedman, Henry Geldzahler, John Gilman, Allen Ginsberg, Grace Glueck, Samuel Adams Green, John Gruen, Pat Hackett, Pat Hartley, Stephen Holden, Jane Holzer, Dale Joe, Ray Johnson, Ivan Karp, Celene Keller, Billy Klüver, Frederick Kraushar, Kenneth Jay Lane, Sarah Dalton Legon, David McCabe, Fred McDarrah, Taylor Mead, Jonas Mekas, François de Menil, Edgar Munhall, Ron Padgett, John Palmer, Robert Pincus-Witten, James Rosenquist, Bruce Rudow, Edita Sherman, Stephen Shore, Harold Stevenson, Tony Towle, Maureen Tucker, Ultra Violet, Amos Vogel, Chuck Wein, Jane Wilson, Susanna De Maria Wilson, Mary Woronov, and Marian Zazeela.

This book and its author have been enriched by interactions with the by-now worldwide network of Warhol scholars, critics, historians, curators, writers, collectors, and other enthusiasts. In particular, I am grateful to Ochiishi Augustmoon, Fred Camper, Douglas Crimp, Jennifer Doyle, Jonathan Flatley, Peter Gidal, Jim Hoberman, Branden W. Joseph, David James, Wayne Koestenbaum, Tan Lin, Jay Reeg, Esther Robinson, Keith Sanborn, P. Adams Sitney, Amy Taubin, Lynne Tillman, Steven Watson, and Reva Wolf for their insights, intelligence, and support. The work of many academics, curators, and writers has been an important resource for the Warhol Film Project; in particular, and in lieu of a bibliography in this

volume, I want to acknowledge the contributions made by Paul Arthur, Nicholas Baume, Yann Beauvais, Victor Bockris, Bradford Collins, Gary Comenas, Erin Cramer, David Curtis, Donna de Salvo, Trevor Fairbrother, Paul B. Franklin, Kenneth Goldsmith, Vivienne Greene, Roy Grundmann, Juan Guardiola, Pat Hackett, Bill Horrigan, David Joselit, Stephen Koch, Margia Kramer, Olivier Landemaine, Miles McKane, Richard Meyer, Annette Michelson, Debra Miller, Michael O'Pray, Carel Rowe, Steve Seid, Marc Siegel, Art Simon, Patrick Smith, Eric Thiese, Matthew Tinkcom, Tom Waugh, and Mark Webber.

I also want to express my gratitude to the many people who gave assistance to this project in ways too varied and numerous to enumerate here: Richard Abate, Peggy Ahwesh, Richard Barsam, Robert Beavers, Jennifer Berman, Sarah Boxer, Blake Boyd, Valerie Breuvart, Adelaide de Menil Carpenter, Melissa Casey, Miles Champion, James Dowell, Nuria Enguita, Simon Field, Charles Griemsman, Robert Haller, Pablo Helguera, David Hunter, Fredericka Hunter, Stanley Jensen, Francene Keery, Lauren Kern, L. Brandon Krall, James Kruel, Audrey Kupferberg, Kevin Kushel, Ed Leffingwell, Karin Lemstrom-Sheedy, Tom Levin, Saul Levine, Micah Lexier, Jane Lombard, Janice Londraville, Gregory Mair, Dan Marmostein, Anthony McCall, Gillian McCain, Legs McNeil, Patrick Moore, Jose Muñoz, Kay Murray, Vance Muse, Akio Obigane, Edward Oleksak, Doris Palca, Irene J. Patrick, Beatrice Phear, Tony Pipolo, Amos Poe, Robert Polito, Richard Polsky, Richard J. Powell, Donald L. Rheem III, Tiavi Rudow, Paul Ryan, Mark Zane Safron, Joel Samburg, Andrew Sayers, Tony Scherman, Ed Schott, Mark Schwartz, Jonathan Scull, M.M. Serra, Judith Stein, David Sterritt, Dan Streible, Jerry Tartaglia, Amanda Urban, David Watson, Dewey Webb, Joan Weakley, Thea Westreich, Nadia Williams, Mitchell Woo, and Andrew Wylie. Special thanks for legal advice to Ellis Levine, John Thomas, John Delaney, Michael Stout, and Kay Murray. Ken Taranto and Beata Jacubek did a wonderful job creating the high resolution digital scans used in this publication; I would like to thank them for their expertise and their patience. Miko McGinty, the designer of this book, made important contributions to the organization and clarity of its contents; I am grateful to her and to her assistants, Rita Jules and Tina Henderson, for their beautiful work. I would also like to thank Eric Himmel, Deborah Aaronson, Dorothy Fink, and the rest of the staff at Harry N. Abrams for their enthusiasm and for their work on this publication.

Finally, I want to express my gratitude to friends and family who have provided encouragement and support during my years of work on the catalogue raisonné: Alice Angell, Roger and Carol Angell, Richard Bloes, Elliot Caplan, Nikki Di Franks, Christopher Eamon, Roy Grundmann, Branden Joseph, Steve Kokker, Deborah Meehan, Leanne Mella, Barbara Niemczyk, Neil Printz, Kariska Puchalski, Esther Robinson, Felicity Scott, Gretchen Skogerson, Gordon Stewart, and my late mother and stepfather, Evelyn Nelson and Clifford Nelson.

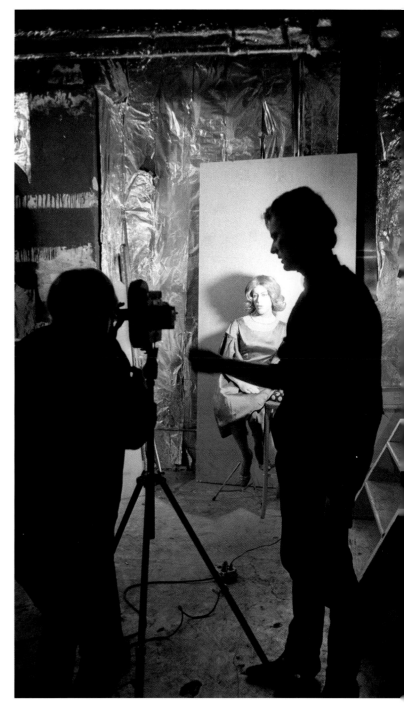

Mario Montez posing for his *Screen Test* (ST222) at the Factory, with Andy Warhol on camera, Paul Morrissey in foreground, 1965. Photograph by Mark Zane Safron.

# Introduction

**I.**

This book, the first installment in a two-volume catalogue raisonné of Warhol's cinema, catalogues Warhol's *Screen Tests*, the series of short, silent black-and-white film portraits he made between 1964 and 1966. In addition to documenting and illustrating 472 individual *Screen Test* films, this volume also includes all of the film series, compilations, and assembled reels constructed from the *Screen Tests*, such as *Six Months*, *The Thirteen Most Beautiful Boys*, *The Thirteen Most Beautiful Women*, *Fifty Fantastics and Fifty Personalities*, as well as various "background reels" projected behind the Velvet Underground during performances of the Exploding Plastic Inevitable. The second volume of the catalogue raisonné, which will be considerably larger, will cover the rest of Warhol's cinema.

The series of *Screen Test* portrait films that Warhol produced between 1964 and 1966 constitutes one of the most ambitious and long-lasting projects in his career as a filmmaker and artist. Although the *Screen Tests* series is a work of accumulation, not of duration—there is no evidence that anyone ever intended to show all the *Screen Tests* end to end—their collective running time of thirty-two hours is surpassed in sheer volume only by the forty-six hours of footage sandwiched into Warhol's twenty-five-hour multiscreen epic, ★★★★ *(Four Stars)*, which was projected only once at the end of 1967. The simplicity of the basic *Screen Test* format—each a silent, black-and-white close-up of a person lasting three minutes—and the casualness

and rapidity with which these films were produced are offset by their conceptual sophistication and by their centrality to Warhol's work as a portrait artist in the mediums of both film and painting. As rigidly formal as his early minimalist films, as society-conscious as his silk-screened portraits of the 1970s, as visually striking as his paintings of Hollywood movie stars, the *Screen Tests* are the stem cells of Warhol's portraiture: short, simple, and somehow more direct than his silk-screened paintings, these films not only contain the technical and conceptual seeds of Warhol's later painted portraits, but also present their subjects to us with an immediacy not often found in his other works.

When he began making his *Screen Test* portrait films, Warhol was a young and successful artist hard at work in the midst of the New York art scene during one of the most exciting and explosive decades in its history. Sally Banes described the significance of the New York scene in her book *Greenwich Village 1963*, when

> numerous small, overlapping, sometimes rival networks of artists were forming the multifaceted base of an alternative culture that would flower in the counter-culture of the late 1960s, seed the art movements of the 1970s, and shape the debates about postmodernism in the 1980s and beyond.[1]

Given the time and place, it is not surprising that the people Warhol filmed were a talented and fascinating group. Intricately interconnected

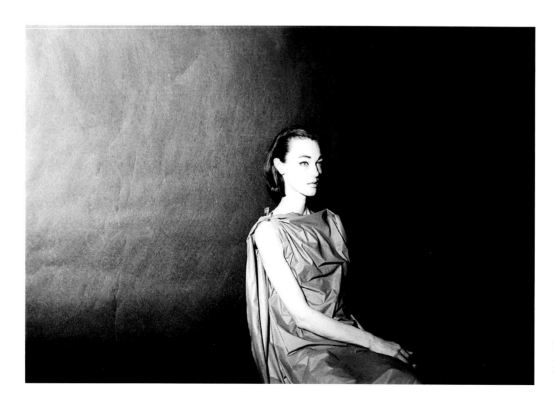

Ivy Nicholson poses for her *Screen Test* (ST235) at the Factory, 1966. Photograph by Billy Name.

and multithreaded, the network of individuals whose pictures Warhol collected in the *Screen Tests* offers a unique map of the New York downtown arts scene during a watershed period. Like a yearbook of the mid-1960s avant-garde, the *Screen Tests* contain photographic portraits of a diverse population of cultural figures, all linked through their shared connection, however brief, with Warhol and his camera: poets, artists, writers, filmmakers, musicians, dancers, models, speed freaks, opera queens, street people, performers, a smattering of celebrities and the wealthy as well as all grades of Factory personnel, from anonymous freshmen to superstars and other seniors.

Although the *Screen Tests* were not all-inclusive—it is interesting to consider who among Warhol's friends and acquaintances does not appear in these films[2]—they do show Warhol, somewhat surprisingly, in the role of social historian or ethnographer, systematically documenting the parade of talented artists and other significant characters he encountered at his studio and assembling a group portrait of considerable cultural and physiognomic complexity. The *Screen Tests* can also be read as a portrait of the artist himself, delineating the breadth of his friendships, his social connections and professional associations, his range of interests, his egalitarianism and opportunism, his eye for beauty and for talent, his appreciation of intelligence, his fascination with personality and the human face.

## II.

Warhol began making films in the early summer of 1963, when he first acquired his silent 16mm Bolex movie camera, on which all the *Screen Tests* would be shot. Warhol's 1963 films are a forecast of the directions his later cinema would take: casually intimate portraits and "home movies" of friends; an improvised feature-length spoof of Hollywood; early minimalist works such as *Sleep* and *Haircut*, which experimented with lack of action and increased duration to create a new kind of formalism for the medium of film; and a cumulative series, *Kiss*, in which individual three-minute rolls, each showing a couple kissing, were collected over a period of many months to create a longer, rather open-ended work.

One of the earliest themes of Warhol's filmmaking was his unique combination of duration with extreme stillness, a concept evident in his announced intention to make an eight-hour film that would show nothing but a man sleeping. Some of his earliest films were surprisingly successful in masquerading as still images, sometimes actually fooling viewers into believing that they were looking not at a motion picture, but at a freeze-frame or photograph. Irving Blum, for example, recalled his reaction on first seeing a very static *Kiss* roll starring Marisol:

> It may have been my first film experience of Andy's and I looked and looked and looked and looked and looked and I said, "It's a still. It's not a motion picture at all." And I looked and looked and looked and looked and *looked* and at one moment I remember Marisol blinking, and the *shocked* response of everybody in the audience. It was something I don't think I'll ever forget. It was just simply extraordinary.[3]

Given the success of this reversed Duchampian ploy—using a moving picture medium to create a still image—it seems natural that Warhol would move on to make films that were conceptualized and shot as direct approximations or imitations of still photography. The *Screen Tests* were, in fact, originally inspired by a collection of photographs, the mug shots of thirteen criminals that Warhol found in a New York City Police Department brochure titled *The Thirteen Most Wanted*. From this brochure, Warhol derived the idea for the first *Screen Test* films, a series of portrait films to be called *The Thirteen Most Beautiful Boys*. The earliest mention of these films is found in the

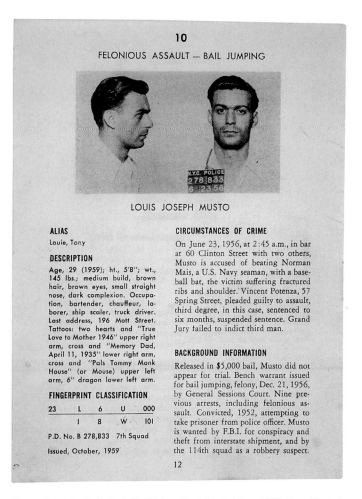

Source image for Andy Warhol's *Thirteen Most Wanted Men*, 1964: Most Wanted Man No. 10. Page 12 from *The Thirteen Most Wanted*, New York City Police Department booklet, February 1, 1962. Archives of The Andy Warhol Museum, Pittsburgh.

diary of Kelly Edey, who noted on January 17, 1964: "This afternoon Andy Warhol made a movie here, a series of portraits of a number of beautiful boys, including Harold Talbot and Denis Deegan and also me."[4] Kelly's description unquestionably identifies the work as *The Thirteen Most Beautiful Boys*; the specific *Screen Tests* mentioned in Edey's diary were also labeled "13" by Warhol (see ST31, ST73, ST89). The New York City Police brochure was also the image source for Warhol's commissioned mural, *Thirteen Most Wanted Men*, installed on the exterior of the New York State Pavilion at the 1964 World's Fair in Flushing Meadows, Queens, as well as for the silkscreened canvases that he produced from the same images (see Chapter Four for further discussion of the relationships between these works).

An earlier source for the *Screen Test* films can also be found in Warhol's series of photobooth photographs, which he began making in the late spring of 1963. For these portraits, Warhol used a public photobooth machine to obtain a vertical strip of black-and-white photographs of his sitter; each strip would contain four different exposures made at intervals of several seconds. The photobooth mechanism—a small room or booth in which a seated poser faces the camera for a predetermined length of time—is remarkably similar to the *Screen Test* setup at the Factory: both devices produce mechanical photographic portraits *over time*, which therefore can record change or movement. Warhol eventually assembled a large collection of photobooth photographs, using these images in some of his commercial projects and also

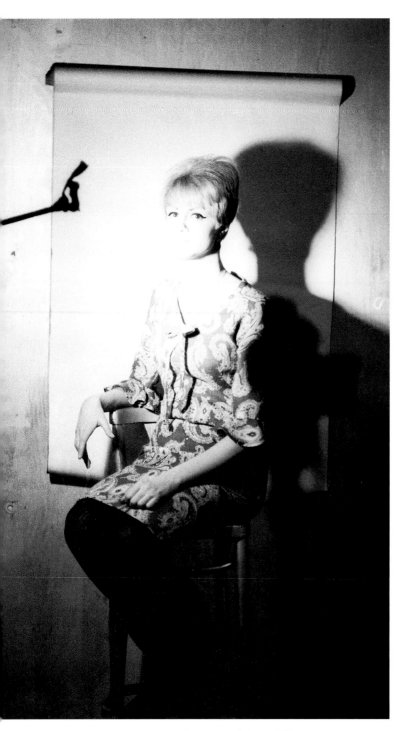

Ingrid Superstar posing for her *Screen Test* (ST332), 1965. Photograph by Billy Name.

created a set of diabolically challenging performance instructions for his sitters, who, suddenly finding themselves up against the wall and face-to-face with Warhol's Bolex, struggled to hold a pose while their brief moment of exposure was prolonged into a nearly unendurable three minutes. The subjects' emotional and physiological responses to this ordeal are often the most riveting aspect of the *Screen Tests*, adding complex layers of psychological meaning to the visual images structured by the artist. The films' silent projection speed further exaggerates these behaviors, revealing each involuntary tremor or flutter of an eyelid in clinical slow motion.

Although there is a great deal of variation throughout the *Screen Tests*, with many of the portrait films shot under much less rigid circumstances, it is interesting to follow the evolution of the static pose from the earliest *Screen Tests* onward. Some of the earlier portrait films were quite successful in achieving absence of motion; the *Screen Tests* of John Giorno and Barbara Rose, for example, resemble high-quality studio photography—flat, graphic, meticulously lit, and nearly entirely free of movement. The more static the films were, the closer they came to more traditional forms of art; by the fall of 1964, Warhol was even considering selling his *Screen Tests* as sculptural objects to be called *Living Portrait Boxes*,

> which might sell for $1,000 or $1,500 each, [and] would be 8 mm. loops of the sort that showed four Warhol films at the New York Film Festival. The LPB's would be just like photographic portraits except that they would move a little.[6]

In most cases, however, the demands of still photography proved too much for the posers. For example, the few people who actually did succeed in not blinking for an entire three minutes under bright lights were usually reduced to reactive weeping by the ordeal; the tears welling up in their eyes and rolling down their cheeks destroy all illusion of still photography, while adding an interesting facade of emotionality to their portraits. Some subjects seem overcome with self-consciousness, squinting into the bright lights, swallowing nervously or visibly trembling, while others rise to the occasion with considerable force of personality and self-assurance, meeting the gaze of Warhol's camera with equal power. As the collection of *Screen Tests* grew, these provoked responses gradually became the overt purpose or content of the films, superseding the original goal of the achieved, static image. Some later *Screen Tests* seem to have been deliberately staged to make things as difficult as possible for the subjects, with bright lights placed close to their faces and shining right into their eyes; some sitters, including Warhol himself, resorted to wearing dark glasses in self-protection.

In light of these intentional difficulties, the *Screen Tests* may be viewed as a series of allegorical documentaries about what it is like to sit for your portrait, with each poser trapped in the existential dilemma of performing as—while simultaneously being reduced to—his or her own image. In this sense the *Screen Tests* should be recognized as true collaborations, films in which the subjects have at least as much control as the artist in determining the outcome of the finished work. Balanced on the borderline between moving and still image, part photography and part film, part portraiture and part performance, the *Screen Tests* are conceptual hybrids, arising, like much of Warhol's work, from the formal transposition of idioms from one medium to another. Their depth of subjectivity is in marked contrast to the cosmeticized faces and depthless surfaces of Warhol's painted portraits, whose flatness, in turn, seems to evoke the ephemerality of the projected film image.

as the basis for silk-screened portraits of Ethel Scull, Bobby Short, Judith Green, Holly Solomon, and himself.[5]

In conceptualizing his film portraits as cinematic versions of mug shots or ID photographs or even photobooth photos, Warhol automatically provided himself with a set of simple rules to follow, rules similar to those required for passport photographs: the camera should not move; the background should be as plain as possible; subjects must be well lit and centered in the frame; each poser should face forward, hold as still as possible, refrain from talking or smiling, and try not to blink. By transposing the conventions of the formal or institutional photographic portrait into the time-based medium of film, he

### III.

The Warhol *Screen Tests* were never real screen tests in the conventional sense of the word; that is, these films were not test rolls used to determine whether or not people would be chosen to perform in other Warhol films. These films were not even called "Screen Tests" at first, but were usually referred to as "film portraits" or "stillies," a playful Factory term derived from the static nature of these famously unmoving "movies." Judging from notes written on the film boxes, the term "Screen Tests" did not come into use until the end of 1965 or the beginning of 1966, around the time that Malanga and Warhol began planning their collaborative compilations, *Screen Test Poems* and *Screen Tests/A Diary*; only twelve films in the series are actually labeled "Screen Test" on their boxes.[7]

The making of *Screen Tests* at the Factory was a casual and irregular process. Although some people recall being specifically invited by Warhol to come to the Factory so he could film their *Screen Test*, other portraits were filmed more spontaneously, arranged on the spot when subjects dropped by. Most people recall that the shooting of their *Screen Test* took place in a matter-of-fact way, without drawing much attention from others at the Factory, in a small space against the wall where the tripod-mounted camera, lights, and a chair had already been set up. Some people recall Warhol adjusting and starting up the camera and then walking away to work on other projects until their three-minute roll was finished, a kind of desertion that could be very unnerving.

Gerard Malanga recalled the spirit in which *Screen Tests* were made:

> There were so many different things happening at the Factory, between painting and making movies and whatever other projects we were doing, that it really wasn't a priority. In fact, just to do a *Screen Test* really became a kind of fun thing, in a sense, because it really wasn't going to amount to much in terms of whether we were going to use this person in something . . .
>
> Sometimes it was a surprise, if a person came to the Factory, they didn't know they were going to get their *Screen Test* done. . . . The Bolex wasn't just set up all the time on the tripod, we did have to take the camera out of the box and put the tripod up. Otherwise, out of carelessness someone could walk into it and knock it over . . . But it was very spontaneous, it was easy to set it up real quick and do it. Most of the time, it was never a pre-arranged thing.[8]

This casualness did not always extend to the personal feelings of the subjects; many people recall feeling anxious, self-conscious, and even trapped during their three minutes in front of the camera, while others found the experience enjoyable. Only a few people were filmed without their knowledge, captured from a distance by Warhol's camera while they happened to be absorbed in reading (see Arman, Grace Glueck, Alan Solomon). Many people never saw their *Screen Tests* afterwards; some recalled being disappointed by not seeing themselves included in screenings of *The Thirteen Most Beautiful Women*.

There are some significant evolutions in the style of these films during the three years that Warhol worked on them. The earliest portraits, shot for the *Thirteen Most Beautiful* series, are mostly centered head shots, with people facing forward and lit evenly from both sides, a lighting design that had the effect of creating symmetrical, Rorschach-like shadows down the center of the subjects' faces. Others

Ivy Nicholson prepares for the shooting of her *Screen Test* (ST235) at the Factory, 1966. Photograph by Billy Name.

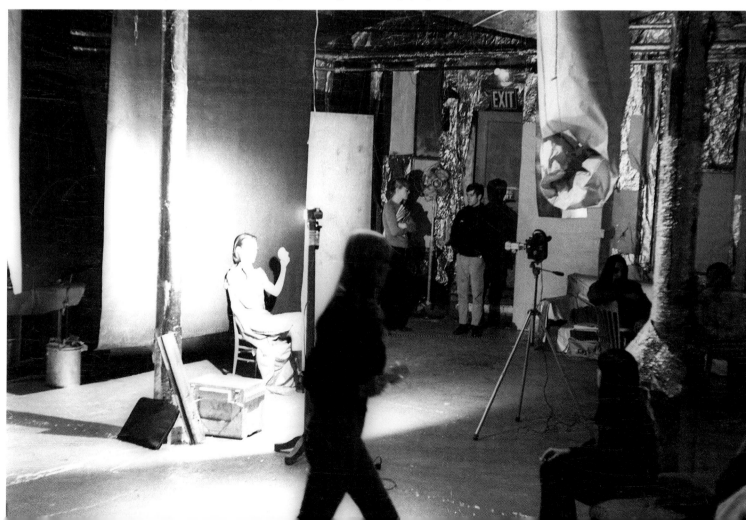

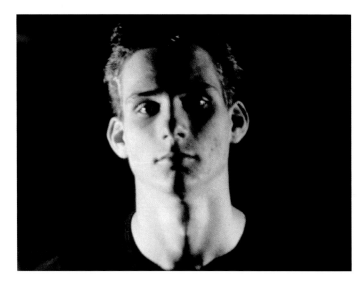

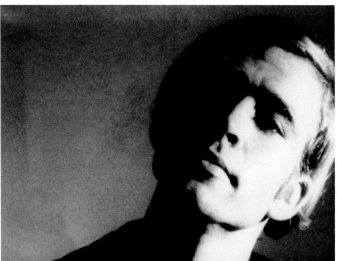

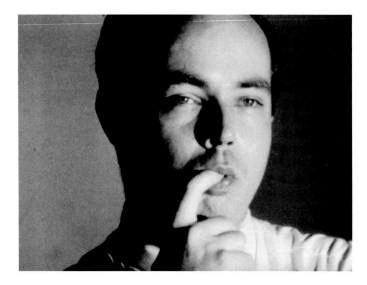

ST24. *Binghamton Birdie*, 1964.
ST218. *George Millaway*, 1966.
ST151. *Ed Hood*, 1966.

were posed in three-quarter profile, which resulted in more three-dimensional, sculptural images. The lighting gradually became more diverse and sophisticated, progressing from symmetrically placed light sources to multiple, asymmetrical light sources, backlighting, and indirect or diffused lighting. Later films from 1965 and 1966 were more dramatically lit, with bright "sun-gun" lights used to create high-contrast, half-moon lighting, which bisected people's faces into stark areas of light and shadow.

Warhol's care in the making of these films is apparent throughout. A number of different backgrounds were used: black or white cloths pinned to the wall, a pull-down movie screen, a painted brick wall, a sheet of plain plywood, painted plywood, a large paper backdrop, or sometimes just the glittering, out-of-focus space of the silver Factory. In some cases (see, for example, Lawrence Casey and Katha Dees), Warhol would select a white background to set off the dark hair and pale skin of one poser, and then, a few minutes later, purposefully switch to a black background for a fair-haired subject. Warhol often shot two, or sometimes three, rolls of a particular person in one session: in many of these sequences, one *Screen Test* would be more formal than the other, with the poser carefully holding still in one roll, and then appearing much more casual and relaxed, sometimes smoking or talking, in the other. Other adjustments in the camerawork and posing are apparent as well; a shift from close-up in one film to slightly tighter close-up in the second (see Olga Klüver), or simply a slight change in the tilt of the head between rolls (see Barbara Rose). Some pairs of *Screen Tests* (see Cliff Jarr, Peter Hujar, Donyale Luna) include a close-up roll as well as a long shot showing the full figure of the poser in the surroundings of the Factory.

This degree of attention is also evident in the number of times that Warhol reshot certain subjects, carefully noting on the boxes when films weren't good, and trying again later. The extended series of *Screen Tests* of certain people that were shot over weeks, months, or years, such as those of Jane Holzer, Edie Sedgwick, Ivy Nicholson, Susan Sontag, Lou Reed, and Nico, suggests that some people, perhaps those with star potential, particularly interested him as subjects and that their *Screen Tests* therefore deserved repeated and sustained effort. Warhol's extensive experience in shooting these portrait films, and what he learned in the process about the framing, lighting, and posing of his subjects, would form the foundation of his later work as a portrait painter in the 1970s and 1980s, when he used his own Polaroid photographs to create scores of silk-screened portraits.

Another pattern noticeable in the *Screen Tests* is the great number of oral activities that posers engage in, a major variation on the frozen nonblinking pose of the "classic" *Screen Test*. These bits of oral busyness include smoking, gum chewing, eating, drinking, finger-sucking, toothbrushing, the application of dental floss or lip balm, and sometimes talking or even singing. Occasional head-bobbing and shaking and other rhythmic movements are indicators of music being played in the background during the filming. Other films are more clearly performative, with Donyale Luna demonstrating her modeling moves, Harry Smith making Eskimo string figures, Beverly Grant ensnaring herself in her own hair, and James Rosenquist spinning on a piano stool. Some posers break the rules entirely, leaving the frame altogether (Bob Dylan, Harry Fainlight) or helplessly collapsing in laughter (Irving Blum).

Some additional patterns have emerged in the process of researching and cataloguing the *Screen Tests*. One discovery has been the surprising number of couples included in these portraits, some of whom appear together in the same film (see, for example, Eric Andersen and Debbie Green, Debbie Caen and Gerard Malanga, Mary Woronov and Gerard Malanga). A number of other couples and even families had their portrait films made separately, but possibly at the same

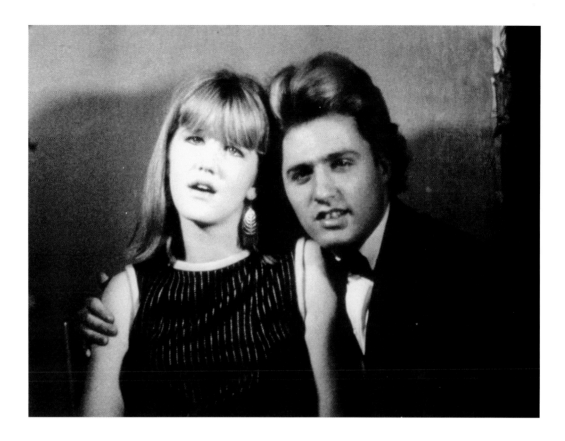

time: Ivy Nicholson, John Palmer, and their daughter, Penelope; Ivan and Marilynn Karp; the actor Zachary Scott, his wife Ruth Ford, and her brother Charles Henri Ford; Dennis Hopper and Brooke Hayward; Allen Ginsberg and Peter Orlovsky; Piero and Kate Heliczer; Willard Maas and Marie Menken; Katha Dees and Lawrence Casey. Another discovery has been a series of portraits of wives of artists and other notable men: Julie Judd, wife of Donald Judd; Susanne De Maria, wife of Walter De Maria; Clarice Rivers, wife of Larry Rivers; Marian Zazeela, wife of the composer La Monte Young; Sheila Oldham, wife of the Rolling Stones's manager Andrew Loog Oldham; and Olga Klüver, wife of the engineer and art collaborator, Billy Klüver. It is not certain what significance this collection of famous spouses held for Warhol, but it seems to be a clear trend; none of their husbands appear in the *Screen Tests*, and apparently none were invited to pose. Intellectuals, especially intellectual women, also seemed to hold a certain fascination for Warhol: the *Screen Tests* of Susan Sontag, Grace Glueck, Barbara Rose, and Rosalind Constable represent yet another minor grouping among the numerous ethnographic categories discernible in these films.

The production of *Screen Tests* at the Factory could be something of a group effort, with Warhol variously receiving assistance from Billy Linich, Gerard Malanga, Paul Morrissey, Dan Williams, or others in loading and positioning the camera, setting up the chair and lights, and so on. There are no photographs that show anyone other than Andy Warhol operating the camera during a *Screen Test* shoot, but Malanga or Morrissey are sometimes seen standing close by; a 1966 photograph by Nat Finkelstein, for example, shows Morrissey using a light meter as he helped Warhol prepare to shoot Marcel Duchamp's *Screen Test* at the Cordier and Ekstrom Gallery. The lighting was often arranged by Linich, but could also be done by Warhol alone (as can be seen from his notes on the film boxes for *Six Months*). A few *Screen Tests* were shot by people other than Warhol, notably Gerard Malanga, Dan Williams, and possibly Paul Morrissey, but these occasions were

exceptions; as a rule, it seems, if Warhol was present at the shooting of a *Screen Test*, he retained control of the camera.

Given the absence of specific credits for individual *Screen Tests*, the question of proper credit for these films remains a contentious issue. Gerard Malanga, who was Warhol's paid studio assistant, often assisted Warhol with this project, working diligently to bring in subjects to pose for Warhol's camera and sometimes shooting *Screen Tests* when Warhol was not present (see, for example, Giangiacomo Feltrinelli, Charles Henri Ford, François de Menil, Phoebe Russell). But many *Screen Tests* were filmed without Malanga's involvement, and other people, especially Billy Linich, made significant contributions to the series. It seems to have been clearly understood, at the time, that any such assistance was given exclusively for Warhol's films, that is, not for films made by or credited to anyone else. Although Malanga feels he should receive equal credit as collaborator for all the *Screen Tests*, it is the view of this author that Malanga's real collaborations with Warhol should be considered to be those projects, such as *Screen Test Poems* and *Screen Tests/A Diary*, in which Malanga's poems were combined, in different media formats, with Warhol's films.[9]

**IV.**

Throughout 1964, Warhol used his silent Bolex camera for the making of all his movies, loading it over and over again with 100' lengths of film to shoot his minimalist classics *Eat* and *Blow Job*, the lengthy (and largely unfinished) compilations *Couch*, *Soap Opera*, and *Batman Dracula*, and other titles like *Taylor Mead's Ass*, *Dinner at Daley's*, and *Banana*, as well as more than 200 *Screen Tests*. At the end of 1964, Warhol acquired his 16mm Auricon camera, a sync-sound camera that could hold 1,200' (or thirty-three minutes) of film at a time, the same camera he had rented in July for the making of *Empire* and *Henry Geldzahler*. This was the camera on which he would shoot all of his feature-length sound films from then on.

With the arrival of the Auricon, the Bolex was now freed up, available at any time for the making of *Screen Tests*; nevertheless, the production of *Screen Tests* declined somewhat during 1965, as Warhol and his colleagues became more and more involved with the weekly organization of elaborate, sometimes scripted narrative films. Apart from a few short rolls shot mostly in connection with these features, the *Screen Tests* are the only silent films made by Warhol after 1964.[10]

Around the beginning of 1966, the making of *Screen Tests* at the Factory underwent a noticeable shift. The original compilation series, *The Thirteen Most Beautiful Boys* and *The Thirteen Most Beautiful Women*, which had served so successfully as conceptual pretexts for the shooting of so many portrait films, were abandoned as Warhol and his colleagues became involved with a new project, the organization of large-scale multimedia presentations surrounding performances of the Velvet Underground, the rock-and-roll group whose management Warhol had taken on. The production of *Screen Tests* actually increased in 1966, as more portrait films were shot specifically for these mixed-media environments, known as the Exploding Plastic Inevitable. These 1966 *Screen Tests*, which frequently featured EPI performers (Lou Reed, John Cale, Sterling Morrison, Maureen Tucker, Nico, Gerard Malanga, Mary Woronov), often demonstrate a surprising amount of camera movement—jiggles, swerves, sudden in-and-out zooms, as well as in-camera edits, extreme close-ups, and rapid changes in aperture settings. Some of these stylistic developments might be traced to the influence of Dan Williams, whose films from this same period (also shot on Warhol's Bolex) contain many of the same techniques. The camerawork also reflects the circumstances under which the *Screen Tests* were now being projected: large and dramatic camera movements were intended as accompaniments to the overpowering sound of the Velvet Underground's rock-and-roll music, adding to the generally disorienting effect of the EPI, which

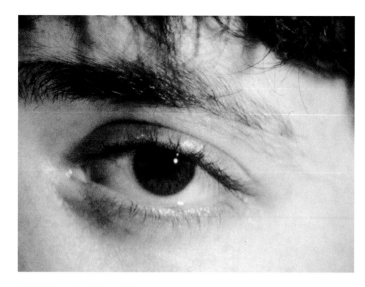

**ST265.** *Lou Reed (Eye)*, 1966.

**Lou Reed, in silhouette, appears against a Nico** *Screen Test*, **ST238 (roll 12 in ST370,** *EPI Background*)**, projected during a performance of the Exploding Plastic Inevitable at the Dom, New York City, April 1966. Photograph by Nat Finkelstein.**

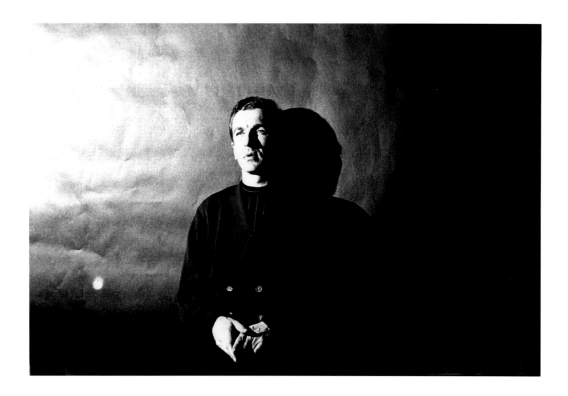

included strobe lights, dancers, patterned slides, multiscreen film projections, and filmmakers moving through the audience with bright lights. (Reels of *Screen Test* prints used in the EPI are catalogued in Chapter Five.)

During 1966, a few other *Screen Tests* were also shot for inclusion as "background reels" projected behind the actors during the filming of *The Chelsea Girls*. The last *Screen Tests* were made around the end of 1966, as Warhol and his colleagues moved on to the production of the many reels and sequences needed for their enormous multi-screen project, ★★★★ *(Four Stars)*, which would not be completed until December 1967.

The *Screen Tests* were not often shown in public in the 1960s; in addition to some limited distribution of *Six of Andy Warhol's Most Beautiful Women* through the Film-Makers' Cooperative and in Europe, the largest number of public showings of *Screen Tests* occurred during performances of the Exploding Plastic Inevitable in 1966 and 1967. The explanation for this lies, in part, in their physical unwieldiness; hundreds of individual 100' films could not easily be projected or assembled into reels without considerable trouble and expense. However, individual *Screen Tests* were apparently projected at the Factory fairly often and also at parties, sometimes even with colored filters placed over the projector lens (see Bob Dylan); the discovery of heavy scratches on some originals indicates that these films were particularly popular and frequently projected.

After Warhol withdrew his films from circulation around 1970, all the Warhol films, including the *Screen Tests*, remained unseen and unavailable for nearly twenty years. After Warhol's death in 1987, the first exhibition of Warhol's 1960s films was held at the Whitney Museum in New York in 1988, followed shortly by the release of newly restored prints of thirteen Warhol films by The Museum of Modern Art. The first group of *Screen Tests* was preserved and released by MoMA in 1995 (see Appendix C for a detailed listing of the preserved *Screen Tests*).

Warhol is now acclaimed as one of the most important artists of the second half of the twentieth century; his films are finally receiv-ing long-overdue recognition as one of his greatest accomplishments, a body of work central to his achievement as artist, filmmaker, and portraitist. With many of the portrait films now preserved, new prints made available, and screenings regularly held in museums, theaters, and universities around the world, the *Screen Tests* will undoubtedly accumulate a more extensive exhibition history than they have had in the past. They will also acquire new meanings in the course of this regeneration. No longer simply casual, homemade portraits of friends and acquaintances, these films must now be seen through added layers of cultural and art historical significance—as one of Warhol's earliest and most ambitious investigations into the art of portraiture, as his largest and most complex film series and a major achievement of his minimalist cinema, and as a detailed record of a specific period in the history of avant-garde art, a complex group portrait of an intricately interrelated art world of multiple disciplines and enormous creativity. Nevertheless, like all the Warhol films, the *Screen Tests* are best appreciated as living remnants not only of the mid-1960s Warhol Factory and its occupants but also of Warhol's mind and eye. The immediacy of these works and the access they provide to Warhol's creative process will, one hopes, lead to new and more fully informed interpretations of his work as well as greater understanding of the scope of his genius as both a filmmaker and an artist.

# Chapter One
# Cataloguing and Methodology

The cataloguing of the Warhol films in this publication is based on the recognition that: (a) film is a specific physical medium with particular characteristics; and (b) any real understanding of Warhol's cinema must be founded on an understanding of the physical medium in which he worked. Now that motion pictures are widely and most readily accessible in electronic formats, shown as videotapes and digital transfers on television, the Internet, at home, and even in movie theaters and museum galleries, it has become more important than ever to ground the Warhol films in the specific physical medium to which they belong—and that is the translucent, photographic, mechanical, and by now nearly historical medium of film.

At the same time, the replacement of celluloid film formats with cheaper, more accessible, easy-to-use electronic formats is an unavoidable fact of contemporary media practice; fewer and fewer institutions have 16mm film equipment or the experienced staff needed to operate it. Although all the Warhol films have been preserved in 16mm, and only in 16mm, by The Museum of Modern Art, they have also been shown as digital transfers on video monitors or as projected video images or even broadcast on television, forms of exhibition that will undoubtedly continue into the future despite the unfortunate loss of image quality involved.

The cataloguing of the film materials in this book is based on the premise that motion picture film has two manifestations—that, in a sense, it can occupy two different realities and demonstrate different characteristics in each of these two states. The first and most familiar manifestation of film is its appearance when it is screened—what a motion picture looks like in motion, while you are watching it. A projected movie is black-and-white or color; it has sound or it is silent; it has a content composed of moving images, possibly including different shots; and it has a specific duration, its running time. In a way, these characteristics transcend medium, since they should (at least in theory, if not always in practice) remain the same whether the film is projected as a film, transferred to videotape or digitized, or broadcast on television. The other manifestation of film lies in its reality as a physical object—the characteristics that a film exhibits when you hold it in your hands. In its hands-on, material form, a film is composed of sequences of single images (or frames), it has length (but no running time), it may or may not contain physical splices, and it has a host of other technical characteristics (gauge, type of stock, date of stock, type of sound track, generation of image) that are not readily apparent when it is projected.

These two sets of characteristics are, of course, interrelated: for example, a film's running time is a direct function of its physical length and its projection speed. The quality of the film image is in part determined by the type of film stock on which it was shot, as well as by the generation of the image (original or internegative, first or second-generation print, video or digital transfer, etc.). The relationship between these two realities of cinema—film as moving image and film as physical object—defines the craft of filmmaking and much of the art as well. This is something Warhol understood very well: the development and direction of much of his silent cinema, including all

the *Screen Tests* as well as the minimalist works, which began with *Sleep* (1963) and culminated in *Empire* (1964), were founded upon his recognition of the direct physical relationship between footage, projection speed, and running time—a phenomenon that allowed him to pursue his interests in cinematic duration and stillness to lengths never achieved before or since.

The history and descriptions of Warhol's cinema outlined in these books rely heavily on an informed comparison of these two sets of motion picture data. A great deal of information about these films, and about Warhol's filmmaking practice, can be derived from inspection of actual film materials. For example, a certain film may contain a series of different shots; if physical inspection of the camera original reveals that there are no splices in the original film, this is definitive evidence that these are in-camera edits—that is, these different shots were obtained by turning the camera off and on again during shooting and not by cutting and splicing the film after it was developed. Scratches and dirt on a particular *Screen Test* are a clue that this film was projected frequently at the Factory or elsewhere. The addition of white leader at the beginning of an original *Screen Test* suggests that a copy of this film was made at some point, since this white leader was often added by the laboratory before printing.

This dual approach to the cataloguing of the films is reflected in the individual film listings, each of which contains: (a) a standard filmographic entry, which catalogues title, date, medium (gauge, color or black-and-white, sound or silent), running time, cast, and credits; and (b) a film materials entry, which records date and type of stock, generation of film image, length in feet, as well as any notations found on the original film box. The materials catalogued in this publication are those found in the Warhol Film Collection after Warhol's death. Now the property of The Museum of Modern Art, they are kept in climate-controlled storage at MoMA's Celeste Bartos Film Preservation Center. Internegatives and new prints, which have been generated since Warhol's death as part of MoMA's preservation process, are not catalogued herein, although preserved materials have been identified. Some prints and/or originals of Warhol films located elsewhere, outside MoMA's holdings, have also been included in this catalogue, although inspections of these film materials were usually not performed and less information is available, as noted.

The 472 *Screen Tests* catalogued in this volume were located and identified in the course of screening the 834 silent 100' rolls found in the Warhol Film Collection. The remaining 100' rolls not identified as *Screen Tests* were mostly shot for longer film projects like *Sleep*, *Kiss*, *Batman Dracula*, *Soap Opera*, *Couch*, and *Banana* (these rolls will be catalogued separately under the applicable titles in Volume 2). A few additional *Screen Tests* were found in other locations, either spliced into longer compilation reels or documented from other sources; some *Screen Tests* exist in print form only, as noted in the individual entries.

The procedure for cataloguing the *Screen Tests* was as follows: each film was inspected on a 16mm Cinescan machine, a screening machine designed for viewing archival materials that handles film

very gently. All notations written on the boxes and film cans as well as on the heads and tails of the rolls were copied down. Each film was screened in its entirety and a brief description of its contents was written up. The exact footage for each roll was measured on the Cinescan's mechanical footage counter, the date code and stock type of each film was noted, and at least one 35mm photograph of each film was taken from the Cinescan screen, with the film's inventory number included in the photograph as a reference. These photographs and the cataloguing data were then used as a general guide for the preservation of the *Screen Tests*. The photographs were also used to obtain further identifications of the subjects in interviews with Warhol's colleagues, and also to match prints of *Screen Tests* with their originals; the photos also helped to avoid confusion in cases of very similar *Screen Tests*. All the *Screen Tests* were subsequently rephotographed in 35mm, using a macro lens and light stand and with the Cinescan photos as a guide, to create the illustrations for this publication. Since the *Screen Tests* are often so static, in many cases a single still image really does serve as adequate representation of the film's content. For other *Screen Tests*, two stills were made. The illustrations in this catalogue were created from high-resolution digital scans of the 35mm negatives.

---

**Catalogue Data Sample Entry**

**1 ST308   2 *Edie Sedgwick,*   3 1965**
**4** 16mm **5** b&w **6** silent; **7** 4.6 min. @ 16 fps, 4.1 min. @ 18 fps
**8** Cast and credits
**9** Preserved 1995, MoMA *Screen Tests* Reel 10, no. 6
**10** COMPILATIONS *Screen Test Poems* (ST372); *Screen Tests/A Diary* (Appendix A)
FILM MATERIALS
**11** ST308.1 *Edie Sedgwick*
**12** 1965 **13, 14** Kodak 16mm b&w double-perf. reversal original
**15** 110'
ST308.1.p1 *Screen Test Poems*, Reel 2 (ST372.2), roll 14
Undated Gevaert 16mm b&w reversal print, 100'
**16** NOTATIONS On original box in AW's hand: *edie. split*
On box in Gerard Malanga's hand: *Edie Sedgwick. One double frame negative and one 8" x 10" glossy double-frame print*

---

**1.** *Catalogue number*
Each individual *Screen Test* has been assigned its own catalogue number. The number before the decimal point refers to the titled work itself, which may exist in multiple copies or in different formats. Numbers after the decimal point are used to indicate physical film materials, both originals and prints, associated with that work (see also "Film Materials" below). In addition, each compilation title or reel has been assigned its own catalogue number, with its contents cross-referenced to individual *Screen Tests* by their catalogue numbers.

**2.** *Title*
In most cases, the title of a Warhol *Screen Test* is the name of the person who appears in it. For many films, this name matches the name found on the box; in some cases, further identifications were required. In a few instances, especially where there are a number of *Screen Tests* of one person, more information has been added in parentheses to aid in differentiating similarly titled films (see, for example, *Lou Reed*

*[Coke]* or *John Cale [Lips]*). In cases where a person's last name is unknown, the first name is used as the title and in the alphabetical listing of names.

**3.** *Date of film*
As explained below under "Date of Film Stock," the *Screen Tests* have been roughly dated by the year code that is printed on the Kodak film stock, which usually—but not always—corresponds to the year the film was made. Additional information from other sources, such as dates written on the film boxes or notations found in people's diaries, sometimes allows more specific dating, as explained in the notes on individual films.

**4.** *Film gauge*
Motion picture film comes in various sizes: 8mm, 16mm, 35mm, 70mm. With very few exceptions (see Volume 2), all the Warhol films are 16mm; all *Screen Tests* are 16mm.

**5.** *Black-and-white or color*
Although the great majority of the *Screen Tests* are black-and-white, nine of these portrait films were shot in color, as noted and as illustrated (see Philip Fagan (ST94), Cathy James (ST164), Gerard Malanga (ST200), Edie Sedgwick (ST310–313), Patrick Tilden-Close (ST339–340)).

**6.** *Silent*
All the Warhol *Screen Tests* lack sound tracks and are silent.

**7.** *Running time*
As a rule, all of Warhol's silent films were shot at the regular sound speed of 24 frames per second (fps), and then projected at the silent film speed of 16 fps. This has the effect of creating a kind of slow motion and increasing the running time of the projected film by about 50 percent. It takes 2.77 minutes to shoot 100' of 16mm film at sound speed (24 fps), which lasts 4.2 minutes when projected at silent speed (16 fps).

Until the end of the 1960s, the standard for 16mm silent projection speed was 16 fps. Around 1970, however, the industry standard for silent speed was increased to 18 fps in order to eliminate perceptible flicker; most projectors in use these days run at a silent speed of 18 fps. This means that the Warhol films are now usually projected at a rate slightly faster than the speed he used in the 1960s. The difference is slight for 100' films, but becomes increasingly significant as the length of a film increases. Running times for both 16 fps and 18 fps have been provided for each *Screen Test*.

The running time of 16mm film is calculated as follows:

At 24 fps, $\dfrac{\text{footage}}{36}$ = running time in minutes

At 18 fps, $\dfrac{\text{footage}}{27}$ = running time in minutes

At 16 fps, $\dfrac{\text{footage}}{24}$ = running time in minutes

All running times have been calculated to the nearest tenth of a minute.

**8.** *Cast and credits*
With a few exceptions, the cast of each individual *Screen Test* is named specifically in the title, and has therefore not been listed separately. The casts of the compilation reels have been listed in order of appearance.

It has been very difficult, if not impossible, to determine exactly who shot a particular *Screen Test*. Judging from the recollections of subjects and from contemporary photographs, the great majority of the *Screen Tests* seem to have been posed and shot by Warhol himself; Gerard Malanga identified a few other films to the author as having been shot by himself (see Charles Henri Ford (ST105), Phoebe Russell (ST288), and Giangiacomo Feltrinelli (ST101)).[1] Given the general lack of specific information for the technical credits for the *Screen Tests*, the filmographic entries do not include categories for "camera" or "lighting."

**9.** *Preservation*
This entry indicates whether a particular *Screen Test* has been preserved, the date of preservation, and its exact location within the preserved MoMA *Screen Test* reels. See Appendix C for a description of the preservation process, and a complete listing of the 277 *Screen Tests* available from The Museum of Modern Art at the time of publication. The internegatives and prints made during the preservation process have not been assigned catalogue numbers in this book.

**10.** *Compilations*
Many of the Warhol *Screen Tests* were shot or selected for inclusion in various compilation works, which have also been catalogued in this volume. These compilations fall into several categories: (1) the conceptual series *The Thirteen Most Beautiful Boys*, *The Thirteen Most Beautiful Women*, and *Fifty Fantastics and Fifty Personalities*; (2) the "background reels," which are longer reels of assembled prints of selected *Screen Tests* that were projected during performances by the Velvet Underground or during poetry readings by Gerard Malanga; and (3) the collaborative publication *Screen Tests/A Diary* by Malanga and Warhol, which apposed double-frame images from *Screen Tests* of fifty-four people with poems written by Malanga (see Appendix A). All *Screen Tests* have been cross-referenced to the compilations in which they were included. Multiple versions of some compilations, such as *The Thirteen Most Beautiful Women*, have been differentiated by alphabetical suffixes.

**Film Materials**

**11.** *Catalogue number*
As explained above, each separate piece of film has been assigned a decimal number. A print is indicated by the addition of the letter "p" to the catalogue number for the original from which it was made.

**12.** *Date of film stock*
All Kodak original motion picture stock is manufactured with a yearly date code preprinted into the edge of the film. This date code—which consists of combinations of symbols such as triangles, squares, circles, and crosses—records the year that that particular piece of film was manufactured by Kodak.

Kodak stock has a shelf life of about eighteen months—that is, the film does not become outdated until eighteen months after it has been manufactured. After 1963 Warhol tended to buy most of his film stock directly from Kodak or from professional suppliers, whose stock would be fresher and more up to date than, say, that of a local camera store. In the Warhol *Screen Tests*, films shot on last year's stock

seem to occur only in the first two to three months of the new year. A *Screen Test* shot on 1965 stock could not possibly have been shot in 1964, but might have been shot as late as March 1966.

**13.** *Types of film stock*
The vast majority of the Warhol *Screen Tests* were shot on Kodak Tri-X motion picture reversal stock, which is high-contrast black-and-white film. On rare occasions, Kodak Ektachrome color film was used, as well as other brands of 16mm black-and-white film stock, such as Dupont, Gevaert, or Anscochrome, but these non-Kodak stocks cannot be dated.

Reversal motion picture stock is just like slide film: the original film is exposed in the camera, sent to a lab for developing, and then this same piece of film is returned as a positive image. This piece of exposed, developed film is called the "camera original." Reversal stock is also used to make reversal prints from camera originals. No original negatives or internegatives of *Screen Tests* were found in the Warhol Film Collection. With one exception (see Edie Sedgwick, ST313), all *Screen Tests* were shot on reversal original stock, and all prints of *Screen Tests* found in the Collection are reversal prints. The words "reversal original" in this catalogue refer, therefore, to the actual piece of film exposed in Warhol's camera. In some cases, as noted in specific entries, the original film was not found in the Collection, and only a print has been catalogued.

**14.** *Perforated stock*
Most motion picture film is "single-perf.": that is, it has a single row of sprocket holes, or perforations, running down one edge of the film strip. The other, unperforated edge can carry a sound track. Single-perf. film can be run through a projector right side up or upside down and backward, but it cannot be projected with the image flipped right to left, since the sprockets would not fit the machine.

"Double-perf." film has sprocket holes running down both sides of the film strip; it is always silent. Double-perf. film is reversible in two directions: that is, the film can be run through a projector flipped left to right, as well as upside down. Early in his filmmaking, Warhol occasionally used double-perf. film stock for the *Screen Test* films, but this practice was later discontinued, possibly to reduce mis-winding of films and confusion about image orientation.

**15.** *Footage*
The footage of a film is its physical length, measured in feet; footage and projection speed determine the running time (see "Running Time" above). A brand-new 100' roll of 16mm film actually contains about 110' of film, to allow for extra footage for threading the camera and for damaged footage exposed to light in the normal course of loading and unloading the camera. This overexposure is visible in most of the Warhol *Screen Tests* in the fade-in, from clear footage into image, at the beginnings of most rolls, and the fade-out, from image into whiteness, at the ends. Although many filmmakers cut out the overexposed frames at the beginnings and ends of their rolls, Warhol usually did not. When he spliced 100' rolls together to make longer films, he usually included all the clear footage at the beginnings and ends of the rolls, so the individual rolls are separated by sections of whiteness.

The footage counts for the *Screen Tests* in this book therefore include *all* the footage in each roll, not just image-bearing footage, and are therefore often longer than 100'. Since *Screen Tests* are seldom projected individually and are instead usually shown assembled into larger reels, with the clear footage at the head and tail of each roll included in between the films, this longer footage count allows a

more accurate calculation of running times for compilation reels. The actual image-bearing footage for each *Screen Test* is, on average, about 3' (or six seconds) shorter than the footage listed.

**16.** *Notations*

The great majority of the *Screen Tests* were found stored on 100' metal reels inside metal cans inside small yellow cardboard Kodak boxes, the same boxes in which the original 100' rolls were sold by Kodak. Most of these boxes bear some kind of handwritten notes. Some of these notations appear to have been made at the time the film was shot; others were made when the film came back from the lab and was screened for the first time; and occasionally additional notes were added later. Boxes are identified as "original" when the only notations written on them clearly refer to the films they contain. Some boxes originally contained different footage, and were relabeled when used for *Screen Test* storage. A few *Screen Tests* were found stored in the wrong boxes, as noted in individual entries. Where possible, the handwriting in the notations on each box has been identified. Misspellings have not been corrected. For purposes of clarity, some punctuation has been added to the notations: a period indicates the end of a line. Some notations found on the film boxes were considered irrelevant and have been omitted from this catalogue; these include numbering systems used by film labs (usually batch numbers used in processing, such as, for example, "512 on 14—3") and internal numbering and labeling systems used for storage at the Factory, usually written on the box flaps.

Some additional notations were found written on the clear footage at the head and/or tail of some *Screen Tests*, or on leader spliced to a few of the films. These notations—usually numbers—are mostly related to the ordering of *Screen Test* films into larger compilation reels, and match the numbers that appear at the beginnings and ends of the prints in these reels (see Chapter Five for details on these numbering systems).

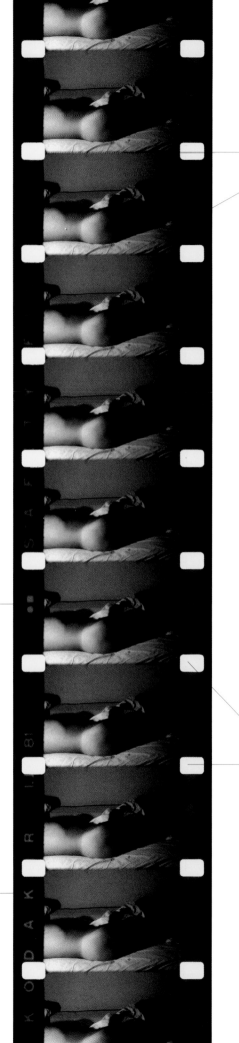

Frame lines

Date code

Sprocket holes

Manufacturer

1962 Kodak 16mm b&w double-perf. film
(from Andy Warhol's 1963 film *Sleep*).

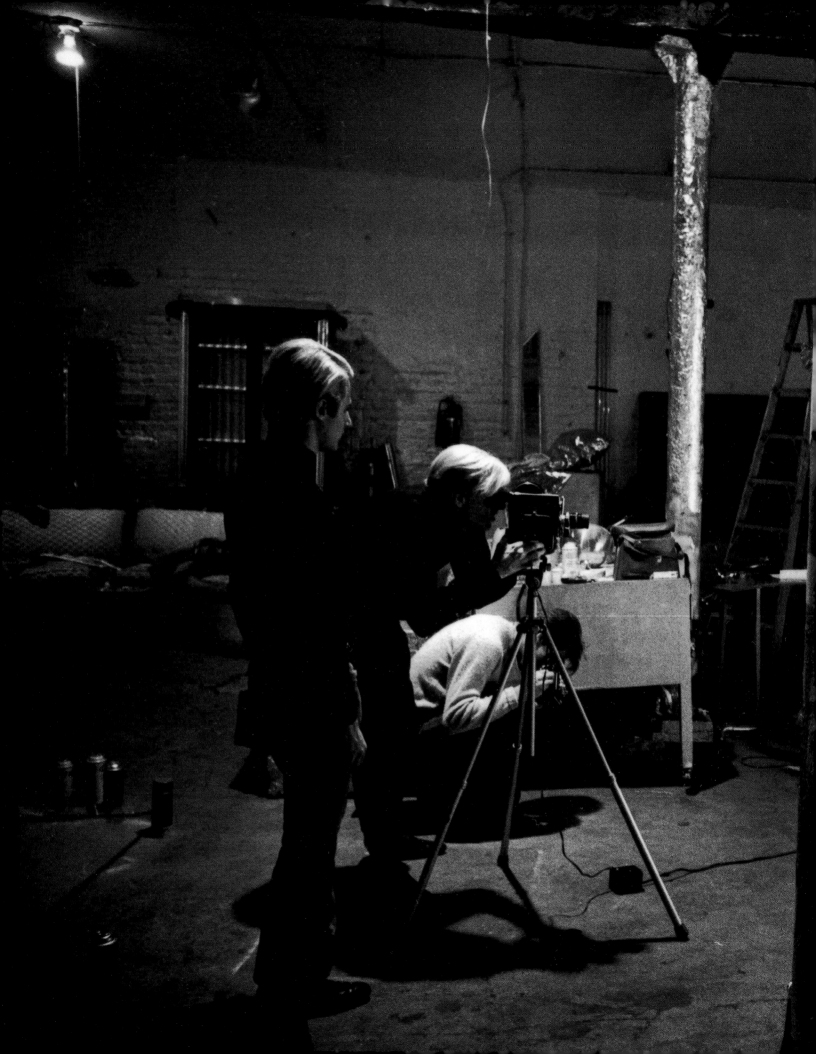

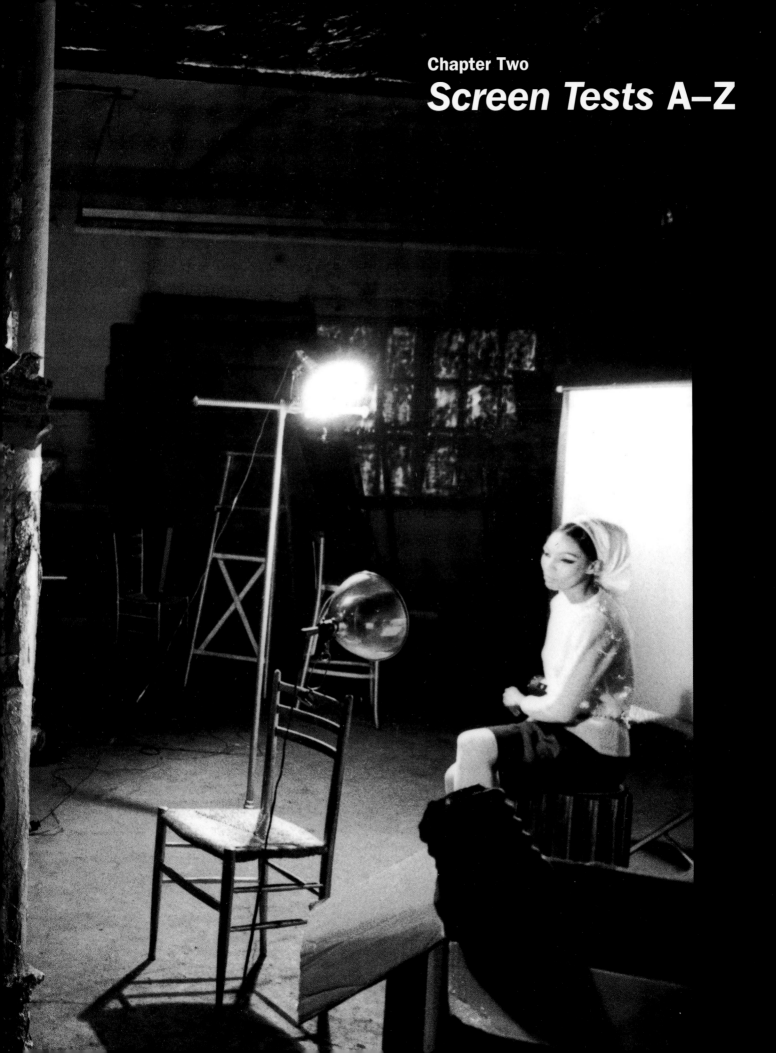

**Chapter Two**
# *Screen Tests A–Z*

## ST1  *Charles Aberg,* 1966
16mm, b&w, silent; 3.9 min. @ 16 fps, 3.4 min. @ 18 fps
Preserved 1995, MoMA *Screen Tests* Reel 1, no. 1
**FILM MATERIALS**
ST1.1  *Charles Aberg*
1965 Kodak 16mm b&w reversal original, 93'
**NOTATIONS**  On box in AW's hand, crossed out: *Benedetta, Duchamp Charles Osberg*
On flap in AW's hand: *Charles Arsberg*

## ST2  *Charles Aberg,* 1966
16mm, b&w, silent; 4.2 min. @ 16 fps, 3.7 min. @ 18 fps
Preserved 1995, MoMA *Screen Tests,* Reel 6, no. 9
**FILM MATERIALS**
ST2.1  *Charles Aberg*
1965 Kodak 16mm b&w reversal original, 100'
**NOTATIONS**  On box in AW's hand: *Charlie. Charles Feb. 14*
On box, very faint, in AW's hand: *Banana – full orgasm*

## ST3  *Charles Aberg,* 1966
16mm, b&w, silent; 4.3 min. @ 16 fps, 3.8 min. @ 18 fps
Preserved 1995, MoMA *Screen Tests* Reel 3, no. 8
**FILM MATERIALS**
ST3.1  *Charles Aberg*
1965 Kodak 16mm b&w reversal original, 103'
**NOTATIONS**  On original box in AW's hand: *Charles Asberg. Osberg. DW2. Scr. Stu.*
On box in AW's hand, crossed out: *Charlie*

Charles Aberg was the obscure star of Warhol's unreleased 1966 feature *Withering Sights,* a spoof of *Wuthering Heights* in which Aberg played Heathcliff opposite Ingrid Superstar's Cathy. In later years, Aberg became a painter based in Dallas, where he died in 1982.[1]

These three films, which were shot on February 14, 1966, a few weeks before the making of *Withering Sights,* show a callow young man in a black turtleneck squinting warily at the camera. As he often did with his *Screen Test* subjects, Warhol shot several rolls at one sitting: two tightly framed shots of Aberg's head, and a third, more free-form portrait (ST3) that begins with the zooms, in-camera edits, and experimental framings characteristic of Warhol's later shooting style. Aberg, who seems rather uncomfortable throughout his sitting, squinting into the bright light, has a nervous habit of opening his mouth and rubbing his teeth with his tongue. At one point in the third film, he holds a finger to his ear, indicating he didn't hear what the cameraman has just said to him. Whatever was said, it appears to make him quite anxious, and he immediately looks even more unhappy, cracking his knuckles and rubbing his hands.

## ST4  *Paul America,* 1965
16mm, b&w, silent; 4.6 min. @ 16 fps, 4.1 min. @ 18 fps
Preserved 1998, MoMA *Screen Tests* Reel 16, no. 1
**COMPILATIONS**  *Screen Tests Poems* (ST372); *Screen Tests/A Diary* (Appendix A)
**FILM MATERIALS**
ST4.1  *Paul America*
1965 Kodak 16mm b&w reversal original, 110'
ST4.1.p1  *Screen Test Poems,* Reel 1 (ST372.1), roll 9
Undated Gevaert 16mm b&w reversal print, 100'
**NOTATIONS**  On original box in AW's hand: *Paul*
On box in Gerard Malanga's hand, with frame drawing: *1 double frame neg. marked by masking tape and 1 8" x 10" double frame print. PRINT EXACTLY AS MARKED*
On box flap: *9*
On clear film at head of roll: *9*
On clear film at tail of roll: *–9–*

Paul America, whose real name was Paul Johnson, has in recent decades become something of a gay icon, thanks to his performance in the title role of Warhol's 1965 feature, *My Hustler.* According to most stories, America was discovered at a New York discotheque called Ondine in mid-1965 and brought back to the Factory, where he hung around making repairs to a motorcycle and was eventually asked to sit for this *Screen Test.*[2] He soon developed close friendships with some of the Warhol crowd, living briefly as Chuck Wein's roommate and later becoming involved in a short romance with Edie Sedgwick.[3]

Warhol described Paul America as "unbelievably good-looking— like a comic strip drawing of Mr. America, clean-cut, handsome, very symmetrical," and also suggested, somewhat contradictorily, that perhaps he got his name because he lived at the Hotel America, "a super-funky midtown hotel that was the kind of place Lenny Bruce, say, stayed in."[4] America himself had some problems with his name:

> I went through a period of paranoia about it. I mean, every time I saw that word—and it's everywhere—I related it to *myself.* The country's problems were *my* problems. I think that if I weren't called Paul America it would have been easier for me to register in hotels.[5]

After *My Hustler,* America appeared in a few other Warhol films from 1965: the unreleased sequels, *My Hustler: In Apartment* and *My Hustler: Ingrid,* and also Dan Williams's silent film *Harold Stevenson,* in which America, Gerard Malanga, Stevenson, Sedgwick, and others converse and drink wine while posing photogenically on a couch in a New York hotel suite. Another four-minute silent portrait of Paul America, shot on the beach during the making of *My Hustler,*

**Preceding pages:** Andy Warhol filming Kellie's *Screen Test* (ST175) at the Factory in 1965, while Stephen Shore takes a photograph and Gerard Malanga stands by. Photograph by Nat Finkelstein.

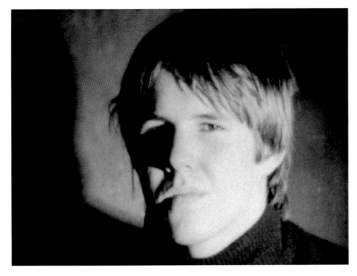

ST1

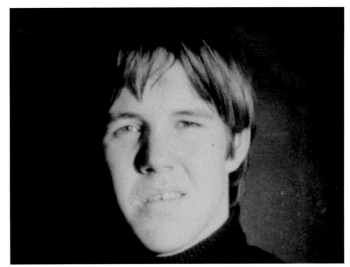

ST2

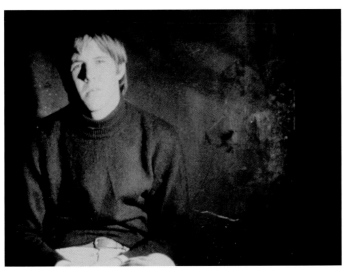

ST3

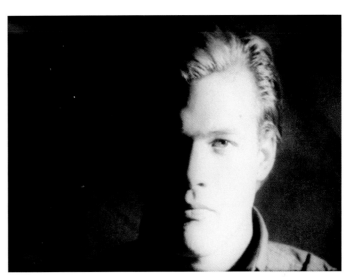

ST4

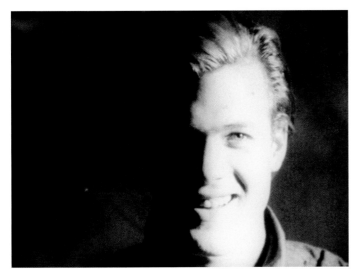

ST4

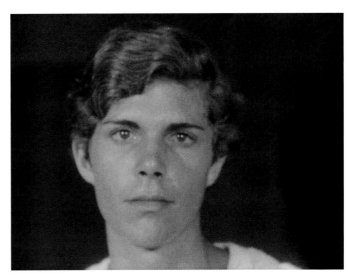

ST5

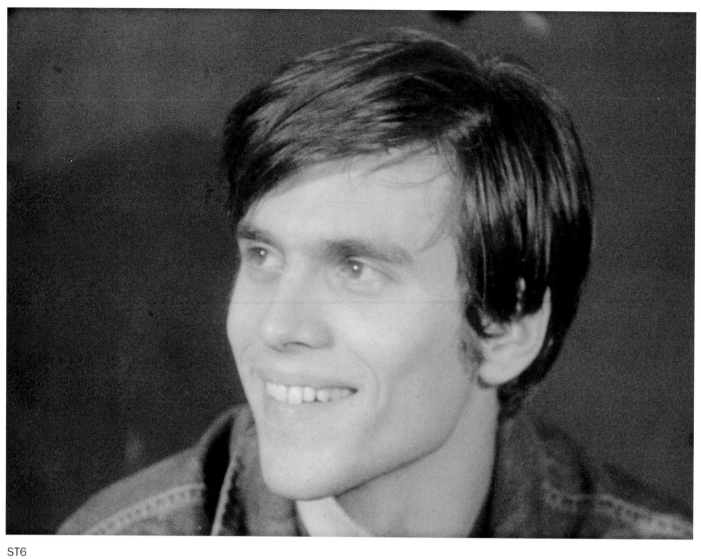

ST6

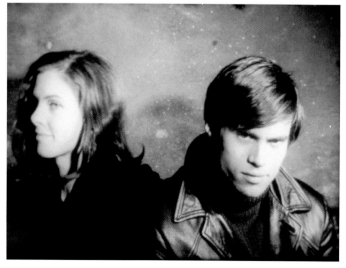

ST7

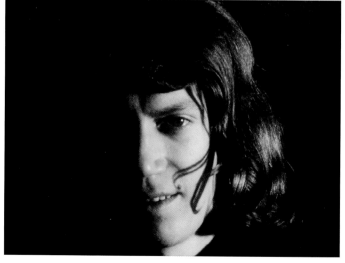

ST8

has been found in the "long version" of that film, in the edited montage by Dan Williams that was added to the sixty-six-minute film in 1967. At the end of 1967, after a brief spell in the U.S. Army, America obtained some legal assistance and convinced Warhol to reimburse him retroactively for his role in the by-then commercially successful *My Hustler*; America reportedly received $1,000 in several installments.[6] That year America also starred with Edie Sedgwick in John Palmer and David Weisman's film *Ciao! Manhattan* (1967–71), but his role in the movie ended in 1968 when he was imprisoned in Michigan on drug-related charges.[7] Paul Johnson (America) was reportedly killed in a car accident in the 1980s.

America's *Screen Test*, his first Warhol film, is charming enough to have functioned as a real screen test—that is, to have led to his starring role in *My Hustler* later that year. Strongly lit from the right, with the left side of his face in deep shadow, America chews gum, gazes around, smiles at people offscreen, and treats the camera to a series of slyly amused, seductive glances. The intimacy and cheerfulness of America's behavior in this film are in interesting contrast to his more remote, unsmiling performance as the contested object of desire in *My Hustler*.

### ST5   *Steve America*, 1965

16mm, b&w, silent; 4 min. @ 16 fps, 3.5 min. @ 18 fps
Preserved 2001, MoMA *Screen Tests* Reel 27, no. 8

**FILM MATERIALS**

ST5.1 *Steve America*
Undated Ansco 16mm b&w double-perf. reversal original, 96'
**NOTATIONS** On Sovereign film box in AW's hand: *Steve America*
Return address on mailing label on box: *ANDY WARHOL, 231 E. 47th ST., N.Y.C.*

This *Screen Test*, shot on undated Ansco stock, is of a blond young man identified as Steve America only by Warhol's notes on the film box. The subject might possibly be a relative of Paul America's or a resident of the Hotel America; in either case, like Paul America, he probably was given his name by Warhol. This portrait film is tentatively dated to the summer of 1965, when Eric Andersen's *Screen Test* (ST6), shot on the same unusual stock, was made.

In his sitting, Steve America faces the camera with considerable edginess, biting his lips, widening his eyes, and occasionally smiling nervously. As the film progresses, a layer of sweat accumulates on his upper lip. The focus is soft throughout and deteriorates toward the end of the roll; the image is very low contrast, which may be due to the Ansco stock on which this film was shot.

### ST6   *Eric Andersen*, 1965

16mm, b&w, silent; 3.9 min. @ 16 fps, 3.5 min. @ 18 fps
Preserved 2001, MoMA *Screen Tests* Reel 28, no. 10

**FILM MATERIALS**

ST6.1 *Eric Andersen*
Undated Ansco 16mm b&w double-perf. reversal original, 94'
**NOTATIONS** On Sovereign film box in AW's hand: *Eric Andersennnn*
Return address filled out on box: *ANDY WARHOL, 231 E. 47th St., N.Y.C.*

### ST7   *Eric Andersen and Debbie Green*, 1966

16mm, b&w, silent; 4.5 min. @ 16 fps, 4 min. @ 18 fps
Preserved 1998, MoMA *Screen Tests* Reel 15, no. 3

**FILM MATERIALS**

ST7.1 *Eric Andersen and Debbie Green*
1965 Kodak 16mm b&w reversal original, 108'
**NOTATIONS** On box in AW's hand: *Eric anderson. eric anderson*
On blue label on box in unidentified hand: *Tri-X IV. Screen Test*
On box in unidentified hand, crossed out: *VUs at Cinematheque. Dom*

The folk singer and songwriter Eric Andersen was part of the Greenwich Village folk music scene in the 1960s, appearing in clubs and coffeehouses with other musicians like Phil Ochs and Bob Dylan; his best-known songs of the period were "Thirsty Boots," "Come to My Bedside," and "Violets of Dawn." According to Warhol, Andersen came to the Factory in 1965 when Danny Fields and Donald Lyons ran into him performing in a café on MacDougal Street, and "thought he was so handsome they went up and asked him if he wanted to be in an Andy Warhol movie."[8] Andersen's main role in a Warhol film was in *Space* (1965), in which he appears with his guitar, at first singing his lines from the Ronald Tavel script and later leading Edie Sedgwick and her friends in unscripted, satirical sing-alongs of popular tunes like "Puff the Magic Dragon" and "The Battle Hymn of the Republic."

Andersen's first *Screen Test* (ST6) was probably shot in the summer of 1965, around the time of *Space*. In this solo portrait, Andersen, wearing a blue-jean jacket and smoking, seems relaxed and cocky, intrigued by the experience of being filmed. The focus gets worse as the film progresses; there are occasional light leaks into the image. The second film (ST7), probably shot in early 1966, is a double portrait of Andersen with his girlfriend, the folk musician Debbie Green, seated side by side in front of a wooden backdrop covered with paint splatters. They lean against each other, smiling; Green glances often at Andersen. The camera work includes in-camera edits and many different shots, rhythmic zooms and pans, as well as individual close-ups of each of them. At the end of the roll, Andersen seems to be singing or humming, nodding his head as if to music. In 1970 Warhol received a card from Eric and Debbie announcing the birth of their daughter, Sarah Gallatin.[9]

### ST8   *Antoine*, 1966

16mm, b&w, silent; 4.7 min. @ 16 fps, 4.1 min. @ 18 fps
Preserved 2001, MoMA *Screen Tests* Reel 28, no. 4

**FILM MATERIALS**

ST8.1 *Antoine*
1966 Kodak 16mm b&w reversal original, 112'
**NOTATIONS** On box in AW's hand: *Antoine*
On box in Gerard Malanga's hand: *124—Cambridge Diary—Everybody*

On October 5, 1966, the French "protest" singer Antoine arrived for a highly publicized one-day visit to New York, a "non-stop happening" arranged by Warner Brothers Records, with whom he had recently signed an American contract. Antoine, whose real name was Pierre Antoine Muracciolo, was known as the "French Dylan"; his album, *Les Elucubrations d'Antoine*, sold more than one million copies in 1966. Warhol was Antoine's host for the day, a whirlwind of heavily reported media events: Antoine's arrival at the airport, where he was greeted by Nico holding a bunch of bananas; a press

conference at the Warwick Hotel; a stop at Betsey Johnson's boutique, Paraphernalia, where he was fitted with a black velvet suit; an attempt to visit the Erotic Art '66 exhibition at the Sidney Janis Gallery, which was prevented by the police; a filming session at Warhol's Factory; and an evening "protest meeting" with the Fugs.[10]

At the Factory, Warhol presented Antoine with a large peel-off *Banana* poster, posed with him for the press cameras, and then shot color rolls of Antoine with Nico and Susan Bottomly sitting under the poster eating more bananas (see *Nico/Antoine*, 1966, Volume 2). Warhol also shot this black-and-white *Screen Test* of the twenty-two-year-old French singer—a portrait that seems surprisingly serene considering the media frenzy surrounding its making. The image is rather underexposed, with Antoine's face illuminated only on the right side. He holds very still throughout, smiling slightly, and doesn't blink until halfway through the roll. Because of a technical problem with the Bolex, there was intermittent loss of registration during filming, which makes the image appear to slip and blur vertically.[11]

### ST9  *Archie,* 1966
16mm, b&w, silent; 4.5 min. @ 16 fps, 4 min. @ 18 fps
Preserved 1999, MoMA *Screen Tests* Reel 19, no. 5
**FILM MATERIALS**
ST9.1 *Archie*
1966 Kodak 16mm b&w reversal original, 107'
**NOTATIONS** On original box in AW's hand: *Archie screentest Archie Reikerhove* (or "*Reikerhue*"—the name is mostly illegible)

### ST10  *Archie,* 1966
16mm, b&w, silent; 4.6 min. @ 16 fps, 4.1 min. @ 18 fps
**COMPILATIONS** *Chelsea Girls Background: 3 Min. Mary Might* (1966) (see Vol. 2)
**FILM MATERIALS**
ST10.1 *Archie*
Roll 2 in *Chelsea Girls Background: 3 Min. Mary Might* (see Vol. 2)
1966 Kodak 16mm b&w reversal original, 110'

### ST11  *Archie,* 1966
16mm, b&w, silent; 4.5 min. @ 16 fps, 4 min. @ 18 fps
Preserved 2001, MoMA *Screen Tests* Reel 26, no. 9
**FILM MATERIALS**
ST11.1 *Archie*
1966 Kodak 16mm b&w reversal original, 109'
**NOTATIONS** On original box in AW's hand: *Archie Screen Test*
On red label on head of roll: *KIN-O-LUX, 117 E. 45th St.*

A young man clearly identified only as "Archie" appears in three *Screen Tests* from 1966. His last name, written on one of the film boxes, is not entirely legible, but seems to be "Reikerhove" or "Reikerhue." The first of these portrait films (ST9) is one of the few films actually labeled "screen test" by Warhol. Posed against a white backdrop and harshly lit from the right, Archie squints suspiciously at the camera in close-up, the left side of his face in dark shadow. He and the camera both hold quite still, while tears accumulate in his one visible eye. A large hair appears in the frame about halfway through the roll.

The two remaining *Screen Tests* of Archie appear to have been made at the same time but contain much movement on the part of both camera and subject. In one *Screen Test* (ST10), roll 2 in the 1966 compilation reel *3 Min. Mary Might*, Archie looks rather thuggish in a ribbed "wife-beater" undershirt, rubbing his face and scratching his head while the camera performs a series of rhythmic in-and-out zooms. A third portrait film (ST11) contains a wide variety of camera movements, including single-framing, circular and vertical pans, and occasional zooms. At the beginning of the roll, Archie lights a cigarette and blows smoke while the camera repeatedly and slowly pans in close-up from the top of his head down his torso to his tight, pin-striped pants. He appears to have the letter "A" tattooed on his left bicep.

Archie also appears, in the nude and with the word "THE" tattooed (or perhaps written in pen) on his left buttock, in four other rolls that were found in *3 Min. Mary Might* and *Eric—Background*, assembled background reels that were projected behind the actors during the filming of certain reels in *The Chelsea Girls* in 1966. These four rolls were probably shot at the same time as Archie's *Screen Tests*. Although little is known about this young man, his tough appearance and homemade tattoos suggest his suitability for these particular background reels, which served as visual illustrations to the *Their Town* segment of *The Chelsea Girls*, a script written by Ronald Tavel that was based on "The Pied Piper of Tucson," a true crime story about a serial killer that appeared in *Life* magazine in March 1966.[12]

### ST12  *Arman,* 1964
16mm, b&w, silent; 4.5 min. @ 16 fps, 4 min. @ 18 fps
Preserved 2001, MoMA *Screen Tests* Reel 26, no. 4
**COMPILATIONS** *Fifty Fantastics and Fifty Personalities* (ST366)
**FILM MATERIALS**
ST12.1 *Arman*
1964 Kodak 16mm b&w reversal original, 109'
**NOTATIONS** On original box in AW's hand: *Arman 50*

The French artist Arman, one of the founders of the Nouveaux Réalistes movement, was known in the 1960s for creating serial accumulations of various substances or objects sealed in Plexiglas boxes; for example, his *Poubelles*, begun in 1959, contain assemblages of rubbish, while *Combustions*, begun in 1963, contain assorted burned objects. Arman can also be seen in Warhol's film *Dinner at Daley's*, a documentation of a dinner performance by the Fluxus artist Daniel Spoerri that Warhol filmed on March 6, 1964. Warhol owned two of Arman's *Poubelles* and another accumulation called *Amphetamines*, which were put up for sale at Sotheby's auction of the Andy Warhol Collection in May 1988.[13]

Throughout his portrait film, Arman sits in profile, looking down, and appears to be absorbed in reading, completely unaware of Warhol's camera. Occasionally he rubs his eye or licks the corner of his mouth, while his gaze moves over the pages of what seems to be a newspaper. This is one of three *Screen Tests* (see also Grace Glueck (ST118) and Alan Solomon (ST316)) in which a subject was filmed, perhaps without his knowledge, while reading; the film may have been shot from a distance using the zoom lens.

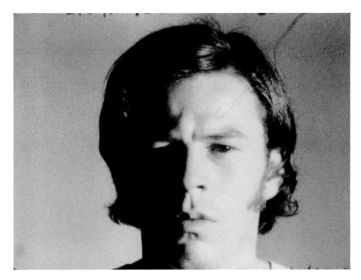

ST9

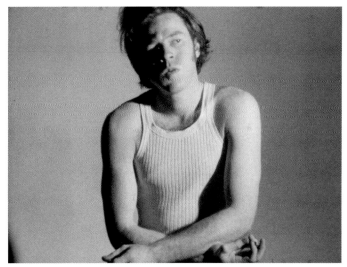

ST10

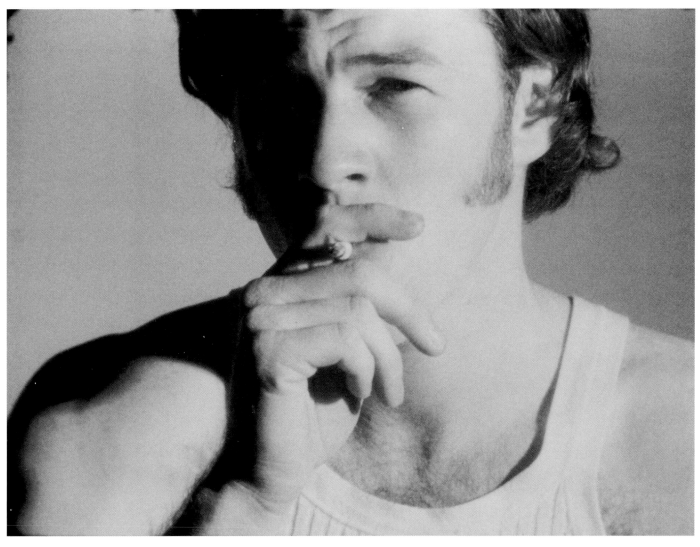

ST11

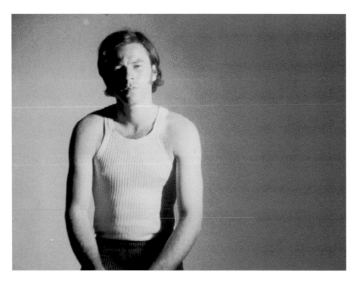

ST11

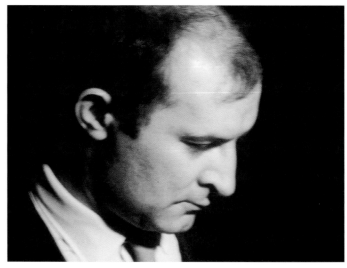

ST12

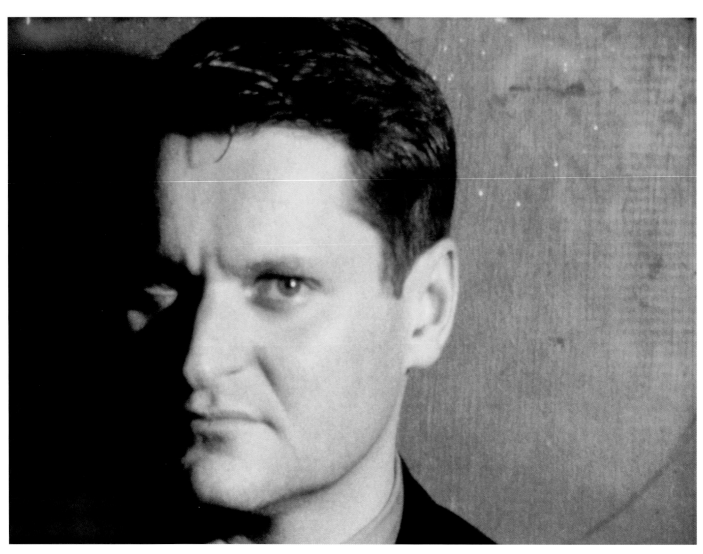

ST13

## ST13  *John Ashbery,* 1966

16mm, b&w, silent; 4.1 min. @ 16 fps, 3.7 min. @ 18 fps
Preserved 1995, MoMA *Screen Tests* Reel 10, no. 7
COMPILATIONS  *Screen Tests/A Diary* (Appendix A)
FILM MATERIALS
ST13.1  *John Ashbery*
1965 Kodak 16mm b&w reversal original, 99'
NOTATIONS  On box in Gerard Malanga's hand: *John Ashbery. 1 double frame negative and 2 double frame glossy prints 8" x 10" marked by masking tape*
On box in unidentified hand, crossed out: *by Jack (6)*
On typed label found in can: *JOHN ASHBERY*

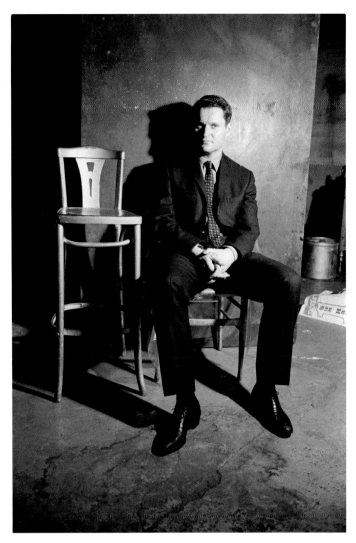

John Ashbery posing for his *Screen Test* (ST13), 1966. Photograph by Stephen Shore.

The American poet John Ashbery first met Andy Warhol in the fall of 1963, when Ashbery visited New York and gave a poetry reading at the Living Theatre. As Ashbery recalled, Gerard Malanga, who was a poet as well as Warhol's assistant, took him to the artist's studio for an introduction.[14] Ashbery, who lived in Paris between 1955 and 1965, had written several favorable reviews of Warhol's art. In 1965 he reviewed Warhol's *Flowers* exhibition at Galerie Ileana Sonnabend in Paris, describing Warhol's visit to Paris as "the biggest transatlantic fuss since Oscar Wilde brought culture to Buffalo in the nineties."[15] When Ashbery moved back to New York at the end of 1965, Warhol threw a big party for him at the Factory.[16] Ashbery maintained his interest in Warhol's work after his return to New York, and also became friends with Malanga, on whom he had an important influence as a poet.[17]

Ashbery recalled that his *Screen Test* was shot one day when he had dropped by the Factory from his job as executive editor of *Art News* magazine: "I found it kind of intimidating," he confessed, "because there were all these people doing their strange tasks."[18] Formally dressed in a suit and tie, Ashbery gives a formidable performance, meeting the camera's stare with a fiercely critical scowl. His suspicious expression does relax somewhat in the course of the film; toward the end, he appears momentarily lost in his own thoughts.

## ST14  *Steve Balkin,* 1964

16mm, b&w, silent; 4.4 min. @ 16 fps, 3.9 min. @ 18 fps
Preserved 1995, MoMA *Screen Tests* Reel 2, no. 6
COMPILATIONS  *The Thirteen Most Beautiful Boys* (ST364)
FILM MATERIALS
ST14.1  *Steve Balkin*
1964 Kodak 16mm b&w reversal original, 106'
NOTATIONS  On original box in AW's hand: *Oct 26/64. 13. Steve Bachin*

Steve Balkin had been close friends with the Happenings artist Al Hansen since the 1950s, when the two were roommates at the Pratt Institute in Brooklyn. In the 1960s, Balkin occasionally worked with the Judson Dance Theater and also had his own theater company, the World Theater, which organized Monday night happenings at the Café au Go Go in 1965.[19] Balkin also painted and pursued a career in photography, working as a freelance photographer for the Whitney Museum and the Leo Castelli Gallery in the 1970s. Balkin has always been a toy soldier enthusiast, and in 1978 he opened Burlington Antique Toys on upper Madison Avenue in New York, a business he recently expanded to the Internet.

In 1962 Balkin was introduced to Warhol by Ivan Karp; they developed a friendship based on their mutual interests in art and performance. In 1964, as Balkin recalls, Warhol called him up and told him he was making a film called *The Thirteen Most Beautiful*

*Boys in New York* (sic), and asked him if he would come over to the Factory to sit for his portrait film. When he arrived, Warhol loaded the camera with the help of Gerard Malanga and then, to Balkin's surprise, pushed the button and walked away. After the three minutes were up, Warhol came back and said, "that was great, Steve."[20]

Balkin's *Screen Test* was shot on October 26, 1964, a date that Warhol uncharacteristically noted on the film box; the box also bears the notation "13." Balkin's portrait demonstrates the frozen pose and symmetrical lighting that Warhol often utilized during this period (see, for example, Philip Fagan (ST93)). The carefully arranged lighting, falling evenly on both sides of Balkin's face, creates a Rorschach pattern of shadows down the midline of his features, highlighting the chiseled clefts in his chin and upper lip, and between his brows. Balkin blinks frequently and earnestly into the bright lights; the image is slightly out of focus throughout.

Benedetta Barzini posing for her *Screen Test* (ST17), 1966. Photograph by Billy Name.

## ST15    *Benedetta Barzini,* 1966

16mm, b&w, silent; 4.6 min. @ 16 fps, 4.1 min. @ 18 fps
**COMPILATIONS** *Screen Test Poems* (ST372)
**FILM MATERIALS**
Original not found in Collection
ST15.1.p1 *Screen Test Poems,* Reel 3 (ST372.3), roll 24
Undated Gevaert 16mm b&w reversal print, 110'

## ST16    *Benedetta Barzini,* 1966

16mm, b&w, silent; 4.5 min. @ 16 fps, 4 min. @ 18 fps
**COMPILATIONS** *Screen Test Poems* (ST372)
**FILM MATERIALS**
Original not found in Collection
ST16.1.p1 *Screen Test Poems,* Reel 3 (ST372.3), roll 29
Undated Gevaert 16mm b&w reversal print, 107'

## ST17    *Benedetta Barzini,* 1966

16mm, b&w, silent; est. 4 min. @ 16 fps, 3.6 min. @ 18 fps
**COMPILATIONS** *Screen Tests/A Diary* (Appendix A)
**FILM MATERIALS**
Original not found in Collection

By 1965 the young Italian actress and model Benedetta Barzini, daughter of the Italian journalist and author Luigi Barzini Jr. and stepsister of Giangiacomo Feltrinelli, had established a successful fashion career in New York City; in December 1966 she was named one of the "100 Great Beauties of the World" by *Harper's Bazaar.*[21] In 1966 Barzini became the object of Gerard Malanga's romantic attentions; he wrote a number of poems and made a film about her. He also published an article about her, illustrated with his own photographs, in *Status and Diplomat* magazine.[22]

Two *Screen Tests* of Barzini were found in the Warhol Film Collection in print form only. These solo portraits of her, which appear to have been shot at the Factory, were found in Reel 3 of the *Screen Test Poems* background films (ST372.3). The second of these (ST16) has rather intricate camerawork, including changes of pose and in-and-out zooms. A third film (ST81), a double portrait of Barzini with Marcel Duchamp, was shot at an opening at the Cordier and Ekstrom Gallery in New York in February 1966 (see the entry on Marcel Duchamp for data on this particular roll).

A fourth *Screen Test* (ST17) of Barzini in a turtleneck sweater was illustrated in Malanga and Warhol's book, *Screen Tests/A Diary* (see Appendix A); a photograph by Billy Name (Linich) shows

Barzini posing for this film at the Factory. This Barzini *Screen Test* also appears in Malanga's 1967 film, *In Search of the Miraculous,* for which Warhol received credit for "2nd unit cinematography."[23] A double-frame enlargement of this film is also reproduced in Malanga's recent book, *Archiving Warhol,* where it is identifed in a caption as *Benedetta Barzini Screen Test,* 1966.[24] The original film has not been found in the Collection.

## ST18    *Gregory Battcock,* 1964

16mm, b&w, silent; 4.5 min. @ 16 fps, 4 min. @ 18 fps
Preserved 1995, MoMA *Screen Tests* Reel 4, no. 10
**COMPILATIONS** *The Thirteen Most Beautiful Boys* (ST364); *Fifty Fantastics and Fifty Personalities* (ST366)
**FILM MATERIALS**
ST18.1 *Gregory Battcock*
1964 Kodak 16mm b&w reversal original, 108'
**NOTATIONS** On original box in unidentified hand: *Gregory Badcock. (13)*

Gregory Battcock, the writer and art critic, appears in a number of Warhol films, including *Batman Dracula* and *Soap Opera* in 1964, *Horse* in 1965, and *Eating Too Fast,* the 1966 sound remake of *Blow Job.* Battcock was one of the first critics to write seriously about Warhol's cinema; in the second half of the 1960s, he published articles on *Empire* (1964), *Screen Test No. 2* (1965), *Kitchen* (1965), and *The Chelsea Girls* (1966) in *Film Culture* and other arts magazines.

ST14

ST15

ST16

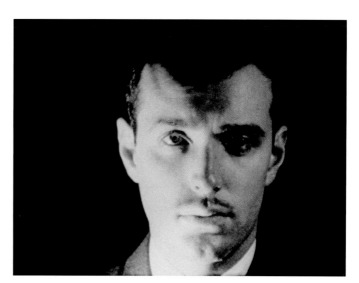

ST18

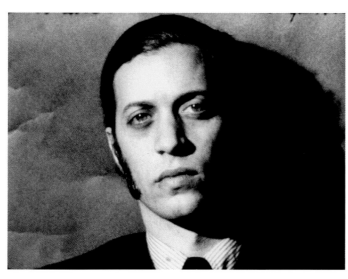

ST19

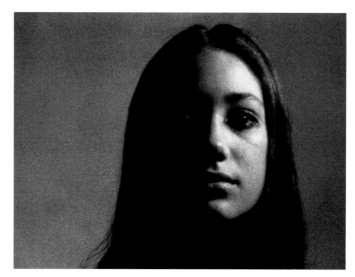

ST20

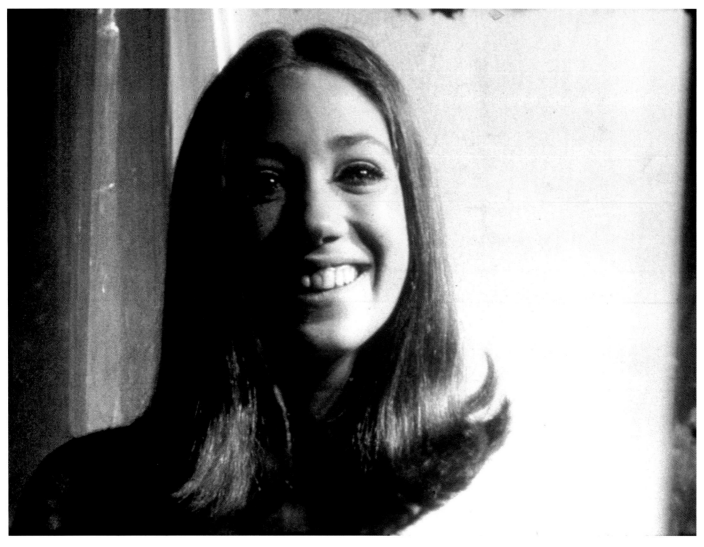

ST21

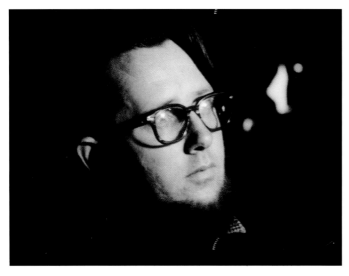

ST22

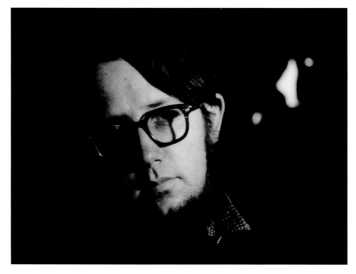

ST22

In 1965 he published "Humanism and Realism—Thek and Warhol," an essay that compared a glass-enclosed meat sculpture by Paul Thek with Warhol's 1964 film *Blow Job*.[25]

In 1968 Battcock edited one of the first collections of essays on avant-garde cinema, *The New American Cinema: A Critical Anthology*; he also edited other critical anthologies on minimal art, earth art, and "the new art," all published by Dutton. Battcock wrote frequently on contemporary art, and in 1969–70 contributed a column, a sexually adventurous travel journal called "The Last Estate," to the magazine *Gay: The New York Review of Sex and Politics*. Battcock died tragically in 1980 at the age of forty-three, found murdered in his apartment in San Juan, Puerto Rico.[26]

In his interview with Patrick Smith, Battcock confessed that he had never seen his *Screen Test* projected, although he had seen a photograph of it.[27] Formally dressed in a white shirt and jacket, Battcock has been lit obliquely from below, which gives him a somewhat sinister, Svengali-like appearance. It is nearly impossible to read anything in his expression—the kind of deadpan performance that Battcock would take to even further lengths in *Eating Too Fast*. The misspelling of Battcock's name on the film box is probably a joke.

## ST19    Timothy Baum, 1966
16mm, b&w, silent; 4.5 min. @ 16 fps, 4 min. @ 18 fps
Preserved 1995, MoMA *Screen Tests* Reel 7, no. 8
COMPILATIONS *Screen Tests/A Diary* (Appendix A)
FILM MATERIALS
ST19.1 *Timothy Baum*
1966 Kodak 16mm b&w reversal original, 108'
NOTATIONS On original box in unidentified hand: *Timothy Baum*
On typed label found in can: TIMOTHY BAUM

Art dealer, scholar, and collector of Surrealist and Dada art, Timothy Baum was the subject of several of Warhol's "Photobooth Pictures" (1964–66), serial photographic portraits that seem to predate this 1966 *Screen Test*.[28] In his portrait film, Baum is turned out in the mod style of the mid-1960s, with a high collar and long sideburns, but he is edgy in his confrontation with Warhol's camera and seems unable to relax, repeatedly swallowing, taking deep breaths, and even speaking briefly to the camera. The roll begins almost in overexposure, with a very bright light blazing onto the left side of Baum's face. The aperture, however, is quickly stopped down to create deep shadows on the right.

## ST20    Marisa Berenson, 1965
16mm, b&w, silent; 4.6 min. @ 16 fps, 4.1 min. @ 18 fps
COMPILATIONS *Screen Test Poems* (ST372); *Screen Tests/A Diary* (Appendix A)
FILM MATERIALS
Original not found in Collection
ST20.1.p1 *Screen Test Poems*, Reel 1 (ST372.1), roll 7
Undated Gevaert 16mm b&w reversal print, 110'

## ST21    Marisa Berenson, 1965
16mm, b&w, silent; 4.5 min. @ 16 fps, 4 min. @ 18 fps
COMPILATIONS *Screen Test Poems* (ST372); *EPI Background* (ST370)
FILM MATERIALS
Original not found in Collection
ST21.1.p1 *Screen Test Poems*, Reel 1 (ST372.1), roll 10
Undated Gevaert 16mm b&w reversal print, 109'
ST21.1.p2 *EPI Background* (ST370), roll 2
Undated Dupont 16mm b&w reversal print, 109'

Like the Benedetta Barzini films, the Marisa Berenson *Screen Tests* were found in print form only (see *Screen Test Poems*, Reel 1, ST372.1); the camera originals seem to be missing from the Warhol Film Collection. Another film by Dan Williams, *Lester Persky I & II*, found in the Collection, was shot on November 14, 1965, and shows Berenson visiting the Factory, an occasion that is also documented in a Stephen Shore photograph. It seems likely that these two *Screen Tests* were made around the same time, if not on the same day, since Berenson is wearing the same white sweater in both the Warhol and Williams films.

One screen test of the young actress is a straightforward static head shot, in the style of many of *The Thirteen Most Beautiful Women* (ST365) films. The other film is much livelier: Berenson laughs and dances back and forth in her seat, while the camera mirrors the gaiety of her mood with repeated zooms and bursts of single-framing.

## ST22    Ted Berrigan, 1965
16mm, b&w, silent; 4.5 min. @ 16 fps, 4 min. @ 18 fps
COMPILATIONS *Fifty Fantastics and Fifty Personalities* (ST366); *Screen Tests/A Diary* (Appendix A)
FILM MATERIALS
ST22.1 *Ted Berrigan*
1964 Kodak 16mm b&w reversal original, 109'
NOTATIONS On original box in AW's hand: *Ted*
On box in Gerard Malanga's hand: *Ted Berrigan. at beginning of film—marked by masking tape—1 double frame negative + 1 8 x 10 double frame stillie*

The poet Ted Berrigan was part of what Frank O'Hara wittily called "the *soi-disant* Tulsa School of Poetry"—a group of young poets and friends who moved to New York City from Oklahoma in the early 1960s.[29] Berrigan met Warhol in July 1963 at a poetry reading by O'Hara,[30] and shortly thereafter invited Warhol to design the cover for the September issue of *C*, the poetry magazine he edited.[31] Berrigan published more than thirty books of poetry in the course of his career, including three editions of his *Sonnets* and several collaborations with Ron Padgett and Ann Waldman. Berrigan died in 1983; his *Selected Poems* was published by Penguin Books in 1994.[32]

The shooting of Berrigan's *Screen Test* at the Factory on March 3, 1965, was documented by David Ehrenstein during an interview with Warhol. The interview records Warhol's instructions to Berrigan, as he positions him before the camera.

> AW: Oh. Ted, do you want to do a picture? . . . Oh, pull that chair in so it's more out, out in the open. Move it over, uh, yeah, over there, yeah, just right there, that's great. Oh, I know. We're going to have to do something about that chair.
> DE: What are you going to ask Ted to do?
> AW: Uh. Just pretend he's not doing anything.

After the filming, Ehrenstein asks Berrigan if he liked being filmed:

> TB: Sure, it was wonderful . . . I was looking at the light to
> see what it looks like . . . It was all really wonderful; I just
> loved myself every second. I looked at the camera and the
> light made it look like a big blue flower. And so I looked
> at it until the flower effect wore off and then I looked at
> the light for a few more minutes until it came on again.[33]

The *Screen Test* does indeed show Berrigan looking into the
light, offscreen to the right, and then glancing briefly at the camera,
but his mood seems to be one of uneasiness rather than entrance-
ment. The shadows of his glasses sometimes hide his eyes.

### ST23    *Betty Lou,* 1964
16mm, b&w, silent; 4.5 min. @ 16 fps, 4 min. @ 18 fps
Preserved 1995, MoMA *Screen Tests* Reel 11, no. 5
**COMPILATIONS**  *The Thirteen Most Beautiful Women* (ST365)
**FILM MATERIALS**
ST23.1 *Betty Lou*
1964 Kodak 16mm b&w reversal original, 107'
**NOTATIONS**  On original box in AW's hand: *Betty Lou—13 Girls. Betty
Lou—13 Girls. (Bad)*

This unknown young woman, identified only as "Betty Lou" in
Warhol's notes, posed for her *Screen Test* sometime in 1964. Wear-
ing no makeup, and with her pinned-up hair standing out around
her head in wisps, Betty Lou endures her sitting with considerable
poise. Toward the end of the film, as her eyes begin to water, she
seems to smile ever so slightly, and her head trembles visibly.
Although this film appears to have been shot for *The Thirteen Most
Beautiful Women* (ST365), Warhol seems to have decided it wasn't
good enough and labeled it "Bad," perhaps because there is a hair
printed into the frame at lower right.

### ST24    *Binghamton Birdie,* 1964
16mm, b&w, silent; 4.4 min. @ 16 fps, 3.9 min. @ 18 fps
Preserved 1995, MoMA *Screen Tests* Reel 9, no. 8
**FILM MATERIALS**
ST24.1 *Binghamton Birdie*
1964 Kodak 16mm b&w reversal original, 106'
**NOTATIONS**  On original box in AW's hand: *Birdie*

### ST25    *Binghamton Birdie,* 1964
16mm, b&w, silent; 4.4 min. @ 16 fps, 3.9 min. @ 18 fps
Preserved 1995, MoMA *Screen Tests* Reel 9, no. 3
**FILM MATERIALS**
ST25.1 *Binghamton Birdie*
1964 Kodak 16mm b&w reversal original, 106'
**NOTATIONS**  On original box in AW's hand: *Birdie 4/1*

Binghamton Birdie, whose real name is Richard Stringer, was one of
the "A-heads" or "opera people," a subset of the Factory crowd who
shared an enthusiasm for opera, amphetamine, and staying up all
night.[34] Other members of this clique included Ondine, Rotten
Rita, Stanley the Turtle, Billy Linich, and the Duchess; their original
hangout was the San Remo coffee shop, but their gatherings shifted
to the back spaces of the Factory after Linich moved in as Factory
manager in early 1964.[35] Birdie also appeared in Warhol's 1964 film

*Couch,* and was responsible for the pornographic mural in the Fac-
tory's silver bathroom.

These two *Screen Tests* of Birdie, one with shirt and one with-
out, may possibly have been shot on April 1, 1964 (the date may
have been written on the box for ST25). His head and shoulders
are lit equally from both sides, creating deep, symmetrical shadows
down the center of his face and throat, with a square of darkness
centered on his forehead. In the first film (ST24), Birdie holds
quite still, only occasionally smiling, widening and blinking his
eyes as if trying to bring them into focus. In the second film
(ST25), Birdie seems to have been given permission to remove his
T-shirt and also to move more freely; he now appears much more
relaxed, laughing openly at the camera and constantly moving and
swaying in place.

### ST26    *Irving Blum,* 1964
16mm, b&w, silent; 4.4 min. @ 16 fps, 3.9 min. @ 18 fps
Preserved 1998, MoMA *Screen Tests* Reel 17, no. 10
**FILM MATERIALS**
ST26.1 *Irving Blum*
1964 Kodak 16mm b&w reversal original, 106'
**NOTATIONS**  On original Kodak box in AW's hand: *Irving*

Irving Blum, the owner of the Ferus Gallery in Los Angeles, gave
Warhol his first one-man show in 1962, an exhibition of the *32
Campbell Soup Cans* paintings. In October 1963, Blum presented a
second Warhol exhibition of *Elvis* and *Liz* paintings. Blum makes
a brief appearance in *Elvis at Ferus,* Warhol's short film of that
installation, and can also be glimpsed in *Tarzan and Jane Regained,
Sort Of . . .* and *Duchamp Opening,* which Warhol also shot in Los
Angeles during his 1963 visit.

In this charming portrait film, Blum at first faces the camera
glumly, with dark, Frankenstein-like shadows cast across his brow
by the symmetrical lighting. By the middle of the film, he is visibly
struggling to maintain a straight face; he tries to suppress a smile,
begins to shake with laughter, then gives up and laughs outright at
the camera. He shakes his head, rolls his eyes, and then sobers up
and resumes a solemn expression, which he manages to maintain to
the end of the roll.

### ST27    *DeVerne Bookwalter,* 1964
16mm, b&w, silent; 4.5 min. @ 16 fps, 4 min. @ 18 fps
Preserved 1998, MoMA *Screen Tests* Reel 14, no. 4
**COMPILATIONS**  *The Thirteen Most Beautiful Boys* (ST364)
**FILM MATERIALS**
ST27.1 *DeVerne Bookwalter*
1963 Kodak 16mm b&w reversal original, 107'
**NOTATIONS**  On original box, in AW's hand: *FACE 13 BOY Devorn*
(followed by illegible word). *Devon 13*

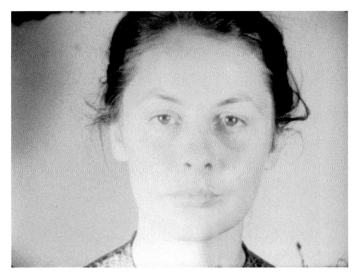

ST23

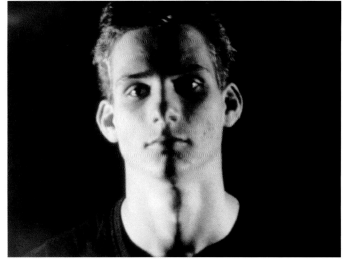

ST24

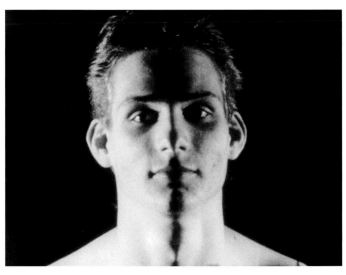

ST25

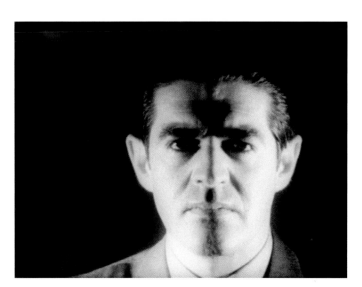

ST26

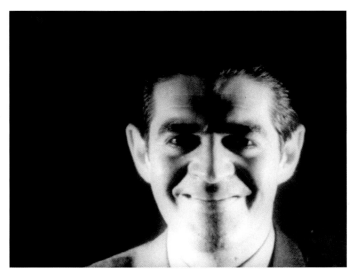

ST26

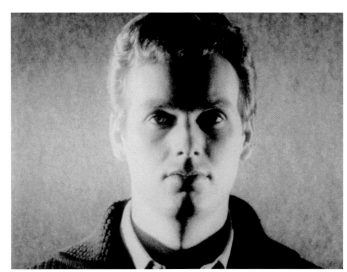

ST27

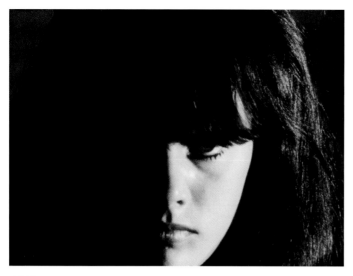

ST28

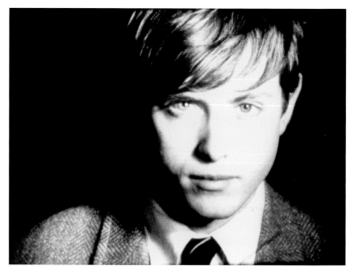

ST29

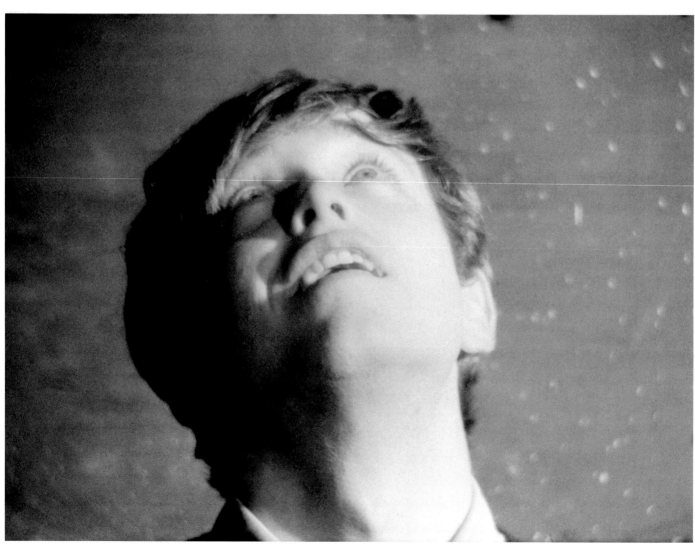

ST30

The actor DeVerne Bookwalter starred, famously and yet anonymously, in Warhol's 1964 film *Blow Job*. Bookwalter, who was born in Brookville, Pennsylvania, in 1939, majored in art at Edinboro State College, and later studied acting, specializing mostly in Shakespearean roles. In the summer of 1963, prior to his involvement in the Warhol films, Bookwalter appeared in the Shakespeare in the Park production of *Macbeth* in New York. In later years, Warhol claimed never to have known Bookwalter's name, referring to him in *POPism* only as "a good-looking kid who happened to be hanging around the Factory that day"; again, in 1984, Warhol reported that he had visited his doctor "and who should be there in the waiting room but the star of my movie, *Blow Job*. I never did know his name."[36]

Nevertheless, the fact that Warhol wrote Bookwalter's name on the *Screen Test* box suggests that this forgetfulness may have been deliberate; perhaps he was honoring Bookwalter's wish that he remain anonymous as the star of such a pornographically titled film. In 1967 Bookwalter sent Warhol his updated résumé and a head shot, apparently hoping for further film roles. According to his résumé, he had changed his first name to DeVeren, and had been acting in repertory and summer stock at the American Shakespeare Festival, the Rochester Repertory Company, and the Corning Summer Theatre.[37]

DeVeren Bookwalter later had a small role in *The Omega Man* (1971), and also played the main villain, the hippy terrorist Bobby Maxwell, in Clint Eastwood's 1976 film, *The Enforcer*. He also had a few small television roles, appearing in episodes of *Starsky and Hutch* and *Ryan's Hope* in 1975, and in a couple of made-for-TV movies, *The Cover Girls* (1977) and *Evita Peron* (1981). Bookwalter died in 1987. In 1994 Bookwalter was identified as the star of *Blow Job* by a fellow student from Edinboro State College, who happened to see the film at The Andy Warhol Museum in Pittsburgh and recognized him.[38]

This portrait film, which was probably shot around the same time as *Blow Job* in February or March 1964, seems to be one of the very earliest *Screen Tests*, shot on 1963 stock. It was marked for inclusion in *The Thirteen Most Beautiful Boys* (ST364). Bookwalter appears surprisingly clean-cut and wholesome, very different from the leather-clad street tough he plays in *Blow Job*. Wearing a button-down shirt and a roll-neck cardigan sweater, with his blond hair carefully combed, he resembles Tab Hunter more than James Dean. Placed against a wall and shot slightly from below, Bookwalter dutifully holds still for the entire roll, fixing his eyes on a point slightly above the camera. The symmetrical lighting casts a pattern of diamond-shaped shadows down the center of his face.

### ST28   *Susan Bottomly,* 1966
16mm, b&w, silent; 4.5 min. @ 16 fps, 4 min. @ 18 fps
Preserved 2001, MoMA *Screen Tests* Reel 26, no. 10
COMPILATIONS   *Screen Tests/A Diary* (Appendix A)
FILM MATERIALS
ST28.1  *Susan Bottomly*
1966 Kodak 16mm b&w reversal original, 107'
NOTATIONS  On original box in AW's hand, crossed out: *Susan*
On box in Gerard Malanga's hand: *International Velvet*
On box in unidentified hand: *TRI-X reversal. 7–9–66*

Susan Bottomly, daughter of a prominent Wellesley and Boston family, was only seventeen in 1966 when her photo appeared on the cover of *Mademoiselle* magazine. Bottomly had met Warhol at a party in Boston earlier that year. When she moved to New York that summer with plans of becoming an actress, she dropped by

the Factory, where her *Screen Test* was shot on July 9, 1966.[39] Bottomly continued to work as a successful model in New York and appeared in many Warhol films in 1966 and 1967, including several reels of *The Chelsea Girls*, *The Velvet Underground Tarot Cards*, the black-and-white and color versions of *Susan-Space*, *The Bob Dylan Story*, *Superboy*, *Paraphernalia*, *Nico/Antoine*, and *Since* (all 1966), and numerous segments of ★ ★ ★ ★ *(Four Stars)* (1966–67), in which she frequently performed opposite her boyfriend David Croland.[40] She was given a new name at the Factory, International Velvet, which never really caught on.

Billy Name recalled that "when Susan first arrived at the Factory she had her 'fresh Boston look,' and then later developed her sixties look with heavy makeup and earrings."[41] Bottomly's *Screen Test* reflects this early look; she is wearing little makeup, her bangs are combed down over her face, and she seems rather subdued, without the bold, animated expression of her later performances. The film is somewhat underexposed, with light striking only the right side of Bottomly's face; her eye is barely visible under the heavy fringe of her bangs.

### ST29   *Randy Bourscheidt,* 1966
16mm, b&w, silent; 4.6 min. @ 16 fps, 4.1 min. @ 18 fps
Preserved 1999, MoMA *Screen Tests* Reel 22, no. 1
COMPILATIONS   *Screen Test Poems* (ST372)
FILM MATERIALS
ST29.1  *Randy Bourscheidt*
1965 Kodak 16mm b&w reversal original, 110'
ST29.1.p1  *Screen Test Poems*, Reel 3 (ST372.3), roll 25
Undated Gevaert 16mm b&w reversal print, 110'
NOTATIONS  On original box in AW's hand: *Randy*
On box in Gerard Malanga's hand: *Randy Bourcheidt. 1 Double Frame Negative, 1 Double Frame 8 x 10 Glossy Print*
On clear film at head of roll in black: *25*

### ST30   *Randy Bourscheidt,* 1966
16mm, b&w, silent; 4.5 min. @ 16 fps, 4 min. @ 18 fps
FILM MATERIALS
ST30.1  *Randy Bourscheidt*
1965 Kodak 16mm b&w reversal original, 109'
NOTATIONS  On original box in Gerard Malanga's hand: *Randy Bouschedit. MO 3 5007*

Randall Bourscheidt, now the president of the Alliance for the Arts in New York, appeared in several Warhol films in 1966, playing one of Mario Montez's five husbands in *Hedy*, the overnight guest stuck in bed between Susan Bottomly and David Croland in *Susan-Space*, Nico's shy companion in *The Closet*, and, finally, a Secret Service agent in the Kennedy assassination reels in *Since*.

Bourscheidt's seductive, schoolboy charm is evident in both of his portrait films, which were probably shot in early 1966, around the time of *Hedy*. In the first film (ST29), Bourscheidt, preppily dressed in a tie and tweed jacket, looks up and down, then shyly faces the camera, trying not to smile. He bites his lip, grins, relaxes, and then brushes the hair out of his eyes, a gesture that suddenly makes him appear much more knowing and sophisticated. In the second film (ST30), he looks up, smiles, turns from side to side to show both profiles, and then strains his gaze upward, as if playing a choirboy gazing toward heaven.

## ST31  *Boy,* 1964

16mm, b&w, silent; 4.5 min. @ 16 fps, 4 min. @ 18 fps
Preserved 1998, MoMA *Screen Tests* Reel 14, no. 1
**COMPILATIONS**  *The Thirteen Most Beautiful Boys* (ST364)
**FILM MATERIALS**
ST31.1  *Boy*
1963 Kodak 16mm b&w double-perf. reversal original, 108'
**NOTATIONS**  On original box, in AW's hand: *BOY—13 13* ★
On box in unidentified hand: *USED*
Stamped on box: *LAB TV The Lab for Reversal Films, 923 7th Avenue*

This very early *Screen Test*, shot on 1963 stock, is of an unnamed young man identified only as "Boy" in Warhol's notes. His head, placed slightly off center to the right, is framed against a background of paneled wainscotting, leafy tapestry, and mantelpiece,

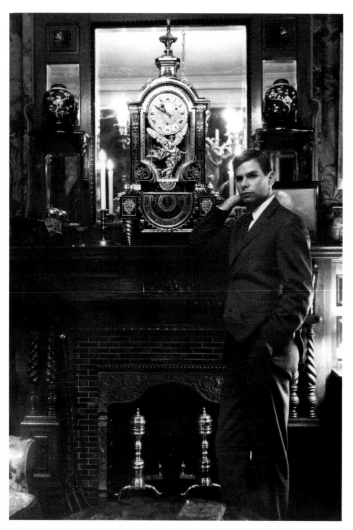

Winthrop Kellogg Edey in his living room, ca. 1970. Photograph courtesy of Beatrice Phear.

indicating that the film was shot not at the Factory but most likely at Winthrop Kellogg Edey's town house on West 83rd Street, where some of the very first *Screen Tests* were shot. A similar background is visible in a 1970 photograph of Edey at his home; in fact, one of Edey's clocks from his famous clock collection seems to be partially visible in the film image. This young man may be the Harold Talbot mentioned in Edey's diary entry for January 17, 1964: "This afternoon Andy Warhol made a movie here, a series of portraits of a number of beautiful boys, including Harold Talbot and Denis Deegan and also me."[42] (See ST89–90.)

The solemn young boy in glasses holds completely still for the duration of the film, with deep shadows spilling down the center of his forehead and chin. As indicated by Warhol's notes on the box, this film was intended for *The Thirteen Most Beautiful Boys* (ST364), and at some point was marked with a star, perhaps indicating its final selection for the series.

## ST32  *Joe Brainard,* 1965

16mm, b&w, silent; 4.5 min. @ 16 fps, 4 min. @ 18 fps
Preserved 1999, MoMA *Screen Tests* Reel 22, no. 9
**FILM MATERIALS**
ST32.1  *Joe Brainard*
1964 Kodak 16mm b&w reversal original, 107'
**NOTATIONS**  On original box in AW's hand: *Joe Barmaid*

The poet and artist Joe Brainard is probably best known for his 1975 book of childhood memories, *I Remember*, which has been frequently used in teaching writing to young students. Brainard and his childhood friend, Ron Padgett, were from Tulsa, Oklahoma, part of a group of young Tulsa poets, including Ted Berrigan, who moved to New York City in the early 1960s. During that decade, Brainard contributed cartoons and illustrations to various poetry magazines and underground newspapers, designed book covers for poet friends, collaborated with poet Frank O'Hara in making comics, and published several books in collaboration with his companion, Kenward Elmslie. Brainard's drawings, collages, and paintings often featured the comic strip character Nancy, whom Warhol painted as well.[43] Brainard died of AIDS in 1994; his prolific career as an artist was celebrated most recently in a 1991 retrospective at P.S. 1 in Long Island City.[44] In 2004 Ron Padgett published a book about his friend, *Joe: A Memoir of Joe Brainard* (Minneapolis: Coffee House Press).

This portrait of Brainard was shot on March 3, 1965, on the same day as Ted Berrigan's *Screen Test* (ST22). David Ehrenstein's interview again documents Warhol's instructions to his sitter: "Joe, is this the first movie you ever made? . . . Could you bring that chair over here?"[45] Brainard's dark-rimmed glasses, button-down collar, and youthful face make his portrait look much like a mobile high school yearbook picture. Although the image is noticeably out of focus in the first half of the roll, Brainard's lively intelligence comes across strongly: he smiles at the camera, glances around, seems to sing to himself, and appears quite at ease. The moment when the focus is corrected in the middle of the film is legible not only in the improved clarity of the image but also in Brainard's face, who watches curiously as adjustments are made to the camera. The misspelling of Brainard's name on the film box may be an example of Warhol's dyslexic wit.

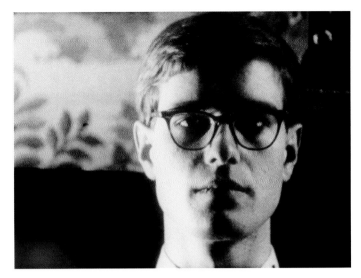

ST31

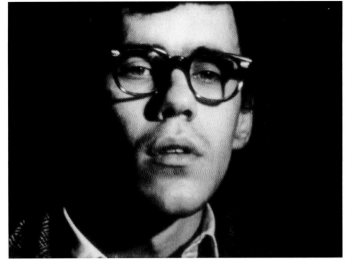

ST32

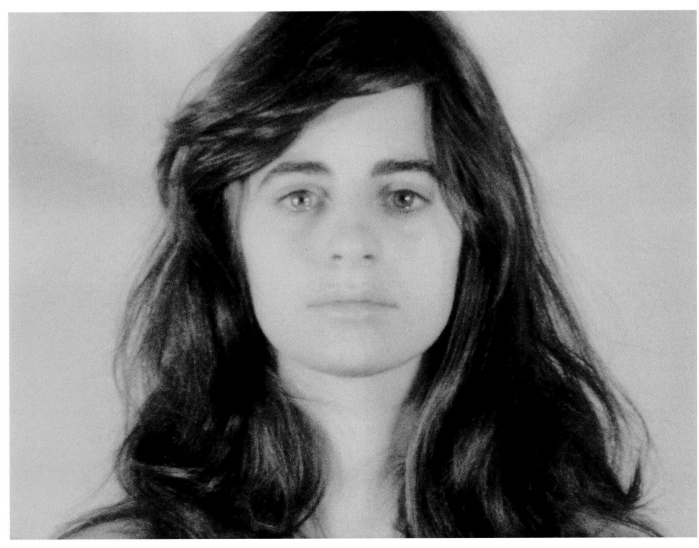

ST33

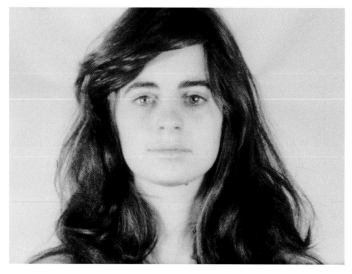

ST33

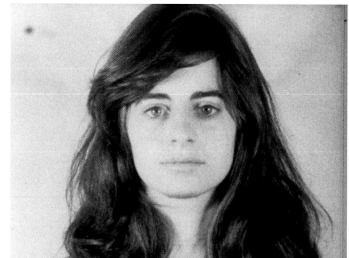

ST34

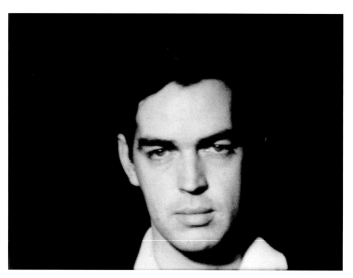

ST35

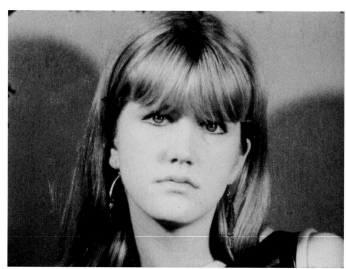

ST36

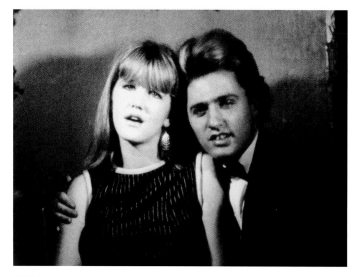

ST37

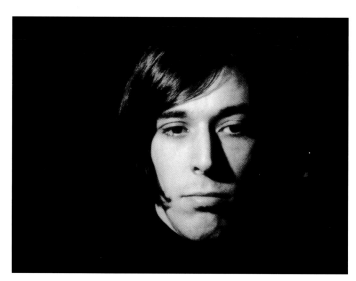

ST38

## ST33 *Ann Buchanan,* 1964

16mm, b&w, silent; 4.5 min. @ 16 fps, 4 min. @ 18 fps
Preserved 2001, MoMA *Screen Tests* Reel 25, no. 10; also preserved
as roll 2 in *Four of Andy Warhol's Most Beautiful Women* (ST365f)
**COMPILATIONS** *The Thirteen Most Beautiful Women* (ST365); *Four of
Andy Warhol's Most Beautiful Women* (ST365f)
**FILM MATERIALS**
ST33.1 *Ann Buchanan*
1964 Kodak 16mm b&w reversal original, 107'
**NOTATIONS** On plain brown box, in unidentified hand: *Girl Who
Cries a Tear*
On box flap: *8*

## ST34 *Ann Buchanan,* 1964

16mm, b&w, silent; 4.4 min. @ 16 fps, 3.9 min. @ 18 fps
Preserved 1995, MoMA *Screen Tests* Reel 10, no. 9
**COMPILATIONS** *The Thirteen Most Beautiful Women* (ST365); *Screen
Test Poems* (ST372); *Screen Tests/A Diary* (Appendix A)
**FILM MATERIALS**
ST34.1 *Ann Buchanan*
1964 Kodak 16mm b&w reversal original, 105'
ST34.1.p1 *Screen Test Poems,* Reel 2 (ST372.2), roll 12
Undated Gevaert 16mm b&w reversal print, 100'
**NOTATIONS** On original box in AW's hand: *Anne (13). Anne Buchanan.
Anne (13). terrific. cross-eyed*
On box in AW's hand, crossed out: *Rynell*
On flap in red: *12*
On typed label found in can: *ANNE BUCHANAN*
On clear film at both head and tail of roll: *12*

In the 1960s, Ann Buchanan was a young bohemian with connections
to Beat writers and poets on both coasts; she lived with and then
married the Kansas-born poet and writer Charles Plymell in 1963.
That summer, as Plymell recalled in his memoir, *The Frisco Kid, 1963,*
the couple shared an apartment in San Francisco with Allen Ginsberg
and Neal Cassady, who had been the model for Dean Moriarty, the
main character in Jack Kerouac's 1957 novel *On the Road.* In early
1964, Buchanan and Plymell stayed in Wichita, Kansas, for a few
months and eventually moved on to New York; as Plymell later
recalled, "I drove to New York with my girlfriend Ann. She ran off to
Andy's factory and later took up with [Barry] Miles (the official Gins-
berg biographer)."[46] Plymell later became the publisher of Zap Comix
in San Francisco, where he introduced the work of Robert Crumb
in 1967. Barry Miles is the author of biographies of Ginsberg and
William Burroughs; books about the Beatles, the Rolling Stones, and
the Beat Poets; and a recent memoir entitled *Hippie.* Ann Buchanan's
name can be found in a few of Ginsberg's poems from the early 1960s,
"Nov. 23, 1963: Alone" and "Hiway Poesy: L.A.–Albuquerque–
Texas–Wichita," in which Ginsberg mentions "Charlie Plymell come
Now to San Francisco/Ann Buchanan passing thru."[47]

The *Screen Tests* of Ann Buchanan are among the best-known
images from Warhol's elusive compilation, *The Thirteen Most Beau-
tiful Women* (ST365). A double-frame image of Buchanan appeared
in the *New York Herald Tribune* on January 10, 1965, in an article
describing a screening of *The Thirteen Most Beautiful Women.* Warhol
told the reporter that Buchanan's *Screen Test* was his "favorite per-
formance: 'She did something wonderful marvelous,' he said in his
pale voice. 'She cried'."[48]

In Buchanan's first *Screen Test* (ST33), labeled "Girl Who Cries
a Tear," she does indeed weep. Seated under bright lights and
apparently under instructions not to blink, she heroically holds her

eyes wide open while they slowly well up with glistening tears.
Halfway through the film, the first tear falls from her right eye and
rolls down her cheek. By the end of the roll, teardrops are dripping
from her jaw and her face is quite wet, but she has still not blinked
even once. This performance is uncanny to watch, like staring at a
religious icon that has miraculously begun to weep.[49]

In the second film (ST34), Buchanan's face is still wet with tears
and a droplet hangs from her jawline, but this time she fixes the
camera with a moist, wide-eyed gaze and then very slowly crosses
her eyes—a bit of deadpan humor that apparently delighted Warhol,
who wrote "terrific. cross-eyed" on the box.

## ST35 *Walter Burn,* 1964

16mm, b&w, silent; 4.4 min. @ 16 fps, 3.9 min. @ 18 fps
Preserved 1995, MoMA *Screen Tests* Reel 11, no. 2
**COMPILATIONS** *The Thirteen Most Beautiful Boys* (ST364)
**FILM MATERIALS**
ST35.1 *Walter Burn*
1964 Kodak 16mm b&w reversal original, 105'
**NOTATIONS** On original box in AW's hand: *Walter Burn. #13*

Although this single *Screen Test* of Walter Burn is slightly out of
focus throughout, Burn's ability to hold still for the full three minutes
while scarcely blinking at all makes him one of the more successful
performers in the static portrait films. The soft focus works almost
like an airbrush, simplifying his features into an iconic image of
generic handsomeness.

## ST36 *Debbie Caen,* 1965

16mm, b&w, silent; 4.5 min. @ 16 fps, 4 min. @ 18 fps
Preserved 1995, MoMA *Screen Tests* Reel 8, no. 7
**COMPILATIONS** *Screen Test Poems* (ST372); *Screen Tests/A Diary*
(Appendix A)
**FILM MATERIALS**
ST36.1 *Debbie Caen*
1965 Kodak 16mm b&w reversal original, 109'
ST36.1.p1 *Screen Test Poems,* Reel 2 (ST372.2), roll 17
Undated Gevaert 16mm b&w reversal print, 100'
**NOTATIONS** On original box in Gerard Malanga's hand: *Debbie Caen.
1 double-frame neg. marked by masking tape and one 8" x 10" glossy stillie*
On box in unidentified hand: *Debbie Portrait*
On typed label found in can: *DEBBIE CAEN*
On clear film at both head and tail of roll: *17*

## ST37 *Debbie Caen and Gerard Malanga,* 1965

16mm, b&w, silent; 4.5 min. @ 16 fps, 4 min. @ 18 fps
Preserved 1999, MoMA *Screen Tests* Reel 20, no. 7
**FILM MATERIALS**
ST37.1 *Debbie Caen and Gerard Malanga*
1965 Kodak 16mm b&w reversal original, 107'
**NOTATIONS** On box in unidentified hand: *Debbie & Gerard*
On box in Gerard Malanga's hand: *2 double frame negatives and
2 double frame 8" x 10" prints from each negative*

Debbie Caen, also known as "Debbie Drop-Out" or "Debbie High
School Drop-Out," was a onetime girlfriend of Gerard Malanga's
and also a friend of many other artists and filmmakers in the down-
town scene. Warren Sonbert's 1966 film *Amphetamine* was shot in

Caen's apartment on Eighth Avenue. In a letter to Malanga, Sonbert recalled "the first time I met Debbie—I walked into a room strewn with Ondine's pornography collection and the Supremes's "Where Did Our Love Go" was playing on the record player (this is the opening shot of *Amphetamine*). I met Debbie and the others and knew I was hooked to a new world."[50]

In her solo portrait, Caen coolly faces the camera with a rather distant expression; nervous swallowing reveals a certain tension. By the end of the film, the bright lights have filled her black-rimmed eyes with tears. A double portrait of Caen with Malanga was apparently shot at the same time, since Caen is wearing the same dress and earrings. Malanga, dressed in a tuxedo and with his hair combed into a high pompadour, poses with his arm around Caen's shoulders, leaning his head against her. They occasionally whisper to each other and smile ("Don't move," Debbie visibly says to Malanga); near the end of the film Malanga plants a kiss on her cheek. A double-frame image from this film, identified as a "'Stillie' from Andy Warhol's *Black Tie*," was reproduced on a flyer for Malanga's reading of "The Debbie High School Drop-Out Poems," at the Folklore Center on Sixth Avenue on January 31, 1966.[51]

## ST38  *John Cale*, 1966
16mm, b&w, silent; 4.5 min. @ 16 fps, 4 min. @ 18 fps
Preserved 2001, MoMA *Screen Tests* Reel 24, no. 3
COMPILATIONS  *Screen Test Poems* (ST372)
FILM MATERIALS
ST38.1  *John Cale*
1965 Kodak 16mm b&w reversal original, 108'
ST38.1.p1  *Screen Test Poems*, Reel 3 (ST372.3), roll 28
Undated Gevaert 16mm b&w reversal print, 108'
NOTATIONS  On original box in unidentified hand: *JOHN CALE. SCR. TEST*
Written inside box flap in Paul Morrissey's hand: *John's Screen Test. Great*
On clear film at both head and tail of roll: *28*

## ST39  *John Cale (Eye)*, 1966
16mm, b&w, silent; 3.8 min. @ 16 fps, 3.4 min. @ 18 fps
Preserved 1999, MoMA *Screen Tests* Reel 18, no. 8
COMPILATIONS  *EPI Background: Velvet Underground* (ST369)
FILM MATERIALS
ST39.1  *John Cale (Eye)*
1965 Kodak 16mm b&w reversal original, 92'
ST39.1.p1  *EPI Background: Velvet Underground* (ST369), roll 11
16mm b&w reversal print, 100'
NOTATIONS  On original box, with frame drawing, in Paul Morrissey's hand: *orig. John's eyes. Eye. Zoom back to face*

## ST40  *John Cale (Eye)*, 1966
16mm, b&w, silent; 4.1 min. @ 16 fps, 3.7 min. @ 18 fps
Preserved 1999, MoMA *Screen Tests* Reel 21, no. 9
COMPILATIONS  *EPI Background: Gerard Begins* (ST368)
FILM MATERIALS
ST40.1  *John Cale (Eye)*
1965 Kodak 16mm b&w reversal original, 97'
ST40.1.p1  *EPI Background: Gerard Begins* (ST368), roll 2
16mm b&w reversal print, 100'
NOTATIONS  On original box in AW's hand: *Orig John eyes. EYES*
On clear film at head of roll in red: *8*
On clear film at head of roll in black: *4*

## ST41  *John Cale (Lips)*, 1966
16mm, b&w, silent; 4.6 min. @ 16 fps, 4.1 min. @ 18 fps
Preserved 1998, MoMA *Screen Tests* Reel 15, no. 6
COMPILATIONS  *EPI Background: Gerard Begins* (ST368)
FILM MATERIALS
ST41.1  *John Cale (Lips)*
1965 Kodak 16mm b&w reversal original, 110'
ST41.1.p1  *EPI Background: Gerard Begins* (ST368), roll 4
1965 Kodak 16mm b&w reversal print, 108'
NOTATIONS  On white MPE box in unidentified hand: *Orig of John lips. John Cale's lips*
On clear film at head of roll: *5*

## ST42  *John Cale*, 1966
16mm, b&w, silent; 4.4 min. @ 16 fps, 3.9 min. @ 18 fps
COMPILATIONS  *EPI Background: Gerard Begins* (ST368)
FILM MATERIALS
Original not found in Collection
ST42.1.p1  *EPI Background: Gerard Begins* (ST368), roll 10
1965 Kodak 16mm b&w reversal print, 106'

## ST43  *John Cale*, 1966
16mm, b&w, silent; 4.2 min. @ 16 fps, 3.7 min. @ 18 fps
COMPILATIONS  *EPI Background: Velvet Underground* (ST369)
FILM MATERIALS
Original not found in Collection
ST43.1.p1  *EPI Background: Velvet Underground* (ST369), roll 3
1965 Kodak 16mm b&w reversal print, 100'
NOTATIONS  On clear film at head of roll: *4*

## ST44  *John Cale*, 1966
16mm, b&w, silent; 4.2 min. @ 16 fps, 3.7 min. @ 18 fps
COMPILATIONS  *EPI Background: Velvet Underground* (ST369)
FILM MATERIALS
Original not found in Collection
ST44.1.p1  *EPI Background: Velvet Underground* (ST369), roll 6
1965 Kodak 16mm b&w reversal print, 101'
NOTATIONS  On clear film at head of roll: *9*

John Cale, musician, composer, and founding member of the Velvet Underground, trained primarily as a classical musician in Wales and London before moving to New York in 1963. That September, Cale was one of a team of pianists who, under the direction of John Cage, completed the first full-length performance of Eric Satie's *Vexations*, a work in which a 180-note piano composition was repeated 840 times over a period of eighteen hours and forty minutes.[52] Cale also worked closely with the avant-garde composer La Monte Young during this period, performing with Young and his wife, Marian Zazeela, Terry Riley, and the musician and filmmaker Tony Conrad in the Theatre of Eternal Music, creating minimalist drone music in which certain notes would be repeated or sustained for long periods of time. Cale usually played electric viola in these performances, an instrument that he had altered by adding guitar strings and an amplifier. Cale also worked with Conrad on the sound tracks for Jack Smith's films *Flaming Creatures* and *Normal Love*.

In early 1965 Cale met the rock-and-roll musician and lyricist Lou Reed and, with Reed, Conrad, and the sculptor Walter De Maria, temporarily formed a rock band called the Primitives, which performed Reed's song "The Ostrich" on the TV show *American Bandstand*. Reed and Cale continued to work together throughout

ST39

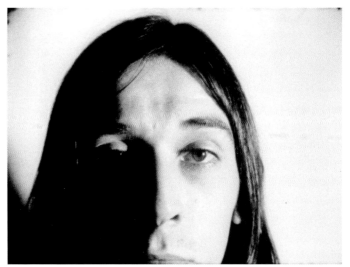

ST39

ST40

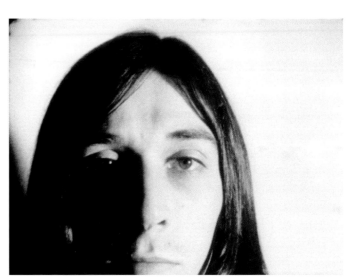

ST40

ST41

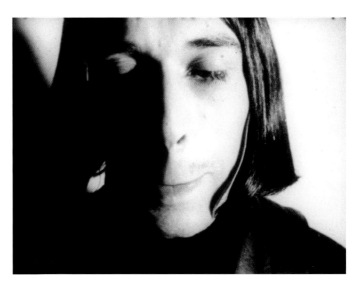

ST41

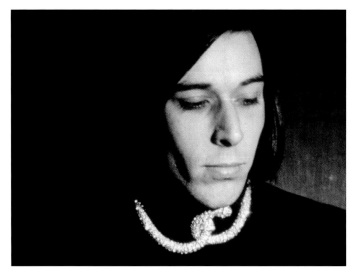

ST42

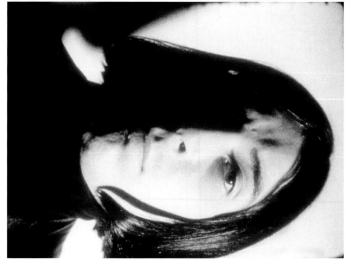

ST43

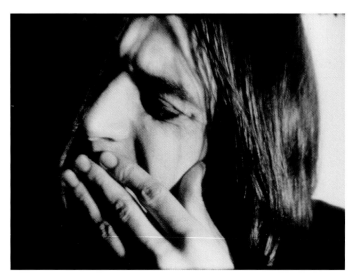

ST44

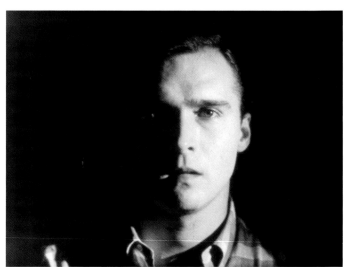

ST45

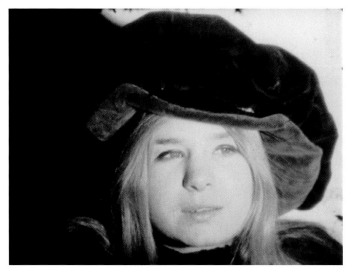

ST46

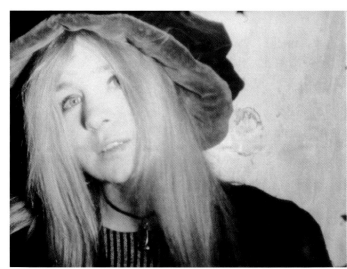

ST47

1965, first calling themselves the Falling Spikes and then, with the addition of Sterling Morrison and Angus MacLise on drums, forming a group called the Warlocks, soon renamed the Velvet Underground. When MacLise quit the group, he was replaced as drummer by Maureen Tucker. Warhol attended the Velvets' first public gig at the Café Bizarre on MacDougal Street, and immediately invited the band to visit the Factory, where they were offered a partnership, with Warhol as manager.

The Velvet Underground performed under Warholian management throughout 1966 and 1967; Warhol added the singer Nico to the group, booked gigs at the Film-Makers' Cinematheque and the Dom in New York, as well as out-of-town dates in Los Angeles, Ann Arbor, Michigan, Boston, Chicago, Provincetown, Massachusetts, and other cities, and produced their first album, *The Velvet Underground and Nico*, in 1967. For their live performances, Warhol and his colleagues, including Dan Williams, Barbara Rubin, and Paul Morrissey, developed a complex multimedia environment called the Exploding Plastic Inevitable (or EPI), which surrounded the Velvets onstage with multiscreen film projections, colored lights, patterned slides, dancers, and strobe lights. During these years, Cale appeared in seven *Screen Tests* as well as a number of other Warhol films: *The Velvet Underground and Nico, The Velvet Underground, The Velvet Underground Tarot Cards, The Velvet Underground in Boston*, and *The Bob Dylan Story* in 1966, and several reels shot for ★★★★ *(Four Stars)* in 1966–67: *Mary I, Tiger Hop, Barbara and Ivy, Ivy and Don McNeil*, and *Philadelphia Stable*. With other members of the Velvet Underground, he also performed the live, offscreen music for *Hedy* and two reels of *The Chelsea Girls* in 1966.

After leaving the Velvet Underground in 1968, Cale embarked on a solo career; he has issued more than two dozen albums of his own music. He has also produced albums for a number of other musicians, including Nico, Patti Smith, and the Stooges, and has created music tracks for a number of movies, including the Warhol/Morrissey film *Heat* (1972), Jonathan Demme's *Something Wild* (1986), Susanne Ofteringer's documentary *Nico Icon* (1995), Mary Harron's *I Shot Andy Warhol* and Julian Schnabel's *Basquiat* (both 1996), and Harron's *American Pyscho* (1999). In 1989 Cale and Lou Reed collaborated on a musical tribute to Warhol, the song cycle *Songs for Drella*, released in 1990 as an album by Warner Bros. In 1993 Cale, Reed, Sterling Morrison, and Maureen Tucker reunited briefly for a Velvet Underground reunion tour in Europe. In 1997 Cale issued an album, *Eat/Kiss: Music for the Films of Andy Warhol*, composed to accompany Warhol's silent films, which was first performed, with film screenings, at The Andy Warhol Museum in Pittsburgh in 1994. Cale's autobiography, *What's Welsh for Zen*, co-written with Victor Bockris, was published in 1999.[53]

Of the seven Cale *Screen Tests* found in the Collection, only one (ST38) seems to be a formal portrait in traditional *Screen Test* style. Cale's medieval-looking face, framed slightly offcenter, emerges out of the darkness, illuminated by a single light; he seems serious, almost glum. After a while, the light is suddenly turned off and then on again, which makes him laugh. By the end of the film, he is smiling often, apparently in response to something funny being said offscreen. A print of this *Screen Test* was included in *Screen Test Poems* (ST372).

The other six filmed portraits of Cale seem to have been intended primarily for projection behind the Velvet Underground in performance, as part of the Exploding Plastic Inevitable multimedia presentations. There are two nearly identical close-ups of Cale's left eye (ST39 and ST40), and one close-up of Cale's mouth (ST41); at the end of each of these films, the camera pulls back to show his full face.

The final three portrait films are prints that were found spliced into two different *EPI Background* reels (ST368 and ST369); the current location of the camera originals is unknown. One of these *Screen Tests* (ST42) is a shot of Cale with a glittery Kenneth Jay Lane snake necklace wrapped around his neck. The next two films (ST43 and ST44) are filled with wild zoomings, single-framing, in-camera edits, and other experimental techniques, with the camera sometimes tilted left and right or even turned horizontally on its side. In the last of these films (ST44), Cale is violently rubbing his face and eyes. These last two EPI *Screen Tests* of Cale may have been shot by Dan Williams, since they duplicate his shooting style in other films (see, for example, Williams's 1965 footage of *The Bed* catalogued in Volume 2).

### ST45  *Joe Campbell,* 1965
16mm, b&w, silent; 4.5 min. @ 16 fps, 4 min. @ 18 fps
Preserved 1995, MoMA *Screen Tests* Reel 9, no. 9
**FILM MATERIALS**
ST45.1  *Joe Campbell*
1965 Kodak 16mm b&w reversal original, 107'
**NOTATIONS**  On original box in AW's hand: <u>SUGAR Plum</u>

At the Warhol Factory, Joe Campbell was sometimes called "the Sugar Plum Fairy," a figure later immortalized in a stanza of Lou Reed's 1972 song "Walk on the Wild Side." Born in Nashville, Campbell met Warhol through his friendship with Ondine, whom he had known as a teenager in Red Hook, Brooklyn. In 1965, having recently ended a nine-year relationship with Harvey Milk, Campbell returned to New York, looked up Ondine, and was eventually enlisted to play the role of the older hustler in Warhol's next major production, *My Hustler*.[54] He also turns up in print as the character "Sugar Plum" in Warhol's tape-recorded novel, *a a novel*, recorded that summer. Campbell later appeared in the unreleased sequel, *My Hustler: In Apartment* (1965), and in the first, all-male version of *The Nude Restaurant*: two reels titled *Allen in Restaurant*, which were shot in early 1966 and included in ★★★★ *(Four Stars)* (1966–67).

Campbell recalled that when his *Screen Test* was shot, around the time of *My Hustler*, Warhol simply turned on the camera and walked away, leaving him alone until the film roll ran out.[55] Spiffily dressed in a madras jacket, Campbell at least partially matches Ondine's description of him as "handsome, smart, decadent, and a southerner."[56] His face, illuminated by a single light source on the right, emerges like a half-moon from complete darkness. Campbell holds quite still for the length of the film, an effort that makes him appear somewhat tense, more boyish than decadent.

### ST46  *Susanna Campbell,* 1966
16mm, b&w, silent; 4.5 min. @ 16 fps, 4 min. @ 18 fps
Preserved 1999, MoMA *Screen Tests* Reel 19, no. 2
**FILM MATERIALS**
ST46.1  *Susanna Campbell*
1965 Kodak 16mm b&w reversal original, 107'
**NOTATIONS**  On original box in AW's hand, with drawing of flower: *ASA 100. Susayne. Suzanne*
On box in unidentified hand with drawing of a flower: *telephone #41. 367 East 2nd Street*

**ST47  *Susanna Campbell*, 1966**
16mm, b&w, silent; 4.5 min. @ 16 fps, 4 min. @ 18 fps
Preserved 1999, MoMA *Screen Tests* Reel 22, no. 7
**FILM MATERIALS**
ST47.1  *Susanna Campbell*
1965 Kodak 16mm b&w reversal original, 109'
**NOTATIONS**  On original box in AW's hand: *Susane*
On box in unidentified hand: *ASA ★ 100*

Susanna Campbell, aka "Tinkerbell," began appearing at the Factory
in early 1966, where she hung around the Velvet Underground and
sometimes accompanied them on road trips.[57] She signed a release
for, but did not actually appear in, Warhol's 1966 unreleased feature
*Withering Sights*, and can also be seen in Barbara Rubin and Dan
Williams's *Uptight* footage of the taping of David Susskind's
"Bohemia" show in January 1966, when Warhol, members of the
Velvet Underground, the Fugs, and other Factory people traveled
to a Newark TV studio on a bus.

In her close-up portrait (ST46), Campbell, wearing a big floppy
velvet hat, strikes a series of flower child–like poses against a plain
plywood backdrop, smiling gently, batting her eyelashes, looking
alternately coy, wistful, filled with wonderment. The second film
(ST47), shot from a more distant perspective with many zooms, in-
camera cuts, and bursts of single-framing, shows her clambering
onto a high stool placed in front of a light on a stand. Campbell seems
to be moving constantly, rocking back and forth on her stool, point-
ing offscreen for something, and making fey, self-conscious faces for
the camera. At the end of the film she bends forward out of frame;
the roll ends on a close-up of a knothole in the plywood behind her.

**ST48  *Lawrence Casey*, 1964**
16mm, b&w, silent; 4.5 min. @ 16 fps, 4 min. @ 18 fps
Preserved 1995, MoMA *Screen Tests* Reel 6, no. 10
**COMPILATIONS**  *The Thirteen Most Beautiful Boys* (ST364)
**FILM MATERIALS**
ST48.1  *Lawrence Casey*
1964 Kodak 16mm b&w reversal original, 108'
**NOTATIONS**  On original box in AW's hand: *13 Larry*

Lawrence Casey was a twenty-two-year-old actor when he and his
girlfriend, Katha Dees, dropped by the Factory one day in 1964 and
had their *Screen Tests* shot by Warhol. Casey grew up in New York
City, one of eight children of a New York City firefighter who was
killed in the line of duty. In 1955 Casey was discovered on a Long
Island beach by a Broadway talent scout, who sent him to audition
for his first acting role in the Broadway play *The Visit*, starring
Alfred Lunt and Lynne Fontanne, with which Casey also toured
nationally. He then returned to New York to study with Lee Stras-
berg, Stella Adler, and Uta Hagen at the Actors Studio.

In 1965 Lawrence and Katha Dees married and moved to Los
Angeles, where he landed a starring role in a new ABC-TV action
series called *The Rat Patrol* (1966–68), which followed the adven-
tures of a four-man Jeep patrol staging commando raids against
German forces in the North African desert during World War II.
Casey also starred briefly as Rodney Harrington in the 1972 series
*Return to Peyton Place*, and appeared as a guest star on more than
fifty other TV programs throughout the 1970s and 1980s, including
episodes of *Gunsmoke*, *The Mod Squad*, *Bonanza*, *Logan's Run*, *The
Love Boat*, *The Rockford Files*, and *MacGyver*, as well as in a number

of made-for-TV movies. He had roles in several Hollywood movies
as well, including *The Great Waldo Pepper* (1975), the Chuck Norris
action film *Good Guys Wear Black* (1978), and the Charles Bronson
vehicle *Borderline* (1980). Casey also starred in several sexploitation
films, including *The Gay Deceivers* (1969) ("they had to keep their
hands off girls in order to keep the Army's hands off them"), Roger
Corman's production *The Student Nurses* (1970), and *The Erotic
Adventures of Robinson Crusoe* (1975), in which he played the title
role. Casey and his wife, Katha, still live in Los Angeles and have
three grown daughters.[58]

Casey recalls that when his *Screen Test* was shot, Warhol instructed
him only to smile, then turned on the camera and walked away to
work on some silk screens. Casey begins his performance staring
solemnly into the camera, one lock of his shining hair fallen onto
his forehead. He then lifts his chin slightly and begins an uncanny,
slow-motion transformation of his expression from complete neu-
trality to manic glee. A faint smile begins to form, his mouth opens,
his eyes widen, and by the end of the three minutes his face is
wreathed in an ecstatic grin—a grin that would be utterly convinc-
ing were it not for the unsettling deliberateness and control with
which it has been achieved.

**ST49  *Dan Cassidy*, 1965**
16mm, b&w, silent; 4.5 min. @ 16 fps, 4 min. @ 18 fps
Preserved 1995, MoMA *Screen Tests* Reel 6, no. 2
**COMPILATIONS**  *Screen Test Poems* (ST372)
**FILM MATERIALS**
ST49.1  *Dan Cassidy*
1964 Kodak 16mm b&w reversal original, 107'
ST49.1.p1  *Screen Test Poems*, Reel 1 (ST372.1), roll 4
Undated Gevaert 16mm b&w reversal print, 100'
**NOTATIONS**  On original box in AW's hand: *Dan Cassidy*
On box in Gerard Malanga's hand: *PRINT EXACTLY AS
MARKED. 2 double frame negatives marked by tape at beginning and
end of reel and 2 8" x 10"* (illeg.)
On clear film at both head and tail of roll: *4*

**ST50  *Dan Cassidy*, 1965**
16mm, b&w, silent; 4.5 min. @ 16 fps, 4 min. @ 18 fps
Preserved 1998, MoMA *Screen Tests* Reel 13, no. 1
**COMPILATIONS**  *Fifty Fantastics and Fifty Personalities* (ST366); *Screen
Test Poems* (ST372); *Screen Tests/A Diary* (Appendix A)
**FILM MATERIALS**
ST50.1  *Dan Cassidy*
1964 Kodak 16mm b&w reversal original, 108'
ST50.1.p1  *Screen Test Poems*, Reel 1 (ST372.1), roll 6
Undated Gevaert 16mm b&w reversal print, 100'
**NOTATIONS**  On original box in AW's hand: *DAN Cassidy 50. good*
On box in Gerard Malanga's hand, with drawing of double frame:
*1 Double Frame 8" x 10" Print + Negative*
On clear film at both head and tail of roll: *6*

**ST51  *Dan Cassidy*, 1965**
16mm, b&w, silent; 4.5 min. @ 16 fps, 4 min. @ 18 fps
Preserved 1995, MoMA *Screen Tests* Reel 9, no. 4
**FILM MATERIALS**
ST51.1  *Dan Cassidy*
1965 Kodak 16mm b&w reversal original, 109'
**NOTATIONS**  On original box in AW's hand: *Dan Cassidy*

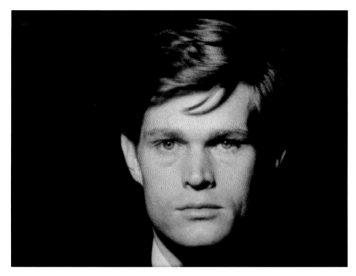

ST48

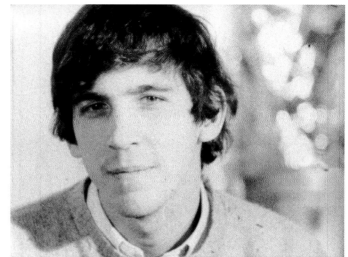

ST49

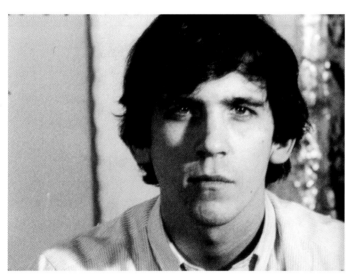

ST50

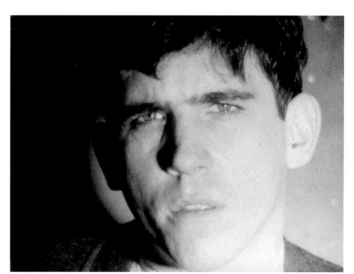

ST51

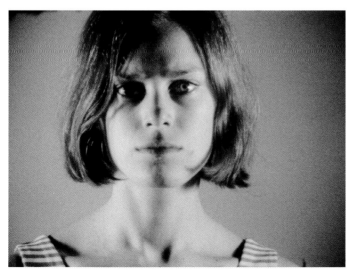

ST52

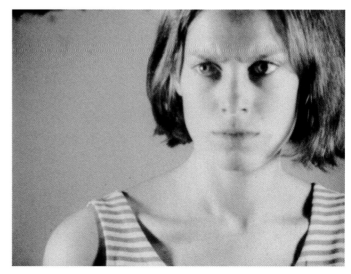

ST53

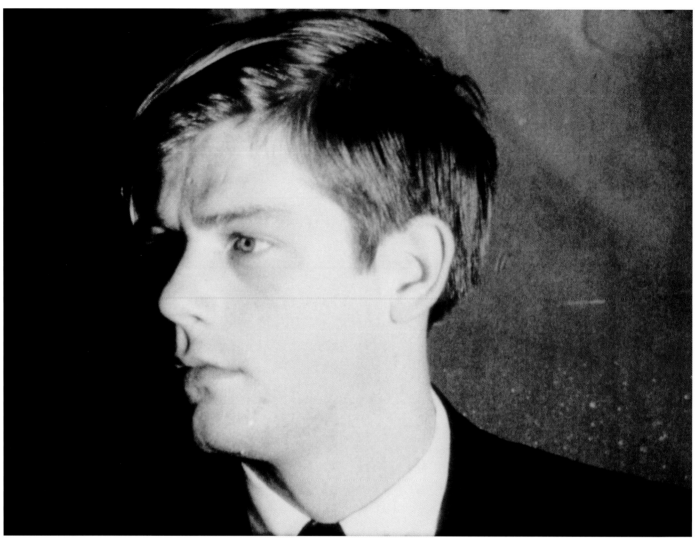

ST54

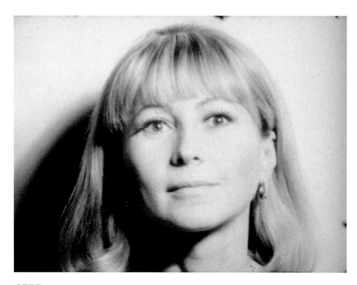

ST55

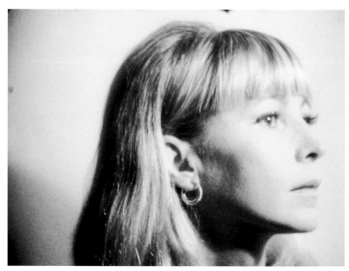

ST56

Dan Cassidy, a young poet friend of Gerard Malanga's who attended Cornell University, appeared in Warhol's early 1965 film *Horse*. His *Screen Tests*, shot on three different occasions, seem to show Cassidy in very different moods and perhaps at slightly different ages. In the first film (ST49), Cassidy, in a light-colored sweater, has been brightly lit against the sparkly, out-of-focus space of the Factory; he smiles often, laughing and responding to what seems to be a crowd of people standing around the camera watching him. In the second film (ST50), which Warhol labeled "good" and marked for inclusion in *Fifty Fantastics and Fifty Personalities*, Cassidy faces the camera purposefully, almost squinting with concentration, his gaze inadvertently distracted from time to time by someone standing to the right of the camera. In the last film (ST51), Cassidy sports a new haircut and appears older and more experienced, even somewhat jaded. Harshly lit from the right against a pockmarked plywood backdrop, he seems almost suspicious of the camera's approach into tighter close-up.

### ST52   *Lucinda Childs*, 1964

16mm, b&w, silent; 4.5 min. @ 16 fps, 4 min. @ 18 fps
Preserved 2001, MoMA *Screen Tests* Reel 24, no. 2
COMPILATIONS   *The Thirteen Most Beautiful Women* (ST365)
FILM MATERIALS
ST52.1   *Lucinda Childs*
1964 Kodak 16mm b&w reversal original, 107'
NOTATIONS   On original box in AW's hand: *13 beautiful girls. Lucinda portrait 13*
On clear film at head of roll: *L. 7*

### ST53   *Lucinda Childs*, 1964

16mm, b&w, silent; 4.4 min. @ 16 fps, 3.9 min. @ 18 fps
Preserved 1995, MoMA *Screen Tests* Reel 7, no. 7
FILM MATERIALS
ST53.1   *Lucinda Childs*
1964 Kodak 16mm b&w reversal original, 106'
NOTATIONS   On box in AW's hand: *Lucinda (A)*
On box in AW's hand, crossed out: *Roofis and Jack Induction. zooms seduction*
On box in unidentified hand, crossed out: *Drac. Rufus Telephone*

The postmodern dancer and choreographer Lucinda Childs originally studied with Merce Cunningham and Judith Dunn. In the early 1960s, she appeared with James Waring's dance company, and was an active member in the community of downtown dancers and artists connected with the Judson Dance Theater, a circle that included dancers such as Yvonne Rainer, Trisha Brown, and Freddy Herko as well as other Warhol associates like Billy Linich.[59]

These two *Screen Tests* of Childs were clearly made at the same time as another short film, *Shoulder* (1964), a four-minute close-up of Childs's shoulder in the same striped tank top. According to Gerard Malanga's recollection, these films were probably shot on the same day as *Jill Johnston Dancing* (1964), a series of short films of Jill Johnston, the *Village Voice* dance critic, improvising a dance performance at Warhol's freshly painted silver studio.[60] In the first of her *Screen Tests* (ST52), which Warhol apparently selected for *The Thirteen Most Beautiful Women* (ST365), Childs, framed in tight close-up, holds completely still and fixes the camera with a determined, leonine stare, frowning slightly. Her second *Screen Test* (ST53) is a small performance piece in its own right: Childs glares suspiciously around her, suggesting, in the muscular tension of her upper body and the slow-motion shifting of her gaze, the wariness of a trapped and dangerous animal.

### ST54   *James Claire*, 1966

16mm, b&w, silent; 4.5 min. @ 16 fps, 4 min. @ 18 fps
Preserved 1999, MoMA *Screen Tests* Reel 19, no. 8
COMPILATIONS   *The Thirteen Most Beautiful Boys* (ST364)
FILM MATERIALS
ST54.1   *James Claire*
1965 Kodak 16mm b&w reversal original, 108'
NOTATIONS   On box in AW's hand: *James Clair 13. James Claire*
On box in unidentified hand, crossed out: *Print. Screen Test II. Gerard and Mary. Tri-XXX*

James Claire played one of Hedy Lamarr's five husbands in *Hedy*; this *Screen Test* was probably shot around that time, in February 1966. Claire's portrait film is one of the last *Screen Tests* that Warhol designated for *The Thirteen Most Beautiful Boys* (ST364), as interest in that project began to evaporate in 1966. In his sitting, Claire stares in three-quarter profile offscreen to the left, holding very still and not blinking at all for the full three minutes (although his eyelids do quiver from time to time). Moisture slowly accumulates in his one visible eye; at the end of the film, two tears form on his lower lid and run glistening down his cheek.

### ST55   *Alicia Purchon Clark*, 1965

16mm, b&w, silent; 4.5 min. @ 16 fps, 4 min. @ 18 fps
Preserved 1995, MoMA *Screen Tests* Reel 1, no. 6
FILM MATERIALS
ST55.1   *Alicia Purchon Clark*
1965 Kodak 16mm b&w reversal original, 108'
NOTATIONS   On box in unidentified hand: *Alisca*

### ST56   *Alicia Purchon Clark*, 1965

16mm, b&w, silent; 4.5 min. @ 16 fps, 4 min. @ 18 fps
Preserved 2001, MoMA *Screen Tests* Reel 27, no. 1
FILM MATERIALS
ST56.1   *Alicia Purchon Clark*
1965 Kodak 16mm b&w reversal original, 109'
NOTATIONS   On original box in AW's hand: *Alisa*

These two *Screen Tests* of Alicia Purchon Clark were probably shot on November 4, 1965, the same day that Dan Williams shot a short film of Clark talking with Henry Geldzahler on the Factory couch. Since all of Williams's films were carefully dated on the leader, and since Clark is wearing the same dress and the same earrings in both the Williams and Warhol films, it seems likely that all three films were made on the same day.

Alicia Clark's film portraits are good illustrations of the difficulties some people encountered while enduring the three-minute ordeal of their *Screen Test*. Clark begins with a smile and a collected, self-possessed pose that directly addresses the camera. But as the seconds pass she becomes more and more uneasy—turning her head in profile, shifting her weight, swallowing nervously, and glancing about with what appears to be an increasingly fearful look in her eyes. The delicacy of Clark's features and the gentleness of her expression seem to highlight the intrusiveness of the camera's unmitigated attention.

**ST57** *Roderick Clayton,* 1966
16mm, b&w, silent; 4.6 min. @ 16 fps, 4.1 min. @ 18 fps
Preserved 1995, MoMA *Screen Tests* Reel 6, no. 5
COMPILATIONS *The Thirteen Most Beautiful Boys* (ST364)
FILM MATERIALS
ST57.1 *Roderick Clayton*
1965 Kodak 16mm b&w reversal original, 110'
NOTATIONS On original box in AW's hand: *Rodrich. (13)*

**ST58** *Roderick Clayton,* 1966
16mm, b&w, silent; 4.5 min. @ 16 fps, 4 min. @ 18 fps
Preserved 1995, MoMA *Screen Tests* Reel 3, no. 5
FILM MATERIALS
ST58.1 *Roderick Clayton*
1965 Kodak 16mm b&w reversal original, 109'
NOTATIONS On original box in AW's hand: *Roderick Clayton. Rick Clayton*

**ST59** *Roderick Clayton,* 1966
16mm, b&w, silent; 4.6 min. @ 16 fps, 4.1 min. @ 18 fps
Preserved 1995, MoMA *Screen Tests* Reel 1, no. 2
FILM MATERIALS
ST59.1 *Roderick Clayton*
1965 Kodak 16mm b&w reversal original, 110'
NOTATIONS On original box in AW's hand: *Roderick Clayton*

**ST60** *Roderick Clayton,* 1966
16mm, b&w, silent; 4.5 min. @ 16 fps, 4 min. @ 18 fps
Preserved 1999, MoMA *Screen Tests* Reel 21, no. 5
FILM MATERIALS
ST60.1 *Roderick Clayton*
1965 Kodak 16mm b&w reversal original, 109'
NOTATIONS On original box in AW's hand: *Roderick Clayton*

Roderick Clayton, a young man from Yellow Springs, Ohio, had a small role playing one of Hedy Lamarr's five husbands in Warhol's 1966 film *Hedy*, and also appeared as the solo star of an unreleased 1966 feature titled *Rick*, in which Clayton sustains a monologue on the subject of drugs for a full sixty-six minutes, with occasional assistance from *The Physician's Desk Reference*. Clayton's time at the Factory seems to have been rather brief; by June 1966 he was back in Yellow Springs, from where he wrote Warhol a letter describing his new job—taking body measurements from photographs of 40,000 Air Force pilots for use in future uniform and cockpit design.[61]

These four *Screen Tests* of Roderick Clayton appear to have been shot at the same time. Clayton sits in close-up in front of a plywood backdrop, starkly lit from the right. In the first film (ST57), he holds completely still, with one side of his face and one eye completely hidden in the shadows. He apparently has been told not to blink; by the end of the film his left eyelid is quivering. In the next film (ST58), Clayton's performance is less constricted; he looks around in all directions, squints into the light, peers upward, and turns to show both profiles.

The third film (ST59) presents a complete shift in camera style: as soon as Clayton lights a cigarette, the camera zooms back to show him against the plywood backdrop, with a bright light on a stand placed to the right. This is followed by a series of alternating in-and-out zooms, in-camera cuts, and experimental framings (from the mouth up, from the nose down), a fragmented, rhythmic portrait of Clayton that is very different from his unchanging pose in

ST57. The last film (ST60) appears to capture the end of the portrait session: Clayton, shot in extreme close-up, smokes the last of his cigarette, squints against the light, closes his eyes, and seems barely to tolerate the final moments of filming.

**ST61** *Rufus Collins,* 1964
16mm, b&w, silent; 4.3 min. @ 16 fps, 3.9 min. @ 18 fps
Preserved 1995, MoMA *Screen Tests* Reel 11, no. 7
COMPILATIONS *The Thirteen Most Beautiful Boys* (ST364)
FILM MATERIALS
ST61.1 *Rufus Collins*
1964 Kodak 16mm b&w reversal original, 104'
NOTATIONS On original box in AW's hand: *Rufus for (13). Good*

**ST62** *Rufus Collins,* 1964
16mm, b&w, silent; 4.4 min. @ 16 fps, 3.9 min. @ 18 fps
Preserved 1995, MoMA *Screen Tests* Reel 9, no. 10
FILM MATERIALS
ST62.1 *Rufus Collins*
1964 Kodak 16mm b&w reversal original, 106'
NOTATIONS On original box in AW's hand: *Rufus*

The actor Rufus Collins, whose friendship with Warhol began in the 1950s, trained at the Actors Studio in New York and was a member of the Living Theatre in the 1960s;[62] he appeared in their notorious production of Kenneth Brown's play *The Brig*, filmed by Jonas Mekas in 1963. Collins was also one of the earliest stars of Warhol's cinema, beginning in August 1963 with *Naomi and Rufus Kiss*, the film from which Warhol's Plexiglas sculpture *The Large Kiss* was derived. Collins appears in several other Warhol films from 1963 and 1964, including *Kiss*, *Batman Dracula*, *Soap Opera*, and *Couch*. Later in his career, Collins played a Transylvanian in the cult feature *The Rocky Horror Picture Show* (1975), and had a few small roles in more mainstream pictures such as *Shock Treatment* (1981) and *The Hunger* (1983). He settled in Europe, dying from AIDS in Holland in 1996.

Warhol apparently shot two *Screen Tests* of Collins at one sitting, and marked one of them "Good" for inclusion in *The Thirteen Most Beautiful Boys* (ST364). In this first film (ST61), Collins faces the camera straight on, his face lit equally from right and left, divided down the center by dark, symmetrical shadowing in which his eyes seem almost lost. In the second film (ST62), Collins gazes intently off to the right, apparently fascinated by something that is taking place off-camera. Occasionally he turns back to the camera, and breaks out laughing as if at a shared joke, only to turn and stare off-screen again. The intensity of Collins's absorption and the laughs he directs at the camera create the unmistakable impression that he is watching some sort of sexual activity. At the end of the film, Collins turns to face the camera, stretches his neck, and yawns just as the film ends.

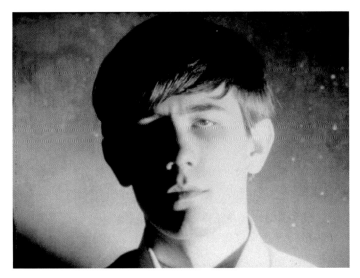

ST57

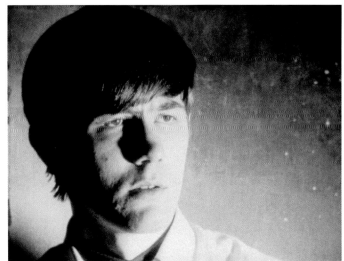

ST58

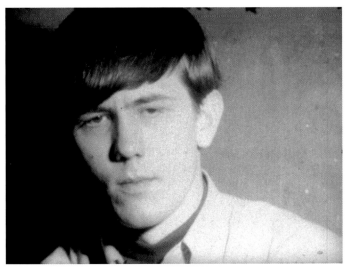

ST59

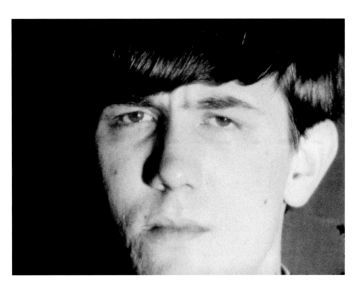

ST60

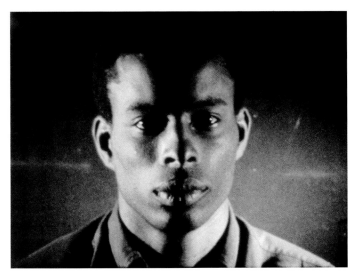

ST61

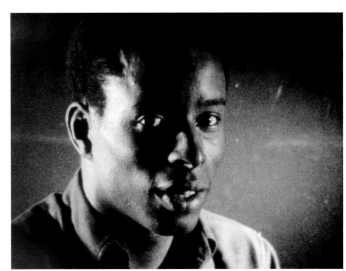

ST62

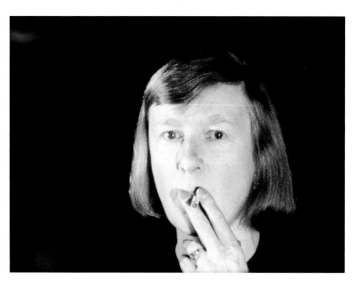

ST63

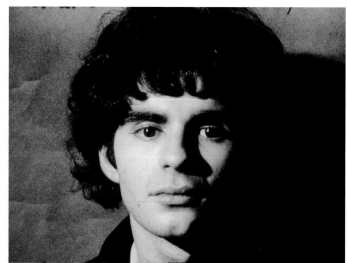

ST64

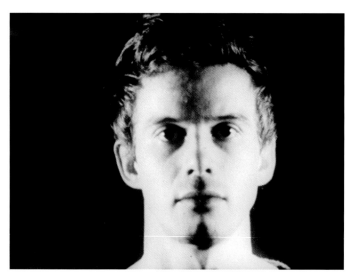

ST65

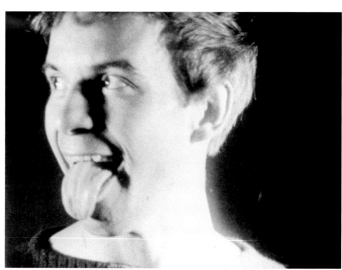

ST66

ST67

ST68

**ST63**   *Rosalind Constable,* 1964

16mm, b&w, silent; 4.5 min. @ 16 fps, 4 min. @ 18 fps
Preserved 1998, MoMA *Screen Tests* Reel 13, no. 5
COMPILATIONS   *Fifty Fantastics and Fifty Personalities* (ST366)
FILM MATERIALS
ST63.1   *Rosalind Constable*
1964 Kodak 16mm b&w reversal original, 109'
NOTATIONS   On original box in unidentified hand: *Rosalind Constable. 50*

The New York journalist and writer Rosalind Constable was well known as a cultural trend-spotter; she worked for several decades as an editorial adviser on the avant-garde for Time-Life, Inc.[63] As *New York* magazine observed in 1966, "Everyone knew that Rosalind Constable was the person to ask about anything ranging from the latest slang to the first stirrings of a literary style or new arts movement."[64] Constable was the companion of gallery owner Betty Parsons and since the 1940s had been a close friend of the writer Patricia Highsmith, who dedicated her novel *The Tremor of Forgery* to her.[65] She was also a friend of the painter Harold Stevenson, who introduced her to Warhol in 1963.[66] In the 1970s Constable moved to Santa Fe, New Mexico, where she continued to write about contemporary art, and where she died in 1995.

Constable's *Screen Test* is a portrait of an intelligent and formidable woman. Framed slightly offcenter against a black background, Constable smokes continuously while gazing casually about. Occasionally she gives the camera a demure half-smile, but most of the time seems comfortably occupied with her own thoughts. Her pageboy bangs and painted, blunt-cut fingernails give her a look of slightly dated European avant-gardism.

**ST64**   *Ronnie Cutrone,* 1966

16mm, b&w, silent; 4.6 min. @ 16 fps, 4.1 min. @ 18 fps
COMPILATIONS   *Screen Tests/A Diary* (Appendix A)
FILM MATERIALS
ST64.1   *Ronnie Cutrone*
1966 Kodak 16mm b&w reversal original, 110'
NOTATIONS   On original box in Gerard Malanga's hand: *Ronald Cutrone*
On typed label found in can: *RONALD CUTRONE*

The artist Ronnie Cutrone began hanging around the Factory as a teenage art student in early 1966. Cutrone danced with the Velvet Underground as part of the Exploding Plastic Inevitable performances, and appeared in several Warhol films during this year, including *The Chelsea Girls,* parts of ★ ★ ★ ★ *(Four Stars),* and *Since,* in which he and Gerard Malanga alternated roles as Jack Ruby and Lee Harvey Oswald. Cutrone was one of Warhol's main studio assistants in the 1970s and 1980s, and later became known as an artist for his "post-Pop" style, producing large-scale paintings of cartoon figures such as Mighty Mouse and Felix the Cat.

In his *Screen Test,* Cutrone appears very young and rather Pan-like, with dark eyes and wildly curling hair. His face is brightly lit from the left side of the screen, with the dark shadow of his nose and brow falling across the right side of his face. The sitting seems to make him somewhat anxious; he nervously looks in all directions, and then turns his head stiffly from side to side as if following instructions.

**ST65**   *Walter Dainwood,* 1964

16mm, b&w, silent; 4.4 min. @ 16 fps, 3.9 min. @ 18 fps
Preserved 1998, MoMA *Screen Tests* Reel 15, no. 8
COMPILATIONS   *The Thirteen Most Beautiful Boys* (ST364)
FILM MATERIALS
ST65.1   *Walter Dainwood*
1964 Kodak 16mm b&w reversal original, 105'
NOTATIONS   On original box in AW's hand: *Walter Dainwood. 13. Walter. Beverly GR-3-7649*

**ST66**   *Walter Dainwood,* 1964

16mm, b&w, silent; 4.4 min. @ 16 fps, 3.9 min. @ 18 fps
Preserved 1995, MoMA *Screen Tests* Reel 5, no. 9
COMPILATIONS   *The Thirteen Most Beautiful Boys* (ST364)
FILM MATERIALS
ST66.1   *Walter Dainwood*
1964 Kodak 16mm b&w reversal original, 105'
NOTATIONS   On original box in AW's hand: *Walter (13). Canyon*

A friend of Ondine's, Walter Dainwood was, like Binghamton Birdie, one of the crowd known as the "opera people," a group who would gather at the Factory to listen to records and to Ondine's lectures on the operatic arts.[67] Dainwood appeared with Ondine in several Warhol films, including the pornographic works *Three* and *Couch* from 1964, and a reel of *Since* from 1966. Dainwood was also a friend of the filmmakers Marie Menken and Willard Maas, and published an essay about Maas's work in *Filmwise* magazine in 1967.[68]

In the first of his two *Screen Tests* (ST65), Dainwood is symmetrically lit from both sides, a Rorschach-like shadow running down the center of his face. Dainwood faces down the camera with a series of intense, unfocused stares; at times he seems to have fallen into a state of self-hypnosis, which is broken occasionally by the rolling or blinking of his eyes. In the second film (ST66), Dainwood is by contrast wildly animated and flighty, making faces at the camera, smirking, nodding, and rapidly progressing through a whole range of different expressions, from amusement to boredom, irritation, and spaciness. According to Warhol's notes on the film boxes, both films were selected for *The Thirteen Most Beautiful Boys* (ST364).

**ST67**   *Salvador Dalí,* 1966

16mm, b&w, silent; 3.7 min. @ 16 fps, 3.3 min. @ 18 fps
Preserved 1999, MoMA *Screen Tests* Reel 23, no. 2
COMPILATIONS   *EPI Background: Lost Reel* (ST371)
FILM MATERIALS
ST67.1   *Salvador Dalí*
1965 Kodak 16mm b&w reversal original, 89'
Film was shot with the camera upside down; it is broken at the head and begins in image
NOTATIONS   On box in Gerard Malanga's hand, with drawing of double frame: *Salvador Dali. 1 double-frame negative and 1 double-frame glossy 8 x 10 print marked by masking tape*
On clear film at tail of roll: *R. 1*

**ST68  *Salvador Dalí*, 1966**
16mm, b&w, silent; 3.8 min. @ 16 fps, 3.4 min. @ 18 fps
Preserved 1999 by MoMA as roll 1 in *EPI Background: Original Salvador Dalí* (ST367)
COMPILATIONS  *EPI Background: Original Salvador Dalí* (ST367); *Screen Tests/A Diary* (Appendix A)
FILM MATERIALS
ST68.1  *EPI Background: Original Salvador Dalí* (ST367), roll 1
1965 Kodak 16mm b&w reversal original, 91'
ST68.1.p1  *Salvador Dalí*
1965 Kodak 16mm b&w reversal print, 91', 93' with black head leader
NOTATIONS FOR ST68.1.P1  On box in AW's hand: *Salvator Dali Print*
On typed label found in can: *SALVADOR DALI*
On clear film at head of roll: *R. 2*

The artist Salvador Dalí appears in two *Screen Tests* from 1966. The first film (ST67), oddly enough, seems to have been shot with the camera deliberately inverted, so that Dalí appears upside down, with his eccentric, upturned mustachios now pointing down. Dalí gives a typically surreal performance in this film: gazing imperiously upward (or, actually, down), he slowly lifts a small, glittery handbag into view and turns it this way and that, accompanying these manipulations with suggestive glances in various directions. The handbag is held briefly to his cheek, then tapped rhythmically with his fingers, as if he were listening to music.

In his second, right-side-up *Screen Test* (ST68), the artist glares aghast at the camera, his head held high and lit dramatically from below. Halfway through the film, there is a sudden in-camera edit, and Dalí disappears from view; the rest of the film shows only the speckled wooden backdrop behind him. This second Dalí portrait was found spliced into the beginning of a compilation reel labeled *Original Salvador Dalí* (ST367), which contains four original *Screen Tests* and two other 100' rolls. This reel was apparently projected behind the Velvet Underground during their performances; in fact, an early ad for Andy Warhol Up-Tight at the Film-Makers' Cinematheque lists Salvador Dalí as one of the participants in "The Up-Tight Series: Up-tight Rock 'n' Roll, Whip Dancers, Film-maker Freaks, Tapers, Anchovie Filming live episodes of the 'Up-Tight' series . . ."[69]

The fact that both of these Dalí portrait films were numbered on the head leaders suggest that they may possibly have been intended to be projected together, perhaps side by side (one right side up, one upside down) in double-screen projection in one of the mixed-media EPI events.

**ST69  *Sarah Dalton*, 1964**
16mm, b&w, silent; 4.5 min. @ 16 fps, 4 min. @ 18 fps
Preserved 1999, MoMA *Screen Tests* Reel 21, no. 10
COMPILATIONS  *The Thirteen Most Beautiful Women* (ST365)
FILM MATERIALS
ST69.1  *Sarah Dalton*
1964 Kodak 16mm b&w reversal original, 107'
NOTATIONS  On original box in AW's hand: *Sara. SARA 13*

Sarah Dalton was introduced to Andy Warhol by Ivan Karp in 1962, when she was thirteen years old; she and her older brother David became friends with Warhol because they lived near each other on East 89th Street in Manhattan.[70] In the fall of 1963, Warhol enlisted Dalton's help with the editing of his first major

film, *Sleep*; he also made a short film of her for use in a commissioned illustration for *Harper's Bazaar* (*Sarah-Soap* [1963]). In April 1964 Sarah Dalton wore Warhol's special *Fragile—Handle with Care* dress to the Factory party for the opening of his *Brillo Soap Pads Boxes* exhibition at the Stable Gallery. In 1966 David Dalton collaborated with Warhol in designing a special issue of *Aspen* magazine.

Sarah Dalton's *Screen Test* was shot at the Factory in 1964, possibly on Sunday, March 8 (when Warhol recorded her name in his date-book),[71] and was subsequently selected for *The Thirteen Most Beautiful Women* (ST365). The fifteen-year-old Dalton holds consistently still, determinedly staring back at the camera while maintaining a perfect stone face. The vulnerability legible in her large, dark eyes enhances the tension of the film, which is finally broken when she looks away from the camera momentarily near the end of the film.

**ST70  *David*, 1966**
16mm, b&w, silent; 4.6 min. @ 16 fps, 4.1 min. @ 18 fps
Preserved 1998, MoMA *Screen Tests* Reel 15, no. 10
FILM MATERIALS
ST70.1  *David*
1966 Kodak 16mm b&w reversal original, 110'
NOTATIONS  On original box in AW's hand: *DAVID*

In this *Screen Test*, a young man identified only as "David" drinks a bottle of Coca-Cola as a performance for the camera—doggedly swallowing, belching, draining every last drop, peering into the bottle, then holding the empty bottle up to the light to examine its facets. The film is shot with much fancy camerawork: dramatic shifts in framing and aperture settings, bursts of single-framing, rapid sideways pans, sudden changes in pace from fast to slow. The camerawork and the quasi-commercial content suggest that this roll was probably shot around the same time as other 1966 *Screen Tests* such as *Nico (Coke)* (ST244), *Nico (Hershey)* (ST245–246), *Lou Reed (Coke)* (ST269), and *Lou Reed (Hershey)* (ST270–1).

**ST71  *Susanne De Maria*, 1964**
16mm, b&w, silent; 4.5 min. @ 16 fps, 4 min. @ 18 fps
Preserved 2001, MoMA *Screen Tests* Reel 25, no. 9
COMPILATIONS  *The Thirteen Most Beautiful Women* (ST365)
FILM MATERIALS
ST71.1  *Susanne De Maria*
1964 Kodak 16mm b&w reversal original, 109'
NOTATIONS  On plain brown box in unidentified hand: *Suzanne de Maria. 1*
On white tape on tail of film: *de Maria*

**ST72  *Susanne De Maria*, 1964**
16mm, b&w, silent; 4.4 min. @ 16 fps, 3.9 min. @ 18 fps
Preserved 1995, MoMA *Screen Tests* Reel 1, no. 8
COMPILATIONS  *The Thirteen Most Beautiful Women* (ST365)
FILM MATERIALS
ST72.1  *Susanne De Maria*
1964 Kodak 16mm b&w reversal original, 106'
NOTATIONS  On original box in unidentified hand: *Beautiful Girl. Suzanne*

ST69

ST70

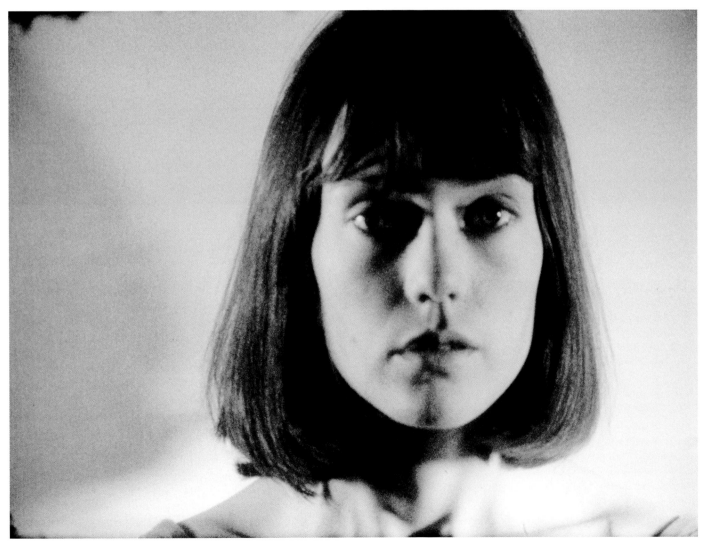

ST71

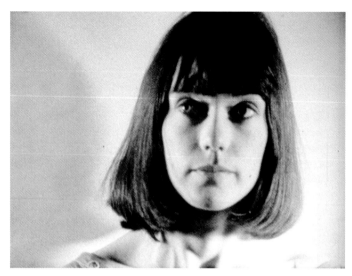

ST72

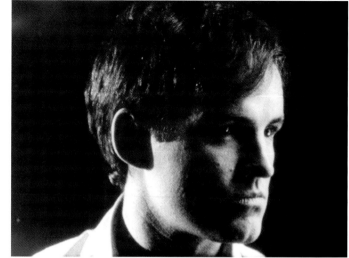

ST73

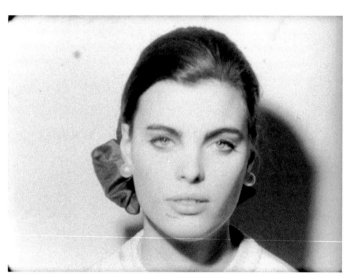

ST74

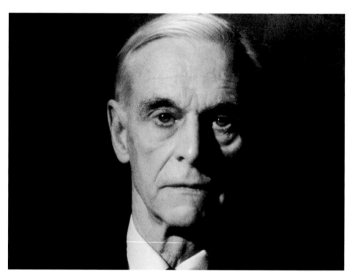

ST75

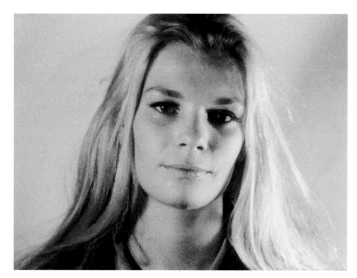

ST76

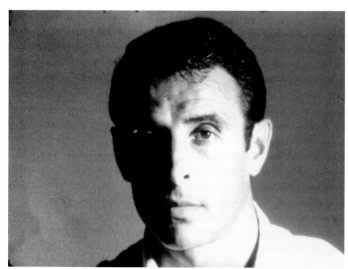

ST77

In 1964 Susanne De Maria, wife of the artist Walter De Maria, met Warhol at a musical evening at composer La Monte Young's loft. She noticed Warhol staring at her during the music; afterward he asked her to be in a film. When she came to her scheduled filming at the Factory a few days later, Warhol at first asked her if she would be willing to make love on the couch with a young man who was present (see *Couch* (1964)). When she refused, Warhol shot these two *Screen Tests*, which he marked for inclusion in *The Thirteen Most Beautiful Women* (ST365).[72] De Maria recalls that she was very disappointed when her *Screen Test* was not included in the premiere of *The Thirteen Most Beautiful Women* (ST365) later that year; however, one of her *Screen Tests* (ST71) was later included in the excerpted version of *The Thirteen Most Beautiful Women* (ST365) licensed to German television in 1969, copies of which ended up in London and Paris.

In the 1960s Susanne De Maria studied art and dance, did some modeling, and also performed in some of Robert Whitman's Happenings and Cinema Pieces, including *Dressing Table* (1962). She also appeared in some of Jack Smith's photographs and in Smith's 1968 film *No President*. In later years she changed her name to Susanna Wilson and became a fashion designer and a packaging designer.[73] In late 1964 Walter De Maria became the drummer in a rock band with Lou Reed, John Cale, and Tony Conrad; De Maria was later replaced, first by Angus MacLise and then by Maureen Tucker, when the band became the Velvet Underground.

In the first of her two *Screen Tests* (ST71), De Maria holds very still and gazes wide-eyed at the camera, her head trembling slightly. She swallows nervously and glances to the side only very briefly. In the second film (ST72), she is apparently no longer required to hold still and thus appears much more relaxed. She glances around, tilts her head, leans back, smokes, and occasionally smiles at the camera, revealing her dimples.

## ST73    *Denis Deegan*, 1964

16mm, b&w, silent; 4.6 min. @ 16 fps, 4.1 min. @ 18 fps
Preserved 1995, MoMA *Screen Tests* Reel 11, no. 6
COMPILATIONS *The Thirteen Most Beautiful Boys* (ST364); *Screen Test Poems* (ST372); *Screen Tests/A Diary* (Appendix A)
FILM MATERIALS
ST73.1 *Denis Deegan*
1963 Kodak 16mm b&w reversal original, 110'
ST73.1.p1 *Screen Test Poems*, Reel 1 (ST372.1), roll 2
Undated Gevaert 16mm b&w reversal print, 100'
NOTATIONS  On box in AW's hand: <u>*Dennis Deegan*</u> (*13*)
On box in AW's hand, crossed out: *#4 Jack and MacDermott on bike, some cuts will be made*
On box in Gerard Malanga's hand: *1 double frame negative and one 8" x 10" double frame glossy print*
On box flap in red: *2*
On typed label found inside can: *DENIS DEEGAN*
On clear film at both head and tail of roll in black: *2*

Warhol apparently first met the red-haired actor and model Denis Deegan in Los Angeles in the fall of 1963, when Deegan was instrumental in arranging for some scenes in Warhol's film *Tarzan and Jane Regained, Sort Of . . .* to be shot at the home of actor John Houseman.[74] Two early pre–*Screen Test* portrait films of a bare-chested Deegan may have been shot in California at this time (see Volume 2, *Denis Deegan*, 1963).[75] Deegan then moved to Paris, where he lived for the next two years, and where, in 1965, he introduced Warhol to Nico, the goddesslike German model who

would become a Warhol superstar and singer with the Velvet Underground in 1966. After his return to New York in 1966, Deegan starred in several color sound sequences shot that fall: *Dentist: Nico, Ivy, Denis*, and *Ivy and Denis I* and *II*.

Deegan is mentioned in Kelly Edey's diary as one of the beautiful boys whom Warhol filmed at his home on January 17, 1964, which makes his *Screen Test* one of the first to be shot.[76] He is also mentioned in Gerard Malanga's diary entry for September 24, 1966: "Denis Deegan has arrived in town after living in Europe for over two years. I gave him a present of himself for himself in the form of a 'still' by Andy shot in 1964."[77]

For his *Screen Test*, Deegan has been carefully posed in profile, facing offscreen right and gazing modestly downward. After a couple of minutes, he is apparently given instructions to turn and present his full face to the camera, a pose that generates the dark central shadowing typical of these early, symmetrically lit portrait films. Deegan smiles warmly at the cameraman, lifts his left arm as if to lean on the back of a chair, and then returns to profile.

## ST74    *Katha Dees*, 1964

16mm, b&w, silent; 4.5 min. @ 16 fps, 4 min. @ 18 fps
Preserved 1995, MoMA *Screen Tests* Reel 8, no. 5
FILM MATERIALS
ST74.1 *Katha Dees*
1964 Kodak 16mm b&w reversal original, 108'
NOTATIONS  On original box in AW's hand: *Cathy*
Rewritten over the above in unidentified hand: *Cathy*

The young model Katha Dees appears in a *Screen Test* from 1964. One of three identical triplets, Dees grew up in New York City, where she attended the Birch Wathen School and the Parsons School of Design. In 1963 one of her professors, the painter and art director Marvin Israel, took Katha and her sisters, Megan and Christina, to meet Diana Vreeland, the editor of *Vogue* magazine. At Vreeland's office they were noticed by the preeminent British fashion photographer Norman Parkinson, who followed the sisters down the street and invited them to Paris to model the new collections. The triplets, who were also taken on by Eileen Ford's modeling agency, created quite a sensation in Paris, appeared on the cover of the British magazine *Queen*, and were frequently photographed for German fashion magazines; all three were able to finance their college educations with the income they earned from modeling.

In 1964, while Katha Dees was studying art at Parsons, she and her boyfriend, the actor Lawrence Casey, met Warhol at a party for Tennessee Williams given by Lester Persky; Warhol was fascinated by Dees's glamorous career as a model, and invited the couple to come to the Factory to pose for their film portraits. As Dees recalls, her portrait was shot first, and the three minutes of filming seemed to take forever, making her feel self-conscious and awkward. This self-consciousness is not at all apparent in the film: dressed up in pearl earrings, meticulously made up, and with her hair held back by a large bow, Dees sits through her three minutes of film time with professional poise, blinking naturally but otherwise holding very still.

Lawrence Casey's *Screen Test* was shot a few minutes later. Although the lighting in both films is basically the same, it is interesting to note that the background has been changed from white to black. This suggests that Warhol may have purposefully used a white backdrop to offset Katha Dees's dark hair and white skin, then switched to a black background to highlight Lawrence Casey's blond hair.

After this first encounter at the Factory, Dees and Casey became friends with Warhol, meeting him socially and going out to dinner. In 1965 the young couple married and moved to Los Angeles, so Casey could continue his career as a professional actor. Katha Dees's mother, Kathleen Dees, later became friends with Warhol as well when they met at Sermoneta, a Madison Avenue shop run by Katha's sister, Megan Sermoneta. Katha and Lawrence Casey still live in Los Angeles, and have three grown daughters.[78]

## ST75 *Edwin Denby,* 1964

16mm, b&w, silent; 4.6 min. @ 16 fps, 4.1 min. @ 18 fps
COMPILATIONS *Screen Tests/A Diary* (Appendix A)
FILM MATERIALS
ST75.1 *Edwin Denby*
1963 Kodak 16mm b&w reversal original, 110'
NOTATIONS On original box in Gerard Malanga's hand: *Edwin Denby*
On typed label taped to reel: *EDWIN DENBY*

The poet Edwin Denby, who died in 1983 at the age of eighty, was well known as a dance critic and balletomane, and was a much-admired figure in New York poetry and art circles in the 1950s and 1960s. Denby was especially close to the poet Frank O'Hara and to the filmmaker and photographer Rudy Burckhardt, with whom he collaborated on a number of films and books. In August 1963 Andy Warhol was commissioned by Ted Berrigan to design a cover for a special issue of *C* magazine devoted to Denby's sonnets; Warhol's design for the front and back covers consists of two photographs of Denby posing with Gerard Malanga, with Malanga at first standing behind Denby on the front, and then leaning forward to kiss him on the back cover.[79] In 1965 Denby wrote a dialogue for the film project *Messy Lives,* a planned collaboration between Warhol and the writer Joe LeSueur; although the film was never made, Denby's contribution, "Four Plays by Edwin Denby," was later published and also performed as a play at the Eye and Ear Theatre, with sets designed by the painter Elizabeth Murray.[80]

In his *Screen Test,* probably shot in early 1964, Denby fits Padgett's description of him as "a quietly radiant gentleman,"[81] elegantly dressed in a white collar and necktie, with his hair carefully combed. Denby appears sensitive and a little startled, blinking owlishly against the bright lights of the film set.

## ST76 *Sally Dennison,* 1964

16mm, b&w, silent; 4.5 min. @ 16 fps, 4 min. @ 18 fps
Preserved 2001, MoMA *Screen Tests* Reel 25, no. 8; also preserved as roll 3, *Four of Andy Warhol's Most Beautiful Women* (ST365f )
COMPILATIONS *The Thirteen Most Beautiful Women* (ST365); *Four of Andy Warhol's Most Beautiful Women* (ST365f)
FILM MATERIALS
ST76.1 *Sally Dennison*
1964 Kodak 16mm b&w reversal original, 108', 110' with leader
NOTATIONS[82] On plain brown box in unidentified hand: *Sam's Sally. Friend of Antonio. 3*
On gray head leader in unidentified hand: *BEAUTIFUL GIRL–HEAD–TRI-FILM*
On white tape on tail of film: *Sally*

Sally Dennison, a descendant of the Dennison Paper family, was an old acquaintance of Warhol's friend, the art dealer Samuel Adams Green.[83] Dennison and Green had known each other since they were teenagers, when they had met in summer stock in Woodstock, New York. When Green left Richard Bellamy's Green Gallery in New York City in the fall of 1964 to become director of the Institute of Contemporary Art in Philadelphia, Dennison and Warhol's friend David Whitney together took over his responsibilities at the gallery. In 1965 Dennison met the Italian filmmaker Michelangelo Antonioni and became his girlfriend and also his collaborator and casting director. In the summer of 1967, while in the United States scouting locations for his next film, *Zabriskie Point* (1970), Antonioni attended an advance screening of the unfinished ★★★★ *(Four Stars)* at Warhol's Factory, a visit undoubtedly arranged by Dennison.[84] In 1968 Dennison was interviewed in Boston, where she was searching for "a boy who's involved in the student revolt" to cast in the leading role in *Zabriskie Point.*[85] The untrained actor she discovered in Boston was Mark Frechette, who, like Ronna Page, became a member of Mel Lyman's Fort Hill commune, to which he left all his earnings from the film after his death in 1975.[86] Dennison became a successful casting director and occasional actress, responsible for casting mainstream feature films such as *Close Encounters of the Third Kind* (1977), *1941* (1979), *The China Syndrome* (1979), *Robocop* (1987), *The Accused* (1988), and *Love Field* (1991).

Dennison's 1964 *Screen Test* was included in several versions of *The Thirteen Most Beautiful Women* (ST365), in which she has sometimes been misidentified as Sally Kirkland. Judging from the notes on the film box, no one at the Factory seems to have known her full name, although they apparently were aware of her relationships with both Antonioni and Green.

Placed against a white background, Dennison holds a madonna-like pose, with her head tilted slightly to one side and her long veil of blond hair falling symmetrically into the corners of the film frame. Her face has been lit unequally, with the brightest light coming from the right. Wearing a slight smile, she regards the camera with serene self-possession, an attitude she maintains through the film.

## ST77 *Dino,* 1966

16mm, b&w, silent; 4.5 min. @ 16 fps, 4 min. @ 18 fps
Preserved 1999, MoMA *Screen Tests* Reel 22, no. 5
FILM MATERIALS
ST77.1 *Dino*
1966 Kodak 16mm b&w reversal original, 107'
NOTATIONS On original box in AW's hand: *Dino*

This unknown man, identified only as "Dino," also appears with two other men in another, triple *Screen Test* from 1966 (ST119, *Peter Goldthwaite*), probably shot at the same time as this film. Lit dramatically in high contrast from the right, with the other side of his face almost completely hidden in shadow, Dino holds perfectly still throughout and stares fixedly at the camera. At one point he blinks exaggeratedly, as if something had gotten in his eye.

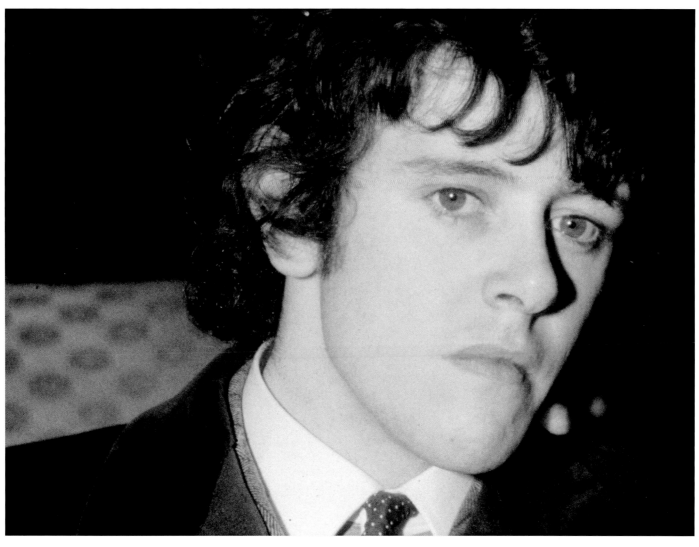

ST78

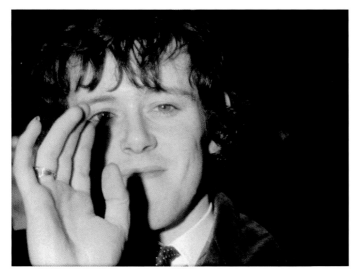

ST78

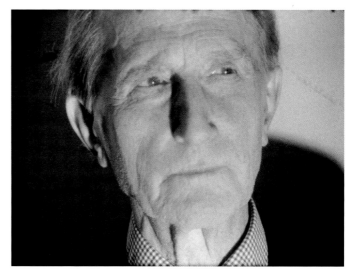

ST79

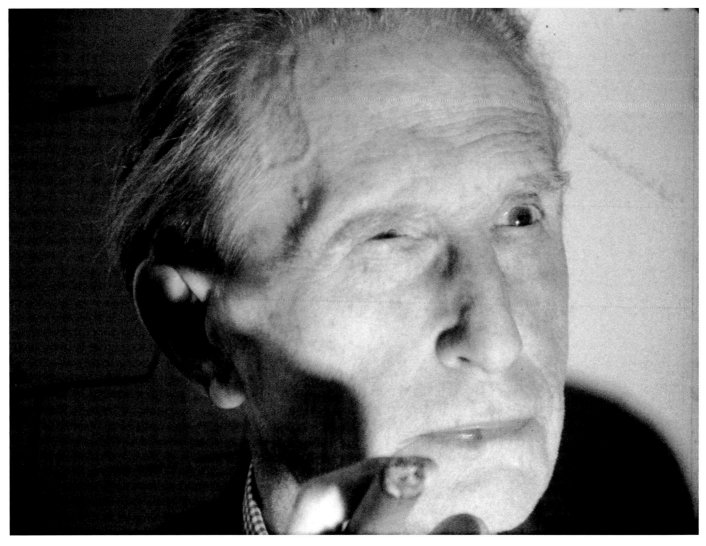

ST79

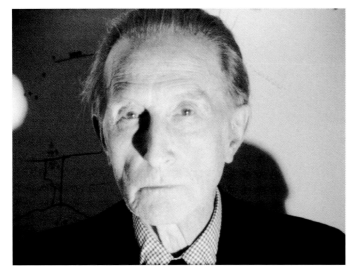

ST80

ST81

## ST78 *Donovan,* 1966

16mm, b&w, silent; 4.2 min. @ 16 fps, 3.7 min. @ 18 fps

**COMPILATIONS** *Screen Tests/A Diary* (Appendix A)

**FILM MATERIALS**

ST78.1 *Donovan*

1965 Kodak 16mm b&w reversal original, 100'

**NOTATIONS** On original box in Paul Morrissey's hand: *TRI-X. Donovan #1*

On box in Gerard Malanga's hand: *1 double-frame negative and 1 double-frame glossy 8" x 10" print marked by masking tape*

On typed label taped to can: *DONOVAN*

The British pop folk singer and songwriter Donovan (Donovan Phillips Leitch) was well known in the 1960s for songs such as "Universal Soldier" (written by Buffy Sainte-Marie) and "Season of the Witch." In the United States, Donovan's songs "Mellow Yellow" and "Sunshine Superman" became almost anthems of the hippy movement, due in part to their faintly veiled references to recreational drug use.

In his *Screen Test*, probably shot in 1966, Donovan seems relaxed and casual, apparently uninstructed in the usual rigors of posing for Warhol's camera. He sits down on the couch, reads a note, folds it up, and puts it in his pocket, looks at the camera, crosses his eyes, smiles and waves to someone offscreen, and then picks his teeth delicately with his little finger.

In 1996, Donovan's son, the actor Donovan Leitch Jr., played the role of Gerard Malanga in Mary Harron's film about Valerie Solanas, *I Shot Andy Warhol.*

## ST79 *Marcel Duchamp,* 1966

16mm, b&w, silent; 4.3 min. @ 16 fps, 3.8 min. @ 18 fps

**FILM MATERIALS**

ST79.1 *Marcel Duchamp*

1965 Kodak 16mm b&w reversal original, 103'

**NOTATIONS** On original box in black marker: *TRI-XX*

On box in AW's hand: *Duchamp*

On box in Gerard Malanga's hand: *Duchamp 2* ("2" circled)

On box flap: *Duchamp #1*

On label on flap: *Duchamp*

## ST80 *Marcel Duchamp,* 1966

16mm, b&w, silent; 4.4 min. @ 16 fps, 3.9 min. @ 18 fps

Preserved 1993, The Andy Warhol Foundation for the Visual Arts, Inc.; preserved 2001, MoMA *Screen Tests* Reel 24, no. 7

**COMPILATIONS** *Fifty Fantastics and Fifty Personalities* (ST366)

**FILM MATERIALS**

ST80.1 *Marcel Duchamp*

1965 Kodak 16mm b&w reversal original, 105'

**NOTATIONS** On original box in AW's hand: *Duchamp. 50* ("50" circled)

On box in unidentified hand: *Unexp. 3x*

On label on flap: *L-496*

On label on can lid: *L496*

On white head leader (added by Warhol Foundation in 1993): *ORIGINAL OF MARCEL*

**Andy Warhol filming Marcel Duchamp's** *Screen Test* **at the Cordier and Ekstrom Gallery, February 7, 1966. Photograph by Nat Finkelstein.**

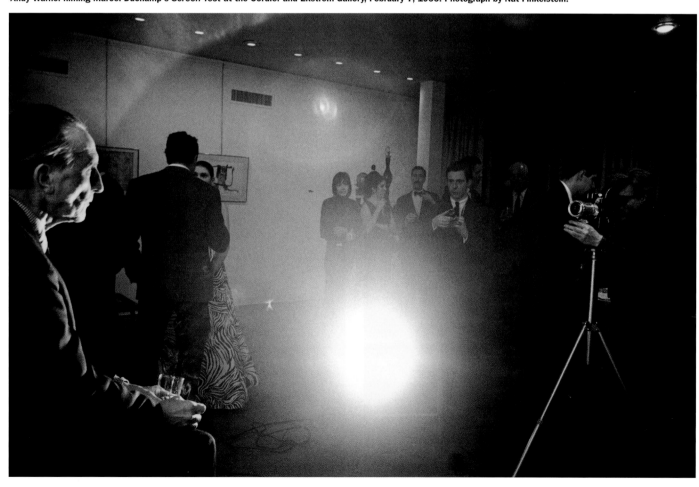

## ST81  *Marcel Duchamp and Benedetta Barzini,* 1966

16mm, b&w, silent; 4.2 min. @ 16 fps, 3.7 min. @ 18 fps
COMPILATIONS  *EPI Background* (ST370)
FILM MATERIALS
Original not found in Collection
ST81.1.p1 *EPI Background* (ST370), roll 7
Undated Dupont 16mm b&w reversal print, 100'

In 1985 Warhol reminisced about his plan to make a major film starring the artist Marcel Duchamp:

> You know, we were going to do this project called "24 Hours in Marcel Duchamp's Life," and we had someone to pay for it and everything. It was going to be like our *Empire State Building,* we were going to shoot him for 24 hours, it would have been really great but then he died. But I still have a couple of three-minute rolls of film of him.[87]

Warhol did in fact make four three-minute rolls of Marcel Duchamp: a short "newsreel" of the opening of Duchamp's retrospective at the Pasadena Art Museum on October 7, 1963 (*Duchamp Opening*), and three other posed portraits shot on February 7, 1966, at the opening of *Hommage à Caissa,* an exhibition at the Cordier and Ekstrom Gallery in New York to benefit the Marcel Duchamp fund of the American Chess Foundation.[88] Aside from these publicly filmed events, no evidence of the larger Duchamp film has been found in the film collection, although a March 9, 1970, letter to Warhol from Ken Tyler of Gemini G.E.L., the design firm specializing in artists' multiples, makes cryptic mention of a prototype for a "Duchamp super 8 movie box."[89] Duchamp died in 1968.

As can be seen in Nat Finkelstein's photographs of the opening, Warhol filmed the seventy-eight-year-old Duchamp sitting on a counter in front of a large painting by his close friend, the Italian artist Gianfranco Baruchello.[90] In the first film (ST79), Duchamp looks amused and sly, sitting erect and peering around him. He spends a few moments finding and lighting a cigar, then makes a "cut" gesture to the camera. In the second film (ST80), he alternates between scrutinizing the camera, and smiling and nodding in response to what seems to be a large crowd of offscreen admirers trying to get his attention. Occasionally he puts his fingers to his

Barbara Rubin films Bob Dylan at the Factory, 1966. Photograph by Nat Finkelstein.

lips, indicating that he is not supposed to talk. In the third film (ST81), Duchamp has been joined by Benedetta Barzini. The original of this last film has not been located, although a print was found spliced into an *EPI Background* reel (ST370); the original Kodak box for this film, marked "Benedetta, Duchamp" in Warhol's handwriting, was reused to store one of Charles Aberg's *Screen Tests* (ST1).

## ST82  *Bob Dylan,* 1966

16mm, b&w, silent; 4.6 min. @ 16 fps, 4.1 min. @ 18 fps
Preserved 2005, MoMA
FILM MATERIALS
ST82.1 *Bob Dylan*
1965 Kodak 16mm b&w reversal original, 110'
NOTATIONS  On original box in AW's hand in red: *Bobby*
On box in AW's hand in black: *Dylan*
On label on box flap: *Bob Dylan*

## ST83  *Bob Dylan,* 1966

16mm, b&w, silent; 4.6 min. @ 16 fps, 4.1 min. @ 18 fps
Preserved 2005, MoMA
COMPILATIONS  *Screen Test Poems* (ST372)
FILM MATERIALS
ST83.1 *Bob Dylan*
1966 Kodak 16mm b&w reversal original, 110'
ST83.1.p1 *Screen Test Poems,* Reel 2 (ST372.2), roll 13
Undated Gevaert 16mm b&w reversal print, 100'
NOTATIONS  On original box in AW's hand in red: *Bobby dylan*
On box in Gerard Malanga's hand in black, with drawings of double frames: *1 double frame negative and one double frame glossy print*
On box flap in red: *13*
On can lid in black: *Bobby Dylan*
On clear film at head in black: *13*
On clear film at tail in black: *13*

> I liked Dylan, the way he'd created a brilliant new style. He didn't spend his career doing homage to the past, he had to do things his own way, and that was just what I respected.
>
> —Andy Warhol[91]

Andy Warhol and Bob Dylan at the Factory in front of the *Double Elvis* painting that Warhol gave to Dylan, 1966. Photograph by Nat Finkelstein.

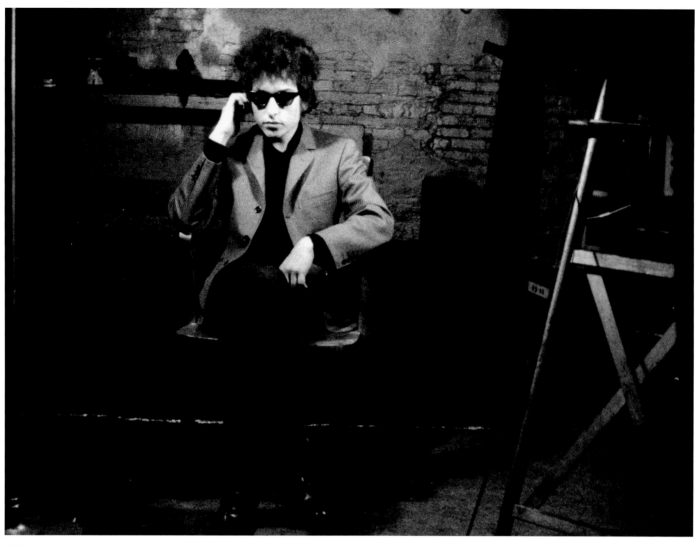

ST82

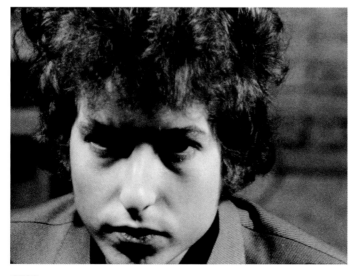

ST83

ST84

ST85

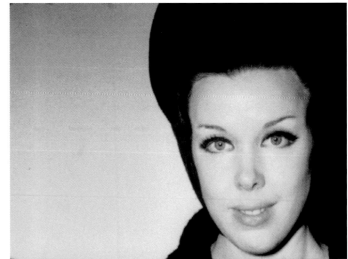

ST86

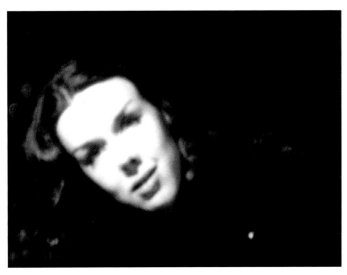

ST87

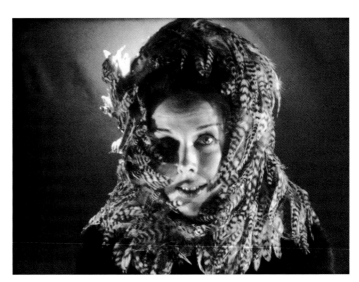

ST88

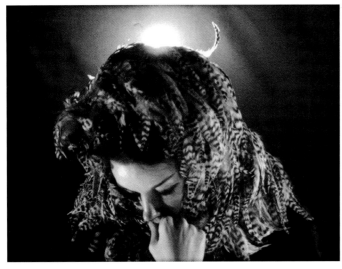

ST88

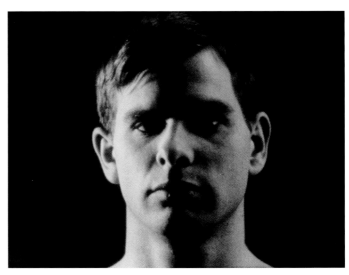

ST89

The day Bob Dylan visited the Factory and had his *Screen Test* shot is a fabled episode in the lore of the Warhol 1960s, most notably as the occasion when Warhol gave Dylan a silver *Elvis* painting, which Dylan later gave to his manager Albert Grossman in exchange for a couch.[92] The presence of photographers Billy Name (Linich) and Nat Finkelstein as well as several other filmmakers, including Barbara Rubin and Dan Williams, accounts for the fact that this visit was so heavily documented.

Bob Dylan had significant connections with a number of people at the Warhol Factory: he was a friend of Barbara Rubin's, who introduced him to Allen Ginsberg; he wrote a song for Nico, "I'll Keep It with Mine," which she later recorded; his manager Bob Neuwirth encouraged Edie Sedgwick's defection from the Factory at the end of 1965, after which Dylan reportedly wrote two songs about her, "Just Like a Woman" and "Leopard Skin Pillbox Hat," for his *Blonde on Blonde* album; and he was also friends with Patrick Tilden-Close, the star of Warhol's 1967 film *Imitation of Christ*. Although Warhol certainly admired Dylan and followed his work, and even thought of him as a possible influence on his own painting career,[93] there seems to have been a certain amount of competitive scorn directed toward Dylan at the Factory after Sedgwick's departure, at least judging from the references that appear in several Warhol films from this period. These satires include a harmonica-playing Dylan look-alike in *More Milk Yvette* (1965), a feature-length spoof called *The Bob Dylan Story* (1966), and the repeated playing of a Dylan song at the wrong speed in *Imitation of Christ* (1967).

In 1967 a profile of Dylan with an enlarged, multicolored nose, which could be lifted up in layers to reveal the real nose underneath, was included as a foldout in the Factory publication *Andy Warhol's Index (Book)*,[94] a satirical reference to Warhol's 1961 *Before and After* painting of a nose job.[95] In spite of all this fun-making, Ondine's later recollection that "Bob Dylan sat for sixteen hours in the middle of the Factory hoping to get a screen test, and every time one of his records went on we would take it off and put Maria Callas on instead,"[96] seems to have been entirely fantastical, judging from the many photographs taken on this day, and from the two *Screen Tests* themselves.

In one of his two *Screen Tests* (ST82), Dylan is framed in long shot against the silver wall of the Factory, wearing dark glasses and sitting in isolation in a wooden chair, the frame of a ladder to his right. His right hand to his temple, he holds the same pose throughout. At one point, Billy Name crosses behind Dylan's chair holding a camera. In the other *Screen Test* (ST83), Dylan is shot in close-up and without his dark glasses, smoking. About one-quarter of the way into the film, he suddenly stands and leaves the frame, then returns and sits down again. He looks up, rolling his eyes up into his head, then speaks briefly to someone offscreen; a muscle works in his jaw.

An unpublished manuscript by Ingrid Superstar titled "Movie Party at the Factory: A Trip & Half" describes a late-night party on the evening of March 26, 1966, when a number of films were shown at the Factory: "They also showed a 'stillie' of Bob Dylan in color with violet coloring over the screen. This trippy illusion is achieved by swaying a thin block of colored plastic in front of the projector. This technique is is (sic) used quite alot (sic) in Andy's underground uptight movies."[97] The use of colored gels during projections of black-and-white films was a technique employed by Barbara Rubin in exhibitions of her 1963 film *Christmas on Earth*; it was also a common practice in the multimedia Up-Tight events that Warhol and his crew staged to accompany performances by the Velvet Underground, events later known as the Exploding Plastic Inevitable or EPI.

**ST84    *Isabel Eberstadt,* 1964**
16mm, b&w, silent; 4.6 min. @ 16 fps, 4 min. @ 18 fps
Preserved 1998, MoMA *Screen Tests* Reel 17, no. 4
COMPILATIONS  *The Thirteen Most Beautiful Women* (ST365)
FILM MATERIALS
ST84.1  *Isabel Eberstadt*
1964 Kodak 16mm b&w reversal original, 110'
NOTATIONS  On original box in AW's hand: *Isabel (talk) #1. 13 most*

**ST85    *Isabel Eberstadt,* 1964**
16mm, b&w, silent; 4.5 min. @ 16 fps, 4 min. @ 18 fps
Preserved 2001, MoMA *Screen Tests* Reel 26, no. 1
COMPILATIONS  *The Thirteen Most Beautiful Women* (ST365)
FILM MATERIALS
ST85.1  *Isabel Eberstadt*
1964 Kodak 16mm b&w reversal original, 108', 110' with head leader
NOTATIONS  On box in AW's hand: *13 Sally Sam's Sally* (these notes indicate this was originally the box for ST76)
On tape on box in Paul Morrissey's hand: *Isabel Eberstadt Screen Test*
On leader at head of film: *MEKAS*

**ST86    *Isabel Eberstadt,* 1964**
16mm, b&w, silent; 4.5 min. @ 16 fps, 4 min. @ 18 fps
Preserved 1999, MoMA *Screen Tests* Reel 21, no. 8
FILM MATERIALS
ST86.1  *Isabel Eberstadt*
1964 Kodak 16mm b&w reversal original, 109'
NOTATIONS  On original box in unidentified hand: *Isabel (wrist day)*

**ST87    *Isabel Eberstadt,* 1964**
16mm, b&w, silent; 4.4 min. @ 16 fps, 3.9 min. @ 18 fps
Preserved 1999, MoMA *Screen Tests* Reel 18, no. 7
COMPILATIONS  *Fifty Fantastics and Fifty Personalities* (ST366)
FILM MATERIALS
ST87.1  *Isabel Eberstadt*
1964 Kodak 16mm b&w reversal original, 105'
NOTATIONS  On original box in AW's hand: *"isabel" 50*

**ST88    *Isabel Eberstadt (Feathers),* 1964**
16mm, b&w, silent; 4.5 min. @ 16 fps, 4 min. @ 18 fps
COMPILATIONS  *Fifty Fantastics and Fifty Personalities* (ST366)
FILM MATERIALS
ST88.1  *Isabel Eberstadt (Feathers)*
1964 Kodak 16mm b&w reversal original, 109'
NOTATIONS  On original box in Gerard Malanga's hand: *Isabel + Feathers*
On box in unidentified hand: *50 Phantastics*

Daughter of the poet Ogden Nash and wife of fashion photographer Frederick Eberstadt, Isabel Eberstadt was a society favorite in the early 1960s, when *Women's Wear Daily* called her a "leader of the New Social Wave in America" and placed her on the Best Dressed List in January 1963.[98] In the 1960s, she and her husband were known for their enthusiastic engagement with the arts scene in New York: "The young Eberstadts are in *The Social Register*, but their parties are a *paella* of society, fashion designers and editors and the visual arts."[99] Eberstadt, who was also a friend and supporter of the filmmaker Jack Smith, appeared in several Robert Wilson performances, and later published several books, including two novels and collections of selected poems and letters by her father.

Her daughter Fernanda Eberstadt worked for *Interview* magazine in the late 1970s. Isabel Eberstadt also appears in another short Warhol film from 1964, *Isabel Wrist*, shot on the same day as ST86, as noted on the box.

Isabel Eberstadt's *Screen Tests* are small pieces of performance art, unique and enigmatic. In the first three films, which were clearly shot at the same time, Eberstadt is posed against a white background, with her long hair pinned up in an elegant bun. In two rolls (ST84 and ST85), she is placed in three-quarter profile, gazing slightly off-screen to the left; she holds a slight, inscrutable smile, slowly lowering and raising her long eyelashes. In the third film (ST86), she is placed at the right side of the frame and faces the camera directly, with a scarf tied over her hair. Wearing the same faint smile, she stares wide-eyed into the camera's lens, and performs a series of exaggerated, slow-motion blinks, like a doll with movable eyelids.

Eberstadt's fourth *Screen Test* (ST87) is dramatically different. Placed against a dark background and with her head tilted langorously to the left, Eberstadt is shot slightly out of focus, with her dark hair falling to one side of her face. The high-contrast lighting of her pale skin and dark hair and the romantic soft focus of the image invest her face with an aura of considerable glamour, much like a 1930s movie star portrait of, perhaps, Veronica Lake or Ann Miller. Eberstadt touches her lips with her fingers, lowers her head, sweeps her hair up with one hand, and smiles faintly.

Eberstadt's final *Screen Test* (ST88) is also unusual, if less successful because it is somewhat underexposed. Eberstadt appears wearing a dramatic feather headdress that surrounds her face; the feathers are backlit with a lightbulb placed behind her head. Eberstadt looks down and strokes the feathers, then turns her head from side to side, sweeping the feathers away from her face with her fingers.

## ST89   *Kelly Edey,* 1964

16mm, b&w, silent; 4.5 min. @ 16 fps, 4 min. @ 18 fps
Preserved 1995, MoMA *Screen Tests* Reel 11, no. 1
**COMPILATIONS**  *The Thirteen Most Beautiful Boys* (ST364)
**FILM MATERIALS**
ST89.1 *Kelly Edey*
1963 Kodak 16mm b&w reversal original, 109'
**NOTATIONS**  On original box in AW's hand: *Kelly (13)* ★
On box in unidentified hand: *(6) USED*
Stamped on box: *LAB TV, The Lab for Reversal Films, 923 7th Avenue*

## ST90   *Kelly Edey,* 1964

16mm, b&w, silent; 4.7 min. @ 16 fps, 4.2 min. @ 18 fps
Preserved 1999, MoMA *Screen Tests* Reel 20, no. 10
**COMPILATIONS**  *The Thirteen Most Beautiful Boys* (ST364)
**FILM MATERIALS**
ST90.1 *Kelly Edey*
1963 Kodak 16mm b&w reversal original, 113'
**NOTATIONS**  On box in AW's hand: *Kelly Eddy 13* ★. *Eddy 13*
On box in AW's hand, crossed out: *haircut Jon*
On box in unidentified hand: *USED*

Winthrop Kellogg Edey, perhaps best known for his important private collection of antique clocks and watches, was a legendary and somewhat eccentric figure in New York aesthetic circles in recent decades. Born into a wealthy New York family, Edey, who described himself as "always a great distress to his mother," spent most of his life pursuing his own Proustian interests at home in his period town house on West 83rd Street, rising late in the afternoons and usually staying up all night to work on his collections, continue his studies in Egyptology and classical literature, and make entries in his immensely detailed social diary.[100] The very first *Screen Tests*, including Edey's, were probably shot at his home on January 17, 1964, as he noted in his diary (see entry for ST31). Edey died in 1999, and left his diaries and part of his clock collection to The Frick Collection, which held an exhibition, The Art of the Timekeeper: Masterpieces from the Winthrop Edey Bequest, at the end of 2001.[101]

One of Kelly Edey's two *Screen Tests* (ST89) is very straightforward. Edey, lit from both left and right, stares into the camera, blinking only occasionally. The dark shadows down the center of his face conceal his eyes, so it is hard to tell where he is looking. The second *Screen Test* (ST90), which appears to have been shot at the same time with very similar lighting, may be connected to another entry in Edey's diary from January 20, 1964:

> Andy Warhol wants to make a movie called *Sex* starring Avery and me. I have no objection to acting in his movies but I don't much want him to make them here.[102]

This *Screen Test* appears to have been shot from below, with Edey's head tilted back and somewhat foreshortened. Subtle changes in his expression—twitching an eyebrow, closing his eyes, furrowing his brow, parting his lips, and swallowing repeatedly—suggest that this may indeed be a sex film, perhaps the precursor of Warhol's better-known minimalist work *Blow Job* (1964). Both of Edey's *Screen Tests* were selected for *The Thirteen Most Beautiful Boys* (ST364).

## ST91   *Cass Elliot,* 1966

16mm, b&w, silent; 4.6 min. @ 16 fps, 4.1 min. @ 18 fps
Preserved 2001, MoMA *Screen Tests* Reel 26, no. 2
**FILM MATERIALS**
ST91.1  *Cass Elliot*
1966 Kodak 16mm b&w reversal original, 110'
**NOTATIONS**  On box in AW's hand: *CASS. Mary & George laughing*

## ST92   *Cass Elliot,* 1966

16mm, b&w, silent; 4.3 min. @ 16 fps, 3.9 min. @ 18 fps
Preserved 1999, MoMA *Screen Tests* Reel 23, no. 3
**FILM MATERIALS**
ST92.1  *Cass Elliot*
1966 Kodak 16mm b&w reversal original, 104'
**NOTATIONS**  On original box in AW's hand: *CASS*
On box in Gerard Malanga's hand: *Cass Mama 1*

"Mama" Cass Elliot was one of the members of The Mamas and The Papas, the immensely successful southern California pop group famous in the 1960s for hit songs like "California Dreaming" and "Monday Monday." Elliot was a fan of Warhol's multimedia rock-and-roll show, the Exploding Plastic Inevitable, having attended several performances when the Velvet Underground played at the Trip in Los Angeles in April 1966, but she didn't meet Warhol until August of that year, when The Mamas and The Papas were in New York, and Stephen Shore and Danny Fields arranged for the group to come to the Factory so Elliot's portrait film could be shot.[103] In 1972, Cass Elliot performed the title song for the sound track of the Warhol/Morrissey film *L'Amour*; she died of a heart attack in 1974.

One of Elliot's *Screen Tests* (ST91) begins with a long shot, then zooms rapidly in and out and into close-up. There is a great deal of camera movement and in-camera editing, typical of Warhol's

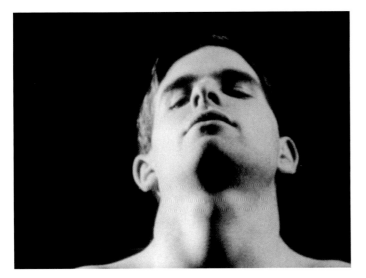

ST90

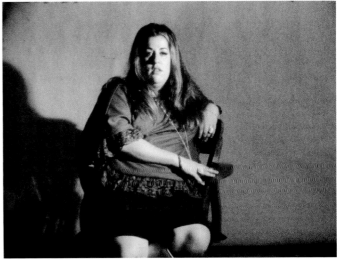

ST91

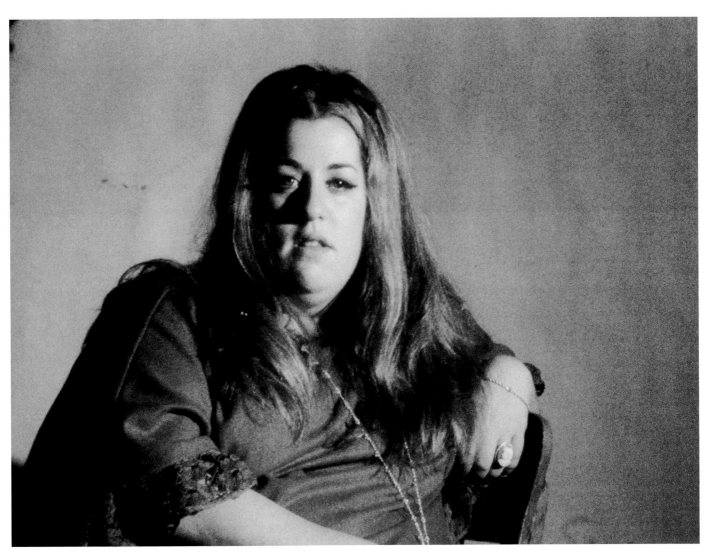

ST91

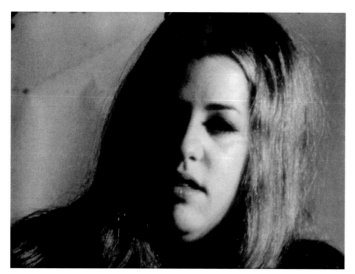

ST92

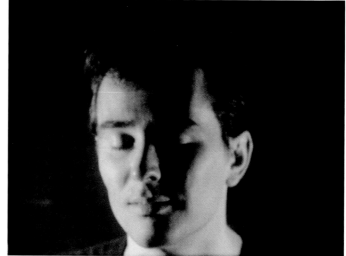

ST93

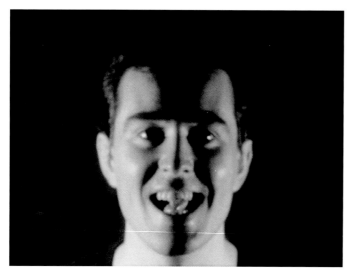

ST93

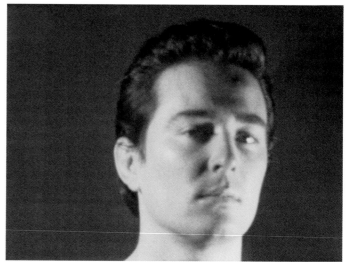

ST94 **See Appendix D for color reproduction.**

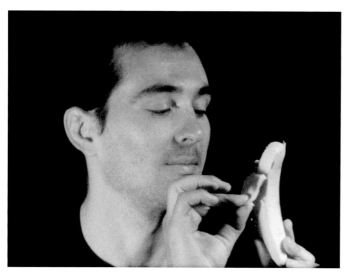

ST95

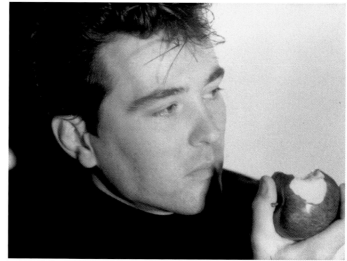

ST96

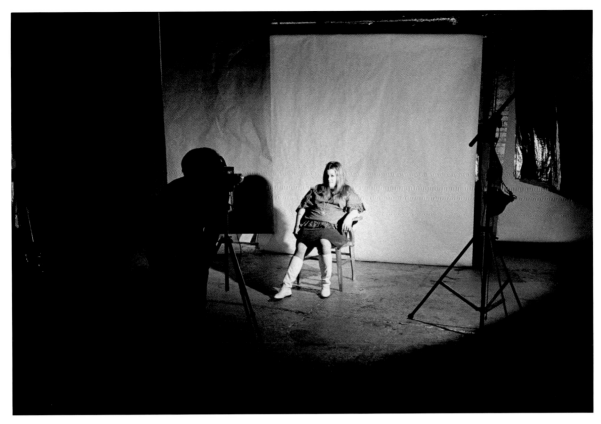

Andy Warhol filming Cass Elliot's *Screen Tests* (ST91–92) at the Factory, 1966. Photograph by Stephen Shore.

shooting style from this period. Halfway through, the film settles down into a single close-up of Elliot; toward the end of the shot, there is a sudden adjustment in the lighting. Elliot seems solemn and slightly nervous, but finally begins to smile. Her second *Screen Test* (ST92), for which Warhol seems to have been preparing in the first, is shot entirely in close-up, with no camera movement at all. Her face dramatically lit from the right in a high-contrast, half-moon effect, Elliot smiles briefly, looks wary and somewhat sad, then suddenly bursts out laughing and mouths an obscenity at the camera. Danny Fields considered these two films to be a single, six-minute portrait of Elliot.[104]

### ST93 *Philip Fagan*, 1964

16mm, b&w, silent; 4.5 min. @ 16 fps, 4 min. @ 18 fps
**FILM MATERIALS**
ST93.1 *Philip Fagan*
1964 Kodak 16mm b&w reversal original, 108'
**NOTATIONS** Scratched on original box in AW's hand: *phillip*

### ST94 *Philip Fagan*, 1964

16mm, color, silent; 4.2 min. @ 16 fps, 3.7 min. @ 18 fps
**FILM MATERIALS**
ST94.1 *Philip Fagan*
Undated Anscochrome 16mm double-perf. reversal original, 100'
**NOTATIONS** Stamped on plain white box, in blue: *VIDEO FILM LABORATORIES, 311 WEST 43RD STREET, NEW YORK 36 N.Y.*
On box in AW's hand: *philip. color*
On box in unidentified hand: *Andy Warhol. anscochrome. Philip. color*

### ST95 *Philip Fagan (Banana)*, 1964

16mm, b&w, silent; 4.5 min. @ 16 fps, 4 min. @ 18 fps
**FILM MATERIALS**
ST95.1 *Philip Fagan (Banana)*
1964 Kodak 16mm b&w reversal original, 108'
**NOTATIONS** On original box in AW's hand: *philip Banana. Nov. 22/64*

### ST96 *Philip Fagan (Apple)*, 1964

16mm, b&w, silent; 4.5 min. @ 16 fps, 4 min. @ 18 fps
**FILM MATERIALS**
ST96.1 *Philip Fagan (Apple)*
1964 Kodak 16mm b&w reversal original, 109'
**NOTATIONS** On original box in AW's hand: *philip apple*

Philip Fagan was Andy Warhol's boyfriend for a period of about three months during the winter of 1964–65. Although Fagan appeared in several films from this period, including *Batman Dracula* (1964), *Harlot* (1964), and *Screen Test No. 1* (1965), his biggest role was in *Six Months*, the sequential series of 107 *Screen Tests* that Warhol shot of Fagan between November 6, 1964, and February 9, 1965. Fagan's history and his relationship with Warhol are discussed in more detail in Chapter Three.

These four films of Philip Fagan are the only Fagan *Screen Tests* that cannot be identified as part of *Six Months*. The first film (ST93) may possibly be Fagan's first *Screen Test*, since his performance is very different from the controlled and rather remote film persona he developed for *Six Months*. Here, Fagan is animated and flirtatious, smiling and laughing, talking to people offscreen, winking at the camera, closing his eyes, shimmying his neck from side to side, and repeatedly rolling his tongue in his mouth, a sort of obscene party trick. Another *Screen Test* (ST94), shot on undated Ansco

color stock, is much more in the *Six Months* style: Fagan maintains a motionless pose and an unvarying stare at the camera.

Two other films, *Philip Fagan (Banana)* and *Philip Fagan (Apple)*, are oral elaborations on the basic *Screen Test. Philip Fagan (Banana)*, (ST95), shot on November 22, 1964, the same day as *Philip #18* in *Six Months* (ST363.020), might conceivably be assigned to the *Banana* series of 1964, in which David Bourdon starred; similarly suggestive banana-eating performances also appear in several other films from the fall of 1964, including *Couch*, both versions of *Mario Banana*, and *Harlot*. Fagan holds up a banana, glances knowingly at it, smiles, and slowly begins to peel it. After pulling the peel down with his teeth, he bites into the tip of the banana just as the roll ends. *Philip Fagan (Apple)* (ST96) contains a more subdued performance, with Fagan looking down at the apple or staring contemplatively offscreen while he bites and chews.

## ST97   *Harry Fainlight*, 1964

16mm, b&w, silent; 4.5 min. @ 16 fps, 4 min. @ 18 fps
Preserved 1999, MoMA *Screen Tests* Reel 23, no. 7
**COMPILATIONS** *Fifty Fantastics and Fifty Personalities* (ST366); *Screen Test Poems* (ST372); *Screen Tests/A Diary* (Appendix A)
**FILM MATERIALS**
ST97.1   *Harry Fainlight*
1964 Kodak 16mm b&w reversal original, 108'
ST97.1.p1 *Screen Test Poems*, Reel 3 (ST372.3), roll 23
Undated Gevaert 16mm b&w reversal print, 108'
**NOTATIONS** On original box in AW's Hand: *Gerry Frend*
On box in Gerard Malanga's hand: *Harry Fainlight. 1 double frame 8" x 10" Print & Neg.*
On box flap: *23*
On typed label found in can: *HARRY FAINLIGHT*
On clear film at both head and tail of roll in black: *23*

The English poet and filmmaker Harry Fainlight made an appearance in Warhol's 1964 film *Couch* and, with Ronald Tavel and Billy Linich, was one of the three offscreen speakers who provided the improvised dialogue for the sound track of *Harlot*, Warhol's first sync-sound film.

In his *Screen Test*, which Gerard Malanga included in both *Screen Test Poems* and *Screen Tests/A Diary*, Fainlight appears to be a highly reluctant, if not recalcitrant poser. He is certainly one of the few people ever to defy the basic imperative of the Warhol *Screen Test* simply by getting up and leaving the frame (see also Bob Dylan, ST83). The poet appears to be an unwilling subject from the beginning, sitting in front of the camera with his eyes lowered and only occasionally glancing up. When he does lift his gaze, he seems to avoid the camera's eye, looking slightly above it or just below it. Appearing increasingly uncomfortable, swallowing repeatedly, and raising his upper lip in a suppressed sneer, Fainlight suddenly gets up, walks toward the camera, and leaves the frame. The camera continues to record the image of a blank, silver-painted brick wall. After a couple of in-camera edits (camera stops during which Fainlight was, presumably, talked into returning), he reappears again for a brief period. Fainlight then smiles up at someone offscreen left, gets up, and leaves for good; the film ends on the image of the blank wall he has left behind him.

Billy Linich, Ronald Tavel, and Harry Fainlight recording the offscreen sound track during the filming of *Harlot* at the Factory, December 1964. Photograph by Edward Oleksak.

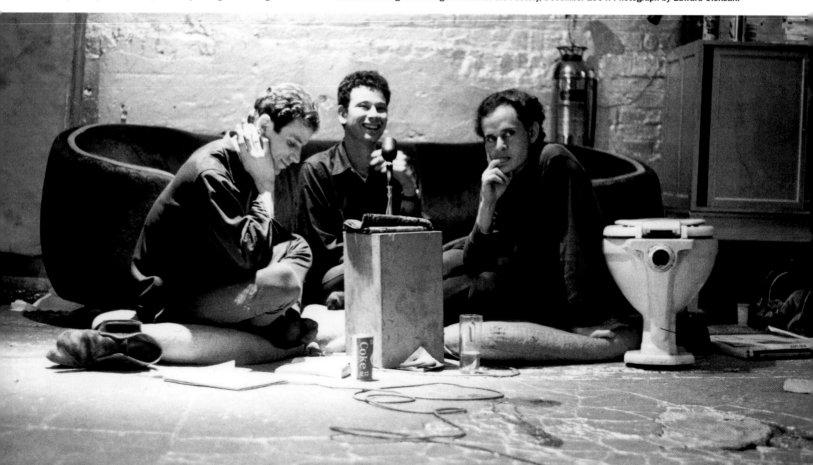

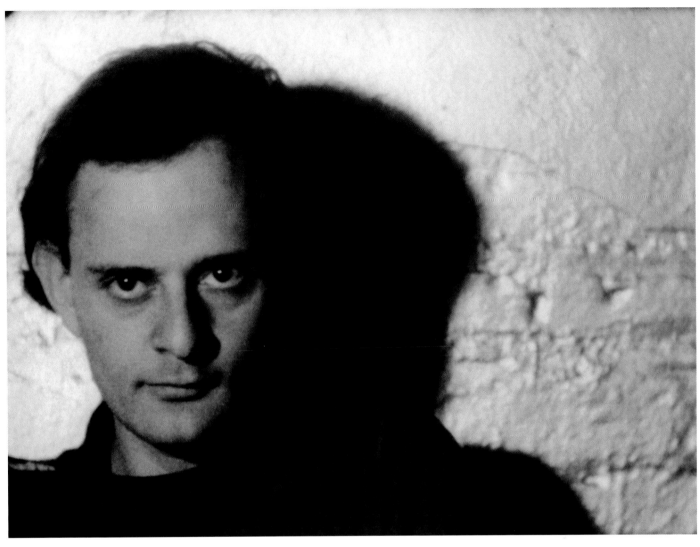

ST97

ST97

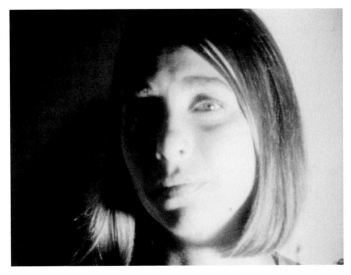

ST98

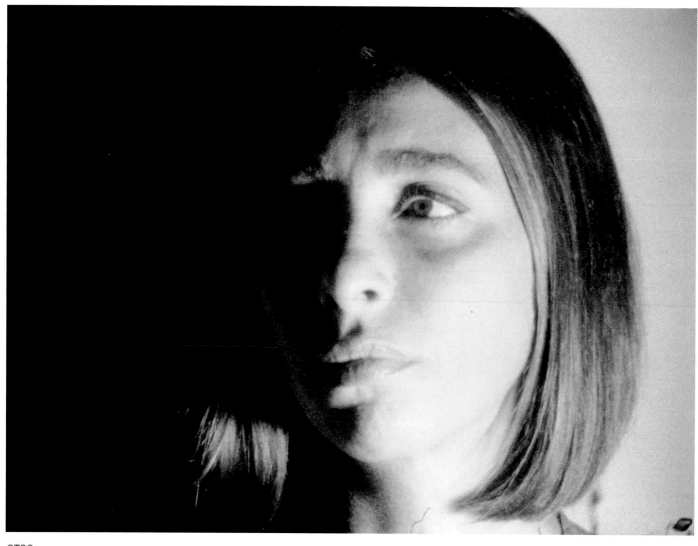

ST99

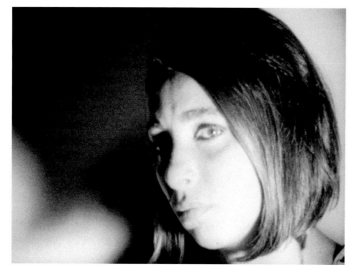

ST100

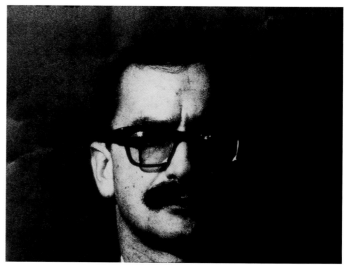

ST101

## ST98  *Bea Feitler,* 1964

16mm, b&w, silent; 4.4 min. @ 16 fps, 3.9 min. @ 18 fps
Preserved 1995, MoMA *Screen Tests* Reel 12, no. 3
**FILM MATERIALS**
ST98.1  *Bea Feitler*
1964 Kodak 16mm b&w reversal original, 105'
**NOTATIONS**  On original box in AW's hand: *Bea. part (1)*

## ST99  *Bea Feitler,* 1964

16mm, b&w, silent; 4.5 min. @ 16 fps, 4 min. @ 18 fps
**FILM MATERIALS**
ST99.1  *Bea Feitler*
1964 Kodak 16mm b&w reversal original, 108'
**NOTATIONS**  On original box in AW's hand: *Bea*

## ST100  *Bea Feitler,* 1964

16mm, b&w, silent; 4.4 min. @ 16 fps, 3.9 min. @ 18 fps
Preserved 1995, MoMA *Screen Tests* Reel 7, no. 4
**COMPILATIONS**  *Fifty Fantastics and Fifty Personalities* (ST366)
**FILM MATERIALS**
ST100.1  *Bea Feitler*
1964 Kodak 16mm b&w reversal original, 105'
**NOTATIONS**  On original box in unidentified hand: *Bea. Personalities*

In 1963 Bea Feitler became the art director at *Harper's Bazaar* magazine, a publication for which Warhol had done a significant amount of work during his very successful career as a commercial illustrator in the 1950s. Warhol continued to do occasional commercial work for *Harper's Bazaar* and other publications in the 1960s, even while he was becoming successful as a fine artist; see, for example, *Sarah–Soap* from 1963 in Volume 2. Feitler continued her career as an art director and graphic designer, helping to create *Ms.* and *Self* magazines, and serving as design director for Straight Arrow Books and *Rolling Stone* magazine. She died in 1982 at the age of forty-four.

In the first two of her three *Screen Tests* (ST98 and ST99), Feitler addresses the camera head-on; a light placed on the right illuminates her face rather harshly from below, casting the other side of her face into dark shadow. Apparently unfazed by this unflattering lighting, Feitler stares severely back at the camera. In her third *Screen Test* (ST100), which Warhol selected for the compilation series *Fifty Fantastics and Fifty Personalities* (ST366), she is turned slightly into three-quarter profile, her head positioned at the right side of the frame and balanced by the large shadow she casts on the wall at left.

## ST101  *Giangiacomo Feltrinelli,* 1966

16mm, b&w, silent; est. 4 min. @ 16 fps, 3.6 min. @ 18 fps
**COMPILATIONS**  *Screen Tests/A Diary* (Appendix A)
**FILM MATERIALS**
Original not found in Collection

A double-frame image from a *Screen Test* of the Italian publisher Giangiacomo Feltrinelli appears in the Warhol/Malanga 1967 collaboration, *Screen Tests/A Diary* (see Appendix A), but the film itself has not been found in the Warhol Film Collection. Its current location is unknown.

Giangiacomo Feltrinelli was a well-known Italian publisher and leftist. Born in 1926 into a wealthy industrial Milan family, he first joined the Communist Party during World War II. After the war, he joined and helped finance the Italian Communist Party (PCI), in collaboration with which he established an important leftist archive and the publishing company, Giangiacomo Feltrinelli Editore. Feltrinelli's extensive and eventually successful fight to publish Boris Pasternak's novel *Doctor Zhivago* against the wishes of the Stalinist bureaucracy led to his expulsion from the PCI in the late 1950s. In 1958 he published Giuseppe di Lampedusa's novel *The Leopard*; throughout the 1960s he published a number of banned novels, such as Henry Miller's *Tropic of Cancer*, and leftist works including the writings of Che Guevara, Fidel Castro, and Ho Chi Minh.

Feltrinelli became increasingly radical in the 1960s and eventually established his own underground organization called the Partisan Action Group (GAP), which carried out a series of small-scale bombing attacks against neo-fascist targets in Italy. Feltrinelli was eventually forced to go into hiding from the government; in March 1972 he died in a fall from an electrical power pylon in Milan, which he had climbed in order to plant a bomb. His Milan-based publishing house is now run by his son Carlo, whose biography of his father, *Feltrinelli: A Story of Riches, Revolution, and Violent Death,* was recently published in English by Harcourt.

After Feltrinelli's father died in 1935 when he was nine years old, his mother married the Italian author and journalist, Luigi Barzini Jr., whose daughter, the model Benedetta Barzini, appears in several Warhol *Screen Tests* from 1966. Feltrinelli undoubtedly found his way to the Factory via Barzini, in whom Gerard Malanga was romantically interested at the time. Feltrinelli's *Screen Test* was filmed by Malanga, according to Malanga's recollections.[105]

Opposite, bottom right: *Giangiacomo Feltrinelli,* 1966 (ST101). From Gerard Malanga, *Gerard Malanga: Screen Tests, Portraits, Nudes, 1964–1996* (Gottingen, Germany 2000: Steidl Publishers), p. 42.

**ST102**  *Nancy Fish,* 1964

16mm, b&w, silent; 4.4 min. @ 16 fps, 3.9 min. @ 18 fps
Preserved 1995, MoMA *Screen Tests* Reel 2, no. 3
COMPILATIONS  *The Thirteen Most Beautiful Women* (ST365)
FILM MATERIALS
ST102.1  *Nancy Fish*
1964 Kodak 16mm b&w reversal original, 106'
NOTATIONS  On original box in AW's hand: *Nancy (1)*

**ST103**  *Nancy Fish,* 1964

16mm, b&w, silent; 4.5 min. @ 16 fps, 4 min. @ 18 fps
COMPILATIONS  *The Thirteen Most Beautiful Women* (ST365); *3 Most Beautiful Women* (ST365d)
FILM MATERIALS
ST103.1  *Dracula/3 Most* (ST365d), roll 5
1964 Kodak 16mm b&w reversal original, 109'

The actress Nancy Fish, aka Nancy Worthington Fish, was introduced to Andy Warhol by the curator Alan Solomon some time in 1964, when Fish was working with Solomon and the photographer Ugo Mulas on their book *New York: The New Art Scene*, which featured photographic essays on a number of important young artists, including Warhol.[106] In addition to her two *Screen Tests*, Nancy Fish also appeared with David Whitney in a couple of rolls shot for Warhol's 1964 film *Couch*, and in an unreleased thirty-three-minute narrative called *Nancy Fish and Rodney* from late 1966. Fish, who also appeared in Robert Frank's uncompleted 1964 film of Allen Ginsberg's *Kaddish*, later became successful as a character actress in Hollywood, playing small roles in films such as *The Fabulous Baker Boys* (1989), *Sleeping with the Enemy* (1991), *Death Becomes Her* (1992), and *The Mask* (1994), among many others.

In her first *Screen Test* (ST102), labeled "Nancy (1)" by Warhol, Fish's eyes peer out from underneath a great mop of disheveled blond hair. She seems to shift slightly from side to side, tilting slowly first to the left, then to the right, and then, by the end of the film, back to the left again. In the second film (ST103), Fish's hair has been combed so that it appears neater, although her bangs now hide her eyes almost completely. She scarcely moves or blinks for the duration of the film, while her eyes slowly fill with tears behind their veil of hair. The film is marred by occasional light flares throughout its length.

The second Fish film was found spliced into a mysterious compilation reel labeled "6 Min. Dracula/3 Most" (ST365d), which contains two 100' rolls shot for *Batman Dracula*, and *Screen Tests* of Sally Kirkland, Ivy Nicholson, and Fish. It is possible that this reel was assembled for a television broadcast in 1966.[107] However, the better *Screen Test* is clearly the first, which was probably the film included in some earlier versions of *The Thirteen Most Beautiful Women* (ST365).

**ST104**  *Patrick Fleming,* 1966

16mm, b&w, silent; 4.4 min. @ 16 fps, 3.9 min. @ 18 fps
Preserved 1995, MoMA *Screen Tests* Reel 5, no. 5
FILM MATERIALS
ST104.1  *Patrick Fleming*
1965 Kodak 16mm b&w reversal original, 106'
NOTATIONS  On original box in unidentified hand: *Patrick Fleming*

Patrick Fleming, an intimate friend of Ed Hood's from Boston, appeared with Hood in several reels of *The Chelsea Girls* (1966): *Boys in Bed, Mario Sings Two Songs,* and a third unreleased reel called *Patrick.* Fleming and Hood acted together again in 1967, when they appeared in a sequence shot in a Boston doctor's office, *Ed Hood,* which was included as Reel 42 in Warhol's twenty-five-hour epic ★★★★ *(Four Stars).*

With his hair carefully slicked back, Fleming appears both tough and sensitive in his *Screen Test,* squinting his eyes defensively against the bright light and looking nervously around him. He seems to have a hard time sitting still, adjusting his collar, wiping his nose, smirking at someone offscreen, and holding up his hand to shield his eyes from the light. There are significant light flares and loss of image in the second half of the film.

**ST105**  *Charles Henri Ford,* 1966

16mm, b&w, silent; 4.2 min. @ 16 fps, 3.7 min. @ 18 fps
Preserved 1995, MoMA *Screen Tests* Reel 8, no. 3
COMPILATIONS  *Screen Tests/A Diary* (Appendix A)
FILM MATERIALS
ST105.1  *Charles Henri Ford*
Undated Ansco 16mm b&w double-perf. reversal original, 100'
NOTATIONS  On plain white box in AW's hand: *WARHOL. German Perutz. asa 100. Used N/D. Naomi and Taylor in Bath tub*
On tape on can lid: *CHARLES HENRI FORD*
On typed label found in can: *CHARLES HENRI FORD*

The prolific poet, artist, author, and editor Charles Henri Ford is significant in the context of Warhol's cinema primarily for his role in encouraging Warhol to become a filmmaker, taking Warhol to exhibitions of underground films, and also accompanying him to purchase his first movie camera, a 16mm Bolex, in the late spring of 1963.[108] Ford's own film *Johnny Minotaur* was released in 1973.

Ford was perhaps best known as the founding editor of two influential journals: *Blues: A Magazine of New Rhythms,* begun in 1929, which first published the works of Paul Bowles, as well as other writers such as Gertrude Stein and William Carlos Williams; and *View,* the most significant literary arts journal of the 1940s. Ford had close friendships with the writer Djuna Barnes and also with the critic Parker Tyler, with whom he edited *View* and also co-authored the early gay novel, *The Young and Evil* (1933). His most important relationship was with the artist Pavel Tchelitchew, with whom he lived for twenty-three years. Ford died in 2002 at the age of ninety-four.[109]

Ford's *Screen Test* was shot by Warhol's studio assistant Gerard Malanga, whom Ford had introduced to Warhol in 1963. Although the film was shot on undatable Ansco stock, Malanga recalls that this portrait was made in April 1966, a day before the Warhol group left for Los Angeles with the Exploding Plastic Inevitable; Ford had just returned to New York from his house in Katmandu.[110]

In his *Screen Test,* Ford seems a rather remote figure, his eyes almost completely hidden behind a pair of enormous round sunglasses. The gleaming metal rims of his glasses and the white stripes of his shirt are the brightest elements in the film image. The film seems to have been poorly processed; circular water marks and occasional light flares are visible throughout.

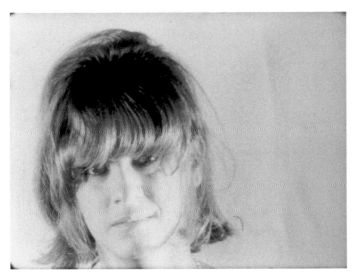

ST102

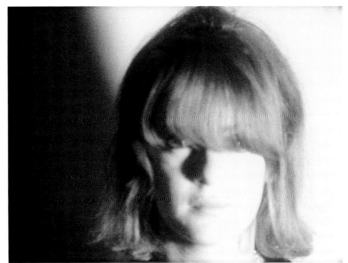

ST103

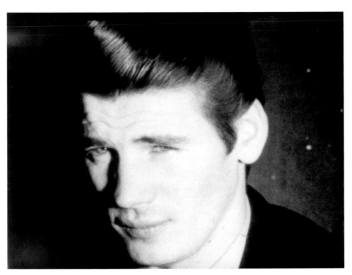

ST104

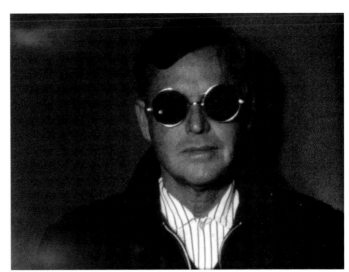

ST105

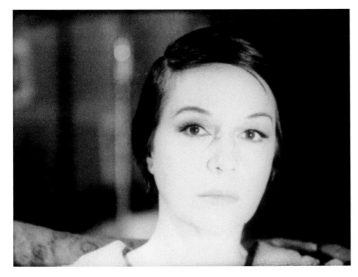

ST106

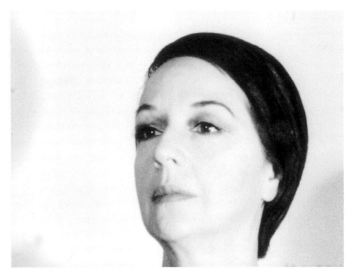

ST107

ST108

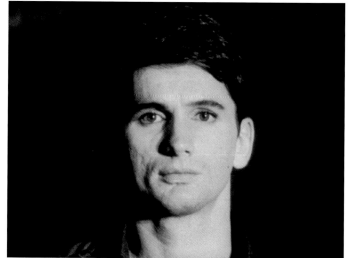

ST109

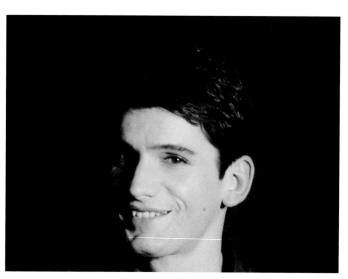

ST110

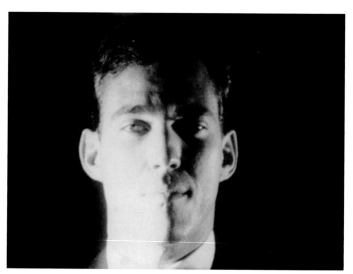

ST111

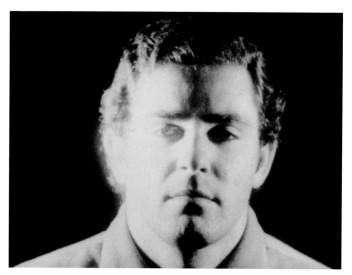

ST112

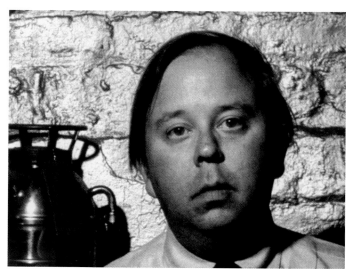

ST113

**ST106** *Ruth Ford,* 1964
16mm, b&w, silent; 4.6 min. @ 16 fps, 4.1 min. @ 18 fps
Preserved 1998, MoMA *Screen Tests* Reel 16, no. 4
COMPILATIONS *Fifty Fantastics and Fifty Personalities* (ST366)
FILM MATERIALS
ST106.1 *Ruth Ford*
1964 Kodak 16mm b&w reversal original, 110'
NOTATIONS On original box in unidentified hand: *Ruth Scott #1. 50*

**ST107** *Ruth Ford,* 1964
16mm, b&w, silent; 4.5 min. @ 16 fps, 4 min. @ 18 fps
Preserved 1999, MoMA *Screen Tests* Reel 19, no. 10
COMPILATIONS *The Thirteen Most Beautiful Women* (ST365); *Fifty Fantastics and Fifty Personalities* (ST366); *Screen Tests/A Diary* (Appendix A)
FILM MATERIALS
ST107.1 *Ruth Ford*
1964 Kodak 16mm b&w reversal original, 109'
NOTATIONS On original box in unidentified hand: *Ruth Scott* ("Scott" crossed out) *Ford #2. 50 or 13*

**ST108** *Ruth Ford (Laugh),* 1964
16mm, b&w, silent; 4.5 min. @ 16 fps, 4 min. @ 18 fps
Preserved 1999, MoMA *Screen Tests* Reel 20, no. 1
FILM MATERIALS
ST108.1 *Ruth Ford (Laugh)*
1964 Kodak 16mm b&w reversal original, 108'
NOTATIONS On original box in unidentified hand: *Ruth Scott #3. laugh*

The actress and writer Ruth Ford, sister of Charles Henri Ford, appeared in approximately two dozen Hollywood B-movies from the 1940s (for example: *Secrets of the Lone Wolf* (1941), *Murder in the Big House* (1942), *Truck Busters* (1943), *Wilson* (1944)), and in the 1950s had a few roles in early television dramas. In the 1960s, when she became friends with Warhol, Ford was married to the actor Zachary Scott. In 1962 she introduced her brother to Warhol at a party in her apartment in the Dakota at 72nd Street and Central Park West, where she still lives.

In Ruth Ford's three *Screen Tests*, which were numbered in order on the boxes, she offers a range of performance that reflects her experience as a professional actress. In the first film (ST106), she is posed before the sparkly, out-of-focus space of the Factory; made up like a silent movie star, with very white skin and dark eyes, she slowly performs a series of emotive expressions, using only her eyes and slight tilts of her head to suggest, in turn, mild astonishment, faint disdain, romantic melancholy, a bitter memory, and so on. In the second film (ST107), Ford has been placed in three-quarter profile against a white background, now apparently under instructions to keep still and try not to blink. With her head held nobly high, Ford maintains her pose admirably, only occasionally raising an eyebrow or blinking briefly. By the end of the film, her eyes are filled with tears from the effort. In the last film, as noted on the box (ST108), Ford smiles and laughs often, responding to someone offscreen left who keeps her amused throughout the three minutes of shooting time. At one point, she playfully forms her fingers into spectacles and peeks through them.

**ST109** *Dan Foster,* 1966
16mm, b&w, silent; 4.5 min. @ 16 fps, 4 min. @ 18 fps
Preserved 1995, MoMA *Screen Tests* Reel 1, no. 9
FILM MATERIALS
ST109.1 *Dan Foster*
1966 Kodak 16mm b&w reversal original, 108'
NOTATIONS On plain white box in AW's hand: *Tri-X. Danny Foster*

**ST110** *Dan Foster,* 1966
16mm, b&w, silent; 4.4 min. @ 16 fps, 3.9 min. @ 18 fps
FILM MATERIALS
ST110.1 *Dan Foster*
1966 Kodak 16mm b&w reversal original, 106'
NOTATIONS On original box in AW's hand: *Tri-X. Dan Foster*

These two portraits of a young man named Dan or Danny Foster follow a common pattern in Warhol's shooting of *Screen Tests*: one film is formally posed, with the subject staring at the camera, trying not to move or blink for the three minutes; while the other is more relaxed and informal, and presumably more enjoyable for the poser. In one film (ST109), Foster succeeds in not blinking at all, although he appears to be on the verge of tears by the end of the roll. In the second film (ST110), he is much more animated, turning his head from side to side, smiling, and talking, as if he were being filmed while surrounded by a group of friends.

**ST111** *Fred,* 1964
16mm, b&w, silent; 4.5 min. @ 16 fps, 4 min. @ 18 fps
Preserved 1999, MoMA *Screen Tests* Reel 22, no. 8
COMPILATIONS *Fifty Fantastics and Fifty Personalities* (ST366)
FILM MATERIALS
ST111.1 *Fred*
1964 Kodak 16mm b&w reversal original, 108'
NOTATIONS On original box in AW's hand: *Fred*
On box in Gerard Malanga's hand: *Personalities*

This *Screen Test* of a young man identified only as "Fred" is an interesting study in photographic lighting. Fred's head is divided vertically down the center by the lighting that illuminates the two halves of his face. On the left, a bright light overexposes the left side of his face, reducing it to a white, nearly featureless expanse; on the right, a softer light, placed somewhat to his rear, reveals the features of the right half of his face in subtle, shadowed tonalities. As in a cubist portrait, the division between dark and light delineates his profile down the center of his face.

The meticulous experimentation with lighting in this film is reminiscent of some of the Philip Fagan portraits in *Six Months* (ST363), which suggests that this *Screen Test* may have been made during the same period, perhaps in late 1964 or early 1965.

**ST112** *Steve Garonsky,* 1964
16mm, b&w, silent; 4.5 min. @ 16 fps, 4 min. @ 18 fps
Preserved 1999, MoMA *Screen Tests* Reel 22, no. 10
FILM MATERIALS
ST112.1 *Steve Garonsky*
1964 Kodak 16mm b&w reversal original, 107'
NOTATIONS On original box in AW's hand: *Howard K.*

Steve Garonsky, known as Stevie, was an employee of the art collector and insurance executive Leon Kraushar. Garonsky worked as Kraushar's driver and also as a kind of companion, helping to smooth over complicated situations in which the high-strung Kraushar would sometimes get himself involved. Garonsky's portrait was probably shot at the same time as Howard Kraushar's *Screen Test* (ST186); indeed, Garonsky was misidentified as "Howard K." on the film box.[111]

Garonsky, impassive and sleepy-eyed, holds perfectly still throughout his *Screen Test*. Lit from both sides, with a symmetrical pattern of shadows running down the center of his features, he betrays no emotion at all and seems impossible to read. The interior of one eye is illuminated by oblique lighting from the left.

## ST113   *Henry Geldzahler,* 1965

16mm, b&w, silent; 4.5 min. @ 16 fps, 4 min. @ 18 fps
Preserved 1995, MoMA *Screen Tests* Reel 3, no. 1
COMPILATIONS  *EPI Background* (ST370)
**FILM MATERIALS**
ST113.1  *Henry Geldzahler*
1965 Kodak 16mm b&w reversal original, 109'
ST113.1.p1 *EPI Background* (ST370), roll 6
Undated Dupont 16mm b&w reversal print, 109'
**NOTATIONS**  On original box in AW's hand: *Henry*
On clear film at head of roll in red: *17*
On clear film at head of roll in black: *– 6 –*

Henry Geldzahler, then curator of contemporary art at the Metropolitan Museum of Art, was one of Warhol's closest friends in the early 1960s. An articulate and powerful champion of the emerging art scene, he was certainly one of the primary intellectual influences on Warhol's early career as an artist. As Geldzahler recalled, "For six or seven years we must have spent five hours a day together. We always woke up in the morning and talked and always spoke for an hour before we went to sleep."[112] They were less close by the end of the 1960s, perhaps because Geldzahler did not select Warhol as one of the artists exhibited in the American Pavilion at the 1966 Venice Biennale.[113] In the mid-1970s Geldzahler became commissioner of cultural affairs for the city of New York; he later worked as an independent curator and critic. In 1979 Warhol painted a silkscreened portrait of Geldzahler. Henry Geldzahler died in 1994 at the age of fifty-nine.

Geldzahler appeared in a number of Warhol's films over the years, starting with *Henry in Bathroom* in 1963 and *Henry Geldzahler* in 1964, his well-known ninety-nine-minute silent portrait film. Geldzahler also makes appearances in a few rolls of *Couch* and *Batman Dracula* in 1964, as well as a couple of color sound reels from 1966, the *Ondine #1* reel of *Since* and *Tiger Hop*. After his long ordeal in front of the camera in 1964, Geldzahler seems to have prepared himself for his 1965 *Screen Test* by planning something to do. Filmed in soft focus against the sharply in-focus, silver-painted Factory wall, he fills his three minutes by placidly untying and removing his necktie, turning his collar up, retying the tie, and smoothing his collar down again. These self-grooming activities, reminiscent of his toothbrushing, hair-combing performance in *Henry in Bathroom*, leave Geldzahler only a short period of unmediated confrontation with the camera at the end of the roll.[114]

## ST114   *Jean-Paul Germain,* 1965

16mm, b&w, silent; 4.5 min. @ 16 fps, 4 min. @ 18 fps
Preserved 1995, MoMA *Screen Tests* Reel 6, no. 7
**FILM MATERIALS**
ST114.1  *Jean-Paul Germain*
1965 Kodak 16mm b&w reversal original, 108'
**NOTATIONS**  On original box in AW's hand: *Jean-Paul. John Paul. One* (illegible word) *spot*

Jean-Paul Germain was an acquaintance of Warhol's friend Lester Persky, the producer of television commercials and "infomercials" who provided Warhol with the 16mm TV ads used in Warhol's 1964 film *Soap Opera*.[115] For his *Screen Test*, Germain has been posed in extreme close-up, his face harshly lit from the left. A dark-haired young man with eyes so light-colored they appear blue even in black-and-white, Germain blinks into the light for a few seconds, smiles briefly, then continues to squint against the glare for the rest of the film. Toward the end of the roll, he turns his head slowly to the right and to the left, as if following instructions.

## ST115   *Allen Ginsberg,* 1966

16mm, b&w, silent; 4.5 min. @ 16 fps, 4 min. @ 18 fps
Preserved 1998, MoMA *Screen Tests* Reel 14, no. 10
COMPILATIONS  *Fifty Fantastics and Fifty Personalities* (ST366); *Screen Tests/A Diary* (Appendix A)
**FILM MATERIALS**
ST115.1  *Allen Ginsberg*
1966 Kodak 16mm b&w reversal original, 109'
**NOTATIONS**  On original box in unidentified hand: *Allen Ginsberg*
On typed label taped to reel: *ALLEN GINSBERG*

Beat poet Allen Ginsberg was an iconic and ubiquitous figure in American countercultures of the 1960s, appearing as a kind of performative spokesperson for a wide variety of movements, from free speech to anti-imperialism, from the sexual revolution to the new drug culture, from Eastern religions to the New York underground. Warhol had filmed Ginsberg once before in 1964, when he shot several rolls of a historic gathering of Ginsberg and his fellow Beats Jack Kerouac, Gregory Corso, and Peter Orlovsky hanging out on and around the Factory couch (see *Couch* and *Allen* in Volume 2). Ginsberg and his lover Peter Orlovsky didn't have their portraits filmed until two years later, on December 4, 1966, making theirs among the very last *Screen Tests* to be shot.[116] In 1970 Paul Morrissey approached Ginsberg with the idea of casting him in the role of Walt Whitman in a Warhol/Morrissey remake of Whitman's Civil War diary, *Specimen Days*; although Ginsberg was at first interested, the project was eventually abandoned.[117] Ginsberg died in 1997 at the age of seventy.

In his *Screen Test*, Ginsberg is placed against a plywood backdrop and brightly lit from the left; the light is reflected in both lenses of his glasses, partially obscuring his left eye. Ginsberg stares at the camera without blinking for the first minute or so, then scrunches his eyes up for a moment. He holds so still throughout the film that his features—his large forehead, bushy hair and beard, white skin, and thick glasses—seem to freeze into an emblematic, high-contrast graphic, from the midst of which his one visible eye aggressively returns the camera's stare. There are a few light flares near the end of the film.

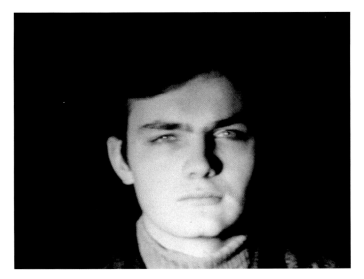

ST114

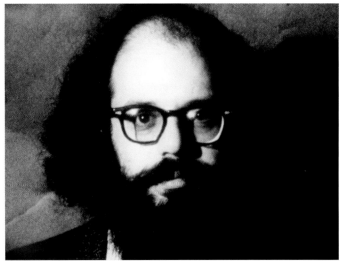

ST115

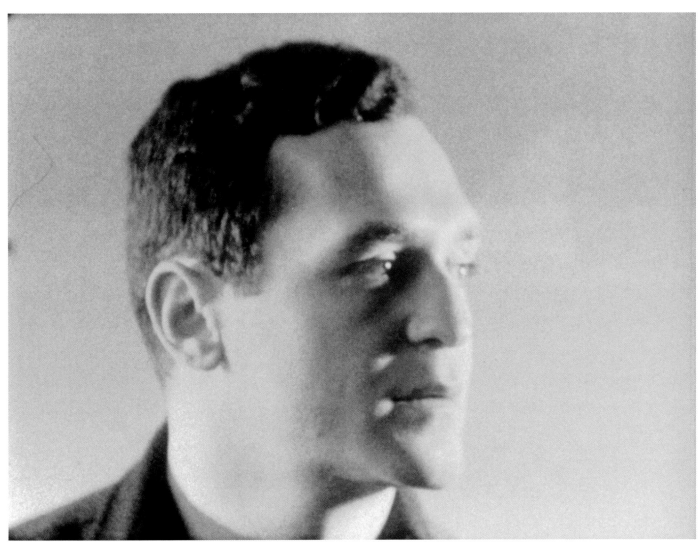

ST116

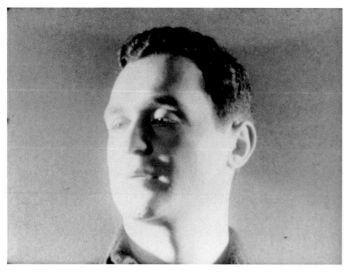

ST117

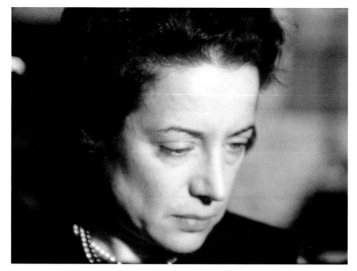

ST118

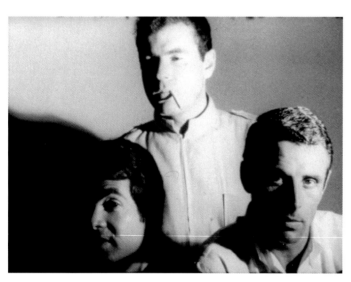

ST119

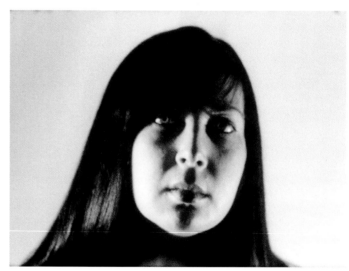

ST120

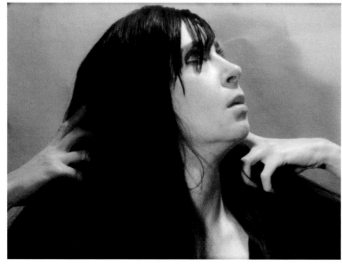

ST121

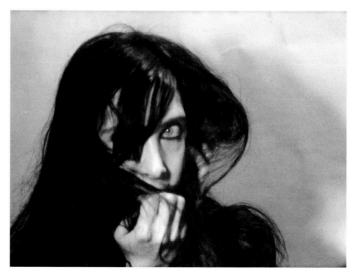

ST121

**ST116  *John Giorno*, 1964**
16mm, b&w, silent; 3.7 min. @ 16 fps, 3.3 min. @ 18 fps
Preserved 1995, MoMA *Screen Tests* Reel 9, no. 5
COMPILATIONS  *The Thirteen Most Beautiful Boys* (ST364)
FILM MATERIALS
ST116.1  *John Giorno*
1963 Kodak 16mm b&w reversal original, 89'
NOTATIONS  On original box in AW's hand: *John Giorno. 13 Most*
Stamped on box: *VIDEO FILM LABORATORIES*

**ST117  *John Giorno*, 1964**
16mm, b&w, silent; 4.4 min. @ 16 fps, 3.9 min. @ 18 fps
Preserved 1995, MoMA *Screen Tests* Reel 4, no. 2
COMPILATIONS  *The Thirteen Most Beautiful Boys* (ST364)
FILM MATERIALS
ST117.1  *John Giorno*
1963 Kodak 16mm b&w reversal original, 105'
NOTATIONS  On original box in AW's hand: *John Giorno. Portrait (13)*
Stamped on box: *Video Film Laboratories, 611 West 43rd Street*

The poet John Giorno, famous in the annals of Warhol's cinema as the unconscious star of the five-hour-and-twenty-minute-long *Sleep* (1963), was a close friend of Warhol's in the early 1960s. In addition to his appearance in *Sleep*, Giorno also turns up in some of Warhol's earliest footage, in previously unknown "home movies" from 1963 such as *Taylor and John, Bob Indiana, Etc., Billy Klüver, John Washing*, and *Naomi and John*. In the 1960s, Giorno was perhaps best known as the developer of the Found Poem (using texts appropriated from news articles and other sources) and as the founder of Giorno Poetry Systems, which presented repackaged poetry in novel forms such as *Dial-a-Poem, Consumer Products Poetry*, LP records, radio, and television.[118] Giorno is one of the few Warhol film stars also to be immortalized in Warhol's art; his image in a frame sequence from *Sleep* appears in the see-through Plexiglas sculpture, *Large Sleep* (1965).[119]

Many *Screen Test* subjects were asked not to move while their portraits were being filmed, with the idea that the results would look as much as possible like an actual photograph. Among these many films, Giorno's two *Screen Tests* probably come closest to achieving the presence and graphic impact of truly nonmoving images. Placed against a white background and lit from both sides, Giorno's head looks like a cutout that has been collaged into the film image. Although he does blink at regular intervals, and even swallows occasionally, Giorno seems to have serenely absented himself from the image-making process, his unfocused eyes gazing offscreen into remote distances, his head held perfectly still.

In the first film (ST116), Giorno gazes off to the right in partial profile, his features sculpted into Rushmore-like relief by the central swath of shadow falling down his face. By the end of the roll, his eyes have become noticeably moist; there are a few light flares in the middle of the roll. This film is also about twenty feet shorter than it should be; since the film begins with a fade-in and ends with a fade-out, the remaining, presumably overexposed footage seems to have been cut out of the roll.

In the second film (ST117), Giorno faces to the left, his face lit from both sides. The narrow band of shadow that bisects his entire head from top to bottom creates an optical illusion of a second, superimposed face—a hook-nosed, skull-like profile cast over Giorno's face and overlapping at lips, nose, and eyes.

**ST118  *Grace Glueck*, 1964**
16mm, b&w, silent; 4.5 min. @ 16 fps, 4 min. @ 18 fps
Preserved 2001, MoMA *Screen Tests* Reel 24, no. 9
FILM MATERIALS
ST118.1  *Grace Glueck*
1964 Kodak 16mm b&w reversal original, 108'
NOTATIONS  On original box in AW's hand, nearly illegible: *Grace Glueck*

Grace Glueck, arts critic and reporter for the *New York Times*, has covered the entirety of Warhol's career, from his 1964 exhibition at the Stable Gallery to his memorial service and the creation of the Andy Warhol Museum in Pittsburgh.[120] In July 1964, Glueck's "Art Notes" column reported that Warhol was working on a film called *Wee Love of Life* (later renamed *Soap Opera*) with Jerry Benjamin, which was the first mention of the Warhol films in the *New York Times*.[121]

Throughout her *Screen Test*, Glueck, elegantly dressed in pearls, is looking down and reading, apparently absorbed in her book or magazine and completely unaware of the camera.[122] Since Glueck has no recollection of ever being filmed by Warhol, it seems likely that this film was shot entirely without her knowledge, probably filmed from some distance away using the zoom lens. Two other *Screen Tests* of readers who seem not to have noticed that they were being filmed (Arman, ST12, and Alan Solomon, ST316) have also been found in the Collection.

**ST119  *Peter Goldthwaite*, 1966**
16mm, b&w, silent; 4.4 min. @ 16 fps, 3.9 min. @ 18 fps
With Peter Goldthwaite, Dino, and an unidentified man
Preserved 1998, MoMA *Screen Tests* Reel 17, no. 5
FILM MATERIALS
ST119.1  *Peter Goldthwaite*
1966 Kodak 16mm b&w reversal original, 105'
NOTATIONS  On original box in AW's hand: *Peter Golf*
On box flap in unidentified hand: *Peter Goldfait*

This roll labeled "Peter Goldthwaite" is the only triple portrait film found among the *Screen Tests*. Three young men have been arranged in a kind of pyramid, with two seated figures flanking a third who is standing; the group has been strongly lit from the right. The young man at lower right is recognizable as the "Dino" who appears in another *Screen Test* (ST77), but the other two are unidentified.

All three men give very different performances: as in his other portrait film, Dino maintains a solemn stare, while the dark-haired young man at lower left occasionally smiles and laughs at the camera. The young man in the center, who is perhaps Peter Goldthwaite, concentrates on smoking a cigarette without removing it from his mouth, squinting against the smoke.

**ST120  *Beverly Grant*, 1964**
16mm, b&w, silent; 4.5 min. @ 16 fps, 4 min. @ 18 fps
COMPILATIONS  *The Thirteen Most Beautiful Women* (ST365)
FILM MATERIALS
ST120.1  *Beverly Grant*
1964 Kodak 16mm b&w reversal original, 109'
NOTATIONS  On plain brown box in Paul Morrissey's hand: *Beverly Grant. 3*

**ST121    *Beverly Grant (Hair),* 1964**
16mm, b&w, silent; 4.5 min. @ 16 fps, 4 min. @ 18 fps
Preserved 2001, MoMA *Screen Tests* Reel 27, no. 5
**FILM MATERIALS**
ST121.1 *Beverly Grant (Hair)*
1964 Kodak 16mm b&w reversal original, 108'
**NOTATIONS**  On original box in unidentified hand: *girl peeking through hair. Beverly Grant through hair*

**ST122    *Beverly Grant,* 1964**
16mm, b&w, silent; 4.5 min. @ 16 fps, 4 min. @ 18 fps
Preserved 1995, MoMA *Screen Tests* Reel 3, no. 3
**FILM MATERIALS**
ST122.1 *Beverly Grant*
1964 Kodak 16mm b&w reversal original, 107'
**NOTATIONS**  On original box in AW's hand: *Beverly Hair #2*

**ST123    *Beverly Grant (Hair),* 1964**
16mm, b&w, silent; 4.4 min. @ 16 fps, 3.9 min. @ 18 fps
Preserved 2000, MoMA *Screen Tests* Reel 25, no. 1
**COMPILATIONS**  *EPI Background* (ST370)
**FILM MATERIALS**
ST123.1 *Beverly Grant (Hair)*
1964 Kodak 16mm b&w reversal original, 106'
ST123.1.p1 *EPI Background* (ST370), roll 3
Undated Dupont 16mm b&w reversal print, 106'
**NOTATIONS**  On original box in AW's hand: *Beverly hair*
On clear film at head in red: *18*
On clear film at head in black: *–3–*

The actress Beverly Grant was known as "Queen of the Undergrounds" in the 1960s, when she appeared in numerous avant-garde films such as Jack Smith's *Normal Love* (1963–64) and Ron Rice's *Chumlum* (1963), and also on stage, such as in the Playhouse of the Ridiculous production of Ronald Tavel's play *Shower* in 1965. Grant, who was married to filmmaker and musician Tony Conrad for a number of years, appears in a good deal of the material shot for the unfinished Smith/Warhol collaboration *Batman Dracula* (1964). She died in 1990.

The first of Grant's four *Screen Tests* (ST120) was apparently included in at least three versions of *The Thirteen Most Beautiful Women* (ST365a, ST365b, ST365c). Compared with her other portraits, Beverly Grant is rather subdued in this film, with her hair combed straight and smooth, although her light-colored eyes are still very dramatic. She bobs her head slightly from side to side, as if listening to music; there are a few light flares in the middle of the film.

The last three *Screen Tests* of Grant are melodramatic, vampish (or vampirelike) performances that look like they could have been shot for *Batman Dracula.* The first two portraits (ST121 and ST122) are close-ups of Grant entangling herself in her own hair; spreading and lifting her long black tresses with long spidery fingers, twisting and wrapping her hair across her face like a veil, peering out fearfully, then cramming her hair into her mouth and widening her large kohl-rimmed eyes in horror. Much like Theda Bara, Grant runs through a gamut of exaggerated, silent-movie facial expressions, from sensual abandon to complete madness, with her hair as her only prop.

The last film (ST123) is a medium shot of Grant standing against a wall holding her hair spread out with both hands, like a Medusa. She holds this pose throughout most of the roll, moving only at the end when her hair slips through her fingers and must be lifted and spread again.

**ST124    *Guy,* 1964**
16mm, b&w, silent; 4.5 min. @ 16 fps, 4 min. @ 18 fps
Preserved 1998, MoMA *Screen Tests* Reel 17, no. 2
**FILM MATERIALS**
ST124.1 *Guy*
1964 Kodak 16mm b&w reversal original, 109'
**NOTATIONS**  On box in AW's hand: *Guy laughing. X*
On box in unidentified hand, crossed out: *Jack laughing. Beverly from sea with creature*

This unknown young man, identified only as "Guy" on the film box, is shot in extreme close-up, his face barely fitting into the film frame. The film is noticeably blurry, although his features do occasionally loom into focus when he happens to lean toward the camera. Guy begins his *Screen Test* smiling at the camera, revealing a set of large and very uneven teeth. He seems to have been given instructions to laugh for the camera, since he repeatedly throws his head back and opens his mouth very wide, revealing large gaps and other dental abnormalities. He covers his mouth with his hand self-consciously from time to time and, understandably, does not seem at all comfortable during this performance. Toward the end of the film, the focus gets much worse; the camera veers left momentarily into a close-up of his shoulder.

**ST125    *Hal,* 1964**
16mm, b&w, silent; 4.5 min. @ 16 fps, 4 min. @ 18 fps
Preserved 1995, MoMA *Screen Tests* Reel 1, no. 7
**FILM MATERIALS**
ST125.1 *Hal*
1964 Kodak 16mm b&w reversal original, 107'
**NOTATIONS**  On original box in unidentified hand: *HAL*

A young man identified only as "Hal" appears in a 1964 *Screen Test.* Wearing a white shirt and filmed against a black background, Hal appears to be leaning forward during the filming, inching gradually closer and closer to the camera. With his dark hair combed across his forehead and his full lower lip, he appears very young; his deep-set eyes are nearly hidden beneath his brows.

**ST126    *David Hallacy,* 1964**
16mm, b&w, silent; 4.4 min. @ 16 fps, 3.9 min. @ 18 fps
Preserved 1995, MoMA *Screen Tests* Reel 7, no. 6
**COMPILATIONS**  *The Thirteen Most Beautiful Boys* (ST364)
**FILM MATERIALS**
ST126.1 *David Hallacy*
1964 Kodak 16mm b&w reversal original, 105'
**NOTATIONS**  On original box in AW's hand: *David Hallacy. 13*

**ST127    *David Hallacy,* 1964**
16mm, b&w, silent; 4.5 min. @ 16 fps, 4 min. @ 18 fps
Preserved 1995, MoMA *Screen Tests* Reel 6, no. 3
**COMPILATIONS**  *The Thirteen Most Beautiful Boys* (ST364)
**FILM MATERIALS**
ST127.1 *David Hallacy*
1964 Kodak 16mm b&w reversal original, 107'
**NOTATIONS**  On original box in AW's hand: *David Hallacy. Cries. 13. #2*

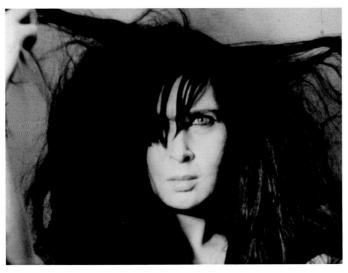

ST122

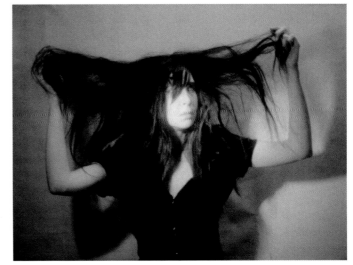

ST123

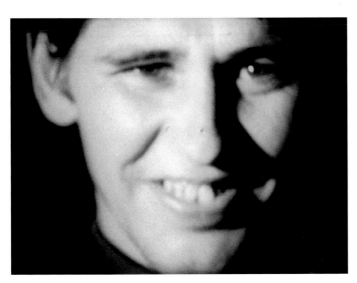

ST124

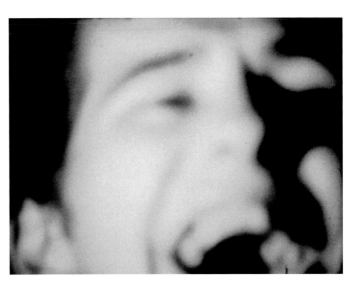

ST124

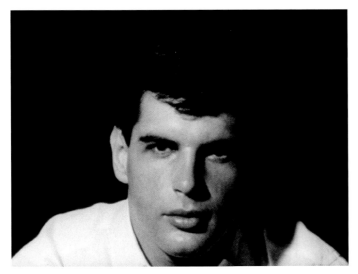

ST125

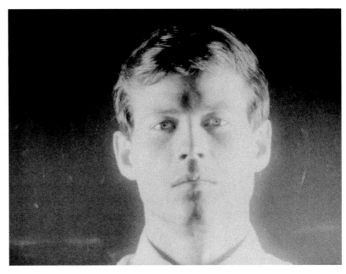

ST126

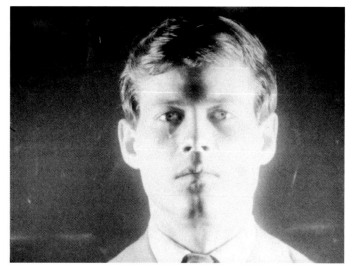

ST127

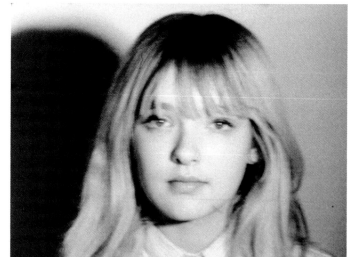

ST128

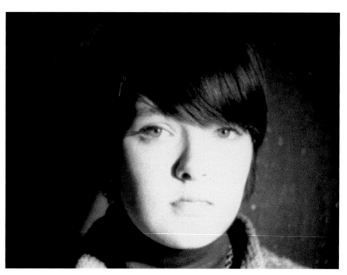

ST129

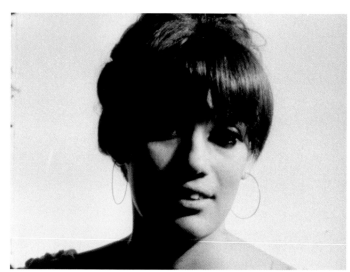

ST130

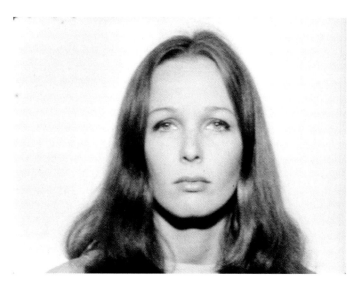

ST131

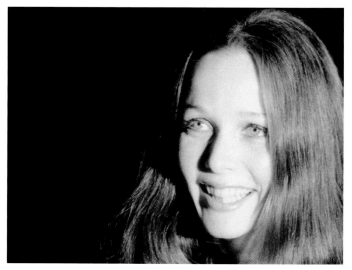

ST132

In October 1964 the writer Glenway Wescott invited Warhol to a dinner party that included architect Philip Johnson, the novelist and screenwriter Anita Loos, and Wescott's friends Walter Steit and David Hallacy.[123] It seems likely that these two *Screen Tests* of Hallacy were shot around the same time. Lit evenly from both sides to create a symmetrical line of shadowing down the center of his features, Hallacy's overexposed face looks flattened against the dark backdrop, depthless as a cutout photograph. Aside from a few flutters of the eyelids and an occasional swallow, he holds perfectly still throughout both rolls. By the second film (ST127), Hallacy is "crying," as Warhol noted on the box; tears run down both cheeks and hang in droplets from his chin.

### ST128  *Bibbe Hansen,* 1965
16mm, b&w, silent; 4.5 min. @ 16 fps, 4 min. @ 18 fps
Preserved 1995, MoMA *Screen Tests* Reel 12, no. 1
**FILM MATERIALS**
ST128.1  *Bibbe Hansen*
1964 Kodak 16mm b&w reversal original, 107'
**NOTATIONS**  On original box in AW's hand: *Bibi. BIBI*

### ST129  *Bibbe Hansen,* 1965
16mm, b&w, silent; 4.5 min. @ 16 fps, 4 min. @ 18 fps
Preserved 1995, MoMA *Screen Tests* Reel 2, no. 2
**COMPILATIONS**  *The Thirteen Most Beautiful Women* (ST365)
**FILM MATERIALS**
ST129.1  *Bibbe Hansen*
1965 Kodak 16mm b&w reversal original, 108'
**NOTATIONS**  On box in unidentified hand: *Tri X Reversal. Bibbe (13)*
On box in unidentified hand, crossed out: *Print*

Bibbe Hansen, the daughter of Happenings artist Al Hansen and the actress Audrey Hansen, was a very young teenager in 1965 when Warhol shot these two *Screen Tests* of her. An avant-garde wild child, Hansen had acted in her father's Happenings and other performance events as well as in summer stock; she had also performed with Janet Kerouac, Jack Kerouac's daughter, in their all-girl rock-and-roll band, the Whippets. The first Warhol feature in which Bibbe Hansen appeared, shot in the first part of 1965, was *Prison,* inspired by her recent experiences in a juvenile detention center, in which she costarred with Edie Sedgwick; her first *Screen Test* was probably shot shortly before *Prison.* Hansen's second *Screen Test,* selected for *The Thirteen Most Beautiful Women,* was shot toward the end of 1965, after her hair had been dyed for the role of Anne Frank in summer stock theater. Hansen can also be glimpsed in Warhol's 1965 film *Restaurant.*

In later years, Bibbe Hansen moved to the West Coast, founded a theater company, operated an arts café in downtown Los Angeles, and became a well-known figure in the L.A. punk music and arts scenes. She continues to write and direct theater and performance pieces, occasionally performs with the drag queen Vaginal Davis in her band Black Fag, and is writing a memoir of her life in the early 1960s. She is the mother of two sons, the artist Channing Hansen and the popular recording artist Beck.[124]

Hansen's first *Screen Test,* although slightly out of focus throughout, is very carefully lit and framed; her blond hair and pale skin stand out against the shadow she casts on the white wall behind her. The second film, selected for *The Thirteen Most Beautiful Women,* is shot in perfect focus and in slightly tighter close-up against a painted plywood backdrop. In both films, Hansen faces the camera with a wide-eyed, impassive gaze, demonstrating considerable poise for someone so young.

### ST130  *Pat Hartley,* 1965
16mm, b&w, silent, 4.5 min. @ 16 fps, 4 min. @ 18 fps
Preserved 1995, MoMA *Screen Tests* Reel 3, no. 4
**FILM MATERIALS**
ST130.1  *Pat Hartley*
1965 Kodak 16mm b&w double-perf. reversal original, 109'
**NOTATIONS**  On original box in unidentified hand: *Pat Hartley*

The filmmaker and actress Pat Hartley was a New York teenager when her *Screen Test* was filmed at the Factory in the fall of 1965. Hartley also appeared in two other Warhol films from 1965: *Prison,* with Bibbe Hansen and Edie Sedgwick, and *My Hustler II,* with Paul America. She later appeared in John Palmer and David Weisman's *Ciao! Manhattan* (1967–72) and in Chuck Wein's 1972 film *Jimi Hendrix: Rainbow Bridge.* She and her husband, Dick Fontaine, have made several documentary films together, including a film about James Baldwin, *I Heard It Through the Grapevine* (1982), and *Art Blakey: The Jazz Messenger* (1987).

Wearing large hoop earrings and with her hair pinned on top of her head, Hartley has been placed against a bright white background and strongly lit from the right. Her eyes are almost completely hidden in the shadows of her bangs and long eyelashes. Midway through the film, she smiles and laughs at the camera. Her full face is briefly visible in the fade-out at the end of the roll.

### ST131  *Brooke Hayward,* 1964
16mm, b&w, silent; 4.5 min. @ 16 fps, 4 min. @ 18 fps
Preserved 1995, MoMA *Screen Tests* Reel 9, no. 1
**COMPILATIONS**  *The Thirteen Most Beautiful Women* (ST365)
**FILM MATERIALS**
ST131.1  *Brooke Hayward*
1964 Kodak 16mm b&w reversal original, 107'
**NOTATIONS**  On original box in AW's hand: *Brooke (13)*

### ST132  *Brooke Hayward,* 1964
16mm, b&w, silent; 4.5 min. @ 16 fps, 4 min. @ 18 fps
Preserved 2001, MoMA *Screen Tests* Reel 25, no. 7
**COMPILATIONS**  *The Thirteen Most Beautiful Women* (ST365)
**FILM MATERIALS**
ST132.1  *Brooke Hayward*
1964 Kodak 16mm b&w reversal original, 109'
**NOTATIONS**  On plain brown box in Paul Morrissey's hand: *Brooke Heyward 10*
On small piece of white adhesive on tail in Paul Morrissey's hand: *Brooke Hayward*

### ST133  *Brooke Hayward,* 1964
16mm, b&w, silent; 4.5 min. @ 16 fps, 4 min. @ 18 fps
Preserved 1999, MoMA *Screen Tests* Reel 22, no. 4
**COMPILATIONS**  *Fifty Fantastics and Fifty Personalities* (ST366)
**FILM MATERIALS**
ST133.1  *Brooke Hayward*
1964 Kodak 16mm b&w reversal original, 108'
**NOTATIONS**  On original box in AW's hand: *Brooke in 50*

Brooke Hayward, the daughter of Hollywood producer Leland Hayward and actress Margaret Sullavan, was married to actor Dennis Hopper in the early 1960s when she first met Andy Warhol. In September 1963, when Warhol, Gerard Malanga, Taylor Mead, and Wynn Chamberlain arrived in Los Angeles to attend the opening of Warhol's one-man exhibition of *Elvis* and *Liz* paintings at Irving Blum's Ferus Gallery, the Hoppers welcomed Warhol with a "movie star party." Warhol was delighted with this reception. "The Hoppers were wonderful to us," he recalled. "This party was the most exciting thing that had ever happened to me."[125] Hopper and Hayward were given small roles in the film Warhol shot during his L.A. visit, *Tarzan and Jane Regained, Sort Of . . . .*

The couple subsequently visited Warhol in New York in 1964, when their *Screen Tests* were shot at the Factory; Hayward also appeared with Henry Geldzahler in a roll shot for the 1964 film *Couch.* In 1973 Warhol painted four silk-screened portraits of Hayward. In 1981 she published *Haywire,* a personal memoir of her family and early life.

Hayward's three *Screen Tests* appear to have been shot on two different occasions. In the first film (ST131) she is posed as if for a mug shot, centered against a white background and facing directly into the camera. Her abstracted gaze is fixed on a point slightly above the lens; she seems somewhat morose, or uncomfortable with being filmed. The next two films are very different in mood: in both rolls, Hayward is framed radically offcenter against a completely dark background, with a single light source sharply angled onto her face from the right. In the first of these two films (ST132), she begins her session with a quick smile at someone offscreen, but then immediately becomes more pensive. After gazing down for a while, she begins to furrow her brow, as if thinking of something that troubles her. In the last portrait (ST133), which seems to have been shot immediately afterward, she appears to have become deeply unhappy, almost on the verge of tears. Hayward periodically turns her head to left and right or gazes upward, striking several tragic poses.

## ST134   *Kate Heliczer,* 1964

16mm, b&w, silent; 4.5 min. @ 16 fps, 4 min. @ 18 fps
COMPILATIONS *The Thirteen Most Beautiful Women* (ST365)
FILM MATERIALS
ST134.1 *Kate Heliczer*
1964 Kodak 16mm b&w double-perf. reversal original, 108'
NOTATIONS On original box in AW's hand: *Kate for 13*
On lid of can in unidentified hand: *DONYLE*

Kate Heliczer, originally from England, married the poet and filmmaker Piero Heliczer in 1961 and moved to New York with him in 1962; her maiden name was Catherine Maxence Cowper.[126] In addition to her *Screen Test,* which was selected for *The Thirteen Most Beautiful Women,* Kate Heliczer also appears in several rolls of Warhol's 1964 film *Couch,* in which she engages in an extended love-making scene with Gerard Malanga and Rufus Collins.

In her portrait film, Kate Heliczer is filmed wearing a white turtleneck sweater and placed against a light background, with her hair falling over one side of her face and a bright light illuminating the other side. Her one visible eye, light-colored and dark-rimmed, is illuminated like a jewel. The focus is slightly soft throughout.

## ST135   *Piero Heliczer,* 1965

16mm, b&w, silent; 4.5 min. @ 16 fps, 4 min. @ 18 fps
Preserved 1999, MoMA *Screen Tests* Reel 23, no. 9
COMPILATIONS *Fifty Fantastic and Fifty Personalities* (ST366); *Screen Test Poems* (ST372); *Screen Tests/A Diary* (Appendix A)
FILM MATERIALS
ST135.1 *Piero Heliczer*
1965 Kodak 16mm b&w double-perf. reversal original, 107'
ST135.1.p1 *Screen Test Poems,* Reel 1 (ST372.1), roll 5
Undated Gevaert 16mm b&w reversal print, 107'
NOTATIONS On original box in Gerard Malanga's hand: *PIERO HELICZER. Piero Heliczer. Personality. marked by masking tape at very beginning 1 Double Frame Negative and 3 8" x 10" single unit Glossy Double Frame positive*
On box flap in red: *5*
On typed label found in can: *PIERO HELICZER*

The avant-garde filmmaker and poet Piero Heliczer was born in Rome in 1939, where he worked as a child film star in the early 1940s. His father, a doctor and a member of the Resistance, was killed by the German Gestapo in 1944; Heliczer and his remaining family emigrated to the United States in 1946. After briefly attending Harvard University, Heliczer relocated to Europe, where he began writing and publishing poetry. He returned to New York in 1962, when he became involved in avant-garde film circles, appearing in Jack Smith's film *Flaming Creatures* (1962), publishing Smith's photographic work *The Beautiful Book* (1962), and making many of his own films, such as *Satisfaction, Venus in Furs,* and *Dirt* (1965). Heliczer's 1967 film *Joan of Arc,* which Warhol appeared in, was shot at the courthouse at Second Avenue and 2nd Street, the current location of Anthology Film Archives, where Warhol also shot several films in 1966–67.[127] In 1967 Heliczer published *Soap Opera,* a book of his own poems illustrated by Warhol, Jack Smith, Wallace Berman, and other artists; Warhol's illustration is a double-frame image from Heliczer's *Screen Test.*[128] Like his wife, Kate, Heliczer also appeared in Warhol's 1964 film *Couch,* as well as in two unreleased Warhol films shot in the fall of 1966: *The Andy Warhol Story* and *Tiger Hop.* Piero Heliczer was killed in a motorcycle accident in Europe in 1993.

For his portrait film, Heliczer is dressed in rabbinical style in a broad-brimmed black hat and high collar. He has been placed in front of some plastic sheeting, which billows slightly during filming. Brightly lit from the right side, Heliczer slowly smokes a cigarette, occasionally blowing a smoke ring or rubbing his lower lip with a finger. At one point, he reaches up and pulls his hat lower over his face. There is a fade-out in the middle of the film during which Heliczer's image disappears completely for a moment. Toward the end of the roll, he smiles, closes his eyes, and sticks his tongue out at the camera. As the film ends, Heliczer slowly bows his head until his face is hidden behind his hat brim.

## ST136   *Helmut,* 1964

16mm, b&w, silent; 4.4 min. @ 16 fps, 3.9 min. @ 18 fps
Preserved 1995, MoMA *Screen Tests* Reel 5, no. 6
COMPILATIONS *The Thirteen Most Beautiful Boys* (ST364)
FILM MATERIALS
ST136.1 *Helmut*
1964 Kodak 16mm b&w reversal original, 105'
NOTATIONS On plain white box in AW's hand: *Boy Portrait (13). (13)*
On box in AW's hand, crossed out: *Sleep*
On box flap in unidentified hand: *Helmet*

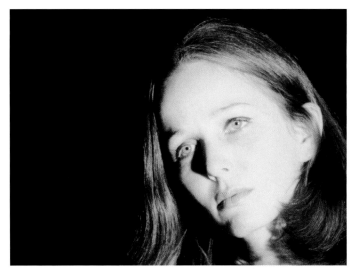

ST132

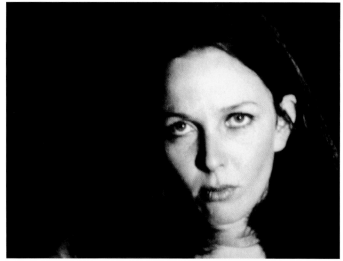

ST133

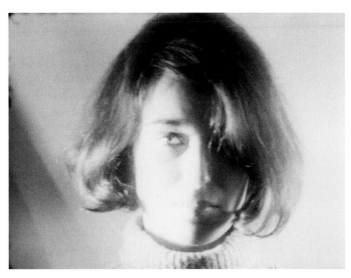

ST134

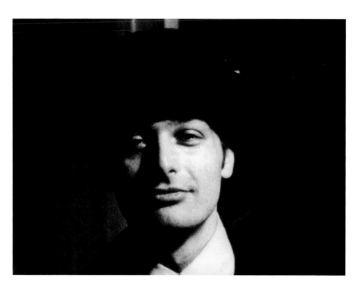

ST135

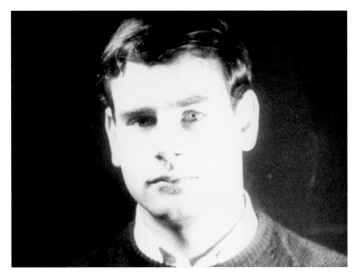

ST136

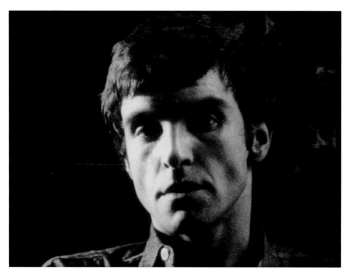

ST137

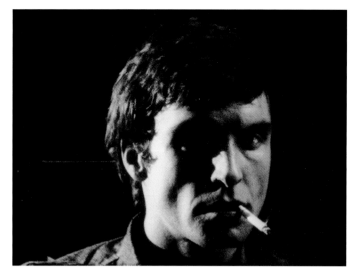

ST137

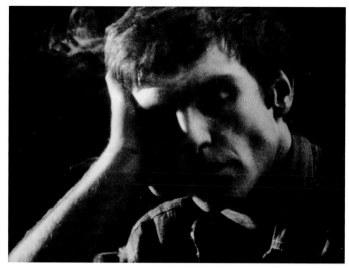

ST137

ST138

This very young man, identified only as "Helmut" or "Boy," posed for his *Screen Test* for *The Thirteen Most Beautiful Boys* in 1964. Preppily dressed in a button-down shirt and sweater, he stares into the camera, obediently trying not to blink. His eyelids flutter from time to time, while moisture slowly accumulates in his right eye.

## ST137    *Freddy Herko,* 1964

16mm, b&w, silent; 4.6 min. @ 16 fps, 4.1 min. @ 18 fps
Preserved 2001, MoMA *Screen Tests* Reel 24, no. 1
COMPILATIONS  *The Thirteen Most Beautiful Boys* (ST364); *Screen Test Poems* (ST372); *Screen Tests/A Diary* (Appendix A)
FILM MATERIALS
ST137.1 *Freddy Herko*
1963 Kodak 16mm b&w reversal original, 110', 122' including yellow tail leader
ST137.1.p1 *Screen Test Poems,* Reel 1 (ST372.1), roll 11
Undated Gevaert 16mm b&w reversal print, 100'
NOTATIONS  On box in AW's hand: *Freddy Herko 13 13*
On box in Gerard Malanga's hand: *Freddy Herko. 1 double frame negative and one 8" x 10" double frame glossy print*
On box in AW's hand, crossed out: *Jane Green 21. 1 Dracula. worry Jack. Heide making up. Jack mary jane. Jack in back of lens*
On box flap in red: *11*
On typed label found in can: *FREDDY HERKO*
On clear film at both head and tail of roll in black: *11*

Sadly, the dancer and choreographer Freddy Herko is perhaps best known now for the flamboyant nature of his suicide when, on October 27, 1964, at the age of twenty-nine, he put on a recording of Mozart's "Coronation Mass in C" and danced out the window of John Dodd's fifth-floor apartment at 5 Cornelia Street in Greenwich Village. Herko was one of the first amphetamine casualties of the 1960s; his death was also the source of one of the better-known Warhol legends—the often-repeated story that Warhol, on hearing of Herko's suicide, remarked that he wished Freddy had told him he was planning to kill himself so he could have filmed it.[129]

Fred Herko, who was accepted as a dance student at the American Ballet Theatre at the age of nineteen, was a striking figure in avant-garde dance and performance events in the early 1960s. After appearing in some off-Broadway revues and ballet revivals, and also on television, Herko became more involved in the downtown scene and a downtown lifestyle, dancing as a regular member of the James Waring Company, and later appearing in Rosalyn Drexler's avant-garde musical *Home Movies.* He often performed his own choreography at the Judson Dance Theater, his best-known piece being "Little Gym Dance Before the Wall for Dorothy." He also was involved in organizing the New York Poets' Theatre with his close friend Diane Di Prima and her husband, Alan Marlowe.

Warhol had immense appreciation for Herko's talents as a performer: "The people I loved were the ones like Freddy, the leftovers of show business, turned down at auditions all over town. They couldn't do something more than once, but their one time was better than anyone else's."[130] Herko appears in a number of Warhol's earliest films from 1963, including *Kiss, Dance Movie* (or *Rollerskate*), *Jill and Freddy Dancing,* and two of the three versions of *Haircut.* After Herko's death, Warhol dedicated a white *Flowers* painting to his memory, which was included in his *Flowers* exhibition at the Leo Castelli Gallery in November 1964. Warhol's films of Herko were also screened at a memorial gathering at the Factory shortly after his death.[131]

In his *Screen Test,* Herko is filmed against a black backdrop and lit from the side so his face is deeply shadowed. Nervously chewing gum and smoking, he appears gaunt and exhausted, shifting his position in his chair, leaning his head on his hand, grimly returning the camera's stare. As James Stoller pointed out, it is hard not to read the darkness of this portrait film as a forecast of Herko's suicide later that same year:

> I wonder what the fragment would have meant to me if I had not recognized him and not recalled admiring his art and reading something about the circumstances of his death. As it is the footage became excruciatingly moving as I uncontrollably invested Herko's glowering expression with meanings brought from outside the film.[132]

On December 7, 1964, Herko's *Screen Test,* billed as an excerpt from *The Thirteen Most Beautiful Boys,* was shown at the New Yorker Theatre, one of several Warhol films that accompanied the presentation of *Film Culture*'s Independent Film Award to Andy Warhol.[133]

## ST138    *Sandra Hochman (Lips),* 1964

16mm, b&w, silent; 4.4 min. @ 16 fps, 3.9 min. @ 18 fps
Preserved 1998, MoMA *Screen Tests* Reel 14, no. 9
FILM MATERIALS
ST138.1 *Sandra Hochman (Lips)*
1964 Kodak 16mm b&w reversal original, 105'
NOTATIONS  On original box in AW's hand: *Sandra Hochman. Lips. Lips. SANDRA HOCHMAN LIPS*
On box in Gerard Malanga's hand, with drawing of double frames: *2 8" x 10" double frame positives*
Stamped on box: *Video Film Laboratories*

The New York poet, playwright, and novelist Sandra Hochman sat for her *Screen Test* in 1964. The tight close-up, erotically centered on her lips, shows only the lower half of her face as she silently reads out loud from what is almost certainly her own writing. Hochman looks down from time to time as she reads, but often raises her head and directly addresses the camera. At the slow-motion speed of 18 fps, she appears to be enunciating her words very clearly, as if making a training film for lip-readers. Toward the end of the film, she lowers her head and one of her eyes is briefly visible.

Hochman is the author of numerous volumes of poetry as well as several novels, plays, and a screenplay. In 1963 she was poet-in-residence at Fordham University; she also received the Yale Younger Poets Award in the same year. In the 1960s she produced and appeared on a weekly poetry program on New York radio station WBAI. In his diary entry for December 14, 1976, Warhol mentions running into Sandra Hochman at a party at Norman Mailer's home in Brooklyn Heights, when "she told me I was a chapter in her upcoming book," and "talked to me about the women's movement and junk like that."[134]

Jane Holzer gets ready for her *Screen Test* (ST148), 1965. Photograph by Nat Finkelstein.

**ST139**   *Jane Holzer*, 1964
16mm, b&w, silent; 4.3 min. @ 16 fps, 3.9 min. @ 18 fps
Preserved 1995, MoMA *Screen Tests* Reel 8, no. 10
COMPILATIONS   *The Thirteen Most Beautiful Women* (ST365)
FILM MATERIALS
ST139.1 *Jane Holzer*
1964 Kodak 16mm b&w reversal original, 104'
NOTATIONS   On original box in AW's hand: *Jane (13). Bad*

**ST140**   *Jane Holzer*, 1964
16mm, b&w, silent; 4.2 min. @ 16 fps, 3.7 min. @ 18 fps
Preserved 1995, MoMA *Screen Tests* Reel 10, no. 4
FILM MATERIALS
ST140.1 *Jane Holzer*
1964 Kodak 16mm b&w reversal original, 101'
NOTATIONS   On original box in AW's hand: *Jane Holzer. Bad*

**ST141**   *Jane Holzer*, 1964
16mm, b&w, silent; 4.4 min. @ 16 fps, 3.9 min. @ 18 fps
Preserved 1995, MoMA *Screen Tests* Reel 8, no. 9
COMPILATIONS   *The Thirteen Most Beautiful Women* (ST365)
FILM MATERIALS
ST141.1 *Jane Holzer*
1964 Kodak 16mm b&w reversal original, 105'
NOTATIONS   On original box in AW's hand: *Jane Holzer Portrait. M. shadow. (13)*

**ST142**   *Jane Holzer*, 1964
16mm, b&w, silent; 4.5 min. @ 16 fps, 4 min. @ 18 fps
Preserved 2001, MoMA *Screen Tests* Reel 25, no. 6; also
preserved as roll 1 of *Four of Andy Warhol's Most Beautiful
Women* (ST365f)
COMPILATIONS   *The Thirteen Most Beautiful Women* (ST365); *Four of
Andy Warhol's Most Beautiful Women* (ST365f)
FILM MATERIALS
ST142.1 *Jane Holzer*
1964 Kodak 16mm b&w reversal original, 108'
NOTATIONS   On flap of plain brown box in Paul Morrissey's hand:
*BABY JANE HOLZER*

**ST143**   *Jane Holzer*, 1964
16mm, b&w, silent; 4.5 min. @ 16 fps, 4 min. @ 18 fps
COMPILATIONS   *The Thirteen Most Beautiful Women* (ST365)
FILM MATERIALS
ST143.1 *Jane Holzer*
1964 Kodak 16mm b&w reversal original, 109'
NOTATIONS   On original box in AW's hand: *Mouth open no good*
On box in Gerard Malanga's hand: *Jane Holzer for 13*

**ST144**   *Jane Holzer*, 1964
16mm, b&w, silent; 4 min. @ 16 fps, 3.6 min. @ 18 fps
COMPILATIONS   *The Thirteen Most Beautiful Women* (ST365); *Screen
Tests/A Diary* (Appendix A)
FILM MATERIALS
ST144.1 *Jane Holzer*
1964 Kodak 16mm b&w reversal original, 96'
Some footage missing at beginning of film;
dirt and scratches throughout
NOTATIONS   On tape on can lid in Gerard Malanga's hand: *Jane Holzer*
On typed label found in can: *JANE HOLZER*

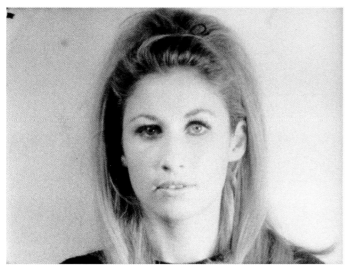

ST139

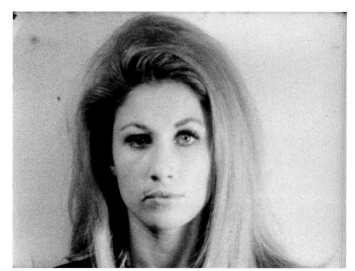

ST140

ST141

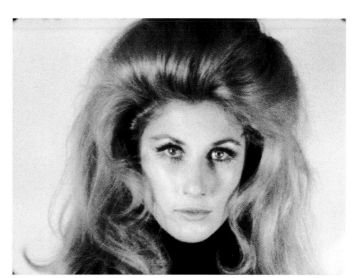

ST142

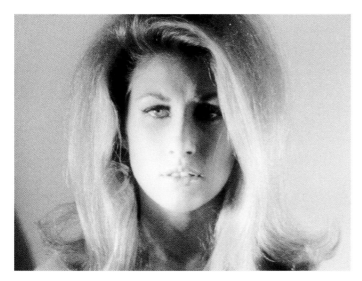

ST143

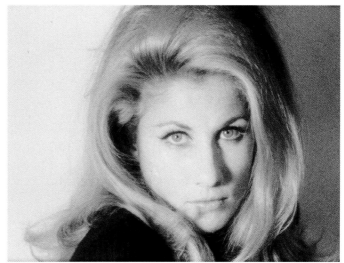

ST144

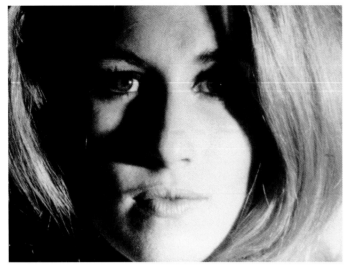

ST145

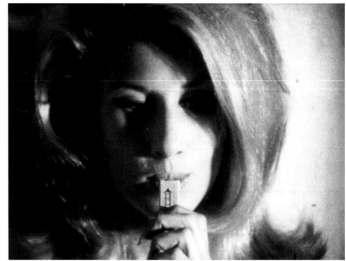

ST146

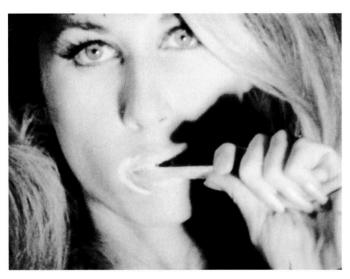

ST147

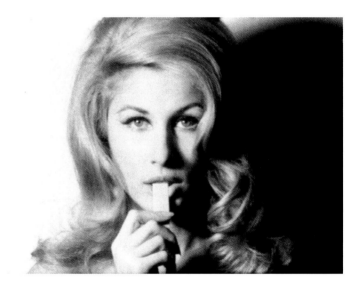

ST148

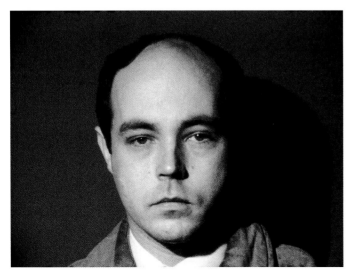

ST149

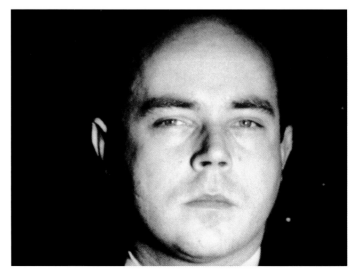

ST150

**ST145  *Jane Holzer,* 1964**

16mm, b&w, silent; 4.2 min. @ 16 fps, 3.8 min. @ 18 fps
Preserved 1999, MoMA *Screen Tests* Reel 21, no. 4
COMPILATIONS  *The Thirteen Most Beautiful Women* (ST365)
FILM MATERIALS
ST145.1 *Jane Holzer*
1964 Kodak 16mm b&w reversal original, 102', 103' with white
tail leader
NOTATIONS  On box in AW's hand: *Taylor Mondo cane 8*
On tape on can lid in red in unidentified hand: *BABY JANE TEST*

**ST146  *Jane Holzer,* 1964**

16mm, b&w, silent; 4.5 min. @ 16 fps, 4 min. @ 18 fps
Preserved 1995, MoMA *Screen Tests* Reel 5, no. 8
FILM MATERIALS
ST146.1 *Jane Holzer*
1964 Kodak 16mm b&w double-perf. reversal original, 107'
NOTATIONS  On box in AW's hand: *Ivy*

**ST147  *Jane Holzer (Toothbrush),* 1964**

16mm, b&w, silent; 4.4 min. @ 16 fps, 3.9 min. @ 18 fps
Preserved 1999, MoMA *Screen Tests* Reel 23, no. 6
COMPILATIONS  *EPI Background* (ST370)
FILM MATERIALS
ST147.1 *Jane Holzer (Toothbrush)*
1964 Kodak 16mm b&w reversal original, 106'
ST147.1.p1 *EPI Background* (ST370), roll 5
Undated Dupont 16mm b&w reversal print, 106'
NOTATIONS  On original box in AW's hand: *Jane lips straight on*
On box in unidentified hand: *JANE HOLZER WITH TOOTH-
BRUSH. A*
On yellow head leader in red: *16*
On yellow head leader in black: *–5–*

**ST148  *Jane Holzer,* 1965**

16mm, b&w, silent; 4.5 min. @ 16 fps, 4 min. @ 18 fps
Preserved 1999, MoMA *Screen Tests* Reel 20, no. 2
COMPILATIONS  *Screen Test Poems* (ST372)
FILM MATERIALS
ST148.1 *Jane Holzer*
1965 Kodak 16mm b&w double-perf. reversal original, 109'
ST148.1.p1 *Screen Test Poems,* Reel 2 (ST372.2), roll 30
Undated Gevaert 16mm b&w reversal print, 109'
NOTATIONS  On original box in Gerard Malanga's hand: *Baby Jane.
NEW SCREEN TEST. 1 double frame neg. marked by masking tape
and 1 8" x 10" double frame print. PRINT EXACTLY AS MARKED*
On clear film at both head and tail of roll in black: *20*

"Baby Jane" Holzer, as she was usually called in the 1960s, was a
successful model and trendsetter, married to the real-estate devel-
oper Leonard Holzer. After she was photographed by David Bailey
in London in the summer of 1963, Holzer became one of the
better-known social celebrities in New York, thanks largely to the
unpretentious enthusiasm with which she moved through the
worlds of modeling and fashion, underground movies, art, and high
society. Holzer's appearance in the October 1, 1964, issue of *Vogue*
was credited with creating the new fashion for big manes of long
hair.[135] Her pop fame reached its zenith in December 1964 with
the publication in *New York* magazine of Tom Wolfe's ironic essay
about her, "The Girl of the Year."[136]

Holzer can be considered the first female superstar in Warhol's
cinema; prior to the arrival of Edie Sedgwick in 1965, Warhol
had shot more footage of Jane Holzer than of any other woman.
Holzer's celebrity was certainly a useful asset in the promotion of
Warhol's movies, especially in films like *Kiss* and *The Thirteen Most
Beautiful Women.* As Billy Name explained, "*The Thirteen Most
Beautiful Girls* received major focus primarily because of Baby Jane
Holzer. And if Baby Jane was in something people would come to
see it, either at the Factory showing or at the Cinematheque."[137]

In addition to her ten *Screen Tests* from 1964–65, Holzer
appeared in *Kiss, Batman Dracula* (in which she played several roles,
including Cat Woman), *Soap Opera, Couch,* and a few other short
films such as *Jane and Darius,* all during 1964. In 1965 she danced
with Paul Swan in *Camp,* and in late 1966 and 1967 she made brief
comeback appearances as a Warhol star in *Bufferin Commercial* and
in *Sally Kirkland,* Reel 39 of ★★★★ *(Four Stars).*

The ten *Screen Tests* of Jane Holzer found in the collection give
some suggestion of her importance to Warhol's film production at
this time; they also reveal that Warhol and Holzer went to a consid-
erable amount of trouble with her portrait films, trying out differ-
ent lighting, different makeup and hairstyles, and different activities
for her to engage in on screen. In the first two films (ST139 and
ST140), both of which Warhol labeled "Bad," Holzer has been
poorly lit with her left eye in shadow. In one roll, her hair has been
tied back from her face with a string, while in the other her hair
has been combed forward. In another attempt (ST141), Holzer's hair
has been combed forward over one eye, and is so brightly lit as to
appear nearly white; the right side of her face, as Warhol noted on
the box, is deeply shadowed. The image is slightly out of focus
and grainy.

The next film (ST142), which was included in several versions of
*The Thirteen Most Beautiful Women,* shows Holzer with enormous fake
eyelashes and a great leonine mass of hair nearly filling the film frame
around her face. She stares into the camera without blinking for most
of the roll, her eyes burning. Another roll shot for *The Thirteen Most
Beautiful* (ST143) was dismissed by Warhol as "mouth open no good."

The next two films seem also to have been included in *The
Thirteen Most Beautiful Women,* perhaps at different times. ST144
was found to be in rather poor condition, dirty and scratched, with
some footage missing from the beginning of the roll, which sug-
gests that it was projected frequently. In this film Holzer maintains
a stationary, catlike pose, looking back at the camera over her
shoulder, her hair curled around her face. The next roll (ST145),
which begins with the kind of white leader often added at the lab
when prints are made, is by far the most intimate portrait of Holzer.
Shot in extreme close-up, Holzer seems relaxed and seductive,
licking her teeth, tilting her head, furrowing her brow, smiling
slightly, and at one point pulling back her hair to reveal a long and
dazzling diamond earring hanging from her right ear.

The next two films received mention in a *Newsweek* article about
a "movie-watching party" at Holzer's apartment in November 1964:

> Jane's real-estate-broker husband watched impassively,
> like a character in a Mailer story, while on the screen
> Baby Jane's face in gigantic close-up chewed gum and
> brushed her teeth. A hypnotic pop tension built up, bro-
> ken by Hollywood producer Sam Spiegel's wife shouting,
> "We're all turned on to you, baby."[138]

In ST146 Holzer, using only her teeth, pulls a stick of Double-
mint from the package, unwraps the foil and takes several bites. She
stretches the gum over her tongue, as if about to blow a bubble, and
rubs her teeth with it, smiling naughtily. The film focuses largely

on her mouth; her eyes and most of her face are in shadow. At one point the camera zooms slowly out, to show Jane seated against a white wall in the company of her shadow, and then zooms in again. In ST147 Holzer brushes her teeth assiduously for three full minutes, creating quite a bit of froth, the camera again focused in extreme close-up on her mouth. Toward the end of the roll she leans out of the frame to spit.

The last *Screen Test* (ST148), probably shot in early 1965, seems to be a remake of ST146. Here Holzer stares fixedly at the camera, slowly extracting and then biting off and chewing first one and then another stick of gum. Her hair is styled differently, with long ringlets. At one point she bats her eyelashes flirtatiously at the camera.

Following her Factory years, Holzer studied acting, appeared in a few television programs and movies, most notably with Edie Sedgwick in John Palmer and David Weisman's film *Ciao! Manhattan* (1967–72), and was tested for a role in the Hollywood film *The Valley of the Dolls*. Warhol painted a silk-screened portrait of Jane Holzer in 1975. In 1985 she and Weisman coproduced the highly successful commercial film *Kiss of the Spider Woman*. She lives in New York City and in Palm Beach, Florida, where she owns real estate.

## ST149   *Ed Hood,* 1965
16mm, b&w, silent; 4.2 min. @ 16 fps, 3.7 min. @ 18 fps
Preserved 1999, MoMA *Screen Tests* Reel 23, no. 4
FILM MATERIALS
ST149.1 *Ed Hood*
1965 Kodak 16mm b&w reversal original, 102'
NOTATIONS   On plain white box in AW's hand: *ed muscle supper*
On box in unidentified hand: *TRI-X reversal 7-9-66*

## ST150   *Ed Hood,* 1966
16mm, b&w, silent; 4.7 min. @ 16 fps, 4.2 min. @ 18 fps
Preserved 2001, MoMA *Screen Tests* Reel 25, no. 4
COMPILATIONS   *Screen Tests/A Diary* (Appendix A)
FILM MATERIALS
ST150.1 *Ed Hood*
1966 Kodak 16mm b&w reversal original, 113'
NOTATIONS   On original box in unidentified hand: *ED HOOD SCREEN TEST*
On typed label found in can: *ED HOOD*

## ST151   *Ed Hood,* 1966
16mm, b&w, silent; 4.5 min. @ 16 fps, 4 min. @ 18 fps
Preserved 1999, MoMA *Screen Tests* Reel 19, no. 3
FILM MATERIALS
ST151.1 *Ed Hood*
1966 Kodak 16mm b&w reversal original, 108'
NOTATIONS   On original box in AW's hand, with drawing of face, crossed out: *Ed Hood. fingers*
On box in unidentified hand in red: *ED HOOD*
On box in unidentified hand: *Warhol*

## ST152   *Ed Hood,* 1966
16mm, b&w, silent; 3.7 min. @ 16 fps, 3.3 min. @ 18 fps
FILM MATERIALS
ST152.1 *Ed Hood*
1966 Kodak 16mm b&w reversal original, 88'
NOTATIONS   No box
On tape on can lid in unidentified hand: *S.T. of Ed*

Ed Hood, literary scholar, longtime Harvard student, resident of Cambridge, Massachusetts, and friend of Edie Sedgwick's, is best known for his role as the bitchy but erudite Fire Islander who rents Paul America from Dial-a-Hustler in Warhol's 1965 film *My Hustler*. Hood also appeared with his boyfriend, Patrick Fleming, in three reels shot for *The John* section of *The Chelsea Girls* (1966). In 1966 Hood also starred in the unreleased silent *Superboy*; in 1967 he had a role in Warhol's commercial feature *Bike Boy*, and also appeared with Fleming in *Ed Hood*, a thirty-three-minute reel in which he pretends to be a mental patient undergoing examination in a Boston doctor's office, which was included as Reel 47 in ★★★★ *(Four Stars)*.

In most of his Warhol film performances, Hood was rightly celebrated for his considerable verbal wit; he seems much less comfortable in some of his silent *Screen Tests*. In the first of these films (ST149), made in 1965, Hood somberly faces the camera head-on, centrally framed against a wall. The contrast is poor; his eyes become more moist as the film progresses. In a later roll (ST150), a bleary-eyed Hood has been blazingly lit from the right; he spends most of the roll looking off to the left, obviously trying to avoid the bright lights. His gaze seems distracted by people offscreen; when he turns toward the light, he closes his eyes or squints, clearly pained by the glare.

The last two films are perhaps more performance films than *Screen Tests*. At the start of ST151, which Warhol labeled "Ed Hood. fingers," Hood is posed with the tip of his index finger pressed between his lips. He then begins an elaborate oral performance: rubbing his lips, sucking his fingertip, then inserting his thumb in his mouth and sucking it like a baby while tilting his head back and closing his eyes. He ends the film by rubbing the inside of his mouth with his middle finger and performing fellatio on his own thumb. The last film (ST152) seems to have been shot in July 1966, at the same time as *Superboy*, and may have been intended to be part of that film. A shirtless Ed Hood, gazing offscreen to the right, drinks Coke out of a can and massages his neck. There is a fade-out followed by fade-in at 69'; the film is slightly underexposed. A few frames from this film of Ed Hood were also included in a silent montage by Dan Williams that was added to the "long" version of *My Hustler* released in 1967.

## ST153   *Dennis Hopper,* 1964
16mm, b&w, silent; 4.5 min. @ 16 fps, 4 min. @ 18 fps
Preserved 1995, MoMA *Screen Tests* Reel 5, no. 1
COMPILATIONS   *The Thirteen Most Beautiful Boys* (ST364)
FILM MATERIALS
ST153.1 *Dennis Hopper*
1964 Kodak 16mm b&w reversal original, 107'
NOTATIONS   On original box in AW's hand: *Denis Hopper (13)*
On tape on can in unidentified hand: *Denis Hopper*

## ST154   *Dennis Hopper,* 1964
16mm, b&w, silent; 4.4 min. @ 16 fps, 3.9 min. @ 18 fps
Preserved 1995, MoMA *Screen Tests* Reel 4, no. 8
COMPILATIONS   *The Thirteen Most Beautiful Boys* (ST364)
FILM MATERIALS
ST154.1 *Dennis Hopper*
1964 Kodak 16mm b&w reversal original, 105'
NOTATIONS   On original box in AW's hand: *Dennis Hopper #13*

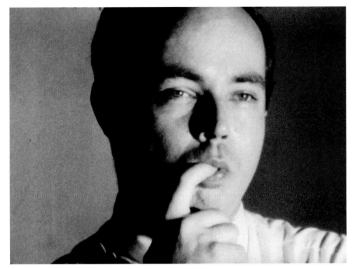

ST151

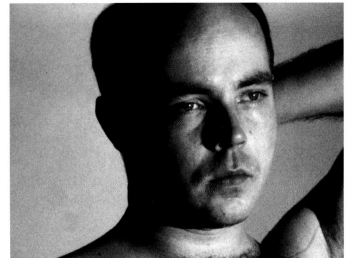

ST152

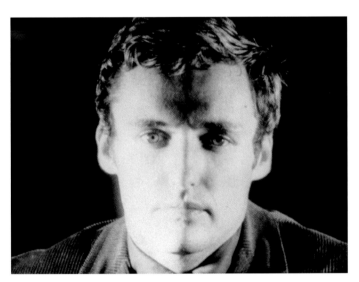

ST153

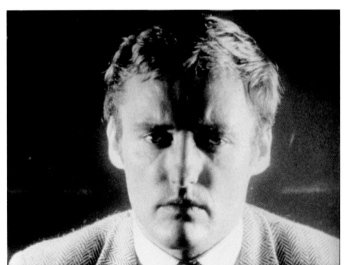

ST154

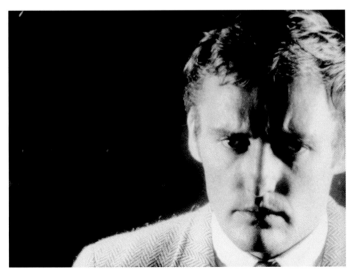

ST155

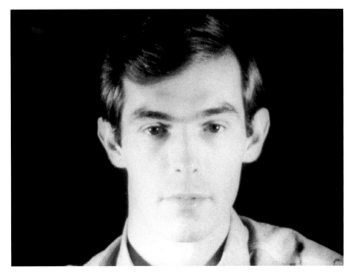

ST156

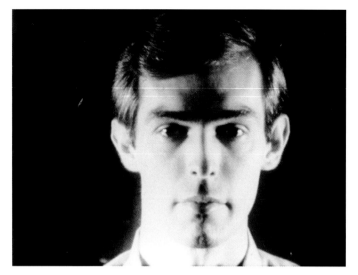

ST157

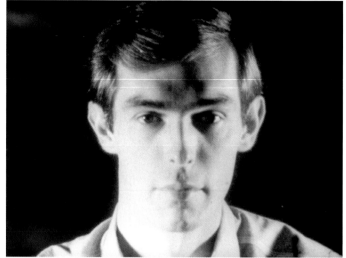

ST158

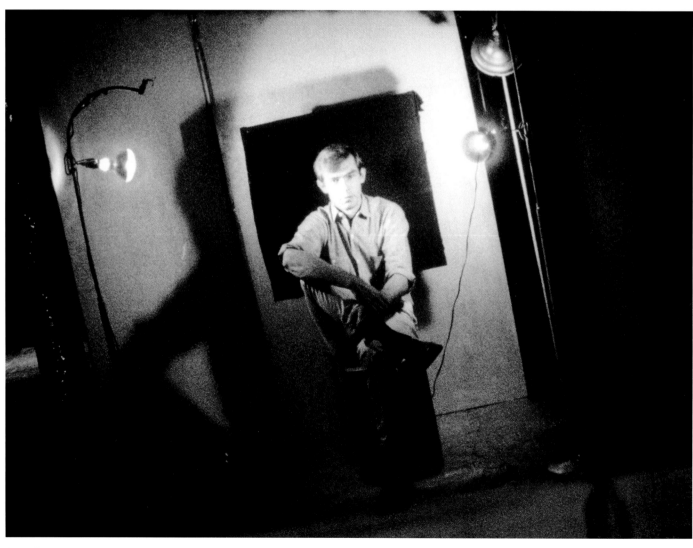

ST159

**ST155 *Dennis Hopper*, 1964**
16mm, b&w, silent; 4.3 min. @ 16 fps, 3.9 min. @ 18 fps
Preserved 1995, MoMA *Screen Tests* Reel 4, no. 5
**FILM MATERIALS**
ST155.1 *Dennis Hopper*
1964 Kodak 16mm b&w reversal original, 104'
**NOTATIONS** On original box in AW's hand: *Dennis Hopper*

The actor, photographer, and filmmaker Dennis Hopper was an early fan and collector of Warhol's art; Hopper purchased one of Warhol's *Campbell Soup Can* paintings from the artist's first solo exhibition at the Ferus Gallery in Los Angeles in 1962.[139] In 1963 curator Henry Geldzahler took Hopper to Warhol's New York studio, where he bought Warhol's *Double Mona Lisa* painting.[140] In the fall of 1963, Hopper and his wife welcomed Warhol to Los Angeles with a party when he arrived for the opening of his exhibition of *Elvis* paintings at the Ferus Gallery; Hopper had a small role in Warhol's Los Angeles film, *Tarzan and Jane, Regained, Sort Of . . .*, playing a Tarzan stand-in for Taylor Mead. The Hoppers visited the Factory in 1964, when Hopper appeared again with Mead in a roll shot for *Couch*, sitting on the Factory couch in front of two *Flowers* paintings; his *Screen Tests* were probably shot during the same visit. Hopper photographed Warhol frequently during the early 1960s. In 1970, the year that Hopper directed *The Last Movie*, Warhol painted several silk-screened portraits of him in a cowboy hat.

Hopper recalled his performance in these *Screen Tests*:

> I was in another film that Andy did called *The 13 Most Beautiful Boys in the World* . . . Andy just told me the title and turned on the camera and walked away . . . [B]eing the egomaniac that I am, I sat there and did a Strasbergian emotional memory.[141]

Hopper's professional training as an actor is indeed legible in his *Screen Tests*. In his first film portrait (ST153), Hopper's face is unevenly lit, brightest on the left side. He frowns, looks down, looks around to both left and right, and then sings to himself, shaking his head as if listening to music. He then looks worried and furrows his brow again, as if dwelling on a disturbing memory. At the end of the roll he closes his eyes. The next two films, which were shot at the same time, show Hopper wearing a tweed jacket, his face symmetrically lit from both sides. In the first of these two portraits (ST154) Hopper adheres to the basic *Screen Test* rules, but even though he holds still and mostly looks straight at the camera, he nevertheless manages to convey a highly emotional narrative. After squinting with great concentration into the lens for a period, he nods his head solemnly as if arriving at some sobering truth, then sighs and looks down, his eyes wandering. The last film (ST155) is a real performance: Hopper stares downward in despair, closes his eyes, then frowns grimly at the camera, puckering his brow and swallowing as if overcome with emotion. Toward the end of the roll, he smiles ironically, nods, shakes his head as if bitterly amused, and sighs in resignation.

**ST156 *Peter Hujar*, 1964**
16mm, b&w, silent; 4.4 min. @ 16 fps, 3.9 min. @ 18 fps
Preserved 1995, MoMA *Screen Tests* Reel 1, no. 4
**FILM MATERIALS**
ST156.1 *Peter Hujar*
1964 Kodak 16mm b&w reversal original, 105'
**NOTATIONS** On original box in AW's hand: *peter Hagar. Peter Hagar*

**ST157 *Peter Hujar*, 1964**
16mm, b&w, silent; 4.4 min. @ 16 fps, 3.9 min. @ 18 fps
Preserved 1995, MoMA *Screen Tests* Reel 9, no. 2
**COMPILATIONS** *The Thirteen Most Beautiful Boys* (ST364)
**FILM MATERIALS**
ST157.1 *Peter Hujar*
1964 Kodak 16mm b&w reversal original, 105'
**NOTATIONS** On original box in AW's hand: *Peter Hagar 13. Peter*

**ST158 *Peter Hujar*, 1964**
16mm, b&w, silent; 4.4 min. @ 16 fps, 3.9 min. @ 18 fps
Preserved 1995, MoMA *Screen Tests* Reel 5, no. 2
**FILM MATERIALS**
ST158.1 *Peter Hujar*
1964 Kodak 16mm b&w reversal original, 106'
**NOTATIONS** On original box in AW's hand: *Peter Aujar. Boy that never Blinked*

**ST159 *Peter Hujar*, 1964**
16mm, b&w, silent; 4.5 min. @ 16 fps, 4 min. @ 18 fps
Preserved 2001, MoMA *Screen Tests* Reel 25, no. 3
**FILM MATERIALS**
ST159.1 *Peter Hujar*
1964 Kodak 16mm b&w reversal original, 109'
**NOTATIONS** On original box in AW's hand: *Peter Hugar. Field*

In 1964, when Warhol made these four portrait films, photographer Peter Hujar was working as studio assistant to the commercial photographer Harold Krieger. Hujar was friends with the artist Paul Thek and with Susan Sontag, whose *Screen Tests* were probably shot around the same time. Hujar's first book of photographs, *Portraits in Life and Death*, with an introduction by Sontag, was published in 1976; by the beginning of the 1980s, his work was regularly exhibited in galleries and museums in America and Europe. In 1981 he began an intimate relationship with the artist David Wojnarowicz. Hujar died of AIDS in 1987; the first retrospective of his work was presented in 1994 at the Stedelijk Museum in Amsterdam.[142]

Hujar's photography bears an interesting and as yet unexamined relationship to the Warhol films, with which it has much in common in terms of both subject matter (drag queens, homosexuals, artists, writers, and other outsiders) and style. Urs Stahel's description of the "classic" style of Hujar's portraiture might apply equally well to the Warhol *Screen Tests*: "the square format, self-contained and even severe at times; the concentration on one thing, one being . . . ; the simplicity, the clarity, the austerity of composition; the subject often photographed in a bare studio, a chair their only prop."[143] Hujar's 1974 photograph of Warhol's transvestite superstar, "Candy Darling on Her Deathbed," is considered one of his masterpieces; Hujar also took photographs of Warhol and other friends who appear in the *Screen Tests*, including Sontag, Thek, and Edwin Denby.

Of these four *Screen Tests*, shot in one sitting, three are close-ups in which Hujar does his best to resemble a still photograph, holding so still that Warhol labeled one roll "Boy that never Blinked." In one film (ST156), Hujar's face is brightly lit from the front, with almost no shadows at all, and he does not blink even once, although his eyelids do flutter occasionally. In the next two rolls (ST157 and ST158) the lights have been moved to either side, which creates

the usual symmetrical pattern of shadows running down the center of Hujar's face. The last roll (ST159) is a tilted long shot, which Warhol labeled "Field," showing Hujar sitting sideways on a chair in front of a black cloth backdrop that has been pinned to the wall—the solid black background that appears in the three close-ups. This long shot is especially interesting because it shows the lighting setup for Hujar's three other *Screen Tests*. On the left, a light mounted on a stand points directly at Hujar's face; on the right, another light has been angled at the wall behind him, creating more diffused lighting on that side of his face.

## ST160 *Imu,* 1964
16mm, b&w, silent; 4.4 min. @ 16 fps, 3.9 min. @ 18 fps
Preserved 1995, MoMA *Screen Tests* Reel 1, no. 3
**COMPILATIONS** *The Thirteen Most Beautiful Women* (ST365)
**FILM MATERIALS**
ST160.1 *Imu*
1964 Kodak 16mm b&w reversal original, 105'
**NOTATIONS** On original box in AW's hand: *(13)* *IMU*

## ST161 *Imu,* 1964
16mm, b&w, silent; 4.4 min. @ 16 fps, 3.9 min. @ 18 fps
Preserved 1995, MoMA *Screen Tests* Reel 7, no. 5
**COMPILATIONS** *The Thirteen Most Beautiful Women* (ST365)
**FILM MATERIALS**
ST161.1 *Imu*
1964 Kodak 16mm b&w reversal original, 105'
**NOTATIONS** On original box in AW's hand: *Imu (13)*
On box in AW's hand in red: *not right*
On box in unidentified hand: *Imu with mouth expressions*

The model Imu appears in two *Screen Tests* from 1964. In the first film (ST160), she faces the camera straight on, her face framed in a helmetlike pageboy haircut. The bright light causes her to blink nearly continuously; there is a hair in the lower right-hand corner of the frame. In the second film (ST161), Imu has shifted her pose, now facing left and looking back over her shoulder at the camera. Here she seems less bothered by the lights and more at ease, talking, smiling, widening her eyes, and making various "mouth expressions," as someone wrote on the film box. Warhol apparently didn't like this film, noting "not right" on the box in red ink. In March 1965, Imu was photographed for a fashion spread in *Life* magazine, wearing "provocatively cut-out pajamas" and standing within the projected image of her own *Screen Test* (ST160).[144]

In addition to these two rolls, Warhol also filmed another portrait of Imu with her young son in 1964, *Imu and Son.*

## ST162 *Cathy James,* 1965
16mm, b&w, silent; 4.5 min. @ 16 fps, 4 min. @ 18 fps
Preserved 2001, MoMA *Screen Tests* Reel 27, no. 4
**FILM MATERIALS**
ST162.1 *Cathy James*
1965 Kodak 16mm b&w double-perf. reversal original, 109'
**NOTATIONS** On original box in AW's hand: *Cathy*
On box in Paul Morrissey's hand: *Cathy Cath*

## ST163 *Cathy James,* 1965
16mm, b&w, silent; 4.5 min. @ 16 fps, 4 min. @ 18 fps
Preserved 1995, MoMA *Screen Tests* Reel 2, no. 8
**FILM MATERIALS**
ST163.1 *Cathy James*
1965 Kodak 16mm b&w double-perf. reversal original, 107'
**NOTATIONS** On original box in unidentified hand: *CATHY*

## ST164 *Cathy James,* 1965
16mm, b&w, color; 4.5 min. @ 16 fps, 4 min. @ 18 fps
**FILM MATERIALS**
ST164.1 *Cathy James*
1965 Kodak 16mm Ektachrome double-perf. reversal original, 107'
**NOTATIONS** On original box in AW's hand: *CATHY I*
On typed Ektachrome label on box: *Date: 11/17/65. From: Video Film Labs. 100' of 7255. Return via Fleet Messenger to Video Film*

In 1969 Cathy James, also known as Catherine James, was identified by *Rolling Stone* magazine as "the 'top groupie' in Los Angeles." The daughter of folk singer Travis Edmonson, from the folk group Bud and Travis, James reportedly left home at the age of fourteen and spent much of her teens moving around between California, the East Coast, and England, often living with various rock musicians.[145] At one point, she had a job as a disc jockey at the New York discotheque Ondine; this may have been in the fall of 1965, when she visited the Factory and posed for these *Screen Tests*.

The two black-and-white *Screen Tests* of Cathy James follow a familiar pattern: in one film (ST162), she tries to hold still and look at the camera, while in the next roll (ST163) she is much more relaxed, laughing and smiling at people off-camera and bouncing slightly, as if keeping time to music. Both films have high-contrast, "half-moon" lighting, with the left side of her face completely in shadow; her eyes are barely visible under the shadow of her bangs. The third film (ST164), dated November 17, 1965, on the box, is in color, and shows James posed in front of a purple backdrop. The lighting seems not quite as severe in this film, although it may have been shot at the same time as the two black-and-white portraits.

## ST165 *Barbara Jannsen,* 1966
16mm, b&w, silent; 4.5 min. @ 16 fps, 4 min. @ 18 fps
Preserved 1999, MoMA *Screen Tests* Reel 21, no. 6
**COMPILATIONS** *Screen Tests/A Diary* (Appendix A)
**FILM MATERIALS**
ST165.1 *Barbara Jannsen*
1966 Kodak 16mm b&w reversal original, 108'
**NOTATIONS** On original box in Gerard Malanga's hand: *Barbara Jensen. should be shot at 8.*

This *Screen Test* of Barbara Jannsen shows her posed against what looks like a paper backdrop; she speaks to the camera, smiling, and then becomes more serious, her eyes scarcely visible beneath her heavy eye makeup. At 70', the film suddenly becomes very underexposed, as if the aperture had been stopped down by mistake. For the rest of the roll, Jannsen's face looms dimly out of the darkness like an apparition, her eyes and lips glistening eerily. Malanga's note on the box indicates the intention to reshoot Jannsen's portrait at a different exposure, something that was apparently never done.

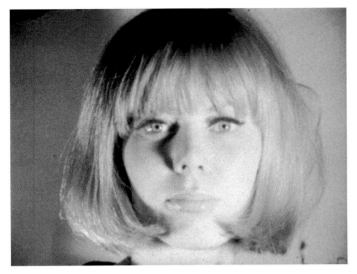

ST160

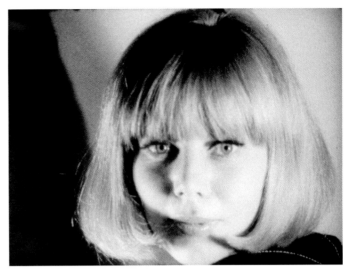

ST161

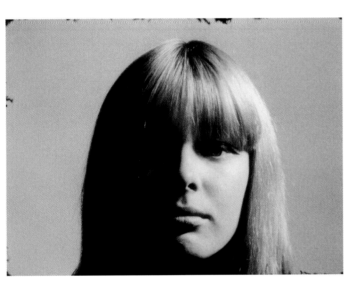

ST162

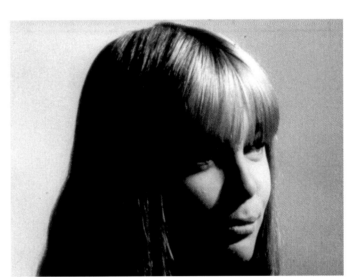

ST163

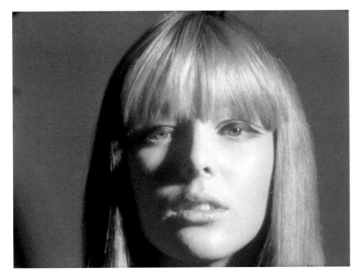

ST164 **See Appendix D for color reproduction.**

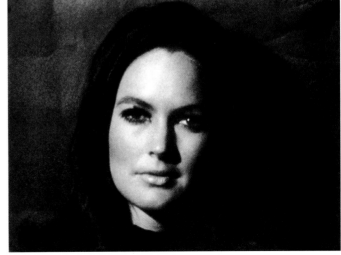

ST165

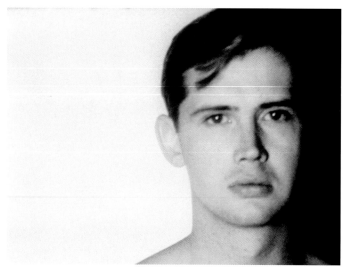

ST166

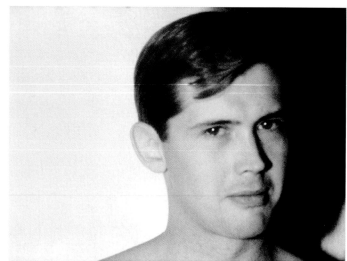

ST167

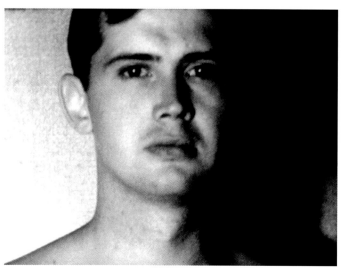

ST168

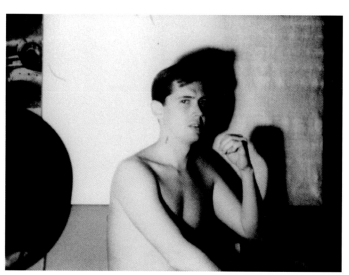

ST168

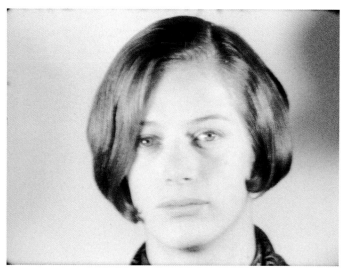

ST169

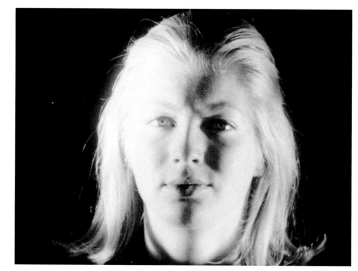

ST170

**ST166   *Cliff Jarr,* 1964**

16mm, b&w, silent; 4.3 min. @ 16 fps, 3.9 min. @ 18 fps
Preserved 1998, MoMA *Screen Tests* Reel 14, no. 3
**FILM MATERIALS**
ST166.1 *Cliff Jarr*
1963 Kodak 16mm b&w double-perf. reversal original, 104'
**NOTATIONS** On box in AW's hand: *Cliff Jarr. CLIFF JARR*
On box in AW's hand, crossed out: *Nomi Rufus*

**ST167   *Cliff Jarr,* 1964**

16mm, b&w, silent; 4.6 min. @ 16 fps, 4.1 min. @ 18 fps
**FILM MATERIALS**
ST167.1 *Cliff Jarr*
1963 Kodak 16mm double-perf. b&w reversal original, 110'
**NOTATIONS** On original box in AW's hand: *Cliff Jarr*
Stamped on box: *LAB. TV*

**ST168   *Cliff Jarr,* 1964**

16mm, b&w, silent; 4.5 min. @ 16 fps, 4 min. @ 18 fps
Preserved 1998, MoMA *Screen Tests* Reel 15, no. 5
**FILM MATERIALS**
ST168.1 *Cliff Jarr*
1963 Kodak 16mm b&w double-perf. reversal original, 109'
**NOTATIONS** On original box in AW's hand: *Cliff. CLIF JAR*
Stamped on box: *LAB TV, The Lab for Reversal Films, 923 7th Avenue*

These three *Screen Tests* of a shirtless young man identified only as Cliff Jarr appear to be very early portrait films, containing some surprisingly experimental variations in technique. The hand-held camera and in-camera editing indicate that these films may have been made when Warhol was still refining his *Screen Test* style. Jarr's nudity and his petulant manner also suggest a level of intimacy rarely apparent in these portraits.

In one roll (ST166), Jarr appears in close-up, asymmetrically posed against a white movie screen, his head abutting the right side of the film frame. He stares straight ahead and holds very still, blinking only two or three times during the course of the film roll. In the next film (ST167), Jarr maintains the same pose, but now looks increasingly uncomfortable; at one point, he appears visibly upset and lowers his head belligerently.

The last film (ST168) begins with a shaky, apparently hand-held, close-up of Jarr in the same pose. There is an in-camera cut to a medium shot of Jarr, bare from the waist up, seated against the movie screen; the light source, a movie light on a stand, is visible on the left. Jarr holds a pose with one hand raised, then gets up and walks toward the camera and out of view. He returns to the screen, then walks over and leans his face directly into the shaded light, which has the effect of overexposing his features and darkening the rest of the image. He then returns to the screen, sits down, and drinks from a coffee cup, his head occupying only the extreme lower left corner of the film image.

**ST169   *Julie Judd,* 1964**

16mm, b&w, silent; 4.5 min. @ 16 fps, 4 min. @ 18 fps
**COMPILATIONS** *The Thirteen Most Beautiful Women* (ST365)
**FILM MATERIALS**
ST169.1 *Julie Judd*
1964 Kodak 16mm b&w reversal original, 107'
**NOTATIONS** On original box in AW's hand: *JULIE JUDD 13*

Julie Finch was married to the artist Donald Judd in 1964 when this *Screen Test* was shot. After studying dance with Merce Cunningham in the 1960s, Finch danced with Beth Jucovy and her troupe, performing the works of Isadora Duncan as well as her own choreography. She is an actress and the mother of two children, the filmmaker Flavin Judd and the actress Rainer Judd.[146]

In her *Screen Test*, which was shot in slightly soft focus throughout, Judd appears very young and a little apprehensive. She almost smiles at the end of the roll.

**ST170   *Karen,* 1964**

16mm, b&w, silent; 4.5 min. @ 16 fps, 4 min. @ 18 fps
Preserved 2001, MoMA *Screen Tests* Reel 28, no. 5
**FILM MATERIALS**
ST170.1 *Karen*
1964 Kodak 16mm b&w reversal original, 109'
**NOTATIONS** On original box in AW's hand: *Karen*

This young woman, identified only as "Karen," has been lit for her *Screen Test* in much the same manner as Peter Hujar, with a bright light shining directly onto her face from the left, and more diffuse lighting on the right. A broad band of dark shadowing runs down the center of her face and her right cheek; her right eye is filled with light, while her left eye is deeply shadowed.

**ST171   *Ivan Karp,* 1964**

16mm, b&w, silent; 4.5 min. @ 16 fps, 4 min. @ 18 fps
Preserved 1998, MoMA *Screen Tests* Reel 14, no. 7
**COMPILATIONS** *Fifty Fantastics and Fifty Personalities* (ST366)
**FILM MATERIALS**
ST171.1 *Ivan Karp*
1964 Kodak 16mm b&w reversal original, 108'
**NOTATIONS** On original box in AW's hand: *Ivan*
On box in unidentified hand: *IVAN KARP. PERSONALITIES*

**ST172   *Ivan Karp,* 1964**

16mm, b&w, silent; 4.5 min. @ 16 fps, 4 min. @ 18 fps
Preserved 1998, MoMA *Screen Tests* Reel 15, no. 1
**FILM MATERIALS**
ST172.1 *Ivan Karp*
1964 Kodak 16mm b&w reversal original, 108'
**NOTATIONS** On box in unidentified hand: *America sand* (illeg.). *2*

According to most accounts, Andy Warhol met the art dealer Ivan Karp in the spring of 1961, when Warhol visited the Leo Castelli Gallery where Karp was sales director, and purchased a Jasper Johns *Light Bulb* drawing.[147] Although Castelli was not enthusiastic about representing Warhol at the time, Karp became an avid champion and unofficial dealer of Warhol's art, frequently bringing clients, curators, and other dealers to see his work, and introducing him to a number of people, including Henry Geldzahler, who would play key roles in his career as an artist. Warhol's first major gallery in New York was Eleanor Ward's Stable Gallery, where he was given important one-artist exhibitions in 1962 and 1964. After Warhol's successful *Brillo Soap Pads Boxes* exhibition at Stable in April 1964, he

was invited to join Castelli's gallery, with which he maintained a lifelong relationship. In 1969 Karp left Castelli to open his own downtown gallery, O.K. Harris, on West Broadway. In 1965 Karp published a novel entitled *Doobie Doo*, with Warhol's silk-screened portrait of the author on the back cover, and a Roy Lichtenstein painting reproduced on the front.[148]

Karp's *Screen Tests* were shot on two different occasions in 1964. In ST171, he wears a seersucker jacket and faces the camera with a calm and business-like expression; toward the end of the roll, his head begins to wobble slightly, perhaps from tension. In the second film (ST172), a slightly plumper Karp is wearing a pair of sunglasses in which the lights and space of the Factory are reflected, and through which his eyes are also visible. At one point, he removes his glasses and rubs his eyes.

### ST173    *Marilynn Karp,* 1964

16mm, b&w, silent; 4.5 min. @ 16 fps, 4 min. @ 18 fps
Preserved 1995, MoMA *Screen Tests* Reel 2, no. 7
COMPILATIONS   *The Thirteen Most Beautiful Women* (ST365)
FILM MATERIALS
ST173.1  *Marilynn Karp*
1964 Kodak 16mm b&w reversal original, 107'
NOTATIONS  On original box in AW's hand: *Marilyn 13 Girls. Marilyn 13 Girls*

Ivan Karp's wife, the sculptor Marilynn Gelfman Karp, was also filmed in 1964 for *The Thirteen Most Beautiful Women*. She holds very still throughout the film, serenely returning the camera's stare and not even trying not to blink. Her pale skin, white shirt, and blond hair framed against a light background create a subtle study in bright tonalities.

### ST174    *Paul Katz,* 1966

16mm, b&w, silent; 4.5 min. @ 16 fps, 4 min. @ 18 fps
Preserved 1995, MoMA *Screen Tests* Reel 5, no. 10
COMPILATIONS   *Screen Tests/A Diary* (Appendix A)
FILM MATERIALS
ST174.1  *Paul Katz*
1966 Kodak 16mm b&w reversal original, 109'
NOTATIONS  On plain white box in AW's hand: *Paul Katz*
On box in unidentified hand: *Print Roll #8*
On tape on can lid in AW's hand: *Paul Katz*
On typed label found in can: *PAUL KATZ*

Paul Katz was a classmate and friend of Gerard Malanga's at Wagner College on Staten Island in the early 1960s and also friends with Lou Reed, John Cale, and Sterling Morrison. Katz, who died in 1998, posed for his *Screen Test* in the fall of 1966. With harsh, half-moon lighting illuminating only the right side of his face, he squints quizzically at the camera, his gaze fixed on a point slightly above the lens. There is occasional loss of registration in the film, which intermittently turns Katz's face into a vertical blur. The loss of registration, which becomes continuous by the end of the roll, dates this film to October 1966, when other *Screen Tests* showing evidence of the same technical problem were shot (see also Antoine (ST8), Richard Rheem (ST272–275), and Ronna Page (ST252)).

### ST175    *Kellie,* 1965

16mm, b&w, silent; 4.5 min. @ 16 fps, 4 min. @ 18 fps
Preserved 1995, MoMA *Screen Tests* Reel 2, no. 10
FILM MATERIALS
ST175.1  *Kellie*
1965 Kodak 16mm b&w reversal original, 109'
NOTATIONS  On original box in AW's hand: *Kellie*
On can lid in AW's hand: *Kellie*

### ST176    *Kellie,* 1965

16mm, b&w, silent; 4.5 min. @ 16 fps, 4 min. @ 18 fps
FILM MATERIALS
ST176.1  *Kellie*
1965 Kodak 16mm b&w reversal original, 107'
NOTATIONS  On box in Gerard Malanga's hand: *Kellie. Kellie*
On box in unidentified hand, crossed out: *BILLY*

This young woman, a model who worked under the name "Kellie," appeared modeling French fashions in the March 1966 issue of *Nova* magazine; she also worked for the English Boy modeling agency in London in the mid-1960s, and appears in an advertisement for this agency recently reprinted in *The Ossie Clark Diaries*.[149] Kellie appears to have been a friend of Donyale Luna's; Nat Finkelstein's contact sheets show their *Screen Tests* being shot by Warhol at the Factory on the same day.

Kellie appears in two *Screen Tests* from 1965. In one film (ST175), she attempts a static, formal pose, staring straight into the camera and occasionally suppressing a smile; her dark hair and elaborate eye makeup stand out dramatically against her white sweater, head scarf, and the white background behind her. By contrast, in the next film (ST176), she is in constant motion, dancing to apparent music and sometimes laughing happily. The focus in this roll is slightly soft.

### ST177    *King,* 1964

16mm, b&w, silent; 4.5 min. @ 16 fps, 4 min. @ 18 fps
Preserved 1999, MoMA *Screen Tests* Reel 23, no. 10
FILM MATERIALS
ST177.1  *King*
1964 Kodak 16mm b&w reversal original, 109'
NOTATIONS  On original box in unidentified hand: *KING*

### ST178    *King,* 1964

16mm, b&w, silent; 4.5 min. @ 16 fps, 4 min. @ 18 fps
FILM MATERIALS
ST178.1  *King*
1964 Kodak 16mm b&w reversal original, 109'
NOTATIONS  On original box in AW's hand: *King*

This young man, identified only as "King", gives a rather remarkable performance in his two *Screen Tests*. In one film (ST177), his face has been evenly lit from the sides to create a dark band of shadows down the center of his face. In the second film (ST178), his face has been lit from the right only, leaving the left in shadow. In both films, the deadpan King works his way through a series of slow-motion grimaces: furrowing his brow, crossing his eyes, raising his eyebrows, blinking at the camera, twisting his mouth to one side, violently twitching his nose, etc. The slow-motion projection exaggerates the elasticity and distortion of his features.

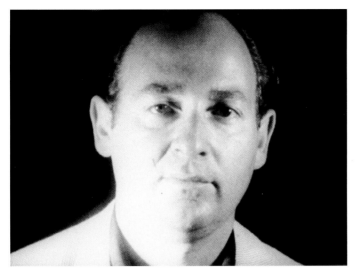

ST171

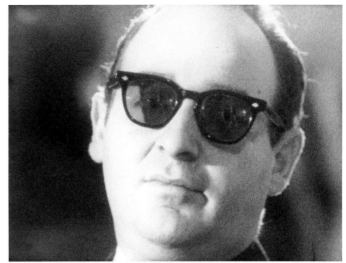

ST172

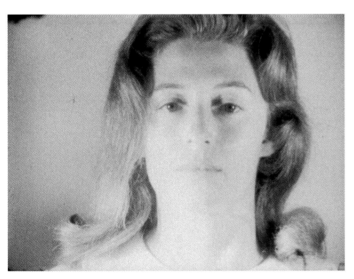

ST173

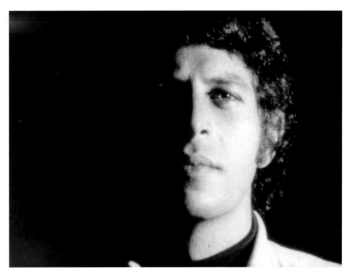

ST174

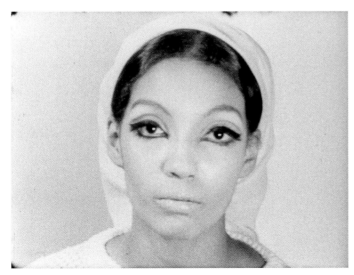

ST175

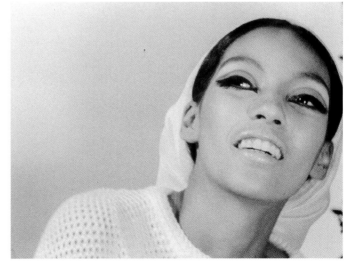

ST176

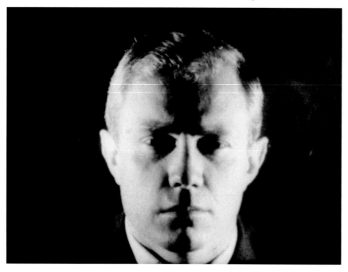

ST177

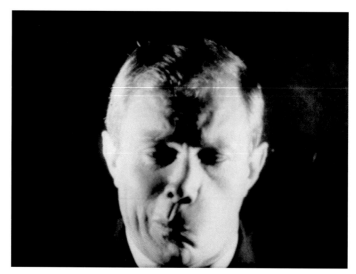

ST177

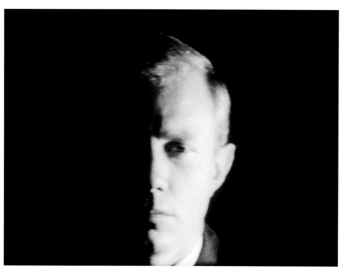

ST178

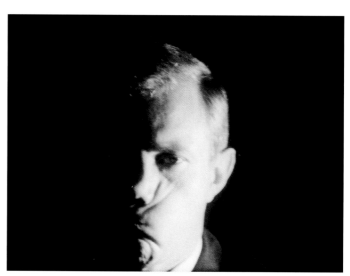

ST178

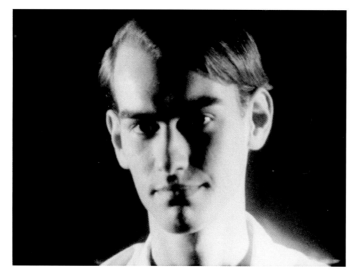

ST179

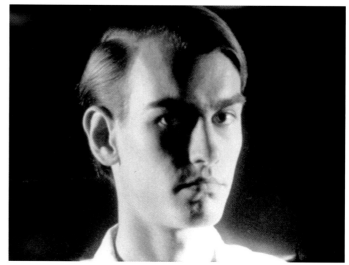

ST180

## ST179  *Kenneth King,* 1964

16mm, b&w, silent; 4.4 min. @ 16 fps, 3.9 min. @ 18 fps
Preserved 1995, MoMA *Screen Tests* Reel 4, no. 4
**COMPILATIONS**  *The Thirteen Most Beautiful Boys* (ST364)
**FILM MATERIALS**
ST179.1  *Kenneth King*
1964 Kodak 16mm b&w reversal original, 105'
**NOTATIONS**  On original box in AW's hand: *Kenneth King (1). B. Boy*

## ST180  *Kenneth King,* 1964

16mm, b&w, silent; 3.9 min. @ 16 fps, 3.5 min. @ 18 fps
Preserved 1995, MoMA *Screen Tests* Reel 6, no. 8
**COMPILATIONS**  *The Thirteen Most Beautiful Boys* (ST364)
**FILM MATERIALS**
ST180.1  *Kenneth King*
1964 Kodak 16mm b&w reversal original, 95'
**NOTATIONS**  On original box in AW's hand: *Beautiful boys. 13. Kenneth King*

The dancer and choreographer Kenneth King was part of what has been identified as "the second generation of Judson dancers," a group, including Meredith Monk and Phoebe Neville, who began presenting work in New York in the mid-1960s in association with the Judson Dance Theater.[150] In 1964, while still studying dance at Antioch College, King gave several performances in New York; his postmodern work *cup/saucer/two dancers/radio* was particularly well-received by the *New York Times*.[151] During that same year, King appeared in several rolls shot for Warhol's film *Couch* as well as in his two *Screen Tests*; he also had a sit-in role in Jonas Mekas's *Award Presentation to Andy Warhol* (1964) and was filmed by Gregory Markopoulos for his 1965 film *The Iliac Passion*. In 1966 King published an essay/manifesto titled "Toward a Trans-Literal and Trans-Technical Dance-Theater," which described "the new theater" as an "arena of transacting techniques assimilated from what we previously called 'play,' 'modern dance,' 'sculpture,' and 'movies'"; the essay contains a short section on the Warhol films.[152] King, who later grew a dramatic red beard, has continued to choreograph and perform his own works, which often include his own written texts, with his troupe Kenneth King and Dancers. His book of essays, dance scripts, and philosophical writings, *Writing in Motion: Body—Language—Technology*, was published in 2003.[153]

The standard *Screen Test* head shot might seem inappropriately cerebral for the portrait of a dancer like Kenneth King, especially in comparison with the impressive contortions he performs in his *Couch* rolls (1964). Nevertheless, these two portrait films communicate a strong sense of physical grace. In the first film (ST179), King begins with a big laugh into the camera, then moves systematically through a series of briefly held poses, as if following instructions: turning to the left and right, looking into the camera then away, turning his face from side to side. He is noticeably well groomed, with long, winglike eyebrows and hair elegantly slicked behind his ears. His second *Screen Test* is an entirely static performance: King, posed, like John Giorno, in three-quarter profile, stares straight into the camera, his white shirt emitting a kind of solarized glow against the black background. This effect, called halation, is caused by light passing through the emulsion layer, bouncing off the film base at an angle, and re-exposing the film, thus forming halos around bright objects.

## ST181  *Sally Kirkland,* 1964

16mm, b&w, silent; 4.5 min. @ 16 fps, 4 min. @ 18 fps
Preserved 2001, MoMA *Screen Tests* Reel 27, no. 3
**COMPILATIONS**  *The Thirteen Most Beautiful Women* (ST365); *Screen Tests/A Diary* (Appendix A)
**FILM MATERIALS**
ST181.1  *Sally Kirkland*
1964 Kodak 16mm b&w reversal original, 107'
**NOTATIONS**  On plain brown box in Paul Morrissey's hand: *Sally Kirkland. 15*
On box in Gerard Malanga's hand, crossed out: *Emma Malanga, 194th St. End Roll*

## ST182  *Sally Kirkland,* 1964

16mm, b&w, silent; 4.5 min. @ 16 fps, 4 min. @ 18 fps
**COMPILATIONS**  *The Thirteen Most Beautiful Women* (ST365); *3 Most Beautiful Women* (ST365d)
**FILM MATERIALS**
ST182.1  *3 Most Beautiful Women* (ST365d.1), roll 3
1964 Kodak 16mm b&w reversal original, 108'

The actress Sally Kirkland made her screen debut in the Warhol films in 1964, appearing in two *Screen Tests* as well as rolls shot for *Batman Dracula* and *Couch*. She also appears in a 1967 sound reel titled *Sally Kirkland*, which was exhibited as Reel 37 in ★★★★ *(Four Stars)*. In the 1960s Kirkland studied acting with Lee Strasberg at the Actors Studio and with Uta Hagen, and performed in New York with the La Mama experimental theater troupe.

In later decades Kirkland became highly successful as an actress, appearing in numerous Broadway and off-Broadway productions, in both mainstream and B movies, and in a large number of television dramas and other programs. She had long-lived parts in several TV series, including *Roseanne* and *Valley of the Dolls*, and has had roles in a number of well-known Hollywood movies, including *The Way We Were* (1973), *Cinderella Liberty* (1973), *The Sting* (1973), *Private Benjamin* (1980), and, more recently, Oliver Stone's *JFK* (1991) and Ron Howard's *Edtv* (1999). In 1987 she was nominated for an Academy Award for Best Actress for her performance in Yurek Bogayevicz's film *Anna*, for which she received a Golden Globe Award. She is a respected acting coach and yoga instructor, and an ordained minister in the Church of the Movement of Spiritual Inner Awareness.

In March 1965, Sally Kirkland's mother, Sally Kirkland Sr., then fashion editor of *Life* magazine, gave Warhol some valuable publicity by featuring some of his films and female stars in a fashion spread called "Underground Clothes."[154] Earlier that year, in January, Kirkland Sr. gave a party at which a version of *The Thirteen Most Beautiful Women* (ST365a) was shown, with *Screen Tests* of fourteen women projected on three walls. One of the fourteen was her daughter Sally, who wasn't very happy with her filmed portrait. "I look like a refugee from the Menninger Clinic," she told the reporter from the *New York Herald Tribune*. "You sit staring at the camera and after a while your face begins to disintegrate."[155]

In one of her two *Screen Tests* (ST181), Kirkland seems to have concealed herself behind her wild mop of hair, her eyes nearly invisible in the shadows. She holds perfectly still for the full three minutes and blinks only once, a spot of moisture glistening in her left eye. As the film progresses, the solemn expression of her mouth becomes more and more emotional; by the end of the film she looks stricken, on the verge of tears.

Her other *Screen Test* (ST182) is by contrast full of movement and exuberance. Kirkland, her face still half hidden under her hair, performs a kind of erotic dance, bumping and grinding as if to music. She smiles, tosses her head, and leers cheerfully at the camera. This camera original roll was found spliced into a mysterious compilation reel (ST365d) containing *Screen Tests* of Ivy Nicholson and Nancy Fish, and two rolls from *Batman Dracula*.

### ST183 *Kyoko Kishida,* 1964

16mm, b&w, silent; 4.5 min. @ 16 fps, 4 min. @ 18 fps
Preserved 1995, MoMA *Screen Tests* Reel 3, no. 7
**COMPILATIONS** *Fifty Fantastics and Fifty Personalities* (ST366)
**FILM MATERIALS**
ST183.1 *Kyoko Kishida*
1964 Kodak 16mm b&w reversal original, 107'
**NOTATIONS** On original box in AW's hand: *Kyoko Kishida (50)*

The Japanese actress Kyoko Kishida was the star of the avant-garde film *Woman in the Dunes*, directed by Hiroshi Teshigahara, which opened in New York on October 25, 1964.[156] It seems likely that her Warhol *Screen Test* was shot around this time, when Kishida may have come to New York for the opening of her film (see also Noboru Nakaya, ST229). Kishida is well known in Japan as a character actress on stage, screen, and television, and has become something of a gay icon. She is known for her distinctive voice, and has often worked as a narrator of TV shows and films, even performing the voice of the main character in a hit anime film.[157]

Posed against the dark, silvery background of the open Factory space, Kishida is extraordinarily self-possessed throughout her *Screen Test*. At the beginning of the roll, she picks up a paper cup and drinks from it, then gives the camera a dazzling smile. She then looks off into the distance, comfortable enough to become lost in her own thoughts. From time to time she gives the camera a casual, unintimidated glance. Smoke from a cigarette drifts through the upper right corner of the image. At the end of the roll, she begins smiling at people offscreen.

### ST184 *Olga Klüver,* 1964

16mm, b&w, silent; 4.5 min. @ 16 fps, 4 min. @ 18 fps
Preserved 2001, MoMA *Screen Tests* Reel 28, no. 7
**FILM MATERIALS**
ST184.1 *Olga Klüver*
1964 Kodak 16mm b&w reversal original, 108'
**NOTATIONS** On original box in AW's hand: *Olga*

### ST185 *Olga Klüver,* 1964

16mm, b&w, silent; 4.5 min. @ 16 fps, 4 min. @ 18 fps
Preserved 2001, MoMA *Screen Tests* Reel 28, no. 2
**COMPILATIONS** *The Thirteen Most Beautiful Women* (ST365)
**FILM MATERIALS**
ST185.1 *Olga Klüver*
1964 Kodak 16mm b&w reversal original, 109'
**NOTATIONS** On original box in AW's hand: *Olga 13*

The artist and performer Olga Adorno became involved in the New York art scene as early as 1959, appearing in early Happenings by artists such as Claes Oldenburg, Robert Whitman, Allan Kaprow, and Red Grooms. In September 1964, Adorno performed with

Charlotte Moorman, Nam June Paik, and others in Allan Kaprow's presentation of Karlheinz Stockhausen's *Originale* at the Judson Hall in New York, an event which was itself picketed by dissident Fluxus artists including George Maciunas, Henry Flynt, and Tony Conrad. Adorno also posed for an Oldenburg painting of a reclining nude, and had her leg cast in plaster by Jasper Johns for his mixed-media painting *Watchman* (1964).[158]

In 1963 Olga Adorno was living with the engineer and artistic collaborator Billy Klüver in a rented house in New Jersey, when she appeared briefly in Warhol's short silent film *Billy Klüver* (see Volume 2). When the couple married the next year, Warhol threw a big surprise party for them at the Factory. In 1965 Billy Klüver, who was an engineer at Bell Telephone Laboratories and later one of the founders and director of Experiments in Art and Technology (E.A.T.), collaborated with Warhol on the design and production of the *Silver Clouds*, helium-filled, floating Mylar pillows that Warhol premiered at his 1966 exhibition at the Leo Castelli Gallery. In later years Olga Adorno worked and lived with the artist Jean Dupuy, presenting mixed-media performances at the Grommet Art Theater in New York in the 1970s; they now live in France. Billy Klüver died in January 2004 at the age of seventy-six.

There are two *Screen Tests* of Olga Adorno Klüver, both apparently shot at the same time. In one of her portraits (ST184), which is slightly overexposed, she holds her chin up and regards the camera mournfully with startlingly large, myopic eyes (Adorno usually wore glasses, but had removed them for the film). In the second film (ST185), which Warhol selected for *The Thirteen Most Beautiful Women*, Klüver is filmed in tighter close-up, her head inclined slightly forward into a more direct, intimate engagement with the camera.

### ST186 *Howard Kraushar,* 1964

16mm, b&w, silent; 4.6 min. @ 16 fps, 4.1 min. @ 18 fps
Preserved 1998, MoMA *Screen Test* Reel 15, no. 7
**COMPILATIONS** *The Thirteen Most Beautiful Boys* (ST365)
**FILM MATERIALS**
ST186.1 *Howard Kraushar*
1964 Kodak 16mm b&w reversal original, 110'
**NOTATIONS** On original box in AW's hand: *Howie for 13.*
*HOWIE–THE ART DEALER'S SON*

The Pop art collector Leon Kraushar received a fair amount of press coverage in the mid-1960s. An insurance executive from Lawrence, New York, Kraushar filled his home with pop sculptures and paintings, including a group of four plaster figures by George Segal called *Rock 'n' Roll*, an enormous John Chamberlain crushed metal work, a stuffed cotton sculpture by Yayoi Kusama, and a stack of Warhol box sculptures, as well as large paintings by Warhol, Roy Lichtenstein, Robert Indiana, Claes Oldenburg, and others.[159] The subject of this *Screen Test*, Howard Jason Kraushar, misnamed on the film box as "Howie the Art Dealer's Son," was Leon's oldest son.

According to the recollections of Fred Kraushar, Howard's younger brother, their father Leon "was a bit of a pied piper. As his collection grew, my older brother began to pay attention. My dad preached to Howard and his buddies to start collections of their own."[160] The existing *Screen Tests* of Howard Kraushar, his friends Steve Stone (ST330–331) and Richie Markowitz (ST204–205), and that of Leon Kraushar's driver Steve Garonsky (ST112), suggest that Kraushar brought his son and his son's friends along with him when he visited Warhol's studio. Although there are no films of Leon Kraushar, Howard and his friends also appear in a few rolls shot for *Couch* in 1964.

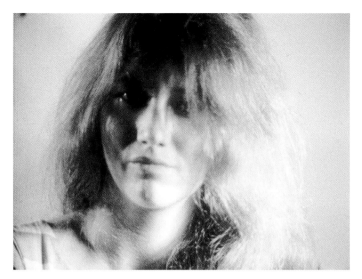

ST181

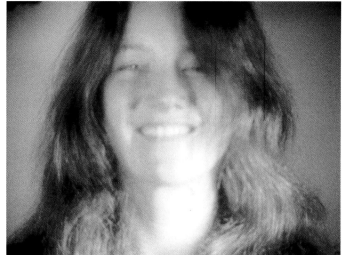

ST182

ST183

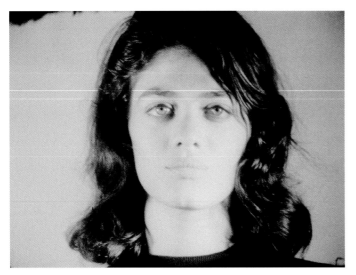

ST184

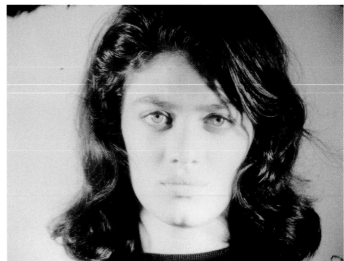

ST185

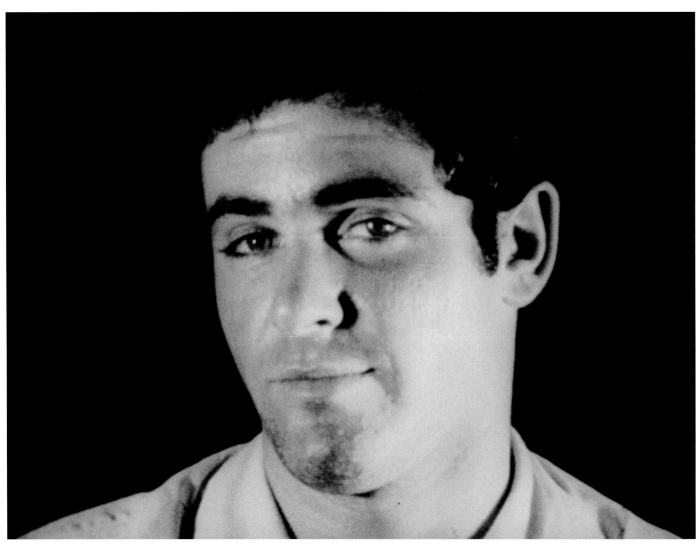

ST186

Leon Kraushar died suddenly from a coronary in 1967; most of his art was sold to the German collector Karl Ströher, whose collection was subsequently sold by Sotheby's in 1989. After his father's death, Howard emulated him by becoming an insurance broker and starting his own collection of photo-realist art, including works by Chuck Close and Duane Hansen. Howard Kraushar died in 1974 at the age of thirty-two.[161]

In his *Screen Test*, which was either shot or selected for *The Thirteen Most Beautiful Boys*, the twenty-one-year-old Kraushar has been evenly lit from the front. He seems to be in constant motion throughout the film, tilting his head from side to side, smirking at the camera, and bobbing his head as if to music. His large light-colored eyes, which were bright blue, are in dramatic contrast with his dark hair and swarthy complexion.

### ST187  *Vivian Kurz*, 1965

16mm, b&w, silent; ca. 2.7 min. @ 24 fps

**FILM MATERIALS**

ST187.1 16mm b&w reversal original, ca. 100'
The first of three Warhol *Screen Tests* included in Andrew Meyer, *The Match Girl*, 1966; 16mm, color and b&w, sound, 26 min. @ 24 fps
Collections of The Museum of Modern Art, Department of Film and Media

### ST188  *Vivian Kurz*, 1965

16mm, b&w, silent; ca. 2.7 min. @ 24 fps

**FILM MATERIALS**

ST188.1  16mm b&w reversal original, ca. 100'
The second of three Warhol *Screen Tests* included in Andrew Meyer, *The Match Girl*, 1966; 16mm, color and b&w, sound, 26 min. @ 24 fps
Collections of The Museum of Modern Art, Department of Film and Media

### ST189  *Vivian Kurz*, 1965

16mm, b&w, silent; ca. 2.7 min. @ 24 fps

**FILM MATERIALS**

ST189.1  16mm b&w reversal original, ca. 100'
The third of three Warhol *Screen Tests* included in Andrew Meyer, *The Match Girl*, 1966; 16mm, color and b&w, sound, 26 min. @ 24 fps
Collections of The Museum of Modern Art, Department of Film and Media

Three original black-and-white *Screen Tests* of the underground actress Vivian Kurz shot by Andy Warhol have been found in a 1966 film by Andrew Meyer called *The Match Girl*. Meyer's film, an allegory about a lonely superstar trying to survive in the pop environment of the Warhol Factory, is based on the Hans Christian Andersen tale of the same title. The film stars Kurz in the title role, with Gerard Malanga as "the Actor" and Andy Warhol as "the Artist." *The Match Girl* also features a voice-over narration of Warhol reading aloud from Andersen's fairy tale.

Kurz's *Screen Tests* may have been shot in December 1965, at least according to a possibly fictional excerpt from Gerard Malanga's diary that is read aloud in Meyer's film: "12/31. Miss Match Girl of 1965 comes to the Factory for her *Screen Test*." The three black-and-white *Screen Tests* of Kurz appear at intervals in the course of Meyer's twenty-six-minute color film. Kurz is seen seated on the Factory couch with a large mirror behind her; she keeps lighting matches and blowing them out. The *Screen Tests* have a sound track, added later, of a voice-over of Kurz's thoughts: "I feel like such a fool sitting here like this." The second *Screen Test*, in its entirety, appears spliced into the middle of Meyer's color footage of Warhol in the act of shooting it, bending over the Bolex and looking through the lens, which has gauze wrapped around it (which accounts for the foggy quality of the image). It seems clear that Warhol shot these three films specifically for Meyer's project; Warhol's authorship of the *Screen Tests* would, of course, have been essential to Meyer's narrative—which seems, in turn, to be a scarcely veiled reference to Warhol's superstar Edie Sedgwick. (Andrew Meyer also appears in a roll of Warhol's film *Kiss* [1963–64].)

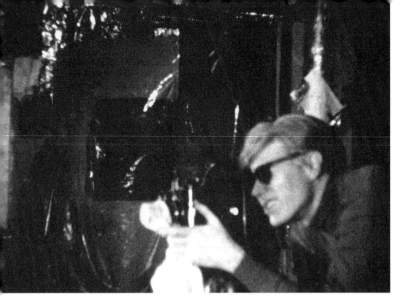

Andy Warhol filming Vivian Kurz's *Screen Test* with gauze wrapped over the lens, from Andrew Meyer's *The Match Girl*, 1966 (original is in color). Collections of The Museum of Modern Art Department of Film and Media.

Vivian Kurz was a close friend of the filmmaker Warren Sonbert, who wrote a brief essay about her in *Film Culture* magazine, describing her as "indeed a glowing star in the cinema firmament."[162] Kurz also appeared in Bruce Conner's 1964 film *Vivian*, in the Kuchar Brothers' *Corruption of the Damned* (1965), and in Gerard Malanga's *Cambridge Diary* (1966).

## ST190  *Kenneth Jay Lane,* 1966

16mm, b&w, silent; 4.3 min. @ 16 fps, 3.9 min. @ 18 fps
Preserved 1999, MoMA *Screen Tests* Reel 23, no. 8
COMPILATIONS  *Screen Test Poems* (ST372); *Screen Tests/A Diary* (Appendix A)
FILM MATERIALS
ST190.1  *Kenneth Jay Lane*
1965 Kodak 16mm b&w reversal original, 104'
ST190.1.p1 *Screen Test Poems*, Reel 2 (ST372.2), roll 16
Undated Gevaert 16mm b&w reversal print, 108'
NOTATIONS  On box in Gerard Malanga's hand: *Kenneth Jay Lane. Ken Lane*
On box in unidentified hand, crossed out: *Unexp. 3 ft. Don Don*
On box in red: *16*
On typed label found in can: *KENNETH JAY LANE*
On clear film at both head and tail of roll in black: *16*

Kenneth Jay Lane, the celebrated designer and popularizer of costume jewelry, became friends with Andy Warhol in the 1950s when Lane designed shoes for Christian Dior and Warhol was a highly successful illustrator of shoes for I. Miller. Lane reportedly attended Warhol's "coloring parties," when friends would gather at his home to help him color in his commercial artworks.[163] In 1958 Warhol produced an ink and watercolor drawing of Lane entitled *Portrait of Kenneth Jay Lane with Butterflies.*[164]

In the early 1960s, Lane began designing what he called "faque" jewels for the rich and famous, launching a successful career as a designer of inexpensive fantasy jewelry that became immensely popular in high society as well as with ordinary consumers. For several decades he has been a "fixture of New York and international society," the "indefatigable escort of Princess Margaret, Brooke Astor, and Nan Kempner," and jeweler and friend to several first ladies.[165] Since 1992 Lane has been a popular personality on cable

television, selling jewelry on the QVC home shopping channel while regaling the audience with anecdotes from his career. Lane's memoir, *Faking It*, was published by Harry N. Abrams in 1996. In 1999 the Museum at the Fashion Institute of Technology in New York organized an exhibition of his work, *Dazzling by Design: Fashion Jewelry by Kenneth Jay Lane.*[166]

Lane's early jewelry sometimes appeared in association with the Warhol superstars. Lane was friends with Edie Sedgwick and also with her family; in 1965 Sedgwick appeared in a fashion photograph in *Life* magazine wearing long, dangling earrings by "K.J.L."[167] Another example of Lane's jewelry, a glittery snake necklace, can be seen in a 1966 *Screen Test* of John Cale (ST42). In February 1967, Lane lent his sumptuous apartment, filled with objects he had gathered on his travels, including "a large collection of ivory statues of skulls and *memento mori* things,"[168] for the filming of two reels of ★ ★ ★ ★ (*Four Stars*), Reel 4, *Ivy*, and Reel 10, *Nico and Ivy*. In 1971 a portion of *Women in Revolt* was filmed in Lane's town house on 38th Street.[169]

In his 1966 *Screen Test*, Lane has been posed slightly offcenter and strongly lit from the left, with the right side of his face completely in shadow; a pattern of light and shadow, possibly caused by a reflection, falls across the backdrop behind him. Lane at first seems to bridle at the camera, arching his neck, pursing his lips, and turning his head from side to side. He smiles graciously at offscreen passersby, but continues to fix the camera with a look of unamused and increasingly critical ennui. The high-contrast, half-moon lighting illuminates the fine line of his profile and his carefully brilliantined hair. As the image fades out at the end of the film, Lane coughs into his fist.

## ST191  *Larry Latreille,* 1965

16mm, b&w, silent; 4.5 min. @ 16 fps, 4 min. @ 18 fps
Preserved 1998, MoMA *Screen Tests* Reel 13, no. 3
COMPILATIONS  *The Thirteen Most Beautiful Boys* (ST364)
FILM MATERIALS
ST191.1  *Larry Latreille*
1964 Kodak 16mm b&w reversal original, 108'
NOTATIONS  On original box in AW's hand: *LARRY Latrae–13*

Larry Latreille appeared in two Warhol films from 1965: *Vinyl*, in which he played a background masochist; and *Horse*, in which he had a major role as the Kid from Laramie ("I'm the Kid from Laramie/ Hang me on yonder tree"). Not much is known about Latreille's life beyond these films. Ronald Tavel remembered only that he was an underage French Canadian runaway, and Bibbe Hansen recalls that she and Latreille had a brief romance in the mid-1960s.[170]

In his *Screen Test*, which was probably shot around the same time as his other two Warhol films, in the first half of April 1965, Latreille does indeed seem young, with a tense, guarded expression. His pale skin contrasts strongly with his black hair, black turtleneck, and the black background against which he is filmed. As the film progresses, his dark eyes, which are scarcely visible beneath his eyebrows, begin to glisten with moisture; Latreille blinks only occasionally during his sitting.

Opposite: Vivian Kurz's Warhol *Screen Tests*, from Andrew Meyer's *Match Girl*, 1966. Collections of the Museum of Modern Art Department of Film and Media.

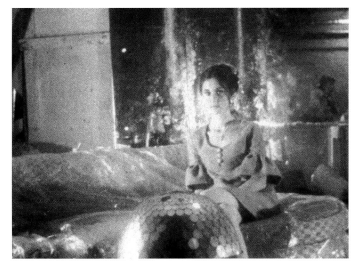

ST187

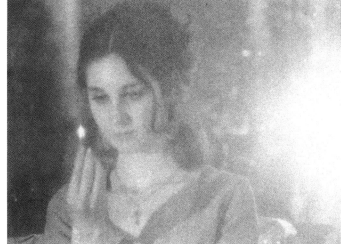

ST188

ST189

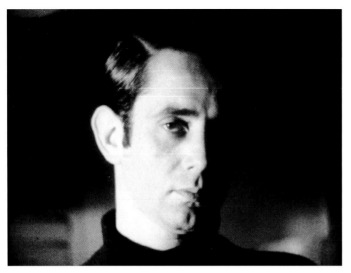

ST190

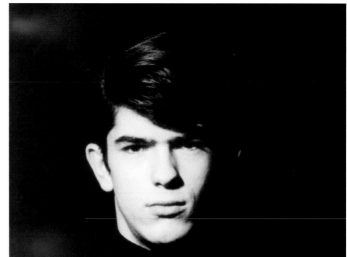

ST191

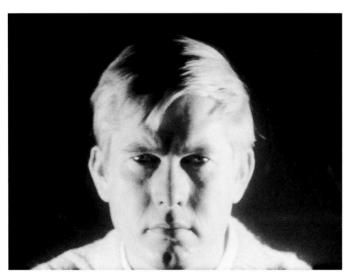

ST192

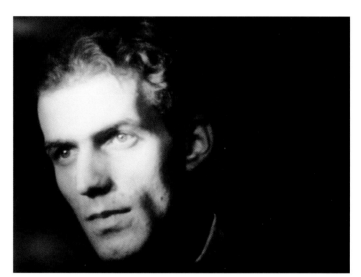

ST193

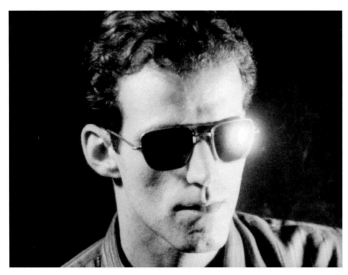

ST194

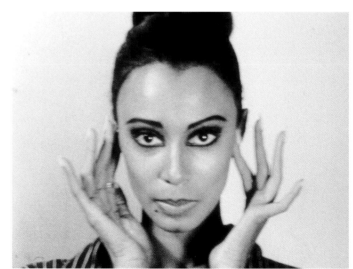

ST195

## ST192 *Joe LeSueur,* 1964

16mm, b&w, silent; 4.5 min. @ 16 fps, 4 min. @ 18 fps
COMPILATIONS *The Thirteen Most Beautiful Boys* (ST364)
FILM MATERIALS
ST192.1 *Joe LeSueur*
1964 Kodak 16mm b&w reversal original, 108'
NOTATIONS On original box in Gerard Malanga's hand: *Joe La Seuer for 13*

In 1964 the writer Joe LeSueur, who had been the roommate of the poet Frank O'Hara since the mid-1950s, collaborated with Warhol on an idea for a feature film to be called *Messy Lives.* LeSueur had the idea of using "a dozen screen writers who'll use roughly the same sets of characters, each writer setting up a different story," and invited a number of downtown poets including O'Hara, Diane di Prima, Edwin Denby, and Ron Padgett to write dialogue.[171] In January 1965 LeSueur wrote to Warhol suggesting they postpone production for a month or two, since he was now busy with a full-time job.[172] No footage for *Messy Lives* was apparently ever shot, and the project was eventually abandoned, although some parts of the script were completed, including sections by Denby and Padgett.[173] Frank O'Hara and Frank Lima also wrote a piece called "Love on the Hoof" for the *Messy Lives* project, later published in O'Hara's collection of selected plays, *Amorous Nightmares of Delay.*[174] LeSueur said later that he doubted that Warhol was ever serious about the film, "although it was hard to tell with him."[175]

LeSueur appears in two rolls of Warhol's 1964 film *Couch,* eating fruit on the Factory couch with Gerard Malanga, Ivy Nicholson, and John Palmer. The filming of these *Couch* rolls in the late fall of 1964 was described by Howard Junker in *The Nation,* as was the shooting of LeSueur's *Screen Test,* or "stillie," on the same day:

> After a "take-five," Joey was persuaded to sit down on the small stool in the corner portrait gallery to pose for a stillie. He was filmed looking glum and puckish.[176]

LeSueur does indeed look quite glum in his portrait film. Wearing the same white cable-knit sweater he wears in *Couch,* he scowls morosely into the camera; the dark shadows on his forehead and under his eyes form a kind of "X" in the middle of his face. As the film progresses, LeSueur slumps lower and lower in his seat until his chin seems to be resting on the bottom edge of the film frame.

LeSueur's grim mood may reflect the strain of his relationship with O'Hara at this time, a difficult period that LeSueur later suggested could itself have been titled "Messy Lives."[177] In January 1965, not long after this film was shot, the roommates separated and LeSueur moved into his own apartment, although the two remained friends until O'Hara's tragic death in July 1966.[178] LeSueur continued to write, publishing occasional reviews in the *Village Voice,* including a review of Ronald Tavel's plays *Screen Test* and *Indira Gandhi's Daring Device* in 1966.[179] LeSueur died in East Hampton, New York, in 2001; his detailed, gossipy memoir, *Digressions on Some Poems by Frank O'Hara,* was posthumously published in 2003.

## ST193 *Billy Linich,* 1964

16mm, b&w, silent; 4.5 min. @ 16 fps, 4 min. @ 18 fps
Preserved 1998, MoMA *Screen Tests* Reel 14, no. 2
COMPILATIONS *Fifty Fantastics and Fifty Personalities* (ST366)
FILM MATERIALS
ST193.1 *Billy Linich*
1964 Kodak 16mm b&w reversal original, 108'
Tape splice at 8' broken and repaired
NOTATIONS On original box in AW's hand: *Billy Linich. 50*

## ST194 *Billy Linich,* 1964

16mm, b&w, silent; 4.4 min. @ 16 fps, 3.9 min. @ 18 fps
Preserved 1995, MoMA *Screen Tests* Reel 7, no. 10
COMPILATIONS *The Thirteen Most Beautiful Boys* (ST364); *Screen Test Poems* (ST372); *Screen Tests/A Diary* (Appendix A)
FILM MATERIALS
ST194.1 *Billy Linich*
1964 Kodak 16mm b&w reversal original, 105'
ST194.1.p1 *Screen Test Poems,* Reel 3 (ST372.3), roll 22
Undated Gevaert 16mm b&w reversal print, 105'
NOTATIONS On box in AW's hand: *BILLY LINICH. Billy Linich #13*
On box in AW's hand, crossed out: *Taylor*
On flap in red: *22*
On typed label found in can: *BILLY LINICH*
On clear film at head of roll in black: *22*

Billy Linich, who permanently changed his name to Billy Name in 1966, was resident manager (and astrologer) of the Warhol Factory from 1964 through 1969. Name was responsible for creating and maintaining the studio's famous decor of tinfoil and silver paint, and he was also the official photographer of its activities. His "Factory Fotos," shot on Warhol's 35mm Pentax camera, are among the best known images of Warhol and the Factory scene in the 1960s. Name's work includes numerous production stills of the films, which have been the most widely reproduced images of Warhol's cinema.

Name, who had previously studied lighting with Nick Cernovich and worked as lighting director at the Judson Dance Theater, designed the lighting for many of the Warhol films, and seems to have had a significant aesthetic influence on Warhol's filmmaking as well as an enormous practical influence on daily life at the Factory. Name performed as the barber in all three *Haircut* films (1963–64) and appeared in a number of later Factory movies as well, including *Couch* (1964), *Harlot* (1964), the sequel to *My Hustler* (1965), *Lupe* (1965), *Since* (1966), and a 1967 reel of ★★★★ *(Four Stars)* called *Philadelphia Stable.*

Name moved with the Warhol Factory to its new premises on Union Square in 1968 and continued to live there through 1969, when he departed, leaving behind a note, "Andy—I am not here anymore but I am fine. Love, Billy."[180] In later years, he returned to his home town of Poughkeepsie, New York, where he continues his career as photographer and concrete poet.

In addition to figuring prominently in many exhibitions and publications about Warhol's work, Name's photographs have received a number of exhibitions on their own, including a 1997 retrospective at the Institute of Contemporary Art in London. Name's photographs are included in the collections of several museums, including the Whitney Museum of American Art, the Boston Museum of Fine Arts, and the San Francisco Museum of Modern Art. At least three publications have been devoted to Name's photographs: *Billy Name: Stills from the Warhol Films* by Debra Miller (Munich: Prestel, 1994); *Andy Warhol's Factory Fotos: Factory Foto by Billy Name* (Tokyo: Uplink Co., 1996); and *All Tomorrow's Parties: Billy Name: Photographs of Andy Warhol's Factory* (London and New York: Frieze and D.A.P., 1997).

Name/Linich's first *Screen Test* (ST193) appears to be an early one, from the first half of 1964. Framed slightly offcenter and uncharacteristically dressed in a button-down collar and pullover sweater, Name gives an expressive performance. Looking down, wrinkling his brow, gazing off to one side or the other, Name also often looks directly at the camera, engaging the cameraman (and viewer) in a series of intimate, humorous glances.

The second *Screen Test* (ST194), which seems to have been shot later the same year, is almost the conceptual opposite of the first. Linich, who obviously has been deliberately posed for this shot, remains expressionless and nearly motionless for the duration of the film, carefully balancing the dazzling burst of light that reflects off his dark glasses into the camera lens. His eyes are totally invisible; smoke from a cigarette rises into the right half of the frame. This portrait of Linich as the perfect image of impenetrable Factory "cool" was considered quite successful; not only did Warhol select this film for *The Thirteen Most Beautiful Boys* (ST364), but a print of it was also included in one of the *EPI Background* reels (ST372). There are a few light flares in the middle of the roll.

## ST195   *Donyale Luna,* 1965

16mm, b&w, silent; 4.5 min. @ 16 fps, 4 min. @ 18 fps
Preserved 1995, MoMA *Screen Tests* Reel 11, no. 9
**COMPILATIONS**   *EPI Background* (ST370)
**FILM MATERIALS**
ST195.1   *Donyale Luna*
1965 Kodak 16mm b&w reversal original, 108'
ST195.1.p1   *EPI Background* (ST370), roll 11
Undated Dupont 16mm b&w reversal print, 108'
**NOTATIONS**   On original box in AW's hand: *Donyle*
On clear film at head of roll in black: *11*

## ST196   *Donyale Luna,* 1965

16mm, b&w, silent; 4.5 min. @ 16 fps, 4 min. @ 18 fps
Preserved 1995, MoMA *Screen Tests* Reel 2, no. 5
**FILM MATERIALS**
ST196.1   *Donyale Luna*
1965 Kodak 16mm b&w reversal original, 109'
**NOTATIONS**   On original box in AW's hand: *Part II. Donyle*

Donyale Luna, a six-foot-one-inch model from Detroit, was one of the first black women to achieve national and international recognition in the world of high fashion, identified as "the most photographed mannequin in Europe in mid-1966."[181] In April 1965 she was photographed by Richard Avedon for two feature articles in *Harper's Bazaar* magazine; in 1967 she inspired a line of fiberglass mannequins created by the British designer Adel Rootstein.[182]

In addition to the Warhol films, Luna may be seen in several movies from 1968, playing God's (Groucho Marx) mistress in Otto Preminger's *Skidoo*, the fire-eater's assistant in the Rolling Stones's *Rock and Roll Circus,* and appearing in Peter Whitehead's documentary about "swinging London," *Tonite Let's All Make Love in London.* She also played the role of Oenothea in Fellini's *Satyricon* (1970), and starred in Carmelo Bene's 1972 film *Salomé.* Donyale Luna died in Rome in 1979.

In addition to her *Screen Tests,* Luna can be seen in Warhol's 1965 film *Camp* performing a runway walk in a fur coat; in 1967 she also starred in a thirty-three-minute color reel titled *Donyale Luna,* a version of "Snow White" in which she wears bright blue contact lenses and has thirteen young boyfriends. In one of her two *Screen Tests* (ST195), the nineteen-year-old Luna has been shot in close-up against a white background. Luna smooths back her hair with strikingly long fingers, hugs her shoulders, and then uses the camera lens as a mirror for a bit of self-grooming—stroking her eyebrows, smoothing her face, checking her profile. Occasionally she suppresses a smile. In the second portrait (ST196), she has been filmed

in medium long shot standing in front of a movie screen, a light clamped to a stand next to her. Luna appears extremely high-strung and edgy in this film, repeatedly standing up and sitting down, striking a few poses, dancing in place, and apparently finding it hard to keep still. At the end of the film, she covers her mouth with her hands and seems to be on the verge of tears.

## ST197   *Willard Maas,* 1965

16mm, b&w, silent; 4.1 min. @ 16 fps, 3.6 min. @ 18 fps
Preserved 1995, MoMA *Screen Tests* Reel 8, no. 8
**COMPILATIONS**   *Screen Tests/A Diary* (Appendix A)
**FILM MATERIALS**
ST197.1   *Willard Maas*
1965 Kodak 16mm b&w reversal original, 98'
**NOTATIONS**   On original box in AW's hand: *Tri-X. Willard Maas*
On box in Billy Name's hand: *WILLARD MAAS*
On typed label found in can: *WILLARD MAAS*

Warhol recollected that he first met Willard Maas and his wife, Marie Menken, when the poet Charles Henri Ford took him to a party at their penthouse in Brooklyn Heights:

> Willard and Marie were the last of the great bohemians. They wrote and filmed and drank (their friends called them "scholarly drunks") and were involved with all the modern poets. . . . The Maases were warm and demonstrative and everyone loved to visit them.[183]

Maas and Menken were reported to be the models for the harddrinking, belligerent couple George and Martha in Edward Albee's play *Who's Afraid of Virginia Woolf?*[184] Maas, a poet and filmmaker, was an English professor at Wagner College on Staten Island. He and Menken functioned as unofficial godparents to Warhol's studio assistant, Gerard Malanga; in the fall of 1961, Maas anonymously secured a fellowship that allowed Malanga to enroll in Wagner College.[185]

Warhol and Maas seem to have followed each other's work closely. Maas's early film *Geography of the Body* (1943), a series of magnified close-ups of nude bodies, certainly could be considered a possible influence on Warhol's 1963 film *Sleep.* In early 1964 Maas reportedly performed a key offscreen role in Warhol's film *Blow Job.*[186] Both Maas and Menken made films about Warhol and his art,[187] and Warhol reciprocated with *Bitch,* a 1965 film about the couple shot in their living room on a Sunday afternoon. Warhol also created a photographic portrait of Menken and Maas for the frontispiece of a special issue of *Filmwise* magazine devoted to their work.[188] Maas nevertheless appears to have been somewhat ambivalent about Warhol, alternating between approval and resentment. In 1966 Maas sent Warhol a note thanking him for withdrawing as a judge of the Brooklyn Heights Art Show, to which Menken had not been invited.[189] But Jonas Mekas recalled another occasion when Maas stood up during the screening of a Warhol film and denounced him for having so much money, when his wife Marie had no money to make her own films.[190] Willard Maas died in early 1971, only a few days after his wife passed away.

For his *Screen Test* in 1965, Maas, formally dressed in a suit and tie, has been dramatically lit from the right; the left side of his face is in nearly total darkness. Maas glowers at the camera, blinking often and moving his jaw rhythmically, as if he has a slight nervous tic.

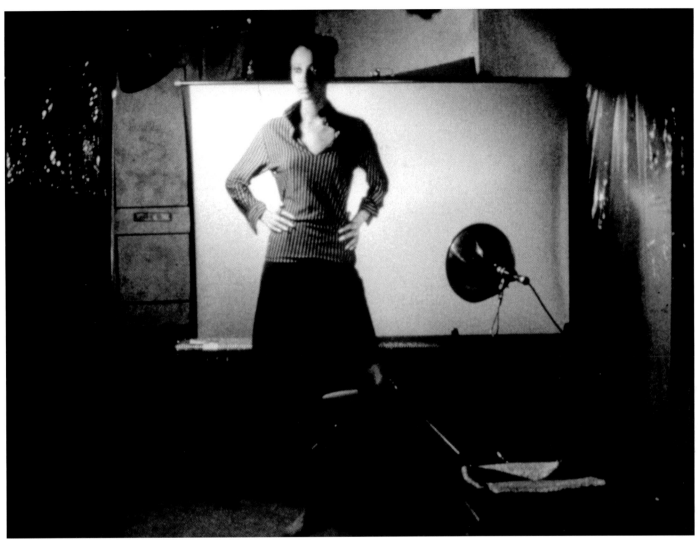

ST196

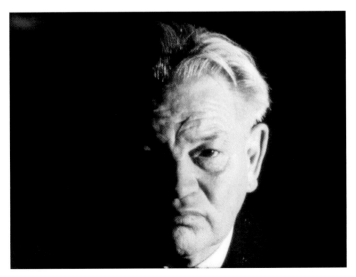

ST197

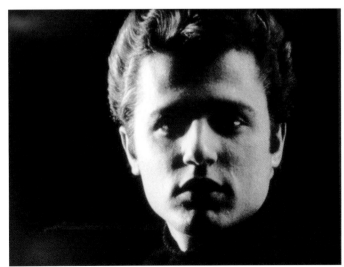

ST198

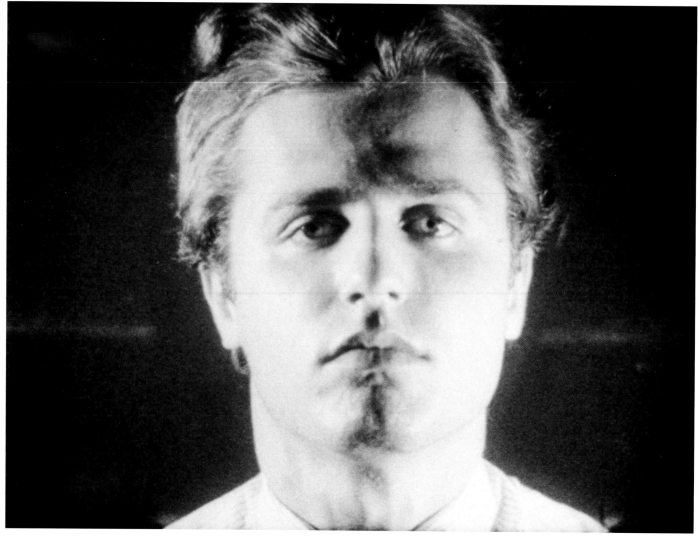

ST199

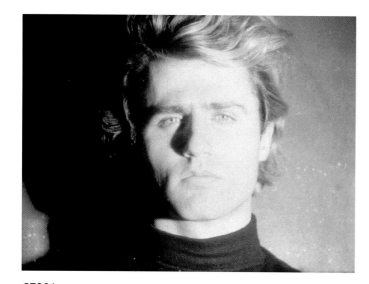

ST201

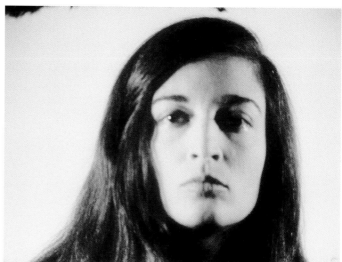

ST202

**ST198** *Gerard Malanga*, 1964

16mm, b&w, silent; 4.6 min. @ 16 fps, 4.1 min. @ 18 fps
Preserved 1995, MoMA *Screen Tests* Reel 3, no. 10
**COMPILATIONS** *The Thirteen Most Beautiful Boys* (ST364)
**FILM MATERIALS**
ST198.1 *Gerard Malanga*
1963 Kodak 16mm b&w reversal original, 110'
Open cement splice at head, repaired in 1995
**NOTATIONS** On box in AW's hand: *Gerry. Girard. Gerard #13*
On box in AW's hand, crossed out: *Freddy and the magic light*

**ST199** *Gerard Malanga*, 1964

16mm, b&w, silent; 4.5 min. @ 16 fps, 4 min. @ 18 fps
Preserved 1995, MoMA *Screen Tests* Reel 6, no. 6
**FILM MATERIALS**
ST199.1 *Gerard Malanga*
1964 Kodak 16mm b&w reversal original, 108'
**NOTATIONS** On original box in AW's hand: <u>*Gerard*</u> *(Bad)*

**ST200** *Gerard Malanga*, 1965

16mm, color, silent; length unknown
**COMPILATIONS** *Screen Tests/A Diary* (Appendix A)
**FILM MATERIALS**
Original not found in Collection

**ST201** *Gerard Malanga*, 1966

16mm, b&w, silent; 3.9 min. @ 16 fps, 3.5 min. @18 fps
**COMPILATIONS** *EPI Background: Gerard Begins* (ST368); *Screen Tests/A Diary* (Appendix A)
**FILM MATERIALS**
Original not found in Collection
ST201.1.p1 *EPI Background: Gerard Begins* (ST368), roll 8
1965 Kodak 16mm b&w reversal print, 94'

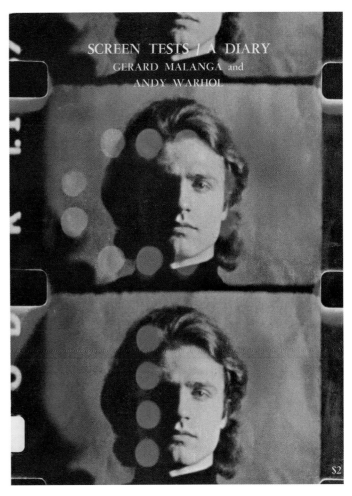

ST200. The cover of *Screen Tests/A Diary* by Gerard Malanga and Andy Warhol (New York: Kulchur Press, 1967). See Appendix D for color reproduction.

In June 1963, when Warhol was looking for a studio assistant, his friend Charles Henri Ford introduced him to Gerard Malanga, a young poet studying at Wagner College on Staten Island. Malanga, who had previous experience working on textile silk screens for a manufacturer of men's ties, began working for Warhol at minimum wage, helping to silk-screen paintings at the abandoned fire station on West 89th Street where Warhol had his first studio.[191] After Warhol moved into his new studio, the Factory, on East 47th Street in January 1964, they continued working together on the production of paintings, box sculptures, and other works. Malanga also assisted with and appeared in many of the Warhol films during this time and became a familiar fixture at Warhol's studio; visitors described him as "a perfect lieutenant" to Warhol, "the Prime Minister" of the Factory.[192]

In addition to his *Screen Tests*, Malanga appeared in a number of the 1960s Warhol films: *Kiss, Tarzan and Jane Regained, Sort Of . . . ,* and *Duchamp Opening* from 1963; *Three, Allen, Batman Dracula, Soap Opera, Couch, Taylor Mead's Ass,* and *Harlot* from 1964; *Vinyl, Beauty #2, Bitch, Camp,* and *My Hustler II* from 1965; *Hedy, Kiss the Boot, Salvador Dalí, The Chelsea Girls, Bufferin, Bufferin Commercial, The Beard, Since,* and several other reels shot for ★ ★ ★ ★ *(Four Stars)* in 1966–67.[193] During 1966 Malanga traveled with the EPI (Exploding Plastic Inevitable), performing dance routines on stage with other dancers such as Mary Woronov and with various props, including a whip, flashlights, and an enormous hypodermic needle, while the Velvet Underground played.

In 1966 Malanga organized a multimedia performance called *Screen Test Poems* (ST372), which combined multiscreen projections of the Warhol *Screen Tests* with music and readings of Malanga's poetry. In 1967 Malanga and Warhol collaborated on the publication of *Screen Tests/A Diary*, which juxtaposed double-frame images from the Warhol *Screen Tests* with poems written by Malanga (see Appendix A). In the summer of 1967, Malanga left for Italy to work on a film of his own; after his return in 1968, he resumed part-time work at the Factory, handling film distribution for Andy Warhol Films, Inc. and serving as the first editor of *Interview* magazine, while continuing to write poetry, take photographs, and make his own films.[194] In 1968 Warhol and Malanga again collaborated as editors of *Intransit: The Andy Warhol-Gerard Malanga Monster Issue* (Toad Press, 1968), a massive collection of poems and other writings by New York poets, artists, and assorted Factory personnel for which, one suspects, Malanga probably did most of the work. In June 1969, Malanga lent his name to the presentation of a program of eight, explicitly homosexual films from San Francisco, which were shown at the Fortune Theater in New York under the title, "Gerard Malanga's *Male Movie Magazine.*" According to *Variety,* Warhol was approached first and asked to present the films under his name; when both Warhol and Morrissey refused to lend their names, Malanga agreed to the arrangement.[195]

Malanga's poems have been published in numerous journals and magazines; he has also published at least eighteen collections of his own poetry. His films, which include *In Search of the Miraculous* (1967), *Prelude to International Velvet Debutante* (1966), and *April Diary* (1970), have been shown at numerous venues, including the Hirshhorn Museum in Washington, D.C., the Guggenheim Museum, and the Fine Arts Club of New York University. His photographs have also been published in several collections, most recently in *Gerard Malanga: Screen Tests, Portraits, Nudes, 1964–1996* (Göttingen, Germany: Steidl, 2000). Malanga's memoirs of working with Warhol were recently published in *Archiving Warhol: An Illustrated History* (London: Creation Books, 2002).

Malanga recalled that his first *Screen Test* (ST198) was shot in late 1963 or early 1964, "around the time of our move to the Factory."[196] For this portrait film, Malanga has been posed slightly off-center against a black background; a horizontal board, part of the frame on which the backdrop has been stretched, is faintly visible on the left side of the image. Lit evenly from both sides, and with symmetrical shadows darkening his brow and nearly obscuring his eyes, Malanga has turned sideways to face the camera attentively. He holds very still, blinking only occasionally; at one point he licks his lips and swallows. This film was selected by Warhol for inclusion in *The Thirteen Most Beautiful Boys*, but a later *Screen Test* (ST199) from 1964 was apparently less successful, since Warhol wrote "bad" on the box. In this second portrait, Malanga has been brightly lit from the front, and has tilted his head slightly backwards, which makes his neck bulge. Again, he holds still throughout the film, his left eye filled with light.

Several later *Screen Tests* of Malanga have been found in print form only; the current location of the camera originals is unknown. In ST201, Malanga, wearing a black turtleneck, is posed in front of a speckled dark wooden backdrop. Prints of two other films of Malanga posing with Mary Woronov (see ST355–356), which seem to have been shot on the same day, February 6, 1966, as was a Woronov solo portrait (ST357), have been found in Reels 1 and 3 of *Screen Test Poems* (ST372.1, ST372.3). Malanga also posed for a double *Screen Test* with Debbie Caen (ST37) and another, non-*Screen Test*, double-portrait film from 1964 called *Philip and Gerard*, with Philip Fagan.

A double-perf. 16mm silent color *Screen Test* of Gerard Malanga from 1965 (ST200), reproduced on the cover of *Screen Tests/A Diary*, has not been found in the Warhol Film Collection in either original or print form; its current location is unknown.[197]

### ST202   *Marisol*, 1964

16mm, b&w, silent; 4.5 min. @ 16 fps, 4 min. @ 18 fps

**COMPILATIONS** *The Thirteen Most Beautiful Women* (ST365)

**FILM MATERIALS**

ST202.1 *Marisol*

1964 Kodak 16mm b&w reversal original, 109′

**NOTATIONS** On original box in AW's hand: *Marisol #13*

### ST203   *Marisol and Man*, 1964

16mm, b&w, silent; 4.6 min. @ 16 fps, 4.1 min. @ 18 fps

**FILM MATERIALS**

Original not found in Collection

ST203.1.p1 *Marisol and Man*

1964 Kodak 16mm b&w reversal print, 111′

**NOTATIONS** On box in AW's hand: *Jane w gloves*

On box in unidentified hand: *Warhol*

The artist Marisol Escobar was born to Venezuelan parents in Paris in 1930. In the 1950s she moved to New York to study art, where she began to develop her own distinctive forms of assemblage art, combining found objects with painting, wood, metal, and other materials to create whimsical sculptural figures, often with carved or painted masklike faces. Marisol's work, often associated with Pop art, became well known in the 1960s. In 1965 the Sidney Janis Gallery, which represented Marisol for most of her career, presented an installation of Marisol's sculptures entitled *The Party*, in which each of the many figures was painted with the artist's face.

As a glamorous woman, successful in the male-dominated arena of contemporary art, Marisol received a considerable amount of press attention in the 1960s, which may be one of the reasons why Warhol was attracted to her. The artists were close friends in the early 1960s, when they were both represented by Eleanor Ward's Stable Gallery. As Warhol recalled, "She was always very sweet to me—for instance, whenever we were out together, she used to insist on taking me home instead of the other way around."[198] The two friends sometimes saw each other on weekend visits to Ward's summer home in Old Lyme, Connecticut; one of Warhol's earliest films, *Bob Indiana, Etc.*, shows Ward with Marisol and other artists in Connecticut on a summer's evening. Another Warhol film from 1964, *Marisol—Stop Motion*, shot with much single-framing, shows Marisol walking around a group of her sculptures and posing with various self-portraits. Marisol can also be seen in a 1963 roll from *Kiss*, embracing the painter Harold Stevenson. In 1962–63, Marisol created a sculpture entitled *Andy*, a life-size paint and wood portrait of Warhol seated on a chair.

In her *Screen Test*, which Warhol selected for *The Thirteen Most Beautiful Women* (ST365), Marisol has been posed against a light-colored background and carefully lit from left and right. Her dramatically pale, sculpted face emerges from the dark mass of her hair like one of her own assemblaged self-portraits. The film is slightly out of focus throughout; at one point, Marisol glances offscreen briefly, then resumes her mournful gaze into the camera.

A second double portrait of Marisol with an unidentified but distinguished-looking older man has been found in the collection in print form only; the location of the camera original is unknown.[199] The man and Marisol appear in medium shot posed against a black backdrop, a black cloth that has been stretched on a frame and placed against an empty wall. (This same stretched backdrop appears in *Screen Tests* of Freddy Herko (ST137) and Gerard Malanga (ST198), which suggests these three films may have been shot around the same time, perhaps in late January or early February 1964, when Warhol first moved into his new studio space on 47th Street, before the Factory was painted silver.) The man and Marisol face the camera together; at first the man stands, then sits, lowering himself in the frame. He then stands up again, looming over Marisol, who laughs up at him. The two turn to face the camera, their heads close together; Marisol then walks toward the camera, obscuring the image, and leaves the frame. After a moment, the man walks offscreen as well, and the film ends with an image of the empty backdrop against the wall.

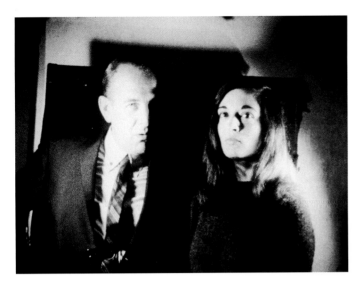

ST203

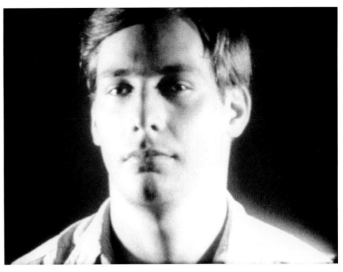

ST204

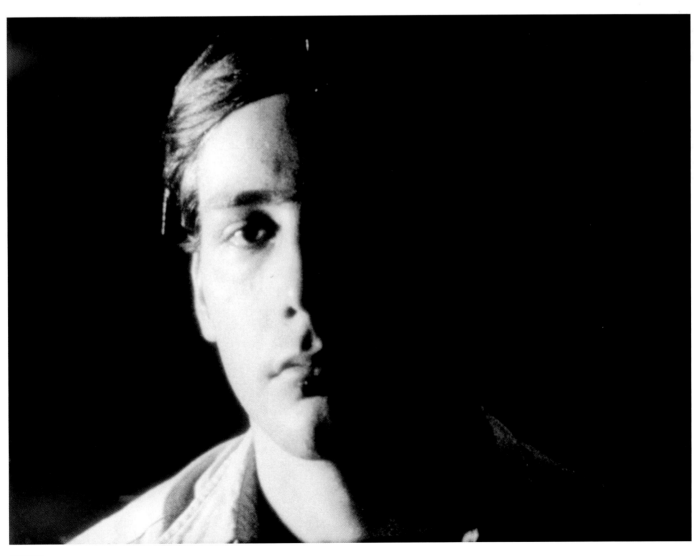

ST205

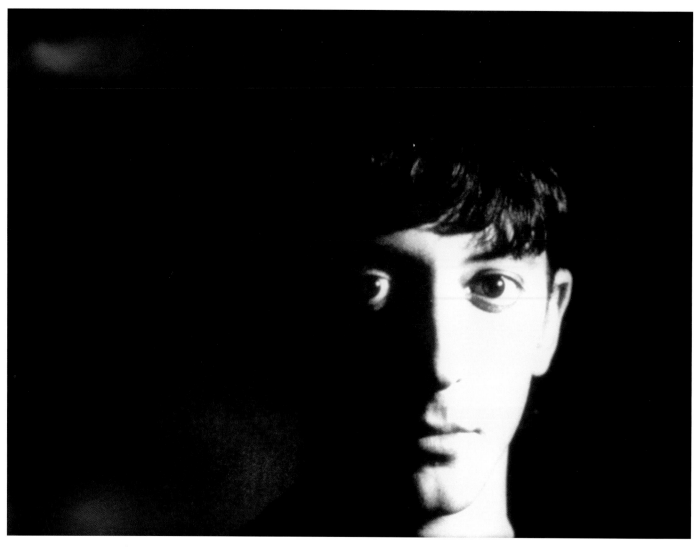

ST206

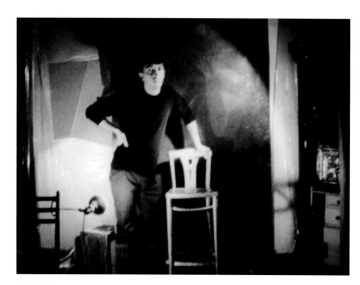

ST207

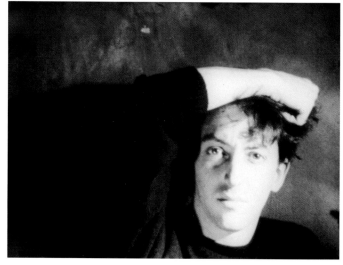

ST207

**ST204  *Richard Markowitz*, 1964**
16mm, b&w, silent; 4.4 min. @ 16 fps, 3.9 min. @ 18 fps
Preserved 1999, MoMA *Screen Tests* Reel 18, no. 6
COMPILATIONS *The Thirteen Most Beautiful Boys* (ST364)
FILM MATERIALS
ST204.1 *Richard Markowitz*
1964 Kodak 16mm b&w reversal original, 105'
NOTATIONS On original box in AW's hand: *Helmut. 13 Most Beautiful Boys. Bad*

**ST205  *Richard Markowitz*, 1964**
16mm, b&w, silent; 4.5 min. @ 16 fps, 4 min. @ 18 fps
Preserved 1995, MoMA *Screen Tests* Reel 4, no. 7
COMPILATIONS *The Thirteen Most Beautiful Boys* (ST364)
FILM MATERIALS
ST205.1 *Richard Markowitz*
1964 Kodak 16mm b&w reversal original, 108'
NOTATIONS On original box in AW's hand: *Helmet (2). Beautiful Boy. Bad*

A young man who posed for two *Screen Tests* in 1964 has been iden-tified as Richie Markowitz, a friend of Howard Kraushar's from Long Island.[200] In one film (ST204), Markowitz's face has been lit evenly from both sides, leaving a slender line of shadow running down the center of his face. With unblinking, heavy-lidded eyes, he stares off into space, holding so still that much of the film really does resemble a freeze-frame. In the second *Screen Test* (ST205), the lighting has been changed to create a kind of half-moon effect, with the right side of his face eclipsed in deep shadow. Markowitz has apparently been given permission to move more freely in this film; he smokes, looks away from the camera occasionally, and at one point suppresses a smile. Although both films appear to have been shot for *The Thirteen Most Beautiful Boys* (ST364), Warhol's notes indicate that he wasn't happy with either of them.

**ST206  *Louis Martinez*, 1966**
16mm, b&w, silent; 4.5 min. @ 16 fps, 4 min. @ 18 fps
Preserved 1998, MoMA *Screen Tests* Reel 17, no. 7
FILM MATERIALS
ST206.1 *Louis Martinez*
1965 Kodak 16mm b&w reversal original, 107'
NOTATIONS On original box in AW's hand: *Louis. Louis Martinez*

**ST207  *Louis Martinez*, 1966**
16mm, b&w, silent; 4.5 min. @ 16 fps, 4 min. @ 18 fps
Preserved 1998, MoMA *Screen Tests* Reel 15, no. 9
FILM MATERIALS
ST207.1 *Louis Martinez*
1965 Kodak 16mm b&w reversal original, 109'
NOTATIONS On original box in AW's hand. *Louis 1. Louis Martinez*
On tape on head of film: *10*

A young man identified only as Louis Martinez posed for two *Screen Tests* in late 1965 or early 1966; judging from his appearance, he was probably a dancer or a performer of some kind. In one of the two films (ST206), Martinez has been shot in close-up against a black background. The stark, high-contrast lighting illuminates only the right side of his face, highlighting his preternaturally large eyes. Martinez heroically manages not to blink at all throughout the three-minute film. As the stationary camera grinds on, a tear forms

on one of his lower eyelids, underscoring his uncanny resemblance to a "big eye" waif painting by Margaret and Walter Keane.[201]

The second film of Martinez (ST207), shot at the same time, is a very different kind of portrait, filled with in-camera edits, zooms, and many different framings. The film opens with a long shot of Martinez seated on a tall, silver-painted stool in front of a black backdrop; a light clamped to a chair is visible at the left. Wearing a visored cap, Martinez leans back on the stool, his long muscular legs clad in tight pants and knee-high boots stretched in front of him. Martinez strikes a series of Dietrich-like poses: wrapping his arms around one knee, walking around the stool, resting coyly on one knee, removing his hat, and running his fingers through his hair. The camerawork, which is remarkably busy for a *Screen Test*, alternates between long shots and quick, in-camera cuts to close-ups of Martinez's head against the dark backdrop; there is one close-up of his crotch. Although this film was shot on 1965 stock, the shooting style suggests it might have been made in early 1966.

**ST208  *John D. McDermott*, 1965**
16mm, b&w, silent; 4.5 min. @ 16 fps, 4 min. @ 18 fps
Preserved 2001, MoMA *Screen Tests* Reel 27, no. 10
COMPILATIONS *Fifty Fantastics and Fifty Personalities* (ST366)
FILM MATERIALS
ST208.1 *John D. McDermott*
1964 Kodak 16mm b&w reversal original, 108'
NOTATIONS On original box in AW's hand: *John McDemot*
On box in unidentified hand: *Personalities*

The actor John D. McDermott is best known for his appearances in two other Warhol films from 1965: *Vinyl*, in which he played the laughing policeman; and *My Hustler*, in which he played the mostly silent houseboy. He also appears in a few rolls shot for *Batman Dracula* in 1964. According to the recollections of Gerard Malanga, McDermott was something of a professional actor, having taken courses at the Actors Studio; in later years he became a horse trainer.[202] This *Screen Test* was probably shot in early 1965, prior to his appearance in *Vinyl*.

In his portrait film, a relaxed McDermott smiles briefly at the camera, then squints against the lights, casually smoking a cigarette. His broken nose and scarred chin give him the pleasantly tough look of a French movie gangster; the oblique lighting highlights his asymmetrical features.

**ST209  *Taylor Mead*, 1964**
16mm, b&w, silent; 4.4 min. @ 16 fps, 3.9 min. @ 18 fps
Preserved 1999, MoMA *Screen Tests* Reel 19, no. 4
COMPILATIONS *The Thirteen Most Beautiful Boys* (ST364)
FILM MATERIALS
ST209.1 *Taylor Mead*
1964 Kodak 16mm b&w reversal original, 108'
NOTATIONS On original box in AW's hand: *Taylor Mead. 13*
On box in Gerard Malanga's hand, crossed out: *Personalities*

## ST210 *Taylor Mead,* 1964

16mm, b&w, silent; 4.4 min. @ 16 fps, 3.9 min. @ 18 fps
Preserved 1998, MoMA *Screen Tests* Reel 13, no. 4
COMPILATIONS *Fifty Fantastics and Fifty Personalities* (ST366)
FILM MATERIALS
ST210.1 *Taylor Mead*
1964 Kodak 16mm b&w reversal original, 105'
NOTATIONS On original box in unidentified hand: *Personalities Taylor's Mead's* (illeg.)

The actor, poet, writer, and filmmaker Taylor Mead can rightly be called the doyen of underground performance, having appeared in avant-garde plays and movies more or less continuously since the early 1960s. Although he has taken on many different roles, Mead specializes in loose-limbed improvisations that are wistful, raunchy, often wildly comic, and sometimes surprisingly athletic.

The son of a prominent Detroit political family, Mead left home at the age of twenty-two for San Francisco, where he read his poetry in coffeehouses and was eventually "discovered" by the filmmaker Ron Rice, who used Mead as the star of his 1960 film *The Flower Thief*; Mead also starred in Vern Zimmerman's film *Lemon Hearts* the same year. Mead soon moved to New York where, in 1963, he was awarded an Obie for his performance in Frank O'Hara's play, *The General Returns from One Place to Another.* Mead has appeared in underground and art films of all types, including Adolfas Mekas's *Hallelujah the Hills* (1963); Ron Rice's *The Queen of Sheba Meets the Atom Man* (1963, restored and preserved by Mead in 1982); Jerome Hill's *Open the Door and See All the People* (1964); Robert Downey's *Babo 73* (1964, in which he played the president of the United States); in the title role in John Chamberlain's *The Secret Life of Hernando Cortez* (1968); John Schlesinger's *Midnight Cowboy* (1969); Jose Rodriguez-Soltero's film *Dialogue with Che* (1968); Jean-Luc Godard's *Sympathy for the Devil (One Plus One)* (1968), and Eric Mitchell's *Underground U.S.A.* (1984). Mead has published numerous articles and letters, including excerpts from his memoirs *The Anonymous Diary of A New York Youth*, Volume IV of which is titled *Son of Andy Warhol*.[203] He remains a familiar fixture of the downtown scene in New York City, regularly giving performances and poetry readings, accompanied by his trademark transistor radio, at night spots like the Bowery Poetry Club.

Taylor Mead met Warhol in the summer of 1963, when Henry Geldzahler took him along on a visit to Warhol's home on Lexington Avenue. A few weeks later, Warhol invited him to drive out to Los Angeles along with Gerard Malanga and Wynn Chamberlain for the opening of Warhol's new exhibition at the Ferus Gallery. As Warhol recalled:

> Taylor agreed to split the cross-country driving with Wynn—Gerard and I didn't know how to drive. I frankly couldn't believe from looking at Taylor that he really knew how to drive—I've always been surprised at the people who can drive and the people who can't.[204]

In Los Angeles, Warhol filmed *Tarzan and Jane Regained, Sort Of . . .*, a feature film conceptualized by Mead that starred Mead and Naomi Levine; once they returned to New York, Mead edited the film and created a separate sound track with his own narration and musical arrangements.

Mead had a long career in the Warhol films, beginning with early 1963 films such as *Taylor and Me, Duchamp Opening, Taylor and John,* and continuing into 1964 with appearances in rolls shot for *Allen, Batman Dracula,* and *Couch* and the starring role in *Taylor Mead's Ass.* After a hiatus of a couple of years in Europe, Mead

returned to New York in 1967 to star in a number of Warhol's later features: *The Nude Restaurant, Tub Girls,* and *Imitation of Christ* in 1967, and *Lonesome Cowboys* and *San Diego Surf* in 1968. Mead also appears in several additional reels of ★ ★ ★ ★ *(Four Stars)* from 1967: *Viva and Taylor* (Reel 70), *Taylor* (Reel 78), and *Lil Picard* (Reel 79).

In one of his two *Screen Tests* from 1964 (ST209), a bare-chested Mead faces the camera placidly at first but, clearly unable to hold still for more than a few seconds, soon begins cutting up—rolling his eyes, sneering, pouting, grinning goofily, sticking out his tongue, singing, barking at the camera, twitching his nose, making kissing motions, and snarling. In the next film (ST210), Mead again misbehaves; after a series of exaggerated yawns, he picks his nose, grins impishly, wipes his mouth, smooths his hair, laughs outright, and blows kisses to the camera.

## ST211 *Jonas Mekas,* 1966

16mm, b&w, silent; 4.5 min. @ 16 fps, 4 min. @ 18 fps
Preserved 1995, MoMA *Screen Tests* Reel 10, no. 8
COMPILATIONS *Screen Tests/A Diary* (Appendix A)
FILM MATERIALS
ST211.1 *Jonas Mekas*
1966 Kodak 16mm b&w reversal original, 108'
NOTATIONS On original box in AW's hand: *Jonas Mekas*

Filmmaker, poet, critic, and film activist Jonas Mekas has been the foremost advocate of avant-garde cinema in the United States since the late 1950s. As David James described Mekas, "in his interwoven career as a journalist, an exhibitor and distributor, an archivist, a tireless publicist, polemicist, and fundraiser, he was a self-styled 'raving maniac of the cinema'."[205] Mekas was one of the earliest and most important champions of Warhol's cinema in the 1960s and the first person to organize public exhibitions of Warhol's movies, many of which premiered at the Film-Makers' Cinematheque. Mekas regularly reviewed and promoted Warhol's films in his weekly "Movie Journal" column in the *Village Voice*, where he was also the first critic ever to mention a Warhol film in print.[206] In 1964, *Film Culture* presented its Sixth Independent Film Award to Warhol for his films *Sleep, Haircut, Eat, Kiss,* and *Empire.*[207]

Jonas Mekas and his brother, Adolfas, emigrated to New York from Lithuania after the Second World War. In 1955 he founded *Film Culture* magazine; in 1958 he began writing a weekly movie column for the *Village Voice*, which he continued through 1976. In 1962 he founded the Film-Makers' Cooperative, which was the main distributor of the Warhol films from 1964 through 1970, and in 1964 he founded the Film-Makers' Cinematheque, which regularly screened programs of avant-garde films at a variety of locations in Manhattan. In 1970 Mekas, together with his colleagues P. Adams Sitney, Peter Kubelka, James Broughton, Stan Brakhage, and Ken Kelman, founded Anthology Film Archives, the first American museum devoted to the art of film; Warhol's films *Eat* (1964) and *The Chelsea Girls* (1966) were included in Anthology's founding collection as part of "The Essential Cinema."

Mekas has received international acclaim as a filmmaker, especially for his diary films, poetic assemblages of everyday life shot on his 16mm Bolex: *Diaries, Notes, and Sketches* (1968–69); *Lost, Lost, Lost* (1949–1975); *Paradise Not Yet Lost* (1969–79); *He Stands in a Desert Counting the Seconds of His Life* (1969–85). Mekas has made

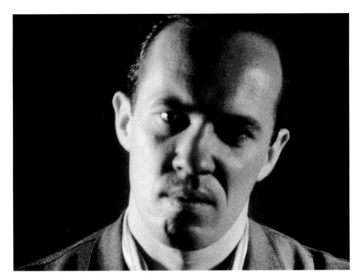

ST208

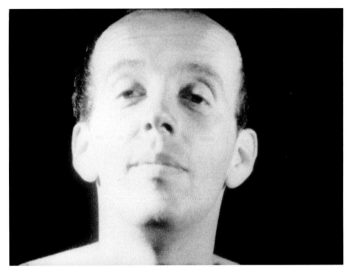

ST209

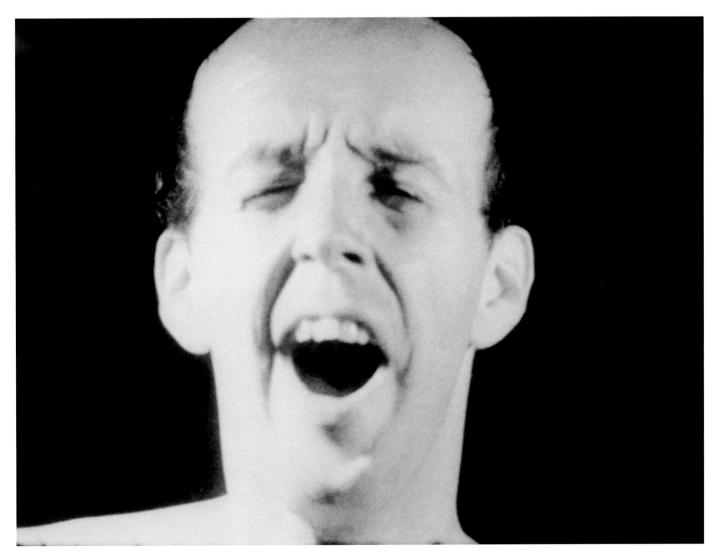

ST210

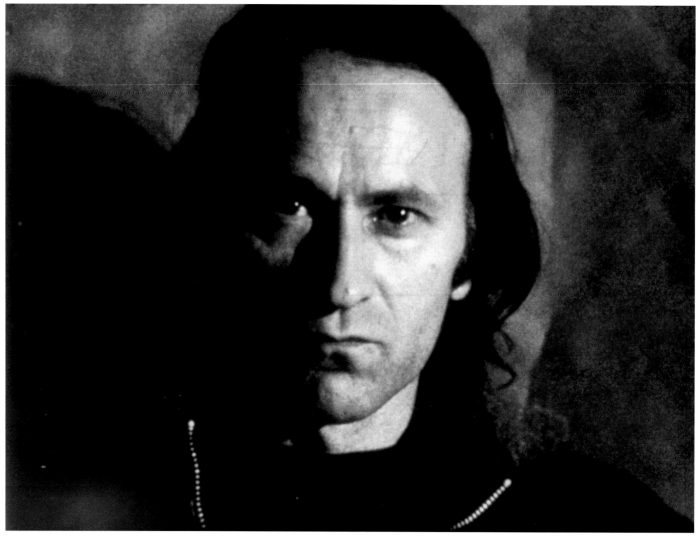

ST211

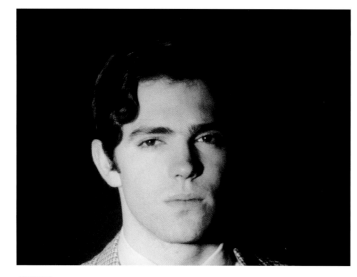

ST212

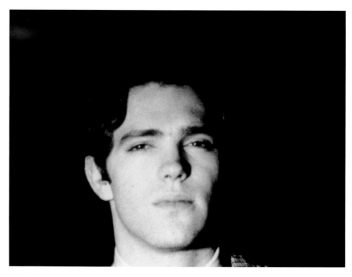

ST213

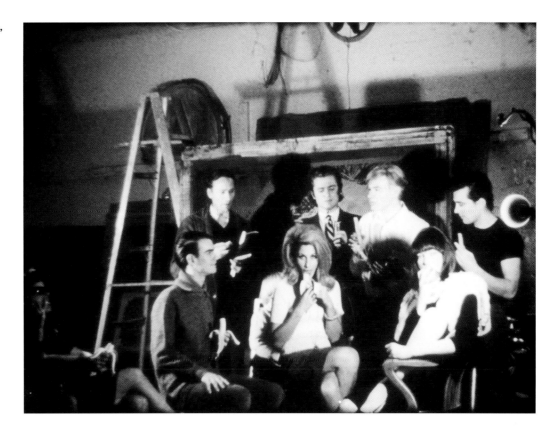

From left: Kenneth King, Jonas Mekas, Jane Holzer, Gerard Malanga, Andy Warhol, Ivy Nicholson, and Philip Fagan in Jonas Mekas's film *Award Presentation to Andy Warhol*, 1964.

two films about Warhol: *Award Presentation to Andy Warhol* (1964),[208] and *Scenes from the Life of Andy Warhol* (1965–1990). Mekas also served as the cameraman on Warhol's *Empire*, shot on a rented Auricon sync-sound camera identical to the camera Mekas himself had recently used to shoot *The Brig* (1964).

In this 1966 *Screen Test*, Mekas has been harshly lit from the right side only. Wearing a zippered jacket with a furry collar, he glares fiercely at the camera, a revolutionary on the ramparts of cinema. Mekas blinks frequently and swallows occasionally, suggesting that he is not quite as comfortable on this side of the camera lens.

### ST212   *François de Menil,* 1965

16mm, b&w, silent; 4.5 min. @ 16 fps, 4 min. @ 18 fps
Preserved 2001, MoMA *Screen Tests* Reel 26, no. 6
COMPILATIONS   *The Thirteen Most Beautiful Boys* (ST364)
FILM MATERIALS
ST212.1  *François de Menil*
1965 Kodak 16mm b&w reversal original, 109'
NOTATIONS   On original box in AW's hand: *Demille. 13? little moving, not BAD*

### ST213   *François de Menil,* 1965

16mm, b&w, silent; 4.5 min. @ 16 fps, 4 min. @ 18 fps
Preserved 1995, MoMA *Screen Tests* Reel 6, no. 4
FILM MATERIALS
ST213.1  *François de Menil*
1965 Kodak 16mm b&w reversal original, 109'
NOTATIONS   On original box in AW's hand: *Demenille Francois*

### ST214   *François de Menil,* 1965

16mm, b&w, silent; 4.5 min. @ 16 fps, 4 min. @ 18 fps
Preserved 1995, MoMA *Screen Tests* Reel 5, no. 4
FILM MATERIALS
ST214.1  *François de Menil*
1965 Kodak 16mm b&w reversal original, 109'
NOTATIONS   On original box in AW's hand: *Demenille, Francois*

The architect and filmmaker François de Menil is the son of John and Dominique de Menil, the wealthy Houston art patrons and collectors who commissioned the Rothko Chapel in the late 1960s; Dominique later founded the Menil Collection museum in Houston. In 1967 the Menils commissioned Warhol to make a series of religious films about sunsets for the Ecumenical Chapel at the San Antonio HemisFair, an uncompleted work for which Warhol shot several reels (see *Sunset*, 1967, Volume 2). In 1969 they invited Warhol to create the exhibition Raid the Icebox at the Rhode Island School of Design in Providence. Fred Hughes, who was Warhol's business manager and closest colleague throughout the 1970s and 1980s, was originally a student and protégé of Dominique de Menil's, through whom he first met Warhol.

In 1965, the twenty-year-old François de Menil, who knew Warhol through his parents, was studying acting in New York City and pursuing his interests in film. He recently recalled the occasion on which his *Screen Test* was shot:

> The factory was all covered with tinfoil and was one of the strangest places I had seen. You always had the impression that something was going on there that you didn't exactly understand . . . The Screen Test consisted of sitting in a chair while Gerard Malanga filmed the test. There was a chair with the tinfoil background and a 16mm camera on a tripod and lights on stands . . . I don't

think you were asked to do very much other than to look at the camera, so I remember feeling very self conscious and uncomfortable.[209]

Menil does seem somewhat uncomfortable in these three *Screen Tests*, squinting into the camera with a guarded expression. In one film (ST212), which Warhol notated as "13? Little moving, not bad," Menil has been lit at a three-quarter angle from the left. He glances briefly at the camera and then stares straight in front of him as if avoiding catching the camera's eye; the right side of his face fades off into deep shadow. The second film (ST213) begins with the same lighting arrangement, but after a few moments the light source is moved closer to his face, brightening it considerably. Menil seems to find this intensified lighting quite annoying; he narrows his eyes and blinks frequently, trying to look away from the light. In the third film (ST214), he has been given more freedom to look around, and frequently does so, turning his head left and right or tilting it back to look up at the ceiling.

François de Menil did indeed become a filmmaker: one of his early films is a 1968 work titled *Evening of Light*, in which Nico and rock star Iggy Pop cavort in a field filled with mannequins. Menil has received various awards for his work as an architect, most notably for the Byzantine Fresco Chapel Museum in Houston and for the Bottega Veneta retail stores.

## ST215   *Marie Menken,* 1966
16mm, b&w, silent; 4.5 min. @ 16 fps, 4 min. @ 18 fps
Preserved 1995, MoMA *Screen Tests* Reel 7, no. 9
COMPILATIONS   *Screen Tests/A Diary* (Appendix A)
FILM MATERIALS
ST215.1   *Marie Menken*
1966 Kodak 16mm b&w reversal original, 109'
NOTATIONS   On box in unidentified hand: *Warhol. MARIE MENKEN*

The filmmaker and painter Marie Menken, wife of Willard Maas, seems to have been an early influence on Warhol's cinema: her hand-held, pixillated shooting style turns up in some of Warhol's earliest films, such as *Tarzan and Jane Regained, Sort Of . . .* (1963) and *Marisol—Stop Motion* (1963). In 1965 Menken made a film called *Andy Warhol,* which shows Warhol and his assistant Gerard Malanga at work at the Factory. Shot with much single-framing or "stop-action," Menken's film reanimates the activity of Warhol's studio into a high-speed production line, churning out rows of *Brillo Soap Pads Box* sculptures and *Jackie* and *Flowers* paintings that march rapidly across the screen.

Warhol was very fond of Menken, an affection she returned. As he recalled:

> The first time I went out to their house with Charles Henri [Ford], Marie was the only person there who'd ever heard of me. She introduced me to the poets Frank O'Hara and Kenneth Koch and she had her arms around me and was telling them how famous I was going to be someday, and that sounded great to me. Naturally I thought she was wonderful.[210]

Warhol used Menken in several of his movies. She appeared in his 1965 film *The Life of Juanita Castro,* in which she played the title role. That same year, Warhol shot *Bitch,* a film of Menken and Maas at home in their apartment at 62 Montague Street in Brooklyn. Menken also played the role of Edie Sedgwick's prison warden

in *Prison,* and in 1966 appeared as Gerard Malanga's mother in a two-reel sequence called *The Gerard Malanga Story,* one reel of which was included in *The Chelsea Girls.* Marie Menken died on December 29, 1970, at the age of sixty-one at her home in Brooklyn, followed a few days later by her husband, Willard Maas.

In this *Screen Test,* shot in 1966, Menken, with the high collar of her coat pulled up around her throat, has been posed against a light-colored background and strongly lit from the right; her shadow fills the left side of the frame. Menken stares inscrutably at the camera through puffy, slanted eyes, blinking occasionally but otherwise holding perfectly still. Her weathered face reflects her life as a heavy drinker, and seems to confirm Mario Montez's observation that Menken "looked like Broderick Crawford in drag."[211]

## ST216   *Michael,* undated
16mm, b&w, silent; 4 min. @ 16 fps, 3.6 min. @ 18 fps
Preserved 2001, MoMA *Screen Tests* Reel 28, no. 3
FILM MATERIALS
ST216.1   *Michael*
Undated Ansco 16mm b&w reversal original, 97'
NOTATIONS   On Sovereign film box in AW's hand: *Micheal Rene* (or "Gene"—handwriting is not clear)
Return address on mailing label on box: *ANDY WARHOL, 231 E. 47th ST., N.Y.C.*

A young man identifiable only as "Michael" appears in a single *Screen Test,* shot on undatable, low-contrast Ansco stock. Michael's last name is not clearly legible in Warhol's handwriting on the film box, but could be either "Rene" or "Gene." Filmed against a dark backdrop, Michael has been lit from the left, which illuminates his shiny skin and reveals a number of spots on his face, which could be either freckles or blemishes. He holds a steady pose throughout the roll, nervously eyeing the camera and occasionally looking down or blinking. His self-consciousness makes him seem very young.

## ST217   *Allen Midgette,* 1967
16mm, b&w, silent; 4.5 min. @ 16 fps, 4 min. @ 18 fps
Preserved 1998, MoMA *Screen Tests* Reel 14, no. 5
COMPILATIONS   *Screen Tests/A Diary* (Appendix A)
FILM MATERIALS
ST217.1   *Allen Midgette*
1966 Kodak 16mm b&w reversal original, 108'
NOTATIONS   On original box in unidentified hand: *Allen Midgette*
On box flap in AW's hand: *(ALLEN MIDGETTE)*

Allen Midgette came to the Warhol Factory with more professional acting experience than most other Warhol film stars, having appeared in two Bernardo Bertolucci films, *The Grim Reaper* (1962) and *Before the Revolution* (1964), before he met Warhol. Midgette was introduced to Warhol by Susan Bottomly in December 1966, and was immediately invited along on a trip to Philadelphia with a group of Factory performers that included Ivy Nicholson, Rod La Rod, Ultra Violet, and Mary Woronov. Midgette and the other superstars performed in several color reels shot in a swimming pool on the roof of the Drake Hotel and in the Egyptian wing of the Philadelphia Museum of Art; two of these reels, *Ivy Swimming* and *Ivy in Philadelphia,* were eventually included in the 1967 screening of the twenty-five-hour ★ ★ ★ ★ *(Four Stars).*

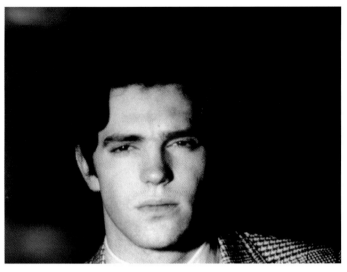

ST214

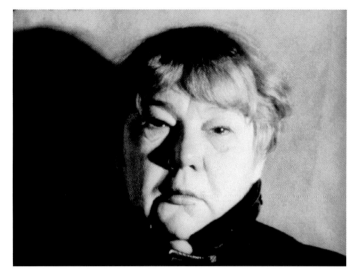

ST215

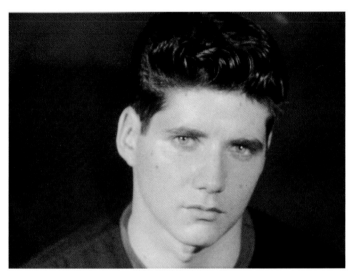

ST216

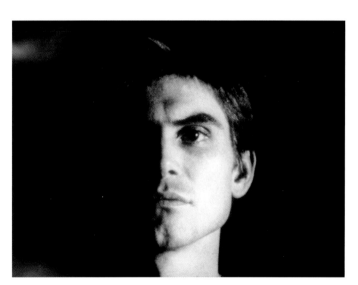

ST217

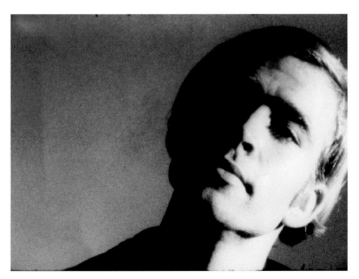

ST218

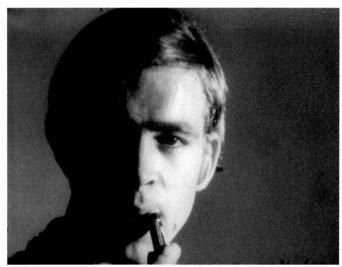

ST219

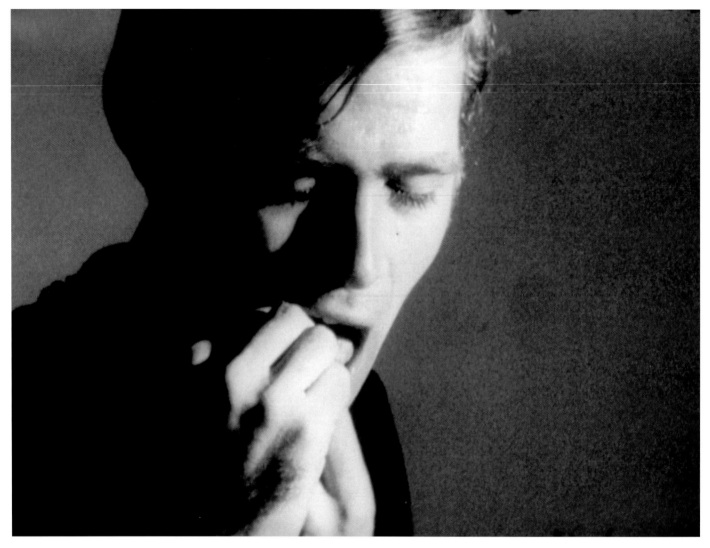

ST219

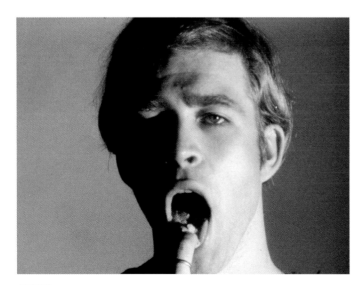

ST220

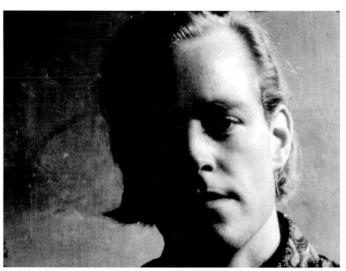

ST221

Although Midgette's time at the Factory was relatively brief, he does appear in a great deal of Warhol footage from 1967, including nearly two dozen half-hour reels shot for ★ ★ ★ ★ (Four Stars), as well as the released features *The Nude Restaurant* and *Imitation of Christ* from 1967, and *Lonesome Cowboys* in 1968.[212] Midgette left New York in the summer of 1967 for San Francisco, but agreed to impersonate Warhol at a series of lectures at college campuses in the western United States that fall. Disguising himself in Warhol's leather jacket, a silver wig, and some pale makeup, Midgette made undetected public appearances at universities and colleges in New York, Montana, Utah, and Oregon. The uncovering of this hoax in early 1968 garnered Warhol some press coverage, although the Warhol organization did have to return the lecture fees.[213] Warhol later reflected on Midgette's role in this imposture:

> I still thought that Allen made a much better Andy Warhol than I did—he had high, high cheekbones and a full mouth and sharp, arched eyebrows, and he was a raving beauty and fifteen/twenty years younger. Like I always wanted Tab Hunter to play me in a story of my life—people would be so much happier imagining that I was as handsome as Allen and Tab were.[214]

Bearing little resemblance to Warhol, Midgette has been posed for his *Screen Test* against a background of darkness and lit only from the right side, with the left side of his face hidden in shadow. Midgette stares straight ahead and slightly to the left throughout the film; toward the end of the roll he opens his mouth slightly. There is a strange rhythmic flickering in the film image, which may indicate some kind of problem with the camera shutter.

Midgette continued to work as a film actor after his Warhol period, appearing in two more Bertolucci films, *The Spider's Stratagem* (1970) and *1900* (1976), as well as in Jean-Luc Godard's 1969 film *Wind from the East*. After Warhol's death in 1987, Midgette occasionally reprised his performance as Warhol's double, materializing at New York openings in wig and white makeup, much to the surprise of other guests.[215] He now works on his own Warhol-influenced art and dresses up as Warhol only when hired to do so.

### ST218   *George Millaway,* 1966
16mm, b&w, silent; 4.6 min. @ 16 fps, 4.1 min. @ 18 fps
Preserved 1998, MoMA *Screen Tests* Reel 14, no. 8
**FILM MATERIALS**
ST218.1 *George Millaway*
1966 Kodak 16mm b&w reversal original, 110'
**NOTATIONS** On original box in unidentified hand: *George scene test*

### ST219   *George Millaway,* 1966
16mm, b&w, silent; 4.5 min. @ 16 fps, 4 min. @ 18 fps
Preserved 1998, MoMA *Screen Tests* Reel 15, no. 2
**FILM MATERIALS**
ST219.1 *George Millaway*
1966 Kodak 16mm b&w reversal original, 107'
**NOTATIONS** On original box in unidentified hand: *Georg. screentest*

### ST220   *George Millaway (Peanut Butter),* 1966
16mm, b&w, silent; 4.5 min. @ 16 fps, 4 min. @ 18 fps
**COMPILATIONS** *Eric Background: Toby Short,* 1966 (See Vol. 2)
**FILM MATERIALS**
ST220.1 *Eric Background: Toby Short,* roll 9
1966 Kodak 16mm b&w reversal original, 108'

George Millaway, a poet, appears in two *Screen Tests* from 1966 and also in several "background reels" that were used during the making of *The Chelsea Girls* that year; these silent, black-and-white reels were projected behind or onto the actors during filming, and can be seen in *Eric Tells All* (Reel 9 of *The Chelsea Girls*).[216] Two of these films, in which Millaway posed with Mary Woronov, have been catalogued under the Mary Woronov *Screen Tests* (ST360–361).

In one of his three solo *Screen Tests* (ST218), Millaway has been posed against a light background and brightly lit from the right side only, with the entire left side of his face and head hidden in blackness. Millaway chews gum and produces a series of rapid and rather artificial grins directed at the camera and at offscreen observers, alternating these smiles with an unsmiling and rather blasé expression. In another, much livelier *Screen Test* (ST219), Millaway continues to chew gum, first while applying lip balm and then while flossing his teeth. This film is shot with a great many in-camera cuts, changes in framing, and rapid fluctuations in exposure. The roll ends in a frenzy of rapid, blurry shots of Millaway, apparently a series of single-frame exposures made while the camera was in motion. A third *Screen Test* (ST220), found in a *Chelsea Girls* background reel titled *Eric Background: Toby Short,* shows Millaway sensuously eating peanut butter out of a jar with a finger, sucking on his finger and rubbing his teeth.

### ST221   *Chip Monck,* 1966
16mm, b&w, silent; 4.4 min. @ 16 fps, 3.9 min. @ 18 fps
Preserved 1999, MoMA *Screen Tests* Reel 18, no. 3
**FILM MATERIALS**
ST221.1 *Chip Monck*
1965 Kodak 16mm b&w double-perf. reversal original, 105'
**NOTATIONS** On original box in AW's hand: *CHICO*

Chip Monck is known for lighting and designing some of the most important rock-and-roll concerts of the 1960s and after. He designed the staging and lighting for both the Newport Folk Festival of 1965, when Bob Dylan shocked the crowd by going electric, and the 1967 Monterey Pop Festival, documented in D. A. Pennebaker's 1969 film *Monterey Pop*. Monck was the lighting and technical designer and emcee at the Woodstock Music and Art Fair in August 1969, and can be seen in Michael Wadleigh's 1970 documentary of that event, warning the crowd to avoid the "brown acid." Monck also worked as stage manager for the Rolling Stones during their 1969 *Let It Bleed* U.S. tour, introducing the band at the beginning of each show, "Ladies and gentlemen, the Rolling Stones"; he was present at the Stones's disastrous concert at the Altamont Motor Speedway on December 6, 1969, an event captured in the Maysles Brothers' 1970 film *Gimme Shelter*. He designed the staging and lighting of George Harrison's *Concert for Bangladesh* in 1971, and also for the Rolling Stones's 1972 U.S. tour, filmed by Robert Frank in his rarely seen documentary *Cocksucker Blues*.

For his *Screen Test*, which was probably shot in early 1966, Monck has been lit severely from the right side only, with the left side of his face and his eyes hidden in dark shadow. With his blond hair tucked behind his ear, Monck smokes, looks around, and occasionally smiles or laughs at the camera. He then becomes more pensive, nodding his head to music while smoke from his cigarette slowly rises in the left side of the frame.

## ST222 *Mario Montez,* 1965

16mm, b&w, silent; 4.5 min. @ 16 fps, 4 min. @ 18 fps

**FILM MATERIALS**

ST222.1 *Mario Montez*

1965 Kodak 16mm b&w reversal original, 109'

**NOTATIONS** On box in AW's hand: *Mario*

With arrow pointing to: *SCREEN TEST*

On box in AW's hand, crossed out: *Naomi*

The drag performer Mario Montez made his first screen appearances in Jack Smith's films, appearing under the name Delores Flores in *Flaming Creatures* (1962–63), playing a mermaid in *Normal Love* (1963–64), and later appearing in Smith's *No President* (1967–70). Montez took his stage name from one of his "favorite screen sirens," the Hollywood "B" actress Maria Montez, who was Jack Smith's muse as well; Mario emulated Maria because, he explained, "she does everything with fire—nothing is pretended."[217] In 1964 Mario Montez appeared in the Warhol/Smith collaboration *Batman Dracula*; by the end of that year, Warhol had started using Montez in his own films, casting him as Jean Harlow in the lead role in his first sync-sound feature, *Harlot.* Like an actress on loan from one Hollywood studio to another, Montez continued to work with Warhol over the next few years, appearing in *Mario Banana* and *Mario Montez Dances* in 1964; *Screen Test No. 2, Camp,* and *More Milk Yvette* in 1965; and *Hedy, The Chelsea Girls, Bufferin Commercial,* and *Ari and Mario* in 1966.

Warhol had immense appreciation for Montez's acting abilities:

> Jack Smith always said that Mario was his favorite underground actor because he could instantly capture the sympathy of the audience . . . Mario had that classic comedy combination of seeming dumb but being able to say the right things with perfect timing: just when you thought you were laughing at him, he'd turn it all around.[218]

As a Warhol film star, Montez became one of the first transvestite actors to receive mainstream recognition. In February 1966, the *New York Post*'s film reviewer Archer Winsten apologized in print for mistakenly calling "Manhattan's best known transvestite" "Maria" in his earlier review of *More Milk Yvette.*[219] In 1967 Montez was interviewed by John Gruen in an article titled "The Underground's M.M.—Mario Montez," and was also singled out by the *New York Times* for his performance in *The Chelsea Girls.*[220]

In his *Screen Test,* Mario is dressed in the same red wig, purple dress, and pearl choker that he wears in four 100' test rolls shot for *More Milk Yvette.* In these silent test rolls, one of which is in lavish color, Montez and his costar Richard Schmidt, rehearsing their roles as Lana Turner and her daughter, Cheryl Crane, kiss and eat a hamburger together while locked in a tight embrace. It seems likely that Montez and Schmidt's *Screen Tests* were both shot on this same day, some time in the late fall of 1965.[221] Mario, his mouth slightly open and his wig carefully disheveled, holds very still throughout the length of his *Screen Test,* sustaining an air of startled vulnerability.

In addition to his Warhol and Smith films, Montez also appeared in many other underground movies, including Ron Rice's film *Chumlum* (1964), Bill Vehr's film *Brothel* (1966), Jose Rodriguez-Soltero's *Lupe* (1966), and two of Avery Willard's Ava-Graphics productions ("dedicated to recording of female impersonators on film"), *Flaming Twenties* (1968) and *Gypsy's Ball* (1969).[222] Montez and Warhol can both be seen in Frank Simon's 1968 film *The Queen,* a documentary about the 1967 Miss All-America Camp Beauty Pageant, at which Warhol was a judge. Montez also appeared in a number of off-off-Broadway performances in the late 1960s and early 1970s, including

the Playhouse of the Ridiculous production of Ronald Tavel's *Screen Test* and *Indira Gandhi's Daring Device* in 1966. In 1972 he and Jackie Curtis starred in an all-male production of *The Trojan Women* at the Theatre of the Lost Continent. In later years, Montez abandoned his career as a performer and resumed his real name, Rene Rivera.

## ST223 *Sterling Morrison,* 1966

16mm, b&w, silent: 4.3 min. @ 16 fps, 3.9 min. @ 18 fps

Preserved 1999, as roll 3 of *EPI Background: Original Salvador Dalí* (ST367)

**COMPILATIONS** *EPI Background: Original Salvador Dalí* (ST367); *EPI Background: Gerard Begins* (ST368)

**FILM MATERIALS**

ST223.1 *EPI Background: Original Salvador Dalí* (ST367.1), roll 3

1965 Kodak 16mm b&w reversal original, 104'

ST223.1.p1 *EPI Background: Gerard Begins* (ST368.1), roll 6

16mm b&w reversal print, 100'

## ST224 *Sterling Morrison,* 1966

16mm, b&w, silent; 4 min. @ 16 fps, 3.6 min. @ 18 fps

**COMPILATIONS** *EPI Background: Lost Reel* (ST371)

**FILM MATERIALS**

ST224.1 *Sterling Morrison*

1965 Kodak 16mm b&w reversal original, 97'

**NOTATIONS** No box

On clear film at head of film roll: *3*

## ST225 *Sterling Morrison (Smoking),* 1966

16mm, b&w, silent; 4 min. @ 16 fps, 3.6 min. @ 18 fps

Preserved 1999, MoMA *Screen Tests* Reel 23, no. 1

**COMPILATIONS** *EPI Background: Lost Reel* (ST371)

**FILM MATERIALS**

ST225.1 *Sterling Morrison (Smoking)*

1965 Kodak 16mm b&w reversal original, 96'

**NOTATIONS** On box in AW's hand: *John* (illeg. word)

On box flap in unidentified hand: *Lou Smoking*

On clear film at head of film roll: *7*

Sterling Morrison, founding member of the Velvet Underground, was born on Long Island and attended various colleges including Syracuse University, where he studied literature and met Lou Reed before joining the rock band as bass guitarist in 1965. In 1966 he appeared in several Warhol films, including *The Velvet Underground and Nico, The Velvet Underground,* and *The Velvet Underground Tarot Cards.* After the Velvet Underground broke up in 1971, Morrison earned a Ph.D. in medieval studies from the University of Texas at Austin, and also worked as a licensed tugboat captain. He participated in the 1993 European reunion of the Velvets, and was a featured performer with the Hudson Valley Philharmonic in 1994.[223] In August 1995, Morrison died of non-Hodgkin's lymphoma at his home in Poughkeepsie, New York, at the age of fifty-three; in January 1996, he and the other members of the Velvet Underground were inducted into the Rock and Roll Hall of Fame.

The earliest of Morrison's three *Screen Tests* (ST223) was found spliced together with other *Screen Tests* in an assembled roll labeled *Original Salvador Dalí* (ST367). Morrison, who is wearing a polka-dot shirt and a tired, bleary expression, moves very little during the

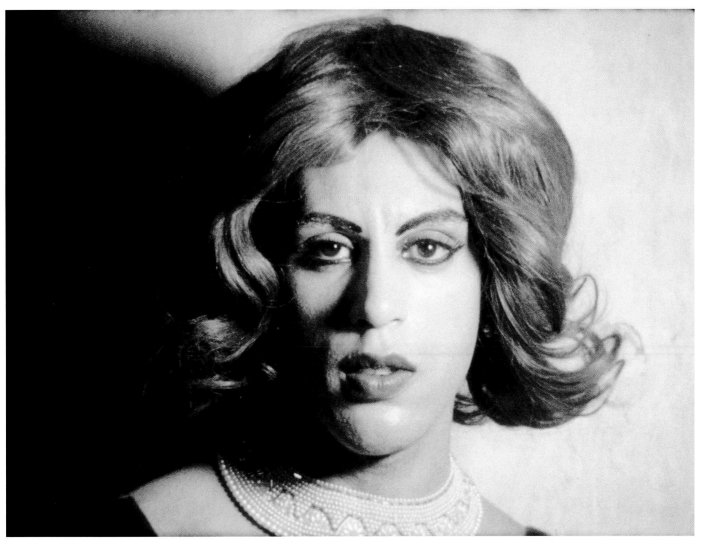

ST222

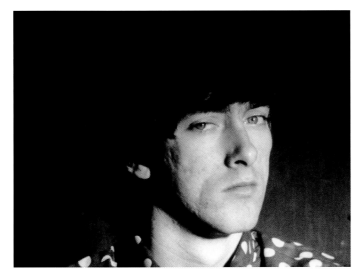

ST223

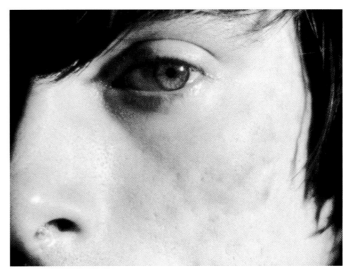

ST224

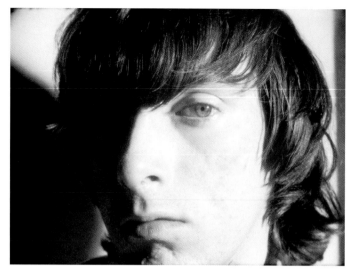

ST224

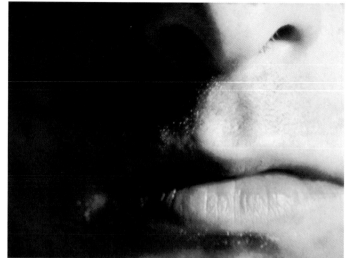

ST225

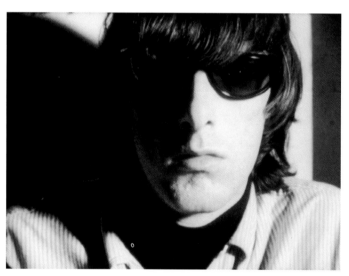

ST225

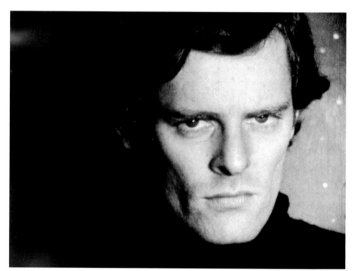

ST226

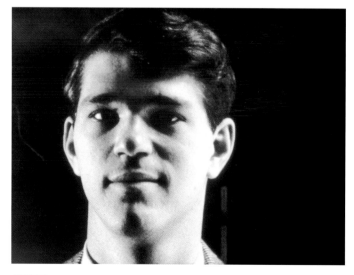

ST227

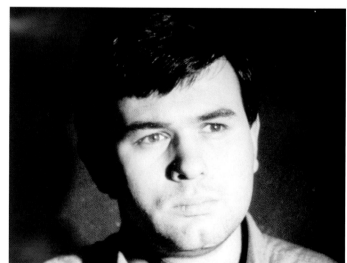

ST228

length of the roll. The other two films of Morrison are close-ups of details of his face; the numbers written on the head leader for these films indicate that they were probably used for projection behind the Velvet Underground during their performances in the EPI (Exploding Plastic Inevitable). One film (ST224) is an extreme close-up of Morrison's left eye, which looks around in all directions; halfway through the film, the camera zooms out to a full view of his half-lit face. The third *Screen Test* (ST225) starts with a close-up of Morrison's mouth, dragging heavily on a cigarette. After three drags, the camera zooms back to show Morrison looking pale and punk in a pair of dark sunglasses, his long hair falling around his face. His left eye is faintly visible through the lens of his glasses.

## ST226   *Paul Morrissey,* 1965

16mm, b&w, silent; 4.5 min. @ 16 fps, 4 min. @ 18 fps
Preserved 1995, MoMA *Screen Tests* Reel 10, no. 10
**COMPILATIONS** *Screen Tests/A Diary* (Appendix A)
**FILM MATERIALS**
ST226.1   *Paul Morrissey*
1965 Kodak 16mm b&w reversal original, 109'
**NOTATIONS** On original box in unidentified hand: *Paul Morrissey*
On typed label found in can: *PAUL MORRISSEY*

Paul Morrissey began making experimental films in the early 1960s, silent 16mm shorts filled with social satire and dark humor. During this period, he also ran a cinema showcase called Exit Film in the storefront where he lived on East 4th Street. In the summer of 1965, Morrissey was introduced to Warhol by Gerard Malanga at a screening of Warhol films at the Film-Makers' Cinematheque; Morrissey's films were being shown at the Cinematheque that same summer as well.[224] At Warhol's invitation, Morrissey started coming by the Factory

> to see how we did things and if there was any way he could get involved . . . He was fascinated to see our setup and he asked Buddy Wirtschafter, who was then our sound man, a lot of questions. Gerard was right, Paul was very resourceful—eventually to the point where he came to seem magical to us.[225]

The first Warhol film Morrissey worked on was *Space* (1965), for which he receives spoken credit on the sound track for "special assistance," having given Warhol some advice on camera angles. Soon after, on Labor Day weekend, he accompanied the Warhol cast and crew to Fire Island for the shooting of *My Hustler,* for which he did the sound; Morrissey also talked Warhol into panning the camera during one scene. Morrissey thereafter became increasingly involved in the making of most of Warhol's films, eventually outlasting other assistants and collaborators such as Bud Wirtschafter, Chuck Wein, Dan Williams, Malanga, and Ronald Tavel. When asked in 1975 to define his and Warhol's respective roles in the making of earlier films like *My Hustler* and *The Chelsea Girls,* Morrissey recalled: "I just understood what Andy was doing and helped him to do it. Andy usually operated the camera. I always did the lights, organized the film, got the actors together, told them what to do."[226]

As Warhol became more commercially ambitious about his films, Morrissey's input into their production became more important; he often made up the unscripted stories or "situations" that formed the basis of the later feature-length narratives, and he did try to give the actors direction (although they usually didn't listen to him). By 1966 Morrissey had become something like Warhol's

film business partner, receiving percentages in some of the films and in Warhol's contracts with the Velvet Underground, while continuing to work on the films and travel with the Exploding Plastic Inevitable. In 1967 Morrissey received credit as "executive producer" on several of the released films, including *The Loves of Ondine* (1967) and *Lonesome Cowboys* (1968).

After Warhol was shot and almost killed by Valerie Solanas in June 1968, Morrissey wrote, photographed, and directed his first "solo" feature for Andy Warhol Films, Inc., *Flesh* (1968). This was followed by other commercial "Warhol" movies (*Trash* (1970), *Heat* (1971), *Women in Revolt* (1971), and *L'Amour* (1972)), which were written and/or directed by Morrissey, and for which Warhol functioned primarily as producer and occasional cameraman. During this time, Morrissey also served as director of and principal spokesperson for Andy Warhol Films, Inc., giving lengthy interviews to the press, negotiating bookings and distribution deals, and developing ideas for more films. In 1973 Morrissey directed two Andy Warhol features, *Flesh for Frankenstein* and *Blood for Dracula,* which were shot at the Cinecittá studio in Italy.

Morrissey ended his association with Warhol in 1975, and in 1977 made his first feature film outside the Warhol brand name, *The Hound of the Baskervilles.* This was followed by a series of features, each entirely written, directed, and photographed by Morrissey himself: *Madam Wang's* (1981), *Forty Deuce* (1981), *Mixed Blood* (1985), *Beethoven's Nephew* (1985), and *Spike of Bensonhurst* (1988).

In his 1965 *Screen Test,* Morrissey lowers his brow and stares back at the camera with a stern and determined look. A bright light falls from the right; the left side of the frame is completely black. As the film progresses, Morrissey lowers his brow further, as if trying to hide from the lights; by the end of the roll his eyes have begun to tear up.

## ST227   *Sophronus Mundy,* 1964

16mm, b&w, silent; 4.1 min. @ 16 fps, 3.7 min. @ 18 fps
Preserved 1995, MoMA *Screen Tests* Reel 11, no. 3
**COMPILATIONS** *The Thirteen Most Beautiful Boys* (ST364)
**FILM MATERIALS**
ST227.1   *Sophronus Mundy*
1963 Kodak 16mm b&w double-perf. reversal original, 98'
**NOTATIONS** On box in AW's hand: *Sofrano. (13) Sofranes (13)*
On box in AW's hand, crossed out: *Good Naomi. Freddy. Jimmy*

Sophronus Mundy, a friend of the collector Kelly Edey, was born in 1945 in upstate New York; later in life he worked as the chef at the Empire Diner, the famous Art Deco eatery at Eleventh Avenue and 22nd Street, when it reopened in 1977. Mundy also served as chef and companion to the composer Aaron Copland at Copland's home in Peekskill, New York, and cooked for the art historian John Pope-Hennessey. Sophronus Mundy died of AIDS in 1985.[227]

It seems likely that Mundy's *Screen Test* was among the earliest, probably shot at Edey's town house on West 83rd Street in January 1964. Mundy, framed offcenter to the left against a black background, has been lit evenly from both sides, with dark symmetrical shadows spilling down the center of his face. His eyes are mostly hidden in shadow, making it impossible to tell where he is looking, and giving him the appearance of a blind person. Mundy maintains a slight smile throughout the film.

**ST228  *David Murray*, 1965**
16mm, b&w, silent; 4.2 min. @ 16 fps, 3.7 min. @ 18 fps
Preserved 1998, MoMA *Screen Tests* Reel 13, no. 7
COMPILATIONS *Screen Test Poems* (ST372); *Screen Tests/A Diary*
(Appendix A)
FILM MATERIALS
ST228.1 *David Murray*
1965 Kodak 16mm b&w reversal original, 100', 104' with white
head leader
ST228.1.p1 *Screen Test Poems*, Reel 2 (ST372.2), roll 21
Undated Gevaert 16mm b&w reversal print, 99'
NOTATIONS On box in AW's hand: *David Murray*
On box in Gerard Malanga's hand: *at beginning of film marked by*
*masking tape—1 double frame negative and one 8 x 10 double frame stillie*
On box in unidentified hand, crossed out: *Moe, Reel B*
Typed label taped to inside of can: *DAVID MURRAY*
On white head leader: *12 – 22*
On clear film at head of roll: *12 – 22*
On clear film at tail of roll: *– 21 –*

The writer and poet David Murray was a friend of the actress Mary
Woronov when she was a student at Cornell University in 1965;
Murray's connections to Warhol and Gerard Malanga in New York
eventually led to Woronov's introduction into the Warhol circle.
In 1968, portions of David Murray's journal were published in the
special Warhol/Malanga issue of *Intransit* magazine. These journal
entries, a neo-Beat mélange of sex, drugs, and alienation, mention
Murray's friends Malanga, Dan Cassidy, Harry Fainlight, and also
Andy Warhol, "his inverted army crushing old art rebellions, in cel-
luloid and lace blankets."[228]

Murray appears in a *Screen Test* from 1965. Harshly lit from the
right, he looks past the camera, holding very still and making tiny
motions with his jaw, as if surreptitiously chewing gum. After a
while he turns to face the camera directly. As tears begin to well up,
he squeezes his eyes shut, keeping them closed until just before the
roll ends.

**ST229  *Noboru Nakaya*, 1964**
16mm, b&w, silent; 4.5 min. @ 16 fps, 4 min. @ 18 fps
Preserved 1999, MoMA *Screen Tests* Reel 20, no. 8
COMPILATIONS *Fifty Fantastics and Fifty Personalities* (ST366)
FILM MATERIALS
ST229.1 *Noboru Nakaya*
1964 Kodak 16mm b&w reversal original, 108'
NOTATIONS On original box in AW's hand: *Naboru Nakaya 50*

The Japanese actor Noboru Nakaya, born in 1929, worked prima-
rily in theater, but has appeared in a number of feature films as well.
He is probably most familiar to Western audiences for his role in
Masaki Kobayashi's 1964 *Kwaidan*, a film based on four supernatu-
ral tales by Lafcadio Hearn, in which Nakaya played a ghost-
samurai; the film was released in the United States in July 1965. In
1970 Nakaya appeared in Hideo Gosha's 1970 film *Tenchu*, a histor-
ical drama about imperial Japan in which the writer Yukio Mishima
also had a small role. Nakaya can also be seen in Toshiya Fujita's
1973 samurai action film *Lady Snowblood: Blizzard from the Nether-
world*, rereleased with English subtitles in 1997.

Nakaya's portrait film may have been shot at the end of October
1964, at the same time as Kyoko Kishida's *Screen Test* (ST183), when
the two actors seem to have been in New York to promote their
recent films. Placed against the glittering, out-of-focus space of the
silver Factory, Nakaya faces the camera with solemn poise, maintain-
ing the same unwavering position for the full three minutes. His
abstracted gaze seems to look not at the camera but right through it.

**ST230  *Ivy Nicholson*, 1964**
16mm, b&w, silent; 4.5 min. @ 16 fps, 4 min. @ 18 fps
Preserved 2001, MoMA *Screen Tests* Reel 25, no. 5; also preserved as
roll 4 in *Four of Andy Warhol's Most Beautiful Women* (ST365f)
COMPILATIONS *The Thirteen Most Beautiful Women* (ST365); *Four of
Andy Warhol's Most Beautiful Women* (ST365f)
FILM MATERIALS
ST230.1 *Ivy Nicholson*
1964 Kodak 16mm b&w reversal original, 107', 111' with tail leader
NOTATIONS On plain brown box in Paul Morrissey's hand: *Ivy
Nicholson 2*
On white tail leader in AW's hand: *FOOT. TRI-FILM. BEAUTI-
FUL GIRL*

**ST231  *Ivy Nicholson*, 1965**
16mm, b&w, silent; 4.5 min. @ 16 fps, 4 min. @ 18 fps
COMPILATIONS *The Thirteen Most Beautiful Women* (ST365); *3 Most
Beautiful Women* (ST365d)
FILM MATERIALS
ST231.1 *3 Most Beautiful Women* (ST365d.1), roll 4
1964 Kodak 16mm b&w original reversal, 108'

**ST232  *Ivy Nicholson*, 1965**
16mm, b&w, silent; 4.5 min. @ 16 fps, 4 min. @ 18 fps
Preserved 1995, MoMA *Screen Tests* Reel 5, no. 7
FILM MATERIALS
ST232.1 *Ivy Nicholson*
1964 Kodak 16mm b&w reversal original, 108'
NOTATIONS On original box in AW's hand: *Ivy PORTRAIT. Bl-eyed girl*

**ST233  *Ivy Nicholson*, 1966**
16mm, b&w, silent; 4.5 min. @ 16 fps, 4 min. @ 18 fps
FILM MATERIALS
ST233.1 *Ivy Nicholson*
1964 Kodak 16mm b&w reversal original, 109'
NOTATIONS On original box in AW's hand: *Ivy*
On box in Gerard Malanga's hand: *IVY N. PORTRAIT*

**ST234  *Ivy Nicholson*, 1965**
16mm, b&w, silent; 3.9 min. @ 16 fps, 3.5 min. @ 18 fps
Preserved 1995, MoMA *Screen Tests* Reel 11, no. 8
FILM MATERIALS
ST234.1 *Ivy Nicholson*
1965 Kodak 16mm b&w reversal original, 94'
NOTATIONS On box in AW's hand: *Ivy Screen Test*
On box in unidentified hand in heavy black marker: *Ivy N.
SCREEN TEST*
On box in unidentified hand, crossed out: *Taylor*

ST229

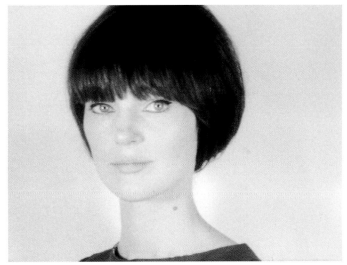

ST230

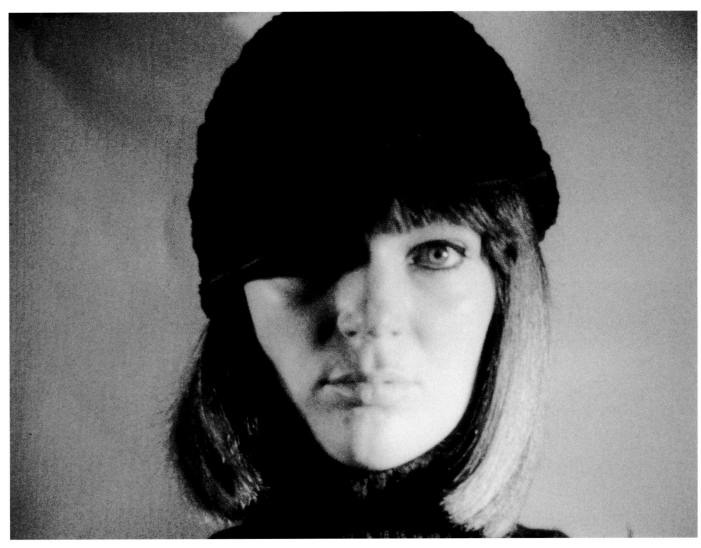

ST231

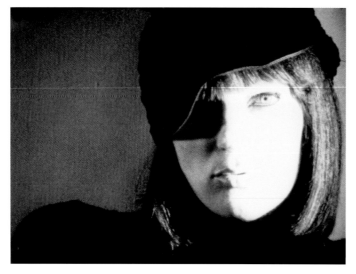

ST232

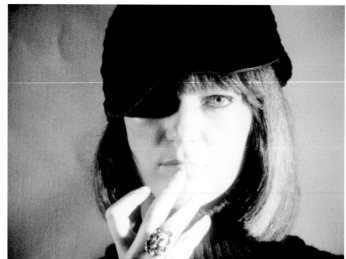

ST233

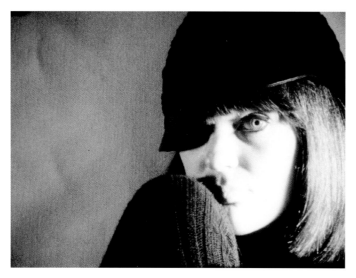

ST233

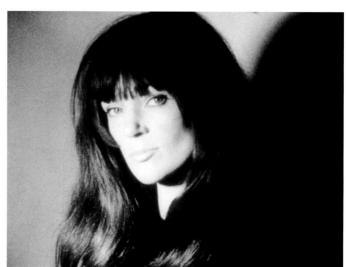

ST234

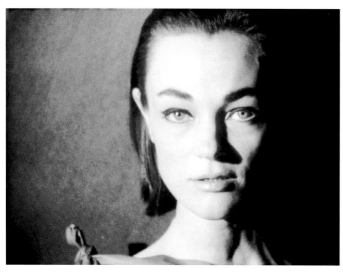

ST235

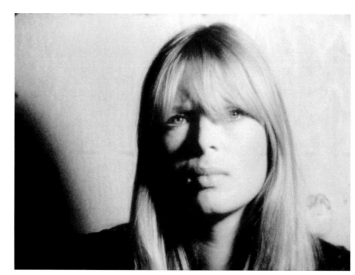

ST236

**ST235** *Ivy Nicholson*, 1966
16mm, b&w, silent; 4.6 min. @ 16 fps, 4.1 min. @ 18 fps
COMPILATIONS *Screen Tests/A Diary* (Appendix A)
FILM MATERIALS
ST235.1 *Ivy Nicholson*
1966 Kodak 16mm b&w reversal original, 110'
NOTATIONS Stamped on box: *LAB. TV*
Scratched on box: ★
On tape on can lid in unidentified hand: *IVY*
On typed label found in can: *IVY NICHOLSON*

In the 1950s, the lanky, long-legged Ivy Nicholson was a highly successful fashion model, working mostly in Europe and often appearing on the covers of *Vogue* and *Harper's Bazaar*.[229] In the 1960s, she also worked as a fashion photographer while continuing to model occasionally. When Nicholson first met Warhol in the early 1960s, she had two young children from previous marriages—Darius de Poleon, son of Count Regis de Poleon, and Sean Bolger, son of Larry Shaw—who often accompanied her to the Factory and who may be seen in some of the early films.[230]

In 1964 Nicholson appeared in several *Screen Tests*, as well as in *Couch*, *Batman Dracula*, and a few rolls of *Soap Opera*. In January 1965, Warhol filmed one of his earliest sound films, *John and Ivy*, showing Nicholson, her two sons, and her husband, the filmmaker John Palmer, at home in their tenement apartment in the East Village. After *John and Ivy*, Nicholson appears to have taken maternity leave from her career as a Warhol superstar; in November 1965, she gave birth to twins, Gunther Ethan and Penelope Palmer.[231] Warhol shot a *Screen Test* of the infant Penelope in early 1966 (ST255), but Nicholson did not appear in a Warhol film again until the late fall of 1966, following the release of *The Chelsea Girls*.

Nicholson's return to the Factory led to her starring in a great many color sound reels shot between late 1966 and the summer of 1967. Indeed, *Vibrations*, the original working concept from 1966 for the immensely long film that would eventually become the twenty-five-hour ★ ★ ★ *(Four Stars)* (1967), seems to have been centered largely around Nicholson and her long-winded, mystical monologues about her personal life. In addition to *Bufferin Commercial* and the released features *I, a Man* and *The Loves of Ondine*, Nicholson appears in at least thirty-five half-hour, color reels from this period, many of which ended up in the final version of ★ ★ ★ *(Four Stars)*.[232] Nicholson's involvement with the making of *Vibrations* extended to writing an outline of how she thought the film should be edited. Her handwritten manuscript, titled "Vibrations (Part One)," has been found in Warhol's papers, but her editing plan for the film was apparently never adopted.[233]

By mid-1967, Nicholson had begun to frighten Warhol with her growing conviction that the two of them should marry, an insistence that seems to have led to the end of her career as a Warhol star. As Warhol told the author Frederick C. Castle in June, "we wanted to shoot her babies and her but I think now maybe we'll just call it quits."[234] Nicholson did not appear in any Warhol films after that summer; after Warhol was shot in June 1968 she returned to Paris, where her children were raised. In 1987 *People* magazine ran a brief item about Nicholson that described her panhandling in San Francisco; as Warhol remarked in his *Diaries*: "She looks like the most beautiful bag lady you'll ever see."[235] Her son Darius de Poleon is the guitarist in a European aristocratic rock band called Eurotrash; her younger son Gunther Palmer appeared in soap operas on French television as a teenager and now writes poetry and performs in the band Stagefright. Her daughter has acted in several French movies under the name Pénèlope Palmer.

The shooting of what may be Nicholson's first *Screen Test* (ST230), shot in the fall of 1964 on the same day as one of her rolls in *Couch*, was witnessed by Howard Junker:

> Andy looked through the view finder. Ivy looked very good. Andy said she was glorious. He said she was fantastic. An assistant took a look and suggested a two-hour film of Ivy looking the way she was. It was a beautiful look. Ivy sat motionless while the camera ground through 100 feet.[236]

Looking catlike with her long neck, slanted blue eyes, and thick cap of black hair, Nicholson heroically struggles not to blink, narrowing her eyes and occasionally breathing through her mouth. This portrait was included in several versions of *The Thirteen Most Beautiful Women* (ST365e, ST365f).

A later series of three *Screen Tests*, showing Nicholson wearing a black visored cap, a ribbed turtleneck sweater, and with slightly longer hair, was probably shot in early 1965. In the first of these three films (ST231), which was also included in one version of *The Thirteen Most Beautiful Women* (ST365d), she has been posed against a light background, with the cap pulled down over her right eye; she occasionally purses or licks her lips, and only looks away from the camera briefly. A projected image of this *Screen Test* can be seen in a March 1965 *Life* fashion photograph in which a "shoeless Ivy Nicholson" models a Geoffrey Beene dress, "the top of which acts as a ready-made movie screen for Ivy's own close-up."[237]

In a second film shot at the same time (ST232), she has been posed quite differently: brightly lit from the right, Nicholson's

**Ivy Nicholson models clothes in the light of her own *Screen Test* image, "Underground Clothes," *Life*, March 19, 1965, p. 117. Photograph by Howell Conant.**

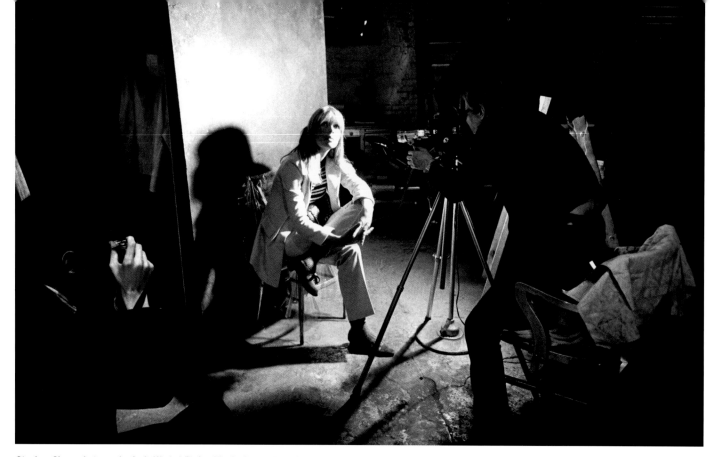

Stephen Shore photographs Andy Warhol filming Nico's *Screen Test* (ST241) at the Factory, 1966. Photograph by Nat Finkelstein.

off-center face fills the right half of the film frame, while her shadow darkens the left half: her cap, pulled down over one eye, casts a black shadow that looks like an eye patch. Near the end of the roll, she straightens up from her slouched position and centers herself in the film image. In the last film in this series (ST233), Nicholson seems to have been encouraged to move freely, and assumes a series of quick modeling poses. She pulls the brim of her cap down over one eye, runs her fingertips over her lips, turns her head from side to side while making eyes at the camera, pouts, chews gum, leans back with her hands clasped behind her head, crosses her eyes, and smiles slightly.

In another, later film from 1965 (ST234), in which she has much longer hair, Nicholson has been placed against a white wall and lit from the left. With her head turned to face the camera, she looks up and down, smiles, and then nods her head and seems to sing along with music that we can't hear. In her final portrait film from 1966 (ST235), Nicholson has been dressed in a long gown or length of material tied at the shoulders. With her hair slicked severely back from her face and her features starkly lit from the left, she faces the camera with her mouth slightly open; the slanting light highlights the sculptural dimensions of her left eye.

### ST236    *Nico,* 1966
16mm, b&w, silent; 4.6 min. @ 16 fps, 4.1 min. @ 18 fps
Preserved 1999, MoMA *Screen Tests* Reel 20, no. 3
**FILM MATERIALS**
ST236.1 *Nico*
1965 Kodak 16mm b&w reversal original, 110'
**NOTATIONS**  On original box in AW's hand: *NICO*

### ST237    *Nico,* 1966
16mm, b&w, silent; 4.5 min. @ 16 fps, 4 min. @ 18 fps
Preserved 1999 as roll 2 of *EPI Background: Original Salvador Dalí* (ST367)
**COMPILATIONS**  *EPI Background: Original Salvador Dalí* (ST367)
**FILM MATERIALS**
ST237.1 *EPI Background: Original Salvador Dalí* (ST367.1), roll 2
1965 Kodak 16mm b&w reversal original, 108'

### ST238    *Nico,* 1966
16mm, b&w, silent; 4.5 min. @ 16 fps, 4 min. @ 18 fps
Preserved 1995, MoMA *Screen Tests* Reel 12, no. 4
**COMPILATIONS**  *EPI Background* (ST370); *Screen Tests/A Diary* (Appendix A)
**FILM MATERIALS**
ST238.1 *Nico*
1965 Kodak 16mm b&w reversal original, 107'
ST238.1.p1 *EPI Background* (ST370.1), roll 12
Undated Dupont 16mm b&w reversal print, 107'
**NOTATIONS**  On box in Paul Morrissey's hand: *Best orig. of Nico. Used in show. Best orig. of Nico for show*
On box in red: *12*
On box in unidentified hand, crossed out: *Print 3 of Sterling's eyes*
On typed label found in can: *NICO*

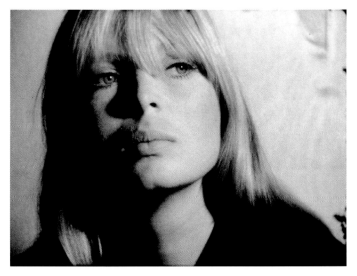

ST237

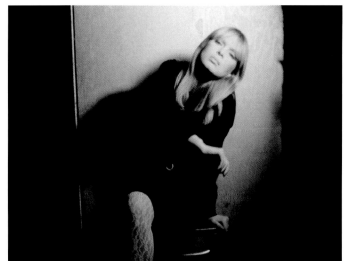

ST237

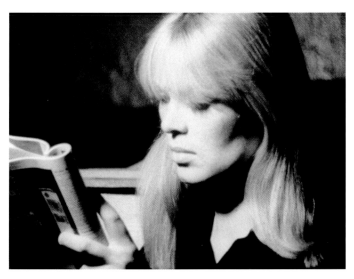

ST238

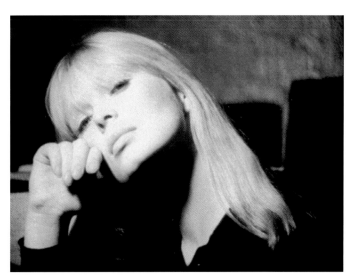

ST238

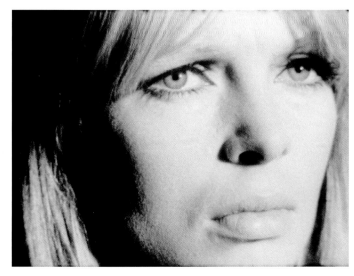

ST239

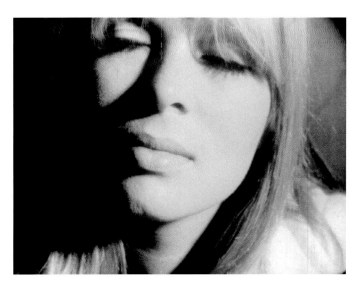

ST240

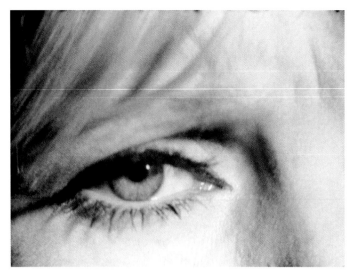

ST241

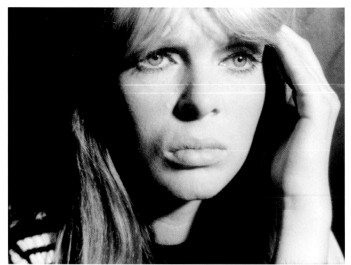

ST241

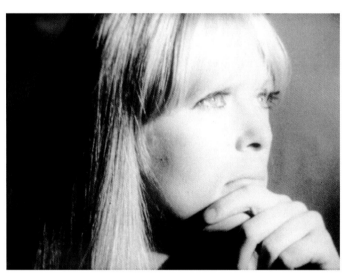

ST243

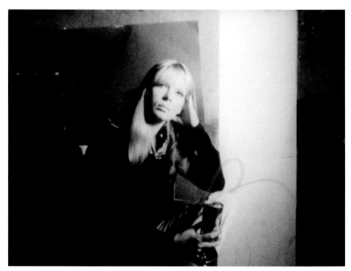

ST243

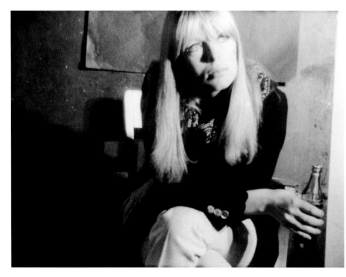

ST244

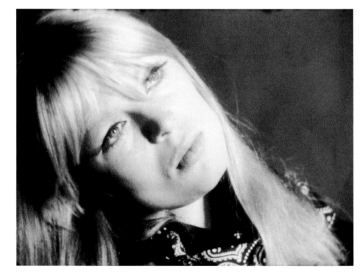

ST244

**ST239** *Nico,* 1966
16mm, b&w, silent; 4.2 min. @ 16 fps, 3.8 min. @ 18 fps
Preserved 1999, MoMA *Screen Tests* Reel 21, no. 2
**FILM MATERIALS**
ST239.1 *Nico*
1965 Kodak 16mm b&w reversal original, 102'
**NOTATIONS** On plain white box in unidentified hand: *Nico original.*
*face and clicks*

**ST240** *Nico,* 1966
16mm, b&w, silent; 3.6 min. @ 16 fps, 3.2 min. @ 18 fps
**COMPILATIONS** *EPI Background: Velvet Underground* (ST369)
**FILM MATERIALS**
Original not found in Collection
ST240.1.p1 *EPI Background: Velvet Underground* (ST369.1), roll 1
1965 Kodak 16mm b&w print, 86'

**ST241** *Nico,* 1966
16mm, b&w, silent; 4.3 min. @ 16 fps, 3.9 min. @ 18 fps
**COMPILATIONS** *EPI Background: Velvet Underground* (ST369)
**FILM MATERIALS**
ST241.1 *Nico*
1965 Kodak 16mm b&w reversal original, 104'
ST241.1.p1 *EPI Background: Velvet Underground* (ST369.1), roll 2
1965 Kodak 16mm b&w reversal print, 106'
**NOTATIONS** On box in AW's hand: *Taylor*
On clear film at head of roll in black: *4*

**ST242** *Nico (Eyes and Mouth),* 1966
16mm, b&w, silent; 4.7 min. @ 16 fps, 4.1 min. @ 18 fps
**FILM MATERIALS**
ST242.1 *Nico (Eyes and Mouth)*
Kodak 16mm b&w reversal original, 112'
(Too underexposed to read date code)
**NOTATIONS** On original box in unidentified hand: *Nico Eyes and Mouth I. +. Thurs. March 3, 66*
On box in AW's hand, crossed out: *No Too good*
On box in unidentified hand: *Nico. but very interesting on double screen*

**ST243** *Nico (Beer),* 1966
16mm, b&w, silent; 3.8 min. @ 16 fps, 3.4 min. @ 18 fps
Preserved 1998, MoMA *Screen Tests* Reel 16, no. 7
**COMPILATIONS** *EPI Background: Lost Reel* (ST371)
**FILM MATERIALS**
ST243.1 *Nico (Beer)*
1966 Kodak 16mm b&w reversal original, 92'
**NOTATIONS** On plain brown box in AW's hand: *NICO beer*
On box in unidentified hand: *Tri-X*
On clear film at head of roll in red: *16*
On clear film at head of roll in black: *– 3 –*

**ST244** *Nico (Coke),* 1966
16mm, b&w, silent; 4.6 min. @ 16 fps, 4.1 min. @ 18 fps
Preserved 2001, MoMA *Screen Tests* Reel 27, no. 6
**COMPILATIONS** *EPI Background: Lost Reel* (ST371)
**FILM MATERIALS**
ST244.1 *Nico (Coke)*
1966 Kodak 16mm b&w reversal original, 110'
**NOTATIONS** On original box in AW's hand: *NICO coke*
On box in unidentified hand: *TRIX*
On clear film at head of roll in black: *"–6–"*

**ST245** *Nico (Hershey),* 1966
16mm, b&w, silent; 4.6 min. @ 16 fps, 4.1 min. @ 18 fps
Preserved 2001, MoMA *Screen Tests* Reel 26, no. 7
**COMPILATIONS** *EPI Background: Lost Reel* (ST371)
**FILM MATERIALS**
ST245.1 *Nico (Hershey)*
1966 Kodak 16mm b&w reversal original, 110'
**NOTATIONS** On box in AW's hand: *Silent Speed. KISS. original*
On typed note taped to box: *Del: Please send these to: ANDY WARHOL, 231 East 47th St., New York, N.Y. Thankx, Saundra*
On clear film at head of roll: *L.L. – 10 –*

**ST246** *Nico (Hershey),* 1966
16mm, b&w, silent; 4.3 min. @ 16 fps, 3.8 min. @ 18 fps
Preserved 1999, MoMA *Screen Tests* Reel 18, no. 1
**COMPILATIONS** *EPI Background: Lost Reel* (ST371)
**FILM MATERIALS**
ST246.1 *Nico (Hershey)*
1966 Kodak 16mm b&w reversal original, 103'
**NOTATIONS** On original box in AW's hand: *Nico Hershy*
On clear film at head of roll in red: *16*
On clear film at head of roll in black: *– 5 –*

Born in Cologne, Germany, in 1938, Christa Päffgen grew up in postwar Berlin, where she began modeling as a teenager. In 1956 she adopted Nico as her professional name and moved to Paris, where she became a leading cover girl and print model. Nico's first movie performances were in Federico Fellini's 1960 film *La Dolce Vita,* and in the lead role in Jacques Poitrenaud's 1963 film *Strip-Tease.* In the early 1960s, she had a brief relationship with the French actor Alain Delon, with whom she had a son, Ari Boulogne (a connection Delon has always denied). She also came to know Bob Dylan, who helped her to sing professionally, and who wrote the song "I'll Keep It with Mine" for her.[238] In London Nico had a short romance with Brian Jones; her first single was released by the Rolling Stones's manager Andrew Loog Oldham in 1965. That year Nico met Warhol and Gerard Malanga in Paris through their mutual friend Denis Deegan. When she came to New York in late 1965 seeking work as a singer, Warhol arranged for her to sing with the Velvet Underground, who was just preparing for their first public performances under Warhol's management.

Nico immediately began posing for Warhol's movie camera, beginning probably with the earliest of her ten *Screen Tests.* Over the next two years, she would appear in many Warhol films, including *The Closet, The Velvet Underground, The Velvet Underground and Nico, The Velvet Underground Tarot Cards, Nico/Antoine,* three reels shot for *The Chelsea Girls,* and *Ari and Mario* in 1966, *I, a Man* and *Imitation of Christ* in 1967, and at least eighteen reels shot for or included in ★ ★ ★ ★ (*Four Stars*) (1967).[239] In the summer of 1966, she was joined in New York by her four-year-old son, Ari, who appeared with her in several of these films.[240]

Nico performed and traveled with the Velvet Underground in the EPI (Exploding Plastic Inevitable) from January 1966 off and on until the summer of 1967. She also sang three out of eleven songs ("Femme Fatale," "All Tomorrow's Parties," and "I'll Be Your Mirror") on their first album, *The Velvet Underground and Nico,* released in 1967. In the fall of 1966, Nico began giving solo singing performances at the Dom on St. Mark's Place, accompanied by a tape recorder playing prerecorded instrumentals by Lou Reed and John Cale.[241] In 1967 her performances at the Dom were backed

with live music played by Tim Buckley and, later, Jackson Browne, and accompanied by projections of *Screen Tests* and other silent films provided by Paul Morrissey.[242]

By the summer of 1967, Nico was living in California and involved in a drug-ridden romance with Jim Morrison, the lead singer of The Doors. Her final appearances in the Warhol films were filmed in California that fall; in fact, Warhol and his crew obligingly flew out to the West Coast to shoot Nico's scenes of *Imitation of Christ* at the Castle, the palatial rock-and-roll residence where she was staying.

After her Warhol years, Nico continued to work as a songwriter and chanteuse, a career she would seriously pursue for the rest of her life; her music has been recorded in six solo albums and seven live concert albums, as well as in a number of singles. Nico's first solo album, *Chelsea Girl*, was released in 1968; two of her later albums, *The Marble Index* (1969) and *The Drama of Exile* (1981), were produced by John Cale. In the 1970s, Nico lived with the French avant-garde filmmaker Philippe Garrel and appeared in a number of his films, of which the best known is probably *La Cicatrice intérieure* (1970–72). In the 1980s, she toured frequently in Europe, performing with a small group of musicians or accompanying herself on a harmonium. In July 1988, at the age of forty-nine, Nico died from a cerebral hemorrhage following a bicycle accident near her home on the island of Ibiza. Her life has been documented in several books and in Susanne Ofteringer's 1995 documentary *Nico Icon*.[243]

Nico's first *Screen Tests* seem to have been shot in late 1965 or early 1966. In her two earliest portrait films, she has been seated in a chair against a plain plywood backdrop, and lit brightly from the right, with the left side of her face in shadow. In one of these films (ST236), there is no camera movement; although Nico's eyes are partly hidden under her bangs, she still puts up her hand to block the light from time to time. She appears bored or vaguely pained for most of the roll, occasionally giving the camera an amused smirk. In a second film (ST237), shot at the same time, there is a great deal of camera movement—zooms, pans, in-camera edits, and experimental framings. At one point the camera zooms back to show Nico seated against the wall, a light mounted on a stand to her right; she stands up, revealing white lace stockings. Another portrait (ST238), shot with an unmoving camera on 1965 stock, shows Nico reading a magazine. She scratches her head, flips her hair, looks glumly at the camera, and then rolls the magazine into a tube and peers through it. Notations written on the film box, "Best orig. of Nico. Used in show," indicate that this film was projected during the Exploding Plastic Inevitable; a print of it was found in one of the *EPI Background* reels (ST370).

Other *Screen Tests*, also used in the EPI, may have been shot—or at least influenced—by Dan Williams. ST239, which has Williams's trademark phrase "clicks" written on the box, begins with a tight shot of Nico's melancholy face filling the frame, followed by in-camera cuts to close-ups of her eyes and mouth. In following shots, the camera is tilted at a forty-five-degree angle, and then at a ninety-degree angle, so at one point her face appears entirely horizontal; images of her full face alternate with zooms and close-ups of individual features. Another similar film, found in print form only (ST240), also zooms repeatedly in on Nico's features, concentrating on her mouth and eyes. Some footage from this roll appears to be missing, and the film itself is heavily scratched. A similar film (ST241) was shot by Warhol, as Nat Finkelstein's photograph shows; the camera jiggles and zooms wildly in and out while Nico, in a striped sweater, frowns and presses her fingers to her temples, as if the camerawork itself were giving her a headache. Another portrait of Nico (ST242), dated March 3, 1966, is seriously underexposed and too dark to

photograph; it is composed of many rapid zooms in and out on her face, shot with a wildly jiggling camera. Warhol wrote "No too good" on the box, but someone else, perhaps Morrissey or Dan Williams, disagreed with him and wrote, "but very interesting on double screen."

Four later *Screen Tests*, shot on 1966 stock, are pseudo "commercials," in which Nico poses for the camera with various prominently labeled products (see entries on David (ST70) and Lou Reed (ST269–271) for other similar "commercials"). In *Nico (Beer)* (ST243), Nico, wearing white pants, decorated leather boots, a bandanna, and false eyelashes, sips unenthusiastically at a Ballantine beer while the camera zooms and pans energetically. In another film, *Nico (Coke)* (ST244), apparently made during the same shooting session, she swigs from a Coke bottle while the camera maintains constant movement, zooming in and out, panning right and left. At the end of the film, she turns her back on the light and bows her head into the shadows.

Two other films show Nico "advertising" Hershey's chocolate. In one (ST245), Nico holds a large, partially unwrapped Hershey bar to her chin, with the labeling upside down; the camera remains stationary while Nico gazes morosely into the distance. In the other (ST246), she unwraps the chocolate bar, breaks off a small piece, and eats it while the camera zooms, jiggles, and circles sickeningly. At the end of the roll, she covers her mouth, as if suppressing a giggle. The markings on the heads of these films indicate that they were at some point compiled into larger reels, probably *EPI Background* reels.

### ST247  *Sheila Oldham*, 1966

16mm, b&w, silent; 4.4 min. @ 16 fps, 3.9 min. @ 18 fps
Preserved 1995, MoMA *Screen Tests* Reel 12, no. 7
**FILM MATERIALS**
ST247.1  *Sheila Oldham*
1966 Kodak 16mm b&w reversal original, 105'
**NOTATIONS**  On original box in AW's hand: *Shelley Oldham*

In 1966 Sheila Klein Oldham was the wife of Andrew Loog Oldham, the twenty-two-year-old impresario who was the manager of the Rolling Stones in the early 1960s and who produced Nico's first single recording in 1965. The daughter of a well-known London psychiatrist, Klein began dating Oldham when she was a teenage art student; they were married in Glasgow, Scotland, in September 1964. It is not known how Sheila Oldham came to be in a Warhol *Screen Test*; however, the Rolling Stones were in New York in the summer of 1966 on their U.S. tour, and Brian Jones appeared with Warhol at the opening of Betsey Johnson's fashion boutique, Paraphernalia, at the end of July.[244] It seems likely that Andrew Oldham and his wife would have been in New York around that time, and may very well have visited the Factory, perhaps through their connection with Nico. In 1967 Nico and her then boyfriend Brian Jones stayed with Sheila Oldham in San Francisco for a brief while.[245] Sheila and Andrew Oldham ended their relationship after ten years; she now uses the name Sheila Klein.[246]

Wearing a ribbed turtleneck and with her big mop of dark hair arranged in a symmetrical flip, a bright-eyed Sheila Oldham peers out from under heavy bangs. She seems quite relaxed throughout her *Screen Test*, rolling her eyes, smiling, talking to the camera, and at one point laughing broadly. The even lighting of her face enhances the overall symmetry of her image.

ST245

ST246

ST247

ST248

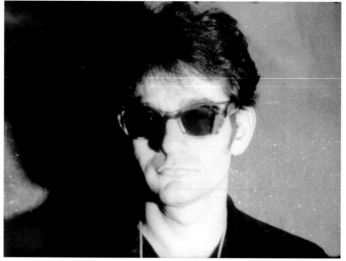

ST249

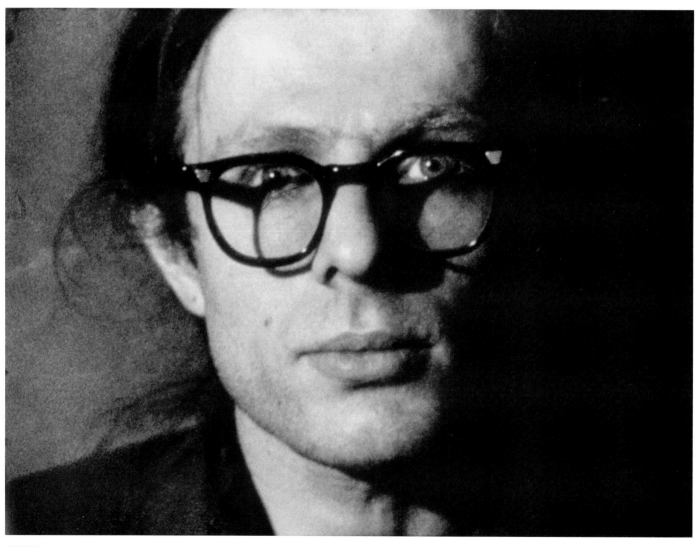

ST250

## ST248 *Ondine*, 1966
16mm, b&w, silent; 4.3 min. @ 16 fps, 3.9 min. @ 18 fps
Preserved 1999, MoMA *Screen Tests* Reel 19, no. 9
**FILM MATERIALS**
ST248.1 *Ondine*
1965 Kodak 16mm b&w reversal original, 104'
**NOTATIONS** On original box in AW's hand: *Ondine I. Tri XX*

## ST249 *Ondine*, 1966
16mm, b&w, silent; 4.2 min. @ 16 fps, 3.7 min. @ 18 fps
Preserved 1995, MoMA *Screen Tests* Reel 7, no. 3
**COMPILATIONS** *Screen Tests/A Diary* (Appendix A)
**FILM MATERIALS**
ST249.1 *Ondine*
1965 Kodak 16mm b&w reversal original, 101'
**NOTATIONS** On box in AW's hand: *Ondine #2. ONDINE*
On box in unidentified hand, crossed out: *Print. Screen Test.*
*Gerard and Mary I*
On typed label found in can: *ONDINE*

The actor Robert Olivo, who called himself Ondine, was arguably Warhol's favorite actor, since he appears in more Warhol footage than any other individual.[247] Sharp-witted and sharp-tongued, Ondine was a marathon talker, especially when high on amphetamine. His unique improvisational monologues—hilarious blends of aesthetic rant, erudite wordplay, campy outbursts, assumed personae, opera lore, street smarts, and poetic introspection, inflected with unpredictable moods of bitchiness or sweetness—were not only recorded in nearly twenty-five hours of Warhol footage, but also served as the topic of Warhol's only published novel, *a a novel*, an uncorrected, typo-filled transcription of twenty-four tape-recorded hours of Ondine talking.[248]

Born in New York City in 1939, Robert Xavier Francis Peter Michael Olivo changed his name to Ondine in the mid-1950s, naming himself after the Jean Giraudoux play *Ondine*, in which Audrey Hepburn starred on Broadway in 1954. By the early 1960s, when he first met Warhol, Ondine had become what would now be recognized as a performance artist, reading comics on stage at the Caffe Cino or hanging out at the San Remo coffee shop on MacDougal Street, where he would assume the role of the "Pope of Greenwich Village," hearing confessions and handing out advice to other customers. The first Warhol film Ondine appeared in was the pornographic *Three*, filmed in March 1964; he also had a central role in the equally X-rated *Couch* later that year. In 1965 Ondine appeared in *Vinyl*, *Restaurant*, and *Afternoon*. In 1966 he had a major role in a three-reel sequence called *The Pope Ondine Story*, two reels of which began and ended the three-and-a-half-hour double-screen feature *The Chelsea Girls*. One of these reels, Reel 11 of *The Chelsea Girls*, in which Ondine injects himself with speed and then loses his temper and assaults Ronna Page, is considered by many to be one of the highlights of Warhol's cinema. A subsequent, commercially unsuccessful feature film shot in 1967, *The Loves of Ondine*, was an attempt to capitalize on this performance by giving Ondine his own vehicle. In 1967 Ondine also appeared as President Lyndon Johnson in seven reels of *Since*; played the role of Patrick Tilden-Close's father and Brigid Polk (Berlin)'s husband in *Imitation of Christ*; and appeared in at least nineteen reels of ★★★★ *(Four Stars)*, as well as in several other unreleased reels shot in 1966–67.[249]

Ondine also performed frequently in off-off-Broadway theater, appearing in various Theatre of the Ridiculous productions directed by John Vacarro, and in other plays directed by Michael

Smith. In 1967 he played Scrooge in Søren Agenoux's play *Chas. Dickens' Christmas Carol* at the Caffe Cino, a performance, directed by Smith, which was filmed by Warhol and incorporated into ★★★★ *(Four Stars)* as Reel 27. Ondine appeared in other films as well, including Michel Auder's *Cleopatra* (1970).

In 1969 Ondine began writing a regular column, "Beloved Ondine's Advice to the Shopworn," which was published in *Kiss*.[250] In the 1970s Ondine and his companion, Roger Jacoby, moved to Pittsburgh, where Ondine taught acting at the University of Pittsburgh. He also began traveling around the country giving lectures accompanied by screenings of his Warhol films; in the 1980s he toured Europe with the underground comedy review Hot Peaches. Ondine became ill in 1984 and moved back to New York to be cared for by his mother, Ann Olivo; he died of organ failure in 1989.

In his two *Screen Tests* from early 1966, Ondine faces the movie lights reluctantly: as he later explained, "My crowd took a lot of drugs and avoided bright lights."[251] In the first film (ST248), Ondine squints, blinks, looks away from the light, closes his eyes, laughs good-naturedly at the camera, and endures his sitting the best he can. Toward the end of the reel, he appears to be having trouble keeping his eyes open. In the second portrait (ST249), he has put on dark glasses which, he seems to think, provide enough cover for him to close his eyes and take a nap. Even though Ondine occasionally raises his eyebrows, as if simulating alertness, he really does seem to be drifting off to sleep during this roll. There is an in-camera edit toward the end of the roll, where the camera seems to have mistakenly been turned off and then on again.

The painted wooden backdrop behind Ondine exhibits a specific pattern of speckles that can also be identified in *Screen Tests* of Charles Aberg (ST1–3), Salvador Dalí (ST68), Gerard Malanga (ST198), Ultra Violet (ST348), and Mary Woronov (ST357). The *Screen Tests* of Ultra Violet and Woronov are dated February 6, 1966, on the box, which provides a rough date for the rest of this group.

## ST250 *Peter Orlovsky*, 1966
16mm, b&w, silent; 4.5 min. @ 16 fps, 4 min. @ 18 fps
Preserved 1999, MoMA *Screen Tests* Reel 20, no. 4
**COMPILATIONS** *Fifty Fantastics and Fifty Personalities* (ST366)
**FILM MATERIALS**
ST250.1 *Peter Orlovsky*
1966 Kodak 16mm b&w reversal original, 108'
**NOTATIONS** On original box in unidentified hand: *Peter Orlovsky*

The poet Peter Orlovsky, Allen Ginsberg's companion for forty-three years, appeared with Ginsberg in Warhol's 1964 films *Couch* and *Allen*. The two poets also had their *Screen Tests* shot on the same day, December 4, 1966.[252]

Orlovsky was born in 1933 in New York City and grew up on Long Island and in Queens. He dropped out of high school to help support his family. After working as an orderly at Creedmore State Mental Hospital in New York and being drafted and then discharged during the Korean War, Orlovsky met Ginsberg in 1954 and moved in with him, a marriage that lasted until Ginsberg's death in 1997. Ginsberg encouraged Orlovsky to start writing poetry while they were living in Paris in 1957; a collection of his poetry, *Clean Asshole Poems & Smiling Vegetable Songs: Poems, 1957–1977*, was published by City Lights in 1978. Although Ginsberg and Orlovsky settled on the Lower East Side of New York, Orlovksy spent periods of time traveling in the Middle East and Africa, farming in Cherry Valley, New York, and teaching at the

Naropa Institute in Boulder, Colorado. He also appears in Robert Frank's 1969 film, *My Brother and Me*, a documentary about his brother Julius Orlovsky's mental illness.[253]

In his *Screen Test*, Orlovsky, wearing dark-framed glasses and with his hair in a ponytail, has been placed on a chair in front of a sheet of dark, wrinkled paper. Orlovsky smiles and talks to someone off-camera, then begins singing or chanting, accompanying himself with the harmonium on his lap; at the end of the film he lifts his bare foot into his lap and examines his toes. Orlovksy's intense energy is matched by the camerawork, which zooms in and out, circles wildly, jiggles, and explodes into quick bursts of single-framing and rapid shifts in exposure.

## ST251   *Ron Padgett*, 1964

16mm, b&w, silent; 4.5 min. @ 16 fps, 4 min. @ 18 fps
Preserved 2001, MoMA *Screen Tests* Reel 28, no. 8
**COMPILATIONS** *Screen Test Poems* (ST372); *Screen Tests/A Diary* (Appendix A)
**FILM MATERIALS**
ST251.1   *Ron Padgett*
1964 Kodak 16mm b&w reversal original, 109'
ST251.1.p1   *Screen Test Poems*, Reel 2 (ST372.2), roll 18
Undated Gevaert 16mm b&w reversal print, 109'
**NOTATIONS**  On box in AW's hand: *Ron Padgett 2*
On box in AW's hand, crossed out: *Ultra*
On box in Gerard Malanga's hand: *Ron Padgett. One double frame negative. One 8″ x 10″ double frame glossy print*
On box flap in red: *18*
On clear film at both head and tail of roll in black: *18*

Ron Padgett was part of what John Ashbery jokingly called "the *soi-disant* Tulsa School of Poetry"—a group of young poets, including Joe Brainard, Ted Berrigan, and Dick Gallup, who moved from Tulsa, Oklahoma, to New York City in the early 1960s.[254] In Tulsa, Padgett and his fellow poets had started a little magazine called the *White Dove Review*, which published poems by Allen Ginsberg, Jack Kerouac, Robert Creeley, and others. Padgett studied English literature at Columbia University in 1960–64, and began giving readings and publishing his writings in small literary magazines during this period. In 1964 Padgett published "Sonnet: Homage to Andy Warhol," a poem in honor of Warhol's film *Sleep*, which consisted of thirty-five lines of z's.[255] In 1965 Padgett published *Two Stories for Andy Warhol*, which consisted of a single page of text repeated ten times; Warhol designed the cover for this book, using a Thermofax of a double-frame image from his pornographic film *Three* (1964).[256] Padgett also contributed a dialogue titled "Falling in Love in Spain or Mexico" for the unrealized Warhol/Joe LeSueur film project *Messy Lives*.[257]

In 1967 Padgett, Brainard, and Berrigan published *Bean Spasms* (Kulchur Press), a collaborative collection of their poetry. Padgett taught poetry to children for many years, and served as the director of the St. Mark's Poetry Project, and as publications director at the Teachers and Writers Collaborative. He has published numerous collections of his poems and other writings, books about the teaching of poetry writing, and is a noted translator of French poetry.[258] In 2004 Padgett published a book about his friend Joe Brainard, *Joe: A Memoir of Joe Brainard* (Minneapolis: Coffee House Press).

Ron Padgett's *Screen Test* was shot when he and Ted Berrigan stopped by the Factory one day in early 1965.[259] As soon as they walked in, Warhol casually asked Padgett if he could film his

portrait; he then led him off to a small dark alcove where a stool, a single light, and the movie camera were already set up. After making some quick adjustments to the camera and lighting, Warhol turned the camera on and, without giving any instructions at all, walked away to talk with Berrigan, leaving Padgett alone with the camera. As Padgett recalled, he at first felt quite anxious, thinking that he could do anything he wanted and that the *Screen Test* was like "doing an instant Rorschach test on yourself." But after a while, he realized that it really didn't matter what he did, and "a calm came over me."[260] This moment of realization is apparent in the film itself, in which Padgett, wearing large metal-framed glasses, is posed against a dark background and lit harshly from the right. In the first half of the film, he gazes offscreen and blinks frequently; after looking down shyly for a few moments, Padgett raises his eyes and looks directly into the camera, an open gaze he maintains until the end of the roll. The film is slightly out of focus throughout.

## ST252   *Ronna Page*, 1966

16mm, b&w, silent; 4.8 min. @ 16 fps, 4.3 min. @ 18 fps
**COMPILATIONS** *Screen Tests/A Diary* (Appendix A)
**FILM MATERIALS**
ST252.1   *Ronna Page*
1966 Kodak 16mm b&w reversal original, 115'
Film torn in clear footage at head
**NOTATIONS**  Nothing written on box
On tape on can lid in Gerard Malanga's hand: *Rona Page*
On typed label found in can: *RONNA PAGE*

Ronna Page[261] is best known for her role as the unfortunate victim of Ondine's amphetamine-fueled rage in *The Chelsea Girls* (1966), where, in Reel 11, she makes the mistake of calling Pope Ondine a "phony" and is consequently slapped and driven offscreen. Page appeared in several other Warhol films from late 1966 to early 1967, including *Bufferin*, *Bufferin Commercial*, and a few sequences shot for but not included in ★★★★ *(Four Stars)*: *Barbara and Ivy I*, *Mary I*, *Mary and Richard II*, *Ivy and Don McNeil*, and *Tiger's Place*.

In the late 1960s, Ronna Page made movies and lived in both New York and Boston. Her film *Himalaya West: Children of the Lower East Side* was screened at the Last Open House of 1966 at the Film-Makers' Cinematheque. Page lived for a time in Jonas Mekas's loft on Third Avenue and 23rd Street, a connection that explains Ondine's statement during his outburst in *The Chelsea Girls*: "I don't know if it even is the same girl . . . but I think it's the saint's wife. And the saint, who's supposed to know a lot about movies, had better be sharp!"[262]

Page was connected with the Lyman Family or Fort Hill Community, a messianic Boston-based commune centered around the musician Mel Lyman, who was a member of the Jim Kweskin Jug Band. In 1966, Page signed a talent release for the Warhol films under the name "Ronna Page Lyman," giving Mekas's address as her own. Page's name also can be found in Lyman's underground magazine *The Avatar*, where she is referred to as "the darkly voluptuous superstar."[263] In later years, Ondine came to believe that Page's attack on his papacy in *The Chelsea Girls* was religiously motivated: "She was very involved in proving that Mel Lyman was the next Christ."[264] In 1971, the Lyman Family was the subject of a two-part exposé by David Felton published in *Rolling Stone* magazine;[265] the commune still exists, with businesses and houses in Kansas, Los Angeles, and Massachusetts.

By the end of the 1960s, Page seems to have become unstable, and spent time in and out of Bellevue and other hospitals.[266] In 1972

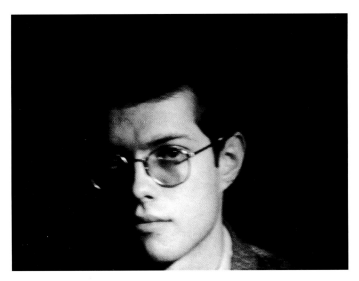

ST251

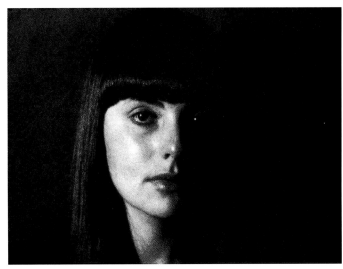

ST252

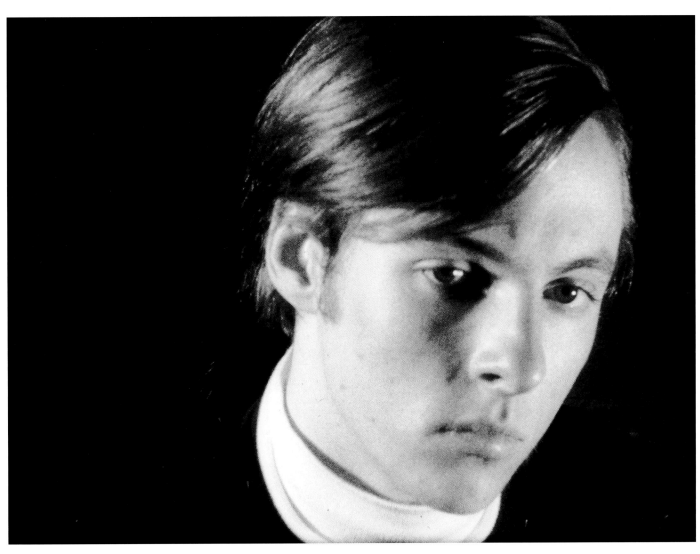

ST253

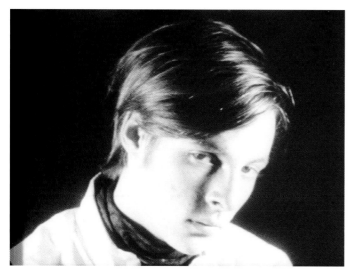

ST254

ST255

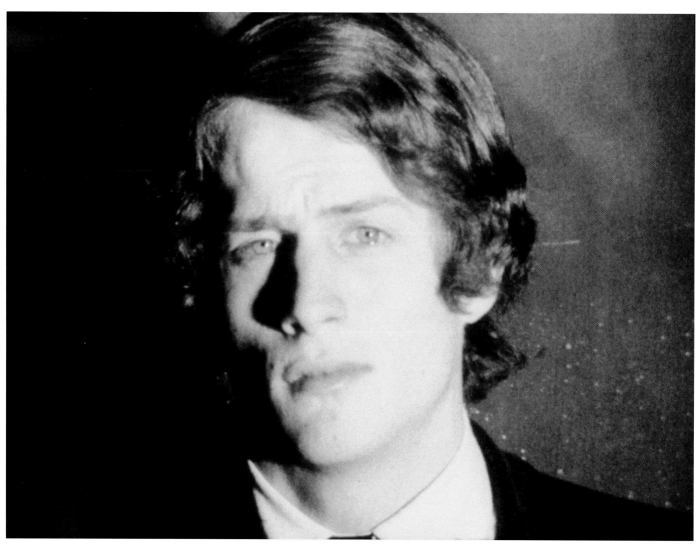

ST256

she and the designer Bruce Rudow, the subject of an early Warhol *Screen Test* (ST287), had a son, Tiavi. By the 1980s Ronna Page had become a marginalized but familiar figure on St. Mark's Place in New York, where she often hung out at the Yaffa Café smoking and drinking coffee all day long.[267] She died in the early 1990s.

Ronna Page's 1966 *Screen Test* is quite underexposed and therefore very dark. Lit only from the left, she stares hard at the camera without blinking, until her eyes tear up halfway through the roll. There is some loss of registration toward the end of the film, which makes the image slip and blur vertically; this technical problem dates this film to early October 1966 (see also Antoine (ST8), Paul Katz (ST174) and Richard Rheem (ST272–275)).

## ST253   *John Palmer,* 1964

16mm, b&w, silent; 4.5 min. @ 16 fps, 4 min. @ 18 fps
Preserved 2001, MoMA *Screen Tests* Reel 26, no. 8
COMPILATIONS   *Screen Test Poems* (ST372); *Screen Tests/A Diary* (Appendix A)
FILM MATERIALS
ST253.1   *John Palmer*
1964 Kodak 16mm b&w reversal original, 108'
ST253.1.p1 *Screen Test Poems,* Reel 2 (ST372.2), roll 19
Undated Gevaert 16mm b&w reversal print, 100'
NOTATIONS   On original box in AW's hand: *John Palmer*
On box in Gerard Malanga's hand, with drawing of two frames:
*1 double-frame negative and one 8" x 10" double-frame print*
On box in unidentified hand: *John Palmer*
On box flap in red: *19*
On typed label found in can: *JOHN PALMER*
On clear film at both head and tail of roll: *19*

## ST254   *John Palmer,* 1964

16mm, b&w, silent; 4.5 min. @ 16 fps, 4 min. @ 18 fps
Preserved 1999, MoMA *Screen Tests* Reel 18, no. 5
COMPILATIONS   *The Thirteen Most Beautiful Boys* (ST364)
FILM MATERIALS
ST254.1   *John Palmer*
1964 Kodak 16mm b&w reversal original, 108'
NOTATIONS   On original box in Gerard Malanga's hand: *John Palmer for 13*

The filmmaker John Palmer is probably best known in the context of the Warhol films for his role as codirector of the 1964 *Empire,* a credit that Warhol gave him because it was Palmer's idea to make a film of the floodlit skyscraper, because Palmer worked on the film, and also because his mother, Mary Palmer, donated money to get the film out of the lab.[268]

Palmer, who came from West Hartford, Connecticut, first moved to New York at the age of eighteen with a Bolex movie camera that his mother had given him and camped out on the roof of the Film-Makers' Cooperative on Park Avenue South, where he had a dazzling view of the newly lit spire of the Empire State Building. In addition to his involvement with *Empire* (in which he also makes a brief appearance, reflected in the window at the beginning of the last reel), Palmer also worked on *Henry Geldzahler* and *Batman Dracula* in 1964, temporarily forming a production company called "Rom Palm Hol" with Henry Romney and Warhol. Palmer can be seen in Warhol's films *Kiss* (1963–64), *Soap Opera* (1964), *Couch* (1964), and in the early sound film *John and Ivy* (1965), a portrait of Palmer and his wife Ivy Nicholson at home in their East Village apartment

in January 1965. Palmer and Nicholson had two children, the twins Gunther and Penelope Palmer, born on November 2, 1965.

Between 1967–72, Palmer and David Weisman made the feature film *Ciao! Manhattan,* which starred Edie Sedgwick, shooting scenes over several years in New York and California. After he failed to receive backing for a film about the Vietnam War, Palmer gave up filmmaking and spent fifteen years sailing yachts in the Pacific; eventually he settled in Hawaii and obtained a master's in philosophy. Palmer teaches cognitive restructuring in the Hawaii state corrections system and is raising his grandson, Penelope Palmer's son Donovan, whom he has adopted.

Palmer's two *Screen Tests* are quite similar, although clearly shot at different times. In one film (ST253), wearing a dark jacket over a white turtleneck, he leans slightly forward and gives the camera a sidelong look, as if posing for a studio portrait; the image is slightly underexposed. In the next portrait, which was probably shot during the same session as one of Ivy Nicholson's *Screen Tests* (ST230), Palmer's hair is slightly longer and he is dressed in a white shirt with an ascot, but his pose is nearly identical, leaning forward and glancing sideways at the camera. Palmer holds very still throughout both rolls, looking, as Howard Junker observed during the shoot, "like Belmondo."[269]

## ST255   *Penelope Palmer,* 1966

16mm, b&w, silent; 4.1 min. @ 16 fps, 3.6 min. @ 18 fps
Preserved 1998, MoMA *Screen Tests* Reel 13, no. 6
FILM MATERIALS
ST255.1   *Penelope Palmer*
1965 Kodak 16mm b&w reversal original, 98'
NOTATIONS   On original box in Gerard Malanga's hand: *TRI-XXX Penelope Palmer. 2/25/66*
On printed label on box: *F & B Ceco Inc.*

On February 25, 1966, Penelope Palmer, the three-and-a-half-month-old daughter of John Palmer and Ivy Nicholson, "sat" for her *Screen Test.* Throughout her portrait film, Penelope is propped up from below, grasped firmly somewhere below the frame line so she appears to be sitting up on her own in a straight-backed chair. The baby is perfectly unaware of the camera, her large downy head wobbling as she stares down at something in her lap and waves her arms. At one point, she slumps farther down in the chair, and is hoisted up again into the frame; later a hand, presumably her mother's, enters the frame and caresses the back of her head. The date of this sitting was written on the film box. The film has many scratches, which suggests it was projected frequently at the Factory.

Penelope Palmer and her twin brother, Gunther Ethan Palmer, were born on November 2, 1965. One of the twins (it is unclear which) also appears as a toddler in a late 1966 reel titled *Courtroom.* After spending part of her infancy in New York, Penelope was raised in Paris. As a teenager, she appeared in a few French films: Yves Boisset's *La Femme flic* (1980); Christian de Chalonge's apocalyptic tale *Malevil* (1981); and Raphaele Billetdoux's *La Femme enfant* (1982), in which she starred with Klaus Kinski. She has two sons, Donovan and Zarki.

## ST256 *Buffy Phelps,* 1965

16mm, b&w, silent; 4.4 min. @ 16 fps, 3.9 min. @ 18 fps
Preserved 1995, MoMA *Screen Tests* Reel 4, no. 1
**FILM MATERIALS**
ST256.1 *Buffy Phelps*
1965 Kodak 16mm b&w reversal original, 106'
**NOTATIONS** On box in unidentified hand: *BUFFY #1. Tri-XX*
On box in very faint, unidentified hand: *trio. Gerry Mary Red II*

William W. Phelps, nicknamed Buffy, was a film student in 1965 when he sat for his *Screen Test* at the Factory. A year or two later, he wrote Warhol a letter from Los Angeles, where he had been studying filmmaking at the University of Southern California; Phelps mentioned his new film *California Speed,* and expressed the desire to work for Warhol that summer.[270] In 1970, Phelps entered two films, *Sweet Return* and *The Reversal of Richard Sun,* in the Ann Arbor Film Festival in Ann Arbor, Michigan.

Placed against a speckled backdrop, Phelps squints and blinks furiously at the camera, as if allergic to the harsh light falling across his face from the right. His nose casts a dark shadow onto his cheek. His hair is very shiny and appears to be red or auburn-colored. After suffering through the full three minutes, the photo-sensitive Phelps can be seen finally closing his eyes in the fade-out at the end of the roll.

## ST257 *Robert Pincus-Witten,* 1964

16mm, b&w, silent; 4.5 min. @ 16 fps, 4 min. @ 18 fps
**FILM MATERIALS**
ST257.1 *Robert Pincus-Witten*
1964 Kodak 16mm b&w reversal original, 108'
**NOTATIONS** On original box in AW's hand: *Bobbie Pie*

## ST258 *Robert Pincus-Witten,* 1964

16mm, b&w, silent; 4.5 min. @ 16 fps, 3.9 min. @ 18 fps
Preserved 1998, MoMA *Screen Tests* Reel 17, no. 6
**COMPILATIONS** *The Thirteen Most Beautiful Boys* (ST264)
**FILM MATERIALS**
ST258.1 *Robert Pincus-Witten*
1964 Kodak 16mm b&w reversal original, 105'
**NOTATIONS** On original box in AW's hand: *Bobby Pie*

The art historian and critic Robert Pincus-Witten became friends with Warhol in the mid-1960s, and posed for his *Screen Test* in 1965. Pincus-Witten recalled the shooting of his portrait film for *The Thirteen Most Beautiful Boys* in an interview with Patrick Smith:

> During the shooting of it there was nothing much to do . . . one is simply in front of the camera in a very neutral way. I remember Gerry Malanga and Andy were there, and Andy would say things like, "Isn't this wonderful! Isn't he terrific! He's doing it!" As if one is really doing something wonderful by simply remaining static and unmoving before the lens, but the hype was very, very exciting. It's a tremendous kind of adrenalin-hype.[271]

During one of Pincus-Witten's *Screen Tests* (ST257), there seems to have been a technical problem with the camera, so his image flutters and flares throughout the roll; there is also a kind of halo effect around his face caused by halation, the reflection of light off the base layer of the film stock. In the other, more successful film, Pincus-Witten, wearing a plaid shirt, stares with an open, slightly inquisitive expression at the camera, his face lit evenly from both sides. The diffused lighting makes his skin seem to glow. Toward the end of the roll, he looks up quickly, apparently watching someone approach the camera.

After a start as a painter, Pincus-Witten became an art historian, doing graduate research in Paris and eventually becoming a founding member of the doctoral faculty of the City University of New York. He worked as editor at both *Artforum* and *Arts Magazine,* has published several books of criticism, and has contributed to numerous museum catalogues, mostly in the field of postminimalism. He has also written about Warhol, mostly notably "Margins of Error: Saint Andy's Devotions," published in *Arts Magazine* in 1989.[272] He is presently director of exhibitions at C & M Arts in New York.

## ST259 *Gino Piserchio,* 1965

16mm, b&w, silent; 4.5 min. @ 16 fps, 4 min. @ 18 fps
Preserved 2001, MoMA *Screen Tests* Reel 28, no. 9
**COMPILATIONS** *Screen Test Poems* (ST372); *Screen Tests/A Diary* (Appendix A)
**FILM MATERIALS**
ST259.1 *Gino Piserchio*
1965 Kodak 16mm b&w reversal original, 107'
ST259.1.p1 *Screen Test Poems,* Reel 2 (ST372.2), roll 15
Undated Belgium 16mm b&w reversal print, 100'
**NOTATIONS** On original box in unidentified hand: *Gino Pisicchi. Gino Piserchio. 15*
Written inside box flap in unidentified hand: *15*
On clear film at both head and tail of roll in black: *15*

The musician and filmmaker Gino Piserchio is best known for the title role in Warhol's 1965 film *Beauty #2,* in which he plays Edie Sedgwick's new boyfriend, lolling on a bed with her while her ex-boyfriend, Chuck Wein, aggressively questions the two from off-screen. Piserchio appeared with Sedgwick in two other films from 1965, *Space,* and the "horse alone" reel of *Horse.*

Piserchio began studying music at the age of eight, and attended the Mannes School of Music; his main career was as a musician and composer of electronic music. In 1968 Piserchio had a small role in a Hollywood film, David Lowell Rich's *A Lovely Way to Die,* which starred Kirk Douglas; in the early 1970s he and his fiancée Gillian Fuller made an "experimental" film called *The Tacky Woman,* which starred Holly Woodlawn. In the 1970s, he played the Moog synthesizer for the sound track of John Palmer and David Weisman's film *Ciao! Manhattan;* made audio tracks for the video artists Steina and Woody Vasulka; and was selected by Bell Laboratories to create a score for a movie on molecular dynamics. In 1972 Piserchio married Fuller, the former Lady Charles Spencer-Churchill, in Aspen, Colorado, at a ceremony attended by Holly Woodlawn; Richie Berlin, Brigid Berlin's sister, was the maid of honor. Piserchio died of AIDS in the mid-1980s.[273]

For his *Screen Test,* Piserchio has been lit from the right and filmed in very tight close-up, his large, handsomely sculpted face filling the frame. Neatly dressed in a tie, and with his carefully groomed hair combed down over one eye, he blinks and squints against the light, closing his eyes briefly and smiling at his own discomfort. The left side of the frame has been blackened by his shadow.

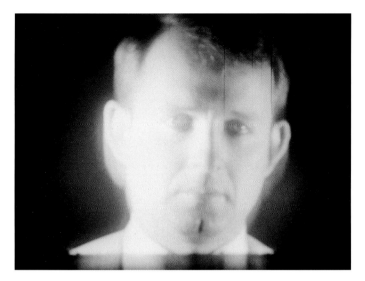

ST257

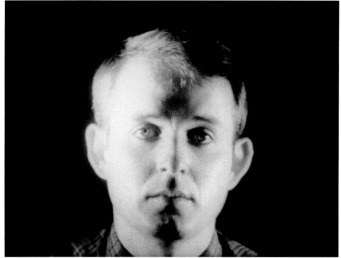

ST258

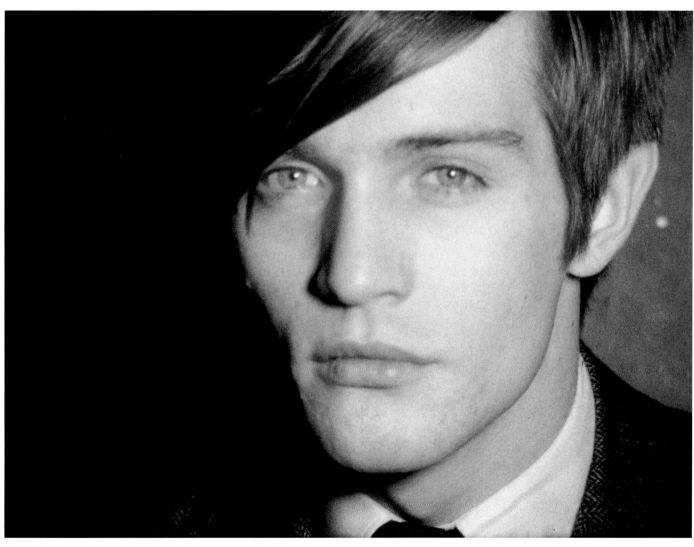

ST259

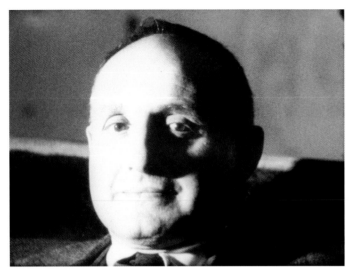

ST260

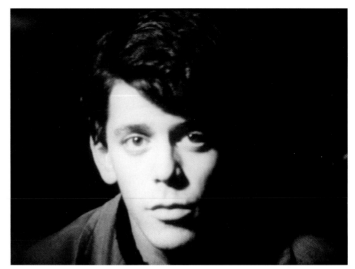

ST261

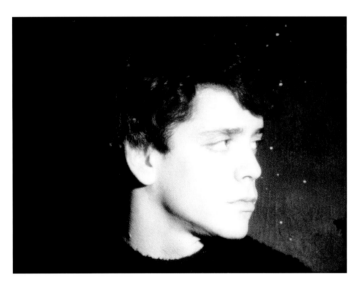

ST262

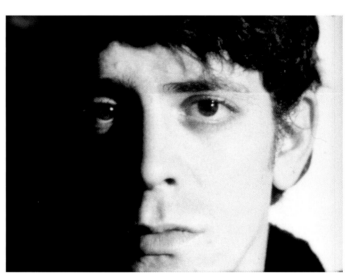

ST263

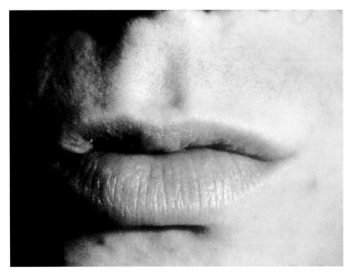

ST264

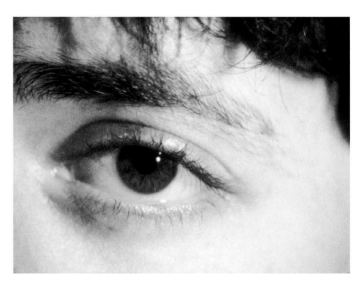

ST265

**ST260**  *Henry Rago*, 1965

16mm, b&w, silent; 4.5 min. @ 16 fps, 4 min. @ 18 fps
Preserved 1998, MoMA *Screen Tests* Reel 16, no. 6
**COMPILATIONS**  *Fifty Fantastics and Fifty Personalities* (ST366)
**FILM MATERIALS**
ST260.1  *Henry Rago*
1965 Kodak 16mm b&w reversal original, 108'
**NOTATIONS**  On original box in AW's hand: *Henry Rago*
On box in Gerard Malanga's hand: *About 10' into the film marked with tape 1 double frame 8" x 10" print + neg.*

The Chicago poet Henry Rago (1915–1969) taught humanities at the University of Chicago from 1947 to 1954; from 1955 to 1969, he was the influential editor of *Poetry* magazine, the oldest and most prestigious poetry journal in America. In 1969, shortly before his death, Rago returned to the University of Chicago, where he received the Quantrell Award for Excellence in Undergraduate Teaching. His wife, the artist Juliet Maggio Rago, created cover designs and drawings for *Poetry*, and also illustrated her husband's poetry books.

In his 1965 *Screen Test*, Rago appears to be a rather small man with a large, remarkably round head; the back of the Factory couch on which he is seated rises up behind his ears. A bright light placed on the left highlights the cleft in his chin and creates a wedge-shaped shadow alongside his nose. Rago smiles broadly at the beginning of the film, then gazes benevolently about, as if mildly intrigued by his surroundings. At one point he peers inquiringly into the camera, then suppresses a half-smile.

**ST261**  *Lou Reed*, 1966

16mm, b&w, silent; 4.6 min. @ 16 fps, 4.1 min. @ 18 fps
Preserved 1998, MoMA *Screen Tests* Reel 16, no. 3
**FILM MATERIALS**
ST261.1  *Lou Reed*
1965 Kodak 16mm b&w reversal original, 110'
**NOTATIONS**  On original box in AW's hand: *LOUIS Reed. LOU REED*

**ST262**  *Lou Reed*, 1966

16mm, b&w, silent; 4.4 min. @ 16 fps, 3.9 min. @ 18 fps
Preserved 1999, as roll 4 of *EPI Background: Original Salvador Dalí* (ST367)
**COMPILATIONS**  *EPI Background: Original Salvador Dalí* (ST367); *EPI Background: Gerard Begins* (ST368)
**FILM MATERIALS**
ST262.1  *EPI Background: Original Salvador Dalí* (ST367.1), roll 4
1965 Kodak 16mm b&w reversal original, 105'
ST262.1.p1  *EPI Background: Gerard Begins* (ST368.1), roll 7
16mm b&w reversal print, 100'

**ST263**  *Lou Reed*, 1966

16mm, b&w, silent; 4.3 min. @ 16 fps, 3.8 min. @ 18 fps
Preserved 1995, MoMA *Screen Tests* Reel 10, no. 5
**COMPILATIONS**  *EPI Background: Lost Reel* (ST371); *Screen Tests/A Diary* (Appendix A)
**FILM MATERIALS**
ST263.1  *Lou Reed*
1965 Kodak 16mm b&w reversal original, 103'
**NOTATIONS**  On original box in AW's hand: *Orig. as Louis Reed*
On box in unidentified hand: *Tri-X Rev.*
Typed label found in can: *LOU REED*
On clear film at head of roll in black: *5*

**ST264**  *Lou Reed (Lips)*, 1966

16mm, b&w, silent; 4.4 min. @ 16 fps, 3.9 min. @ 18 fps
Preserved 2001, MoMA *Screen Tests* Reel 24, no. 6
**COMPILATIONS**  *EPI Background: Velvet Underground* (ST369)
**FILM MATERIALS**
ST264.1  *Lou Reed (Lips)*
1965 Kodak 16mm b&w reversal original, 106'
ST264.1.p1  *EPI Background: Velvet Underground* (ST369.1), roll 5
1965 Kodak 16mm b&w reversal print, 106'
**NOTATIONS**  On original box in Paul Morrissey's hand: *2 copies. Louis orig.*
On box in unidentified hand in red: *TRI-X*
On clear film at head of roll in black: *2+*

**ST265**  *Lou Reed (Eye)*, 1966

16mm, b&w, silent; 4.4 min. @ 16 fps, 3.9 min. @ 18 fps
Preserved 2001, MoMA *Screen Tests* Reel 24, no. 5
**COMPILATIONS**  *EPI Background: Lost Reel* (ST371)
**FILM MATERIALS**
ST265.1  *Lou Reed (Eye)*
1965 Kodak 16mm b&w reversal original, 106'
ST265.1.p1  *Lou Reed (Eye)*
1965 Kodak 16mm b&w reversal print, 106'
**NOTATIONS FOR ST265.1**
On plain brown box in Paul Morrissey's hand: *orig. of Louis.* <u>*6*</u>
On box in unidentified hand in red: *TRI-X-REV*
On clear film at head of film roll in black: *6*
**NOTATIONS FOR ST265.1.P1**
On box in AW's hand: *Louis* ("is" crossed out) *Reed*
On box in unidentified hand: *PRINT*
On tape on head of roll: *Print*
Print-through on head of roll: *6*

**ST266**  *Lou Reed*, 1966

16mm, b&w, silent: 4.4 min. @ 16 fps, 3.9 min. @ 18 fps
**COMPILATIONS**  *EPI Background: Velvet Underground* (ST369)
**FILM MATERIALS**
ST266.1  *Lou Reed*
1965 Kodak 16mm b&w reversal original, 105'
Collection of Pat Hackett
ST266.1.p1  *EPI Background: Velvet Underground* (ST369.1), roll 4
1965 Kodak 16mm b&w reversal print, 105'
**NOTATIONS**  Written on plain brown box in AW's hand: *Louis —
2 copies*
Written on box: *Tri-X Rev. 2 copies*
Written on back of box in AW's hand: *2 copies*

**ST267**  *Lou Reed*, 1966

16mm, b&w, silent; 4.6 min. @ 16 fps, 4.1 min. @ 18 fps
**COMPILATIONS**  *EPI Background: Velvet Underground* (ST369)
**FILM MATERIALS**
Original not found in Collection
ST267.1.p1  *EPI Background: Velvet Underground* (ST369.1), roll 10
1965 Kodak 16mm b&w reversal print, 110'

## ST268 *Lou Reed (Apple),* 1966

16mm, b&w, silent; 4.5 min. @ 16 fps, 4 min. @ 18 fps
Preserved 1999, MoMA *Screen Tests* Reel 20, no. 5
**COMPILATIONS** *EPI Background: Lost Reel* (ST371)
**FILM MATERIALS**
ST268.1 *Lou Reed (Apple)*
1966 Kodak 16mm b&w reversal original, 108'
**NOTATIONS** On original box in AW's hand: *Louis apple. TRIX*
On can in unidentified hand in red: *Kellie*
On clear film at head of roll in red: *16*
On clear film at head of roll in black: *– 8 –*

## ST269 *Lou Reed (Coke),* 1966

16mm, b&w, silent; 4.5 min. @ 16 fps, 4 min. @ 18 fps
Preserved 1999, MoMA *Screen Tests* Reel 20, no. 6
**COMPILATIONS** *EPI Background: Lost Reel* (ST371)
**FILM MATERIALS**
ST269.1 *Lou Reed (Coke)*
1966 Kodak 16mm b&w reversal original, 108'
**NOTATIONS** On original box in AW's hand: *Louis Coke*
On clear film at head of roll in red: *16*
On clear film at head of roll in black: *– 4 –*

## ST270 *Lou Reed (Hershey),* 1966

16mm, b&w, silent; 4.4 min. @ 16 fps, 3.9 min. @ 18 fps
Preserved 2001, MoMA *Screen Tests* Reel 24, no. 10
**COMPILATIONS** *EPI Background: Lost Reel* (ST371)
**FILM MATERIALS**
ST270.1 *Lou Reed (Hershey)*
1966 Kodak 16mm b&w reversal original, 106'
**NOTATIONS** On plain brown box in unidentified hand: *Louis Hershey.
TRIX*
On clear film at head of roll in red: *16*
On clear film at head of roll in black: *– 9 –*

## ST271 *Lou Reed (Hershey),* 1966

16mm, b&w, silent; 4.5 min. @ 16 fps, 4 min. @ 18 fps
Preserved 1999, MoMA *Screen Tests* Reel 18, no. 9
**COMPILATIONS** *EPI Background: Lost Reel* (ST371)
**FILM MATERIALS**
ST271.1 *Lou Reed (Hershey)*
1966 Kodak 16mm b&w reversal original, 108'
**NOTATIONS** On original box in AW's hand: *Louis Hershey*
On clear film at head of roll in red: *16*
On clear film at head of roll in black: *– 7 –*

Rock musician and writer Lou Reed was a founding member and
lead singer in the Velvet Underground, the rock-and-roll group
that Warhol began to manage in early 1966. Growing up in
Freeport, Long Island, Reed began playing guitar in rock groups in
high school, and continued during his years at Syracuse University,
where he studied literature and met Sterling Morrison. After a
short stint as a songwriter for Pickwick Records, in 1964 he began
performing with a rock-and-roll band comprised of John Cale, the
filmmaker Tony Conrad, and the artist Walter De Maria. This
group, which was called the Primitives, eventually became the Vel-
vet Underground with the departure of Conrad and De Maria and
the addition of Sterling Morrison and also Angus MacLise on
drums, soon replaced by Maureen Tucker.

Reed met Warhol in December 1965, when Gerard Malanga
and Barbara Rubin took Warhol to see the Velvet Underground
performing at the Café Bizarre. In early 1966 Warhol became the
band's manager, and he, Paul Morrissey, Rubin, and Dan Williams
began organizing the elaborate multimedia rock-and-roll show that
eventually became the Exploding Plastic Inevitable, or EPI. The
Velvet Underground's first album, *The Velvet Underground and Nico,*
was released in 1967.

After performing with the Velvets for a number of years, Reed
produced his first solo albums in 1972, *Lou Reed* and *Transformer,*
now considered to be the beginnings of glam rock. Several of
Reed's songs, "Chelsea Girls," "Candy Says," and "Walk on the
Wild Side," make direct reference to the Warhol films and to Factory
personalities such as the drag queens Candy Darling, Holly Wood-
lawn, and Jackie Curtis, and Joe Campbell, the Sugar Plum Fairy.

In 1989 Reed and Cale collaborated on *Songs for Drella,* a musi-
cal biography of Andy Warhol, released as an album in 1990. In
1993 the Velvet Underground was temporarily reunited for a brief
tour of Europe. Reed has published several books of his lyrics,
including *Between Thought and Expression: Selected Lyrics of Lou Reed*
(Hyperion, 1991) and, most recently, *Pass Thru Fire: The Collected
Lyrics* (Hyperion, 2000).

In addition to his eleven *Screen Tests,* Reed appears in several
other films from 1966: *The Velvet Underground, The Velvet Under-
ground and Nico,* and *The Velvet Underground Tarot Cards;* he also
plays offscreen live music with other members of the Velvet Under-
ground in both *Hedy* and *The Chelsea Girls.* Reed can also be seen in
two other reels from the fall of 1966, *Mary I* and *Tiger Hop,* in
which he and John Cale play guitar and viola on-screen in the midst
of a large crowd of Factory personalities.

Reed's *Screen Tests* seem to have begun in early 1966; most of
them appear to have been intended for projection behind the Velvet
Underground during their EPI performances. In ST261, Reed,
wearing a jacket, faces the camera in medium close-up, lit from the
left, and posed against a black background. Rolling his eyes, looking
almost anywhere except directly at the camera, he appears more
uncomfortable than in his other portrait films, which suggests that
this may have been his first *Screen Test.* Near the end of the roll, he
leans toward the camera, temporarily going out of focus; leaning
back again, he begins to nod his head as if to music. In another roll
(ST262), which appears to have been shot at the same time, Reed
deliberately turns his head from side to side, as if following instruc-
tions to show both profiles to the camera.

In the next series of *Screen Tests,* Reed wears a black turtleneck
sweater and poses against a pale background, with a bright light
sharply angled onto his face from the right. In ST263, he stares
intently into the camera, his face, in much tighter close-up, filling
the frame. The next two films (shot at the same time as ST263)
focus on individual features. ST264 is a four-minute close-up of
Reed's mouth, as he takes nine drags on a cigarette, smiles a couple
of times, licks his lips, and grimaces. Unlike similar films of John
Cale (ST41) and Sterling Morrison (ST225), the camera does not
pull back at the end to show Reed's full face. In another roll
(ST265), the film begins with a tight close-up of Reed's eye with
the same half-moon lighting as ST263; the camera then zooms out
to a slightly broader view of his face. Toward the end of the roll,
Reed glances briefly away from the camera.

Two other *Screen Tests* of Reed, which were found in the collec-
tion in print form only, were filmed with a great deal of wild camera
movement, which suggests that they might have been shot by Dan
Williams. In one (ST266), the camera zooms in and out on Reed's
face so rapidly that the image begins to pulsate, creating an odd,

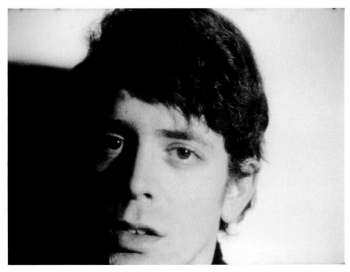

ST265

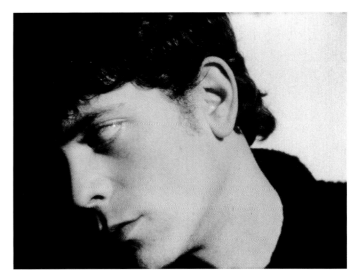

ST266

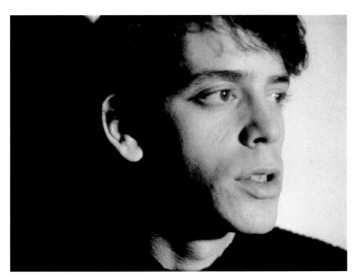

ST267

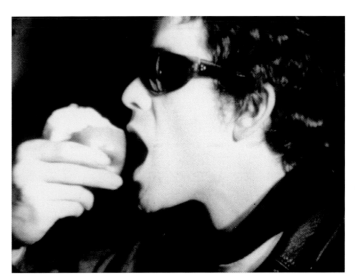

ST268

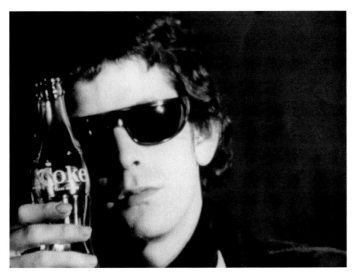

ST269

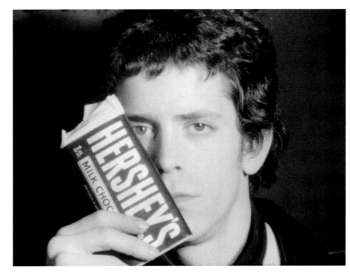

ST270

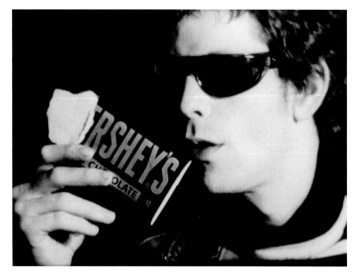

ST271

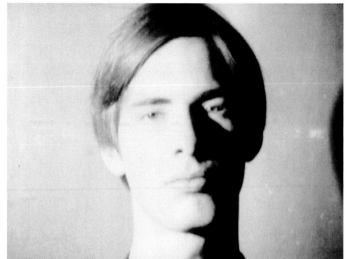

ST272

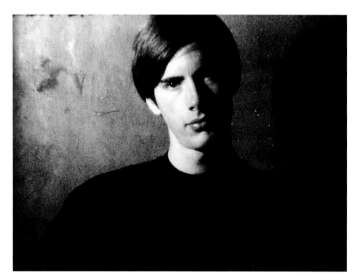

ST273

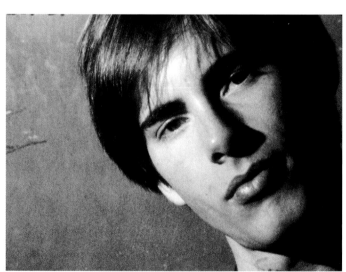

ST273

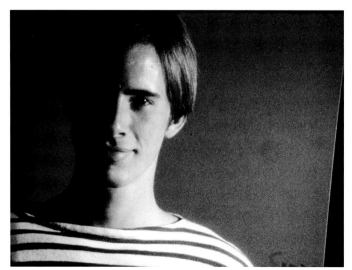

ST274

ST274

psychedelic distortion of his features. (The original of this *Screen Test* is in the collection of Pat Hackett.) In another similar roll (ST267), the camera zooms in and out on Reed as he smokes, then interrupts itself with flashes of single-framing and chaotic jiggling, reducing his face and a close-up of his eyes to mere blurs.

The last four *Screen Tests* of Reed are very similar to a series of pseudo-commercials that starred Nico (ST243–246), and were probably shot around the same time. In one (ST268), Reed, posed in profile wearing dark glasses and with shorter hair, slowly eats a large apple, chewing carefully between bites; there is no camera movement. In ST267, he faces the camera directly, still wearing his shades, and drinks from a Coca-Cola bottle, holding the bottle up beside his face between swigs so that the label is clearly legible. After he finishes the Coke, he holds the bottle up and slouches forward, settling into the lower left corner of the frame; the camera has not moved once. In another roll (ST270), Reed faces the camera without his dark glasses, posing with a large, partially unwrapped Hershey chocolate bar held up next to his face. He holds quite still throughout the film until, near the end of the roll, he blinks rapidly and tilts his head to the right. In a second film (ST271), Reed, again wearing dark glasses, opens the Hershey bar and takes a bite; the camerawork is extremely busy in this roll, zooming, panning, single-framing, jerking from side to side, and jiggling up and down. Reed licks his fingers and chews; the camera zooms out to show the black paper backdrop taped up behind him, pans up to the top of his head, then down to his striped shirt. At the end of the roll, he poses with the partially-eaten bar held up next to his face.

In February 1967, an article in *Night Owl* magazine described Nico singing with guitarist Jackson Browne at the Dom, while movies in which "Lou eats an apple . . . hershey bar" were projected behind her.[274]

## ST272   *Richard Rheem,* 1966
16mm, b&w, silent; 4.5 min. @ 16 fps, 4 min. @ 18 fps
Preserved 1999, MoMA *Screen Tests* Reel 21, no. 7
**FILM MATERIALS**
ST272.1 *Richard Rheem*
1966 Kodak 16mm b&w reversal original, 108'
**NOTATIONS** On box in AW's hand: *Richard Rheem*
On box in AW's hand, with frame drawing of two heads, crossed out: ★ *good. Freddie*

## ST273   *Richard Rheem,* 1966
16mm, b&w, silent; 4.6 min. @ 16 fps, 4.1 min. @ 18 fps
**FILM MATERIALS**
ST273.1 *Richard Rheem*
1966 Kodak 16mm b&w reversal original, 110'
**NOTATIONS** On box in AW's hand: *Richard*
On box in Gerard Malanga's hand: *8-11. slightly underexposed. #4 Rene in Ruthie's shop. 4*
On tape on can lid in AW's hand: *Richard*

## ST274   *Richard Rheem,* 1966
16mm, b&w, silent; 4.5 min. @ 16 fps, 4 min. @ 18 fps
Preserved 2001, MoMA *Screen Tests* Reel 26, no. 5
**FILM MATERIALS**
ST274.1 *Richard Rheem*
1966 Kodak 16mm b&w reversal original, 108'
**NOTATIONS** On original box in AW's hand: *#3 Richard Rheem*
On box in red: *3*

## ST275   *Richard Rheem,* 1966
16mm, b&w, silent; 3.9 min. @ 16 fps, 3.4 min. @ 18 fps
Preserved 2001, MoMA *Screen Tests* Reel 28, no. 6
**FILM MATERIALS**
ST275.1 *Richard Rheem*
1966 Kodak 16mm b&w reversal original, 93'
**NOTATIONS** On box in AW's hand, crossed out: *Antoine*
On box in AW's hand: *Richard Rheem*

Richard Rheem, a young man from a prominent California family, first met Warhol in San Francisco on May 27, 1966, at a party given by his uncle Bob Rheem and the artist/poet Liam O'Gallagher to celebrate the opening of Warhol's multimedia rock-and-roll show, the Exploding Plastic Inevitable, at the Fillmore Auditorium. As Rheem reminded Warhol by letter in July, Warhol asked him if he would like to come to New York to be in his movies. Enthused by this opportunity, Rheem wrote several letters to Warhol, spoke to him by telephone, and arrived in New York around the beginning of October 1966.[275]

In New York, Rheem and Warhol developed an intimate relationship; as Gerard Malanga noted in his diary at the time, Rheem was "young and obvious about his feelings and will be needing much of Andy's attentions."[276] Rheem stayed at least part of the time in Warhol's town house at 1342 Lexington Avenue, where he developed a warm friendship with Warhol's mother, Julia Warhola (a friendship that is apparent in Warhol's 1966 film *Mrs. Warhol*).[277] According to Victor Bockris, who identified Rheem as "Richard Green" in his biography of Warhol, Rheem lived with Warhol until the second week of December 1966.[278] Rheem maintained a friendly correspondence with Warhol for several years after this.[279]

Rheem performed in quite a few Warhol films during his brief two-and-a-half months at the Factory in 1966. In addition to his four *Screen Tests*, he had a small role in *The Bob Dylan Story*, played Gerard Malanga in *The Andy Warhol Story*, starred with Mary Woronov in a visually stunning hour–long dinner sequence titled *Richard and Mary*, played Governor Connelly in two reels of the Kennedy assassination film, *Since*, appeared with Susan Bottomly in the color version of *Susan–Space*, starred with Ingrid Superstar in *Ingrid and Richard*, was taught to iron by Julia Warhola in *Mrs. Warhol*, and appeared amid the crowd in two reels shot at Tiger Morse's apartment, *Tiger's Place* and *Richard and Mary II*. Rheem also appears in at least fifteen of Warhol's photobooth portraits made during this time.[280]

Rheem's film portraits are virtuoso examples of Warhol's experimental shooting techniques, in spite of—or perhaps because of—an intermittent loss of registration or slippage occurring in all four rolls, caused by a technical problem with the Bolex camera. In ST272, Rheem has been brightly lit from the left; he stares calmly back, blinking occasionally, while the camera progresses through a series of deliberate maneuvers: going slowly out of focus on an image of Rheem's face or body, zooming or panning or jerking away to a different shot, and then coming into focus on a different framing.[281] There is an occasional vertical blurring of the image, caused by slippage in the film gate. Although it was not something Warhol could have physically controlled, this blurring seems almost purposeful at times, since it fits so well with the deliberate pattern of repeated loss and recovery of the image that Warhol is creating in the camerawork. In another similar film, ST273, the camera zooms raggedly in and out and occasionally erupts into staccato bursts of single-framing while Rheem tilts his head and smiles. The intermittent loss of registration once again fits almost imperceptibly into Warhol's shooting style; after a prolonged section of vertical slippage, the film ends on a perfectly in-focus, stationary image.

Two other portraits, which are somewhat underexposed, also explore the same techniques. In one (ST274), Rheem, wearing a striped fisherman's jersey and brightly lit from the right, performs for the camera, tilting his head, showing both profiles, and smiling flirtatiously. The camerawork alternates rhythmically between still shots, occasional zooms, different framings, rapid bouts of single-framing, quick changes in aperture (which intermittently darken or lighten the image), and the recurrent vertical slippage, which again seems nearly deliberate. In the other film (ST275), which is also underexposed, Rheem holds still and faces the camera seriously, while a tear slowly wells up in his eye. There is a slight loss of registration at the beginning of the film; this becomes continuous by the end of the roll, so that Rheem's face appears to dematerialize into a vertical blur.

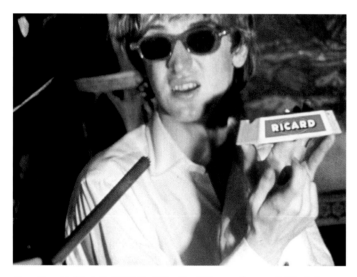

Rene Ricard in Warhol's 1966 film *Tiger Hop* (16mm, color, sound, 33 min.).

## ST276    *Rene Ricard*, 1966

16mm, b&w, silent; est. 4 min. @ 16 fps, 3.6 min. @ 18 fps
COMPILATIONS  *Screen Tests/A Diary* (Appendix A)
FILM MATERIALS
Original not found in Collection

The poet, artist, and critic Rene Ricard appears in a *Screen Test* from 1966. Although Ricard's *Screen Test* is illustrated in Warhol and Gerard Malanga's collaborative publication *Screen Tests/A Diary* (see Appendix A), the film itself has not been found among the reels in the Warhol Film Collection. Its current location is unknown.

In addition to this portrait film, Ricard also played the houseboy in Warhol's film *Kitchen* (1965), appeared in the *Boys in Bed* sequence in *The Chelsea Girls* (1966), and played the role of Warhol in *The Andy Warhol Story* (1966). He also appears in several reels shot for or included in ★★★★ (*Four Stars*): *Ondine Dead, Katrina Dead, Courtroom, Tiger Hop, Mary I,* and *Ultra,* in which he pretends to be Susan Bottomly.

Ricard worked with a number of other filmmakers as well, appearing in Warren Sonbert's *Hall of Mirrors* (1966), Piero Heliczer's *Joan of Arc* (1967), and Gerard Malanga's *Pre-Raphaelite Dream* (1968). Ricard has published four books of poetry and numerous pieces of art criticism; his first book of paintings and drawings has recently been published in a limited edition (*Paintings and Drawings* [Perceval Press, 2003]). Ricard was a central character in Julian Schnabel's 1996 film *Basquiat,* in which he was played by Michael Wincott.[282]

## ST277    *Clarice Rivers*, 1964

16mm, b&w, silent; 4.5 min. @ 16 fps, 4 min. @ 18 fps
Preserved 1999, MoMA *Screen Tests* Reel 23, no. 5
COMPILATIONS  *Fifty Fantastics and Fifty Personalities* (ST366)
FILM MATERIALS
ST277.1  *Clarice Rivers*
1964 Kodak 16mm b&w reversal original, 108'
NOTATIONS  On original box in AW's hand: *Clarisse 50*
On box in unidentified hand: *CLARISSE*

Clarice Price Rivers, the wife of painter Larry Rivers, sat for a *Screen Test* in late 1964. Clarice Price, originally from Wales, first came to New York in 1960 to work as Rivers's housekeeper. They moved to Paris together in the spring of 1961, and were married in London in the spring of 1962. In Paris the Rivers occupied an atelier on the Impasse Ronsin, previously the site of Brancusi's studio. The artists Niki de Saint Phalle and Jean Tinguely had studios nearby, and often ate meals with the Rivers; Clarice and Niki became close friends.

In 1962 the Rivers moved back to New York, where they lived for a while in the Chelsea Hotel. In 1964 Clarice served as the inspiration and model for the first of Saint Phalle's enormous *Nana* figures, which Saint-Phalle began by tracing a life-size drawing that Rivers had made of his wife when she was hugely pregnant with their first daughter, Gwynneth Venus, born in September 1964. Later that fall, Clarice Rivers and Saint Phalle paid a visit to Warhol at the Factory. As Rivers recalls, Warhol very casually asked each of them to pose for his movie camera, which was set up in an alcove with a chair in front of it.[283]

Larry and Clarice Rivers had a second daughter, Emma, in 1966. The couple separated amicably in 1968, and they remained married and were close friends until Rivers's death in 2002. In 1975 Clarice appeared in Saint-Phalle's film *Daddy*. She continues to reside in New York City.[284]

In her portrait film, Clarice Rivers appears with black-rimmed eyes, frosted lips, and long dark hair shining against the dim, out-of-focus space of the Factory behind her. Her performance wavers between self-possession and uncertainty. At times she gazes unfazed into the camera, wearing a slight Mona Lisa smile. At other moments she seems to be temporarily overcome with self-consciousness, glancing offscreen and readjusting the set of her mouth, but soon drawing herself up to face the camera once again. At one point she nods her head gently, as if to music, and produces a big smile. The shadows of several people can be seen crossing in the darkness behind her.

## ST278    *Robin*, 1965

16mm, b&w, silent; 4.4 min. @ 16 fps, 3.9 min. @ 18 fps
Preserved 1995, MoMA *Screen Tests* Reel 10, no. 3
FILM MATERIALS
ST278.1  *Robin*
1965 Kodak 16mm b&w reversal original, 106'
NOTATIONS  On box in unidentified hand: *Robin*

A young woman identified only as "Robin" appears in a *Screen Test* from 1965. Gerard Malanga remembered Robin as "just a teenager who came by the Factory."[285] Her portrait is slightly out of focus throughout; the image is low-contrast and washed out. With her long wavy hair curving around her heart-shaped face, Robin poses languorously, giving the camera a sidelong glance. There is a hair caught in the top right-hand corner of the frame.

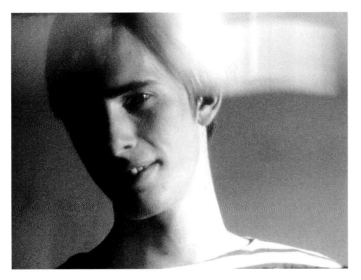

ST274

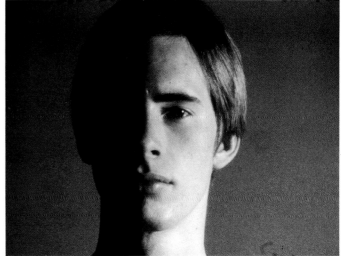

ST275

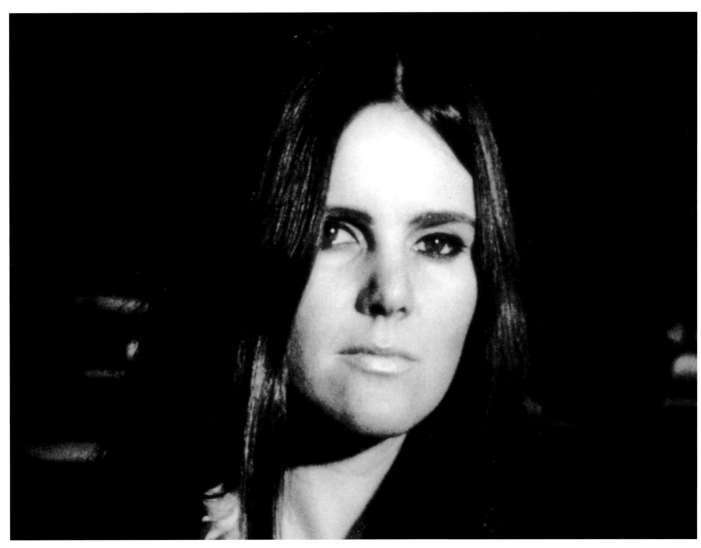

ST277

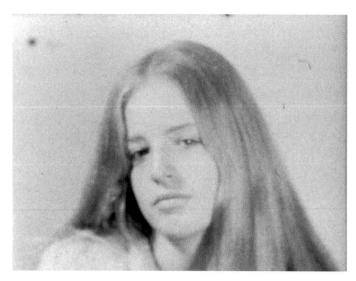

ST278

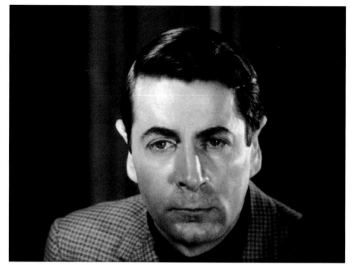

ST279

ST280

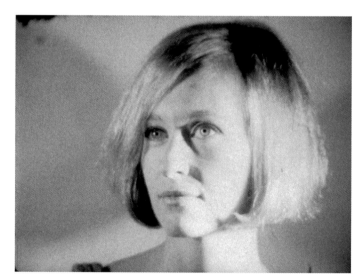

ST281

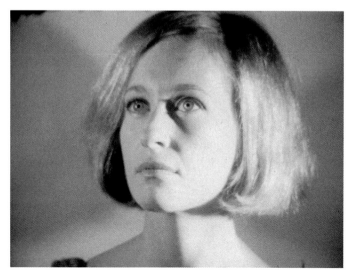

ST282

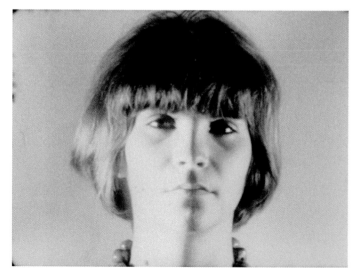

ST283

## ST279  *Henry Romney*, 1964

16mm, b&w, silent; 4.5 min. @ 16 fps, 4 min. @ 18 fps
Preserved 2001, MoMA *Screen Tests* Reel 27, no. 9
**FILM MATERIALS**
ST279.1  *Henry Romney*
1964 Kodak 16mm b&w reversal original, 108'
**NOTATIONS**  On original box in AW's hand: *Henry X.* (illeg.) *acting*

## ST280  *Henry Romney*, 1964

16mm, b&w, silent; 4.5 min. @ 16 fps, 4 min. @ 18 fps
Preserved 1998, MoMA *Screen Tests* Reel 17, no. 9
**COMPILATIONS**  *Fifty Fantastics and Fifty Personalities* (ST366)
**FILM MATERIALS**
ST280.1  *Henry Romney*
1964 Kodak 16mm b&w reversal original, 108'
**NOTATIONS**  On original box in unidentified hand: *Henry X #2. 50*

Henry Romney was, for the most part, a behind-the-scenes presence in Warhol's early filmmaking, instrumental in the production of *Empire* (1964), *Batman Dracula* (1964), and possibly other early works as well. Romney, a German American fluent in both languages, was reportedly active in the OSS during the Second World War.[286] In 1964 he was working for the Rockefeller Foundation, and was able to admit Warhol, John Palmer, Jonas Mekas, and other members of the *Empire* film crew to the foundation's offices on the forty-fourth floor of the Time-Life Building on the night of Saturday, July 25, 1964, when they obtained their now-famous eight-hour shot of the Empire State Building. The secretiveness of this nighttime filmmaking expedition and Romney's role in it, not to mention his wartime experience as a spy, explain the name "Henry X" that appears on his *Screen Test* boxes and also in several interviews.[287]

Romney, Palmer, and Warhol apparently had plans to form a joint film production company, to be called "Rom Palm Hol," under which title at least some of the footage of *Batman Dracula* seems to have been produced.[288] According to John Palmer's recollections, Romney also hoped to obtain the rights to Anthony Burgess's novel, *A Clockwork Orange*, for the Rom Palm Hol company, an idea that later developed into Warhol's 1965 film *Vinyl*. Romney also appears in a couple of rolls shot for *Soap Opera* in 1964.

In the first of Romney's two *Screen Tests*, he appears wearing a tweed jacket against a dark background, positioned at the right of the film image. Hunched forward and staring intently at the camera, Romney does indeed seem to be "acting," as Warhol wrote on the film box. His face remains frozen in an expression of what might be suspiciousness or jealousy, while his unblinking eyes slowly fill with tears. In a second *Screen Test*, shot against a silver-painted brick wall at the Factory, probably in late 1964, Romney resembles the romantic lead in a 1930s Hollywood movie, dapper and handsome in a pin-striped suit and with carefully slicked-back hair. Brightly lit from the left, he stares rigidly back at the camera, looking like Cary Grant caught in a searchlight.

## ST281  *Barbara Rose*, 1964

16mm, b&w, silent; 4.4 min. @ 16 fps, 3.9 min. @ 18 fps
Preserved 1995, MoMA *Screen Tests* Reel 10, no. 2
**COMPILATIONS**  *The Thirteen Most Beautiful Women* (ST365)
**FILM MATERIALS**
ST281.1  *Barbara Rose*
1964 Kodak 16mm b&w reversal original, 106'
**NOTATIONS**  On original box in AW's hand: *Barbara Rose*

## ST282  *Barbara Rose*, 1964

16mm, b&w, silent; 4.4 min. @ 16 fps, 3.9 min. @ 18 fps
**COMPILATIONS**  *The Thirteen Most Beautiful Women* (ST365)
**FILM MATERIALS**
ST282.1  *Barbara Rose*
1964 Kodak 16mm b&w reversal original, 105'
Broken tape splice at 76'; film is extremely dirty
**NOTATIONS**  On plain brown box in Paul Morrissey's hand: *Barbara Rose 8*

The art historian and critic Barbara Rose appears in two *Screen Tests* from 1964. Rose is well known for her writings on twentieth-century American art; she was a particularly central figure in the New York art world of the 1960s and 1970s, when she was married to the artist Frank Stella and wrote frequently about Warhol and his contemporaries in publications such as *Artforum* and *Art in America*. In late 1964 John Palmer and Gerard Malanga gave the journalist Howard Junker some tongue-in-cheek information about one of Warhol's "possible films-in-progress":

> *An Open Letter to Barbara Rose* will show gossipy John Bernard Meyers (Tibor de Nagy Gallery) gossiping for an hour and a half, by implication, to gossipy art critic Barbara Rose. (This would have to be a sound film.)[289]

Rose's first book, *American Art Since 1900*, was published in 1967; her collected critical writings were published in 1988 in *Autocritique: Essays on Art and Anti-Art, 1963–1987*.[290] Rose has taught at Sarah Lawrence and Hunter colleges and at the University of California. She has also curated numerous exhibitions and published catalogues and monographs on many American artists, including Claes Oldenburg, Ellsworth Kelly, Helen Frankenthaler, Lee Krasner, and Patrick Henry Bruce. Rose is the editor of *Art-As-Art: The Selected Writings of Ad Reinhardt*.[291]

Rose's two film portraits are very similar, clearly shot at the same time. In ST281, she has been posed in three-quarter profile, gazing wide-eyed off to the left, her face filled with light, her blond hair and long neck delicately lit against a bright background. Her large eyes stand out vividly within the subtle tonalities of the film image. This carefully lit, low-contrast portrait is quite similar to John Giorno's *Screen Tests* (ST116–117), suggesting that their portraits may have been filmed around the same time.

The condition of ST282, which is quite dirty and has a tear repaired with a tape splice, suggests that this film of Rose may be the one included in screenings of *The Thirteen Most Beautiful Women* (ST365) in the 1960s. It was also found stored in the same kind of plain brown box that characterizes other rolls from *The Thirteen Most Beautiful Women*. It is very similar to her other portrait, except that Rose has tilted her head back slightly and is gazing soulfully upward, a pose that softens her face and makes her neck appear longer.

## ST283  *Rosebud*, 1964

16mm, b&w, silent; 4.5 min. @ 16 fps, 4 min. @ 18 fps
Preserved 1999, MoMA *Screen Tests* Reel 18, no. 2
**COMPILATIONS**  *The Thirteen Most Beautiful Women* (ST365)
**FILM MATERIALS**
ST283.1  *Rosebud*
Undated 16mm b&w reversal original, 108'
**NOTATIONS**  On original box in Gerard Malanga's hand: *Rose for 13*

Rosebud Felieu-Pettet, known in the 1960s only as Rosebud, appears in a *Screen Test* from late 1964. Rosebud was a bohemian New York teenager in the mid-1960s, when she spent a great deal of time hanging out with her close friends Barbara Rubin and Allen Ginsberg. Rosebud and Rubin had hitchhiked across the country together, and in late 1965 Rosebud went along when Rubin first took Warhol to see the Velvet Underground perform at the Café Bizarre. She was also present during Bob Dylan's much-filmed and photographed visit to the Factory. In 1965 Rosebud appeared with Warhol, Rubin, and many other celebrities of the avant-garde in Piero Heliczer's epic 8mm film *Dirt*, in which she and the filmmaker Harry Smith had a central role. She and Smith became particularly close, a relationship that both considered a "spiritual marriage" and that they maintained until the end of his life.[292] Rosebud, who later appeared in Smith's 1970–80 film *Mahagonny*, still keeps Smith's ashes by her bedside.

Her face framed between a mop of thick hair and a necklace of large beads, Rosebud faces the camera with a solemn, heavy-lidded gaze, revealing little emotion, an expression she maintains steadfastly throughout the film. The symmetrical lighting creates a thin line of shadow running down the center of her nose and chin. The focus gets softer as the film progresses, and there are a few light flares in the middle of the roll.

## ST284  *Twist Jim Rosenquist*, 1964
16mm, b&w, silent; 4.5 min. @ 16 fps, 4 min. @ 18 fps
Preserved 1995, MoMA *Screen Tests* Reel 3, no. 2
**COMPILATIONS**  *EPI Background* (ST370)
**FILM MATERIALS**
ST284.1  *Twist Jim Rosenquist*
1964 Kodak 16mm b&w reversal original, 107', 110' with head leader
ST284.1.p1  *EPI Background* (ST370), roll 1
Undated Dupont 16mm b&w reversal print, 107'
**NOTATIONS**  On original box in AW's hand: *Twist Jim Rosenquist*
On yellow head leader in red: *17*
On yellow head leader in black: *–1–*

## ST285  *Jim Rosenquist*, 1964
16mm, b&w, silent; 4.6 min. @ 16 fps, 4.1 min. @ 18 fps
Preserved 1995, MoMA *Screen Tests* Reel 2, no. 4
**COMPILATIONS**  *Fifty Fantastics and Fifty Personalities* (ST366)
**FILM MATERIALS**
ST285.1  *Jim Rosenquist*
1964 Kodak 16mm b&w reversal original, 110'
**NOTATIONS**  On original box in AW's hand: *Jim Rosenquist (50)*

The painter James Rosenquist was a close contemporary of Warhol's in the early days of Pop art; as Warhol recalled, Ivan Karp of the Leo Castelli Gallery discovered Rosenquist's work just days after he discovered Warhol.[293] Rosenquist's first show at Leo Castelli was an exhibition, in 1965, of his enormous 10' x 86' painting, *F-111*. The painting was purchased by the collectors Robert and Ethel Scull; in 1988, *F-111* sold for $2,090,000, at which time it was considered the largest artwork ever auctioned.[294]

Some of the earliest footage Warhol ever shot, a poorly exposed, untitled film from 1963, shows Rosenquist fitting together two large sections of canvas for his 1963 work *Painting for the American Negro*, and then smiling broadly at the camera. Warhol was an admirer of Rosenquist's work and owned several of his paintings, which were put up for auction at Sotheby's after Warhol's death.[295]

Rosenquist appears in two *Screen Tests* from 1964, which appear to have been shot at the same time. In one film, called *Twist Jim Rosenquist*, he has been filmed while seated on a steadily spinning piano stool, which is not visible in the frame.[296] Throughout this unusual performance, Rosenquist's head rotates with a kind of lunar motion, circling in wobbly orbit around an invisible central point toward which his face is always turned. Rosenquist maintains an impressive straight-ahead stare through what must have been a rather dizzying three minutes. Toward the end of the film, the revolving piano stool seems to be edging forward, so his head becomes increasingly out of focus each time its orbit nears the camera. Another roll shows the artist sitting casually in front of the camera, the open space of the Factory visible behind him. The frontal lighting is very bright and his face is rather overexposed; Rosenquist blinks often and keeps glancing away from the camera. At one point he pulls on his collar to loosen it.

## ST286  *Barbara Rubin*, 1965
16mm, b&w, silent; 4.5 min. @ 16 fps, 4 min. @ 18 fps
Preserved 1995, MoMA *Screen Tests* Reel 7, no. 2
**COMPILATIONS**  *Fifty Fantastics and Fifty Personalities* (ST366); *Screen Test Poems* (ST372); *Screen Tests/A Diary* (Appendix A)
**FILM MATERIALS**
ST286.1  *Barbara Rubin*
1965 Kodak 16mm b&w reversal original, 109'
ST286.1.p1  *Screen Test Poems*, Reel 1 (ST372.1), roll 3
Undated Gevaert 16mm b&w reversal print, 100'
**NOTATIONS**  On original box in AW's hand: *Barbara Rubin*
On box in Gerard Malanga's hand: *1 double frame* (words rubbed off) *masking tape* (words rubbed off) *8" x 10" glossy print*
On box flap in red: *3*
On typed label found in can: *BARBARA RUBIN*
On clear film at head of roll in black: *3*

The filmmaker Barbara Rubin was born in New York City in 1945.[297] In 1963, at the age of seventeen, she started working for Jonas Mekas at the Film-Makers' Cooperative. Mekas lent Rubin his 16mm Bolex camera, and that summer she made her first and best-known film, *Christmas on Earth*, a groundbreaking, sexually explicit, multi-image feature whose projection included the use of live radio and colored filters.[298] Later that same year, Rubin was involved in the famous *Flaming Creatures* scandal at the Knokke-le-Zoute International Experimental Film Festival in Belgium, when she and Mekas attempted to screen Jack Smith's notorious film after it had been banned by the film censors.

Rubin was an active and influential figure in underground circles in the 1960s, busy with her own films and scripts, yet often appearing in other peoples' films and plays. Rubin's first appearance in a Warhol film was in a 1964 *Kiss* roll, in which she kisses filmmaker Naomi Levine. Rubin was a kind of cultural cross-pollinator, introducing artists, musicians, poets, and filmmakers to one another, and organizing ambitious group projects; as Allen Ginsberg recalled, Rubin had "dedicated her life to introducing geniuses to each other in the hope that they would collaborate to make great art that

ST284

ST284

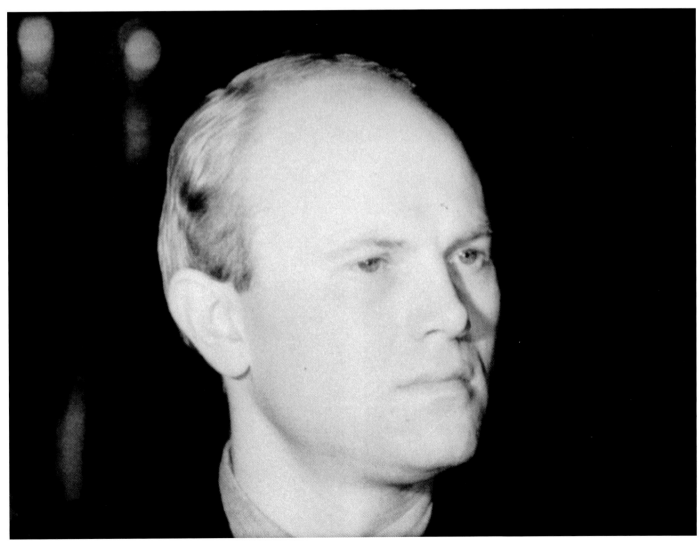

ST285

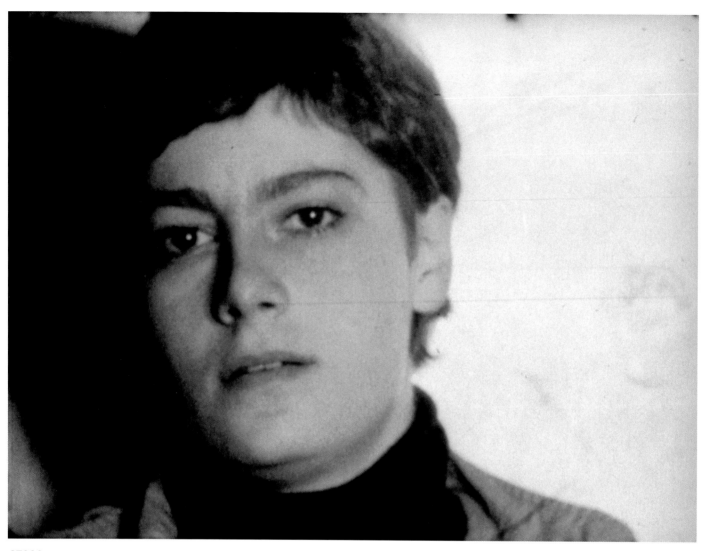

ST286

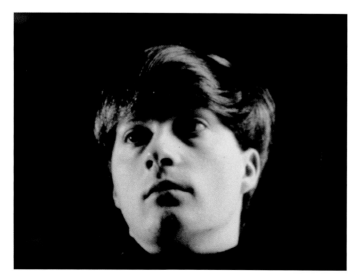

ST287

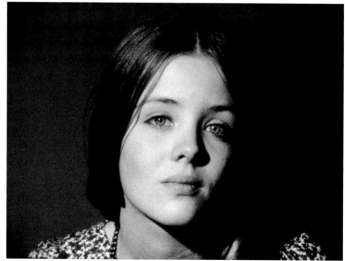

ST288

would change the world."[299] Rubin introduced Ginsberg to Bob Dylan, appeared on the back cover of Dylan's 1965 album *Bringing It All Back Home*, and also introduced Gerard Malanga and Warhol to the Velvet Underground in December 1965. She was centrally involved in organizing the pre-EPI Andy Warhol Up-Tight events in early 1966, at which the Velvet Underground played rock-and-roll while films were screened, superstars danced, colored lights and slides were projected around the room, and Rubin and Dan Williams rushed around with 16mm cameras aggressively filming the audience.[300] Later that same year Rubin also came up with the idea for Warhol's 1966 film *The Closet*.

In 1966 Rubin, Warhol, Ginsberg, Malanga, Peter Orlovsky, Ed Sanders, and Tuli Kupferberg appeared at a press conference to announce the formation of the Kreeping Kreplach Non-Profit Cultural International Foundation of Purple People Art Combine, which planned to present a multimedia concert of music, poetry, films, and filmmakers at the Albert Hall in London; this event was later realized as a ten-day festival called Caterpillar Changes at the Film-Makers' Cinematheque in February 1967.[301]

In 1968 Rubin moved to upstate New York with Ginsberg and Orlovsky, where she became involved in exploring her Jewish heritage. In 1972, when she was teaching at New York's City College, her last film, *Emunah*, was completed; around this time she married Mordecai Levy and changed her name to Bracha Rubin-Levy. Shortly thereafter she left Levy and married the French painter Pierre Besançon, with whom she moved to Europe to live in a Hassidic community. Barbara Rubin died in 1980 while giving birth to her sixth child; she is buried in the Jewish cemetery in Ceffois-le-Bas, Haut Rhin, France.

In her 1965 *Screen Test*, Rubin looks just as intelligent, passionate, and complex as her life history suggests she was. Posed against a white wall and brightly lit from the right, Rubin seems incapable of confining her energy to the parameters of the film frame. She smokes, shifts position constantly, glances around with flashing dark eyes, leans forward to put her cigarette out, and gazes off into space, her brow furrowed in thought. Near the end of the film, she smiles broadly at people offscreen.

## ST287    *Bruce Rudow,* 1964

16mm, b&w, silent; 4.2 min. @ 16 fps, 3.7 min. @ 18 fps
Preserved 1995, MoMA *Screen Tests* Reel 5, no. 3
COMPILATIONS *The Thirteen Most Beautiful Boys* (ST364)
FILM MATERIALS
ST287.1 *Bruce Rudow*
1963 Kodak 16mm b&w reversal original, 100'
NOTATIONS  On original box in AW's hand: *red (13)*

The jewelry designer Bruce Rudow first met Warhol in 1960 or 1961, at a dinner party with Fritzie Miller, Warhol's commercial art agent; Warhol later invited him to his town house on Lexington Avenue. Rudow was one of the first people to have his *Screen Test* shot. He does not appear in any other Warhol films, although he can be seen in John Schlesinger's 1969 film *Midnight Cowboy*, in which he appears in the party scene along with Viva, Paul Morrissey, and other Factory figures.

A few years after his *Screen Test* was made, Rudow was working at a clothing store in Greenwich Village called the Tunnel of Love, when he met another Warhol film veteran, Ronna Page. When Page walked into the store and saw Rudow for the first time, she immediately announced that she was going to bear his child; she pursued

him for some time before they developed a relationship. Their son, Tiavi Rudow, was born on July 7, 1972; in later years, he was raised primarily by his father. Rudow and his son now live in Decatur, Illinois, where Tiavi is a pastor in his own church, the First Church of the Living Dead, and has a rock-and-roll band called Spirit Child, in which his father dances and performs.[302]

Rudow's *Screen Test* was shot at Kelly Edey's town house on West 83rd Street, probably in late January or early February 1964; Rudow recalled that the owner of the house had a great many clocks. Rudow, who had bright red hair (Warhol identified him as "red" on the film box), has been filmed from a low angle, so the camera looks up at him. His head is turned slightly to the left, and his gaze is directed offscreen; he succeeds in not blinking at all throughout most of the film. With his large moist eyes, pale skin, and tilted boyish head, Rudow's portrait film is perhaps the most Caravaggio-esque of the Warhol *Screen Tests*. The wood paneling of Edey's home is briefly visible behind him in the light flares at the beginning and end of the roll.

## ST288    *Phoebe Russell,* 1966

16mm, b&w, silent; 4.4 min. @ 16 fps, 3.9 min. @ 18 fps
COMPILATIONS *Screen Tests/A Diary* (Appendix A)
FILM MATERIALS
ST288.1 *Phoebe Russell*
1966 Kodak 16mm b&w reversal original, 106'
NOTATIONS  Stamped on original box: *LAB TV*
On tape on can lid in Gerard Malanga's hand: *Phoebe Russell*
On typed label found in can: *PHOEBE RUSSELL*

A young woman named Phoebe Russell had her *Screen Test* filmed by Gerard Malanga in the summer of 1966. According to Malanga's recollections, Russell's was the only *Screen Test* ever shot outside of New York City. Malanga filmed her in Ed Hood's apartment in Cambridge, Massachusetts, at a time when Warhol was not present; Warhol seems to have lent Malanga his Bolex camera for this out-of-town trip.[303] Malanga's later diary entry for August 29, 1966, makes mention of someone named Phoebe, "a Radcliffe sophomore and very very pretty," who is almost certainly Phoebe Russell.[304]

Wearing beads and a flowered dress, Russell gazes slightly cross-eyed at the camera, looking very pretty but also increasingly melancholy as her eyes tear up.

## ST289    *Charles Rydell,* 1964

16mm, b&w, silent; 4.4 min. @ 16 fps, 3.9 min. @ 18 fps
Preserved 1995, MoMA *Screen Tests* Reel 9, no. 6
FILM MATERIALS
ST289.1 *Charles Rydell*
1964 Kodak 16mm b&w reversal original, 105'
NOTATIONS  On original box in AW's hand: *Charles Rydel good*

## ST290    *Charles Rydell,* 1964

16mm, b&w, silent; 4.4 min. @ 16 fps, 3.9 min. @ 18 fps
Preserved 1995, MoMA *Screen Tests* Reel 6, no. 1
FILM MATERIALS
ST290.1 *Charles Rydell*
1964 Kodak 16mm b&w reversal original, 106'
NOTATIONS  On original box in AW's hand: *Charles Rydel*

## ST291 *Charles Rydell,* 1964

16mm, b&w, silent; 4.1 min. @ 16 fps, 3.6 min. @ 18 fps
**FILM MATERIALS**
ST291.1 *Charles Rydell*
1964 Kodak 16mm b&w reversal original, 98'
Light leaks throughout roll
**NOTATIONS** On original box in AW's hand: *Charles Rydell. not right*

According to Warhol's recollections in *POPism*, he met the actor Charles Rydell on his very first day in New York City, when Warhol was "just off the bus from Pittsburgh." Warhol also recalled that Rydell was present at an early screening of *Tarzan and Jane Regained, Sort Of . . .* at Jerome Hill's suite at the Algonquin Hotel in the fall of 1963. When another guest made disparaging remarks about the film, Rydell vociferously defended it. As Warhol recalled:

> He was a very big man with a big temper and a real sense of humor. He could really bellow, and he had the deep, full voice to do it right. . . . I liked Charles and I asked if I could call him to be in a movie of mine sometime. He said sure, any time.[305]

Warhol later asked Rydell if he would be willing to star in his film *Blow Job*: "I told him that all he'd have to do was lie back and then about five different boys would come in and keep on blowing him until he came, but that we'd just show his face. He said, 'Fine, I'll do it.'" But when the time came, Rydell didn't show up for the filming; when Warhol called him, he said, "'Are you crazy? I thought you were *kidding*. I'd never do *that*!'"[306]

Rydell did appear in three *Screen Tests* in 1964, and later starred with his friend Brigid Berlin and Sylvia Miles in a 1975 Warhol/Fremont video drama called *Fight*.[307] Rydell and his companion, Jerome Hill, were early sponsors of *Interview* magazine when it was started in 1969.

Rydell has been a professional stage actor and singer for many years; Warhol recalled having seen him with Kitty Carlisle in *Lady in the Dark* at the Bucks County Playhouse.[308] He also appeared in the 1967 off-Broadway revival of the Rodgers and Hart musical *By Jupiter*, and sang on several recordings of old show tunes, *Rodgers and Hart Revisited, Vol. 2* and *Unpublished Cole Porter, Vol. 2*. Rydell appears in two films by Jerome Hill, *The Sand Castle* (1961) and *Open the Door and See All the People* (1964). In 1980, he played a cab driver in Marcus Reichert's film *Union City*, starring Debbie Harry, on which occasion he was interviewed by Warhol and Brigid Berlin for *Interview* magazine.[309]

Rydell's three *Screen Tests* appear to have been shot at the same time. In all three films, Rydell has been lit from both sides, but more brightly on the left, with a halo of light refracting off the left side of his head (this effect is called halation, caused by the reflection of light off the base layer of the film stock). In ST289, which Warhol labeled "good," he holds quite still throughout the film, staring at the camera with an interestingly strained expression, his brows furrowed. Toward the end of the roll, he sighs and his shoulders rise briefly. In ST290, Rydell behaves much more casually, smiling and laughing at the camera, looking around, shifting his shoulders, and nodding his head as if to music. At one point he smiles and then shakes his head, as if amused by the absurdity of his performance. In ST291, Rydell also smiles and looks around, but the film is clearly "not right," as Warhol noted on the box. There are light flares throughout the roll and the entire film is badly overexposed, with sprocket holes printed through into the image throughout. It seems clear that the entire roll was inadvertently exposed to light at some point, probably as it was being rewound or unloaded.

## ST292 *Niki de Saint Phalle,* 1964

16mm, b&w, silent; 4.3 min. @ 16 fps, 3.9 min. @ 18 fps
Preserved 2001, MoMA *Screen Tests* Reel 24, no. 4
**COMPILATIONS** *Fifty Fantastics and Fifty Personalities* (ST366)
**FILM MATERIALS**
ST292.1 *Niki de Saint Phalle*
1964 Kodak 16mm b&w reversal original, 104'
**NOTATIONS** On original box in AW's hand: *Niki de Stant Phiel 50*

The artist and sculptor Niki de Saint Phalle was born in Paris in 1930 but grew up in New York City, where her father managed a branch of the family bank. In 1949 she married the poet and author Harry Mathews; in 1952 they moved to Paris, where Saint Phalle first studied acting. She started painting in 1953 while recovering from a nervous breakdown and soon decided to become a full-time artist. In 1960 Saint Phalle joined the art group Nouveaux Réalistes; she also divorced Mathews to live and work with the Swiss sculptor Jean Tinguely, whom she married in 1971.

Saint Phalle's early work included "target paintings," at which darts could be thrown, and performance events called *Tirs* (or "shootings"), in which she created "shooting paintings" by firing a rifle at assemblaged sculptures containing pockets of paint. She is perhaps most widely known for her *Nanas*, massive, brightly colored figures of voluptuous, small-headed women, which were originally inspired by the pregnancy of her close friend, Clarice Rivers. She is also known for large-scale architectural sculpture such as *Hon*, a gigantic figure of a woman giving birth that served as the entrance to the Moderna Museet in Stockholm during a 1966 exhibition. In later years, Saint Phalle designed public parks, fantasy buildings, and ambitious sculpture gardens, including the Tarot Garden, a park in Garavicchio, Tuscany, filled with monumental sculptures of Tarot figures, on which she labored from 1974–94. She and Tinguely collaborated on many of these projects, including a fountain commissioned in 1982 by the City of Paris for the outside of the Centre Georges Pompidou. Saint Phalle made films, designed furniture, created a perfume named after herself, and wrote a children's book about AIDS, which she and her son Philip Mathews turned into an animated film in 1989. In 1994 Saint Phalle moved to La Jolla, California, where she died in 2002 from respiratory illness caused by long-term exposure to polyester fumes and other materials in her work.[310]

Saint Phalle appears in a Warhol *Screen Test* from 1964, shot in the late fall at the same time as Clarice Rivers's portrait. Filmed against the sparkly background of the Factory, Saint Phalle looks elegant, solemn, and slightly sad. Her large-eyed gaze seems to avoid direct engagement with the camera; toward the end of the roll, she strokes her chin pensively.

## ST293 *Ed Sanders,* 1964

16mm, b&w, silent; 4.3 min. @ 16 fps, 3.8 min. @ 18 fps
Preserved 1998, MoMA *Screen Tests* Reel 17, no. 8
**COMPILATIONS** *Fifty Fantastics and Fifty Personalities* (ST366)
**FILM MATERIALS**
ST293.1 *Ed Sanders*
1964 Kodak 16mm b&w reversal original, 103'
**NOTATIONS** On original box in unidentified hand: *ED SANDERS #1. 50. Portrait*
On box in Gerard Malanga's hand: *1 double frame negative and 1 8" x 10" double frame stillie marked by masking tape*

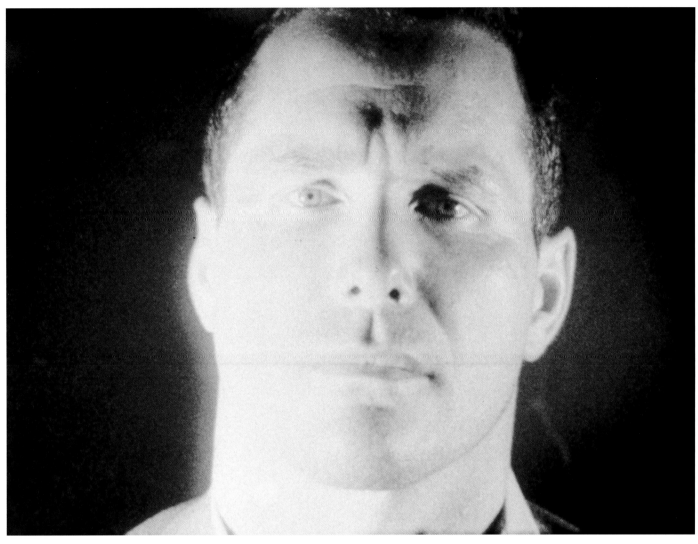

ST289

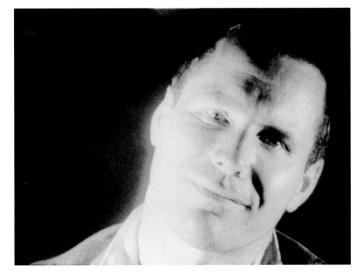

ST290

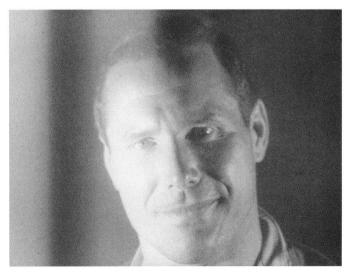

ST291

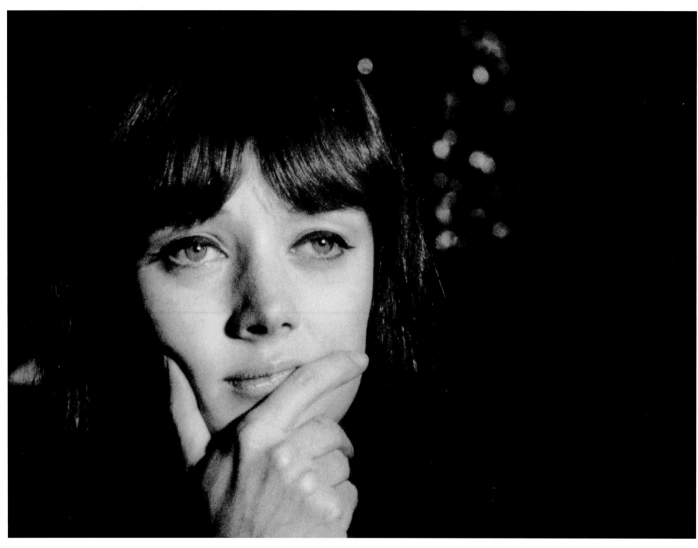

ST292

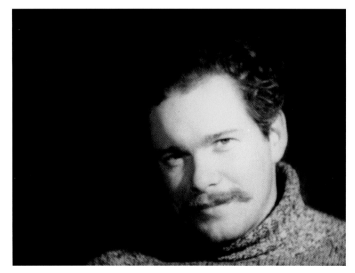

ST293

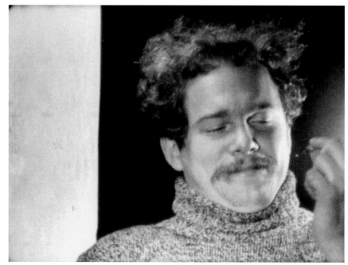

ST294

## ST294 *Ed Sanders,* 1964

16mm, b&w, silent; 4.5 min. @ 16 fps, 4 min. @ 18 fps
Preserved 1999, MoMA *Screen Tests* Reel 22, no. 2
**COMPILATIONS** *Fifty Fantastics and Fifty Personalities* (ST366)
**FILM MATERIALS**
ST294.1 *Ed Sanders*
1964 Kodak 16mm b&w reversal original, 107'
**NOTATIONS** On original box in AW's hand: *Ed Sanders. Good–50*

The poet, writer, and activist Ed Sanders was a key figure in the East Village countercultural scene of the 1960s. As founder, editor, publisher, and distributor of the mimeographed journal *Fuck You: A Magazine of the Arts* (1962–65), Sanders published a number of contemporary poets and writers, including Charles Olson, Frank O'Hara, William Burroughs, Allen Ginsberg, and many others. As its title implied, the magazine took a gleefully confrontational stance toward free speech, drugs, and other political issues of the time. Despite its light-hearted tone, the contents of *Fuck You* led to Sanders's arrest on obscenity charges in 1966; the charges were dismissed by a panel of three judges in June 1967, a decision that Sanders celebrated with a big party.[311]

Sanders was also the proprietor of the Peace Eye Bookstore, which he opened in a storefront on East 10th Street in 1964 and for which Warhol created a special *Flowers* banner; the bookstore became a kind of mecca for poets and other members of the avant-garde.[312] The next year Sanders and poet Tuli Kupferberg founded the underground rock band the Fugs, whose early membership included Ken Weaver, Peter Stampfel, and Steve Weber. The Fugs specialized in raunchy lyrics about sex, drugs, and politics, and performed at antiwar rallies around the country as well as at underground venues like the Bridge in New York City, where satirical songs like "Kill for Peace" and "Slum Goddess" provoked varying amounts of delight and outrage in their audiences. Their first album, released in 1965 by Broadside/Folkways, was produced and recorded by the filmmaker Harry Smith.

In 1970 Sanders closed the Peace Eye Bookstore and moved to Los Angeles, where he began research on *The Family* (Dutton, 1971), his pioneering book-length study of Charles Manson and his followers. Sanders has continued to write journalism and poetry; his books include a collection of Investigative Poetry (poetry pursued in the manner of investigative journalism), a verse biography of Chekhov, and a verse history of the year 1968. He has also invented several original musical instruments, including the Talking Tie and the Lisa Lyre, a contraption involving light-activated switches and an image of the *Mona Lisa*. The Fugs have performed off and on since the 1960s, most recently in the summer of 2003, when they released their latest album, *The Fugs Final CD (Part I)*. Sanders has lived for many years in Woodstock, New York, where he and his wife, the writer and painter Miriam R. Sanders, publish a biweekly newspaper, the *Woodstock Journal*.[313]

Sanders's first appearance in a Warhol film was in 1963, when he performed in an early *Kiss* roll with Naomi Levine. In the summer of 1964, Sanders invited Warhol to design the cover for the March 1965 issue of *Fuck You*; Warhol's design was a frame enlargement from his 1964 film *Couch*, showing a nude, three-way sex scene between Rufus Collins, Kate Heliczer, and Gerard Malanga.

Sanders's *Screen Tests* appear to have been shot in the late fall of 1964 or early 1965, possibly around the time when Warhol was completing his magazine cover. Wearing a burly turtleneck sweater and posed against a black background, Sanders begins one film (ST293) with his eyes closed, jerking his head and apparently singing along to music. He raises his eyes to the camera, smiles devilishly,

twirls the ends of his mustache into points, and shows his teeth. Singing and head-bobbing follow, interspersed with more thoughtful moments when he looks down or gazes off into space. In the second film (ST294), Sanders takes a series of highly exaggerated drags from a joint, which appears to be unlit. After each enormous chest-expanding toke, he holds his breath, squeezes his nose, coughs, eats what appears to be a slice of orange, and smiles contentedly at the camera. The focus is soft at the beginning of the roll, but improves later. The roll fades out on the image of Sanders still inhaling mightily, his eyes widening.

Sanders can also be seen in the 1966 film *Uptight: Susskind Show*, a "Warvel" production shot by Dan Williams and Barbara Rubin that documents the filming of an episode of David Susskind's TV talk show *Open End*, when a large group of young people, supposedly representing the counterculture, was invited to meet with Susskind. Sanders and his fellow Fug Tuli Kupferberg participated, as did Gerard Malanga, Paul Morrissey, the members of the Velvet Underground, and a number of other "freaks."

## ST295 *Andrew Sarris,* 1964

16mm, b&w, silent; 4.3 min. @ 16 fps, 3.8 min. @ 18 fps
Preserved 1998, MoMA *Screen Tests* Reel 15, no. 4
**COMPILATIONS** *Fifty Fantastics and Fifty Personalities* (ST366)
**FILM MATERIALS**
ST295.1 *Andrew Sarris*
1964 Kodak 16mm b&w reversal original, 103'
**NOTATIONS** On original box in AW's hand: *50. Andrew Sarris*

The film critic Andrew Sarris became enormously influential in the 1960s as the foremost American proponent of *auteur* theory, a school of French film criticism that focused on the contribution of the director as the guiding artistic force behind a movie, analyzing themes in the work of underappreciated studio directors such as John Ford, Howard Hawks, Max Ophuls, and Alfred Hitchcock. In addition to writing for a number of film journals including *Film Culture*, in which he first published "Notes on the *Auteur* Theory in 1962," Sarris was for many years a movie critic for the *Village Voice*, a position arranged for him by Jonas Mekas.[314] Between 1965 and 1967 he was the editor in chief of *Cahiers du Cinéma in English*, which published several articles about Warhol in its May 1967 issue, including Sarris's essay on *The Chelsea Girls* (1966), "The Sub-New York Sensibility." Sarris has published numerous books about cinema, of which the best known are *The American Cinema: Directors and Directions, 1929–1968* and *Confessions of a Cultist: On the Cinema 1955–1969*. He has taught at Columbia University since 1969, and presently reviews films for the *New York Observer*.

Sarris wrote about the Warhol films on several occasions in the 1960s and 1970s. One of his earliest pieces was a positive review of *The Life of Juanita Castro* in December 1965, in which Sarris contrasted Warhol with Howard Hawks, and admitted: "I have found in the past that with me a little Warholian cinema goes a long way, but it suddenly strikes me that I have never seen anything by Warhol entirely lacking in interest."[315] In Sarris's review of *The Chelsea Girls* from December 1966, he coined the phrase "traveling typewriter shot" to describe Warhol's enigmatically repetitive horizontal pans.

Sarris's *Screen Test*, which probably dates to late 1964 or early 1965, is underexposed and quite dark, as if filmed in the dim light of a movie theater. Wearing glasses and a suit and tie, Sarris gazes

off to the left as if watching a movie screen; only the very edge of his profile is illuminated, like the new moon. He seems quite solemn, but it is hard to read his expression, since his eyes are invisible. At the end of the roll, the shadow of someone moving offscreen passes over his face.

### ST296 *Francesco Scavullo*, 1966

16mm, b&w, silent; 4.5 min. @ 16 fps, 4 min. @ 18 fps
Preserved 1995, MoMA *Screen Tests* Reel 12, no. 6
COMPILATIONS *Screen Tests/A Diary* (Appendix A)
FILM MATERIALS
ST296.1 *Francesco Scavullo*
1966 Kodak 16mm b&w reversal original, 108'
NOTATIONS On original box in unidentified hand: *Francesco Scavully.
Francesco Scavullo*
On typed label found in can: *FRANCESCO SCAVULLO*

The work of fashion photographer Francesco Scavullo is probably widest known from his covers for *Cosmopolitan* magazine, which he produced between 1965 and 1995, often employing innovative lighting techniques to glamorize his subjects. Scavullo worked for many other fashion magazines as well, including *Seventeen, Town & Country, Mademoiselle, Glamour, Harper's Bazaar,* and *Vogue.* He was an acclaimed photographer of celebrities, creating portraits of Elizabeth Taylor, Grace Kelly, Madonna, Diana Ross, and many others.

Scavullo's well-known publicity photo for *Flesh,* a nude Joe Dallesandro holding a baby, was used in posters and other promotional materials during the film's European release in 1970 and later. His work also appeared in *Rolling Stone* and in *Interview* magazine, where Warhol hired him to help attract fashion advertising. In 1989 Scavullo began making silk screens from his photographs, working with Warhol's silk screener, Rupert Smith.[316] Scavullo died in January 2004 at the age of eighty-two; his work has been collected in a number of books, including *Scavullo on Beauty, Scavullo Women,* and *Scavullo Nudes.*[317]

In his 1966 *Screen Test,* Scavullo has been placed in front of a creased paper backdrop, and brightly lit from the left. Wearing a white shirt and with one shoulder raised, Scavullo stares intensely at the camera, holding his eyes wide open in order not to blink, and appearing rather startled. After a while, his eyelids begin to flutter, he blinks tearfully, and closes his eyes for a moment. As the roll ends, he wipes his mouth with his hand, seemingly exhausted by his ordeal.

### ST297 *Richard Schmidt*, 1965

16mm, b&w, silent; 4.5 min. @ 16 fps, 4 min. @ 18 fps
Preserved 1995, MoMA *Screen Tests* Reel 4, no. 9
FILM MATERIALS
ST297.1 *Richard Schmidt*
1965 Kodak 16mm b&w reversal original, 109'
NOTATIONS On original box in AW's hand: *Richard Smitch. Mario's friend*

Richard Schmidt, who was Mario Montez's boyfriend in the mid-1960s, starred with Montez in Warhol's 1965 film *More Milk Yvette,* in which Schmidt played the role of Lana Turner's daughter, Cheryl Crane. Montez and Schmidt also posed in several test rolls shot for *More Milk Yvette,* in which they embrace and kiss while eating a hamburger together. Judging from their costumes, Schmidt's and Montez's individual *Screen Tests* appear to have been shot on the

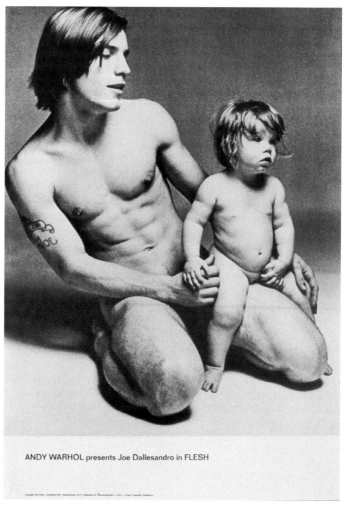

Poster for *Flesh*; photograph of Joe Dallesandro by Francesco Scavullo.

same day as their *More Milk Yvette* test rolls. Schmidt also had a part in *Withering Sights,* a Tavel-scripted takeoff on *Wuthering Heights* from early 1966, in which he played the role of Edgar Linton. Schmidt also appears in some of Jack Smith's photographs, which is not surprising considering his close relationship with Montez, who was one of Smith's favorite stars, or "creatures."

In his *Screen Test* from 1965, Schmidt has been posed against a painted black backdrop, and brightly lit from a single light source placed at the front right. The film begins noticeably out of focus, but eventually improves. Schmidt blinks soberly at the camera, and holds quite still throughout the roll. At the end, he closes his eyes against the light.

### ST298 *Zachary Scott*, 1964

16mm, b&w, silent; 4.6 min. @ 16 fps, 4.1 min. @ 18 fps
Preserved 1999, MoMA *Screen Tests* Reel 22, no. 6
COMPILATIONS *Fifty Fantastics and Fifty Personalities* (ST366)
FILM MATERIALS
ST298.1 *Zachary Scott*
1964 Kodak 16mm b&w reversal original, 110'
NOTATIONS On original box in unidentified hand in red: *Zack Scott*
On box in unidentified hand in black: *Zack Scott #1. 50*

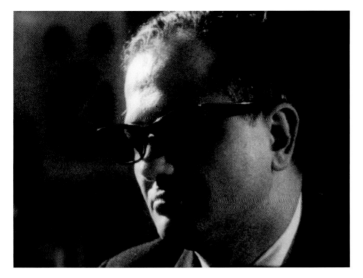

ST295

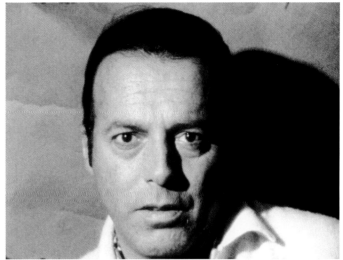

ST296

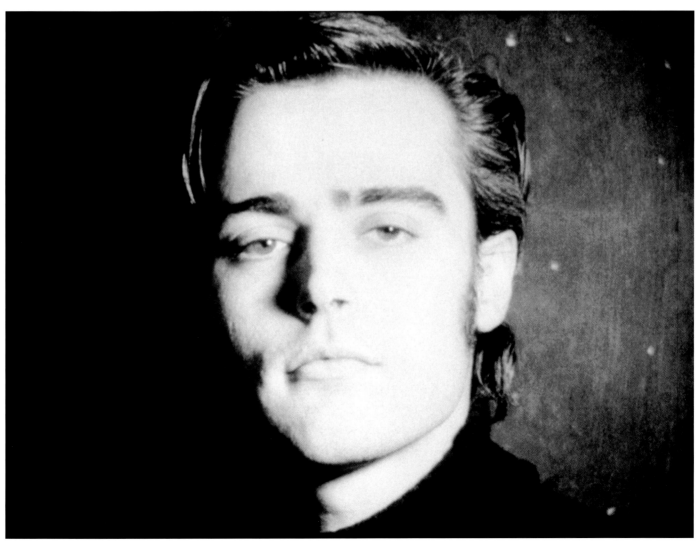

ST297

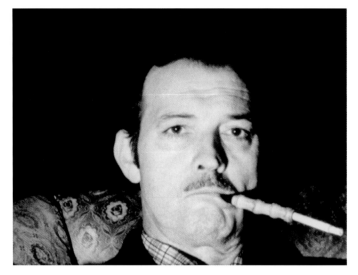

ST298

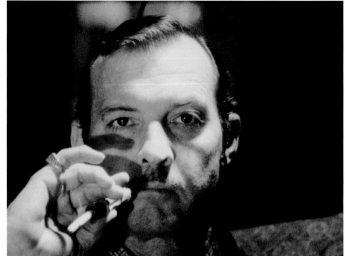

ST299

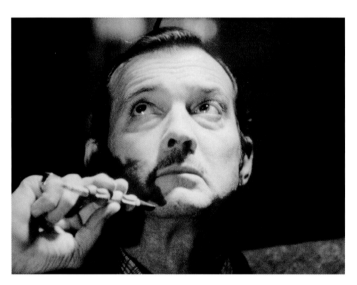

ST299

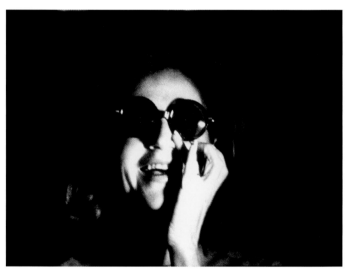

ST300

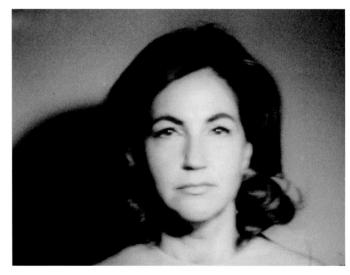

ST301

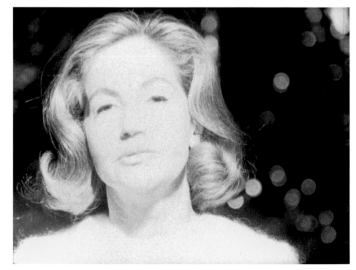

ST302

**ST299** *Zachary Scott,* 1964

16mm, b&w, silent; 4.5 min. @ 16 fps, 4 min. @ 18 fps

COMPILATIONS *Fifty Fantastics and Fifty Personalities* (ST366)

FILM MATERIALS

ST299.1 *Zachary Scott*

1964 Kodak 16mm b&w reversal original, 109'

NOTATIONS On original box in unidentified hand: *Zack Scott #2. 50*

The actor Zachary Scott was married to the actress Ruth Ford, the sister of Warhol's friend, the poet Charles Henri Ford, which is undoubtedly how Scott met Warhol and came to appear in two *Screen Tests.* Scott, who was born in 1914, began his acting career on Broadway; he appeared in his first Hollywood film in 1944, playing the title role in the *film noir* classic *The Mask of Dimitrios.* Scott was famous for his portrayals of villainous characters in a variety of hard-boiled movies from the 1940s and 1950s, including Michael Curtiz's *Mildred Pierce* (1945) and *Flamingo Road* (1949), Edgar G. Ulmer's *Ruthless* (1948), Nicholas Ray's *Born to Be Bad* (1950), and Jacques Tourneur's *Appointment in Honduras* (1953). He also played a more sympathetic character in Jean Renoir's 1945 film *The Southerner,* and appeared in Luis Buñuel's *The Young One* in 1962. By the mid-1950s, Scott's Hollywood career had slumped, and he began working in television, appearing on *Your Show of Shows* (1950), *Alfred Hitchcock Presents* (1955), *Rawhide* (1959), and *The Nurses* (1962), among other programs. Scott died of a brain tumor in 1965, not long after Warhol filmed him.

For the making of his *Screen Tests,* which were apparently not filmed at the Factory, Scott has been seated in a flowery upholstered chair and lit brightly from the left. At the beginning of the first film (ST298), labeled "#1," he inserts a cigarette into a bamboo cigarette holder and then lights it, clamping the holder into the corner of his mouth. Scott's performance in this film might be a deliberate satire of lock-jawed Hollywood masculinity: alternately gritting his teeth, squinting into the light, thoughtfully blowing smoke rings, or fixing the camera with a meaningful macho gaze, he looks like Clark Gable posing for publicity shots. In the second film (ST299), Scott no longer seems to be acting, but faces the camera directly, looking bored and rather tired. The shadow of his hand falls across his face every time he raises his cigarette to his mouth.

**ST300** *Ethel Scull (Glasses),* 1964

16mm, b&w, silent; 4.5 min. @ 16 fps, 4 min. @ 18 fps

FILM MATERIALS

ST300.1 *Ethel Scull (Glasses)*

1964 Kodak 16mm b&w reversal original, 107'

NOTATIONS On original box in AW's hand: *Ethel – glasses*

**ST301** *Ethel Scull,* 1964

16mm, b&w, silent; 4.5 min. @ 16 fps, 4 min. @ 18 fps

Preserved 1998, MoMA *Screen Tests* Reel 14, no. 6

FILM MATERIALS

ST301.1 *Ethel Scull*

1964 Kodak 16mm b&w reversal original, 109'

NOTATIONS On original box in AW's hand: *Ethel*

**ST302** *Ethel Scull,* 1964

16mm, b&w, silent; 4.4 min. @ 16 fps, 3.9 min. @ 18 fps

Preserved 1995, MoMA *Screen Tests* Reel 10, no. 1

COMPILATIONS *The Thirteen Most Beautiful Women* (ST365)

FILM MATERIALS

ST302.1 *Ethel Scull*

1964 Kodak 16mm b&w reversal original, 106'

Film begins in image; broken fragment taped to head of film

NOTATIONS On original box in AW's hand: *ethel skull. SKULL*

**ST303** *Ethel Scull,* 1964

16mm, b&w, silent; 4.5 min. @ 16 fps, 4 min. @ 18 fps

Preserved 1998, MoMA *Screen Tests* Reel 16, no. 10

FILM MATERIALS

ST303.1 *Ethel Scull*

1964 Kodak 16mm b&w reversal original, 108'

NOTATIONS On original box in AW's hand: *E. Skul*

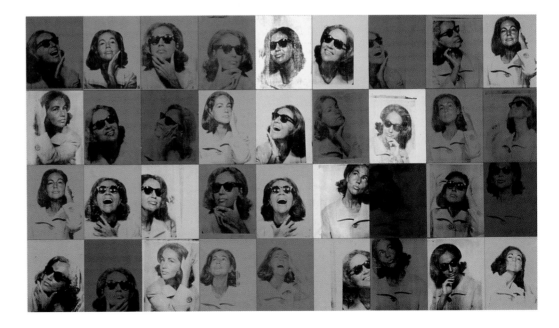

Andy Warhol, *Ethel Scull 36 Times*, 1963. Synthetic polymer paint silk-screened on canvas. Whitney Museum of American Art, New York. Jointly owned by the Whitney Museum of American Art and the Metropolitan Museum of Art; gift of Ethel Redner Scull.

## ST304  *Ethel Scull,* 1964

16mm, b&w, silent; 4.5 min. @ 16 fps, 4 min. @ 18 fps
**FILM MATERIALS**
ST304.1  *Ethel Scull*
1964 Kodak 16mm b&w reversal original, 107'
**NOTATIONS**  On original box in AW's hand: *E. Skul*
On box in unidentified hand: *ETHEL SCULL*

In the 1960s Ethel Redner Scull and her husband, Robert Scull, owners of a fleet of taxis called Scull's Angels, were well-known collectors of Pop and minimalist art. After moving from Great Neck, Long Island, to Fifth Avenue, the couple began collecting the work of younger artists such as Warhol, Jasper Johns, Robert Morris, and Larry Poons. They also actively supported the arts; Robert Scull provided the financial backing for Richard Bellamy's Green Gallery, and the Sculls set up the Robert and Ethel Scull Foundation, which commissioned works and gave stipends to artists. Their lavish parties and art patronage made them celebrities: Mrs. Scull frequently appeared in fashion magazines and gossip columns during these years. In 1963 she commissioned Warhol to paint her portrait, *Ethel Scull 36 Times,* an assembled grid of thirty-six individual silk-screened canvases created from photobooth images of his patroness. The couple were also cast in life-size plaster by George Segal.

In 1973 the Sculls put fifty works from their collection up for auction at Sotheby Parke Bernet; the works sold for $2.2 million, at that time a record for contemporary American art. The auction, documented in a film by John Schott and Jeff Vaughn, was rather controversial;[318] the Sculls were accused of disloyalty and profiteering for selling works they had acquired cheaply. The Sculls were divorced in 1975; in 1985, after years of litigation, Ethel was awarded a third of their remaining art holdings. In 1986 she sold one painting, Jasper Johns's *Out the Window* (1959), for $3.63 million, at the time the highest figure ever paid for a work by a living artist. Ethel Scull died in 2001 at the age of seventy-nine.[319]

Warhol's painting of Ethel Scull was begun in the summer of 1963. As Neil Printz has pointed out in his detailed analysis of the making of this work, Warhol edited exposures from the sequential four-photo photobooth strips into single images, each of which was individually masked and screened onto its own colored canvas. "In this way, he could vary the configuration of poses in the final portrait as he chose, heightening its sense of movement, animating Ethel Scull as a subject."[320]

In comparison with the animated, montagelike construction of the 1963 painting, and in stark contrast with Scull's exaggeratedly expressive posings before the photobooth camera, the five *Screen Tests* that Warhol shot of her the following year seem remarkably static. In only one of these films (ST300) does Scull approach the lively performance of her painted portrait. Reading a newspaper, nervously removing and then replacing her dark glasses, touching her face and hair, Scull occasionally laughs broadly at the camera, an image nearly indistinguishable from some of her photobooth poses. This film is, however, underexposed and rather dark.

The other four *Screen Tests* (it is not known in what order they were shot) show an unmoving Ethel Scull glumly facing down the camera. In ST301 she appears with bare shoulders against a white background, lit strongly from the right. The film begins out of focus, but becomes sharper after a while. Scull holds very still and appears very tense, swallowing, licking her lips, and closing her eyes against the light. The remaining three portrait films show a more glamorous Scull wearing a fuzzy white sweater, with her hair elaborately curled and her makeup carefully applied. With the sparkly, out-of-focus space of the Factory behind her, Scull endures the bright movie lights, her face so overexposed that it appears airbrushed. In ST302, she smiles briefly and turns her head regally from side to side, but still appears uncomfortable, swallowing nervously. ST303 is a slighter tighter close-up; Scull again appears morose, maintaining a deadpan, half-lidded stare at the camera, occasionally swallowing convulsively. The final film (ST304) is quite similar; Scull still looks miserable with tension despite the brightness of her image.

Although none of Scull's *Screen Test* boxes bear the notation "13," one of her portrait films was nevertheless included in a March 1965 screening of *The Thirteen Most Beautiful Women* (ST365a), in a version that had fourteen women in it.[321] As Billy Name noted later, "Ethel would get very angry if Baby Jane was in *Thirteen Most Beautiful Women* and she wasn't. So Ethel Scull would definitely not be in the *Personalities* or *Fantastics,* but *The Most Beautiful Women.*"[322] It is not known exactly which of Scull's portraits was included in the March 1965 screening, but the broken film at the head of ST302 suggests the kind of wear and tear that comes from repeated projection.

## ST305  *Edie Sedgwick,* 1965

16mm, b&w, silent; 4.5 min. @ 16 fps, 4 min. @ 18 fps
Preserved 1995, MoMA *Screen Tests* Reel 11, no. 10
**COMPILATIONS**  *The Thirteen Most Beautiful Women* (ST365)
**FILM MATERIALS**
ST305.1  *Edie Sedgwick*
1965 Kodak 16mm b&w reversal original, 108'
**NOTATIONS**  On original box in AW's hand: *Moving Beauty. Edie*
On box in Gerard Malanga's hand: *1 double frame 8" x 10" print and negative*
On box in unidentified hand: *EDIE S. PORTRAIT*

## ST306  *Edie Sedgwick,* 1965

16mm, b&w, silent; 4.5 min. @ 16 fps, 4 min. @ 18 fps
Preserved 1995, MoMA *Screen Tests* Reel 8, no. 2
**COMPILATIONS**  *The Thirteen Most Beautiful Women* (ST365)
**FILM MATERIALS**
ST306.1  *Edie Sedgwick*
1965 Kodak 16mm b&w reversal original, 109'
Broken sprockets at head of film repaired in 1995
ST306.1.p1  *Edie Sedgwick*
Undated Kodak 16mm b&w reversal print, 112'
**NOTATIONS FOR ST306.1**
On original box in AW's hand: *Edie for 13*
On tape on box in unknown hand: *2nd film*
On can lid in AW's hand: *Bobby Dylan*
**NOTATIONS FOR ST306.1.P1**
On box in Paul Morrissey's hand: *Comp Reversal print. EDIE WITHOUT MAKEUP. turban*

## ST307  *Edie Sedgwick,* 1965

16mm, b&w, silent; 4.5 min. @ 16 fps, 4 min. @ 18 fps
**COMPILATIONS**  *The Thirteen Most Beautiful Women* (ST365); *EPI Background* (ST370)
**FILM MATERIALS**
ST307.1  *Edie Sedgwick*
1965 Kodak 16mm b&w reversal original, 109'
ST307.1.p1  *EPI Background* (ST370), roll 8
Undated Dupont 16mm b&w reversal print, 109'
**NOTATIONS**  On box in AW's hand, crossed out: ★ *Haircut*
On box in unidentified hand: *USED*

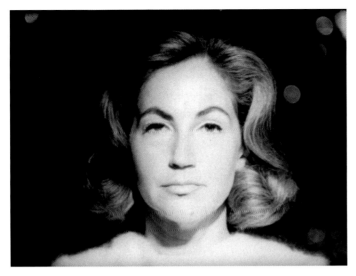

ST303

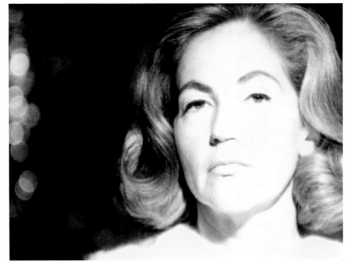

ST304

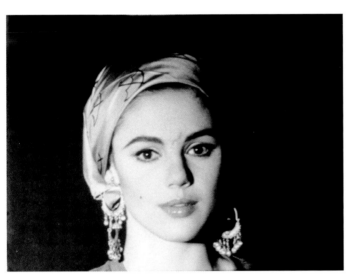

ST305

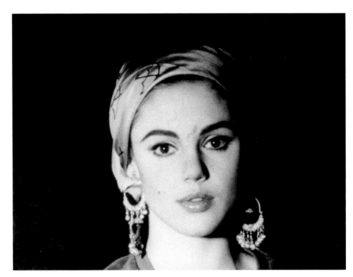

ST306

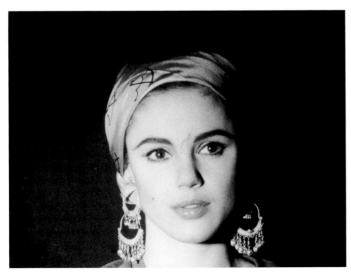

ST307

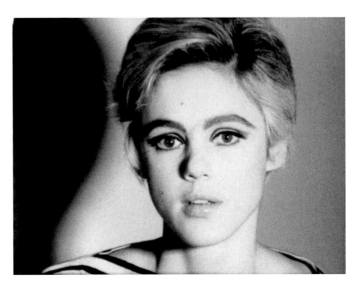

ST308

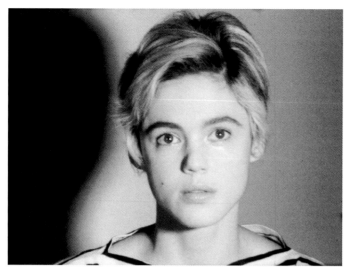

ST309

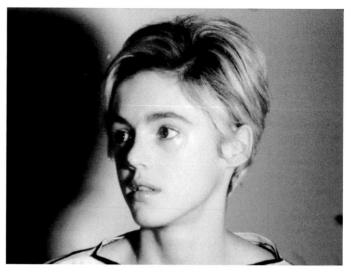

ST309

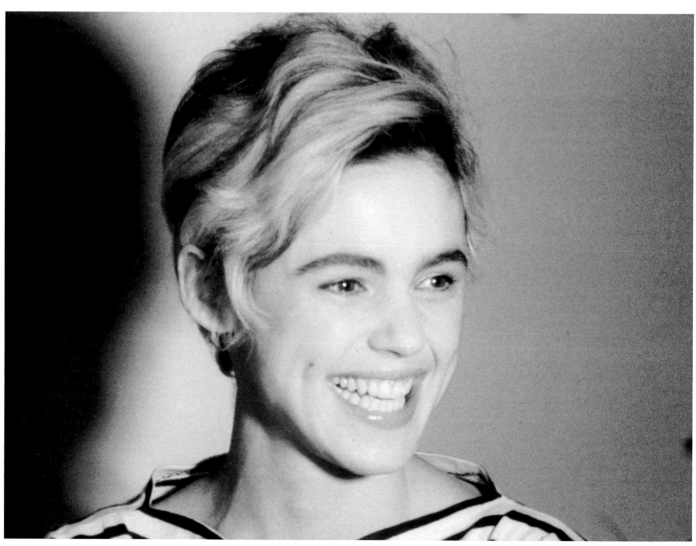

ST309

On tape at end of film: *8 106*
On clear film at head of roll in red: *17*
On clear film at head of roll in black: *– 9 –*

## ST308  *Edie Sedgwick,* 1965
16mm, b&w, silent; 4.6 min. @ 16 fps, 4.1 min. @ 18 fps
Preserved 1995, MoMA *Screen Tests* Reel 10, no. 6
COMPILATIONS  *Screen Test Poems* (ST372); *Screen Tests/A Diary*
(Appendix A)
FILM MATERIALS
ST308.1  *Edie Sedgwick*
1965 Kodak 16mm b&w reversal original, 110'
ST308.1.p1 *Screen Test Poems,* Reel 2 (ST372.?), roll 14
Undated Gevaert 16mm b&w reversal print, 100'
NOTATIONS  On original box in AW's hand: *edie. split*
On box in Gerard Malanga's hand: *Edie Sedgwick. One double frame
negative and one 8" x 10" glossy double-frame print*
On typed label found in can: *EDIE SEDGWICK*
On 2" fragment of white leader spliced to head of roll in black: *14*
On clear film at end of roll in black: *14*

## ST309  *Edie Sedgwick,* 1965
16mm, b&w, silent; 4.5 min. @ 16 fps, 4 min. @ 18 fps
COMPILATIONS  *The Thirteen Most Beautiful Women* (ST365)
FILM MATERIALS
ST309.1  *Edie Sedgwick*
1965 Kodak 16mm b&w reversal original, 108'
NOTATIONS  On box in unidentified hand: *Haircut 1*
Label on box: *FLORMAN + BABB, Inc., Motion Picture Equipment
and Supplies, 68 W. 45th St.*
On clear film at head of roll in black: *8*

## ST310  *Edie Sedgwick,* 1965
16mm, color, silent; 4.5 min. @ 16 fps, 4 min. @ 18 fps
FILM MATERIALS
ST310.1  *Edie Sedgwick*
1965 Kodak Ektachrome 16mm double-perf. reversal original, 107'
NOTATIONS  (These notations indicate this box originally contained
ST309)
On box in AW's hand: *edie. good face. 13*
On box in Paul Morrissey's hand: *Prints have been made of this test*
On box in Gerard Malanga's hand: *without makeup*
On box in unidentified hand in red: *Backwards*

## ST311  *Edie Sedgwick,* 1965
16mm, color, silent; 4.2 min. @ 16 fps, 3.8 min. @ 18 fps
FILM MATERIALS
ST311.1  *Edie Sedgwick*
1965 Kodak Ektachrome 16mm double-perf. reversal original, 101'
NOTATIONS  On original box in AW's hand: *edie. ASA 25, 1.9 – 20,
2.8 – 40, 4 – 60, 5.6 – 80, 8 – 100. Correct at 2.8*

## ST312  *Edie Sedgwick,* 1965
16mm, color, silent; 4.4 min. @ 16 fps, 3.9 min. @ 18 fps
FILM MATERIALS
ST312.1  *Edie Sedgwick*
1965 Kodak Ektachrome 16mm reversal original, 106'
NOTATIONS  On original box in AW's hand: *edie*
Written inside box flap in Paul Morrissey's hand: *exposed ASA 25,
E-2 2.8, plus extra 10 ft. at end. f. 1.9*

## ST313  *Edie Sedgwick,* 1965
16mm, color, silent: 4.5 min. @ 18 fps, 4 min. @ 16 fps
FILM MATERIALS
Original negative not found in Collection
ST313.1.p1  *Edie Sedgwick*
Undated, color print from negative, 109'
Color has deteriorated to magenta
NOTATIONS  On plain white box in AW's hand: *Color prints
from Negative*
On box in unidentified hand in blue: *Edie*
Handwriting printed on head of film in white: *Head. Video Film
Labs. Video Film Labs. 2 Rolls*

> Edie was incredible on camera—just the way she moved
> . . . She was all energy—she didn't know what to do with
> it when it came to living her life, but it was wonderful to
> film. The great stars are the ones who are doing some-
> thing you can watch every second, even if it's just a
> movement inside their eye.
>
> —Andy Warhol[323]

Edie Sedgwick was unquestionably one of Warhol's greatest female film stars. Animated, beautiful, and trend-settingly thin, this unhappy child from a prominent New England family fascinated almost everyone who met her. In the mid-1960s, she became something of an icon, influencing popular style with her dark, heavily made-up eyes, cropped silver hair, elaborate dangling earrings, and long tights-clad legs.

Edie Sedgwick is inseparable from the Warhol films, and also from Warhol's emergence as a celebrity in the mid-1960s. In 1965 Warhol and Sedgwick, "the king of Pop and his star," appeared together in numerous photos, articles, fashion columns, and gossip items in the popular press, as well as on television.[324] The apotheosis of their fame as a Pop couple was the opening of Warhol's exhibition at the Institute of Contemporary Art in Philadelphia on October 8, 1965, when the crush of fans chanting "Andy! Edie!" was so intense that the art had to be removed from the galleries; Warhol, Sedgwick, and their entourage were forced to take refuge in a closed-off staircase, from which they were finally rescued through a hole cut in the floor above.[325]

Although the tragic and sometimes sordid details of her short life have been extensively recorded elsewhere, the most compelling record of Sedgwick's personality, the best evidence of her particularly fascinating presence, are to be found in the Warhol films themselves. Sedgwick nearly monopolized Warhol's camera for much of 1965, starring or appearing in every single sound film to come out of the Factory between late March and the shooting of *My Hustler* on Labor Day Weekend in September. In addition to small roles in *Bitch, Horse,* and *Vinyl,* she starred in a film series originally conceived as a day in the life of Edie Sedgwick, a twenty-four-hour film that was to be called *The Poor Little Rich Girl Saga.* These Sedgwick vehicles capture Edie in what are intended to be aspects of her daily life: waking up in the morning and talking with a friend while getting dressed in *Poor Little Rich Girl*; endlessly applying makeup, getting stoned, and chatting with the same friend in *Face*; getting to know new boyfriends in *Beauty #1* and *Beauty #2*; out to dinner with a bunch of friends in *Restaurant*; and hanging out in her apartment with friends in *Afternoon.* Her performances in these films were often "directed" by Chuck Wein, playing the unseen friend and/or interrogator who engages her attention and keeps the conversation rolling from offscreen. During these same months, Sedgwick also starred in two films scripted by Ronald Tavel, *Kitchen* and *Space,*

played a central role in *Prison*, and was the subject of Warhol's earliest double-screen work, the film-and-video portrait *Outer and Inner Space*. By the fall, Sedgwick no longer regularly appeared in Warhol films, although a major production, to be called either *Jane Heir* or *Jane Eyre Bare*, which was to be filmed in the Bahamas and star Sedgwick, was in the planning stages, with a budget written by Dan Williams, scripts written separately by Chuck Wein and Ronald Tavel, and financial backing expected from the A&P heir, Huntington Hartford.

By this time, however, Sedgwick had become somewhat estranged from Warhol: she had developed a personal relationship with Bob Dylan's road manager Bob Neuwirth, who promised her more movie roles, and a "replacement" had been found for her at the Factory in the person of Ingrid Superstar. Perhaps in an attempt to repair this breach, Warhol made one last Sedgwick feature, *Lupe*, that December and also included Edie in some early performances with the Velvet Underground in January and February.[326] Sedgwick returned to the Factory in the fall of 1966 to appear in one reel of *Since*, and also to play herself opposite Rene Ricard's Warhol in *The Andy Warhol Story*. The following summer, she visited the East Hampton beach house where Warhol was filming *The Loves of Ondine*, and thus ended her Warhol career with appearances in four reels of ★ ★ ★ ★ (*Four Stars*): *Rolando* (Reel 37), *Edie Sedgwick* (Reel 38), *Edith and Ondine* (Reel 41), and *East Hampton Beach* (Reel 43).

After her Warhol period, Sedgwick's life became increasingly fragmented; drug problems, apartment fires, and hospital stays were interspersed with occasional modeling jobs, a few more movie roles, including John Palmer and David Weisman's *Ciao! Manhattan*, and a late marriage to Michael Post. She died on November 16, 1971, at the age of twenty-eight, from an accidental overdose of barbiturates, a death that had been oddly prefigured in her 1965 role in *Lupe*.

These nine *Screen Tests* of Edie Sedgwick were apparently shot on four separate occasions, probably ranging from March 1965 to the fall of that year. In the earliest group, shot for *The Thirteen Most Beautiful Women* (ST365), she has been posed against a black background, strongly lit from the left front, and wears long earrings, elaborate makeup, and a head scarf printed with a pattern of umbrellas. A Harry Potter-like scar from a car accident in California is visible between her eyebrows. In ST305, Sedgwick holds very still and stares straight into the camera, her long earrings trembling. When her eyes begin to well up, she holds them closed for a moment, revealing that her eyelids have been painted white. In another roll (ST306) (it is not known in which order these three films were shot), she speaks briefly to someone offscreen, then looks at the camera with her mouth open slightly and delicately arches her eyebrows, which enhances her resemblance to Marilyn Monroe. In the third roll (ST307), which Warhol labeled "moving beauty," she is much more animated, speaking to someone off-camera, looking around inquisitively, frowning briefly, bobbing her head to music, and showing her dimples when she smiles.

The next two *Screen Tests* seem to have been shot somewhat later: a boyish Edie appears with bobbed, silvered hair, dressed in the striped fisherman's jersey that became a kind of Factory uniform in 1965. She has been posed against a white wall and lit from the right, with her shadow cast behind her on the left. In ST308, which is a little out of focus at the beginning, she holds still, looking serious and a little sad, her huge eyes carefully made up, her mouth slightly open. Her gaze is abstracted except when she glances upward, presumably looking at Warhol standing over the camera in front of her. The film is heavily scratched, suggesting frequent screenings. In the next *Screen Test* (ST309), which is similar enough to have been shot at the same time, Sedgwick is wearing no make-up, her eyes wet and swollen as if she had been crying, or had just washed her face. Without makeup, she looks extraordinarily vulnerable and childlike. After looking sad for a while, she laughs briefly, talks to people offscreen, and then seems to cheer up considerably, flashing a huge smile at someone off to her right.

The remaining *Screen Tests* of Sedgwick are all in color. One film (ST310) contains much camerawork, which probably dates it to the fall of 1965 and the influence of Dan Williams. The film begins in close-up on Edie's face, which she is powdering with a powder puff. She is wearing two different earrings, and has been lit harshly from the right. She holds her hand up against the light, laughs, and says something to the camera. The camera then zooms out, showing Edie, wearing a black tank top and orange skirt, seated on a stool against a plywood backdrop, smoking a cigarette; a light on a stand is visible at the right of the frame. Various in-camera edits show different framings of her figure, shots of her torso and skirt. Her eyes become redder and tearier as the film nears its end.

The last three films show Sedgwick posed against a colorful, collaged plastic backdrop. These seem to be professional color tests, perhaps shot with a commercial project in mind; in other words, these films, unlike other *Screen Tests*, may have been intended as real screen tests. The first of these films (ST311) is an exposure test, with a poorly focused image of Sedgwick getting darker and darker at regular intervals. As Warhol's notes on the box indicate, the film was exposed in twenty-foot sections at various aperture settings, from 1.9 through 8; Warhol noted that the exposure is "correct at 2.8." The next film (ST312), shot at 2.8, begins with an extremely tight close-up of Sedgwick's face; she takes a drag from her cigarette. After one minute, there is an in-camera edit to a medium close-up of her head; Edie mugs for the camera, making model-like expressions and forming her lips into a coquettish "O." Another in-camera edit to a medium shot reveals that she is wearing a tank top, seated in front of the colored backdrop, smiling and talking.

A third film from this session has been found in print form only; this print has unfortunately deteriorated to magenta, so the color is no longer accurate. (The original negative has not been located.) Sedgwick again appears in front of the colored backdrop, this time relaxed and animated. She talks cheerfully with someone offscreen, while the smoke from her cigarette drifts into the frame from below. Halfway through the film, there is an in-camera edit to a medium shot of her; near the end of the roll the exposure darkens. At the very end, the image returns to a close-up of her face.

## ST314   *Harry Smith,* 1964

16mm, b&w, silent; 4.4 min. @ 16 fps, 3.9 min. @ 18 fps
Preserved 1998, MoMA *Screen Tests* Reel 13, no. 2
**COMPILATIONS**   *Fifty Fantastics and Fifty Personalities* (ST366)
**FILM MATERIALS**
ST314.1   *Harry Smith*
1964 Kodak 16mm b&w reversal original, 106'
**NOTATIONS**   On original box in AW's hand: *50. Harry Smith. 50*

The filmmaker, painter, musicologist, anthropologist, and collector Harry Smith (1923–91) is one of the more astonishing figures in American avant-garde culture, a vastly knowledgeable polymath whose encyclopedic expertise extended to such diverse subjects as Native American dialects and sign language, folk music and jazz, Ukrainian Easter eggs, paper airplanes, string figures, alchemy, cosmology, numerology, and other occult practices. After early studies in anthropology (including a dictionary of Puget Sound dialects

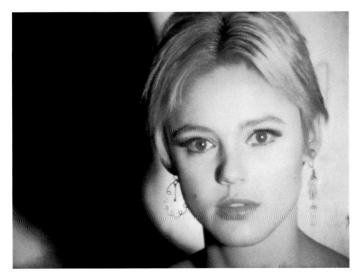

ST310   See Appendix D for color reproduction.

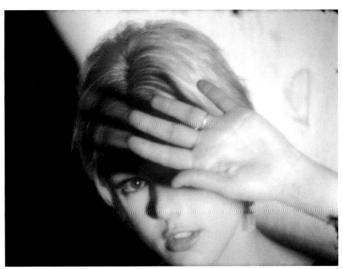

ST310   See Appendix D for color reproduction.

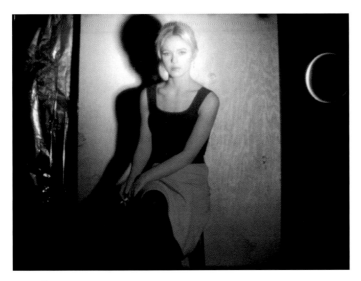

ST310   See Appendix D for color reproduction.

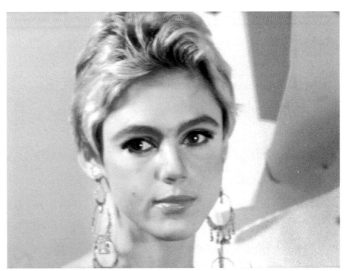

ST311   See Appendix D for color reproduction.

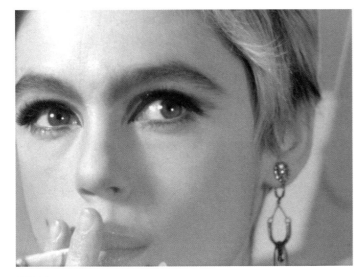

ST312   See Appendix D for color reproduction.

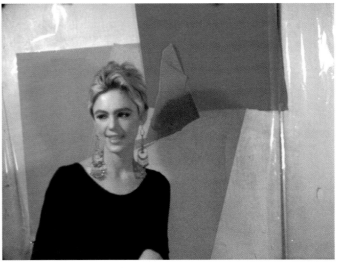

ST312   See Appendix D for color reproduction.

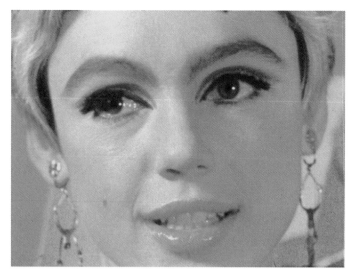

ST313  **See Appendix D for color reproduction.**

ST314

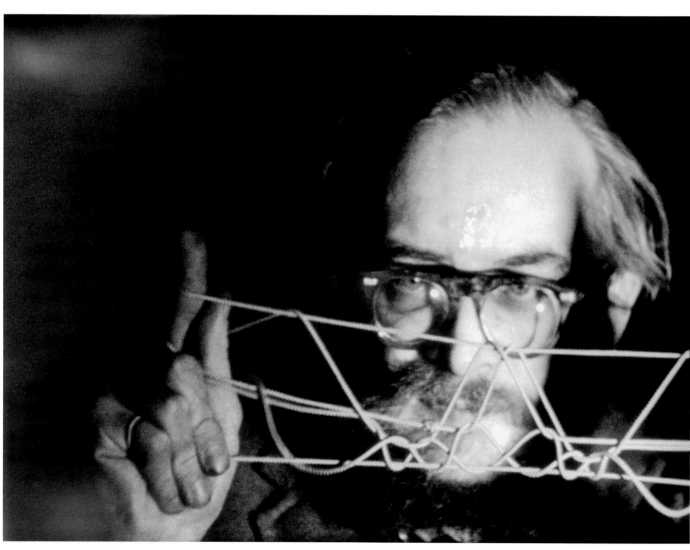

ST314

which he compiled when he was fifteen), Smith began painting, creating Kandinsky-like, note-by-note representations of popular songs. In the 1940s, he moved on to filmmaking, beginning with a series of painstakingly hand-painted, abstract visualizations of pop songs and jazz tunes.

In 1952 Smith assembled the *Anthology of American Folk Music*, an eighty-four-track anthology of songs and ballads culled from his collection of American music recorded between 1927 and 1932. Issued by Folkways Records, this anthology is now recognized as a seminal influence on the folk music revival of the 1950s and 1960s. Also in the 1950s, Smith began producing a series of elaborately collaged and animated films based on alchemical imagery, the best known of which is *Heaven and Earth Magic* (1958–61).

Smith was widely known as a collector, amassing museum quality collections of paper airplanes, hand-painted Easter eggs, Seminole textiles, and other sacred objects, which cluttered his small room at the Chelsea Hotel. He was also considered the world's leading authority on string figures (also called cat's cradles), having mastered hundreds of patterns from around the world. In the 1960s, Smith produced and recorded the Fugs's first album (see Ed Sanders entry); in the 1970s, he produced recordings of Allen Ginsberg's poetry and the peyote songs of the Kiowa Indians. At the 1991 Grammy Awards, Smith received the Chairman's Merit Award for his contribution to American folk music; in 1997 the Smithsonian reissued Smith's *Anthology of American Folk Music*, which received two more Grammy Awards that year.[327]

Smith and Warhol seem to have been well aware of each other's work as filmmakers. In 1965 Smith told P. Adams Sitney that he stole the practice of leaving in the leader between rolls of film from Warhol and also announced that he had been trying to interest Warhol and other filmmakers in collaborating on an ambitious avant-garde feature, for which Warhol had given him $300: "It would be marvelous; for instance, if Andy were able to supervise maybe a twenty-minute color picture of Mount Fuji, but with a really good cameraman and technicians and everything so it would be really his beauty."[328] In the fall of 1965, Smith, wearing dark glasses, made a brief in-focus appearance in one of the sequel reels to *My Hustler*, *My Hustler (Out of Focus)*.

Throughout his 1965 *Screen Test*, Smith busies himself making string figures for the camera. Appearing hunched and rather unhealthy, Smith first peers into the camera through his rolled-up fist, then pulls out a long loop of string and bends over it, intently watching his fingers at work below the frame line. After a while, he holds an elaborate string figure up in front of his face, says something out of the corner of his mouth, then unravels the figure and bends forward to work on the next. This second string figure seems to take a long time, during which only a small portion of Smith's sweaty forehead is visible at the lower edge of the film frame. Smith finally holds up the second figure, which has moving parts, and manipulates it for the camera. He begins working on a third figure, holding one end of the string in his teeth; the film image fades out on this final figure.

### ST315   *Jack Smith,* 1964

16mm, b&w, silent; 4.5 min. @ 16 fps, 4 min. @ 18 fps
Preserved 1998, MoMA *Screen Tests* Reel 16, no. 9
COMPILATIONS *Fifty Fantastics and Fifty Personalities* (ST366)
FILM MATERIALS
ST315.1 *Jack Smith*
1964 Kodak 16mm b&w reversal original, 108'
NOTATIONS On original box in AW's hand: *JACK Smith.*
*50. PORTRAIT*

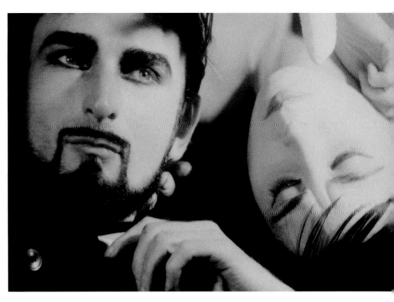

Jack Smith and Beverly Grant in a roll shot for Andy Warhol's *Batman Dracula*, 1964.

The seminal underground artist, filmmaker, and performer Jack Smith was an important influence on much of Warhol's cinema. Warhol worked more extensively with Smith than with any other underground director of the 1960s, collaborating with him on the ambitious, unfinished *Batman Dracula* in 1964, using him as an actor in several of his movies, including *Camp* (1965) and *Hedy* (1966), and also employing several of Smith's actors (or "creatures"), notably Mario Montez, Francis Francine, Arnold Rockwood, and Marian Zazeela, in some of his films.[329] When asked in 1965 whom he admired in the New American Cinema, Warhol replied, "Jaaaaacck Smiiittth," and then explained, cryptically, that what he particularly liked about his movies was that Smith was "the only one I know who uses color—backwards."[330] Later, he was more specific about Smith's influence: "I picked something up from him for my own movies—the way he used anyone who happened to be around that day, and also how he just kept shooting until the actors got bored."[331]

Smith's early work, when he didn't have funds to make films, was mostly in photography. His black-and-white photographs of costumed actors posed in strangely decadent scenes reminiscent of old movie stills were hand-published by Piero Heliczer in a limited edition known as *The Beautiful Book* (1962); other photographs were published as a kind of photo essay called *The Moldy Hell of Men and Women* (*Film Culture* 35, winter 1964/65). In the 1960s, Smith was best known for his prototypically camp film, *Flaming Creatures* (1962), a black-and-white orgiastic fantasy that employed a mobile camera, strange-looking actors, secondhand costumes, crossdressing, a fake coffin, and showers of plaster dust to create a series of tableaux steeped in shopworn exoticism and androgynous sexuality. The notoriety and police repression that *Flaming Creatures* attracted were an indirect inspiration to Warhol, who made his film *Blow Job* as a rejoinder to the intensified police scrutiny of underground films in early 1964.

In the summer of 1963, Warhol, wearing a wig, a dress, and dark glasses, made a brief appearance among a crowd dancing on top of a giant cake in one scene of Smith's new color film *Normal Love*. Warhol also filmed Smith shooting this sequence for a three-minute, color roll titled *Andy Warhol Films Jack Smith Filming "Normal Love."* This short "newsreel" was lost the following winter, when, on March 3, 1964, the police raided a screening of *Flaming Creatures* at

the Film-Makers' Cooperative, arrested Jonas Mekas and the projectionist Ken Jacobs, and seized both films; Warhol's film, which has never been recovered, may still be stored somewhere in the evidence rooms of the New York City Police Department.

Smith's earliest extant appearance in a Warhol film appears to be *Wynn Gerry Claes*, a "home movie" shot in California in the early fall of 1963, which shows Smith with Claes and Patty Oldenburg, Wynn Chamberlain, and Gerard Malanga. Smith and Warhol's extensive collaboration on *Batman Dracula* during the summer of 1964 produced almost seven hours of material, much of it starring Smith. Smith later told Gerard Malanga that *Batman Dracula* was his most challenging as well as his most rewarding role: "we actually got . . . some really lyrically beautiful scenes, and . . . that's why it is my favorite role."[332] The film was unfortunately never completed or released, a fact that Smith makes pointed reference to in his performance in Warhol's 1965 film *Camp*, in which he dramatically crosses the Factory floor and unlocks a closet door to reveal a *Batman* comic book. Warhol also used Smith in the role of the "soothsayer" in *Hedy* in February 1966, and included a reversible flip book of Smith's film *Buzzards Over Bagdad* in the boxed, December 1966 edition of *Aspen* magazine, which he designed with David Dalton; the *Buzzards Over Bagdad* flip book reversed to a *Kiss* flip book on the other side—a single unchanging image from Warhol's film.

Despite these friendly beginnings, Smith eventually turned against Warhol, as he turned against many colleagues over the years; he apparently felt that Warhol had supressed his work and appropriated not only his best actor, Mario Montez, but also his friend, writer Ronald Tavel, who later cited both Smith and Warhol as important influences on the Theatre of the Ridiculous.[333] Smith would later refer to Warhol as "Andy Panda" (because he pandered to his audiences) or "Vampire in the Cocktail World." His hostility sometimes reached extreme levels; one note found among Smith's papers reads: "I am only thankful that God has made it possible for me to purify the projectors after these Warhol films."[334]

Smith made a number of other films (including *Scotch Tape* [1959–62], *Overstimulated* [1959–63], and *No President* [1967–70]) and also appeared in a number of movies by other filmmakers, including Ken Jacobs's *Star Spangled to Death* and *Little Stabs at Happiness*, Ron Rice's *Chumlum* and *The Queen of Sheba Meets the Atom Man*, Gregory Markopoulos's *The Iliac Passion*, and George Kuchar's *The Lovers of Eternity*. He also appeared in plays directed by Charles Ludlum and Robert Wilson, in whose *Deafman Glance* (1971) he appeared under the stage name Sharkbait Starflesh. In Smith's later years, he worked primarily in theater and performance, a practice that began with *Rehearsal for the Destruction of Atlantis*, premiered at the Expanded Cinema Festival in New York in December 1965. Throughout the 1970s and 1980s he staged seemingly endless plays and performance events for small audiences in his duplex loft and other downtown venues. Smith's inventively obsessive titles for these events include: *Withdrawal from Orchid Lagoon* (1971); *Lucky Landlordism of Rented Paradise* (1973) (an adaptation of Sheridan's *The Critic*); *Secret of Rented Island* (1976) (an adaptation of Ibsen's *Ghosts*), *Penguin Panic in the Rented Desert* (1981), and *I Was a Male Yvonne de Carlo for the Lucky Landlord Underground* (1982). Smith also created voluminous series of color photographs, often presented as slide shows accompanied by music, which featured totemic figures such as the Lobster and Yolanda la Penguina, a small, exotically dressed toy penguin whom he photographed in various foreign locales. Smith died of AIDS in 1989, at the age of fifty-seven. Since his death, a number of his films have been restored and distributed by the Plaster Foundation. In 1997 a large exhibition of his work, Flaming Creature: The Art and Times

of Jack Smith, opened at P.S.1 in New York City. Smith's writings have been published in *Wait for Me at the Bottom of the Pool: The Writings of Jack Smith* (New York: High Risk Books, 1997).[335]

Smith's 1964 *Screen Test* is an underexposed and subdued performance. With an overhead light illuminating the top of his head, its cord visible against the wall behind him, Smith engages the camera with a series of meaningful eye movements. At one point he gives a slight, devilish smile, then stares intently into the lens, his expression subtly shifting between thoughtfulness and anxiety.

### ST316 *Alan Solomon,* 1964

16mm, b&w, silent; 4.5 min. @ 16 fps, 4 min. @ 18 fps
Preserved 1998, MoMA *Screen Tests* Reel 16, no. 8
COMPILATIONS *Fifty Fantastics and Fifty Personalities* (ST366)
FILM MATERIALS
ST316.1 *Alan Solomon*
1964 Kodak 16mm b&w reversal original, 108'
NOTATIONS On original box in AW's hand: *Alan Solomon. personality*

The curator and art historian Alan Solomon was an influential figure in contemporary art in the 1960s. As director of the Jewish Museum in New York from 1962–64, he inaugurated the museum's contemporary exhibition program, which presented important retrospectives of Robert Rauschenberg and Jasper Johns in 1963 and 1964, respectively. Solomon also organized The Popular Image exhibition at the Gallery of Modern Art in Washington, D.C., in 1963. After leaving the Jewish Museum, he became director of the Institute of Contemporary Art in Boston, where, in 1966, he gave Warhol a major exhibition including both paintings and films.

Although Alan Solomon was not related to Holly Solomon, he did have a hand in the completion of her Warhol portrait, which he borrowed from Holly for inclusion in Warhol's 1966 exhibition in Boston. At that time, the painting consisted of eight colored panels, each silk-screened from the same photobooth image of Holly Solomon. Alan Solomon asked Warhol to add a ninth panel to the painting for his exhibition, thus completing the 3 x 3 grid structure that has been maintained ever since.

Like Arman and Grace Glueck, Solomon may have been completely unaware that his *Screen Test* was being shot, since he never once looks at the camera and continues to read throughout the film. He is seated on the Factory couch, his face soft and unfocused in contrast with the sharply focused, tinfoil-covered pipe behind him; the poor focus might indicate that the film was shot from a distance using a zoom lens. Solomon looks down throughout the film, his eyes moving as if scanning a newspaper or large magazine. At one point, he scratches his nose unselfconsciously. There is a brief light flare in the middle of the film.

### ST317 *Holly Solomon,* 1964

16mm, b&w, silent; 4.5 min. @ 16 fps, 4 min. @ 18 fps
Preserved 1999, MoMA *Screen Tests* Reel 21, no. 1
COMPILATIONS *Fifty Fantastics and Fifty Personalities* (ST366)
FILM MATERIALS
ST317.1 *Holly Solomon*
1964 Kodak 16mm b&w reversal original, 109'
NOTATIONS On original box in unidentified hand: *Hollis Solomon 50 Make print*

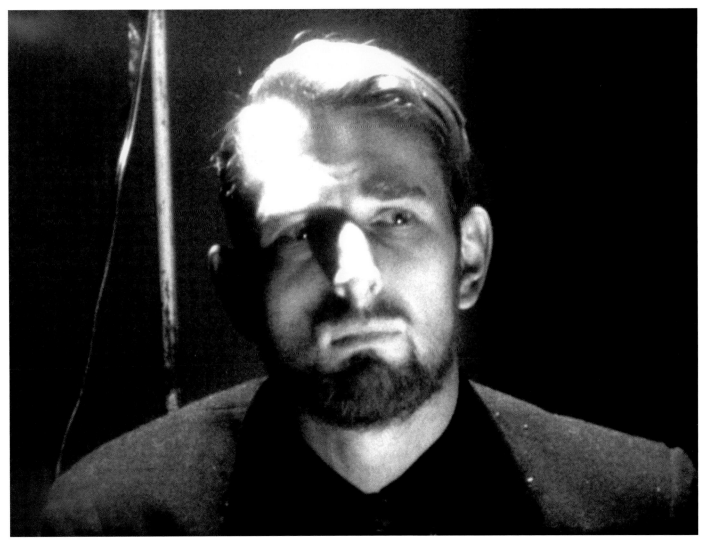

ST315

ST316

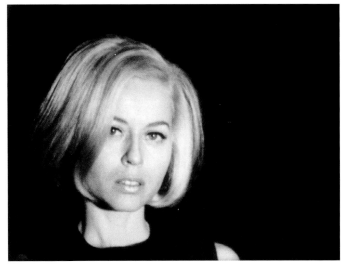

ST317

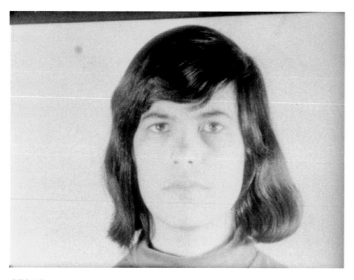

ST318

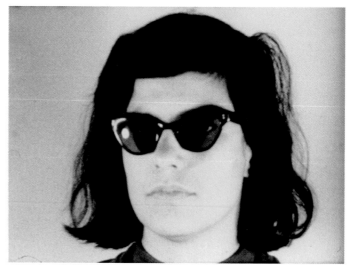

ST319

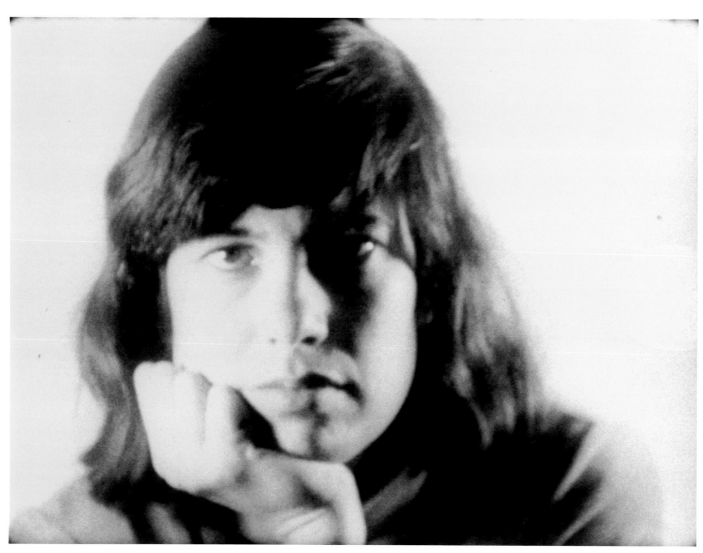

ST320

The collector and art dealer Holly Solomon, née Hollis Dworkin, was an early patron of Warhol's art; she and her husband, Horace Solomon, owned a 1964 *Brillo Soap Pads Box* that they used as a coffee table in their living room. Solomon, who married soon after graduating from Sarah Lawrence College, had at first considered a career in acting; in the 1960s, she studied at the Actors Studio and appeared in one film, Michael Roemer's *The Plot Against Harry* (not released until 1989). Starting out as a collector, she eventually found her life's work in the art world, where she became one of the most influential and well liked of contemporary dealers.

Solomon and her husband were known and appreciated for their lavish parties, to which they invited artists and other denizens of the art world. In 1969 they opened the 98 Greene Street Loft, an alternative space that presented performances, concerts, and exhibitions showcasing the work of new artists such as Robert Mapplethorpe, Laurie Anderson, and Gordon Matta-Clarke. In 1972 Solomon made a documentary film, *98.5*, about five artists from the Greene Street Loft; her film won an award at the Edinburgh Film Festival that year. In 1975 she and her husband opened the Holly Solomon Gallery on West Broadway, which soon became one of the premier galleries in the SoHo art scene, representing an unusual mix of artists including Nam June Paik, William Wegman, and a number of artists from the Pattern and Decoration movement of the 1970s. The gallery relocated to Fifth Avenue and 57th Street in 1983, then moved back to SoHo in the early 1990s before closing in 1999. Holly Solomon died in 2002 at the age of sixty-eight.[336]

Solomon had her portrait done by many artists, including Mapplethorpe, Roy Lichtenstein, and Robert Rauschenberg. In 1964 she posed for a series of photobooth pictures, from which Warhol selected one image that he used to create the nine-panel silkscreened portrait, *Holly Solomon*, completed in 1966. As Solomon said of her glamorous portrait: "I played a role—the Pop Princess. Andy saw this."[337] In 2001, she sold the Warhol portrait at auction at Sotheby's for $2 million.

In Solomon's 1964 *Screen Test*, her hair is shorter than in the photobooth pictures; her performance is equally glamorous but subtler and more nuanced, revealing more of her intelligence. Seated on the Factory couch, with her bare left arm extended along its back, Solomon looks down, gets out a cigarette, lights it, and takes a long drag, tilting her head back and closing her eyes. She then raises her head and looks directly at the camera for the first time, sweeping her hair back behind one ear. After gazing off into space, she smiles into the camera, and shakes her hair. The film is slightly out of focus at the beginning; there is a light flare in the middle.

### ST318 *Susan Sontag*, 1964
16mm, b&w, silent; 4.5 min. @ 16 fps, 4 min. @ 18 fps
Preserved 1995, MoMA *Screen Tests* Reel 8, no. 4
**FILM MATERIALS**
ST318.1 *Susan Sontag*
1964 Kodak 16mm b&w reversal original, 107'
**NOTATIONS** On original box in AW's hand: *Susan*

### ST319 *Susan Sontag*, 1964
16mm, b&w, silent; 4.4 min. @ 16 fps, 3.9 min. @ 18 fps
Preserved 1998, MoMA *Screen Tests* Reel 13, no. 9
**FILM MATERIALS**
ST319.1 *Susan Sontag*
1964 Kodak 16mm b&w reversal original, 106'
**NOTATIONS** On original box in unidentified hand: *Susan Sontag*

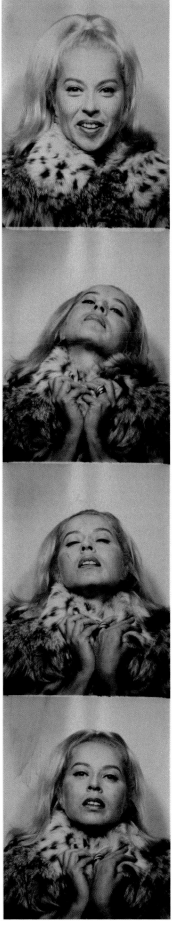

Andy Warhol, *Holly Solomon*, 1966. Gelatin silver print. Whitney Museum of American Art, New York. Gift of The Andy Warhol Foundation for the Visual Arts and purchase, with funds from the Photography Committee.

**ST320  *Susan Sontag*, 1964**
16mm, b&w, silent; 4.6 min. @ 16 fps, 4.1 min. @ 18 fps
Preserved 1998, MoMA *Screen Tests* Reel 17, no. 3
COMPILATIONS  *The Thirteen Most Beautiful Women* (ST365)
FILM MATERIALS
ST320.1  *Susan Sontag*
1964 Kodak 16mm b&w reversal original, 110'
NOTATIONS  On original box in AW's hand: *Susan Sontag 13.*
*Might be OK*

**ST321  *Susan Sontag*, 1964**
16mm, b&w, silent; 4.3 min. @ 16 fps, 3.9 min. @ 18 fps
Preserved 1995, MoMA *Screen Tests* Reel 11, no. 4
COMPILATIONS  *Fifty Fantastics and Fifty Personalities* (ST366)
FILM MATERIALS
ST321.1  *Susan Sontag*
1964 16mm b&w reversal original, 104'
NOTATIONS  On original box in AW's hand: *Susan. personality. good*

**ST322  *Susan Sontag*, 1964**
16mm, b&w, silent; 4.4 min. @ 16 fps, 3.9 min. @ 18 fps
Preserved 1999, MoMA *Screen Tests* Reel 18, no. 4
FILM MATERIALS
ST322.1  *Susan Sontag*
1964 Kodak 16mm b&w reversal original, 106'
NOTATIONS  On original box in Gerard Malanga's hand: *Susan Sontag in chair*

**ST323  *Susan Sontag*, 1964**
16mm, b&w, silent; 4.4 min. @ 16 fps, 3.9 min. @ 18 fps
Preserved 1999, MoMA *Screen Tests* Reel 19, no. 6
COMPILATIONS  *EPI Background* (ST370); *Fifty Fantastics and Fifty Personalities* (ST366)
FILM MATERIALS
ST323.1  *Susan Sontag*
1964 Kodak 16mm b&w reversal original, 105'
ST323.1.p1 *EPI Background* (ST370), roll 10
Undated Dupont 16mm b&w reversal print, 105'
NOTATIONS  On original box in AW's hand: *good personality.*
*Susan Sontag*
On box in unidentified hand: *SUSAN SONTAG. PORTRAIT 10*
On clear film at head of roll in black: *–10–*

**ST324  *Susan Sontag*, 1964**
16mm, b&w, silent; 4.5 min. @ 16 fps, 4 min. @ 18 fps
Preserved 1998, MoMA *Screen Tests* Reel 16, no. 2
COMPILATIONS  *Fifty Fantastics and Fifty Personalities* (ST366)
FILM MATERIALS
ST324.1  *Susan Sontag*
1964 Kodak 16mm b&w reversal original, 108'
NOTATIONS  On original box in AW's hand: *Good personality. Susan Sontag*

The writer and critic Susan Sontag appears in seven *Screen Tests* from late 1964. At this time, Sontag was teaching at Columbia University, had finished her first novel, *The Benefactor* (Farrar, Straus & Giroux, 1963), and had just published her groundbreaking essay, "Notes on 'Camp,'" in the autumn 1964 issue of the *Partisan Review*.[338] Sontag's analysis of the underground, proprietarily gay, camp sensibility launched this term into mainstream culture, where it immediately became confused with Pop; Sontag also became

popularly identified, "deservedly or not, . . . as the high priestess of the camp cult."[339] A March 1965 *New York Times Magazine* article on camp by writer Thomas Meehan described Sontag as the person "who discovered and defined the already existing phenomenon." Meehan also identified Warhol as "the most prominent single figure on the New York Camp scene," and listed Warhol's 1963 film *Sleep* as no. 2 among twelve examples of "things that are generally agreed to be Pure Camp."[340] Sontag's essay, or at least the press coverage of it, seems to have inspired Warhol to make a feature film called *Camp* in October 1965, which offered examples of camp in performances by Paul Swan, Jack Smith, Tally Brown, Mario Montez, Donyale Luna, and others.

In later years, Sontag became one of America's best-known intellectuals, writing frequently in the *New Yorker*, the *New York Review of Books*, and other journals, publishing four novels, a book of short stories, and a number of nonfiction books of criticism and cultural analysis, including *Against Interpretation* (which she dedicated to her close friend Paul Thek), *Styles of Radical Will*, *On Photography*, *Illness as Metaphor*, *Where the Stress Falls*, and *Regarding the Pain of Others*.[341] She has also written and directed four feature films. Her novel *In America* won the National Book Award in 2000. Susan Sontag died in December 2004 at the age of seventy-one.

Warhol was certainly aware of Sontag and her accomplishments in 1964. His friend David Bourdon had told him that Sontag didn't think much of his paintings and suspected Warhol's sincerity, which Warhol found to be "no surprise, since a lot of dazzling intellects felt that way"; but he also thought Sontag had "a good look—shoulder-length, straight dark hair and big dark eyes, and she wore very tailored things."[342] This may explain why there are seven *Screen Tests* of Sontag, apparently filmed over several different sessions.

ST318 is the most straightforward and formal of the portraits: Sontag sits in front of a plain white background, her hair carefully combed, and regards the camera with solemn poise. The film is rather overexposed, especially at the beginning, after which the details of her features gradually become more visible. In another film (ST319), Sontag again sits in front of a white backdrop, wearing a pair of sunglasses; her image is slightly out of focus. Her hair is uncombed and rather wild; her eyes are visible behind her glasses. At one point, she closes her eyes for a few moments, then looks around with a slight smile.

In another, more intimate portrait of Sontag (ST320), which Warhol noted "might be OK" for *The Thirteen Most Beautiful Women*, she seems to lean into the camera, resting her chin on one hand, her face lit most brightly from the left. She seems tired and perhaps a little bored, but gives the camera an entirely serious look, as if it were her equal. She shifts position a few times, resting her cheek on her fist, pushing her hair back with one hand, and then leaning forward again. In another portrait film (ST321), this time posed against a black backdrop, Sontag is livelier, smiling, putting on her dark glasses, removing them, laughing, shrugging, and glancing around.

Sontag's last three *Screen Tests* seem to have been shot at the same time, since she is wearing the same V-necked shirt in all of them. In ST322, she appears in medium long shot, wearing dark glasses and slumped in a silver-painted swivel chair in the open space of the Factory; wrapped boxes and small silk screens can be seen stacked against the wall behind her. Sontag tilts back in her chair, balances herself with her knees up, hugs her ankles, and then sits up and leans forward toward the camera. After a while, she leans back again, raising one knee in a slightly sultry pose. The exposure brightens intermittently throughout the roll.

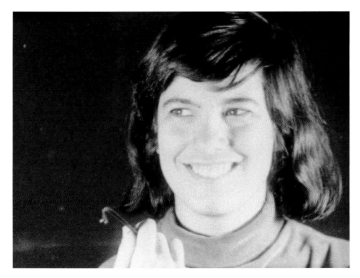

ST321

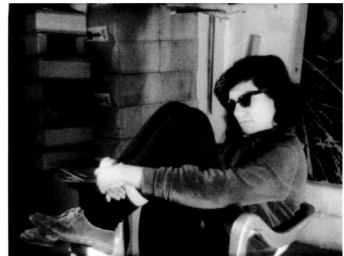

ST322

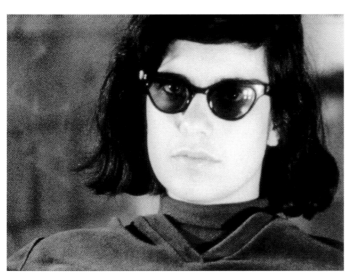

ST323

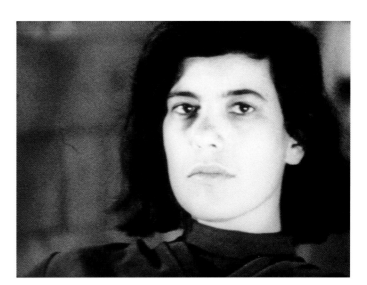

ST324

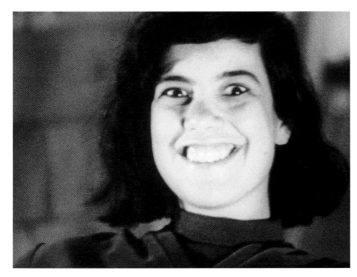

ST324

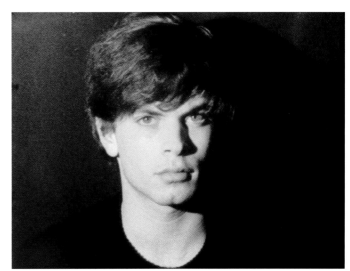

ST325

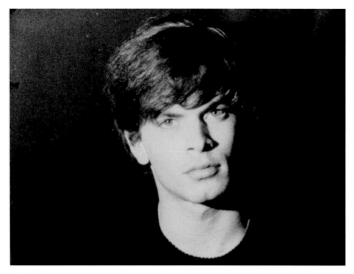

ST326

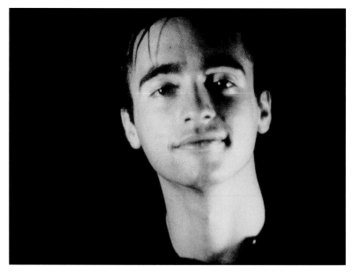

ST327

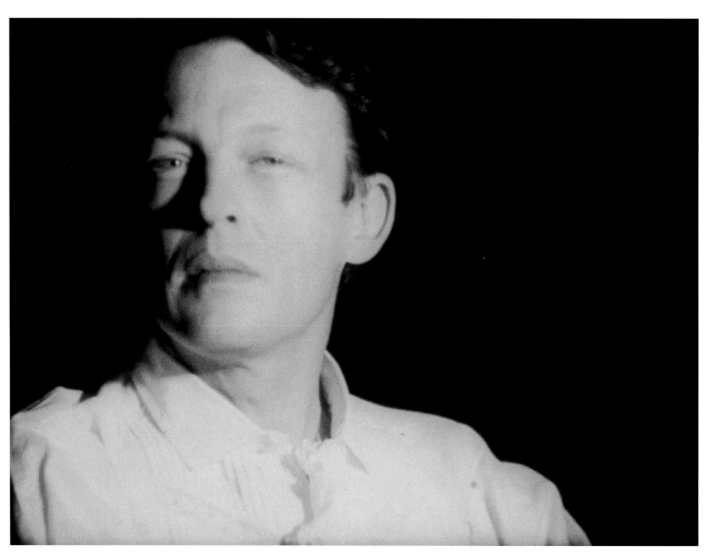

ST328

The next film (ST323) is a close-up of Sontag wearing dark glasses, the out-of-focus space of the Factory visible behind her. At the beginning of the roll she lights a cigarette with a brightly flaring match, then stares straight ahead, smoke from her cigarette rising into the frame. The Factory windows can be seen reflected in her dark glasses, through which her eyes are occasionally visible. In another *Screen Test* shot in the same location (ST324), Sontag performs a series of exaggerated and satirical grins for the camera, during which she seems to be saying "cheese." In between smiles, her face subsides into an expression of distant coldness. Smoke from her cigarette rises through the film image; toward the end of the film, she begins rocking back and forth in her chair. Sontag's habit of smiling satirically was also observed in a 1966 interview, which may give some clue to how she felt about appearing in a Warhol film: "Her face kept breaking out into a grin, which had a bit of a mocking quality about it—as if she found the whole business of being interviewed more than a little absurd."[343]

## ST325  *Kipp Stagg*, 1965

16mm, b&w, silent; 4.5 min. @ 16 fps, 4 min. @ 18 fps
Preserved 1995, MoMA *Screen Tests* Reel 9, no. 7
FILM MATERIALS
ST325.1 *Kipp Stagg*
1965 Kodak 16mm b&w reversal original, 107'
NOTATIONS On original box in AW's hand: *Beauty #1*

## ST326  *Kipp Stagg*, 1965

16mm, b&w, silent; 4.5 min. @ 16 fps, 4 min. @ 18 fps
Preserved 1995, MoMA *Screen Tests* Reel 4, no. 6
FILM MATERIALS
ST326.1 *Kipp Stagg*
1965 Kodak 16mm b&w reversal original, 107'
NOTATIONS On original box in AW's hand: *Beauty #2. Kipp*
Also on box: drawing of a box with an "X" in it

Kipp Stagg starred in the title role of Warhol's 1965 one-reeler, *Beauty #1*, in which he and Edie Sedgwick recline in bed, chatting and occasionally kissing, until they are awkwardly interrupted by the offscreen entrance of a talkative Chuck Wein. Soon thereafter, *Beauty #1* was reshot as the sixty-six-minute *Beauty #2*, with Gino Piserchio in the "Beauty" role. Stagg's two *Screen Tests* were probably shot around the same time as *Beauty #1*, in the early summer of 1965. Little else is known about Kipp Stagg, although he was reportedly uncomfortable about his appearance in *Beauty #1*.[344]

Stagg's two *Screen Tests* were filmed at the same time and labeled "Beauty #1" and "Beauty #2" by Warhol, which apparently refers not to the sound films but to the order in which these rolls were shot. Wearing a black T-shirt and posed against a black background, Stagg has been lit strongly from the left, with the shadow of his nose sharply cast across his cheek. In the first film (ST325), his eyes tear up and he blinks at the camera, tilting his head back and breathing through his mouth, as if trying to relieve tension. At the end of the roll, he wipes a tear from his eye with his finger and says "Sorry" to the camera. In the second film (ST326), he appears less uncomfortable, a little more bored. At one point he rubs and stretches his neck, pulling down the neck of his T-shirt. The notation of a boxed "X" on the film box may indicate that Warhol liked this *Screen Test* better than the other.

## ST327  *Star of the Bed*, 1965

16mm, b&w, silent; 4.4 min. @ 16 fps, 3.9 min. @ 18 fps
Preserved 1999, MoMA *Screen Tests* Reel 18, no. 10
COMPILATIONS *The Thirteen Most Beautiful Boys* (ST364)
FILM MATERIALS
ST327.1 *Star of the Bed*
1964 Kodak 16mm b&w reversal original, 106'
NOTATIONS On original box in unidentified hand: *13. X*
On box flap in unidentified hand: *Star of the Bed*

A young man identified—or misidentified—only as "Star of the Bed" appears in a *Screen Test* from 1964 or early 1965. *The Bed* was a play written by Bob Heide, which premiered at a benefit for the Caffe Cino at the Sullivan Street Theater in March 1965; the play reopened at the Caffe Cino on July 7, 1965, and ran for 150 performances. In the fall of 1965, Warhol and Dan Williams shot a double-screen film version of Heide's play. In 1966 Warhol appropriated the basic idea of the play, without using Heide's script, for a three-reel remake called *The John*, two reels of which, *Boys in Bed* and *Mario Sings Two Songs*, were included in *The Chelsea Girls*.

This young man, unfortunately, is neither Larry Burns nor Jim Jennings, the two stars of the 1965 play and film; nor does he appear in any footage from *The John*. Since his *Screen Test* appears to predate any of Warhol's versions of *The Bed*, it seems possible that it was mislabeled at a later date by someone confused by his slight resemblance to Larry Burns. At any rate, the unidentified star, wearing a black shirt and posed against a black background, faces the camera in a cheerful mood, smiling at people offscreen and bobbing his head as if to music. He gazes about, wide-eyed, and then stares unsmiling into the camera. Toward the end of the film, he wipes his eyes and face with his hands.

## ST328  *Harold Stevenson*, 1964

16mm, b&w, silent; 4.6 min. @ 16 fps, 4.1 min. @ 18 fps
Preserved 1998, MoMA *Screen Tests* Reel 16, no. 5
COMPILATIONS *Screen Test Poems* (ST372); *Screen Tests/A Diary* (Appendix A)
FILM MATERIALS
ST328.1 *Harold Stevenson*
1964 Kodak 16mm b&w reversal original, 110'
ST328.1.p1 *Screen Test Poems*, Reel 3 (ST372.3), roll 26
Undated Gevaert 16mm b&w reversal print, 110'
NOTATIONS On original box in AW's hand: *Harald Stein*
On box in Gerard Malanga's hand: *HAROLD STEVENSON.*
(smeared) *negative 8" x 10" glossy print*
On box flap: *26*
On clear film at both head and tail of roll: *26*

The Oklahoma-born painter Harold Stevenson became friends with Warhol around 1950; later they were both part of the artistic gay circle centered around the New York restaurant Serendipity. Warhol's first solo exhibition in New York, Fifteen Drawings Based on the Writings of Truman Capote, was held in 1952 at the Hugo Gallery, run by Stevenson's dealer, Alexander Iolas. In 1959 Stevenson moved to Paris, where he continued to produce impressively oversized canvases depicting close-ups of nude bodies and other homoerotic images. Stevenson's work was initially associated with the European avant-garde, where he was considered both a Surrealist and a Nouveau Réaliste, but in America in the early 1960s he was identified primarily as a Pop artist. In the fall of 1962, Sidney

Janis included Stevenson, along with Warhol, Claes Oldenburg, Robert Indiana, Roy Lichtenstein, James Rosenquist, and more than twenty other artists, in his seminal New Realists exhibition in New York.

In the same year, Stevenson completed his monumental painting *The New Adam*, a forty-foot-long, multipanel portrait of a sleeping nude male (modeled by the actor Sal Mineo).[345] After Lawrence Alloway withdrew his invitation to include the painting in a 1963 exhibition at the Guggenheim Museum, it was exhibited at the Feigen/Herbert Gallery in New York in November, and then traveled to the Feigen/Palmer Gallery in Los Angeles in January. Stevenson accompanied his painting to New York, where he appeared in several of Warhol's early films, including a *Kiss* roll with the artist Marisol and another, as yet unlocated film called *Harold*, which premiered at the Feigen/Palmer Gallery in Los Angeles on January 5, 1964.[346] According to Stevenson's recollections, Richard Feigen showed *Harold* on a television set in the gallery, so that it ran continuously next to his paintings. The film included Stevenson's *Kiss* roll with Marisol and other footage, shot at the Carlyle Hotel in New York, of Stevenson changing clothes over and over again.[347] No film matching this description has been found in the Warhol Film Collection or elsewhere.

In the fall of 1965, Stevenson posed for his *Screen Test* at the Factory, and also appeared in the Dan Williams film *Harold Stevenson*, which includes 1965 footage of Stevenson attending the filming of *Camp* at the Factory, and romping with his friends Paul America, Edie Sedgwick, Gerard Malanga, Marisol, Ruth Ford, Rosalind Constable, and Louisa Angeletti in his suite at the Carlyle Hotel. In the late fall of 1966, Stevenson again appeared in a Warhol film, this time dressing up as a Mississippi riverboat gambler for an unreleased reel called *Nancy Fish and Rodney*. In 1971 Stevenson appeared under the screen name Harold Childe in Paul Morrissey's film *Heat*, in which he played an ocelot-owning former child star who, like everyone else in the film, succumbs to Joe Dallesandro's sexual attractions.

Stevenson's *Screen Test* is a consummate performance, a portrait of the artist as vaporish aesthete. Brightly lit from the right against a dark background and wearing a white ruffled shirt open at the neck, Stevenson faces the camera with a bandanna held delicately to his lips. He slowly wipes his neck with it, and gazes about inquiringly. Noticing the camera again, he gives it an astonished, open-mouthed stare, then touches his lips with the scarf again. Seemingly overcome with emotion, he continues to pat himself with the bandanna while staring dazedly into the camera's eye. At the end of the roll, he recovers himself and assumes an air of haughtiness, arching his eyebrows ironically.

In 1998, The Andy Warhol Museum in Pittsburgh mounted an exhibition of Stevenson's work, including *The New Adam*. Stevenson continues to divide his time between Long Island and Oklahoma.

### ST329  *Stevie*, n.d.

16mm, b&w, silent; 4.5 min. @ 16 fps, 4 min. @ 18 fps
FILM MATERIALS
ST329.1 *Stevie*
Kodak 16mm b&w reversal original, 107'
Film is completely overexposed, with light flares throughout; too overexposed to read date code
NOTATIONS On original box in AW's hand: *Bad. Stevie* [followed by illegible word: "Zorn" or "Born"]

Steve Stone with another friend of Howard Kraushar's, in Leon Kraushar's living room in Lawrence, New York. Photograph by Ken Heyman.

A young man named Stevie, with an illegible last name, appears in an undated *Screen Test*. The roll is overexposed throughout and filled with light flares; as Warhol noted on the box, the film is "bad." Stevie can be seen talking, making faces, and widening his eyes at the camera. Near the end of the roll, someone throws water on his face from offscreen.

### ST330  *Steve Stone*, 1964

16mm, b&w, silent; 4.4 min. @ 16 fps, 3.9 min. @ 18 fps
Preserved 2001, MoMA *Screen Tests* Reel 24, no. 8
COMPILATIONS *The Thirteen Most Beautiful Boys* (ST364)
FILM MATERIALS
ST330.1 *Steve Stone*
1964 Kodak 16mm b&w reversal original, 106'
NOTATIONS On original box in AW's hand: *Steve Krashur for 13*

### ST331  *Steve Stone*, 1964

16mm, b&w, silent; 4.5 min. @ 16 fps, 4 min. @ 18 fps
Preserved 2001, MoMA *Screen Tests* Reel 26, no. 3
FILM MATERIALS
ST331.1 *Steve Stone*
1964 Kodak 16mm b&w reversal original, 109'
NOTATIONS On original box in AW's hand: *Steve Krashaur*

In 1964 the art collector Leon Kraushar brought his son Howard and several of Howard's friends from Long Island, including Steve Stone and Richie Markowitz, to visit the Warhol Factory, where they had their *Screen Tests* shot and also appeared in a few rolls of *Couch*. Steve Stone's *Screen Tests* were almost certainly shot at the same time as those of Howard Kraushar, Markowitz, and Leon Kraushar's driver, Steve Garonsky.[348]

Steve Stone, misidentified on the film boxes as Steve Kraushar, gives two very different performances in his portrait films, both of which are somewhat out of focus. In one film (ST330), which Warhol marked for *The Thirteen Most Beautiful Boys*, Stone is highly animated, talking, smiling, sticking out his tongue, mugging for the camera, nodding his head to music, gesturing, and constantly looking away from the camera, whose presence he seems to ignore. In

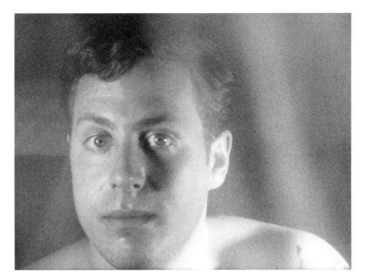

ST329

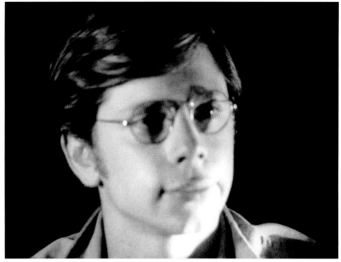

ST330

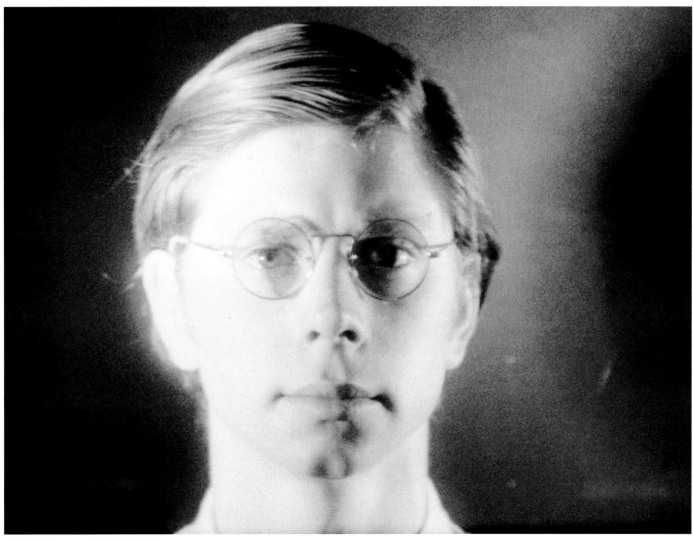

ST331

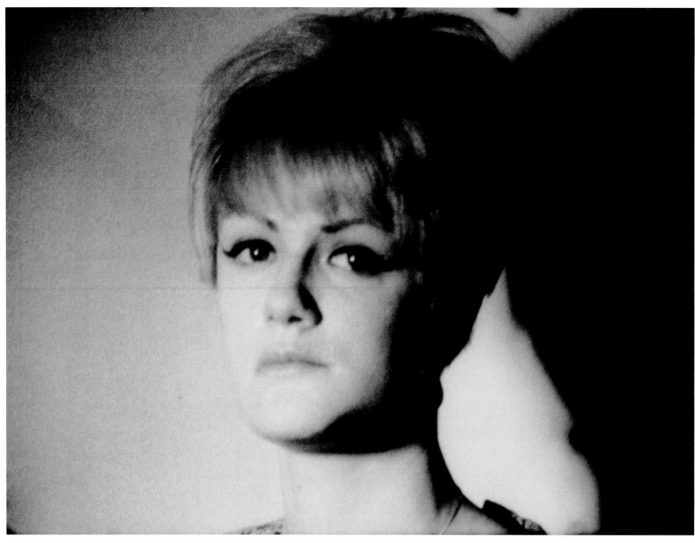

ST332

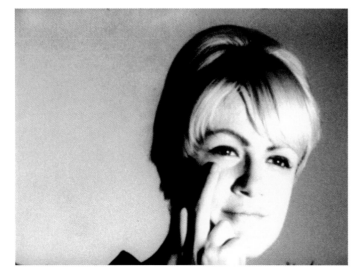

ST333

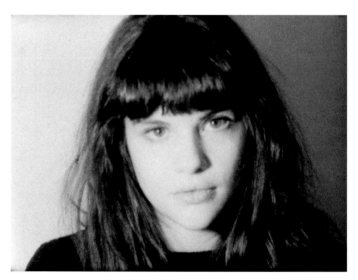

ST334

the other film (ST331), he appears by contrast quite subdued, holding still for the camera and occasionally swallowing nervously. At one point he coughs and then laughs. In this second film, the focus gets worse as the film progresses, as if Stone were gradually inching away from the camera.

### ST332 *Ingrid Superstar,* 1965

16mm, b&w, silent; 4 min. @ 16 fps, 3.5 min. @ 18 fps
Preserved 1999, MoMA *Screen Tests* Reel 20, no. 9
**FILM MATERIALS**
ST332.1 *Ingrid Superstar*
1965 Kodak 16mm b&w reversal original, 95'
**NOTATIONS** On box in AW's hand: *Good* (illeg. word). *Ingrid*
On box in Gerard Malanga's hand: *1 double frame neg. and 1 8" x 10" double frame stillie–marked by masking tape*
On box in unidentified hand, crossed out: *chicken killing. Jack and Greg's hands*
Written inside box flap: *Ingrid Screen Test*

### ST333 *Ingrid Superstar,* 1966

16mm, b&w, silent; 4.5 min. @ 16 fps, 4 min. @ 18 fps
Preserved 1998, MoMA *Screen Tests* Reel 17, no. 1
**FILM MATERIALS**
ST333.1 *Ingrid Superstar*
1966 Kodak 16mm b&w reversal original, 108'
**NOTATIONS** On original box in AW's hand: *Indgrid*

Ingrid Superstar, whose real name was Ingrid Von Scheven, arrived at the Factory in the fall of 1965. According to several accounts, Ingrid was initially promoted as a kind of low-rent parody of the most famous Warhol superstar of that year, Edie Sedgwick, who had become difficult to work with.[349] In spite of the awkwardness of her position as Edie's replacement at the Factory and the teasing she at first attracted, Ingrid embraced her new title of "Superstar" enthusiastically, and became well-liked for her unpretentious, *Born Yesterday* qualities and her good-natured sense of humor. As Warhol recalled:

> Ingrid was just an ordinarily nice-looking girl from Jersey with big wide bone structure posing as a glamour figure and a party girl, and what was great was that somehow it worked . . . It was so funny to see her sitting there on the couch next to Edie or, later, Nico and International Velvet, putting on makeup or eyelashes exactly the way they did, trading earrings and things and beauty tips with them. It was like watching Judy Holliday, say, with Verushka.[350]

Ingrid's first screen roles were in the unreleased 1965 reels known as *My Hustler II: My Hustler: In Apt.* and *My Hustler: Ingrid.* In early 1966 she played a shopgirl (poisoned by Mario Montez) in *Hedy,* and was surprisingly funny in the role of Kathy opposite Charles Aberg's Heathcliff in *Withering Sights.* By the summer of 1966, Ingrid Superstar had become if not a major superstar at least a regular player in the Warhol repertory, with roles in six out of the twelve reels of *The Chelsea Girls,* performances on stage as part of the Exploding Plastic Inevitable, and an appearance in the unreleased Warhol film *The Velvet Underground Tarot Cards.* In the fall of 1966, she played "Looney Bird" Johnson, wife to Ondine's LBJ, in several reels of *Since,* and appeared in a number of other reels shot for, but not included in, the twenty-five-hour ★★★★ *(Four Stars).* In 1967, she had roles in *Bike Boy, I, a Man, The Loves of Ondine,* and

*The Nude Restaurant,* as well as appearing in various reels of ★★★★ *(Four Stars).*[351] In 1968 she traveled to La Jolla, California, with the rest of the Warhol troupe for the shooting of *San Diego Surf.*

In addition to her talents as a film comedienne, Ingrid Superstar also wrote short poems and prose pieces, which were occasionally published, and sometimes gave public readings from her "Trip Book."[352] Warhol thought "her poems were good, really good, half poetry and half comedy."[353] In later years, Ingrid Von Scheven fell on hard times, struggling with a drug problem and eventually ending up in Kingston, New York, where she worked in a sweater factory. She disappeared one day in December 1986, after leaving her apartment to buy cigarettes. Although the Kingston police announced "there's a clear possibility of foul play and we are intensifying our investigation," she was never found.[354] She was forty-two years old at the time of her disappearance.

Judging from the apprehensive expression with which she faces the camera, Ingrid's 1965 *Screen Test* (ST332) was probably her very first appearance in a Warhol film. Placed against a white wall and harshly lit from the left, she holds her head high like a frightened deer, her eyes wide. At one point she rolls her eyes nervously to the right, then watches someone moving behind the camera. By contrast, her 1966 portrait film (ST333) is a relaxed and flirtatious performance. Posed against a light background, Ingrid makes what seems to be a series of rapid hand signals—touching her nose and face with her fingers, laying her fingers along her cheek, covering her mouth, tapping her nose and teeth with her middle finger, sucking on her fingertip, laughing and mugging for the camera. (Ingrid can also be seen making these same gestures in *The Velvet Underground Tarot Cards,* which seem to be a kind of private joke between her and Warhol the cameraman.) When she turns to the side, a large tuft of hair can be seen rising from the back of her head. At one point she turns her face into the light and closes her eyes, as if sunbathing.

### ST334 *Amy Taubin,* 1964

16mm, b&w, silent; 4.3 min. @ 16 fps, 3.9 min. @ 18 fps
Preserved 1995, MOMA *Screen Tests* Reel 1, no. 5
**COMPILATIONS** *The Thirteen Most Beautiful Women* (ST365)
**FILM MATERIALS**
ST334.1 *Amy Taubin*
1964 Kodak 16mm b&w reversal original, 104'
**NOTATIONS** On original box in AW's hand: *Amy (13)*

### ST335 *Amy Taubin,* 1964

16mm, b&w, silent; 4.4 min. @ 16 fps, 3.9 min. @ 18 fps
Preserved 1995, MoMA *Screen Tests* Reel 2, no. 1
**COMPILATIONS** *The Thirteen Most Beautiful Women* (ST365)
**FILM MATERIALS**
ST335.1 *Amy Taubin*
1964 Kodak 16mm b&w reversal original, 106'
**NOTATIONS** On original box in AW's hand: *Amy OK. 13. Good*

In November or December 1964, the actress Amy Taubin appeared in two *Screen Tests* shot for *The Thirteen Most Beautiful Women.* In the spring of that year, Taubin had received critical acclaim for her role in *Doubletalk,* two one-act plays by Lewis John Carlino, and consequently had been invited out to California for a real screen test at a movie studio. Taubin, then married to playwright Richard Foreman, had decided she wasn't interested in being a movie star, and was amused to find that Warhol and his assistants seemed interested in her precisely because of her recent brush with Hollywood.[355]

Taubin was first brought to the Factory by Naomi Levine, the filmmaker who starred in Warhol's 1963 film *Tarzan and Jane Regained, Sort Of . . . .* Taubin's *Screen Tests* were shot by Warhol during this first visit. As she recalled,

> as soon as you arrived for the first time you had your picture taken and that just involves sitting down in front of a white sheet of paper, very much like a fashion photography studio, and one Bolex on a tripod and a single light and you sat there for three minutes and you were told to sit as still as possible and you had your portrait done.[356]

Taubin remembers that Warhol's *Flowers* paintings were being worked on when her portrait films were made. She came to the Factory on other occasions with her friend Barbara Rubin, and during one of these later visits appeared in a roll of *Couch* (1964), in which she, Levine, Gerard Malanga, and Jane Holzer all eat bananas together.[357]

In later years, Taubin continued her acting career, appearing in *The Prime of Miss Jean Brodie* at the Helen Hayes Theater on Broadway in 1968 and also performing in several avant-garde films, including Michael Snow's *Wavelength* (1966–67) and *Rameau's Nephew . . .* (1970–74), and Yvonne Rainer's *Journeys from Berlin/ 1971* (1980). Taubin also made films herself, including *See!/Like/ Duck* (1975) and *In the Bag* (1981). She was the curator of film and video at the Kitchen from 1983 to 1987, and a film critic for the *Village Voice* for many years. Her monograph on Martin Scorsese's 1976 film *Taxi Driver* was published by the British Film Institute in 2000. Taubin teaches at the School of Visual Arts, and is a contributing editor to *Film Comment* and *Sight and Sound* magazines.

In her two *Screen Tests*, Taubin does indeed pose in front of a white sheet of paper, holding very still. A single bright light illuminates her face from the left. In one *Screen Test* (ST334), Taubin faces the camera head-on, looking self-possessed and determined. In the next (ST335), her head is slightly tilted to the left, which gives her a milder, more thoughtful expression. Although both films were marked for *The Thirteen Most Beautiful Women*, Warhol apparently liked the second one better, writing "good" on the film box.

## ST336 *Ronald Tavel*, 1964

16mm, b&w, silent; 4.4 min. @ 16 fps, 3.9 min. @ 18 fps
Preserved 1999, MoMA *Screen Tests* Reel 19, no. 1
COMPILATIONS *Screen Tests/A Diary* (Appendix A)
FILM MATERIALS
ST336.1 *Ronald Tavel*
1964 Kodak 16mm b&w reversal original, 106′
NOTATIONS On original box in Gerard Malanga's hand: *RON TAVEL. Ronald Tavel. 1 Double Frame 8″ x 10″ Print and Negative*

The New York playwright and writer Ronald Tavel was a close friend of the filmmaker and artist Jack Smith, with whom he shared an encyclopedic knowledge of old Hollywood movies and a fondness for Maria Montez. Tavel first met Warhol in the fall of 1964, when Gerard Malanga took Warhol to the Café le Metro to hear Tavel read from his novel *Street of Stairs*. As Warhol later recalled:

> He seemed to have reams of paper around; I was really impressed with the sheer amount of stuff he'd evidently written. While he was reading, I was thinking how wonderful it was to find someone so prolific just at the point when we were going to need "sounds" for our sound movies.[358]

Warhol immediately invited Tavel to participate in the making of his first sound film, *Harlot*, for which Tavel, Billy Linich, and Harry Fainlight provided the soundtrack, improvising an offscreen conversation while the film was being shot. Beginning in January 1965, Tavel began writing scenarios for a number of Warhol's films, movies in which he often performed as offscreen interrogator or appeared on screen as "director" of the action. In addition to his roles in *Harlot* and *Bitch*, in 1965 Tavel wrote scripts for eight other Warhol films: *Screen Test #1*, *Screen Test #2*, *Suicide*, *The Life of Juanita Castro*, *Horse*, *Vinyl*, *Kitchen*, and *Space*, while also making on-screen appearances in *The Life of Juanita Castro*, *Horse*, and *Kitchen*.

That July, Tavel wrote a scenario called *Shower* in which Edie Sedgwick unexpectedly refused to perform, haughtily announcing that she would not be "a spokesman for Tavel's perversities."[359] In compensation, Warhol suggested that Tavel produce the script as a play, and put him in touch with the producer Jerry Benjamin (who had codirected *Soap Opera* with Warhol in 1964); Benjamin suggested John Vacarro as director for Tavel's play. In August 1965, at the Coda Gallery in New York, Tavel and Vacarro opened two one-act plays based on screenplays that Tavel had written for Warhol, *Shower* and *The Life of Juanita Castro*. This was the first production of the Playhouse of the Ridiculous (also known as the Theatre of the Ridiculous), for which Tavel wrote a one-line manifesto: "We have passed beyond the absurd: our position is absolutely preposterous."[360] Other Ridiculous productions, *Vinyl*, *Kitchenette*, and *Screen Test*, were also based on Tavel scenarios previously filmed by Warhol; thus, the origins of the Theatre of the Ridiculous movement, which eventually expanded into several different companies and is now most often associated with the name of Charles Ludlum, may be traced back to Ronald Tavel and to the Warhol films themselves. Tavel and his brother Harvey, who often directed his plays, also used a number of actors who had worked with Warhol and/or Smith, such as Beverly Grant, Mario Montez, and Mary Woronov.

In 1965 Tavel wrote two other scripts for Warhol, a surfing narrative called *Kahuna!* and a spoof of *Jane Eyre* called *Jane Eyre Bare*, neither of which was ever filmed. In early 1966 he wrote and appeared in *Hedy*, wrote the screenplay for *Withering Sights*, and later that year provided scenarios for two sequences for *The Chelsea Girls*: *Hanoi Hannah* and *Their Town*. By the late 1960s, Tavel was devoting his time entirely to theater, writing plays, including *The Life of Lady Godiva*, *Indira Ghandi's Daring Device*, and *Gorilla Queen*, which were performed at various off-Broadway venues such as the Judson Poets Theater and the Caffe Cino. His script for the *Their Town* segment of *The Chelsea Girls*, based on a *Life* magazine story about a Tucson serial killer, eventually became the musical drama *Boy on the Straight-Back Chair*, for which Tavel received an Obie Award in 1969. Tavel's last gig with Warhol was in the fall of 1966, when he appeared briefly with Ondine and Allen Midgette in a reel called *Jail*, shot at the Second Avenue Courthouse. He currently lives in Bangkok, where he has recently completed a new novel, *Chain*, and plans to publish a collection of the screenplays that he wrote for Warhol.

Tavel's *Screen Test*, as he recalls, was shot at the Factory on December 20, 1964, a week after the shooting of *Harlot*. After he and Warhol attended the first private screening of *Harlot* at the uptown New Yorker Theatre, Warhol asked him to come to the Factory to have his portrait film made. As Tavel recalled,

> He just set up the camera and said, "It will be three minutes. Just sit there. You don't have to do anything." And he walked away. I remember I smoked a cigarette, and did a whole communication with the camera. As if it were a person

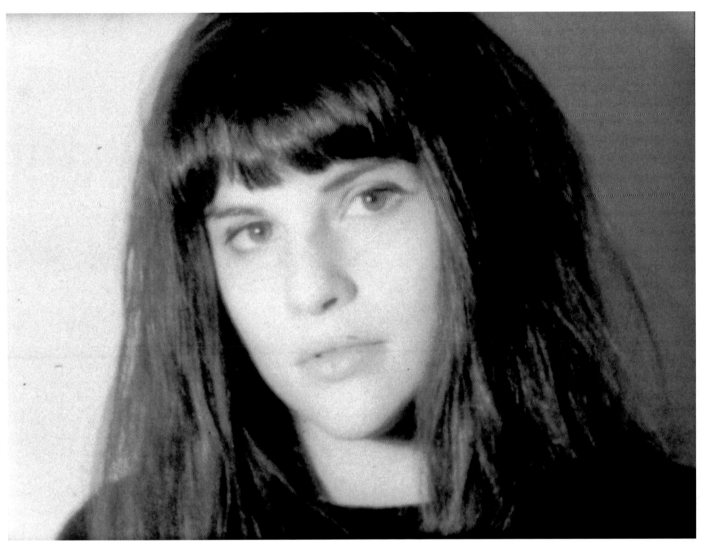

ST335

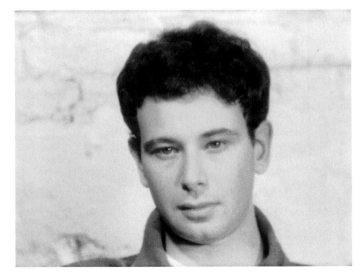

ST336

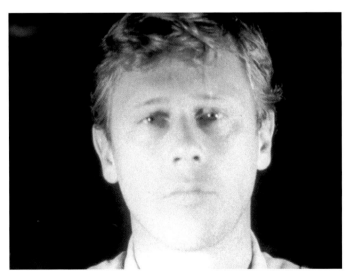

ST337

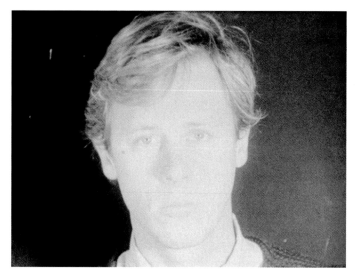

ST338

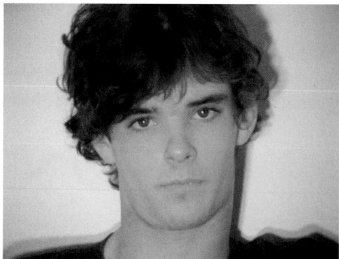

ST339  **See Appendix D for color reproduction.**

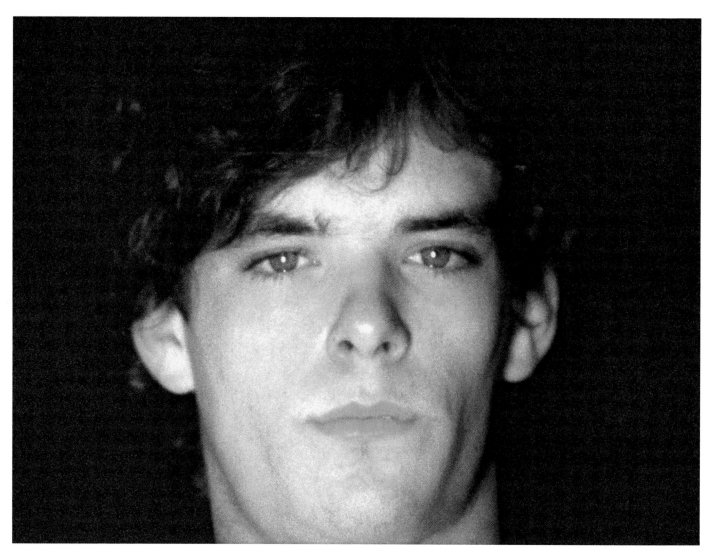

ST340  **See Appendix D for color reproduction.**

that you're making eye contact with but can't talk to. It was really a come-on, but a conservative one. And it worked.[361]

Posed against a white-painted brick wall, with his face evenly lit, Tavel sends a number of intense signals in the direction of the camera. He drags on his cigarette, raises one eyebrow, licks his lips, widens and then narrows his eyes, lets his mouth fall open slightly, and then gazes offscreen as if suddenly interested in someone else.

### ST337 *Paul Thek*, 1964
16mm, b&w, silent; 4.4 min. @ 16 fps, 3.9 min. @ 18 fps
Preserved 1995, MoMA *Screen Tests* Reel 12, no. 5
COMPILATIONS *The Thirteen Most Beautiful Boys* (ST364)
FILM MATERIALS
ST337.1 *Paul Thek*
1964 Kodak 16mm b&w reversal original, 105'
NOTATIONS On original box in AW's hand: *Paul Tach for (13)*

### ST338 *Paul Thek*, 1964
16mm, b&w, silent; 4.4 min. @ 16 fps, 3.9 min. @ 18 fps
Preserved 1995, MoMA *Screen Tests* Reel 3, no. 9
FILM MATERIALS
ST338.1 *Paul Thek*
1964 Kodak 16mm b&w reversal original, 105'
NOTATIONS On original box in AW's hand: *Paul*

Paul Thek, *Meat Piece with Warhol Brillo Box*, 1965. Philadelphia Museum of Art. Purchased with funds contributed by the Daniel W. Dietrich Foundation, 1990.

The artist Paul Thek (1933–88) was a close friend of Susan Sontag's, who dedicated her 1969 book *Against Interpretation* to him. In the 1960s, Thek made unsettling sculptures that he called "technological reliquaries"—realistic lumps of wax molded and painted to resemble flesh or meat and enclosed in Plexiglas boxes, sometimes linked to the outside with surgical tubing. As an artist, Thek has occasionally been compared with Warhol: in 1965 the critic Gregory Battcock published an essay, "Humanism and Reality—Thek and Warhol," which equated Thek's sculptures with Warhol's films in their shared use of technology and literalism.[362] That same year Thek created a sculpture called *Meat Piece with Warhol Brillo Box*; Thek transformed Warhol's sculpture into a container, cutting off the unpainted wooden bottom and filling the box with a wax sculpture of a bloody slab of meat. In 1966 Thek advertised his "Brutality Sculptures" in an underground guidebook to New York City in which Warhol also happened to advertise the Velvet Underground; Thek's ad offered: "Exquisite mountings of your favorite anatomy in boxes . . . lampshades made of your dear, departed pets . . . other works of art with a running theme of gore and violence . . . most costly."[363]

Thek's work varied highly throughout his relatively short career. His installation *The Tomb—Death of a Hippie*, exhibited at both the Stable Gallery and the Whitney Museum in 1967, showed a life-size, pink wax figure lying inside a wooden box structure. Another series of installations called "processions," produced in collaboration with the Artists' Co-op, were temporary environments containing various tableaux. By 1980 Thek had begun producing an extensive series of small, candy-colored paintings, often containing messages. Thek died of AIDS in 1988 at the age of fifty-four. A major retrospective of his work, Paul Thek—The Wonderful World That Almost Was, opened at the Center for Contemporary Art in Rotterdam, the Netherlands, in 1995.

In one of his two *Screen Tests* (ST337), shot for *The Thirteen Most Beautiful Boys*, Thek is framed in tight close-up against a black background and lit brightly from the front. His face seems pale and overexposed, except for the black pupils of his eyes. Near the end of the roll, he blinks, then widens his eyes briefly. In another portrait film (ST338), possibly shot on a different day since he is wearing a sweater, Thek's face is even more overexposed, appearing ghostlike and nearly solarized against the dark backdrop. His eyes can be seen welling up with tears; there is a light flare in the middle of the roll.

### ST339 *Patrick Tilden–Close*, 1966
16mm, color, silent; 4.5 min. @ 16 fps, 4 min. @ 18 fps
FILM MATERIALS
ST339.1 *Patrick Tilden-Close*
1966 Kodak 16mm Ektachrome reversal original, 107'
NOTATIONS Return address label on box filled out in Paul Morrissey's hand: *Customer Name: Andy Warhol Films. 2630 Glendower Avenue. LA. Footage: Patrick Tilden*

### ST340 *Patrick Tilden–Close*, 1966
16mm, color, silent; 4.5 min. @ 16 fps, 4 min. @ 18 fps
FILM MATERIALS
ST340.1 *Patrick Tilden-Close*
1966 Kodak 16mm Ektachrome reversal original, 107'
NOTATIONS Mailing label on original box filled out as follows:
*Customer Name: Andy Warhol Films. Street: 2630 Glendower Avenue City: LA. Footage: "Patrick Tilden"*
On box in unidentified hand: *CFI Ind., 959 Seward, 462-0881*
Also on box: small, rough drawing of head and shoulders inside a film frame

Patrick Tilden-Close was a blond child actor in the early 1960s, appearing under the name "Pat Close" in the role of young Elliot Roosevelt in the 1960 film *Sunrise at Campobello*, with Ralph Bellamy and Greer Garson. Pat Close also appeared on television in episodes of *General Electric Theater* (1961) and *The Twilight Zone* (1962).[364] In 1967, Tilden-Close had a starring role in Warhol's epic eight-hour film, *Imitation of Christ*, in which he played the spaced-out problem child of Ondine and Brigid Berlin. Some of Tilden-Close's scenes in *Imitation of Christ* were shot in Los Angeles in September 1967, at a large mansion called the Castle, a palatial countercultural boardinghouse favored by rock stars and musicians such as Bob Dylan and Jim Morrison. Warhol and the Factory group, including the Velvet Underground, stayed at the Castle during their visit to L.A. in 1966; later, Edie Sedgwick and Nico each lived there for a while.

These two color *Screen Tests* of Patrick Tilden-Close appear to have been shot and processed in Los Angeles; the return address written on both film boxes for "Andy Warhol Films" is 2630 Glendower Avenue, the address of the Castle. Since both *Screen Tests* were shot on 1966 stock, it seems likely that these tests of Tilden-Close were shot and processed in Los Angeles in May 1966, when Warhol, Paul Morrissey, the Velvet Underground, and other Factory personnel spent several weeks at the Castle waiting out the resolution of the Velvets' abortive booking at a Sunset Strip club called the Trip.[365] Unlike most of the portrait series, therefore, these two films of Tilden-Close seem to have actually functioned as real screen tests, leading, perhaps, to his starring role in *Imitation of Christ* months later. In September 1967, Warhol and Morrissey returned to Los Angeles to shoot some of Nico's scenes with Tilden-Close in *Imitation of Christ* at the Castle, where she was living at the time. Tilden-Close apparently returned to New York with Warhol and Morrissey to complete the film in November 1967.

Despite their usefulness as real screen tests, these two films of Tilden-Close are quite similar to other *Screen Tests*: silent, static close-ups of the subject simply facing the camera. The biggest difference is that, unlike the vast majority of *Screen Tests*, they were not shot in black-and-white (color stock was widely used in Warhol's later cinema).[366] In one film (ST339), Tilden-Close poses against a yellow wall, his blue-gray eyes looking red and irritated. At one point he smiles tentatively at the camera. In the other roll (ST340), which seems to have been filmed outside at night, his face appears illuminated, as if with a flashlight, against the black space behind him. He seems tired and sleepy, as if he had just woken up; his bloodshot eyes are glazed and bleary.

## ST341 *Tina*, 1965
16mm, b&w, silent; 4.5 min. @ 16 fps, 4 min. @ 18 fps
Preserved 1995, MoMA *Screen Tests* Reel 2, no. 9
**FILM MATERIALS**
ST341.1 *Tina*
1965 Kodak 16mm b&w reversal original, 107'
**NOTATIONS** On original box in AW's hand: *TINA*

A young woman identified only as "Tina" appears in a *Screen Test* from 1965. Posed against a light backdrop and lit harshly from the right, Tina squints at the camera, blinking under the weight of her false eyelashes. Her hair has been tied back in a big bow that sticks out on either side of her neck; her hoop earrings and ribbed turtleneck sweater are classic 1960s wear. Toward the end of the film, Tina looks up and bats her eyes; her left eyelash seems to be coming loose.

## ST342 *Tony Towle*, 1964
16mm, b&w, silent; 4.4 min. @ 16 fps, 3.9 min. @ 18 fps
Preserved 1995, MoMA *Screen Tests* Reel 3, no. 6
**COMPILATIONS** *The Thirteen Most Beautiful Boys* (ST364); *Screen Test Poems* (ST372)
**FILM MATERIALS**
ST342.1 *Tony Towle*
1963 Kodak 16mm b&w double-perf. reversal original, 105'
ST342.1.p1 *Screen Test Poems*, Reel 3 (ST372.3), roll 27
Undated Gevaert 16mm b&w reversal print, 105'
**NOTATIONS** On original box, in AW's hand: *(13) tony towle*
On box flap in red: *27*
On clear film at head of roll in black: *27*

Tony Towle is a long-standing member of the New York School of Poetry, a group that includes some poets filmed by Warhol (John Ashbery, Ted Berrigan, and Ron Padgett), as well as others who were not (Frank O'Hara, Kenneth Koch, James Schuyler, Peter Schjeldahl, and David Shapiro). Born in New York City in 1939, Towle came under the influence of Frank O'Hara and was also friends with Joe LeSueur, Ted Berrigan, and Ron Padgett; Towle later described this formative period in his career as a poet in his 2002 book, *Memoir 1960–1963*.

On July 18, 1963, Towle had his first indirect contact with Warhol through Gerard Malanga, who invited Towle and some classmates from the New York City Writers Conference at Wagner College on Staten Island to visit Warhol's studio in a converted firehouse, to which Malanga had the key. Towle, who had not heard of Warhol at this point, recalls that the artist was not there; their visit is commemorated in Towle's memoir by a dated snapshot of Malanga, Towle, and the other guests seated on a small couch in front of a box covered with coffee cups.[367] Towle was roommates with Joe Brainard during this period; the materials, including comic books and pulp magazines, that Brainard collected for his collages sometimes provided sources for Towle's appropriation poems.

Towle has been involved with the art world for many years. From 1964 through 1979, he was administrative assistant to Tatyana Grossman, founder of Universal Limited Arts Editions (ULAE), the celebrated Long Island workshop where many of the best-known American artists created prints. In 1997 Towle published a memoir of his time at ULAE in the catalogue of the Corcoran Gallery of Art's exhibition, *Proof Positive: Forty Years of Contemporary American Printmaking at ULAE: 1957–1997* (Abrams). He has also written reviews for the magazines *Art in America* and *Arts*. Towle received the Frank O'Hara Award in 1970 for his book *North*; other publications include *Some Music Episodes: Poetry and Prose* (Hanging Loose Press, 1992), and *The History of the Invitation: New and Selected Poems 1963–2000* (Hanging Loose Press, 2001).[368]

Towle's *Screen Test* was filmed in early 1964; in June 1964, Towle reciprocated with the gift of a typescript of a poem, with a note to Warhol reading: "I hope this is worth three minutes of film."[369] (Towle also appears with Naomi Levine in a roll for *Couch* that was shot around this same time.) Towle recalls that Warhol particularly admired his poem "Skylarks," perhaps because it contained the word "cameras":

> In autumn I look out the window.
> In December I go to the movies.
> The cameras return from the ends of the earth.[370]

In his *Screen Test* (ST342), the twenty-five-year-old poet appears young, sensitive, and fair-skinned. Posed against a black background and lit evenly from both sides, Towle faces the camera directly,

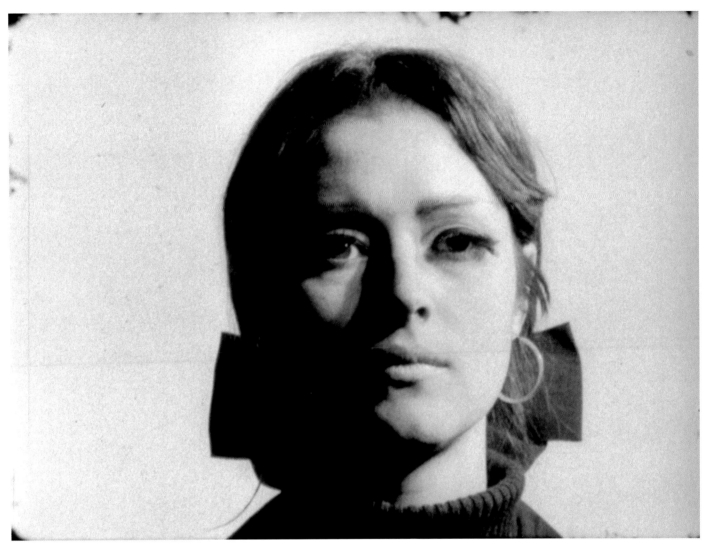

ST341

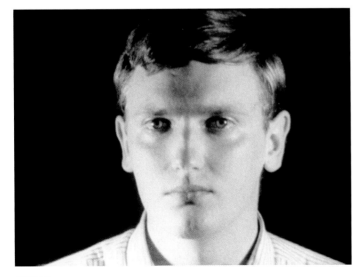

ST342

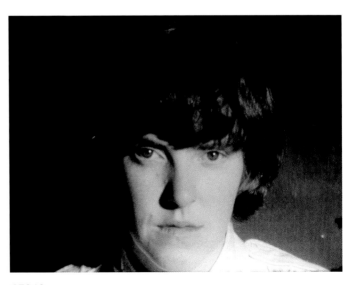

ST343

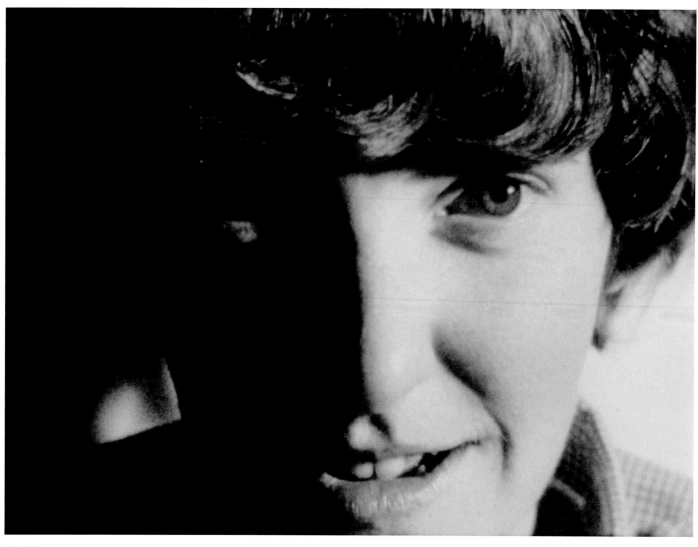

ST344

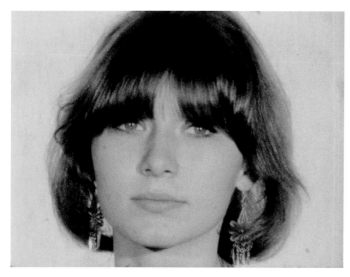

ST345

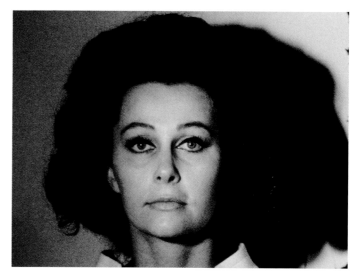

ST346

dressed in a striped shirt with a button-down collar. He holds very still and tries hard not to blink. A pattern of symmetrical shadows runs down the center of his face. In his efforts to keep from blinking, he raises his eyebrows plaintively, widens his eyes, and clenches his chin. Near the end of the film, a tear falls from his right eye, which makes him smile.

## ST343  *Maureen Tucker,* 1966
16mm, b&w, silent; 4.5 min. @ 16 fps, 4.1 min. @ 18 fps
COMPILATIONS  *EPI Background: Gerard Begins* (ST368)
FILM MATERIALS
Original not found in Collection
ST343.1.p1 *EPI Background: Gerard Begins* (ST368.1), roll 9
1965 Kodak 16mm b&w reversal print, 107'

## ST344  *Maureen Tucker,* 1966
16mm, b&w, silent; 4 min. @ 16 fps, 3.6. min. @ 18 fps
Preserved 1999, MoMA *Screen Tests* Reel 21, no. 3
FILM MATERIALS
ST344.1 *Maureen Tucker*
1965 Kodak 16mm b&w reversal original, 96'
NOTATIONS  On original box in AW's hand: *TRX Rev. Marruen*

Maureen ("Moe") Tucker joined the Velvet Underground in 1965, when she replaced Angus MacLise on drums, thus becoming one of the very first female rock-and-roll instrumentalists. From 1965 through 1971, she performed regularly with the Velvets, working with Lou Reed, John Cale, Sterling Morrison, and Nico. After leaving the rock group, Tucker married and had five children, living first in Phoenix, Arizona, and then in Douglas, Georgia, where she worked at a Wal-Mart distribution center for a number of years. She produced two homemade albums during this time, *Playin' Possum* (1981) and *MoeJadKateBarry* (1987).

In 1989 Tucker quit her job at Wal-Mart to go on a European tour with the group Half Japanese; she has supported herself and her family as a musician since then. She was sometimes joined by Sterling Morrison and other former Velvets on her later albums; she also played drums on Lou Reed's *New York* album (1989) and on John Cale's *Eat/Kiss: Music for the Films of Andy Warhol* (1997). Tucker participated in the Velvet Underground's reunion tour of Europe in the summer of 1993. Her recent albums include *I Spent a Week There the Other Night* (1991), *Dogs Under Stress* (1994), *Waiting for My Men* (1998), and *Moe Rocks Terrastock* (2002).[371]

In what looks like her first *Screen Test* (ST343), Tucker, wearing a white turtleneck, has been posed against a dark backdrop, and is brightly lit from the right front, the left side of her face partially shadowed. She faces the camera solemnly, staring back from under her bangs; at one point, she smiles briefly. The camera original of this *Screen Test* has not been located, although a print was found in one of the *EPI Background* (ST370) reels, where Tucker appears between *Screen Tests* of Gerard Malanga (ST201) and John Cale (ST42).

In another, apparently later film (ST344), Tucker appears relaxed and friendly, her smiling face filling the frame as if she were leaning into the camera. Filmed against a white background, and lit from the right, with the left side of her face in shadow, Tucker gazes affectionately at the camera, grinning frequently. Toward the end of the roll she grows thoughtful, looking offscreen to the left, then returns her gaze to the camera, which makes her smile again.

## ST345  *Virginia Tusi,* 1965
16mm, b&w, silent; 4.5 min. @ 16 fps, 4 min. @ 18 fps
Preserved 1995, MoMA *Screen Tests* Reel 1, no. 10
COMPILATIONS  *The Thirteen Most Beautiful Women* (ST365)
FILM MATERIALS
ST345.1 *Virginia Tusi*
1965 Kodak 16mm b&w reversal original, 109'
NOTATIONS  On original box in AW's hand: *Virginia 13*
Written inside box flap in Paul Morrissey's hand: *Virginia Tusi*

A young woman identified only as Virginia Tusi appears in a *Screen Test* shot for *The Thirteen Most Beautiful Women* (ST365) in 1965. Posed against a light plywood backdrop and wearing dangling, flower-shaped earrings, Tusi looks back at the camera from beneath her long, shiny bangs. She speaks to the camera, saying something that looks like "beautiful," then tilts her head back and closes her eyes. The film has been poorly exposed, with light flares and leaks throughout. At the end of the roll, Tusi's image seems to fade away for a long time before it finally disappears.

## ST346  *Ultra Violet,* 1965
16mm, b&w, silent; 4.5 min. @ 16 fps, 4 min. @ 18 fps
Preserved 2001, MoMA *Screen Tests* Reel 27, no. 7
FILM MATERIALS
ST346.1 *Ultra Violet*
1965 Kodak 16mm b&w reversal original, 108'
NOTATIONS  On original box in AW's hand: *Isablel defrenn*

## ST347  *Ultra Violet,* 1965
16mm, b&w, silent; 4.5 min. @ 16 fps, 4 min. @ 18 fps
Preserved 2001, MoMA *Screen Tests* Reel 27, no. 2
FILM MATERIALS
ST347.1 *Ultra Violet*
1965 Kodak 16mm b&w reversal original, 109'
NOTATIONS  On original box in AW's hand: *Ultra defresne*

## ST348  *Ultra Violet,* 1966
16mm, b&w, silent; 4 min. @ 16 fps, 3.5 min. @ 18 fps
FILM MATERIALS
ST348.1 *Ultra Violet*
1965 Kodak 16mm b&w reversal original, 96'
NOTATIONS  On original box in Gerard Malanga's hand: *TRI-X. Isabel Du Friend. 2/6/66*
On can lid in black: *3*

Ultra Violet, whose real name is Isabelle Collin Dufresne, was born in Grenoble, France, the daughter of a French industrialist. In 1953, at the age of seventeen, in rebellion against the restrictions of her convent education, she moved to New York, where she at first shared an apartment with her sister. By the end of the 1950s, Dufresne had, according to her own account, involved herself in a series of glamorous liaisons, including a romance with the artist John Graham and an affair with the wealthy owner of a chain of department stores. She met Salvador Dalí in 1960, and became his companion for the next five years, modeling for some of his paintings.[372]

In early 1965 Dalí introduced Dufresne to Andy Warhol during tea at the St. Regis Hotel. Warhol immediately invited her to be in his movies; she made her first appearance in a Warhol film in *The Life of Juanita Castro*, shot at the Factory in mid-March. Dufresne did not

appear in another Warhol sound film until the second half of 1966, by which time she had changed her name to Ultra Violet, a name she chose for herself from a scientific article she had been reading. Ultra was best known in the 1960s for her public identity as a Warhol superstar, appearing with Warhol at parties, openings, and TV shows. As Warhol recalled, "She was popular with the press because she had a freak name, purple hair, an incredibly long tongue, and a mini-rap about the intellectual meaning of underground movies."[373]

Following a *Screen Test* shot in February 1966, Ultra Violet returned to the Warhol Factory as a film actress that fall, appearing in more than fifteen reels included in or at least shot for ★★★★ (*Four Stars*), some of which were filmed at her apartment near the United Nations.[374] She also appeared in *Bufferin Commercial*, *I, a Man*, *Tub Girls*, and *Imitation of Christ* in 1967, and in 1969 had her last Warhol role in the unreleased Warhol/Morrissey film, *The Brass Bed*. Ultra Violet occasionally appeared on stage; in 1967, she performed, along with a number of other Warhol stars such as Ondine, Mary Woronov, and Taylor Mead, in Charles Ludlum's play *Conquest of the Universe*. She can also be seen in John Schlesinger's 1969 film *Midnight Cowboy*, as well as in Norman Mailer's *Maidstone* (1970), Milos Forman's *Taking Off* (1971), and several other underground films, such as John Chamberlain's *The Secret Life of Hernando Cortez* (1969), in which she starred with Mead. In 1973 she returned to Christianity, a theme that recurs in many of the paintings she has made since then. In 1988, Ultra Violet published her memoir, *Famous for Fifteen Minutes: My Years with Andy Warhol* (Harcourt Brace Jovanovich).

In two of her three *Screen Tests*, Ultra Violet has been posed against a white wall. In one of these two rolls (ST346), her face has been framed in tight close-up and harshly lit from the front, with a dark shadow cast behind her. The image is rather underexposed. Ultra tries not to blink throughout the film, repeatedly resetting her lips and looking increasingly uneasy; her eyelids flutter involuntarily. In the second film (ST347), her face is darker and more softly lit; her image is framed at a slightly wider angle, revealing the stand-up collar of her white mod coat. The strain of the previous sitting is legible in her face from the beginning of the roll; a tear glistens in her eye, and her face appears haggard. Again, Ultra makes a valiant effort not to blink, swallowing repeatedly and licking her upper lip nervously. Her eyes seem to be burning; at one point she briefly puts her hand to her forehead. By the end of the roll, she looks stricken and exhausted.

A third *Screen Test* (ST348), which, as noted on the box, was shot on February 6, 1966, was filmed in front of a painted and speckled wooden backdrop. Wearing several ropes of pearls around her neck, Ultra looks tense and uncomfortable as she stares back at the camera. At one point, she smiles nervously.

## ST349  *Andy Warhol,* n.d.
16mm, b&w, silent; est. 4.2 min. @ 16 fps, 3.7 min. @ 18 fps
**FILM MATERIALS**
Original not found in Collection

At least one *Screen Test* of Andy Warhol does seem to have existed, although its current location is uncertain. A Warhol *Screen Test* was first mentioned in print in May 1966, when it was screened during a performance of *Screen Test Poems* (ST372) at Cornell University, when various *Screen Tests*, credited as "films by Andy Warhol," were projected behind readings of poems by Gerard Malanga.[375]

Reva Wolf has written extensively on Warhol's collaborations with Malanga and also on their 1967 book, *Screen Tests/A Diary* (Appendix A), in which images from Warhol *Screen Tests* of fifty-four

different people were published opposite poems by Gerard Malanga. Wolf noted that although Warhol does not appear in the published version of *Screen Tests/A Diary*, Warhol's name was included in an early version of the manuscript, with his *Screen Test* listed in the table of contents as number forty-four. Although Wolf suggests that Warhol's omission from the final publication might have been the result of tensions and hostility between Warhol and Malanga during 1966 when the book was being prepared, she also reports that Malanga told her in an interview that Warhol's absence from the book was inadvertent.[376] The fact that a *Screen Test* of Andy Warhol was included in a public screening of *Screen Test Poems*, billed as a film by Andy Warhol, and was also included in an early version of *Screen Tests/A Diary* suggests that this portrait film (or films) was, at least originally, considered part of the body of Warhol *Screen Tests*. This film, in fact, may have originally been included in Reel One of *Screen Test Poems* (ST372.1), from which the eighth roll is now missing.

A three-frame film image of Warhol that certainly looks very much like a *Screen Test* appears in a Malanga publication from 2002, where it is identified in the caption as "From *Andy Warhol: Portraits of the Artist as a Young Man*, a film by Gerard Malanga, 1964–65."[377] The image shows Warhol posed against a black background, wearing dark glasses and looking slumped and rather uncomfortable. Since it would have been difficult—although not impossible—for Warhol to film himself, any *Screen Test* of Warhol would presumably have been shot by Malanga, or possibly by another assistant.

A film distribution brochure published by Malanga in 1990 suggests that there may have been as many as seven *Screen Tests* of Warhol filmed by Malanga between 1964 and 1965. The entry for Malanga's film *Andy Warhol: Portraits of the Artist as a Young Man*, lists the film as black-and-white, silent, and twenty-one minutes long, and gives the following description:

> this series of portaits mimicks [sic] the photographic still portrait filmed by Malanga of Warhol at the Factory over a period of several months. . . . When screened at the Hirshhorn Museum in Washington, D.C., the *Smithsonian Associate*, in its January 1988 issue, had commented that the film was "an intriguing series of seven archetypal Warhol screen tests using techniques often used on celebrities at the Factory.[378]

At an earlier screening of this film in 1979, it was titled simply *Portraits of the Artist as a Young Man* and dated to 1964, with a running time of twenty-four minutes. A description from the program notes reads: "A series of film-portraits of Andy Warhol shot at different times during a 6-month period."[379]

## ST350  *Chuck Wein,* 1965
16mm, b&w, silent; 4.5 min. @ 16 fps, 4 min. @ 18 fps
Preserved 2001, MoMA *Screen Tests* Reel 25, no. 2
**COMPILATIONS**  *Screen Tests/A Diary* (Appendix A)
**FILM MATERIALS**
ST350.1  *Chuck Wein*
1965 Kodak 16mm b&w reversal original, 109'
**NOTATIONS**  On original box in AW's hand: *Chuck. good*
On box in Gerard Malanga's hand, with double frame drawing: *Chuck Wein. 1 Double Frame 8" x 10" Print + Negative*
On typed label found in can: *CHUCK WEIN*

**Opposite, below: Andy Warhol's *Screen Test*, as it appears in Gerard Malanga's film *Andy Warhol: Portraits of the Artist as a Young Man*, 1964–65. From Gerard Malanga, *Archiving Warhol: An Illustrated History* (Creation Books, 2002), p. 92.**

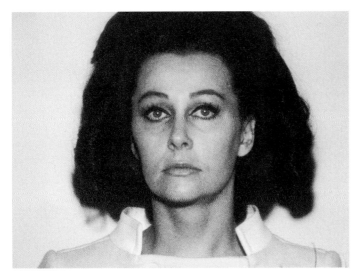

ST347

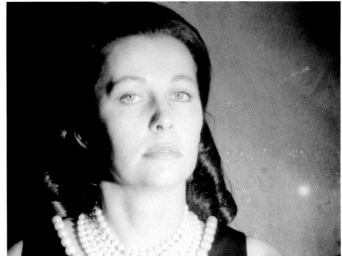

ST348

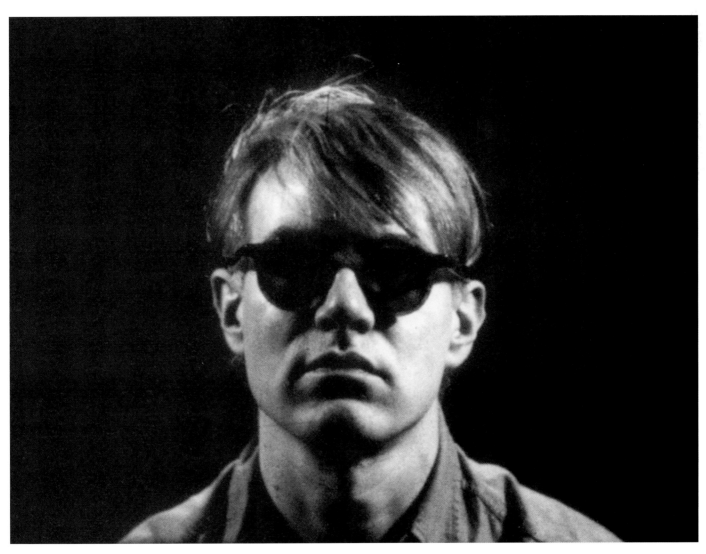

ST349

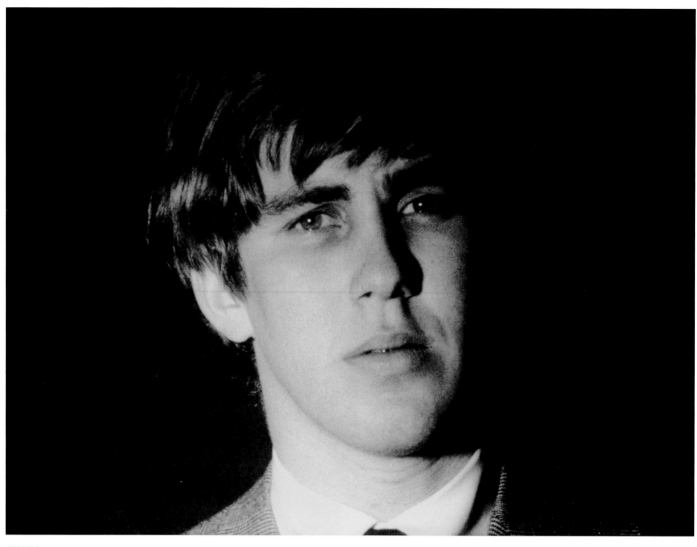

ST350

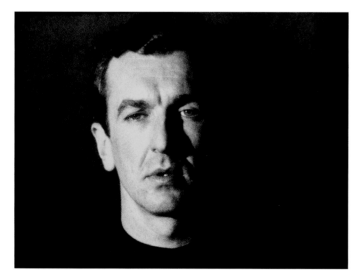

ST351

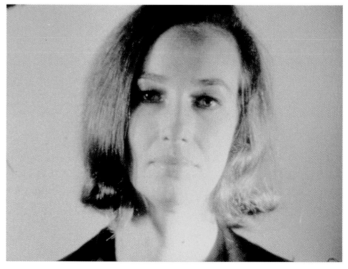

ST352

A friend of Edie Sedgwick's from Harvard University, Chuck Wein came to the Factory in the spring of 1965. Wein was instrumental in a number of the early Sedgwick films that year, such as *Poor Little Rich Girl*, *Face*, *Restaurant*, *Beauty #1*, and *Beauty #2*, offering Warhol film ideas and directorial assistance, accompanying Sedgwick to film shoots, and also acting as Sedgwick's offscreen friend and/or interrogator, engaging her in conversation and giving her something to react to while Warhol filmed her. As Wein recalled, his involvement with Warhol was "an accident. I was at a party with Edie and Andy asked me if I'd like to write a movie for him." Warhol also seemed rather vague about Wein's role; when asked, during the same interview, "Mr. Warhol, why did you pick Chuck as a script writer?" he replied, "When I met him at the party I couldn't think of anything else to say."[380]

Nevertheless, Wein was a major force behind many of the Sedgwick films and also behind the making of *My Hustler*, which he and Dorothy Dean conceptualized as "an anatomy of hustling, male and female" and produced together, obtaining funding and the loan of a Fire Island beach house for the filming.[381] In the fall of 1965, Wein and his friend Dan Williams worked on another ambitious film project for Warhol, a film feature called *Jane Heir* or *Jane Eyre Bare*, which would star Sedgwick and would be shot on Paradise Island in the Bahamas with funding from A&P heir Huntington Hartford, who owned the island. Both Wein and Ronald Tavel were separately asked by Warhol to write scripts for this unreleased film; Wein eventually ended his association with Warhol after a disagreement over this project.

In later years, Wein worked on the early version of *Ciao! Manhattan*, and in 1972 made a film, *Rainbow Bridge*, about Jimi Hendrix's last concert. Wein, who has written an unproduced script titled "Edie, Andy, and Chuck," describes himself as "a clairvoyant adviser to an international humanitarian group," and is known for his ability to "channel" Warhol, who, he reports, wouldn't mind if Wein finally gets proper credit as the director of *My Hustler*.[382]

In his *Screen Test* (ST350), Wein has been posed against a black plywood backdrop and lit with a single light off to the left. He tilts his head slightly and gazes purposefully into the camera, a strong shadow casting his nose into high relief. He squints from under his brows and adjusts the angle of his head, as if trying to protect his eyes from the light without breaking eye contact with the camera. At one point he turns to face the camera directly, then turns his head away again while maintaining his direct stare. Toward the end of the roll, his eyes begin to tear up.

## ST351  *John Wieners*, 1964

16mm, b&w, silent; 4.6 min. @ 16 fps, 4.1 min. @ 18 fps
COMPILATIONS  *Screen Tests/A Diary* (Appendix A)
FILM MATERIALS
ST351.1  *John Wieners*
1963 Kodak 16mm b&w reversal original, 110'
NOTATIONS  Stamped on original box: *LAB TV*
On tape on can lid: *JOHN Wiener*

The American poet John Wieners was born in Milton, Massachusetts, in 1934. After graduating from Boston College, he enrolled in Black Mountain College in North Carolina, where he worked with Charles Olson, Robert Duncan, and Robert Creeley. In 1957 Wieners moved to San Francisco, where he became a close friend of the artist Wallace Berman and also part of the San Francisco Poetry Renaissance, which included Beat poets such as Allen

Ginsberg and Michael McClure. His first book of poems, *The Hotel Wentley Poems*, published by Auerhahn Press in San Francisco in 1958, became a Beat classic.

Wieners returned to the East in 1960, dividing his time between Boston, New York City, and the State University of New York at Buffalo, where he was a graduate student and teaching fellow for several years, a position arranged for him by Olson. Wieners also worked as an actor at the Poet's Theatre in Cambridge, Massachusetts, and had three of his own plays performed by the Judson Poets Theater in New York; a typescript of one of these plays, *Of Asphodel, in Hell's Despite*, was found among Warhol's papers.[383] In 1962 Wieners made an uncredited appearance in Jack Smith's film *Flaming Creatures*.

Wieners struggled with mental illness, publishing in 1969 a book titled *The Asylum Poems (For My Father)*. He settled in Beacon Hill in Boston and remained active in poetry readings, publishing cooperatives, and the gay liberation movement. With the assistance of Allen Ginsberg and Robert Creeley, Wieners's poetry was published by Black Sparrow Press in two anthologies edited by Raymond Foye, *Selected Poems, 1958–1984* (1988) and *Cultural Affairs in Boston: Poetry and Prose 1956–1985* (1990). A tribute to Wieners, *The Blind See Only This World: Poems for John Wieners*, with contributions from Ginsberg, Creeley, Duncan, John Ashbery, Paul Auster, Amiri Baraka, Thom Gunn, and Charles Simic, was published by Granary Books in 2000. John Wieners died in Boston in March 2002, at the age of sixty-eight.[384]

Wieners' *Screen Test*, which was probably shot early in 1964, begins as a very dark, underexposed image. Illuminated only from the left, his face emerges from the darkness like a dim half-moon, one partially eclipsed eye glistening from the shadows. When he opens his mouth, a tooth gleams faintly. Halfway through the film, the exposure improves, revealing more of his face. At the end of the roll, he squints at the camera as if blinded by the light.

## ST352  *Jane Wilson*, 1964

16mm, b&w, silent; 4.3 min. @ 16 fps, 3.9 min. @ 18 fps
Preserved 1995, MoMA *Screen Tests* Reel 12, no. 2
COMPILATIONS  *The Thirteen Most Beautiful Women* (ST365)
FILM MATERIALS
ST352.1  *Jane Wilson*
1964 Kodak 16mm b&w reversal original, 104'
NOTATIONS  On original box in AW's hand: *Jane Wilson*

Born in Iowa in 1924, the artist Jane Wilson moved to New York City with her husband, the composer, writer, and photographer John Gruen, in 1949. In the 1950s Wilson sometimes worked as a fashion model to support her active career as a painter. She was a founding member of the Hansa Gallery (1952–59), the New York artists' cooperative directed by Richard Bellamy (later, the founder of the Green Gallery) and Ivan Karp; other members included Allan Kaprow, George Segal, John Chamberlain, Robert Whitman, Lucas Samaras, and Marisol. Wilson taught art at Pratt Art Institute and Parsons School of Design, and at Columbia University, where she was chair of the art department. Although originally identified with second-generation abstract expressionism, Wilson now works primarily as a landscape painter, assembling layers of paint into luminous evocations of light and weather. She currently lives and works in New York City.

Wilson met Warhol in the late 1950s and sometimes visited him at his first town house on lower Lexington Avenue. In 1960 Wilson

Jane Wilson, *Portrait of Andy Warhol*, 1960. Graphite on paper. Whitney Museum of American Art, New York; gift of the artist.

painted Warhol's portrait, drawing several studies of Warhol in the process. Warhol later donated Wilson's painting to the Whitney Museum; the drawings for this painting were donated to the museum by Wilson.

Wilson recalls that when she sat for her 1964 *Screen Test*, she was told to hold still and left to face the camera alone; although her emotions are not legible in the film, she remembers feeling very isolated and almost panicky, as if in solitary confinement. Posed against a white background, Wilson has been unequally lit from two sides, with the brightest light falling on the right side of her face. The uneven lighting creates a kind of optical illusion in which her head seems divided into two halves: on the darker, left side, she seems to have dark brown hair and a dark eye; on the brighter, right side, her hair appears blond, and her eye is pale and filled with light. Wilson remains poised and very still for the full length of the roll, maintaining an enigmatic half-smile, her eyelids occasionally fluttering.

In January 1965, the *New York Herald Tribune* reported that Jane Wilson was among the fourteen women included in a screening of *The Thirteen Most Beautiful Women* at a party given by Sally Kirkland, the fashion editor of *Life* magazine.[385]

**ST353   *Paul Wittenborn*, 1965**
16mm, b&w, silent; 4.5 min. @ 16 fps, 4 min. @ 18 fps
Preserved 1995, MoMA *Screen Tests* Reel 4, no. 3
FILM MATERIALS
ST353.1  *Paul Wittenborn*
1965 Kodak 16mm b&w reversal original, 108'
NOTATIONS  On original box in AW's hand: *Paul*

**ST354   *Paul Wittenborn*, 1965**
16mm, b&w, silent; 4.5 min. @ 16 fps, 4 min. @ 18 fps
Preserved 1995, MoMA *Screen Tests* Reel 7, no. 1
FILM MATERIALS
ST354.1  *Paul Wittenborn*
1965 Kodak 16mm b&w reversal original, 107'
NOTATIONS  On original box in AW's hand: *Paul*

A young man named Paul Wittenborn appears in two *Screen Tests* from 1965. Wittenborn moved to New York from San Francisco in the mid-1960s, when he was twenty-two years old, and studied ballet at the Metropolitan Opera Ballet school with Celene Keller, with whom he maintained a lifelong friendship. Wittenborn occasionally performed as a dancer and also occasionally acted in small film roles. Beginning in the 1970s, he worked as a salesman for Julie Schafler Dale's Artisans' Gallery on Madison Avenue, "the first gallery devoted to clothing as an art form." Wittenborn died of AIDS in March 1992.[386]

In one of his *Screen Tests* (ST353), Wittenborn faces the camera directly; a strong light from the left casts the shadow of his nose across his face. He at first tries not to blink, then begins to tear up, and closes his eyes briefly. In the second film (ST354) he looks down and away from the camera, his head turned slightly to the right, and doesn't move at all, blinking only occasionally. His neck and ear are bright and overexposed; his right eye seems to be illuminated from within.

**ST355   *Gerard Malanga and Mary Woronov*, 1966**
16mm, b&w, silent; 3.7 min. @ 16 fps, 3.3 min. @ 18 fps
COMPILATIONS  *Screen Test Poems* (ST372)
FILM MATERIALS
Original not found in Collection
ST355.1.p1  *Screen Test Poems*, Reel 3 (ST372.3), roll 31
Undated Gevaert 16mm b&w reversal print, 88'

**ST356   *Gerard Malanga and Mary Woronov*, 1966**
16mm, b&w, silent; 3.8 min. @ 16 fps, 3.4 min. @ 18 fps
COMPILATIONS  *Screen Test Poems* (ST372); *EPI Background: Gerard Begins* (ST368)
FILM MATERIALS
Original not found in Collection
ST356.1.p1  *Screen Test Poems*, Reel 1 (ST372.1), roll 1
Undated Gevaert 16mm b&w reversal print, 91'
ST356.1.p2  *EPI Background: Gerard Begins* (ST368), roll 1
Undated Gevaert 16mm b&w reversal print, 88'

**ST357   *Mary Woronov*, 1966**
16mm, b&w, silent; 4.3 min. @ 16 fps, 3.9 min. @ 18 fps
Preserved 1995, MoMA *Screen Tests* Reel 8, no. 6
COMPILATIONS  *Screen Tests/A Diary* (Appendix A)
FILM MATERIALS
ST357.1  *Mary Woronov*
1965 Kodak 16mm b&w reversal original, 102'
NOTATIONS  On original box in Gerard Malanga's hand: *TRI-X. 3rd Screen Test 2/6/66 MARY WORONOV. Exposed. 1 Double Frame Negative, 2 8 x 10 Double Frame Glossy Prints*
On typed label found in can: *MARY WORONOV*

**ST358   *Mary Woronov*, 1966**
16mm, b&w, silent; 4.2 min. @ 16 fps, 3.7 min. @ 18 fps
Preserved 2001, MoMA *Screen Tests* Reel 28, no. 1
FILM MATERIALS
ST358.1  *Mary Woronov*
1965 Kodak 16mm b&w reversal original, 102'
NOTATIONS  On blue label on box in Gerard Malanga's hand: *TRI-X MARY WORONOV (without hat). Screen Test*

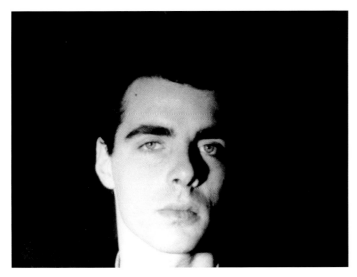

ST353

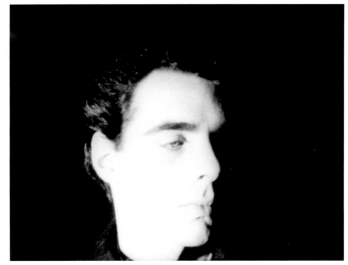

ST354

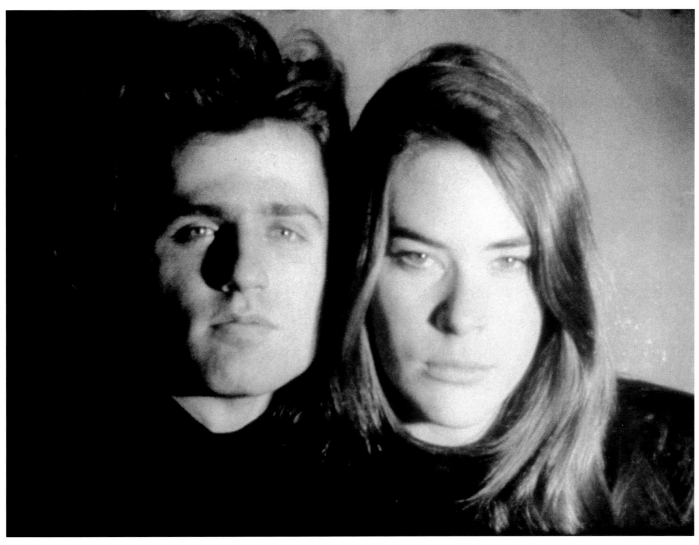

ST355

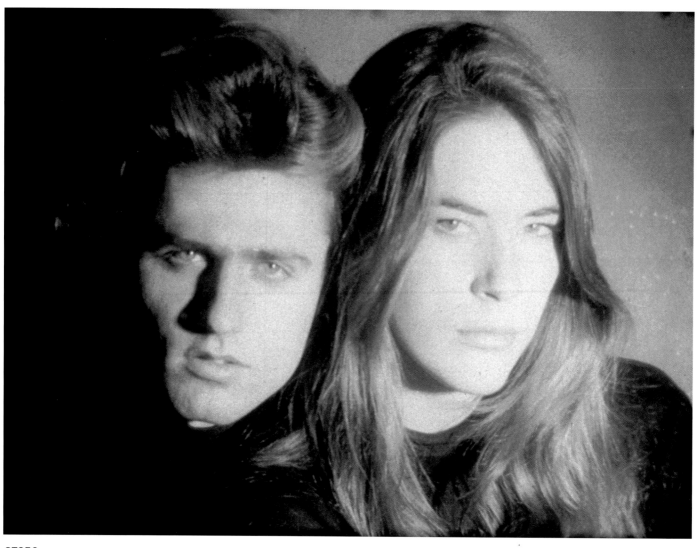

ST356

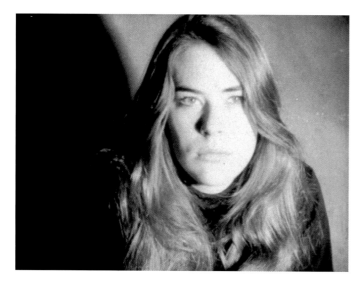

ST357

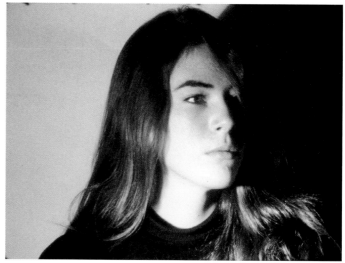

ST358

## ST359  *Mary Woronov,* 1966

16mm, b&w, silent; 4.6 min. @ 16 fps, 4.1 min. @ 18 fps
COMPILATIONS  *Screen Test Poems* (ST372)
FILM MATERIALS
Original not found in Collection
ST359.1.p1 *Screen Test Poems,* Reel 3 (ST372.3), roll 30
Undated Gevaert 16mm b&w reversal print, 111' including 10'
of black leader spliced into center of film

## ST360  *George Millaway and Mary Woronov,* 1966

16mm, b&w, silent; 4.6 min. @ 16 fps, 4.1 min. @ 18 fps
COMPILATIONS  *Chelsea Girls Background: 3 Min. Mary Might* (1966)
(see Vol. 2)
FILM MATERIALS
ST360.1  *George Millaway and Mary Woronov* (roll 7 of *3 Min. Mary Might*)
1966 Kodak 16mm b&w reversal original, 110'

## ST361  *George Millaway and Mary Woronov,* 1966

16mm, b&w, silent; 4.5 min. @ 16 fps, 4 min. @ 18 fps
COMPILATIONS  *Chelsea Girls Background: 3 Min. Mary Might,* 1966
(outtake roll; see Vol. 2)
FILM MATERIALS
ST361.1  *George Millaway and Mary Woronov*
1966 Kodak b&w reversal original, 107.5'
NOTATIONS  On box in AW's hand, with hand-drawn star: *Mary George turning*
On flap in unidentified hand: *Mary Might*

The author, painter, actress, and cult movie star Mary Woronov first came in contact with the Warhol circle when she was an art student at Cornell University. At college, she became friends with the poet David Murray and his friend Gerard Malanga, who made a short film with her in Ithaca, New York. When her class was sent on a studio visit to Warhol's Factory, Malanga immediately invited her to be in a Warhol film: "'Andy's doing something called *Screen Tests,*' he whispered in my ear, 'You just look into the camera for fifteen minutes. Murray's already done one, he was great. Maybe I'll get Andy to do one of us together, we could set it up right now.'"[387]

Woronov traveled back and forth between Cornell and the Factory for several months, finally leaving school that spring to accompany Warhol and the Exploding Plastic Inevitable (EPI) entourage on a trip to California in May 1966. Her first speaking role in a Warhol film was in early 1966 in *Hedy,* in which she played the policewoman who arrests Mario Montez for shoplifting. Because of her imposing beauty and hard-edged, scornful presence, Woronov was almost always cast in dominatrix roles in the Warhol films; an attempt was even made to change her name to Mary Might, a soubriquet that never really took.[388] In films such as *Whips* and *Kiss the Boot,* Woronov and Malanga performed S and M routines, complete with whips and a leather mask, which they also acted out onstage during EPI performances while the Velvet Underground played their song "Venus in Furs."

In 1966 Woronov also starred opposite Malanga in *The Beard,* a Warhol version of Michael McClure's play, and had two important roles in *The Chelsea Girls,* playing Malanga's silent girlfriend in *The Marie Menken Story,* and waxing sadistic as the radio personality Hanoi Hannah in two reels by that name scripted by Ronald Tavel. Woronov also appeared in several unreleased films, including *Superboy, The Velvet Underground Tarot Cards,* and *Bufferin Commercial.* In late 1966, she played the assassinated John F. Kennedy in *Since,* and

also appeared in one reel, *Ivy in Philadelphia,* included as Reel 13 in the final version of ★★★★ *(Four Stars)* (1967). Woronov also acted in several other unreleased reels and sequences shot in late 1966.[389]

By the end of 1966, Woronov had disassociated herself from the Warhol Factory for several reasons: because, as she later explained, "I was very aware that you could wear out your welcome there"; because Paul Morrissey was starting to make very different kinds of films; and also because Warhol had annoyed her by asking her to agree not to be paid.[390] She moved on to avant-garde and off-Broadway theater, reprising her dominatrix role of Hanoi Hannah in Tavel's production of his play *Vinyl* at the Caffe Cino (1967), performing in productions directed by Charles Ludlum (*Conquest of the Universe* [1967]) and John Vacarro (*Night Club* [1970]), and starring in several other Tavel plays, including *Arenas of Lutetia* (1968) and *Kitchenette* (1971). After marrying the filmmaker Theodore Gershuny, she appeared in several of his films (*Silent Night, Bloody Night* and *Sugar Cookies* from 1973), and also in Oliver Stone's first film, *Seizure,* shot in Canada in 1973. That year she obtained a starring role opposite Madeline Kahn in Joseph Papp's production of David Rabe's play *In The Boom Boom Room,* which led to a short-lived role in the TV soap opera *Somerset.*

In 1975 Woronov divorced Gershuny and moved to Los Angeles, where she began appearing in B movies produced by Roger Corman and New World Pictures: *Death Race 2000* (1975); *Cannonball, Hollywood Boulevard, Jackson County Jail* (1976); and *Rock 'n' Roll High School* (1979), in which she gave a memorable performance as Principal Togar. Woronov starred opposite Paul Bartel in Bartel's horror spoof *Eating Raoul* (1982), and also appeared in Bartel's later film *Scenes from the Class Struggle in Beverly Hills* (1989). While continuing to act in B-level cult films, such as *Night of the Comet* (1984), *Hellhole* (1985), and *Mortuary Academy* (1988), Woronov has had cameo roles in several mainstream features, such as *Black Widow* (1987) and *Dick Tracy* (1990). In 1985 she appeared in a performance with the artist Mike Kelley at the Museum of Contemporary Art in Los Angeles; and in 1990 she starred with Ron Vawter and Patricia Arquette in the art film *Made in Hollywood,* by Bruce and Norman Yonemoto. Woronov is also a painter and a writer; her paintings and short stories were published in 1994 in *Wake for the Angels.* She is the author of two novels, *Snake* and *Niagara,* and has published a memoir about her time with Warhol, *Swimming Underground: My Years in the Warhol Factory.*[391]

If Woronov's recollections are correct, it seems likely that her first *Screen Tests* are those in which she posed with Gerard Malanga, apparently shot on February 6, 1966. In these two double portraits (ST355 and ST356), which have been found in the collection in print form only in a compilation for *Screen Test Poems* (ST372), Malanga and Woronov pose against a painted wooden backdrop with their heads close together, occasionally nuzzling each other; both prints are scratched and dirty.[392] Another solo portrait of Woronov (ST357), labeled "3rd Screen Test 2/6/66," shows Woronov posed alone against the same dark backdrop, with the same harsh, three-quarter lighting. With her long gleaming hair framing her face, Woronov faces the camera warily, her shoulders slightly hunched. She stares intently past the camera, her eyes following people moving off-screen. As the film progresses, she seems to relax, and her shoulders get lower and lower. Near the end of the film, she shakes her hair and suppresses a smile.

In another, less successful *Screen Test* (ST358), Woronov has been posed in three-quarter profile against a white wall, facing off-screen to the right. The film is quite dark and underexposed, and Woronov holds very still throughout, never once looking at the camera. With her chin up, she seems both nervous and stubborn; at one point, she smiles briefly, narrowing her eyes. In another film (ST359), found in print form only in a *Screen Test Poems* compilation reel (ST372.3), Woronov, wearing a white sweater and black bowler hat, stares directly into the camera, her eyes watering.

Two later portrait films (ST360 and ST361) of Woronov posing with the actor George Millaway seem to have been shot around the time of *The Chelsea Girls*, probably for inclusion in a "background reel" intended for projection behind the actors during the filming of the *Their Town* segment of that film. In the first of these rolls, which was found in a compilation reel labeled *3 Min. Mary Might*, Millaway, wearing sunglasses, sits beside Woronov, who smiles, laughs, shakes her hair glamorously, and generally acts thrilled to be there. In another roll (ST361), which includes a lot of in-camera editing and single-frame images, Woronov gives a much more hostile performance, glaring at the camera and offscreen in different directions. Sweat runs down Millaway's face in rivulets. The two of them change positions and face past each other, looking in various directions.

## ST362  *Marian Zazeela*, 1964
16mm, b&w, silent; 4.5 min. @ 16 fps, 4 min. @ 18 fps
Preserved 1995, MoMA *Screen Tests* Reel 8, no. 1
**COMPILATIONS**  *The Thirteen Most Beautiful Women* (ST365)
**FILM MATERIALS**
ST362.1  *Marian Zazeela*
1964 Kodak 16mm b&w reversal original, 109'
**NOTATIONS**  On original box in AW's hand: *Marion #13*

The artist and musician Marian Zazeela modeled for a number of Jack Smith's early photographs published in *The Beautiful Book* (1962), whose cover she also created; she also appeared in Smith's 1962 film *Flaming Creatures*. Since 1962 Zazeela has lived, worked, and collaborated with her partner, the composer La Monte Young, one of the most influential avant-garde musicians of the 1960s. Zazeela created the lighting and graphic materials for his concerts and frequently performed as a vocalist with Young and his ensembles. Zazeela was one of the first artists to work primarily with light, designing slide performances, sculptures, neon pieces, and installations that were often combined with Young's music to create total sensory environments.

In the early 1960s she and Young founded the Theatre of Eternal Music to present performances of his compositions; in conjunction with these events, Zazeela created the *Dream House*, an ongoing architectural project designed to present Young's compositions within a continuous sound and light environment. The most ambitious realization of the *Dream House*, commissioned by the Dia Art Foundation in the years 1979–85, was installed in the six-story New York Mercantile Exchange building on Harrison Street in New York City, in which Zazeela and Young created multiple sound and light installations, presented performances and exhibitions, and established archives and research facilities. Zazeela and Young have since continued their project with *Dream House: Seven + Eight Years of Sound and Light*, at the Mela Foundation on Church Street, which also presents performances of the Theatre of Eternal Music. For many years, Zazeela and Young were disciples of the Indian vocalist Pandit Pran Nath; Zazeela continues to teach raga and voice at the Kirana Center for Indian Classical Music in New York.[393]

Zazeela's *Screen Test*, which was included in *The Thirteen Most Beautiful Women*, may have been filmed in the fall of 1964, around the time that Warhol and La Monte Young collaborated on an installation that combined rear-screen loop projections of four Warhol films with a continuous electronic sound track created by Young.[394] Zazeela appears formally dressed for her film portrait, with her hair piled on top of her head, long teardrop-shaped earrings, and black-rimmed eyes. Posed in three-quarter profile against a black background and lit from the front, Zazeela looks right into the camera, her eyes streaming with tears. She tries unsuccessfully not to blink; tears continue to run down her face and drip off her chin. At the end of the film, she holds her eyes closed for a moment, then glances at the camera again in the flare-out at the end of the roll.

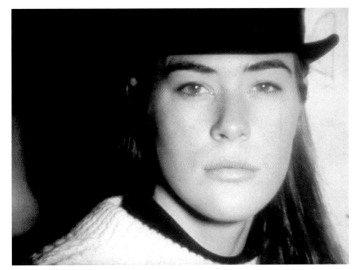

ST359

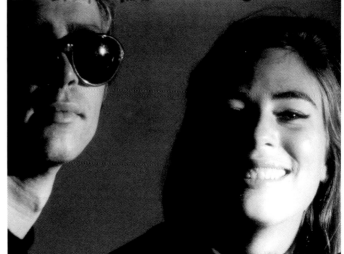

ST360

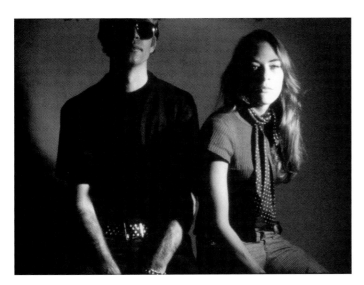

ST361

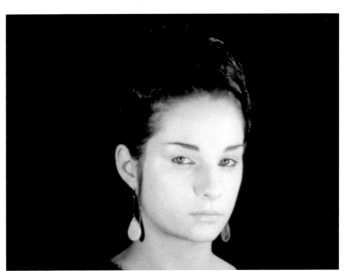

ST362

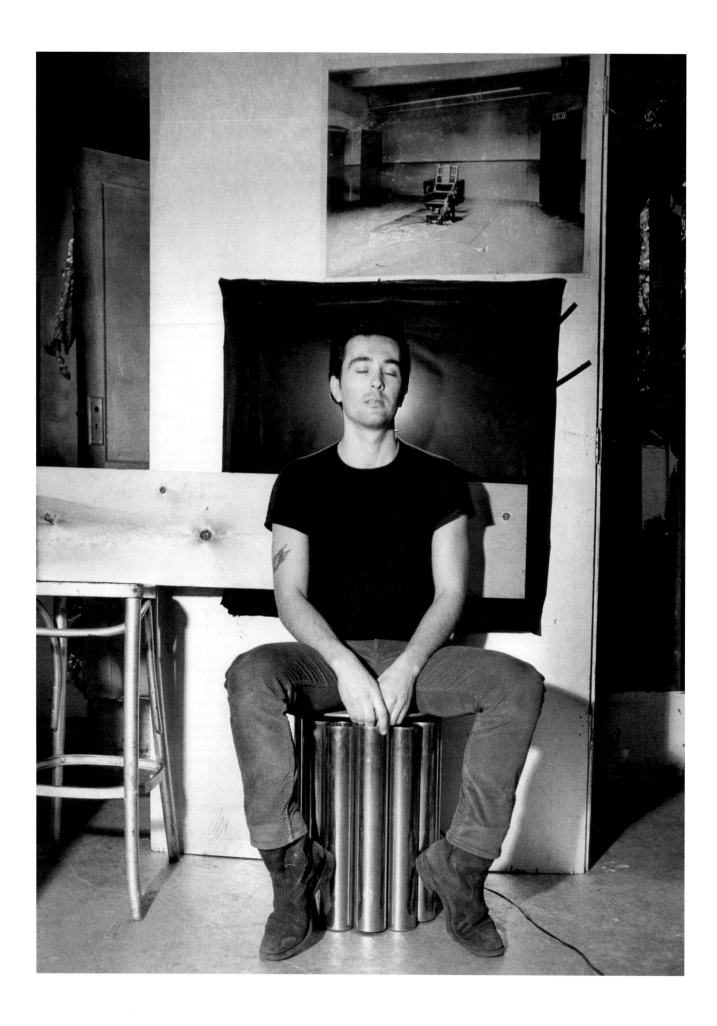

# Chapter Three
# *Six Months*

In the fall of 1964, Warhol began one of his most ambitious ventures into serial portraiture: a cumulative film work for which he would shoot at least one *Screen Test* of Philip Fagan, his boyfriend at the time, every day for a period of six months. The finished film, which would have lasted nearly fourteen hours, would, it was claimed, show Fagan visibly aging on-screen.[1] As it happened, their relationship ended after only three months, so the film was not completed as planned. However, 107 *Screen Tests* of Fagan, shot over a period of ninety-six days, from November 6, 1964, through February 9, 1965, have been catalogued in the Collection. Notations on these boxes, which were numbered and/or dated in sequence by Warhol as he shot them, have allowed reconstruction on paper of the unfinished film series in the exact order in which it was shot.

Warhol met Philip Fagan at a concert in October 1964, and soon developed a romantic relationship with him; for a time, they even lived together in Warhol's town house on Lexington Avenue.[2] Fagan, who had traveled extensively in the Merchant Marines and sported a tattoo of a winged skull, became a Factory regular during this period, helping with the silk-screening of paintings, appearing in photobooth pictures with Warhol and Malanga, and assisting with various film-making projects.[3] Ronald Tavel credits Fagan as the person who first suggested that he begin writing scenarios for the Warhol films; and Fagan starred in the first Warhol film scripted by Tavel, *Screen Test No. 1* (1965), an extended offscreen interrogation of Fagan based on Tavel's prior interviews with him. In addition to *Six Months*, he appeared in other Warhol films from this period, including four additional *Screen Tests* (ST93–96), some rolls shot for *Batman Dracula* (1964) in which he demonstrates his training as a mime, and Warhol's first sync-sound feature, *Harlot* (1964). Fagan also played the role of Cupid in Gregory Markopoulos's film *The Iliac Passion* (1967), and appeared in Jonas Mekas's short film *Award Presentation to Andy Warhol* (1964) in which Warhol can be seen feeding him a carrot. A Super 8mm color film, apparently made by Philip Fagan, has been found in the Collection; it contains brief *Screen Test*-like images of various Factory personalities such as Jane Holzer and Henry Geldzahler.[4]

*Six Months* is possibly the best example of Warhol's proclivity for fusing personal desire and artistic ambition into a single film project. Much like *Sleep* (1963), *Six Months* is an extended portrait of the object of Warhol's affections, in which the filmmaking process itself predetermines and insures the continuation of their relationship, in this case seemingly guaranteed to last at least six months. If Warhol used the narcissistic mirror of his movie camera as a means to maintain Fagan's proximity, by the same token their ongoing relationship insured the availability of a star whose daily cooperation was crucial to the success of Warhol's ambitious and very lengthy film project.

The setup for each short portrait film is basically the same: Fagan is placed on a stool in front of a black backdrop, and framed in close-up

**Philip Fagan posing for *Six Months* at the Factory; a light bulb has been mounted on the board behind his head for backlighting. Photograph by Ugo Mulas.**

from the neck up. Fagan's performance over the three months of filming and throughout 107 rolls of film remains essentially the same: he holds very still and fixes the camera with an intense and unwavering stare, as if posing for a photograph. The most important developments from roll to roll are effected primarily through changes in the lighting, which often varies dramatically from film to film, causing surprising alterations in Fagan's appearance.

In a sense, the *Six Months* project might be seen as a kind of minimalist *film noir* epic, a series of systematic experiments in black-and-white on the effects of different lighting on one human face. (This experimentation would, of course, have been very important, if not formative, to Warhol's future career as a portraitist working from his own photographs.) The notes and sketches about light placement, wattage, and exposures found written on many of the *Six Months* film boxes—which are not found on most other *Screen Test* boxes—underscore the experimental, technical aspect of the project. And it is indeed remarkable how different Fagan can appear from roll to roll. Lit from below, lit from above, lit from left or right, backlit by a light bulb placed behind his head, deeply shadowed or bathed in light, occasionally posed in profile, and with his hair combed into different styles, he seems to appear in a whole series of different character roles: young, then older, callow, dissolute, thuggish, cheerful, sullen, withdrawn, feral, seductive, poorly groomed, intensely handsome. This astonishing range of character seems, strangely enough, to have little to do with Fagan's performances, which remain stoically uniform and rather leaden throughout, but is instead clearly attributable to changes in lighting, exposure, and pose.

The monotonous sameness of Fagan's performance in the individual films is very occasionally interrupted by unplanned events. In *Philip #39* (ST363.045), for example, Fagan begins the film with an irrepressible smile, laughs openly, tries to compose himself, and then smiles again; Warhol wrote "LAUGHS" on the box, and then immediately shot another roll to replace it. In *Philip #71* (ST363.083), Fagan again suddenly smiles, then jumps up and leaves the frame, revealing the light bulb that had been placed behind his head for backlighting. The top of a child's head then passes quickly in front of the camera, revealing the cause of his laughter, and an entire second roll was shot as replacement. On another day, November 13, 1964, Warhol shot two rolls of Fagan, one showing only the back of his head (*Philip Back* (ST363.010)), and another roll (ST363.009) shot from the front that Warhol labeled *Philip #9* and marked with a star to indicate his choice for the continuing series. In other rolls, the image sometimes drifts slightly in and out of focus, a problem possibly caused by fluctuations in the tension of the camera's take-up reel.

It is tempting to try to read these films as a record of Warhol's relationship with Philip Fagan; indeed, some of Warhol's notes on the film boxes ("Thanksgiving Day" (ST363.026), "Christmas" (ST363.059), "Love" (ST363.061)) suggest that the film series functioned as a kind of daily journal of their life together. But the formal rigidity and lack of action in these portrait films ultimately discourage such intimate interpretations. Other handwritten notes by Warhol, in

Original Kodak boxes from *Six Months* (ST363.015 and ST363.016), with Warhol's numbering and notes on lighting. From the Collections of The Museum of Modern Art Department of Film and Media. Photographs by Callie Angell.

which he calculated the running time of the footage he had shot so far, multiplying the numbers of rolls by three or five minutes (ST363.022; ST363.045), suggest that he was just as interested in the length of the footage he was accumulating as in the continuation of their relationship. Toward the end of the series one senses that Fagan too was feeling somewhat oppressed by the daily chore of posing.

The very last roll of *Six Months* was shot on February 9, 1965, the same day that Warhol filmed *Screen Test No. 2*, with Mario Montez. *Screen Test No. 2* was a planned remake of *Screen Test No. 1*, a feature sound film in which Fagan had endured a sixty-six-minute offscreen interrogation by Ronald Tavel. Both Warhol and Tavel had decided that *Screen Test No. 1* was unsuccessful and uninteresting, primarily due to Fagan's wooden performance, and that the same idea should be tried again with a different actor. One imagines Fagan taking umbrage at this rejection of his previous film, and choosing this occasion to refuse further cooperation in the *Six Months* project; it is also likely that his personal relationship with Warhol ended around this time. The film remained uncompleted, and has never been shown in public, or listed in previous Warhol filmographies. The sole source for the title *Six Months* is Ronald Tavel's essay "The Banana Diary."5

Most of the rolls for *Six Months* were found stored together in one carton. Although every film in this series has been dated and/or numbered on the box, there is some confusion in the sequence of numbers, since Warhol sometimes shot more than one film at a time, occasionally repeated numbers, or skipped a day of filming, and eventually, by the end of January 1965, lost track of his numbering system altogether. This catalogue follows Warhol's original numbering system in the titling of individual rolls, even when it means duplication; starting at the point where Warhol stopped numbering the boxes (*Philip #77* (ST363.091)), the numerical order of the titles has been continued in accordance with the dates written on the boxes. All notations from the boxes have been transcribed; dates not found on the original boxes have been extrapolated by superimposing the sequence of numbers onto a calendar. Since Warhol's notes clearly indicate that he intended to use only one film for each day, the running time of the incomplete film is calculated for ninety-six days, or ninety-six rolls averaging 109' each, a total length of 10,464'.

**ST363** *Six Months,* 1964–65
16mm, b&w, silent; 7 hrs., 16 min. @ 16 fps, 6 hrs., 28 min. @ 18 fps
With Philip Fagan

**FILM MATERIALS**

ST363.001 *Philip #1*
Shot November 6, 1964
1964 Kodak 16mm b&w reversal original, 108'
**NOTATIONS** On original box in AW's hand: *Phillip #1*

ST363.002 *Philip #2*
Shot November 7, 1964
1964 Kodak 16mm b&w reversal original, 110'
**NOTATIONS** On original box in AW's hand: *screen test #2. phillip*

ST363.003 *Philip #3*
Shot November 8, 1964
1964 Kodak 16mm b&w reversal original, 110'
**NOTATIONS** On original box in AW's hand: *philip #3. Nov 8*

ST363.004 *Philip #2 of 3*
Shot November 8, 1964
1964 Kodak 16mm b&w reversal original, 110'
**NOTATIONS** On original box in AW's hand: *Philip #3. 2 of 3*

ST363.005 *Philip #5*
Shot November 9, 1964
1964 Kodak 16mm b&w reversal original, 110'
**NOTATIONS** On original box in AW's hand: *phillip #5. Nov.*

ST363.006 *Philip #6*
Shot November 10, 1964
1964 Kodak 16mm b&w reversal original, 109'
**NOTATIONS** On original box in AW's hand: *phillip #6*

ST363.007 *Philip #7*
Shot November 11, 1964
1964 Kodak 16mm b&w reversal original, 110'
**NOTATIONS** On original box in AW's hand: *phillip #7*

ST363.008 *Philip #8*
Shot November 12, 1964
1964 Kodak 16mm b&w reversal original, 110'
**NOTATIONS** On original box in AW's hand: *Phillip #8*

ST363.009 *Philip #9*
Shot November 13, 1964
1964 Kodak 16mm b&w reversal original, 110'
**NOTATIONS** On original box in AW's hand: ★ *Phillip. Nov. 13. 9*

ST363.010 *Philip Back*
Shot November 13, 1964
1964 Kodak 16mm b&w reversal original, 108'
**NOTATIONS** On original box in AW's hand: *philip. back. Nov 13/64*

ST363.011 *Philip #10*
Shot November 14, 1964
1964 Kodak 16mm b&w reversal original, 110'
**NOTATIONS** On original box in AW's hand: *Phillip*
Added later in black marker, in AW's hand: *#10*

ST363.012 *Philip #11*
Shot November 15, 1964
1964 Kodak 16mm b&w reversal original, 109'
**NOTATIONS** On box in AW's hand: *Phillip #11*
On box in unidentified hand, crossed out: <u>*Naomi. Rufus*</u>
Stamped on box: *LAB. TV*

ST363.013 *Philip #12*
Shot November 16, 1964
1964 Kodak 16mm b&w original reversal, 110'
**NOTATIONS** On original box in AW's hand: *Phillip*
Added later in black marker, in AW's hand: *#12*

ST363.014 *Philip #13*
Shot November 17, 1964
1964 Kodak 16mm b&w reversal original, 110'
**NOTATIONS** On original box in AW's hand: *philip*
Added later in black marker, in AW's hand: *13*

ST363.015 *Philip #14*
Shot November 18, 1964
1964 Kodak 16mm b&w reversal original, 110'
**NOTATIONS** On original box in AW's hand: *philip #13*
Also, pencil drawing by AW showing placement of lights, labeled *"head. spot"*

ST363.016 *Philip #15*
Shot November 19, 1964
1964 Kodak 16mm b&w reversal original, 110'
**NOTATIONS** On original box in AW's hand: *Phillip #15*
Also, pencil drawing by AW showing placement of lights, labeled *"spot. overhead"*

ST363.017 *Philip #16*
Shot November 20, 1964
1964 Kodak 16mm b&w reversal original, 110'
**NOTATIONS** On original box in AW's hand: *phillip #16. Nov 20/64*

ST363.018 *Philip #16*
Shot November 20, 1964
1964 Kodak 16mm b&w reversal original, 110'
**NOTATIONS** On original box in AW's hand: *phillip #16. Nov 20/64*

ST363.019 *Philip #17*
Shot November 21, 1964
1964 Kodak 16mm b&w original reversal, 110'
**NOTATIONS** On original box in AW's hand: *Philip #17. Nov 21/64*

ST363.020 *Philip #18*
Shot November 22, 1964
1964 Kodak 16mm b&w reversal original, 110'
**NOTATIONS** On original box in AW's hand: *philip #18. Nov 22/1964*

ST363.021 *Philip #19*
Shot November 23, 1964
1964 Kodak 16mm b&w reversal original, 110'
**NOTATIONS** On original box in AW's hand: *#19 Philip*

ST363.022 *Philip #19*
Shot November 23, 1964
1964 Kodak 16mm b&w reversal original, 108'
**NOTATIONS** On original box in AW's hand: *phillip #19. 1. Nov 23/64*
Inside flap in AW's hand: *19*

$$\frac{3}{57}$$

ST363.023 *Philip #19*
Shot November 23, 1964
1964 Kodak 16mm b&w reversal original, 109'
**NOTATIONS** On original box in AW's hand: *Philip #19. 2. Nov 23/64*

ST363.024 *Philip #20*
Shot November 24, 1964
1964 Kodak 16mm b&w reversal original, 109'
**NOTATIONS** On original box in AW's hand: *phillip #20. Nov 24/64*

ST363.025 *Philip #21*
Shot November 25, 1964
1964 Kodak 16mm b&w reversal original, 110'
**NOTATIONS** On original box in AW's hand in red: *Phillip #. Nov 25/64*
Added in black, in AW's hand: *21*

ST363.026 *Philip #22*
Shot November 26, 1964
1964 Kodak 16mm b&w reversal original, 110'
**NOTATIONS** On original box in AW's hand: *Phillip #22. Thanksgiving Day. Nov 26 1964*

ST363.027 *Philip #23*
Shot November 27, 1964
1964 Kodak 16mm b&w reversal original, 110'
**NOTATIONS** On original box in AW's hand: *philip #23. Nov 27/64*

ST363.028 *Philip #24*
Shot November 28, 1964
1964 Kodak 16mm b&w reversal original, 110'
**NOTATIONS** On original box in AW's hand: *phillip #24. Nov 28/64*

ST363.029 *Philip #25*
Shot November 29, 1964
1964 Kodak 16mm b&w reversal original, 110'
**NOTATIONS** On original box in AW's hand: *phillip 25. Nov 29/64*

ST363.030 *Philip #26*
Shot November 30, 1964
1964 Kodak 16mm b&w reversal original, 109'
**NOTATIONS** On original box in AW's hand: *philip #26. Monday. Nov 30/64*

ST363.031 *Philip #27*
Shot December 1, 1964
1964 Kodak 16mm b&w reversal original, 110'
**NOTATIONS** On original box in AW's hand: *philip #27. Turned. Dec 1/64*

ST363.032 *Philip #28*
Shot December 2, 1964
1964 Kodak 16mm b&w reversal original, 110'
**NOTATIONS** On original box in AW's hand: *phillip #28. Nov.* (crossed out) *Dec 2 1964*

ST363.033 *Philip #29*
Shot December 3, 1964
1964 Kodak 16mm b&w reversal original, 109'
**NOTATIONS** On original box in AW's hand: *philip 29. Dec 3 64*

ST363.034 *Philip #29*
Shot December 3, 1964
1964 Kodak 16mm b&w reversal original, 110'
**NOTATIONS** On original box in AW's hand: *philip 29. No 2 take. Dec 3/64*

ST363.035 *Philip #30*
Shot December 4, 1964
1964 Kodak 16mm b&w reversal original, 110'
**NOTATIONS** On original box in AW's hand: *philip #30. Dec 4/64*

ST363.036 *Philip #31*
Shot December 5, 1964
1964 Kodak 16mm b&w reversal original, 110'
**NOTATIONS** On original box in AW's hand: *phillip #31. Dec 5/64*

ST363.037 *Philip #32*
Shot December 6, 1964
1964 Kodak 16mm b&w reversal original, 109'
**NOTATIONS** On original box in AW's hand: *phillip #32. Dec 6/64*

ST363.038 *Philip #33*
Shot December 7, 1964
1964 Kodak 16mm b&w reversal original, 110'
**NOTATIONS** On original box in AW's hand: *Philip 33. Dec 7 1964*

ST363.039 *Philip #34*
Shot December 8, 1964
1964 Kodak 16mm b&w reversal original, 110'
**NOTATIONS** On original box in unidentified hand: *Dec. 8th 1964. 34 Phillip*

ST363.040 *Philip #35*
Shot December 9, 1964
1964 Kodak 16mm b&w reversal original, 108'
**NOTATIONS** On original box in AW's hand: *Philip. Dec 9*

ST363.041 *Philip #36*
Shot December 10, 1964
1964 Kodak 16mm b&w reversal original, 106'
**NOTATIONS** On original box in AW's hand: *phillip #36. dec 10*

ST363.042 *Philip #37*
Shot December 11, 1964
1964 Kodak 16mm b&w reversal original, 110'
**NOTATIONS** On original box in AW's hand: *Philip #37 #1*
Scratched on box in AW's hand: *Not good*

ST363.043 *Philip #37*
Shot December 11, 1964
1964 Kodak 16mm b&w reversal original, 110'
**NOTATIONS** On original box in AW's hand: *Phillip 37 #2. this one*

ST363.044 *Philip #38*
Shot December 12, 1964
1964 Kodak 16mm b&w reversal original, 109'
**NOTATIONS** On original box in AW's hand: *philip #38. Dec. 12*

ST363.045 *Philip #39*
Shot December 13, 1964
1964 Kodak 16mm b&w reversal original, 109'
**NOTATIONS** On original box in AW's hand: *philip 39. laughs. LAUGHS. Dec 13/64*
On back of box in AW's hand: 39
$$\frac{3}{117}$$

Inside box flap in AW's hand: 39
$$\frac{5}{195}$$

ST363.046 *Philip #39*
Shot December 13, 1964
1964 Kodak 16mm b&w reversal original, 107'
**NOTATIONS** On original box in AW's hand: *philip 39*

ST363.047 *Philip #40*
Shot December 14, 1964
1964 Kodak 16mm b&w reversal original, 110'
**NOTATIONS** On original box in AW's hand: *Philip #40. Dec 14*

ST363.048 *Philip #41*
Shot December 15, 1964
1964 Kodak 16mm b&w reversal original, 110'
**NOTATIONS** On original box in AW's hand: *Philip 41. Dec 15*

ST363.049 *Philip #42*
Shot December 16, 1964
1964 Kodak 16mm b&w reversal original, 109'
**NOTATIONS** On original box in AW's hand: *Philip 42. Dec 16*

ST363.050 *Philip #43*
Shot December 17, 1964
1964 Kodak 16mm b&w reversal original, 105'
**NOTATIONS** On original box in unidentified hand: *Philip 43. Dec. 17*

ST363.051 *Philip #43, #2*
Shot December 17, 1964
1964 Kodak 16mm b&w reversal original, 109'
**NOTATIONS** On original box in AW's hand: *philip #43 #2*

ST363.052 *Philip #44*
Shot December 18, 1964
1964 Kodak 16mm b&w reversal original, 110'
**NOTATIONS** On original box in AW's hand: *philip 44. Friday Dec 18/64*

ST363.053 *Philip #45*
Shot December 19, 1964
1964 Kodak 16mm b&w reversal original, 110'
**NOTATIONS** On original box in AW's hand: *Philip #45. 1*

ST363.054 *Philip #46*
Shot December 20, 1964
1964 Kodak 16mm b&w reversal original, 109'
**NOTATIONS** On original box in AW's hand: *Philip #46. Dec.*

ST363.055 *Philip #47*
Shot December 21, 1964
1964 Kodak 16mm b&w reversal original, 109'
**NOTATIONS** On original box in AW's hand: *philip #47*

ST363.056 *Philip #48*
Shot December 22, 1964
1964 Kodak 16mm b&w reversal original, 109'
**NOTATIONS** On original box in AW's hand: *philip 48*

ST363.057 *Philip #49*
Shot December 23, 1964
1964 Kodak 16mm b&w reversal original, 109'
**NOTATIONS** On original box in AW's hand: *Phillip #49. Dec. 23/64*

ST363.058 *Philip #50*
Shot December 24, 1964
1964 Kodak 16mm b&w reversal original, 109'
**NOTATIONS** On original box in AW's hand: *50 phillip*

ST363.059 *Philip #51*
Shot December 25, 1964
1964 Kodak 16mm b&w reversal original, 109'
**NOTATIONS** Scratched on original box in AW's hand: *Phillip #51. Christmas*

ST363.060 *Philip #52*
Shot December 26, 1964
1964 Kodak 16mm b&w reversal original, 109'
**NOTATIONS** Scratched on original box in AW's hand: *phillip 52*

ST363.061 *Philip #52*
Shot December 27, 1964
1964 Kodak 16mm b&w reversal original, 109'
**NOTATIONS** On original box in AW's hand: *philip #52. Dec. 27/64. Love*

ST363.062 *Philip #53*
Shot December 28, 1964
1964 Kodak 16mm b&w reversal original, 110'
**NOTATIONS** On original box in AW's hand: *philip #53*

ST363.063 *Philip #54*
Shot December 29, 1964
1964 Kodak 16mm b&w reversal original, 110'
**NOTATIONS** On original box in AW's hand: *philip #54*

ST363.064 *Philip #55*
Shot December 30, 1964
1964 Kodak 16mm b&w reversal original, 110'
**NOTATIONS** On original box in AW's hand: *philip #55*
Written over "56": 55

ST363.065 *Philip #56*
Shot December 31, 1964
1964 Kodak 16mm b&w reversal original, 110'
**NOTATIONS** On box in AW's hand: *Philip 56*
On box in AW's hand, crossed out: *MOST. fred. bad*

ST363.066 *Philip #57*
Shot January 1, 1965
1964 Kodak 16mm b&w reversal original, 110'
**NOTATIONS** On original box in AW's hand: *Phillip #57. Jan. 1, 1965*

ST363.067 *Philip #58*
Shot January 2, 1965
1964 Kodak 16mm b&w reversal original, 109'
**NOTATIONS** On original box in AW's hand: *philip #58. Jan 2/65*

ST363.068 *Philip #59*
Shot January 3, 1965
1964 Kodak 16mm b&w reversal original, 110'
**NOTATIONS** On original box in AW's hand: *philip 59. Jan 3/65*

ST363.069 *Philip #60*
Shot January 3, 1965
1964 Kodak 16mm b&w reversal original, 108'
**NOTATIONS** On original box in AW's hand: *Philip #60. Jan 3/65*

ST363.070 *Philip #60*
Shot January 4, 1965
1964 Kodak 16mm b&w reversal original, 110'
**NOTATIONS** On original box in AW's hand: *Philip #60. Jan #4*

ST363.071 *Philip #61*
Shot January 5, 1965
1964 Kodak 16mm b&w reversal original, 110'
**NOTATIONS** On original box in AW's hand: *philip #61. Jan 5/65*

ST363.072 *Philip #62*
Shot January 6 or 7, 1965
1964 Kodak 16mm b&w reversal original, 110'
**NOTATIONS** On original box in AW's hand: *phillip #62*

ST363.073 *Philip #62*
Shot January 8, 1965
1964 Kodak 16mm b&w reversal original, 110'
**NOTATIONS** On original box in AW's hand: *Philip 62. Jan 8/65*

ST363.074 *Philip #63*
Shot January 9, 1965
1964 Kodak 16mm b&w reversal original, 111'
**NOTATIONS** On original box in AW's hand: *philip #63. Jan 9/65*

ST363.075 *Philip #64*
Shot January 10, 1965
1964 Kodak 16mm b&w reversal original, 110'
**NOTATIONS** On original box in AW's hand: *Philip #64.*
*Jan 4 65* (smeared)

ST363.076 *Philip #65*
Shot January 11, 1965
1964 Kodak 16mm b&w reversal original, 110'
**NOTATIONS** On box in AW's hand: *Philip #66/65. Jan. 65*
On box in Gerard Malanga's hand, crossed out: *Rosalind Constable. 50*

ST363.077 *Philip #66*
Shot January 12, 1965
1964 Kodak 16mm b&w reversal original, 110'
**NOTATIONS** Scratched on original box in AW's hand: *Phillip 66. Jan 65*

ST363.078 *Philip #67*
Shot January 13, 1965
1964 Kodak 16mm b&w reversal original, 110'
**NOTATIONS** On original box in AW's hand: *Phillip #67. Jan 13/64*

ST363.079 *Philip #68*
Shot January 14, 1965
1964 Kodak 16mm b&w reversal original, 110'
**NOTATIONS** On original box in unidentified hand: *Philip #68. 300 W. center below. Exp. 4/5. Jan. 14*

ST363.080 *Philip #69*
Shot January 15, 1965
1964 Kodak 16mm b&w reversal original, 110'
**NOTATIONS** On original box in AW's hand: *Philip #69. 300 W. Exp. 5.6. Jan. 15*

ST363.081 *Philip #70*
Shot January 16, 1965
1964 Kodak 16mm b&w reversal original, 107'
**NOTATIONS** On original box in unidentified hand: *Philip #70. Exp 5. 300 W. Jan 16*

ST363.082 *Philip #71*
Shot January 17, 1965
1964 Kodak 16mm b&w reversal original, 110'
**NOTATIONS** On original box in AW's hand: *Philip #71. Jan. 17. 300 W – 2.2*

ST363.083 *Philip #71*
Shot January 17, 1965
1964 Kodak 16mm b&w reversal original, 110'
**NOTATIONS** On original box in unidentified hand: *Philip #71. 1* (circled)

ST363.084 *Philip #71*
Shot January 17, 1965
1964 Kodak 16mm b&w reversal original, 110'
**NOTATIONS** On original box in AW's hand: *philip 71. 3* (circled). *good. 350 watt*
On clear film at head of roll in black: *L.8*

ST363.085 *Philip #72*
Shot January 18, 1965
1964 Kodak 16mm b&w reversal original, 110'
**NOTATIONS** On original box in AW's hand: *philip 71* ("*71*" written over "*72*"). *2* (circled). *Jan 18/65* ("*65*" written over "*64*")

ST363.086 *Philip #72*
Shot January 19, 1965
1964 Kodak 16mm b&w reversal original, 109'
**NOTATIONS** On original box in unidentified hand: *Philip #72. 1.9 at 300*

ST363.087 *Philip #73*
Shot January 20, 1965
1964 Kodak 16mm b&w reversal original, 110'
**NOTATIONS** On original box in unidentified hand: *Philip #73. Jan 20*
Also on box, a labeled drawing of the placement of Fagan in relation to the camera and lights, showing Fagan against a wall, facing the camera, labeled "*Exp. 2.8*," with a light labeled "*150 W.*" directly on his left, and a light labeled "*300 W.*" at a forty-five-degree angle on his right

ST363.088 *Philip #74*
Shot January 21, 1965
1964 Kodak 16mm b&w reversal original, 110'
**NOTATIONS** On original box in AW's hand: *Philip #74. Jan 21/65*

ST363.089 *Philip #75*
Shot January 22, 1965
1964 Kodak 16mm b&w reversal original, 109'
**NOTATIONS** On original box in AW's hand: *Philip #7-7? Friday Jan 22/65*

ST363.090 *Philip #76*
Shot January 23, 1965
1964 Kodak 16mm b&w reversal original, 110'
**NOTATIONS** On original box in AW's hand: *philip #7? Jan 23/65*
Also on box, drawing showing Fagan in relation to camera: Fagan is
placed against the wall, with the notation "*NO LIGHT,*" and the
camera is labeled "*1.9*"

ST363.091 *Philip #77*
Shot January 24, 1965
1964 Kodak 16mm b&w reversal original, 110'
**NOTATIONS** On original box in AW's hand: *philip #7. Jan. 24/65*

ST363.092 *Philip #78*
Shot January 25, 1965
1964 Kodak 16mm b&w reversal original, 111'
**NOTATIONS** On original box in AW's hand: *philip #. Jan 25/65*

ST363.093 *Philip #79*
Shot January 26, 1965
1964 Kodak 16mm b&w reversal original, 110'
**NOTATIONS** On original box in unidentified hand: *Jan. 26. Philip #.
Meter = 2.8. shot at 2.4. Andy Warho*

ST363.094 *Philip #80*
Shot January 27, 1965
1964 Kodak 16mm b&w reversal original, 110'
**NOTATIONS** On original box in AW's hand: *philip #. Jan 27*
On box in unidentified hand: *meter = 2/5. take = 2*

ST363.095 *Philip #81*
Shot January 28, 1965
1964 Kodak 16mm b&w reversal original, 110'
**NOTATIONS** On original box in unidentified hand: *Philip #. Jan. 28.
meter = 2.6. take = 2/3*

ST363.096 *Philip #82*
Shot January 29, 1965
1964 Kodak 16mm b&w reversal original, 110'
**NOTATIONS** On original box in unidentified hand: *Philip #. Jan. 29*

ST363.097 *Philip #83*
Shot January 30, 1965
1964 Kodak 16mm b&w reversal original, 110'
**NOTATIONS** On original box in AW's hand: *Philip #. Jan 30. Jan. 30*

ST363.098 *Philip #84*
Shot January 31, 1965
1964 Kodak 16mm b&w reversal original, 110'
**NOTATIONS** On original box in unidentified hand: *Philip #. Jan 31/65*

ST363.099 *Philip #85*
Shot February 1, 1965
1964 Kodak 16mm b&w reversal original, 110'
**NOTATIONS** On original box in AW's hand: *Phillipp. Feb 1/65*
On box in unidentified hand: *Feb 1. 300 watt left center of subject.
reading 2.8*

ST363.100 *Philip #86*
Shot February 2, 1965
1964 Kodak 16mm b&w reversal original, 110'
**NOTATIONS** On original box in unidentified hand: *Philip #. Feb 2/65*

ST363.101 *Philip #87*
Shot February 3, 1965
1964 Kodak 16mm b&w reversal original, 110'
**NOTATIONS** On original box in unidentified hand: *Philip Feb 3. Exp.
28. 300 watt. slightly above and right of subject*

ST363.102 *Philip #88*
Shot February 5, 1965
1964 Kodak 16mm b&w reversal original, 110'
**NOTATIONS** On original box in unidentified hand: *Philip Feb 5. critical*
(circled). *meter cell facing toward camera. Exp. between 2.3 + 2.8*

ST363.103 *Philip #89*
Shot February 5, 1965
1964 Kodak 16mm b&w reversal original, 110'
**NOTATIONS** On original box in unidentified hand: *Philip Feb 5*

ST363.104 *Philip #90*
Shot February 6, 1965
1964 Kodak 16mm b&w reversal original, 110'
**NOTATIONS** On original box in AW's hand: *Philip. 5.6 at /20. # Feb 6*

ST363.105 *Philip #91*
Shot February 7, 1965
1964 Kodak 16mm b&w reversal original, 110'
**NOTATIONS** On original box in AW's hand: *Philip Feb. #7*
Inside box in unidentified hand: *meter cell toward camera = less exposure*

ST363.106 *Philip #92*
Shot February 8, 1965
1964 Kodak 16mm b&w reversal original, 110'
**NOTATIONS** On original box in AW's hand: *Feb 8/65. Philip #*

ST363.107 *Philip #93*
Shot February 9, 1965
1964 Kodak 16mm b&w reversal original, 111'
**NOTATIONS** On original box in AW's hand: *Feb 9/65. phillip*
On box in unidentified hand: *lens 1/9. 500 W. critical* (boxed)
Also on box, schematic sketch showing Fagan, labeled "*subject,*"
placed against a wall facing the camera, with the light, labeled "*500
w. lamp,*" placed at nine o'clock between them

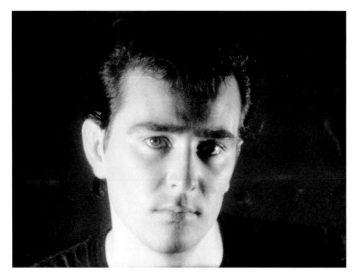

ST363.001

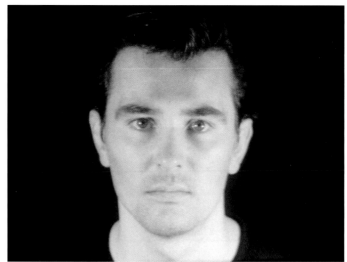

ST363.002

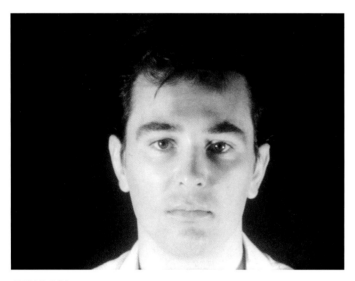

ST363.003

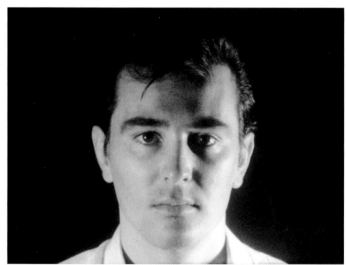

ST363.004

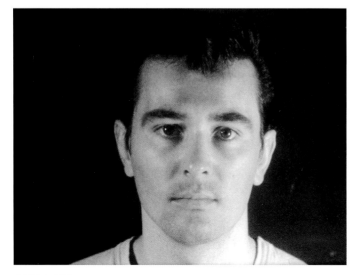

ST363.005

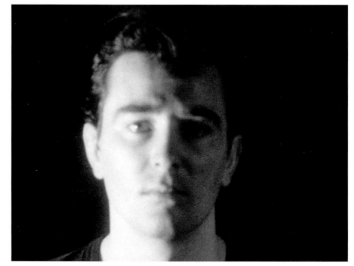

ST363.006

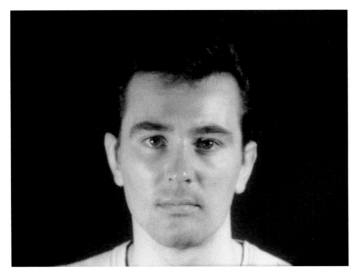

ST363.007

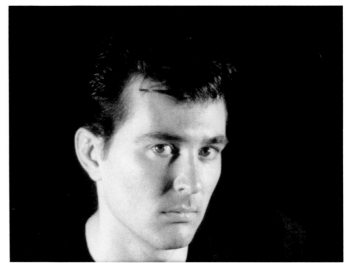

ST363.008

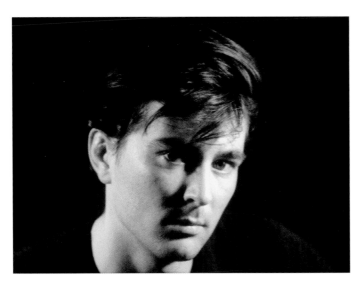

ST363.009

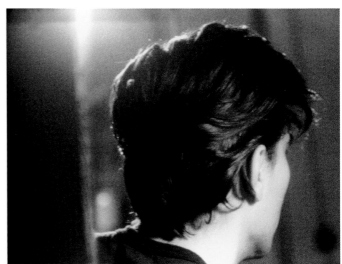

ST363.010

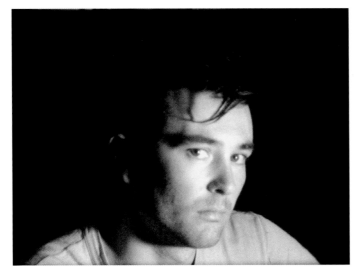

ST363.011

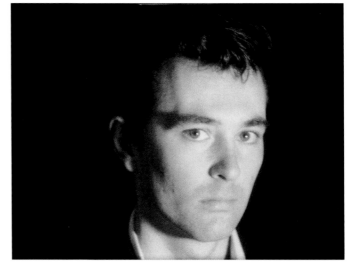

ST363.012

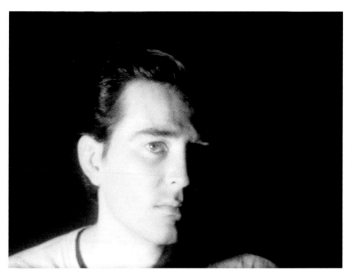

ST363.013

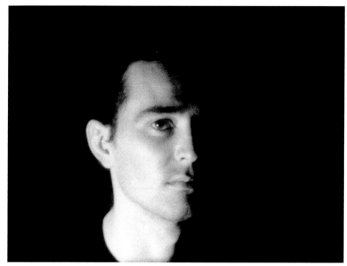

ST363.014

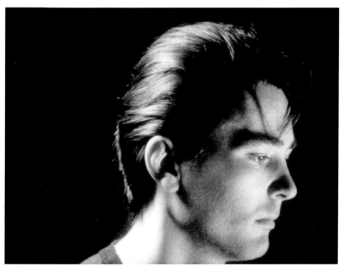

ST363.015

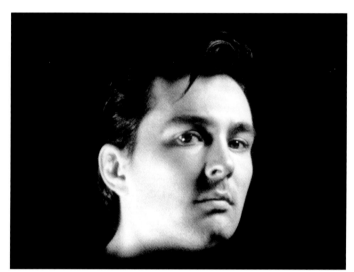

ST363.016

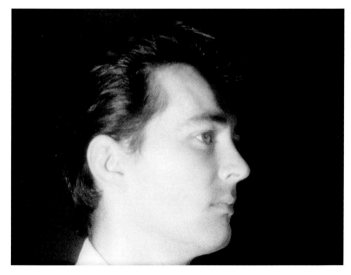

ST363.017

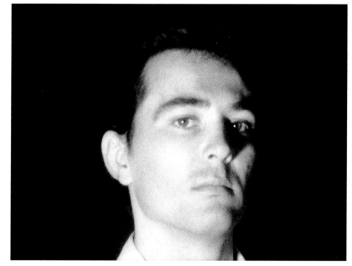

ST363.018

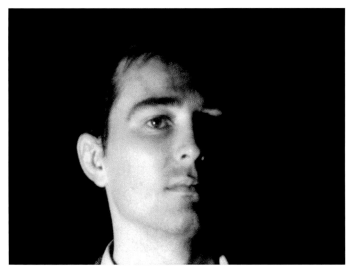

ST363.019

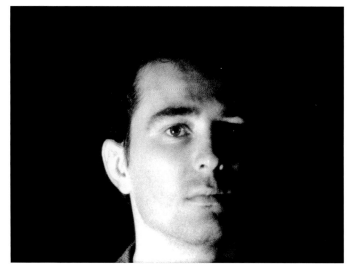

ST363.020

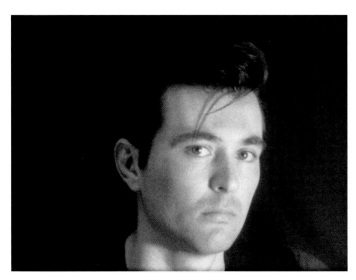

ST363.021

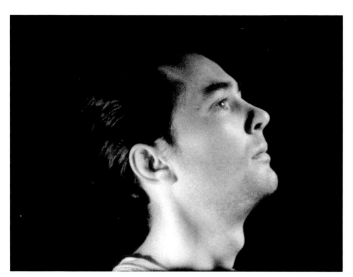

ST363.022

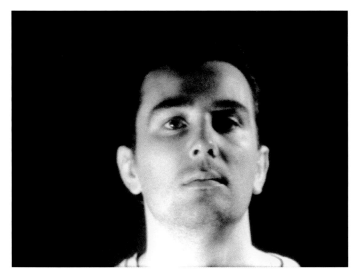

ST363.023

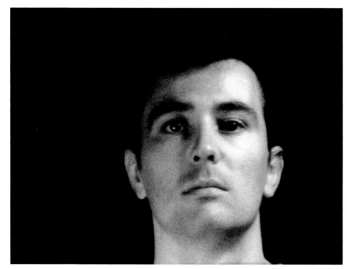

ST363.024

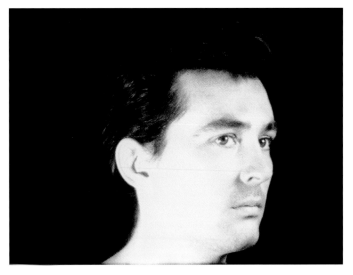

ST363.025

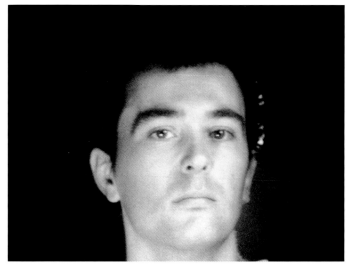

ST363.026

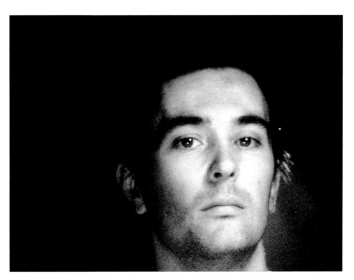

ST363.027

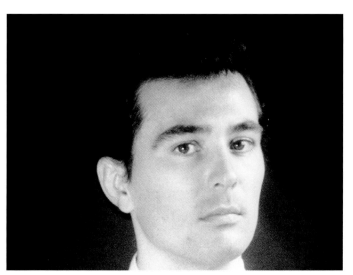

ST363.028

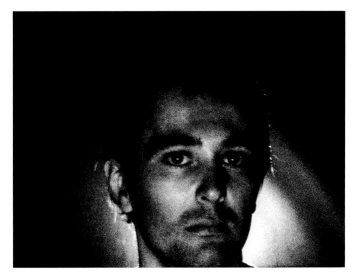

ST363.029

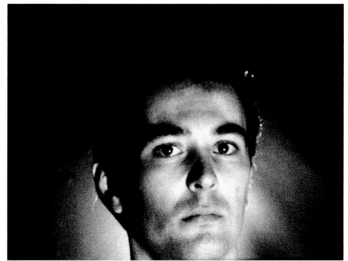

ST363.030

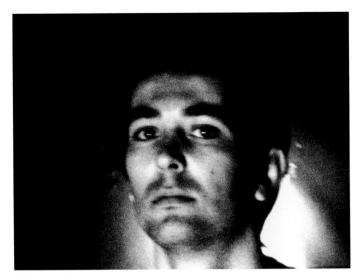

ST363.031

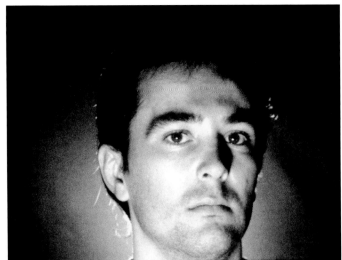

ST363.032

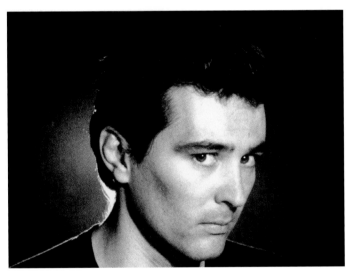

ST363.033

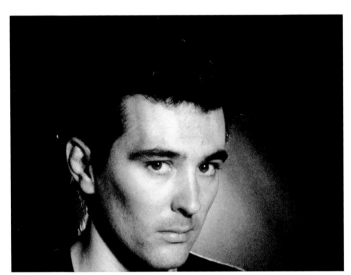

ST363.034

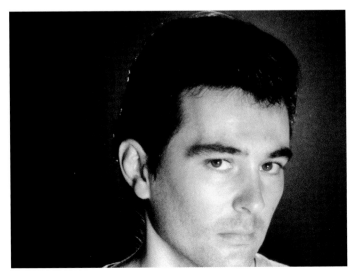

ST363.035

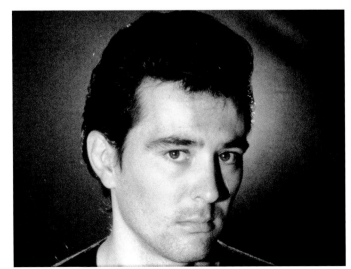

ST363.036

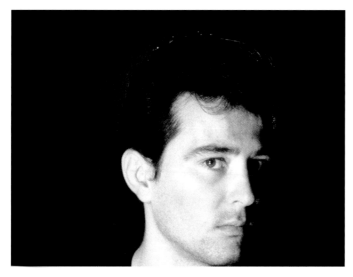

ST363.037

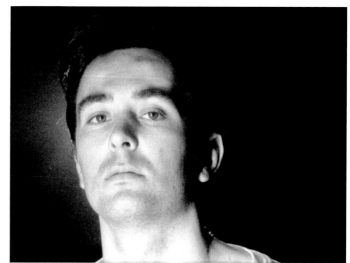

ST363.038

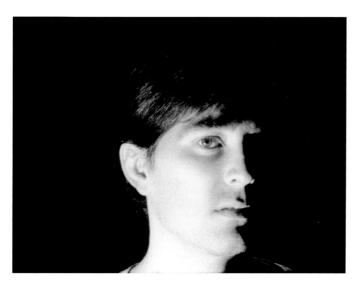

ST363.039

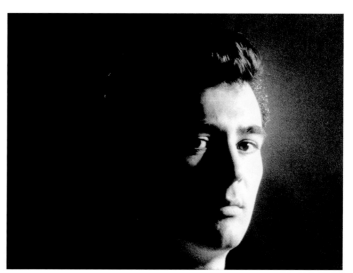

ST363.040

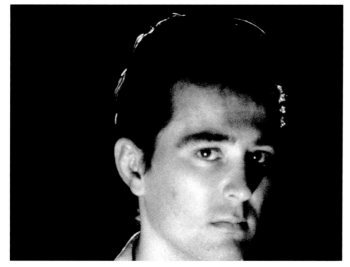

ST363.041

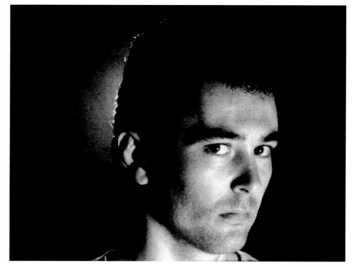

ST363.042

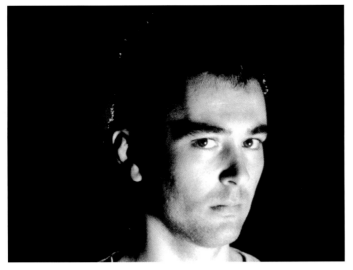

ST363.043

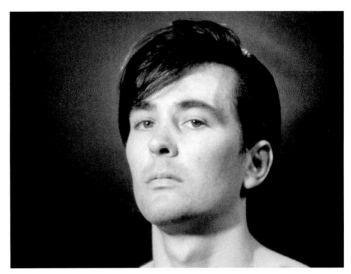

ST363.044

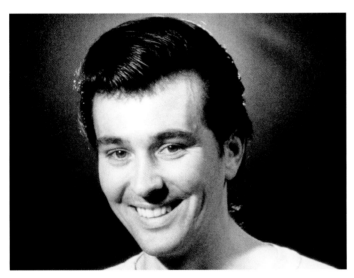

ST363.045

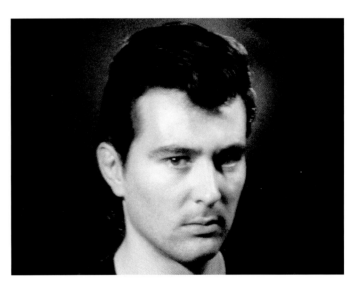

ST363.046

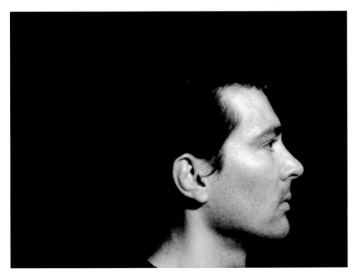

ST363.047

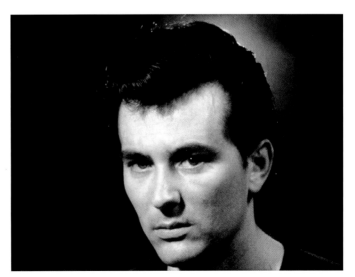

ST363.048

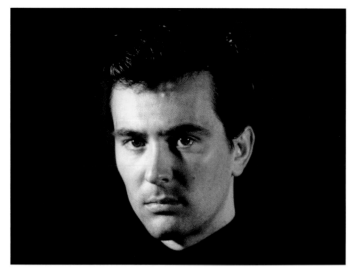

ST363.049

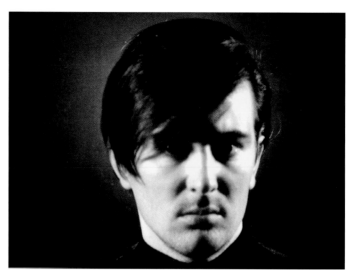

ST363.050

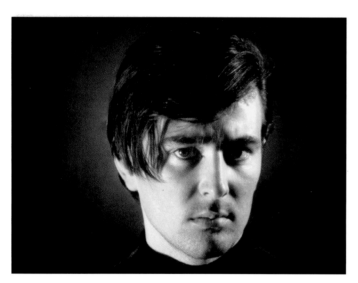

ST363.051

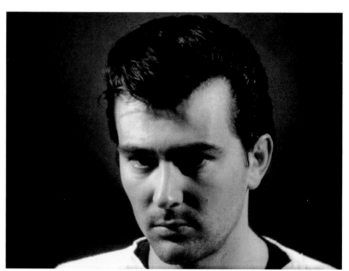

ST363.052

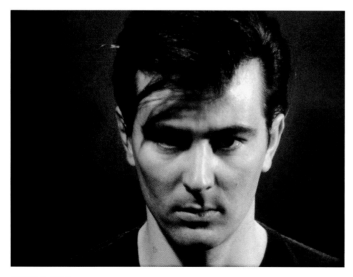

ST363.053

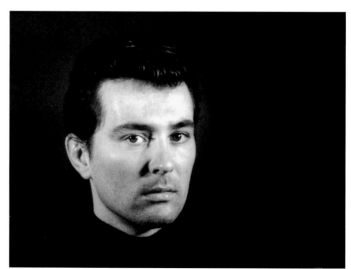

ST363.054

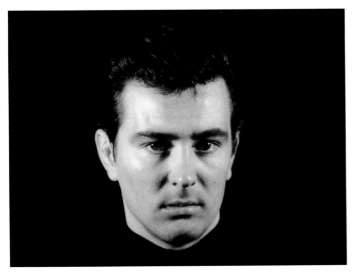

ST363.055

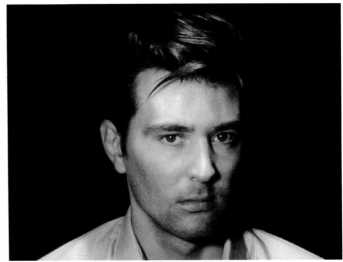

ST363.056

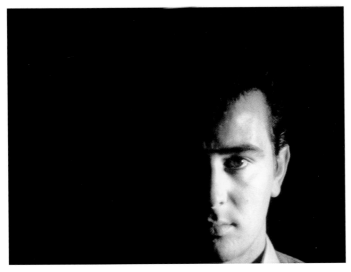

ST363.057

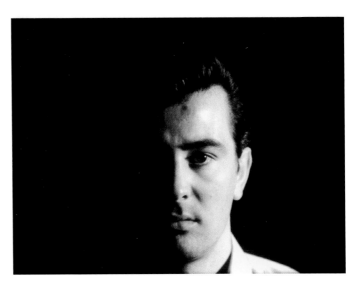

ST363.058

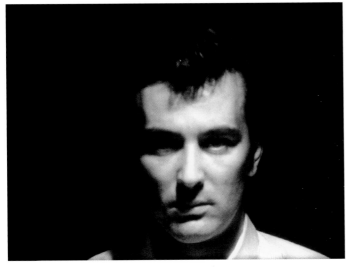

ST363.059

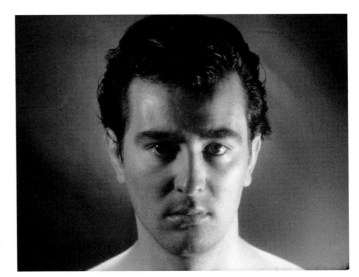

ST363.060

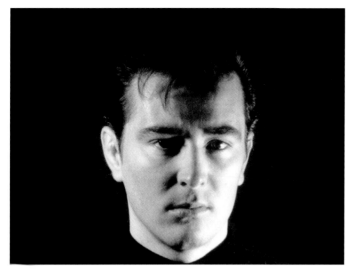

ST363.061

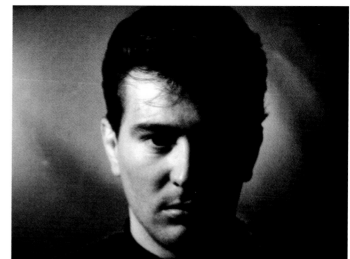

ST363.062

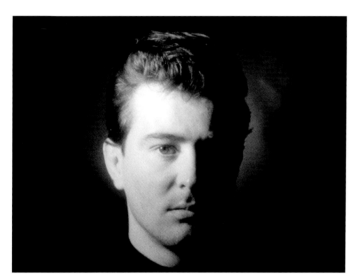

ST363.063

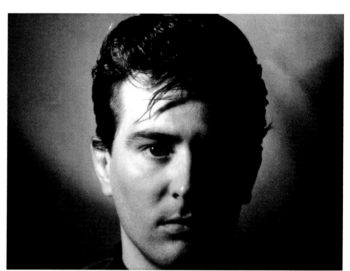

ST363.064

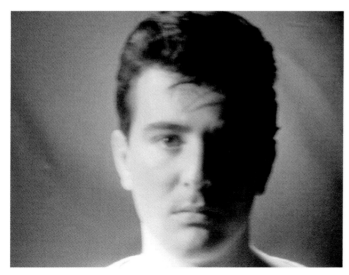

ST363.065

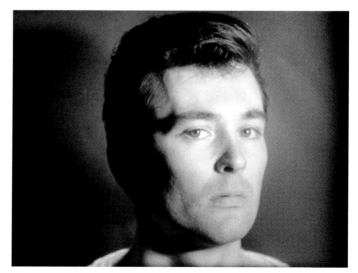

ST363.066

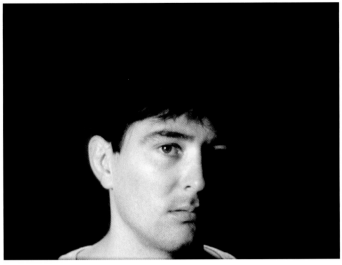

ST363.067

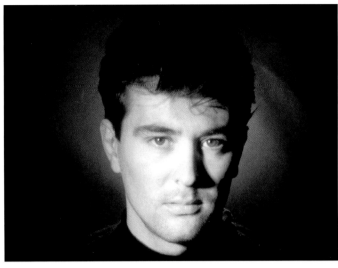

ST363.068

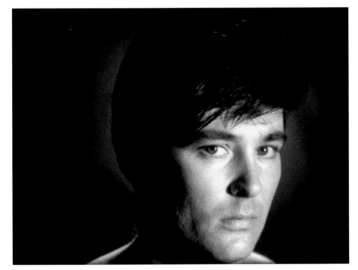

ST363.069

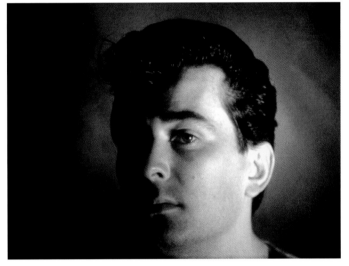

ST363.070

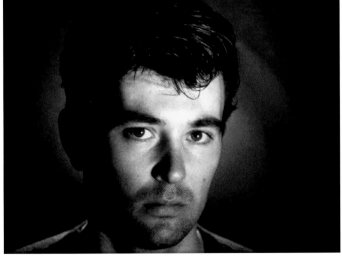

ST363.071

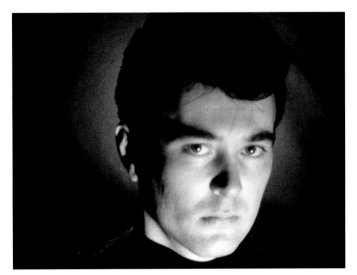

ST363.072

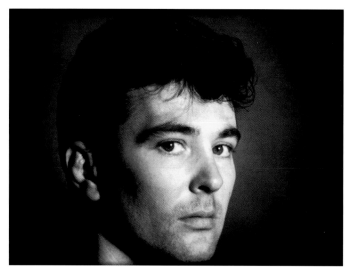

ST363.073

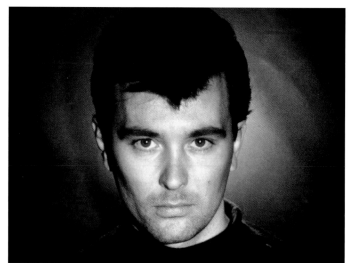

ST363.074

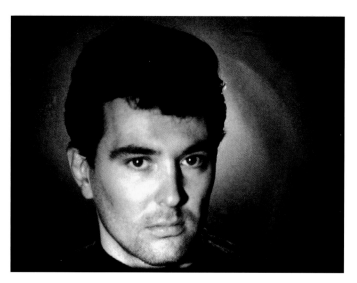

ST363.075

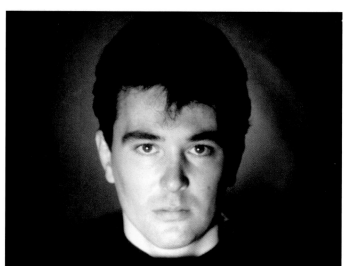

ST363.076

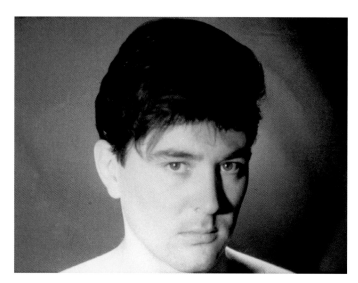

ST363.077

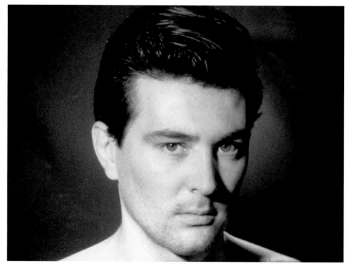

ST363.078

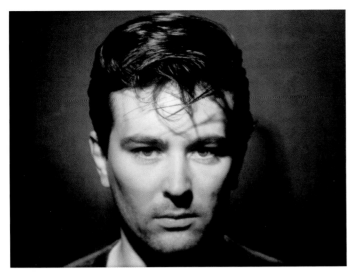

ST363.079

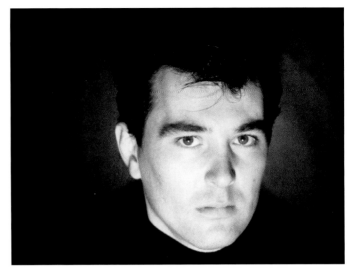

ST363.080

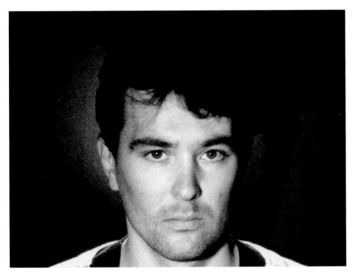

ST363.081

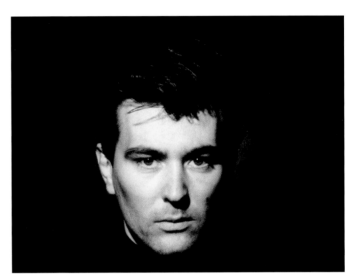

ST363.082

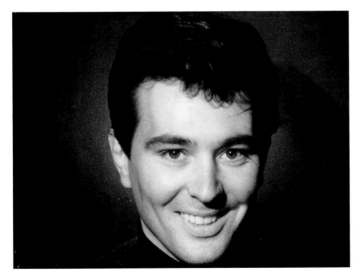

ST363.083

ST363.083

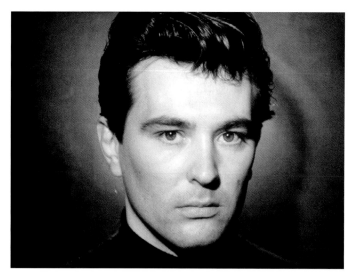

ST363.084

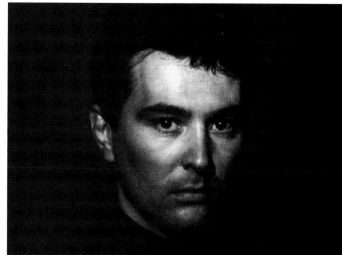

ST363.085

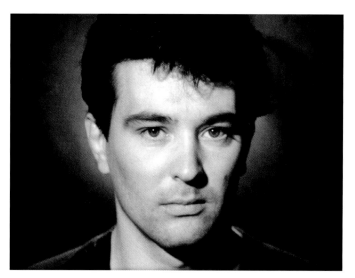

ST363.086

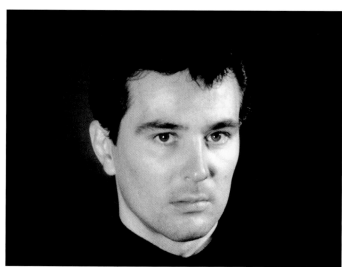

ST363.087

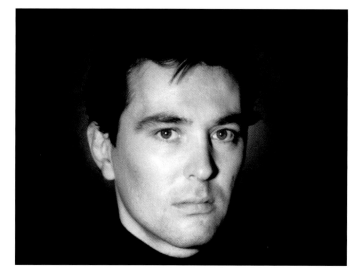

ST363.088

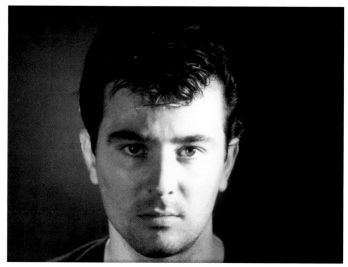

ST363.089

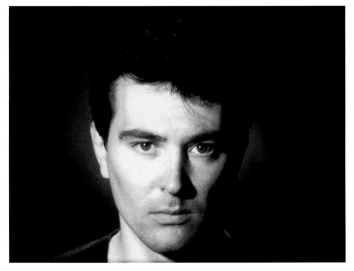

ST363.090

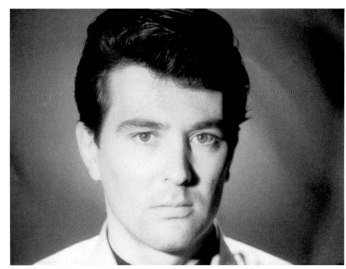

ST363.091

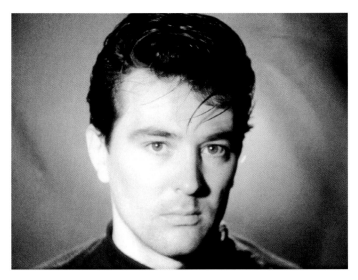

ST363.092

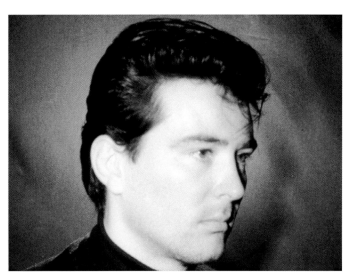

ST363.093

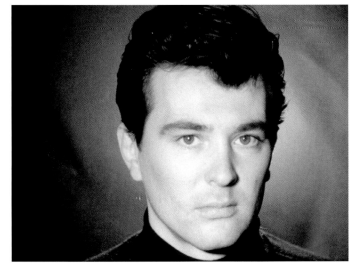

ST363.094

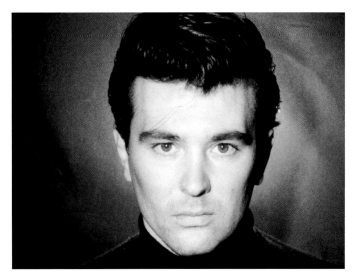

ST363.095

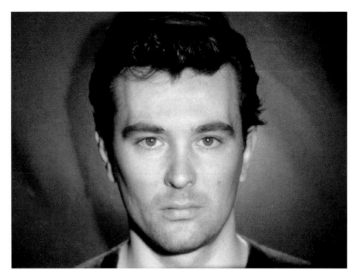

ST363.096

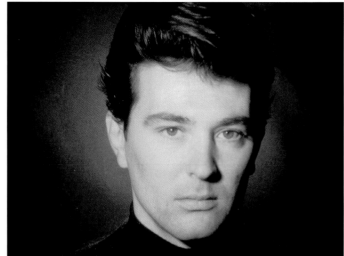

ST363.097

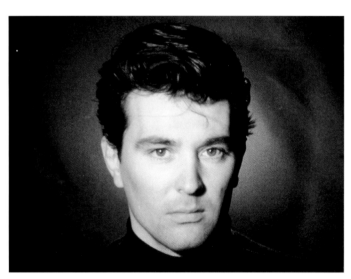

ST363.098

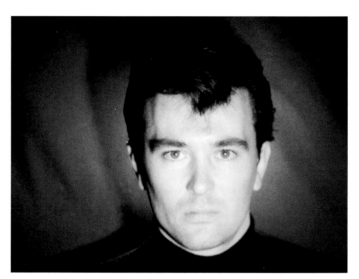

ST363.099

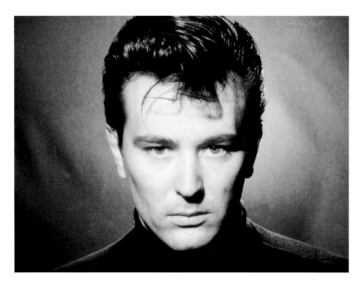

ST363.100

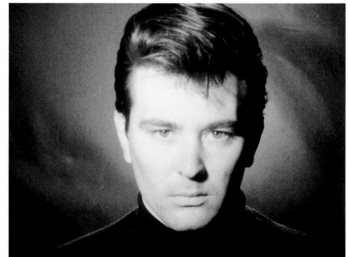

ST363.101

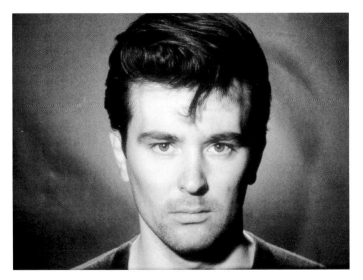

ST363.102

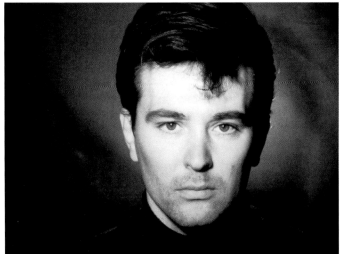

ST363.103

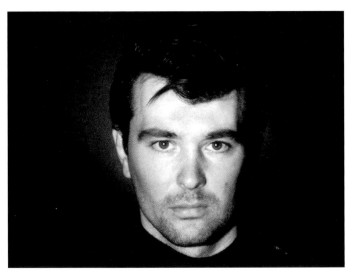

ST363.104

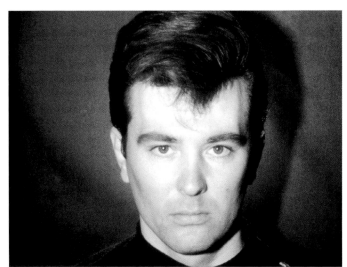

ST363.105

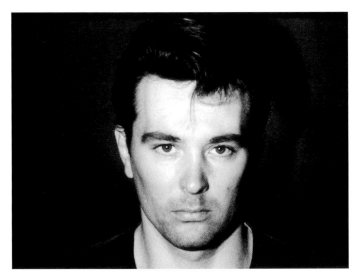

ST363.106

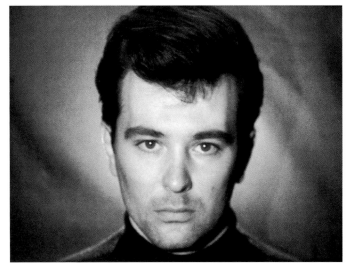

ST363.107

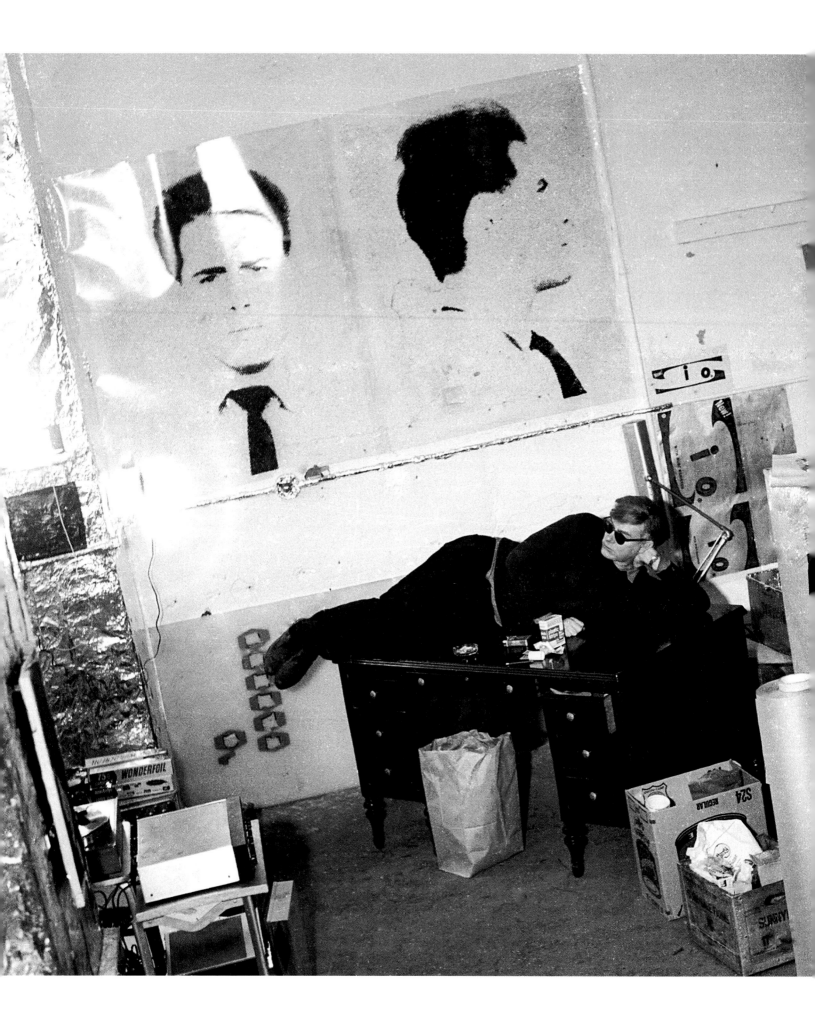

# Chapter Four
# Conceptual Series
*The Thirteen Most Beautiful Boys, The Thirteen Most Beautiful Women,*
*Fifty Fantastics and Fifty Personalities*

For a year once it was in all the magazines that my next movie was going to be *The Beauties*. The publicity for it was great, but then I could never decide who should be in it. If everybody's not a beauty, then nobody is, so I didn't want to imply that the kids in *The Beauties* were beauties but the kids in my other movies weren't so I had to back out on the basis of the title. It was all wrong.

—Andy Warhol[1]

Beginning in early 1964 with the shooting of the first *Screen Tests*, Warhol began selecting certain portrait films for inclusion in three different conceptual series, *The Thirteen Most Beautiful Boys*, *The Thirteen Most Beautiful Women*, and, later, *Fifty Fantastics and Fifty Personalities*. There are no physical film materials in the Collection for either *The Thirteen Most Beautiful Boys* or *The Thirteen Most Beautiful Women*; in fact, with the exception of the four original *Screen Tests* found spliced into *EPI Background: Original Salvador Dalí* (ST367) and the three *Screen Tests* included in *Dracula/3 Most* (ST365d), all of the Warhol *Screen Tests* were stored as individual works, with each camera original roll mounted on a 100' reel and stored inside a 100' can inside its own film box.

Although different versions of *The Thirteen Most Beautiful Boys* and *The Thirteen Most Beautiful Women* were screened from time to time, these titles seem to have functioned primarily as shooting concepts for ongoing series to which new films might always be added, not as actual works intended to reach a final form. The open-ended nature of these series is apparent from the numbers of *Screen Tests* labeled for these titles. Instead of thirteen men and thirteen women, there are forty-two *Screen Tests* of thirty-five different men and forty-seven *Screen Tests* of thirty different women, all of which were either labeled "13" on their film boxes or otherwise documented as having been included in these series at one point or another.

By announcing that he was working on films called *The Thirteen Most Beautiful Boys* and *The Thirteen Most Beautiful Women* and then inviting people to be in them, Warhol created a highly useful pretext for the ongoing collection of film portraits, a concept which allowed him to flatter friends, acquaintances, and near strangers into posing for his movie camera. Warhol was equally flattering in the production of his painted portraits in the 1970s and 1980s, when he retouched and colored high-contrast Polaroid photographs of his subjects to make them look more glamorous, just as he carefully lit, posed, and sometimes reshot his *Screen Test* stars to make them look as good as possible. The nearly irresistible appeal of these *Most Beautiful* projects helps to account for the large numbers of *Screen Tests* found in the collection, not just for those that Warhol or his assistants selected and labeled "13."

Any final or "finished" version of *The Thirteen Most Beautiful Boys* or *The Thirteen Most Beautiful Women* would, however, have caused nothing but problems, offending those who were left out and also depriving Warhol of the ability to continue adding more beautiful people to his collection. The different versions of *The Thirteen Most Beautiful Women* that were publicly screened from time to time were often selected to include *Screen Tests* of women who might be attending the screening or those who would feel especially offended by the omission of their portrait. As Billy Name, the Factory manager, explained, these selections were often political in nature:

> As to who would be *The Thirteen Most Beautiful Boys* or *Girls*, depended on where we were gonna show it, and if we were just showing a segment. At the Factory, we would show the people that we knew were going to come, and their friends, and anybody we were trying to impress to get to buy Andy's paintings, or back one of his films. I mean, we were very mercenary in that sense. But they were all good, and it was legitimate for us to do that.[2]

A later series, *Fifty Fantastics and Fifty Personalities*, seems to have been dreamed up as a means of organizing and exhibiting the growing numbers of *Screen Tests* accumulating at the Factory, and also possibly as a way of including those who didn't make it into *The Thirteen Most Beautifuls*. Again, there is a large discrepancy between the one hundred *Screen Tests* called for by the title and the forty-one films actually labeled "50" on their boxes. One hundred *Screen Tests* shown end to end would have a running time of seven hours at the silent projection speed of 16 fps. The small number of films actually selected for this very large hypothetical compilation indicates that *Fifty Fantastics and Fifty Personalities* was more of a conceptual grouping than a real film; there is no record of any version of this film ever being screened in public.

The fluid nature of these conceptual projects explains why so few *Screen Tests* were found spliced together in bigger reels. Again, Billy Name has been especially articulate in explaining how this worked:

> Think of the title as the piece, and then all the components eligible to be part of it . . . The title is the draw; it's the magnet. The content is the people who were around him at that time and that got their screen test. And that pool can be selected from to be the content of the concept . . . It wasn't rigid and wasn't fixed because for an artist in the New York scene at that time, like Andy was, you were constantly interplaying with your admirers, and with people you wanted for patrons . . . The nature of the content is fluid, the surrounding culture at that time . . . Any one of them could make it the most startling movie.[3]

Acetates for the *Thirteen Most Wanted Men* on the wall of the Factory, 1964.
Photograph by Billy Name.

## The Thirteen Most Beautiful Boys

The very first *Screen Tests* were shot for the film series *The Thirteen Most Beautiful Boys*, a work that was inspired by a 1962 New York City Police Department pamphlet entitled *The Thirteen Most Wanted*.[4] This pamphlet was also the source of the photographic images that Warhol used in his controversial 1964 mural, *Thirteen Most Wanted Men*, which was briefly installed on the exterior wall of Philip Johnson's New York State Pavilion at the New York World's Fair in April. As Billy Name explained:

> *The Thirteen Most Beautiful*—this was derived from the painting Andy did for the 1964 World's Fair in Flushing Meadows, Long Island, Queens . . . This is his version of what you should do. Rather than the "Thirteen Most Wanted Men," what you really should do is *The Thirteen Most Beautiful Boys* and *The Thirteen Most Beautiful Girls*, and that's what everybody would like. This is Andy's overt reasoning; this is how he would talk to you.[5]

Interestingly, the first *Screen Tests* made for *The Thirteen Most Beautiful Boys* seem to have been shot before Warhol started work on the *Thirteen Most Wanted Men* mural. The earliest documented mention of these films is found in Kelly Edey's diary entry for January 17, 1964, in which he noted: "This afternoon Andy Warhol made a movie here, a series of portraits of a number of beautiful boys, including Harold Talbot and Denis Deegan and also me."[6] Warhol, who was facing an April 15 deadline for completion of his mural, seems not to have begun work on the *Thirteen Most Wanted Men* until February, which suggests that he began the film series while his commissioned mural was still in the planning stages.[7]

Warhol's transformation of "most wanted men" into "most beautiful boys" is a good example of the radical literalism with which Warhol often approached American language and culture. Although the law enforcement officials who produced and distributed the *Thirteen Most Wanted* booklet were no doubt oblivious to the homoeroticism implicit in its title and images, it seems to have been entirely obvious to Warhol, who appropriated the concept and the title "The Thirteen Most" for two different, nearly simultaneous projects made with very different audiences in mind. On the one hand, he began to assemble an unambiguously homoerotic film series, *The Thirteen Most Beautiful Boys*, created within and intended for the semiprivate, often explicitly homoerotic world of underground movies. At the same time, he produced a commissioned mural, *Thirteen Most Wanted Men*, specifically designed for the vast civic arena of the World's Fair. For the public project, he retained the decorum of the original title, to which he added only the word "Men." He also reproduced the photographs of the thirteen outlaws, whose authenticity as actual criminals indicted for real crimes would of course reinforce less offensive interpretations of the phrase "most wanted men."[8]

After its unveiling, the *Thirteen Most Wanted Men* was almost immediately painted over. Interestingly, the objections it provoked had little to do with homosexuality, but arose from public and official perceptions of the mural as an outrageously improper celebration of a bunch of crooks, exactly the type of social undesirable who had no place in the World Fair's grand exposition of civic pride and social and scientific progress. One local newspaper account published a photograph titled "Some Not-So-Fair Faces" and began, "Unabashedly adorning the New York State Pavilion at the World's Fair today—resplendent [sic] in all their scars, cauliflower ears, and other appurtenances of their trade—are the faces of the city's 13 Most Wanted Criminals." The piece ended with a detailed list of the wanted men's names and crimes, including "Ellis Ruis 'The Professor' Baez, wanted for the hammer-knife slaying of a fourteen-year-old girl . . . Arthur Alvin 'Skin' Mills, a veteran safecracker and burglar." The article quoted one member of the public who felt that the fair should not be "a backdrop for criminal billboards" and also printed a disavowal from Arnold Whitridge, a trustee of the Metropolitan Museum of Art and a member of the City Art Commission:

> The city commission has nothing to do with art at the World's Fair. I haven't seen the mural but, from what I'm told, it doesn't sound like a good idea to me. I don't know who's in charge out there.[9]

Within three days the mural had been covered with a tarpaulin and painted over with silver paint; this act of censorship was then itself covered up with the official statement that the artist "felt the work was not properly installed and did not do justice to what he had in mind."[10]

By treating the most wanted criminals as legitimate celebrities in their own right (men who had, after all, achieved considerable professional recognition within their field), Warhol's public mural brilliantly critiqued America's obsession with ideas of fame and success. The effectiveness of this critique can by judged by the speed with which the mural was removed from sight. The foresight and accuracy of Warhol's vision are more apparent these days, when the intersection of fame and criminality has become a recurring theme in American culture, unavoidably present in all news media and in television programs like *America's Most Wanted*.

Undaunted or perhaps encouraged by the mural's suppression, Warhol also produced a series of twenty-two canvases, including both frontal and profile views, from the original *Thirteen Most Wanted Men* silk screens; these paintings were exhibited at the Ileana Sonnabend Gallery in Paris from February through May 1967.[11] He also continued shooting and selecting *Screen Tests* for his private collection of *The Thirteen Most Beautiful Boys* and *Women* films throughout 1964 and 1965.

The identification of the very first *Screen Tests* with *The Thirteen Most Beautiful Boys* films made in January 1964 is confirmed by the film materials themselves. Only seventeen *Screen Tests*, all films of men, were found to have been made on 1963 stock, which indicates that they are the earliest *Screen Tests*, shot no later than early 1964. Of the seventeen earliest *Screen Tests*, twelve were marked as selected for

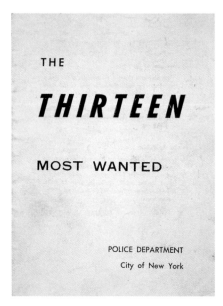

THE

*THIRTEEN*

MOST WANTED

POLICE DEPARTMENT
City of New York

Front cover of *The Thirteen Most Wanted*, New York City Police Department booklet, February 1, 1962. Archives of The Andy Warhol Museum, Pittsburgh.

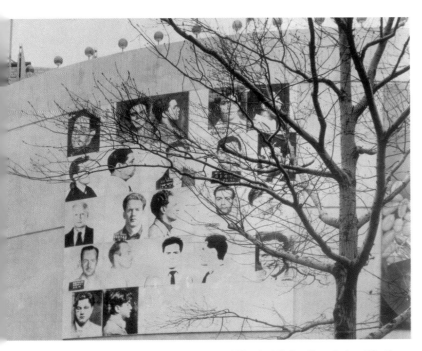

Warhol's mural, *Thirteen Most Wanted Men*, installed on the exterior of the New York State Pavilion at the 1964 New York World's Fair. The Andy Warhol Foundation for the Visual Arts, Inc.

*The Thirteen Most Beautiful Boys*; these are the first twelve films catalogued under this title. The forty-two *Screen Tests* of thirty-five men listed here, in roughly chronological order, under the title *The Thirteen Most Beautiful Boys* (ST364) have been identified from notations found on the film boxes, on which Warhol or someone else wrote "13" or "Beautiful Boy." It is possible that other *Screen Tests* were shot or selected for this series without such notations actually being written down. Robert Pincus-Witten, for example, recalled in his interview with Patrick Smith that he had been filmed for *The Thirteen Most Beautiful Boys*; his *Screen Test* has been included here even though no notations for "13" were found on his film box.[12]

The last *Screen Tests* marked for *The Thirteen Most Beautiful Boys* are those of James Claire and Roderick Clayton, which were shot on 1965 stock probably early in 1966, when both Claire and Clayton appeared in Warhol's film *Hedy*. By this time, however, Warhol seems to have largely abandoned work on *The Most Beautiful* series, perhaps because he was concentrating on making films for the EPI (see Chapter Five). None of the many striking *Screen Tests* shot on 1966 stock, including those of Randy Bourscheidt, John Cale, Allen Midgette, Nico, Lou Reed, Richard Rheem, Phoebe Russell, Mary Woronov, and others, was marked "13."

Interestingly, there seem to have been few if any public screenings of *The Thirteen Most Beautiful Boys* outside of the private venue of Warhol's Factory. Unlike *The Thirteen Most Beautiful Women*, the *Most Beautiful Boys* was never offered for rental through the Film-Makers' Cooperative catalogue, and no distribution records of it being shown have been found.[13] The only references to a public showing of *The Thirteen Most Beautiful Boys* mention a screening at the New Yorker Theatre on December 7, 1964, when *Film Culture* magazine presented its Sixth Independent Film Award to Warhol. Various Warhol films were announced in the flyer, including "excerpts from *The Thirteen Most Beautiful Women*"; although unannounced, Freddie Herko's *Screen Test* from *The Thirteen Most Beautiful Boys* was also shown, according to descriptions by both James Stoller and David Bourdon.[14]

It is not clear why no versions of *The Thirteen Most Beautiful Boys* were publicly screened or offered for rent in the 1960s. It is tempting to speculate that Warhol's decision not to exhibit or release the film was at least partially influenced by the atmosphere of police repression and censorship in New York City in 1964, when attempts were being made to "clean up" the city for the World's Fair; in March 1964, prints of Jack Smith's film *Flaming Creatures* and Jean Genet's *Un Chant d'Amour* were seized by the police. But police interference with underground cinema screenings certainly didn't stop Warhol from shooting and exhibiting his 1964 film *Blow Job*, a carefully nonpornographic representation of an explicitly titled sex act that seems to have been specifically conceived as a witty riposte to this kind of censorship. Billy Name's understanding was that *The Thirteen Most Beautiful Women* had a wider audience because of Jane Holzer's celebrity: the film "received major focus because of Baby Jane Holzer. And if Baby Jane was in something people would come to see it, either at the Factory showing or at the Cinematheque. There was a following there, and so there was a raison d'être so to speak for the film—for Andy to do the film." According to Name, Warhol was eventually distracted by another project and never finished or promoted *The Thirteen Most Beautiful Boys*.[15]

Another, more complex explanation is suggested by Warhol's practice as an artist in the 1950s, when he produced thousands of "public" illustrations in his work as a commercial artist, and also made thousands of drawings, many of them explicitly homoerotic, which, as Neil Printz has pointed out, were "created, circulated, and appreciated" solely within the semicloseted urban gay subculture of the 1950s, a milieu that consisted of "friends . . . , commercial clients, colleagues, and celebrities, many of whom worked within the fields of fashion, design, and the theater."[16] Although Printz believes that Warhol abandoned this subcultural "cycle of production and reception" by the 1960s, when he moved away from commercial art into the more public sphere of Pop art, it is possible to read traces of this practice, with its recurring split between public and private, throughout Warhol's cinema. Some explicitly homoerotic films such as *Blow Job* and *Lonesome Cowboys* were made and released with calculated public effect, while others, such as *The Thirteen Most Beautiful Boys* and more pornographic films such as *Three*, *Couch*, and *David Bourdon Being Beaten* (all 1964), were exhibited and appreciated—at least at first—exclusively in private screenings among friends at the Factory.

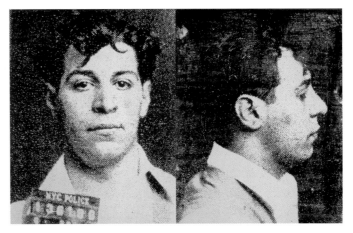

Andy Warhol, *Most Wanted Man No. 12: Frank B.*, 1964. Silk-screen ink on linen. Andy Warhol Foundation for the Visual Arts, Inc.

**ST364**  *The Thirteen Most Beautiful Boys,* 1964–66
16mm, b&w, silent; running time undetermined
(Thirteen 100' *Screen Tests* would have a running time of 55 min.
@ 16 fps, 49 min. @ 18 fps)
Cast: variable

*Screen Tests* Shot or Selected for **The Thirteen Most Beautiful Boys**

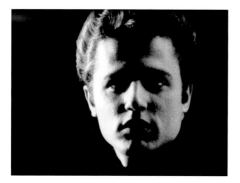

ST198. *Gerard Malanga,* 1964

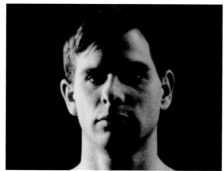

ST89. *Kelly Edey,* 1964

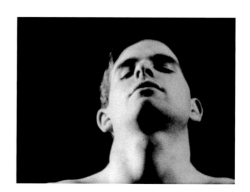

ST90. *Kelly Edey,* 1964

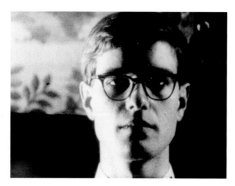

ST31. *Boy,* 1964

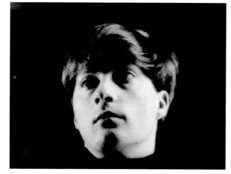

ST287. *Bruce Rudow,* 1964

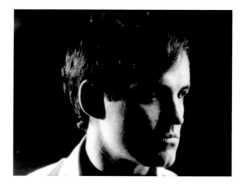

ST73. *Denis Deegan,* 1964

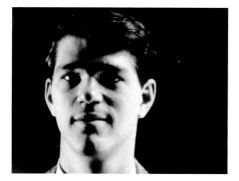

ST227. *Sophronus Mundy,* 1964

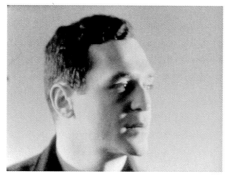

ST116. *John Giorno,* 1964

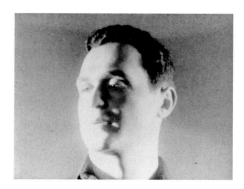

ST117. *John Giorno,* 1964

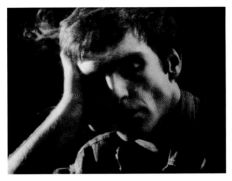

ST137. *Freddy Herko*, 1964

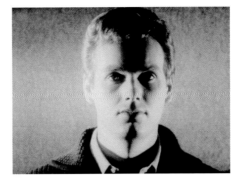

ST27. *DeVerne Bookwalter*, 1964

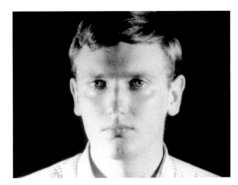

ST342. *Tony Towle*, 1964

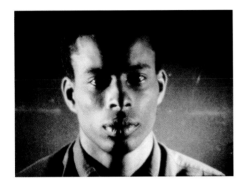

ST61. *Rufus Collins*, 1964

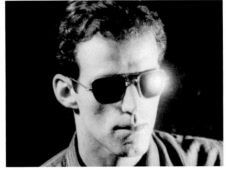

ST194. *Billy Linich*, 1964

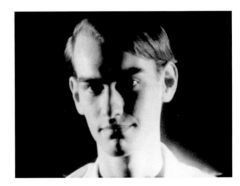

ST179. *Kenneth King*, 1964

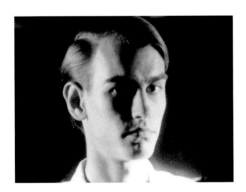

ST180. *Kenneth King*, 1964

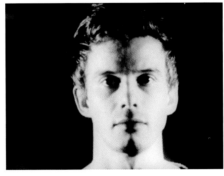

ST65. *Walter Dainwood*, 1964

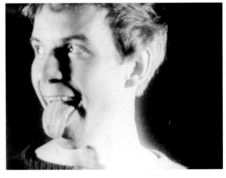

ST66. *Walter Dainwood*, 1964

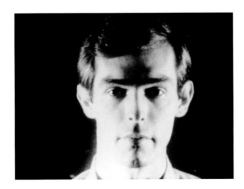

ST157. *Peter Hujar*, 1964

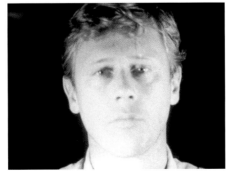

ST337. *Paul Thek*, 1964

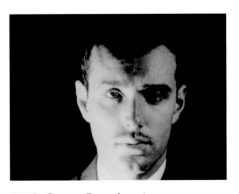

ST18. *Gregory Battcock*, 1964

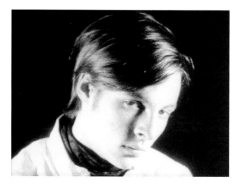

ST254. *John Palmer*, 1964

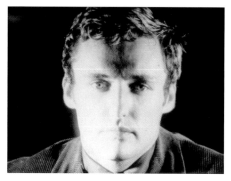

ST153. *Dennis Hopper*, 1964

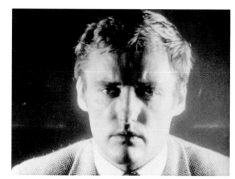

ST154. *Dennis Hopper*, 1964

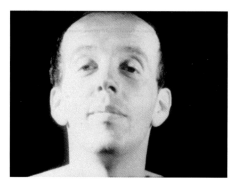

ST209. *Taylor Mead*, 1964

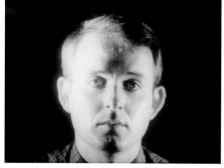

ST258. *Robert Pincus-Witten*, 1964

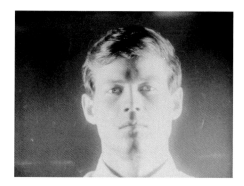

ST126. *David Hallacy*, 1964

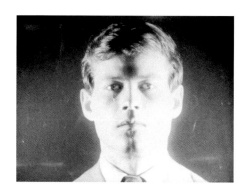

ST127. *David Hallacy*, 1964

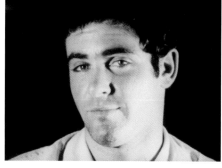

ST186. *Howard Kraushar*, 1964

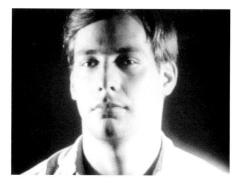

ST204. *Richard Markowitz*, 1964

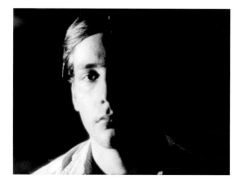

ST205. *Richard Markowitz*, 1964

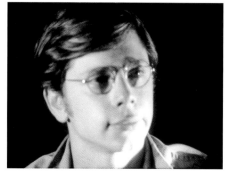

ST330. *Steve Stone*, 1964

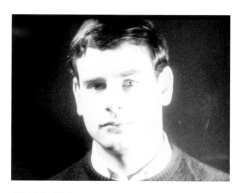

ST136. *Helmut*, 1964

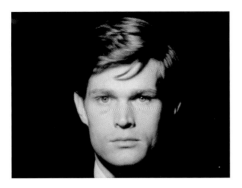

ST48. *Lawrence Casey*, 1964

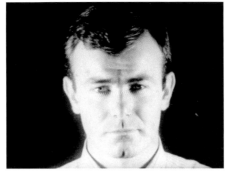

ST14. *Steve Balkin*, 1964

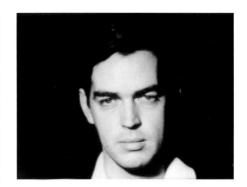

ST35. *Walter Burn*, 1964

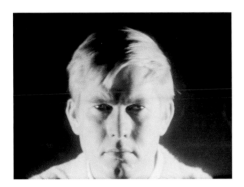

ST192. *Joe LeSueur*, 1964

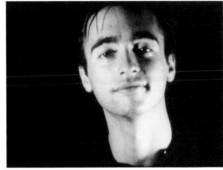

ST327. *Star of the Bed*, 1964

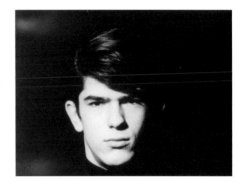

ST191. *Larry Latreille*, 1965

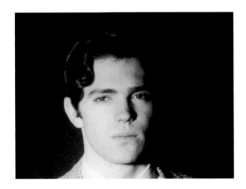

ST212. *François de Menil*, 1965

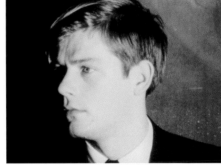

ST54. *James Claire*, 1966

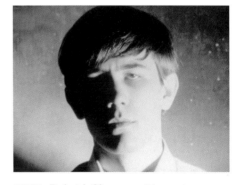

ST57. *Roderick Clayton*, 1966

## The Thirteen Most Beautiful Women

Warhol seems to have started collecting *Screen Tests* for a companion series, *The Thirteen Most Beautiful Women*, a month or two after he began *The Thirteen Most Beautiful Boys*. There are no *Screen Tests* of women shot on 1963 stock, and the earliest portraits of women most likely date to February or March of 1964, a month or two after the first male *Screen Tests*. As in the male version, the material identified as part of *The Thirteen Most Beautiful Women* series includes far more films than the title calls for: forty-seven *Screen Tests* of thirty different women (listed under ST365 in roughly chronological order). Unlike *The Thirteen Most Beautiful Boys*, however, several different versions of *The Most Beautiful Women* were shown in public screenings and also distributed, and can be roughly reconstructed from contemporary documentation and reviews, as well as from a few existing prints.

Although Billy Name has suggested that the larger exposure of *The Thirteen Most Beautiful Women* was due largely to the fame and popularity of Jane Holzer, in the mid-1960s the celebration and appreciation of female beauty would of course have been a much more acceptable theme than the celebration of male beauty. The title itself links the film to similar qualitative listings in other media, such as best dressed lists, beauty pageants, top models, and the whole world of fashion photography and fashion publishing. By establishing himself as the impresario and judge of beauty in his own film series, Warhol may have hoped to endow himself with the power and clout of a fashion editor, using the scales of selection and rejection to influence the various cultural circles through which he moved. As it happened, however, despite a certain amount of publicity, *The Thirteen Most Beautiful Women* seems to have been a much more modest and haphazard undertaking, with limited numbers of public screenings and a cast that includes unknowns like Rosebud and Betty Lou as well as art world figures like Susanne De Maria, Olga Adorno Klüver, and Barbara Rose, and celebrities like Marisol, Jane Holzer, and Susan Sontag.

A certain amount of manipulation can be observed in one of the first reported screenings of *The Thirteen Most Beautiful Women*, which took place in January 1965 at the home of *Life* magazine fashion editor Sally Kirkland. This event was covered by the *New York Herald Tribune*, which noted that, "Andy Warhol's '13 Most Beautiful Girls' didn't compete in some vast nationwide Underground Beauty Contest. He picked them and the stars for his companion movie '13 Most Beautiful Boys,' because they 'just sort of passed by'."[17] In this "Kirkland" version (ST365a) of *The Thirteen Most Beautiful Women*, the *Screen Tests* of fourteen different women were projected simultaneously on three walls; one of these women was Sally Kirkland's daughter, also named Sally (according to Jane Holzer, the two were called "Big" Sally and "Little" Sally).[18]

Another of the fourteen women was Ethel Scull, the Pop art collector whose portrait Warhol had painted in 1963. Interestingly, not one of Scull's five *Screen Tests* was found to have been labeled "13," but one of her portrait films was nevertheless included in this screening, confirming Name's observation that Warhol would selectively cast *The Thirteen Most Beautiful Women* in order to influence his patrons. The political usefulness of this screening can be detected in the publication of an article titled "Underground Clothes" in the March 19, 1965, issue of *Life* magazine. This article presented "wild and way-out clothes . . . in the tradition . . . of the wild and way-out new cinema form known as the underground movie," and featured models posing "against scenes from several underground movies by pop artist Andy Warhol." The models included Ivy Nicholson and Imu, who posed with their *Screen Test* images from *The Thirteen Most Beautiful Women* projected onto their bodies, and also Jane Holzer; projected images of several 1964 Warhol films, including *Henry Geldzahler*, *Eat*, *Batman Dracula*, and *Couch*, appear in the background behind the models.[19] It is hard not to associate the appearance of this article, undoubtedly commissioned by "Big" Sally Kirkland in her capacity as fashion editor at *Life*, with the screening of *The Thirteen Most Beautiful Women* at her party and the press coverage it generated in January.[20]

Since most of the women in the Kirkland version of *The Thirteen Most Beautiful Women* have more than one *Screen Test* marked "13," it is impossible to determine exactly which films were included in this screening. This is also true of another version of *The Thirteen Most*

Screen Tests of Ivy Nicholson and Imu, as well as other Warhol films, appear in a fashion spread in *Life* magazine, March 19, 1965, pp. 117–118. Photographs by Howell Conant.

*Beautiful Women*: a twenty-six-minute film titled *Six of Andy Warhol's Most Beautiful Women* (ST365b), which opened at the Carnegie Hall Cinema in New York on March 1, 1965. This reel of *Screen Tests* was projected continuously in the theater lounge (perhaps on a loop projector) while the feature attraction, Aleksei Batalov's 1959 film adaptation of Gogol's *The Overcoat*, played in the main theater. According to the *New York Times*, the beautiful women included "Sally Kirkland, an actress; Ann Buchanan, a writer; Ivy Nicholson, model and actress; Isabel Eberstadt, child's book writer; Beverly Grant, actress, and Baby Jane Holzer, model."[21] On March 8, the managers of the Carnegie Hall Cinema reported that they had been "stopped from exhibiting the 16mm film 'SIX MOST BEAUTIFUL WOMEN' in the lounge," and requested that the Film–Maker's Cooperative pick up the film immediately.[22] It is unclear why the exhibition was cancelled; perhaps one of the women objected to the continuous exhibition of her *Screen Test*, or perhaps the continuous screening violated some sort of building or union code. A slightly different six-woman version called *Most Beautiful Women* (ST365c), which replaced Ivy Nicholson and Isabel Eberstadt with Barbara Rose and Nancy Fish, was offered for rental through the Film-Makers' Cooperative catalogue, at a fee of $45.00.[23] This seems to be the version that was most widely seen; it was probably the version included in the New American Cinema Exposition in Buenos Aires organized by P. Adams Sitney in August 1965.

Another compilation that includes only three women has been found in an anomalous reel titled *Dracula/3 Most* (ST365d), which contains two original 100' rolls from *Batman Dracula* and three original *Screen Tests* of Sally Kirkland, Ivy Nicholson, and Nancy Fish. It is unclear for what purpose this reel was assembled; perhaps it was intended for a television broadcast or some other special event.[24] In any case, it has been catalogued here as yet another version of *The Thirteen Most Beautiful Women*.

The final versions of *The Thirteen Most Beautiful Women* were created in 1969–70, when Warhol Films Inc. and their British distributor, Vaughan–Rogosin Films, Ltd., licensed a few Warhol titles for broadcast on West German television. The deal listed *Kiss*, *Kitchen*, *The Shopper* (aka *Hedy*), and selections from what was called the *13*

*Most Beautiful Women in the World* (perhaps the film was given an international title for export to Germany).[25] It has been possible to reconstruct this six-woman version (ST365e) fairly exactly because, when the films passed through Jimmy Vaughan's hands in London, 16mm copies were made before they were sent on to Westdeutcher Rundfunk in Cologne; these copies have remained in private collections in London and Paris. Furthermore, the original *Screen Tests* from this 1969 version of *The Thirteen Most Beautiful Women* were found stored together as a group among the hundreds of 100' rolls in the Warhol Film Collection. Each of the six original *Screen Tests* in this group had been removed from its original yellow Kodak box and placed in a plain brown box labeled by hand; the films were probably put into these new boxes at the lab when the prints were made for shipment to England. Although none of these plain brown boxes are labeled "13," two of the films, Dennison and Nicholson, were labeled "BEAUTIFUL GIRL" on their head or tail leader; all six films have been matched to the existing prints in London.

The copies of these six *Screen Tests* made in London appear to be third-generation prints—that is, prints made from prints that were themselves made from the originals. The London prints were eventually formatted into two smaller films: a four-women version and a two-women version. The four-women version in the collection of David Curtis, *Four of Andy Warhol's Most Beautiful Women* (ST365f), was reconstructed and preserved from the original *Screen Tests* in 2001. The two-women version, *Two of Andy Warhol's Most Beautiful Women* (ST365g), exists as a print in the collection of Peter Gidal, who published images from the two *Screen Tests* of Brooke Hayward and Susanne De Maria in his book, *Andy Warhol—Films and Paintings: The Factory Years*.[26]

**ST365** *The Thirteen Most Beautiful Women,* 1964–65
16mm, b&w, silent; undetermined running time
(Thirteen 100' *Screen Tests* projected would have a running time of
55 min. @ 16 fps, 49 min. @ 18 fps)
Cast: variable

*Screen Tests* Shot or Selected for **The Thirteen Most Beautiful Women**

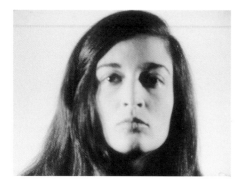
ST202. *Marisol,* 1964

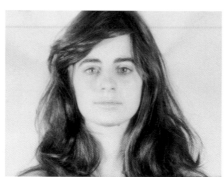
ST33. *Ann Buchanan,* 1964

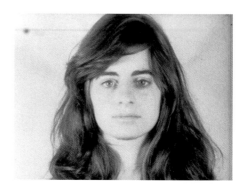
ST34. *Ann Buchanan,* 1964

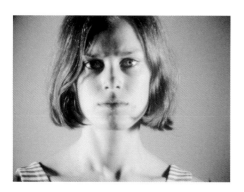
ST52. *Lucinda Childs,* 1964

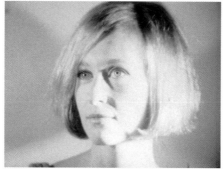
ST281. *Barbara Rose,* 1964

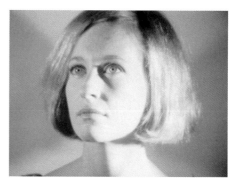
ST282. *Barbara Rose,* 1964

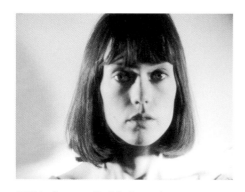
ST71. *Susanne De Maria,* 1964

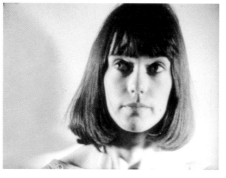
ST72. *Susanne De Maria,* 1964

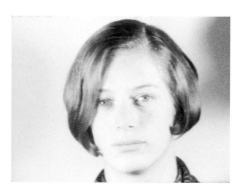
ST169. *Julie Judd,* 1964

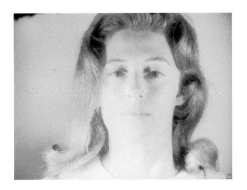

ST173. *Marilynn Karp*, 1964

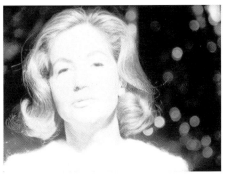

ST302. *Ethel Scull*, 1964

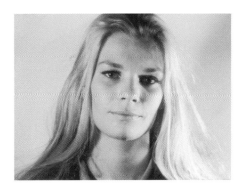

ST76. *Sally Dennison*, 1964

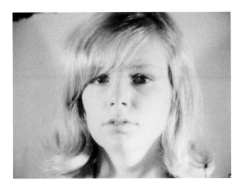

ST69. *Sarah Dalton*, 1964

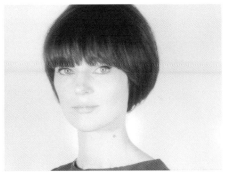

ST230. *Ivy Nicholson*, 1964

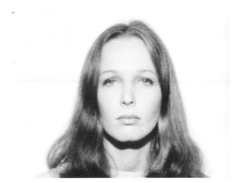

ST131. *Brooke Hayward*, 1964

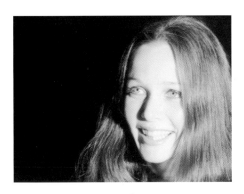

ST132. *Brooke Hayward*, 1964

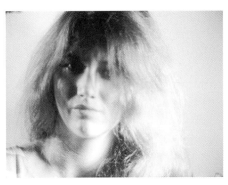

ST181. *Sally Kirkland*, 1964

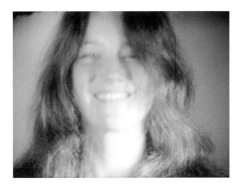

ST182. *Sally Kirkland*, 1964

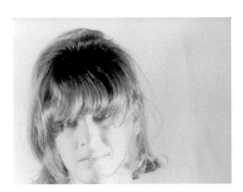

ST102. *Nancy Fish*, 1964

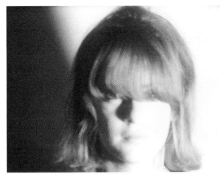

ST103. *Nancy Fish*, 1964

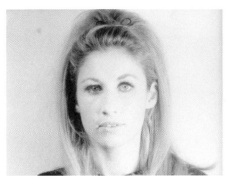

ST139. *Jane Holzer*, 1964

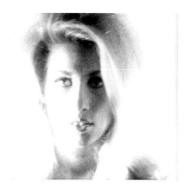

ST141. *Jane Holzer*, 1964

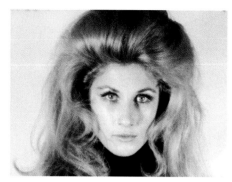

ST142. *Jane Holzer*, 1964

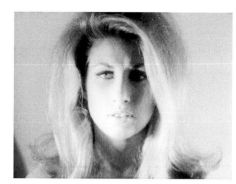

ST143. *Jane Holzer*, 1964

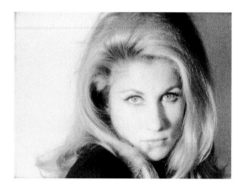

ST144. *Jane Holzer*, 1964

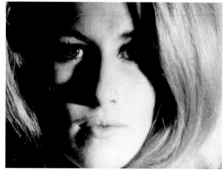

ST145. *Jane Holzer*, 1964

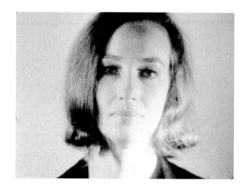

ST352. *Jane Wilson*, 1964

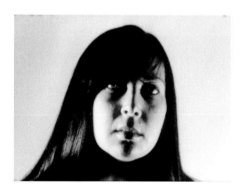

ST120. *Beverly Grant*, 1964

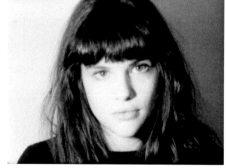

ST334. *Amy Taubin*, 1964

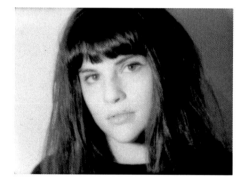

ST335. *Amy Taubin*, 1964

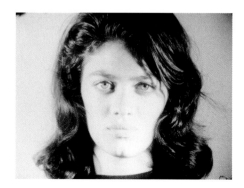

ST185. *Olga Klüver*, 1964

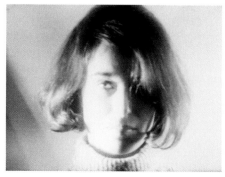

ST134. *Kate Heliczer*, 1964

ST362. *Marian Zazeela*, 1964

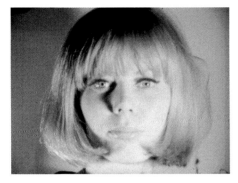

ST160. *Imu*, 1964

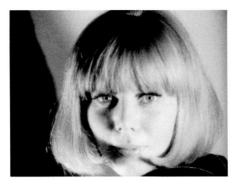

ST161. *Imu*, 1964

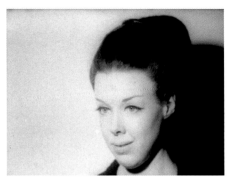

ST84. *Isabel Eberstadt*, 1964

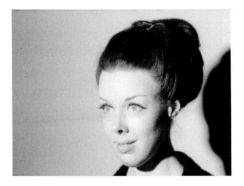

ST85. *Isabel Eberstadt*, 1964

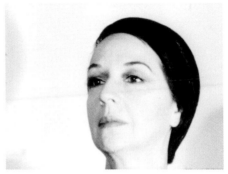

ST107. *Ruth Ford*, 1964

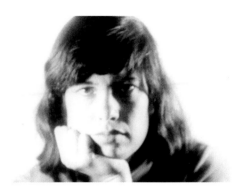

ST320. *Susan Sontag*, 1964

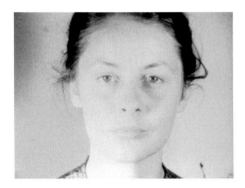

ST23. *Betty Lou*, 1964

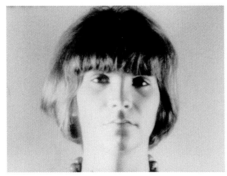

ST283. *Rosebud*, 1964

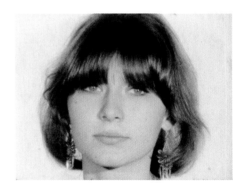

ST345. *Virginia Tusi*, 1965

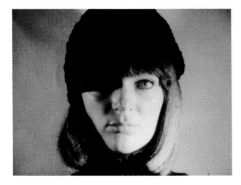

ST231. *Ivy Nicholson*, 1965

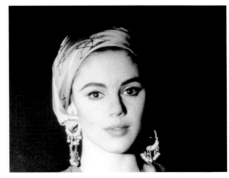

ST305. *Edie Sedgwick*, 1965

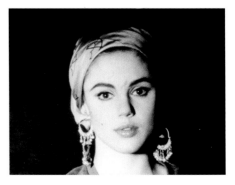

ST306. *Edie Sedgwick*, 1965

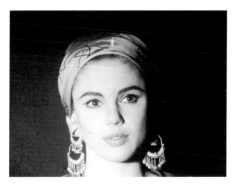 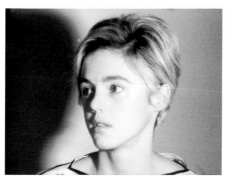 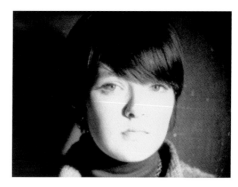

ST307. *Edie Sedgwick*, 1965 ST309. *Edie Sedgwick*, 1965 ST129. *Bibbe Hansen*, 1965

**ST365a**  *The Thirteen Most Beautiful Women (Kirkland version),* 1964–65

16mm, b&w, silent; 14 *Screen Tests* shown on multiple screens, undetermined running time
(Fourteen *Screen Tests* would have a total running time of 59 min. @ 16 fps, 53 min. @ 18 fps)
With (exact order unknown) Ann Buchanan, Lucinda Childs, Isabel Eberstadt, Nancy Fish, Beverly Grant, Jane Holzer, Imu, Sally Kirkland, Olga Klüver, Marisol, Ivy Nicholson, Barbara Rose, Ethel Scull, Jane Wilson

**ST365b**  *Six of Andy Warhol's Most Beautiful Women (Carnegie Hall Cinema version),* 1964–65

16mm, b&w, silent; 26 min. @ 16 fps, 23 min. @ 18 fps, shown continuously
With (exact order unknown) Ann Buchanan, Isabel Eberstadt, Beverly Grant, Jane Holzer, Sally Kirkland, Ivy Nicholson

**ST365c**  *Most Beautiful Women (Film-Makers' Coop version),* 1965

16mm, b&w, silent; 26 min. @ 16 fps, 23 min. @ 18 fps
With (exact order unknown) Ann Buchanan, Nancy Fish, Beverly Grant, Jane Holzer, Sally Kirkland, Barbara Rose

**ST365d**  *3 Most Beautiful Women,* 1966

16mm, b&w, silent; 13.5 min. @ 16 fps, 12 min. @ 18 fps
With Sally Kirkland, Ivy Nicholson, Nancy Fish

**FILM MATERIALS**

ST365d.1  *Dracula/3 Most*
1964 Kodak 16mm b&w reversal original, 542', of which the *Screen Tests* constitute the last 325'. The first 217' are two original rolls from *Batman Dracula* (1964)

**NOTATIONS**

On tape on can lid in Paul Morrissey's hand: *ORIG DRACULA 4–13*
On tape on lid in unidentified hand: *REELS 4–13 DRACULA*
On Eastman Kodak label on lid in unidentified hand: *6 min Dracula. 3 Most. 3*
On tape on rim in Paul Morrissey's hand: *ORIG DRACULA*
On tape on reel in unidentified hand: *Dracula 4–13*

**CONTENTS**

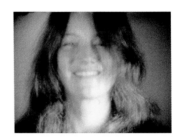

Roll 3
*Sally Kirkland,* 1964
(ST182)

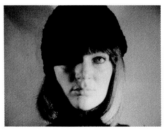

Roll 4
*Ivy Nicholson,* 1965
(ST231)

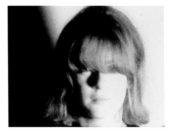

Roll 5
*Nancy Fish,* 1964
(ST103)

## ST365e   The Thirteen Most Beautiful Women in the World (Vaughan version), 1969–70

16mm, b&w, silent; 26 min. @ 16 fps, 23 min. @ 18 fps
With (exact order unknown) Ann Buchanan, Susanne De Maria, Sally Dennison, Brooke Hayward, Jane Holzer, Ivy Nicholson

**CONTENTS**

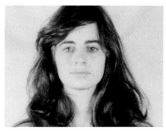

*Ann Buchanan*, 1964
(ST33)

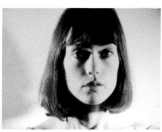

*Susanne De Maria*, 1964
(ST71)

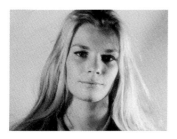

*Sally Dennison*, 1964
(ST76)

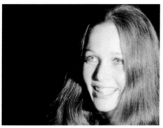

*Brooke Hayward*, 1964
(ST132)

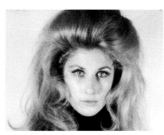

*Jane Holzer*, 1964
(ST142)

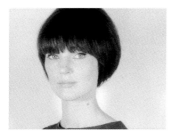

*Ivy Nicholson*, 1964
(ST 230)

## ST365f   Four of Andy Warhol's Most Beautiful Women, 1964–69

16mm, b&w, silent; 18 min. @ 16 fps; 16 min. @ 18 fps
With Jane Holzer, Ann Buchanan, Sally Dennison, Ivy Nicholson
Preserved 2001, The Museum of Modern Art, reconstructed from original *Screen Tests* (ST142, ST33, ST76, ST230) to match prints found in private collections

**FILM MATERIALS**

ST365f.1.p1 *Four of Andy Warhol's Most Beautiful Women*
c. 1970 16mm b&w reversal print; 430'
Collection of David Curtis, London
ST365f.1.p2 *Four of Andy Warhol's Most Beautiful Women*
c. 1970 16mm b&w reversal print; ca 430'
Private collection, Paris

**CONTENTS**

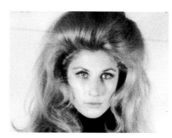

1. *Jane Holzer*, 1964
(ST142)

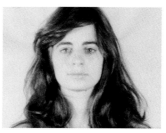

2. *Ann Buchanan*, 1964
(ST33)

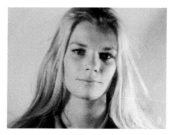

3. *Sally Dennison*, 1964
(ST76)

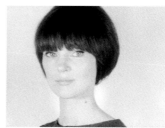

4. *Ivy Nicholson*, 1964
(ST230)

**ST365g**  *Two of Andy Warhol's Most Beautiful Women,*
1969–70
16mm, b&w, silent; 9 min. @ 16 fps, 8 min. @ 18 fps
With (exact order unknown) Susanne De Maria and
Brooke Hayward

**FILM MATERIALS**

ST365g.1.p1 *Two of Andy Warhol's Most Beautiful Women*
ca. 1970 16mm print, b&w, silent; 218'
Collection of Peter Gidal, London

**CONTENTS**

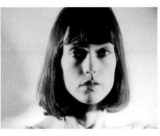

*Susanne De Maria*, 1964
(ST71)

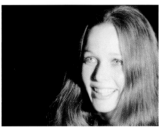

*Brooke Hayward*, 1964
(ST132)

## Fifty Fantastics and Fifty Personalities

Although a film called *Fifty Fantastics and Fifty Personalities* would be expected to contain portraits of one hundred people, only forty-one *Screen Tests* of thirty-five different people were found to have been selected for this title, either with their names listed under this title in earlier filmographies, or with their film boxes notated with the word "personality" or the number "50." Given the small number of films actually selected for this title, the series seems to have been something of an afterthought, conceptualized primarily as a way of organizing and exhibiting the large numbers of *Screen Tests* accumulating at the Factory, especially those not already chosen for *The Thirteen Most Beautifuls.*

Jonas Mekas's 1970 filmography describes *Fifty Fantastics and Fifty Personalities* as "two series of 100-foot portraits" existing in the original only, and lists "Some of the people filmed: Allen Ginsberg, Ed Sanders, Jim Rosenquist, Zachary Scott, Peter Orlovsky, Henry Rago, Ted Berrigan, Roy Lichtenstein, Gregory Battcock, Barbara Rubin, Daniel Cassidy, Harry Fainlight."[27] The fact that many of the *Screen Tests* listed by Mekas do not bear any specific notations for "personalities" or "50" on their boxes underlines the ephemeral and highly changeable nature of this project.

The films selected or shown in this series constitute a rather broad selection of Warhol's friends and colleagues, all of them remarkable people in one way or another. The balance of artists and intellectuals, actors and gallery owners, filmmakers and critics, patrons and poets is reflective of the Factory social scene in the mid-1960s, and gives some idea of the kind of people Warhol admired or was influenced by at the time.

No physical film materials have been found for this title, although an anomalous reel, catalogued in Chapter Five under the title *EPI Background* (ST370), could be a possible candidate for a reel of *Fifty Fantastics and Fifty Personalities.* The reel contains prints of ten *Screen Tests* and prints of two rolls from *Batman Dracula* (1964); however, only one of the original *Screen Tests*, that of Susan Sontag (ST323), was labeled "good personality" on the box. It is more likely that this reel was one of the earliest background reels used in projection behind the Velvet Underground during performances of the Exploding Plastic Inevitable (EPI); this is suggested by the inclusion of a *Screen Test* of Nico (ST238), which was labeled "Best. orig. of Nico. Used in show." Also, each of the *Screen Tests* included in this reel is numbered on the head of the film in a sequence that matches its order in this reel. The exact numbering of the originals in the reel suggests the kind of organized assembling and printing of rolls that was undertaken for the EPI background reels in 1966, a step that seems never to have been taken with the earlier conceptual reels.

**ST366** *Fifty Fantastics and Fifty Personalities,* 1964–66
16mm, b&w, silent; running time undetermined
(One hundred 100' *Screen Tests* would have an estimated running
time of 7 hrs. 10 min. @ 16 fps, 6 hrs. 20 min. @ 18 fps)
Cast: variable

*Screen Tests* Shot or Selected for **Fifty Fantastics and Fifty Personalities**

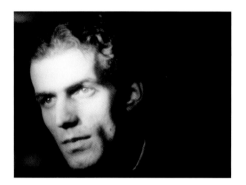

ST193. *Billy Linich*, 1964

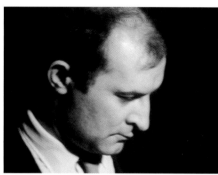

ST12. *Arman*, 1964

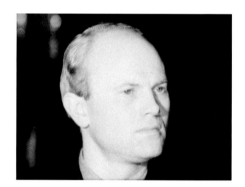

ST285. *Jim Rosenquist*, 1964

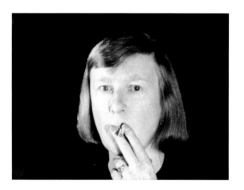

ST63. *Rosalind Constable*, 1964

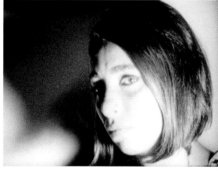

ST100. *Bea Feitler*, 1964

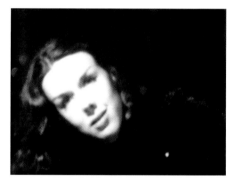

ST87. *Isabel Eberstadt*, 1964

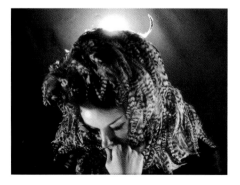

ST88. *Isabel Eberstadt (Feathers)*, 1964

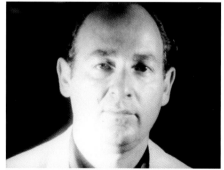

ST171. *Ivan Karp*, 1964

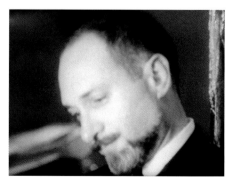

ST316. *Alan Solomon*, 1964

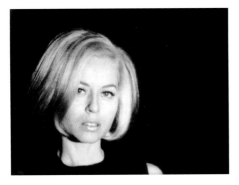

ST317. *Holly Solomon*, 1964

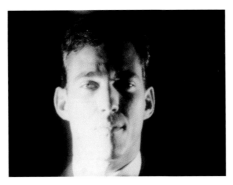

ST111. *Fred*, 1964

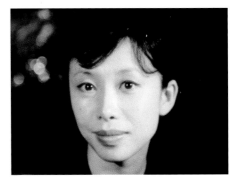

ST183. *Kyoko Kishida*, 1964

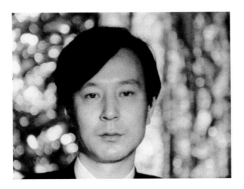

ST229. *Noboru Nakaya*, 1964

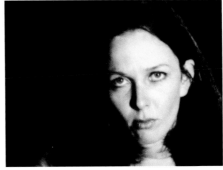

ST133. *Brooke Hayward*, 1964

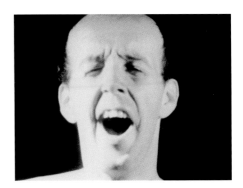

ST210. *Taylor Mead*, 1964

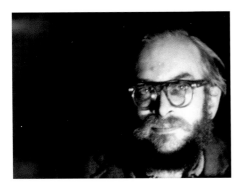

ST314. *Harry Smith*, 1964

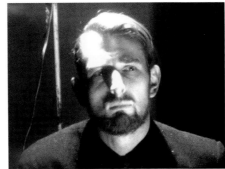

ST315. *Jack Smith*, 1964

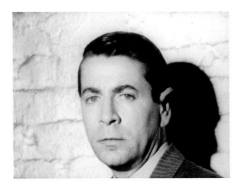

ST280. *Henry Romney*, 1964

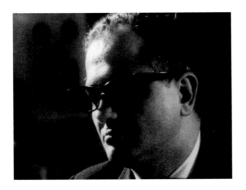

ST295. *Andrew Sarris*, 1964

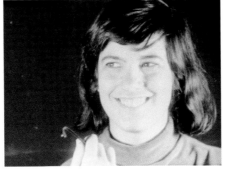

ST321. *Susan Sontag*, 1964

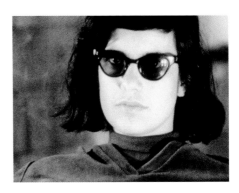

ST323. *Susan Sontag*, 1964

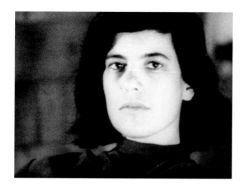

ST324. *Susan Sontag*, 1964

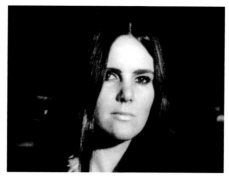

ST277. *Clarice Rivers*, 1964

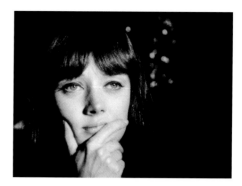

ST292. *Niki de Saint Phalle*, 1964

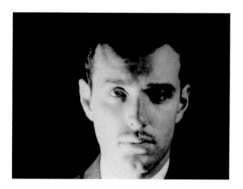

ST18. *Gregory Battcock*, 1964

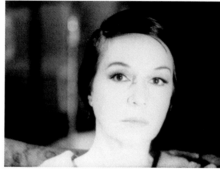

ST106. *Ruth Ford*, 1964

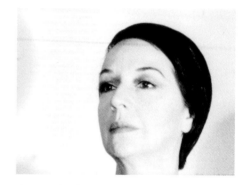

ST107. *Ruth Ford*, 1964

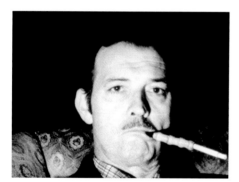

ST298. *Zachary Scott*, 1964

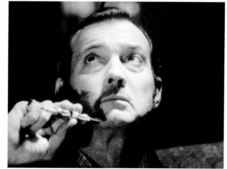

ST299. *Zachary Scott*, 1964

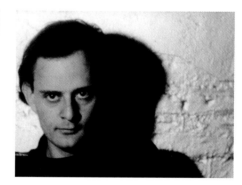

ST97. *Harry Fainlight*, 1964

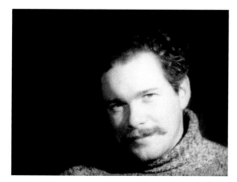

ST293. *Ed Sanders*, 1964

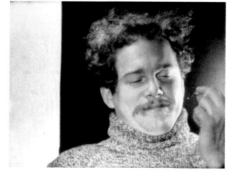

ST294. *Ed Sanders*, 1964

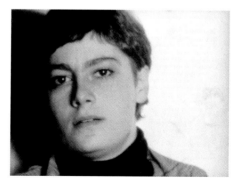

ST286. *Barbara Rubin*, 1965

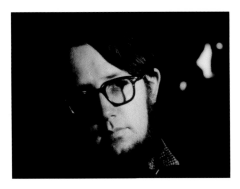

ST22. *Ted Berrigan*, 1965

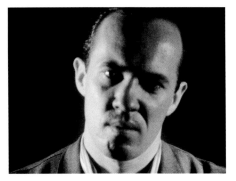

ST208. *John D. McDermott*, 1965

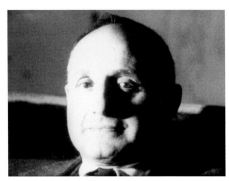

ST260. *Henry Rago*, 1965

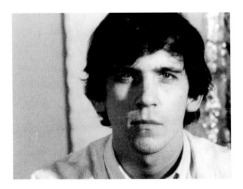

ST50. *Dan Cassidy*, 1965

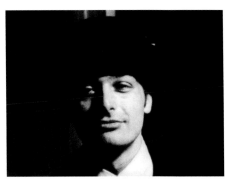

ST135. *Piero Heliczer*, 1965

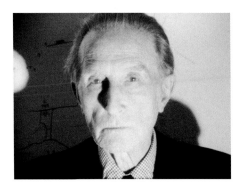

ST80. *Marcel Duchamp*, 1966

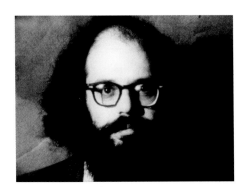

ST115. *Allen Ginsberg*, 1966

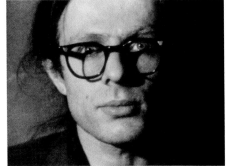

ST250. *Peter Orlovksy*, 1966

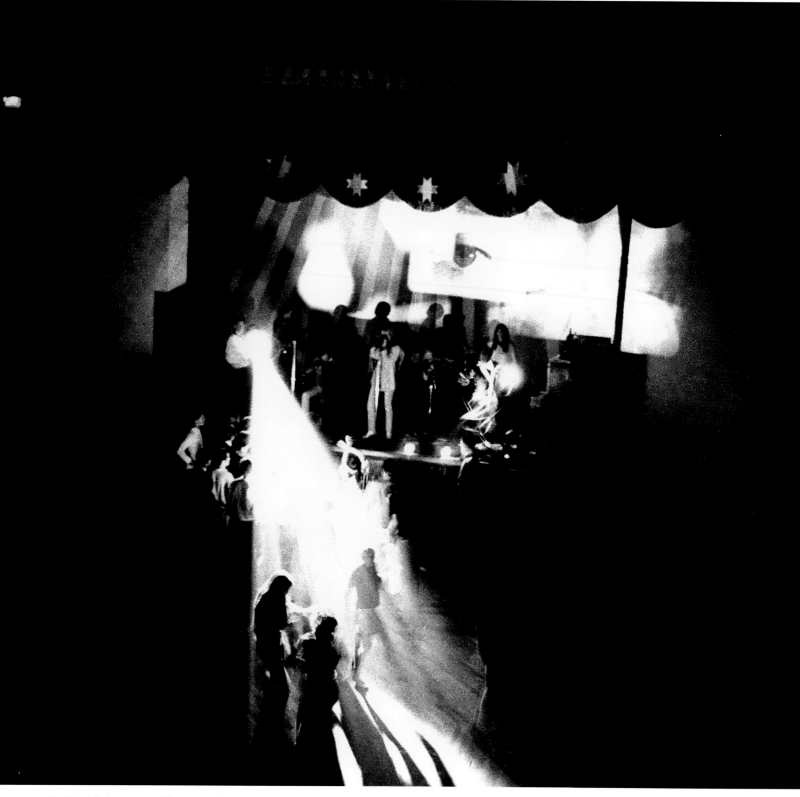

The Velvet Underground and Nico perform in front of a projection of *John Cale (Eye)* (ST39 or ST40) at the Dom, New York City, April 1966. Photograph by Billy Name.

# Chapter Five
# Background Reels
## EPI Background, Screen Test Poems, and Others

### EPI Background Reels

Beginning in early 1966, Warhol and his colleagues, including Paul Morrissey, Dan Williams, and Barbara Rubin, began organizing multimedia events to accompany live performances by the Velvet Underground, the proto-punk rock-and-roll group that Warhol had recently offered to manage. These multimedia environments included dancers, lights, filmmakers, colored and patterned slides, strobe lighting, and the projection of Warhol's films on walls around the auditorium and behind the performers on stage, usually on multiple screens and with sometimes as many as five projectors at once, some of them handheld. The entire performance, including all these visual effects and the Velvet Underground playing live onstage, was first called Andy Warhol Up-Tight; later the name was changed to the Exploding Plastic Inevitable, or EPI. (Volume 2 will contain a more extended discussion of the EPI and its relation to the Warhol films.)

Earlier Warhol films from previous years were often reused for screenings during the EPI, while new features, such as *More Milk Yvette* (1965), were sometimes screened or even premiered in multiscreen at these performances. An April 1966 ad for the Exploding Plastic Inevitable, "Andy Warhol's New Disco-Flicka-Theque," at the Dom at 23 St. Mark's Place, promised "Gerard Malanga and Mary Woronov on Film on Stage on Vinyl" and "movies including *Vinyl, Sleep, Eat, Kiss, Empire, Whips, Faces, Harlot, Hedy, Couch, Banana*, etc., etc., all in the same place at the same time."[1] In addition to this recycling of old footage, a few feature films were produced in 1966 specifically for background screening in the EPI: *The Velvet Underground and Nico, The Velvet Underground*, and *The Velvet Underground Tarot Cards*.

In early 1966, the Warhol film organization also began assembling reels of *Screen Tests*, mostly in print form, for projection during the EPI; these reels are possibly the *Faces* films mentioned in the April 1966 EPI ad. Prints were made of some earlier *Screen Tests*, but a number of new *Screen Tests*, especially those of the Velvet Underground performers Lou Reed, John Cale, Sterling Morrison, Maureen Tucker, and Nico, seem to have been made especially for use as EPI background projections. *Screen Tests* that focus on individual features of people's faces, such as John Cale's or Sterling Morrison's eye (ST39–40, ST224), Lou Reed's lips (ST264), or Nico's eyes (ST242), appear in a number of the *EPI Background* reels, and seem to have been shot specifically for these projections. Other *Screen Tests* used in the background reels are pseudocommercials, parodistic celebrity endorsements in which Lou Reed or Nico pose with Coca-Cola or beer bottles or eat Hershey bars (ST269, ST270–271, ST243–246). Unlike earlier *Screen Tests*, these films are not so much individual portraits as graphic or iconic images of Warhol's underground rock-and-roll stars, mobile montages of fragmented faces and mysteriously frozen poses that would appear and disappear like ephemeral billboards or television commercials amid the overwhelming sensory environment of the Exploding Plastic Inevitable. Other 1966 EPI

*Screen Tests* (see, for example, those included in *EPI Background: Velvet Underground*, ST369) contain notably frenetic camerawork, with rapid zooms and pans, single-framing, and deliberate jigglings and blurrings that approximated the avant-garde "noise" of the Velvets' music and added still more layers of visual disorientation to the choreographed chaos of loud music, flashing lights, and wildly dancing bodies that constituted the EPI.

A total of seven background reels have been found in the collection. Each *Screen Test* print in the background reels has been matched to its original, and cross-referenced accordingly under "Compilations" in the alphabetical entries in Chapter Two. In some cases, where noted, the originals of certain *Screen Test* prints have not been located in the collection; in these cases, the *EPI Background* prints represent the only known material for these particular films, which have also been catalogued individually in the alphabetical *Screen Test* entries.

Only one of these reels, *EPI Background: Original Salvador Dalí* (ST367), contains original material: four original *Screen Tests* of Salvador Dalí (ST68), Nico (ST237), Sterling Morrison (ST223), and Lou Reed (ST262) are followed by two original 100' rolls of a whip dance performed by Gerard Malanga and Mary Woronov. Each of these four original *Screen Tests* has been catalogued individually in the alphabetical *Screen Test* listings. The two whip dance rolls, titled *Whips I* and *Whips II*, show Malanga and Woronov at the Factory performing an S and M dance with whip and leather mask, a routine they performed live when the Velvet Underground played their song "Venus in Furs," during which Warhol's S and M film *Vinyl* was often projected.[2]

There is some evidence that this *Salvador Dalí* film may have been originally conceptualized as a larger project. The fact that both of Salvador Dalí's *Screen Tests* (ST67–68) have numbers written on the heads of the films ("R. 1" and "R. 2") suggests that perhaps they were meant to be shown together, perhaps side by side in double-screen projection as background reels during the EPI. And some sort of ambitious Dalí film project appears to have been in the planning stages in 1966. A telegram, dated June 2, 1966, from Philip Smith to Warhol mentions "arrangements for up to 100,000 dollars to be available for our Warhol-Dalí flick. Call me today . . . without fail or the aforementioned can be written off, and you will find yourself on the receiving end of a 60,000 dollar lawsuit."[3] Philip ("Fu-Fu") Smith later unsuccessfully sued Warhol regarding alleged investments in some Warhol films (*Camp* (1965), *The Bed* (1965), an unrealized project called *Jane Eyre Bare*, and *Withering Sights* (1966)). Smith's threatening tone suggests that this Dalí film venture did not get very far.

The remaining *EPI Background* reels contain print material only. *EPI Background: Gerard Begins* and *EPI Background: Velvet Underground* comprise portraits of the Velvet Underground and of the other performers who appeared in the EPI: Gerard Malanga, Mary Woronov, and Nico. These background reels do contain a few non-*Screen Test* rolls. For example, *EPI Background: Velvet Underground* (ST369) not only contains prints of the *Whips* rolls, but also a print

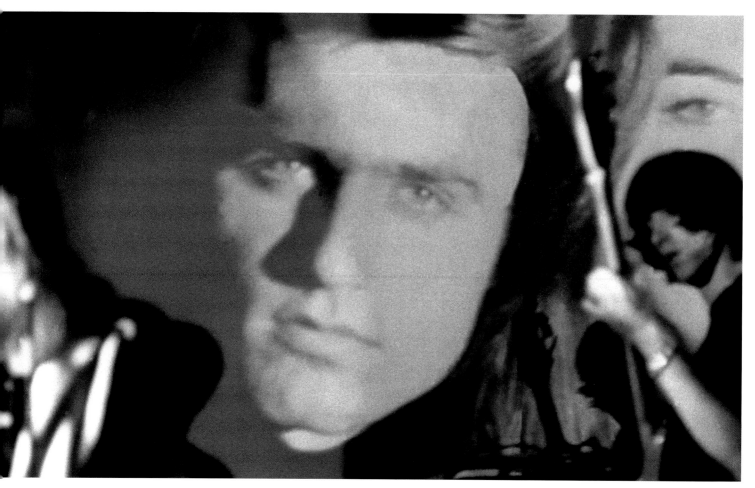

*Screen Test* of Gerard Malanga and Mary Woronov projected behind the Velvet Underground during a performance of the Exploding Plastic Inevitable at the Trip, Los Angeles, May 1966. Photograph by Lisa Law.

(roll 9) of a 100' close-up of someone (presumably a member of the Velvet Underground) clipping his or her fingernails; the original for this *Nail Clipping* roll has not been located.

*EPI Background* (ST370) is such an anomalous reel that it must also be considered a possible candidate for *Fifty Fantastics and Fifty Personalities* (see ST366). This reel contains prints of two 100' rolls from *Batman Dracula* (1964) as well as *Screen Tests* of non-EPI people such as Jim Rosenquist (ST284), Henry Geldzahler (ST113), and Susan Sontag (ST323). But *EPI Background* also contains a print of a *Screen Test* of Nico reading, the original of which (ST238) was annotated "Best orig. of Nico for show." It is possible that this reel began as a compilation for *Fifty Fantastics and Fifty Personalities* and was later appropriated for the EPI, perhaps under the title *Faces*, with a print of Nico's *Screen Test* spliced on at the end. A photograph taken by Nat Finkelstein in April 1966 shows Lou Reed performing at the Dom in front of a large projection of this particular *Screen Test* of Nico, which confirms the use of this particular background reel during the EPI performances (see p. 18).

As noted in the individual *Screen Test* entries, a number of original *Screen Tests* were found to have numbers written on the clear film at the beginning of the rolls. These head numbers correspond to roll positions in assembled background reels: see, for example, the entries for most of the original *Screen Tests* included in *EPI Background* (ST370), where head numbers match roll positions exactly. Numbers were found written on the heads of fourteen original *Screen Tests* of Lou Reed, Sterling Morrison, Nico, and Salvador Dalí that do not appear in any of the existing *EPI Background* reels. This strongly suggests that there was at least one additional background reel that is currently missing from the collection (see ST371, *EPI Background: Lost Reel*). A mention of this missing reel appears in a February 1967 article in *Night Owl* magazine, which describes Nico performing with Jackson Browne at the Dom while movies were projected behind her: "Lou Reed eats an apple . . . hershey bar" apparently describes rolls 8 and 9 in this hypothetical reel.[4]

**ST367** *EPI Background: Original Salvador Dalí,* 1966
16mm, b&w, silent; 25.3 min. @ 16 fps, 22.5 min. @ 18 fps
With (in order of appearance) Salvador Dalí, Nico, Sterling
Morrison, Lou Reed, Gerard Malanga, Mary Woronov
Preserved in 1999 by MoMA under the title *Salvador Dalí*
**FILM MATERIALS**
ST367.1 *EPI Background*: *Original Salvador Dalí*
1965 Kodak 16mm b&w reversal original, 605'
**NOTATIONS** On tape on lid of can: *ORIG. S. DALI*
On tape on rim: *ORIGINAL S. DALI. Gerard Malanga Mary*
*Woronov Whip Dancing*
On white head leader: *R. 2*

CONTENTS

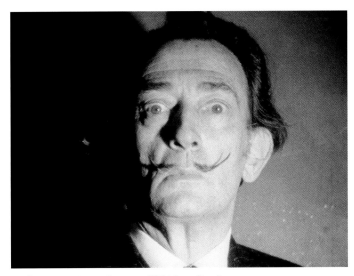

Roll 1. *Salvador Dalí*, 1966 (ST68), spliced to:

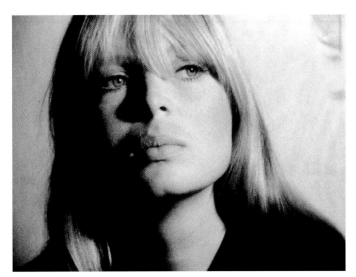

Roll 2. *Nico*, 1966 (ST237), spliced to:

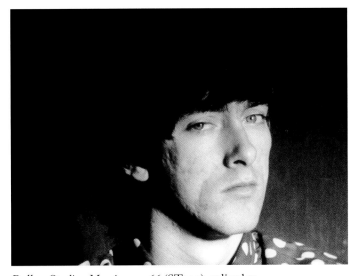

Roll 3. *Sterling Morrison*, 1966 (ST223), spliced to:

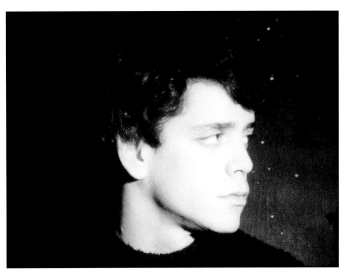

Roll 4. *Lou Reed*, 1966 (ST262), spliced to:

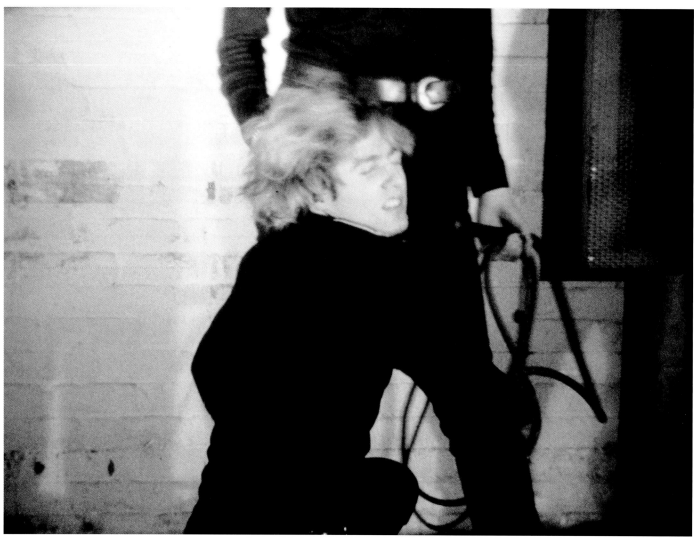

Roll 5. *Whips I*, 1966 (See *EPI Background: Gerard Begins*, ST368, roll 3, for a print of this roll), spliced to:

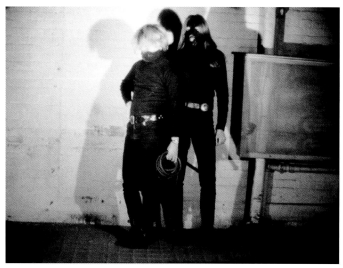

Roll 6. *Whips II*, 1966 (See *EPI Background*: *Gerard Begins*, ST368, roll 5, and *EPI Background*: *Velvet Underground*, ST369, rolls 7 and 8, for additional prints of this roll)

## ST368 *EPI Background: Gerard Begins,* 1966

16mm, b&w, silent; 42 min. @ 16 fps, 37.3 min. @ 18 fps
With (in order of appearance) Gerard Malanga, Mary Woronov,
John Cale, Sterling Morrison, Lou Reed, Maureen Tucker

**FILM MATERIALS**

ST368.1 *EPI Background: Gerard Begins*
1965 Kodak 16mm b&w reversal print, 1,007'

**NOTATIONS**  On lid of original can in AW's hand: *Cinema Scope*
On white tape on rim in unidentified hand: *BACKGROUND FOR
PLASTIC INEVITABLE GERARD BEGINS ST*
On white tape on head of film: *B + W, Velvet Underground
Bckgds – silent*

**CONTENTS**

Roll 1. *Gerard Malanga and Mary Woronov*, 1966 (ST356. Original
not found in Collection; see roll 1 of ST372.1, *Screen Test Poems,
Reel 1*, for another print of this film), spliced to:

Roll 2. *John Cale (Eye)*, 1966 (ST40), spliced to:

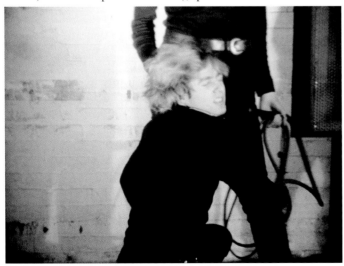

Roll 3. *Whips I*, 1966 (ST367, roll 5, *EPI Background: Original
Salvador Dalí* ), spliced to:

Roll 4. *John Cale (Lips)*, 1966 (ST41), spliced to:

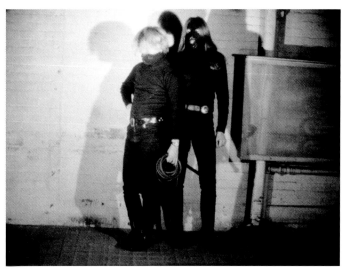

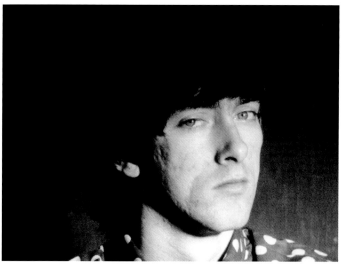

Roll 5. *Whips II*, 1966 (ST367, roll 6, *EPI Background: Original Salvador Dalí*), spliced to:

Roll 6. *Sterling Morrison*, 1966 (ST223; original is ST367, roll 3, *EPI Background: Original Salvador Dalí*), spliced to:

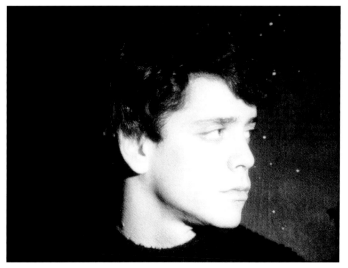

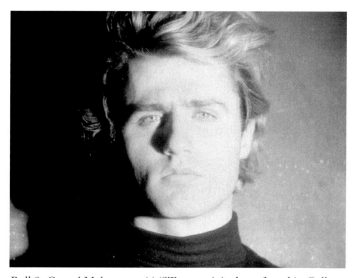

Roll 7. *Lou Reed*, 1966 (ST262; original is ST367, roll 4, *EPI Background: Original Salvador Dalí*), spliced to:

Roll 8. *Gerard Malanga*, 1966 (ST201; original not found in Collection), spliced to:

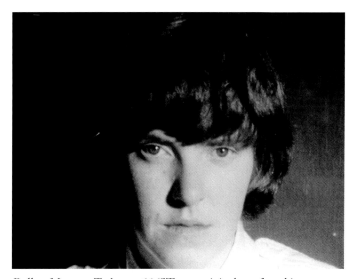

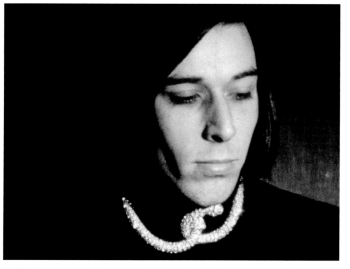

Roll 9. *Maureen Tucker*, 1966 (ST343; original not found in Collection), spliced to:

Roll 10. *John Cale*, 1966 (ST42; original not found in Collection)

**ST369** *EPI Background: Velvet Underground,* 1966
16mm, b&w, silent; 49.3 min. @ 16 fps, 43.8 min. @ 18 fps
With (in order of appearance) Nico, John Cale, Lou Reed, Gerard
Malanga, Mary Woronov

**FILM MATERIALS**
ST369.1 *EPI Background: Velvet Underground*
1965 Kodak 16mm b&w reversal print, 1,183', not including white
head and tail leader
Film broken and repaired at head
**NOTATIONS** Nothing written on can
On white tape on tail leader in unidentified hand: *Tail. B + W Print
Velvet Underground Background – silent*

CONTENTS

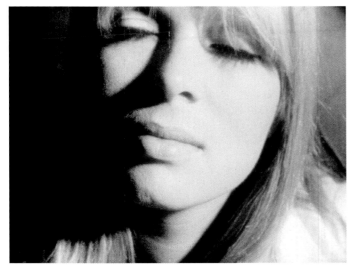

Roll 1. Begins with white head leader. *Nico*, 1966 (ST240; original
not found in Collection), spliced to:

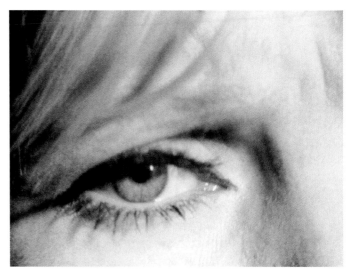

Roll 2. Begins with black leader. On clear film at head of roll: *4.
Nico*, 1966 (ST241), spliced to:

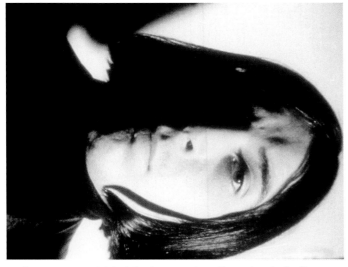

Roll 3. Begins with black leader. On clear film at head of roll: *4.
John Cale*, 1966 (ST43; original not found in Collection), spliced to:

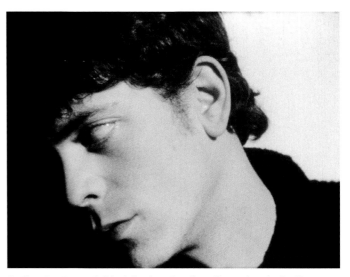

Roll 4. Begins with black leader. On clear film at head of roll: *12.
Lou Reed*, 1966 (ST266), spliced to:

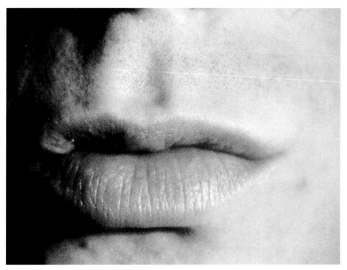

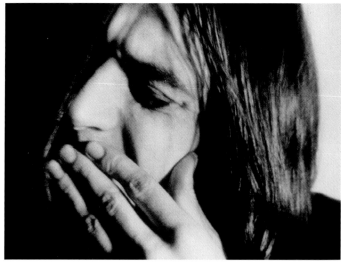

Roll 5. *Lou Reed (Lips)*, 1966 (ST264), spliced to:

Roll 6. Begins with black leader. On clear film at head of roll: *9. John Cale*, 1966 (ST44; original not found in Collection), spliced to:

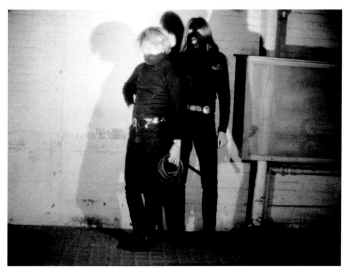

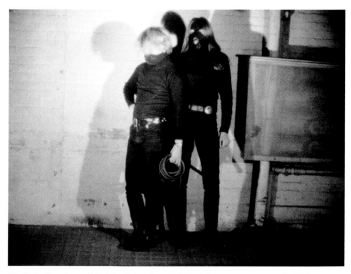

Roll 7. *Whips II*, 1966 (ST367, roll 6, *EPI Background: Original Salvador Dalí*), spliced to:

Roll 8. Begins with black leader *Whips II*, 1966, repeated (ST367, roll 6, *EPI Background: Original Salvador Dalí*), spliced to:

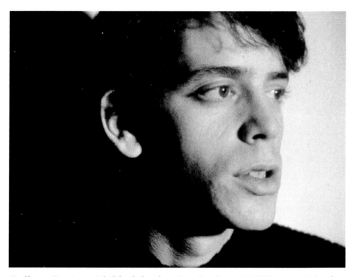

Roll 9. *Nail Clipping*, 1966 (original not found in Collection), spliced to:

Roll 10. Begins with black leader, *Lou Reed*, 1966 (ST267; original not found in Collection), print-through tape splice to:

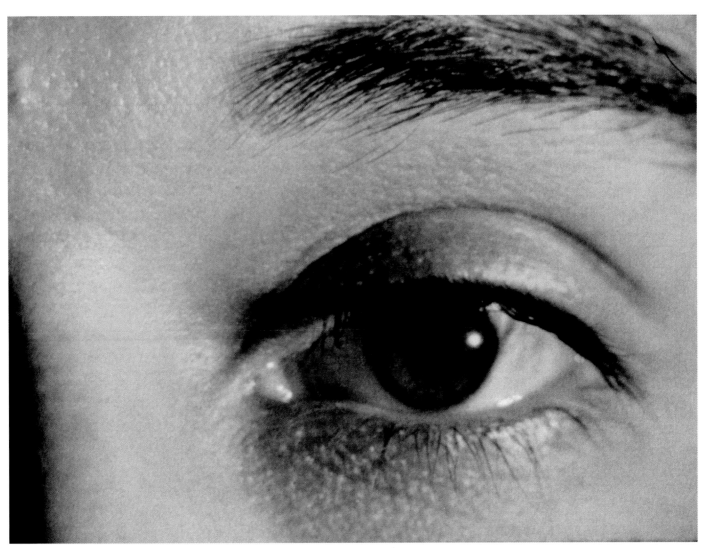

Roll 11. Begins with black leader. *John Cale (Eye)*, 1966 (ST39), spliced to white tail leader

**ST370    *EPI Background,* 1966**

16mm, b&w, silent; 53.5 min. @ 16 fps, 47.6 min. @ 18 fps
With (in order of appearance) James Rosenquist, Marisa Berenson,
Beverly Grant, Ivy Nicholson, Jane Holzer, Henry Geldzahler,
Marcel Duchamp, Benedetta Barzini, Edie Sedgwick, Jack Smith,
Susan Sontag, Donyale Luna, Nico

**FILM MATERIALS**
ST370.1 *EPI Background*
Undated 16mm b&w reversal print, 1,284'
No splices

CONTENTS

Roll 1. *Twist Jim Rosenquist,* 1964 (ST284)

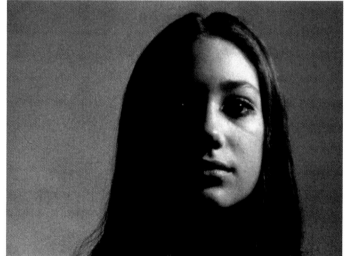

Roll 2. On clear film at head of roll: 2
*Marisa Berenson,* 1965 (ST20; original not found in Collection)

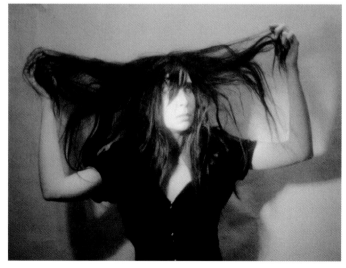

Roll 3. On clear film at head of roll: 3
*Beverly Grant (Hair),* 1964 (ST123)

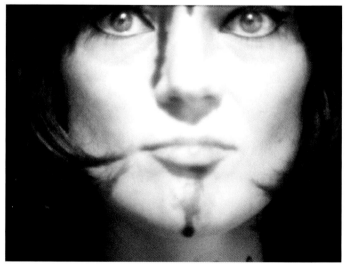

Roll 4. On clear film at head of roll: 4
*Ivy Nicholson,* 1964 (original is in *Batman Dracula,* 1964, see Vol. 2)

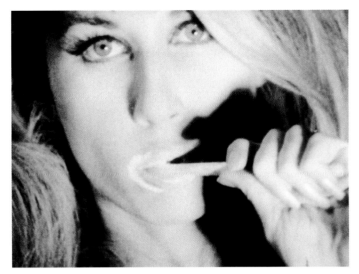

Roll 5. On clear film at head of roll: 5
*Jane Holzer (Toothbrush)*, 1964 (ST147)

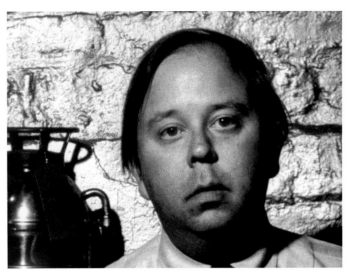

Roll 6. On clear film at head of roll: 6
*Henry Geldzahler*, 1965 (ST113)

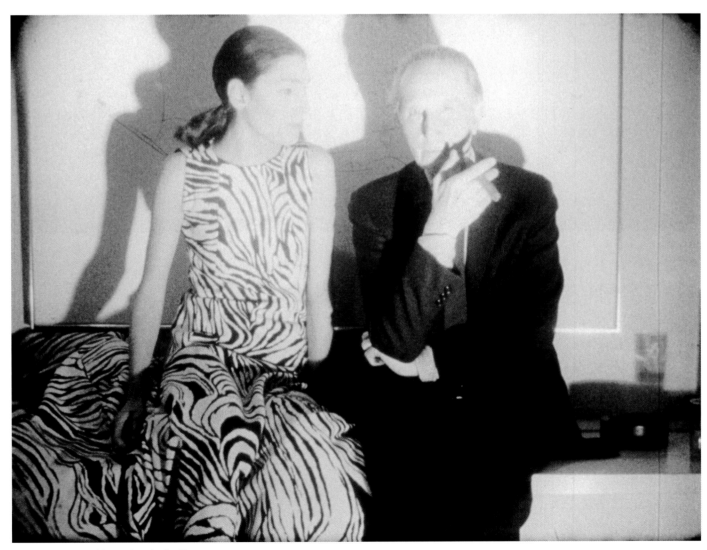

Roll 7. On clear film at head of roll. 7
*Marcel Duchamp and Benedetta Barzini*, 1966 (ST81; original not
found in Collection)

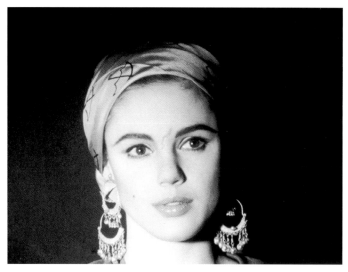

Roll 8. On clear film at head of roll: *8*
*Edie Sedgwick*, 1965 (ST307)

Roll 9. On clear film at head of roll: *9. Batman Dracula: Jack Smith and Beverly Grant*, 1964 (original is in *Batman Dracula*, 1964)

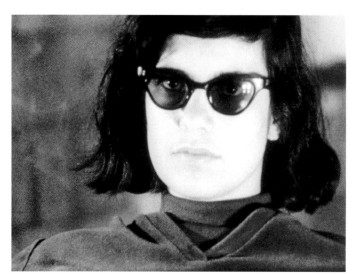

Roll 10. On clear film at head of roll: *10*
*Susan Sontag*, 1964 (ST323)

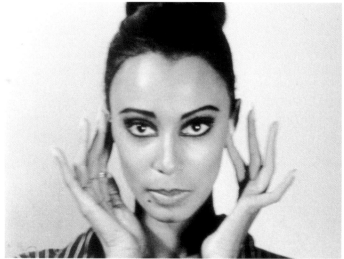

Roll 11. On clear film at head of roll: *11*
*Donyale Luna*, 1965 (ST195)

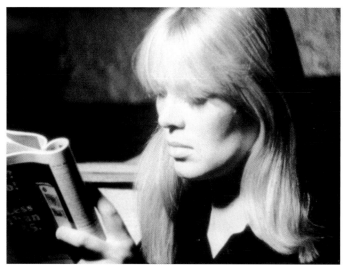

Roll 12. On clear film at head of roll: *12*
*Nico*, 1966 (ST238)

**ST371** *EPI Background: Lost Reel,* 1966

The existence of at least one additional *EPI Background* reel with an estimated length of 1,000', current whereabouts unknown, can be extrapolated from the numbers found written on the clear film at the heads of the following *Screen Tests*, none of which appear in any other existing background reels:

ST67 *Salvador Dalí,* 1966
Written on tail of film: *R. 1*

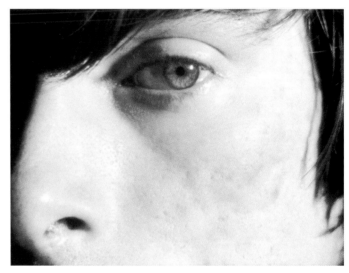

ST224 *Sterling Morrison,* 1966
Written on clear film at head: *3*

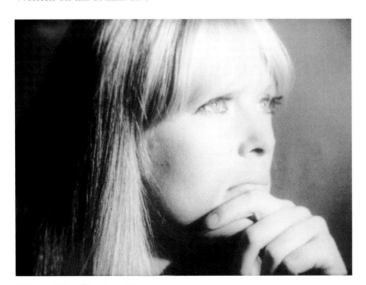

ST243 *Nico (Beer),* 1966
Written on clear film at head: *3*

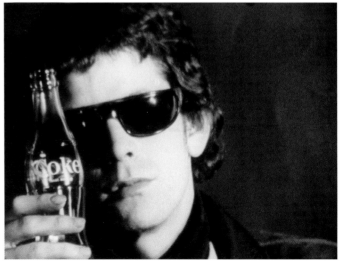

ST269 *Lou Reed (Coke),* 1966
Written on clear film at head: *4*

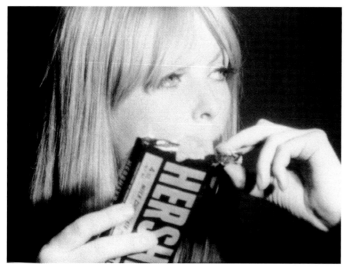

ST246 *Nico (Hershey)*, 1966
Written on clear film at head: 5

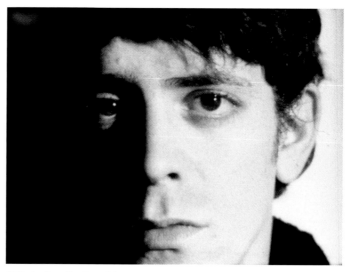

ST263 *Lou Reed*, 1966
Written on clear film at head: 5

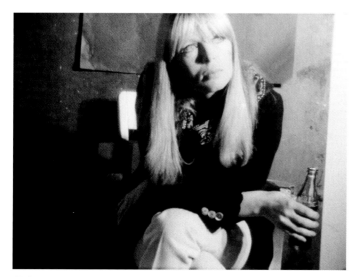

ST244 *Nico (Coke)*, 1966
Written on clear film at head: 6

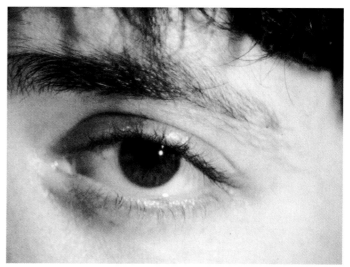

ST265 *Lou Reed (Eye)*, 1966
Written on clear film at head: 6

ST271 *Lou Reed (Hershey)*, 1966
Written on clear film at head: 7

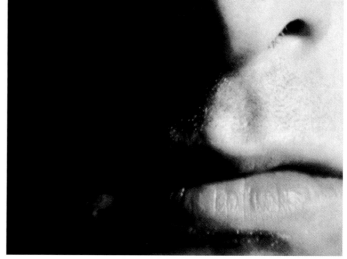

ST225 *Sterling Morrison*, 1966
Written on clear film at head: 7

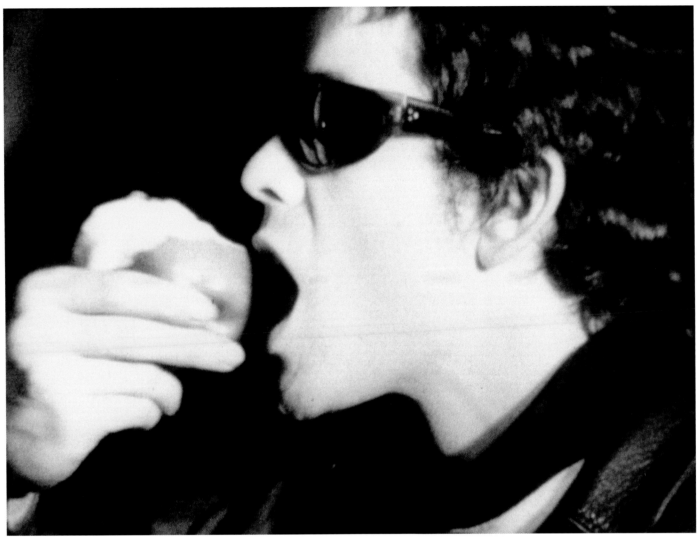

ST268 *Lou Reed (Apple)*, 1966
Written on clear film at head: *8*

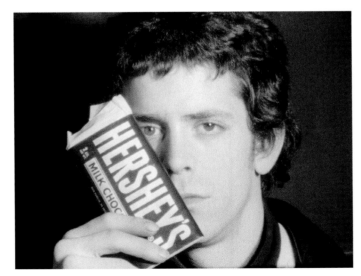

ST270 *Lou Reed (Hershey)*, 1966
Written on clear film at head: *9*

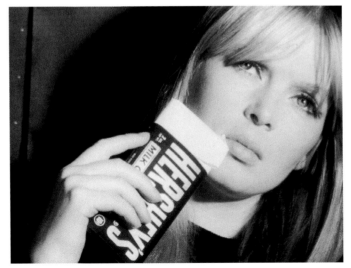

ST245 *Nico (Hershey)*, 1966
Written on clear film at head: *10*

## Screen Test Poems

Another contemporaneous project employing background reels was a collaboration between Gerard Malanga and Warhol called *Screen Test Poems*, which premiered at Cornell University in May 1966. This media/performance event consisted of readings of Malanga's poems, read either by Malanga or "one of his associates," accompanied by projections of three reels of *Screen Tests*, along with pop music and special lighting effects.

> The nature of the program is to bring together the lives of many celebrities and personalities through the combined medias of poetry and film. For each screen portrait that appears on the screen a poem is read aloud, and the film (or films) is projected behind the reader.[5]

This combination of Malanga's poetry with Warhol's *Screen Tests* is obviously the direct precursor of Malanga and Warhol's collaborative book, *Screen Tests/A Diary* (see Appendix A), published by Kulchur Press in 1967, in which double-frame *Screen Test* images of fifty-four people arranged in alphabetical order were printed on facing pages opposite fifty-four poems by Malanga. The three reels of *Screen Test Poems* contain prints of thirty-one *Screen Tests* of twenty-five people, numbered 1–31 on the heads of the originals, and arranged in numerical order; Reel 1 begins with one double portrait film of Malanga and Mary Woronov, and Reel 3 ends with another portrait of the pair. Seventeen of the *Screen Tests* and twenty-one of the people in *Screen Test Poems* appear in *Screen Tests/A Diary* as well.

It is clear that *Screen Test Poems*, like *Screen Tests/A Diary*, is a collaboration largely organized and completed by Malanga, who seems to have been the one to select the people whose *Screen Tests* would be included, choosing friends and fellow poets such as David Murray, Dan Cassidy, Ron Padgett, Piero Heliczer, and Tony Towle, as well as past and present girlfriends such as Benedetta Barzini, Debbie Caen, and Mary Woronov. Warhol's participation seems to have been limited to allowing Malanga to make copies of *Screen Test* films stored at the Factory, and perhaps paying the lab bills for these copies.[6] The first performance of this event, billed as "*Screen Test Poems* by Gerard Malanga, read by Rene Ricard. Films by Andy Warhol," took place at Cornell University on May 4 and was reviewed in the *Cornell Daily Sun*. Neither Malanga nor Warhol was present (they were in Los Angeles at the time, where the Velvet Underground and the EPI were performing at a club called the Trip), and Ricard's delivery of

Malanga's poems did not impress the reviewer. The films, however, were "as always magnificent . . . extended sequences of the faces of Malanga, Warhol, Dylan, Woronov, and other chicks projected by three cameras (sic) and three screens set at both ends of Memorial Room," while "pop music, mainly the Supremes, played continuously." The reviewer also mentioned the spontaneous use of spotlights, which he felt should have been employed with "more thought than the gaggle of hippies appeared capable of."[7]

In late 1966, a three-paragraph description of *Screen Test Poems* was included in the "Expanded Arts Bourse," an extensive listing of multimedia performances and groups available for bookings, which was published in a special "Expanded Arts" issue of *Film Culture*. This text, apparently written by Malanga, lists the following people: "Bob Dylan, Baby Jane Holzer, Denis Deegan, Barbara Rubin, Piero Heliczer, Daniel Cassidy, Jr., Paul America, Marisa Berenson, Kenneth Lane, Edie Sedgwick, Debbie Caen, John Palmer, Billy Linich, Harry Fainlight, Randy Borscheidt (sic), Harold Stevenson, John Cale, Mary Woronov, Benedetta Barzini."[8] Warhol's *Screen Test* had apparently been dropped from the group.

A detailed description of the technical requirements was also included:

> The *Screen Tests* take up three 1200 foot reels, each approximately forty-five minutes projected at silent speed. They are not projected simultaneously. The first (sic) reel begins about five minutes after the first reel, and the third reel is projected about five to ten to any number of minutes after the second reel to fill up a combined one hundred to one hundred and twenty-five minutes reading time. The reading finished (sic) minutes after the last reel runs out . . . It would take at least 2 to 3 members of Malanga's entourage to work the projectors in various fashions of hand-held techniques at various points during the reading.[9]

Judging from the estimated length of reading time, it seems possible that it might have been necessary to show the reels more than once to attain a running time of 100 to 125 minutes. It is unclear if any other performances of *Screen Test Poems* were given after the Cornell event in May 1966, but by September 1966, Malanga was already working on assembling the materials for the book version, *Screen Tests/A Diary* (see Appendix A). As Paul Morrissey noted on the can for Reel 3 of *Screen Test Poems* (ST372.3), Malanga's poetry reading reels were sometimes used in the EPI projections as well.

## ST372   *Screen Test Poems,* 1966

16mm, b&w, silent; in single screen, 132 min. @ 16 fps, 117 min. @ 18 fps. In triple screen, the running time is variable, with Reel 2 beginning 5 mins. after Reel 1, and Reel 3 beginning 10 mins. after Reel 2
By Gerard Malanga and Andy Warhol
With (in order of appearance) Gerard Malanga, Mary Woronov, Denis Deegan, Barbara Rubin, Dan Cassidy, Piero Heliczer, Marisa Berenson, Paul America, Freddy Herko, Ann Buchanan, Bob Dylan, Edie Sedgwick, Gino Piserchio, Kenneth Jay Lane, Debbie Caen, Ron Padgett, John Palmer, Jane Holzer, David Murray, Billy Linich, Harry Fainlight, Benedetta Barzini, Randy Bourscheidt, Harold Stevenson, Tony Towle, John Cale

**FILM MATERIALS**
ST372.1 *Screen Test Poems,* Reel 1
Undated Gevaert 16mm b&w double-perf. reversal print, 1,096'
One cement splice at 756'
**NOTATIONS**  On lid of original can, in AW's hand: *Prints. rolls 1 to 11. Underground*
On brown tape on lid, in unknown hand: *Screen Test*
On white tape on lid, in Paul Morrissey's hand, added in 1991: *Screen Tests – not V.U. Background. Friends of Gerard*
On white tape on rim, in unknown hand: *BACKGROUND – PLASTIC IN. GERARD BEGINS*
On white tape on head of film reel, in Paul Morrissey's hand, added in 1991: *Screen Tests – not V.U. Background*
On clear film at head of film reel: *1 – 11*

**CONTENTS**

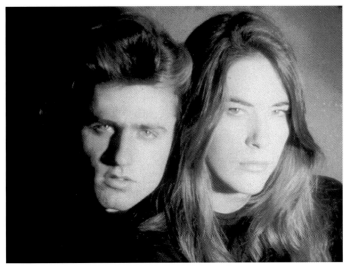

Roll 1. *Gerard Malanga and Mary Woronov,* 1966 (ST356; original not found in Collection), print-through splice to:

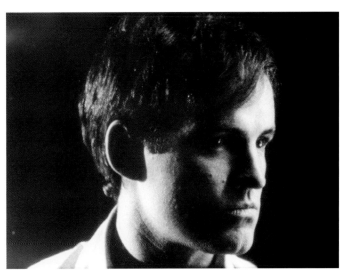

Roll 2. On clear film at head of roll: *2*
*Denis Deegan,* 1964 (ST73), print-through splice to:

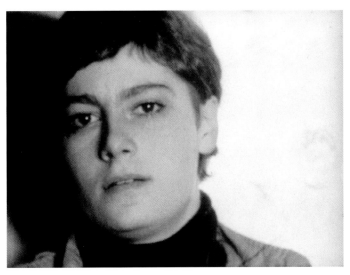

Roll 3. On clear film at head of roll: *3*
*Barbara Rubin,* 1965 (ST286), print-through splice to:

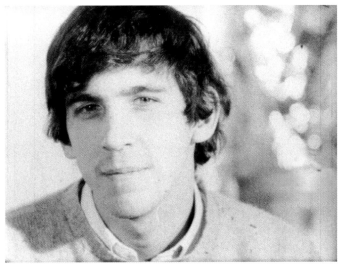

Roll 4. On clear film at head of roll: *4*
*Dan Cassidy,* 1965 (ST49), print-through splice to:

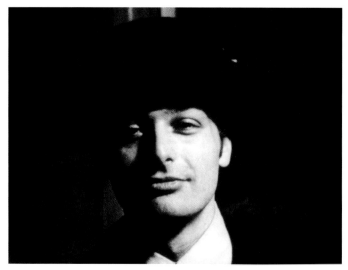

Roll 5. *Piero Heliczer*, 1965 (ST135)
On clear film at tail of roll: 5. Print-through splice to:

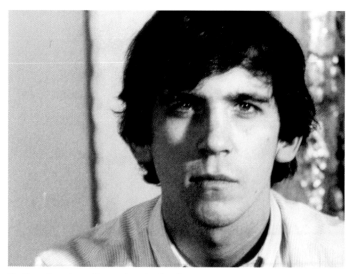

Roll 6. On clear film at head of roll: 6
*Dan Cassidy*, 1965 (ST50), print-through splice to:

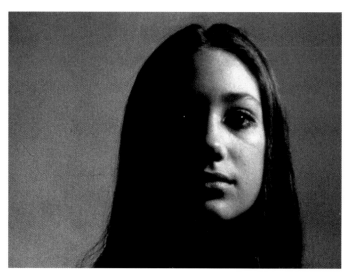

Roll 7. On clear film at head of roll: 7. *Marisa Berenson*, 1965
(ST20; original not found in Collection). On clear film at tail: 7
**Roll 8. Missing, cement splice in reel at 756'**

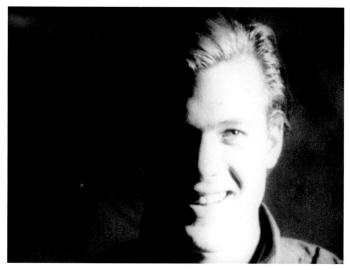

Roll 9. On clear film between rolls: *8–9*. *Paul America*, 1965 (ST4)
On clear film at tail of roll: 9. Print-through splice to:

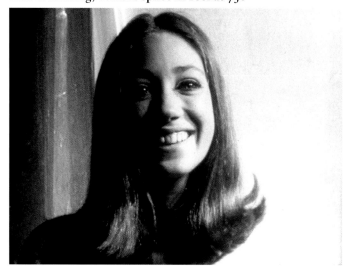

Roll 10. On clear film at head of roll: *10*. *Marisa Berenson*, 1965
(ST21; original not found in Collection). On clear film at tail of
roll: *10*. Print-through splice to:

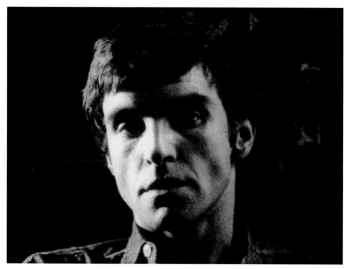

Roll 11. On clear film at head of roll: *11*
*Freddy Herko*, 1964 (ST137)

ST372.2 *Screen Test Poems*, Reel 2
Undated Gevaert 16mm b&w double-perf. reversal print, 1,000'
No splices
**NOTATIONS**  On lid of original can in AW's hand: *GERARD POEMS*
On white label on lid in AW's hand: *Gerard*
On white tape on lid in Paul Morrissey's hand, added in 1991:
*Screen Tests*. *Used by Gerard for Poems. Bob Dylan, Edie Sedgwick, Gino Piserchio, Kenny Lane? Debbie Caen? John Palmer, Jane Holzer*
On tape on rim, in unidentified hand: *GERARD POEMS*
On clear film at head of reel: *12 – 22*
Printed in white in black leader at head: *12 – 22*
On clear film at tail of reel: *12 – 22*

CONTENTS

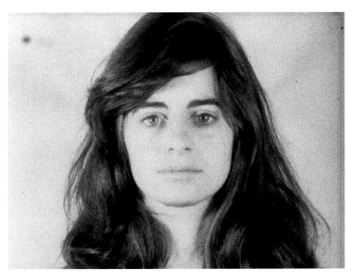

Roll 12. On clear film at head of roll: *12. Ann Buchanan*, 1964 (ST34). On clear film at tail of roll: *12.* Print-through splice to:

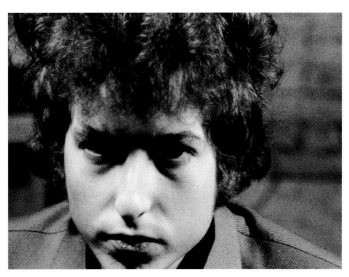

Roll 13. On clear film head of roll: *13. Bob Dylan*, 1966 (ST83). On clear film at tail of roll: *13.* Print-through splice to:

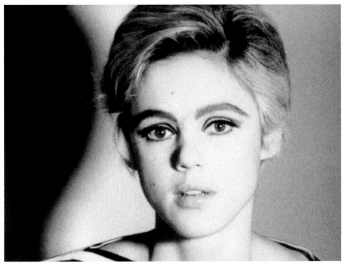

Roll 14. On clear film at head of roll: *14. Edie Sedgwick*, 1965 (ST308). On clear film at tail of roll: *14.* Print-through splice to:

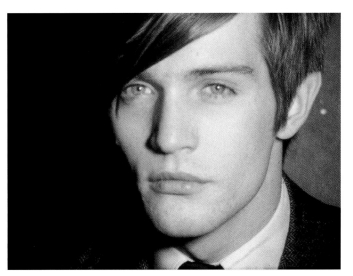

Roll 15. On clear film at head of roll: *15. Gino Piserchio*, 1965 (ST259). On clear film at tail of roll: *15.* Print-through splice to:

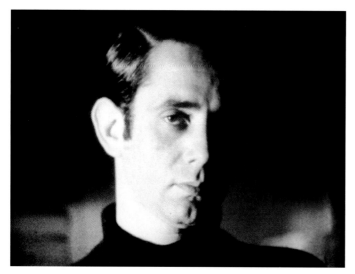

Roll 16. On clear film at head of roll: *16. Kenneth Jay Lane*, 1966 (ST190). On clear film at tail of roll: *16*. Print-through splice to:

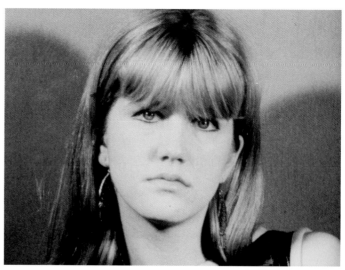

Roll 17. On clear film at head of roll: *17. Debbie Caen*, 1965 (ST36) On clear film at tail of roll: *17*. Print-through splice to:

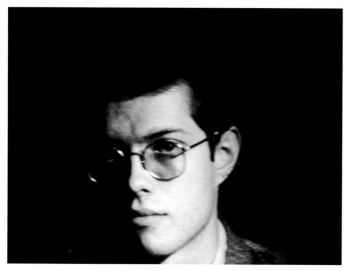

Roll 18. On clear film at head of roll: *18. Ron Padgett*, 1964 (ST251). On clear film at tail of roll: *18*. Print-through splice to:

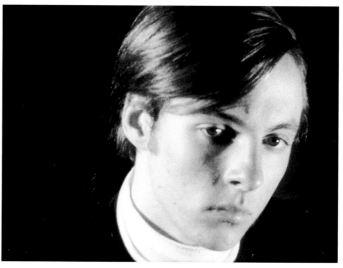

Roll 19. On clear film at head of roll: *19. John Palmer*, 1964 (ST253). On clear film at tail of roll: *20*. Print-through splice to:

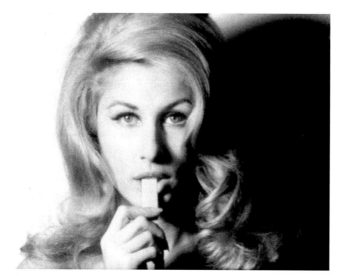

Roll 20. On clear film at head of roll: *20. Jane Holzer*, 1965 (ST148). On clear film at tail of roll: *20*. Print-through splice to:

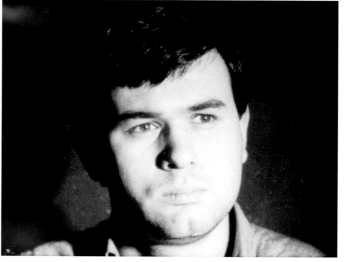

Roll 21. On clear film at head of roll: *21. David Murray*, 1965 (ST228). On clear film at tail of roll: *21*

ST372.3   *Screen Test Poems*, Reel 3
Undated Gevaert 16mm b&w double-perf. reversal print, 1,069'
No splices; film torn at 50'
**NOTATIONS**   On lid of can in unidentified hand: *Print. rolls 12–21*
On white tape on lid in Paul Morrissey's hand, added in 1991:
*Screen Tests. sometimes used as Background for Velvet U., sometimes by*
*Gerard M. for poetry reading*
On white tape on rim in unidentified hand: *BACKGROUND –*
*PLASTIC IN – Gerard Begins*

**CONTENTS**

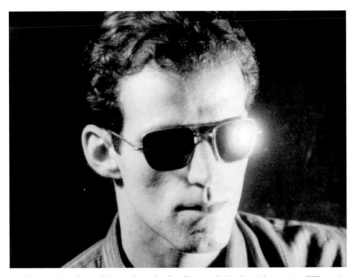

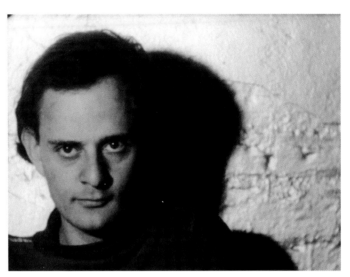

Roll 22. On clear film at head of roll: *22. Billy Linich*, 1964 (ST194)
On clear film at tail of roll: *22.* Print-through splice to:

Roll 23. On clear film at head of roll: *23. Harry Fainlight*, 1964
(ST97). On clear film at tail of roll: *23.* Print-through splice to:

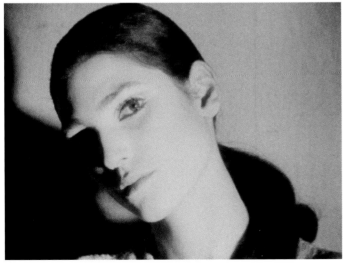

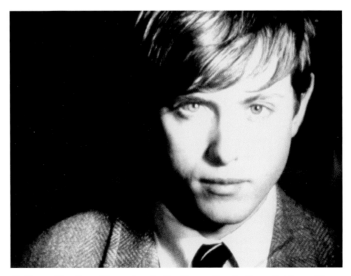

Roll 24. On clear film at head of roll: *24. Benedetta Barzini*, 1966
(ST15; original not found in Collection). On clear film at tail of roll:
*24.* Print-through splice to:

Roll 25. On clear film at head of roll: *25. Randy Bourscheidt*, 1966
(ST29). On clear film at tail of roll: *25.* Print-through splice to:

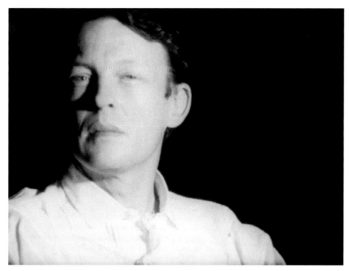

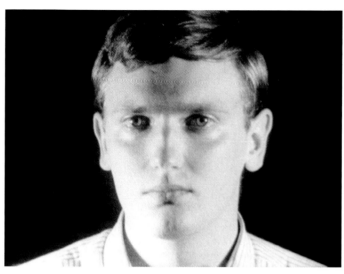

Roll 26. On clear film at head of roll: *26. Harold Stevenson*, 1964 (ST328). On clear film at tail of roll: *26.* Print-through splice to:

Roll 27. On clear film at head of roll: *27. Tony Towle*, 1964 (ST342) On clear film at tail of roll: *27.* Print-through splice to:

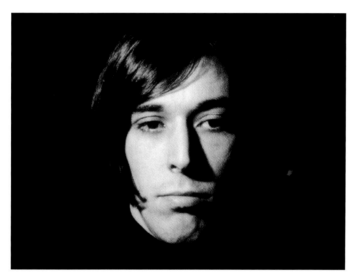

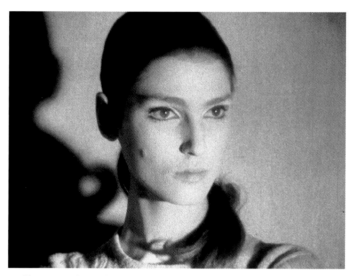

Roll 28. On clear film at head of roll: *28. John Cale*, 1966 (ST38) On clear film at tail of roll: *28.* Print-through splice to:

Roll 29. On clear film at head of roll: *29. Benedetta Barzini*, 1966 (ST16; original not found in Collection). On clear film at tail of roll: *29.* Print-through splice to:

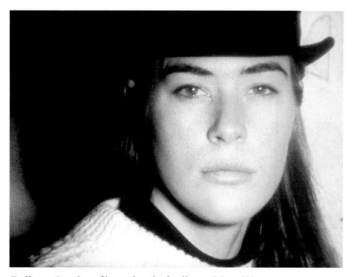

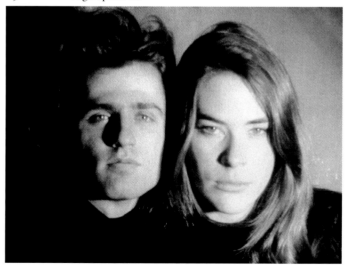

Roll 30. On clear film at head of roll: *30. Mary Woronov*, 1966 (ST359; original not found in Collection). On clear film at tail of roll: *30.* Print-through splice to:

Roll 31. *Gerard Malanga and Mary Woronov*, 1966 (ST355; original not found in Collection)

## Later Background Reels

Following the successful use of background film projections during the Exploding Plastic Inevitable, in the summer of 1966 the Warhol film organization made a few additional background reels that were intended to be projected behind the actors during the filming of Warhol's movies. Two background reels, composed of silent, black-and-white 100' rolls, *Eric Background: Toby Short* (1966) and *3 Min. Mary Might* (1966), seem to have been shot specifically for projection during the making of the *Their Town* and *Eric Tells All* sequences in *The Chelsea Girls*. The performers in the background reels, most of whom also play characters in *The Chelsea Girls*, pose for the camera and also engage in other activities (wrestling, masturbating, kissing, playing dead) that relate to the narrative of the *Their Town* sequence, which was roughly based on the story of a serial killer. The spliced-together background reels were then projected behind the actors while they were filmed in thirty-three-minute color sound reels.[10] These color reels made for *The Chelsea Girls* included elaborately constructed sets and the projection of colored lights, roving spot-lights, and patterned slides, a complexly layered *mise-en-scène* of bodies, lights, colors, geometric patterns, and projected and distorted films that seems to have been derived directly from the mixed-media environments of the EPI. The details of this practice, and the transposition of EPI effects into Warhol's filmmaking, are discussed in more detail in Volume 2, where these background reels have been catalogued under *The Chelsea Girls* (1966).

Several apparent *Screen Tests*, or *Screen Test*-like films, from these *Chelsea Girls* background reels have been catalogued as individual *Screen Tests* in this volume: *Archie* (ST10, or roll 2 from *3 Min. Mary Might*), *George Millaway (Peanut Butter)* (ST220, or roll 9 from *Eric Background: Toby Short*), and *George Millaway and Mary Woronov* (ST360–36).

# Appendix A
# *Screen Tests/A Diary*

In 1967, Kulchur Press published a book called *Screen Tests/A Diary*, which was a collaboration between Gerard Malanga and Andy Warhol. The publication included double-frame (actually two-and-a-half-frame) images taken from fifty-four *Screen Tests* of fifty-four different people, numbered one through fifty-four and arranged in alphabetical order by last name. Each person received a two-page spread: the enlarged frames from each *Screen Test* appeared on the right-hand page opposite a poem, on the left-hand page, written by Malanga about that person. After the book was published in April 1967, ads for *Screen Tests/A Diary* described it as "poems plus film strips."[1]

Malanga's practice of presenting his poetry or other works in association with works by Warhol dates to the fall of 1964, beginning with Malanga's poem "Rollerskate," which was written to be read as an accompaniment to Warhol's 1963 silent film *Dance Movie* at a memorial for the dancer Freddy Herko. At a poetry reading on December 16, 1964, during an exhibition of Warhol *Flowers* paintings at the Leo Castelli Gallery, Malanga read "his poems to a jam-packed crowd (overflow lines of people waited outside hoping to get in) with a backdrop of Andy Warhol's paintings."[2] The flyer for this event described it as "Poem Visuals by Andy Warhol and Gerard Malanga: The New Realism, Yeah Yeah, Fashion, and Disaster series read by Gerard Malanga," but Warhol himself apparently did not attend the reading or participate in its conceptualization or in the writing of the announcement. Nevertheless, as Reva Wolf has pointed out, Malanga seems to have been convinced, "in his mind," that this event was a collaboration between himself and Warhol. The collective title that Malanga gave it, "Poem Visuals by Andy Warhol and Gerard Malanga," implied that "his poetry and the art on view were, rather than distinct entities, pieces of a kind of *Gesamtkunstwerk*."[3] Malanga's "mental collaboration" with Warhol also extended to the poems he read at this event, which were in many cases inspired by or written about Warhol's paintings.[4]

This ambiguity of influence, collaboration, and credit is a recurring theme in the relationship between Malanga and Warhol. Such ambiguity seems to have been the direct result of not only Warhol's well–known practice of deliberately blurring the lines of authorship in his own work, but also of Malanga's ambivalent position as Warhol's minimum-wage studio assistant, in which role he did in fact help to paint the *Flowers* paintings as well as many of Warhol's other works from this period. In this context, "Poem Visuals by Gerard Malanga and Andy Warhol" might be interpreted more specifically to mean something like: "Poems by Gerard Malanga inspired by Andy Warhol. Visuals by Andy Warhol assisted by Gerard Malanga." Of course, Malanga had his own ambitions as a poet and an artist, ambitions that could benefit enormously from the creative space of the Factory and from association with Warhol's fame and success. Perhaps Malanga's publicly uncredited role in the production of Warhol's artworks encouraged Malanga to expect, *quid pro quo*, Warhol's availability as publicly credited collaborator for associated projects that Malanga himself might want to do—an arrangement, more tacit than explicit, that nevertheless resulted in a number of works including the names and contributions of both artists.[5]

Another Warhol-associated work by Malanga from 1964–65 is the Thermofax poems, which he typed or wrote by hand on single sheets of Thermofax paper onto which photographs of car crashes and other violent images culled from Warhol's collection of news photographs had been copied. Warhol's involvement in the project appears to have been minimal or nonexistent, even though some of the Thermofaxes bear the "Andy Warhol" stamp, and even though the Thermofaxed images themselves bear undeniable resemblances to Warhol's series of *Death and Disaster* paintings. Several of these Thermofax poems were read aloud at the Castelli Gallery, and were later included in Malanga's 1971 book, *Chic Death*, in which reproductions of Warhol's *Death and Disaster* paintings accompanied Malanga's poems.[6]

A more elaborate Warhol/Malanga collaboration from the first half of 1966, discussed in detail under "Background Reels," was *Screen Test Poems* (ST372), in which print reels of selected and assembled *Screen Tests* were projected behind readings of Malanga's poetry. Again, this was a collaboration that seems to have been conceptualized and brought to fruition almost single-handedly by Malanga, who apparently selected the films to be included, choosing *Screen Tests* of friends, fellow poets, and other people significant in his personal life as well as at the Warhol Factory. Warhol's participation may have been limited to allowing Malanga to make prints of his *Screen Test* films, and perhaps paying for the lab work. Neither Malanga nor Warhol was present at the premiere of *Screen Test Poems* at Cornell University in May 1966, when Malanga's poems were read by Rene Ricard; the event was billed as "*Screen Test Poems* by Gerard Malanga . . . Films by Andy Warhol."[7]

*Screen Test Poems* is clearly an early version of the *Screen Tests/A Diary* book project, which extended the concept of juxtaposing Warhol's *Screen Tests* with Malanga's poems into print; indeed, many of the same people and films were included in both projects. As in *Screen Test Poems*, Malanga's selections included friends and fellow poets (Ashbery, Berrigan, Cassidy, Denby, Fainlight, the Fords, Ginsberg, Heliczer, Katz, Maas, Menken, Murray, Padgett, Ricard, Wieners), Warhol stars and other Factory figures (America, Bottomly, Holzer, Linich, Midgette, Morrissey, Nicholson, Nico, Ondine, Reed, Sedgwick, Tavel, Wein, Woronov), a smattering of celebrities (Berenson, Dalí, Donovan), and a number of women whom Malanga either had been involved with or was interested in, including Barzini and Caen. Interestingly, twenty-six, or nearly half, of the *Screen Tests* included in the book were shot in 1966, while fifteen date to 1965 and only thirteen were made in 1964, which is the year when the largest number of *Screen Tests* (232) were shot. It seems possible that some 1966 *Screen Tests* may have been shot specifically for inclusion in *Screen Tests/A Diary*, which Malanga began working on that summer.

Warhol's involvement in *Screen Tests/A Diary* seems to have been, at least in its initial stages, more truly collaborative. Malanga's diary entry for August 29, 1966, reports: "I'm almost finished with the writing of the *Screen Test* diary text, but Andy has a lot of stills that have to be made." On September 24, 1966, Malanga noted that he had obtained "five out of the 45 releases for *Screen Tests*" at lunch, but "I

still need to type up the *Screen Tests/A Diary* manuscript. I've already accumulated twelve or thirteen signatures from the forty-five listed. There might be some substitutes."[8]

According to Reva Wolf, the book itself was originally designed by Warhol. The initial plan was to print the film images on pages of clear acetate that would overlay Malanga's poems, so the faces of the *Screen Test* subjects would appear superimposed over the lines of poetry that Malanga had written about them. As it happened, acetate proved too difficult to print, and so sheets of semitransparent vellum were used instead.[9]

As Malanga's diary entry of August 29, 1966, makes clear, there seems to have been a fairly clear division of labor between Warhol and Malanga, at least at first: Malanga's job was to produce the text, by writing poems about the people whose *Screen Tests* had been selected for the book, while Warhol was to provide images from his films. The selection of people was largely left up to Malanga; according to Malanga, Warhol did ask him to include Henry Geldzahler and Ultra Violet, but he didn't feel inspired to write poems about these two people, and so they were left out.[10]

Several different attempts seem to have been made to organize the films and film images for *Screen Tests/A Diary*, which eventually expanded from forty-five to fifty-four images, poems, and people. Although Warhol was supposed to be responsible for the illustrations, the making of the frame enlargements seems to have required Malanga's hands-on attention, perhaps in his role as Warhol's studio assistant. A total of nineteen of the original *Screen Tests* illustrated in the book bear Malanga's handwritten lab instructions for the making of double-frame stills on their boxes; the selected film frames were apparently marked with bits of tape, which were later removed. Donovan's *Screen Test*, for example (ST78), has lab instructions written in Malanga's handwriting: "1 double-frame negative and 1 double-frame glossy 8" x 10" print marked by masking tape."[11] Another system for differentiating and labeling films selected for *Screen Tests/A Diary* was apparently used as well: many of the *Screen Tests* in this series were marked with special typed labels bearing the person's name (see, for example, *John Ashbery* (ST13)). These labels were originally taped to the lids of the film cans with Scotch tape; most of these labels have since fallen off, and were found loose inside the film boxes.[12]

A few *Screen Tests* marked with handwritten instructions for the making of stills did not end up in *Screen Tests/A Diary*, perhaps because Malanga was not able to get signed releases from the posers, or because the stills were made for other purposes.[13] Several double-frame images of *Screen Tests*, most of which were included in *Screen Tests/A Diary*, were published in the special December 1966 boxed issue of *Aspen* magazine, which Warhol designed with David Dalton, where they appear as illustrations to an article about "What's happening in modern poetry?" by Malanga.[14]

As notated in the following list, the *Screen Test* images appearing in *Screen Tests/A Diary* have been matched to the original *Screen Tests* catalogued in this book. A few of the films have not been found in the collection; their current location is not known. These missing *Screen Tests*, nevertheless, have been included in this catalogue, sometimes solely on the strength of their appearance in *Screen Tests/A Diary*, which is considered a strong indication that these missing films were originally part of the body of Warhol *Screen Tests*. As Reva Wolf noted, a *Screen Test* of Andy Warhol was originally included as number forty-four in one of the early manuscripts for *Screen Tests/A Diary* but later dropped from the final version of the book; this missing Warhol *Screen Test* has also been given a catalogue entry (ST349).[15]

Cover: *Gerard Malanga* (ST200)
1. *Paul America* (ST4)
2. *John Ashbery* (ST13)
3. *Benedetta Barzini* (ST17)
4. *Timothy Baum* (ST19)
5. *Marisa Berenson* (ST20)
6. *Ted Berrigan* (ST22)
7. *Ann Buchanan* (ST34)
8. *Debbie Caen* (ST36)
9. *Dan Cassidy* (ST50)
10. *Ronnie Cutrone* (ST64)
11. *Salvador Dalí* (ST68)
12. *Denis Deegan* (ST73)
13. *Edwin Denby* (ST75)
14. *Donovan* (ST78)
15. *Harry Fainlight* (ST97)
16. *Giangiacomo Feltrinelli* (ST101)
17. *Charles Henri Ford* (ST105)
18. *Ruth Ford* (ST107)
19. *Allen Ginsberg* (ST115)
20. *Piero Heliczer* (ST135)
21. *Freddy Herko* (ST137)
22. *Jane Holzer* (ST144)
23. *Ed Hood* (ST150)
24. *International Velvet (Susan Bottomly)* (ST28)
25. *Barbara Jannsen* (ST165)
26. *Paul Katz* (ST174)
27. *Sally Kirkland* (ST181)
28. *Kenneth Jay Lane* (ST190)
29. *Billy Linich* (ST194)
30. *Willard Maas* (ST197)
31. *Gerard Malanga* (ST201)
32. *Jonas Mekas* (ST211)
33. *Marie Menken* (ST215)
34. *Allen Midgette* (ST217)
35. *Paul Morrissey* (ST226)
36. *David Murray* (ST228)
37. *Ivy Nicholson* (ST235)
38. *Nico* (ST238)
39. *Ondine* (ST249)
40. *Ron Padgett* (ST251)
41. *Ronna Page* (ST252)
42. *John Palmer* (ST253)
43. *Gino Piserchio* (ST259)
44. *Lou Reed* (ST263)
45. *Rene Ricard* (ST276)
46. *Barbara Rubin* (ST286)
47. *Phoebe Russell* (ST288)
48. *Francesco Scavullo* (ST296)
49. *Edie Sedgwick* (ST308)
50. *Harold Stevenson* (ST328)
51. *Ronald Tavel* (ST336)
52. *Chuck Wein* (ST350)
53. *John Wieners* (ST351)
54. *Mary Woronov* (ST357)

# Andy Warhol *Screen Tests*: A Chronology

The information in this chronology comes from a variety of sources. Dates when *Screen Tests* were shot were often found written on the film boxes or were obtained from other sources, as noted in individual *Screen Test* entries. Some exhibition dates were obtained from the "Film-makers' Income and Expense Balance Sheet" from the Film-Maker's Cooperative, which distributed Warhol's films between 1964 and 1968.[1] Although it seems likely that *EPI Background* reels of *Screen Tests* were projected at most if not all performances of Andy Warhol Up-Tight and the Exploding Plastic Inevitable, only those EPI dates where screenings of *Screen Tests* were documented in photographs or mentioned in contemporary newspaper or magazine articles have been included; a complete chronology of EPI and Velvet Underground performances can be found at the Velvet Underground Web Page, http://members.aol.com/olandem/vu.html.

Since the first reels of *Screen Tests* were preserved by MoMA in 1995, there have been various screenings and exhibitions of these films. These contemporary exhibitions are not included in this historical listing.

**June 1963** Warhol purchases his 16mm Bolex camera

**January 17, 1964** First *Screen Tests* shot, according to Kelly Edey's diary: "This afternoon AW made a movie here, a series of portraits of a number of beautiful boys, including Harold Talbot and Denis Deegan and also me."[2]

**January 28, 1964** Warhol moves into his new studio, the Factory, at 231 East 47th Street[3]

**February 25, 1964** Warhol receives first silk screens for his 1964 mural, *Thirteen Most Wanted Men*[4]

**March 8, 1964** Sarah Dalton *Screen Test* (ST69) shot

**April 1, 1964** Binghamton Birdie *Screen Test* (ST25) shot

**April 15, 1964** *The Thirteen Most Wanted Men* mural unveiled at the New York World's Fair in Flushing Meadows, Queens; painted over with silver paint a few days later

**October 26, 1964** Steve Balkin *Screen Test* (ST14) shot

**October 27, 1964** Freddy Herko commits suicide

**November 6, 1964** First roll of *Six Months* (ST363.001) shot

**November 24, 1964** Philip Fagan (Banana) *Screen Test* (ST95) shot

**December 7, 1964** Excerpts from *The Thirteen Most Beautiful Women* and *The Thirteen Most Beautiful Boys* (Freddy Herko *Screen Test* (ST137)) screened at the New Yorker Theatre, New York City at the *Film Culture* Sixth Independent Film Award presentation to Andy Warhol

**December 20, 1964** Ronald Tavel *Screen Test* (ST336) shot

**January 1965** Fourteen-women version of *The Thirteen Most Beautiful Women* (ST365a) screened at a party at Sally Kirkland's loft; covered by the *New York Herald Tribune*, January 10, 1965

**February 9, 1965** Last roll of *Six Months* (ST363.107) shot

**February 28, 1965** *Six of Andy Warhol's Most Beautiful Women* (ST365b) begins continuous screenings in the lounge of Carnegie Hall Cinema, New York City, ending prematurely on March 7

**March 3, 1965** Ted Berrigan (ST22) and Joe Brainard (ST32) *Screen Tests* shot

**March 19, 1965**  The article "Underground Clothes" appears in *Life* magazine, with Imu and Ivy Nicholson photographed with projections of their *Screen Tests* from *The Thirteen Most Beautiful Women*

**August 3–17, 1965**  A thirty-minute version of *The Thirteen Most Beautiful Women* shown in "New American Cinema" program, Cineteca Argentina, Buenos Aires

**November 4, 1965**  Alicia Purchon Clark *Screen Tests* (ST55–56) shot

**November 14, 1965**  Marisa Berenson *Screen Tests* (ST20–21) shot

**November 17, 1965**  Cathy James color *Screen Test* (ST164) shot

**February 6, 1966**  Mary Woronov *Screen Test* (ST357) shot

**February 7, 1966**  Marcel Duchamp *Screen Tests* (ST79–81) shot

**February 8–13, 1966**  Andy Warhol Up-Tight premieres at the Film-Makers' Cinematheque, 125 West 41st Street, New York City

**February 14, 1966**  Charles Aberg *Screen Tests* (ST1–3) shot

**February 25, 1966**  Penelope Palmer *Screen Test* (ST255) shot

**March 1966**  Bob Dylan *Screen Tests* (ST82–83) shot

**March 3, 1966**  Nico *Screen Test* (ST242) shot

**March 12, 1966**  *Screen Tests* of Nico projected during performance of Andy Warhol Up-Tight, University of Michigan, Ann Arbor

**April 1966**  *Screen Tests* of Nico and John Cale projected during performances of the Exploding Plastic Inevitable, the Dom, 23 St. Mark's Place, New York City

**May 3–5, 1966**  *Nico (Coke)* (ST244) and *Lou Reed (Hershey)* (ST270 or ST271) projected during performances of the Exploding Plastic Inevitable, the Trip, Los Angeles

**May 4, 1966**  *Screen Test Poems* premieres at Cornell University, Ithaca, New York

**May 27–29, 1966**  *Nico (Hershey)* (ST245 or ST246) projected during performances of the Exploding Plastic Inevitable, Fillmore Auditorium, San Francisco

**June 21–26, 1966**  *Screen Tests* of Nico projected during the Exploding Plastic Inevitable, Poor Richard's, Chicago

**July 7, 1966**  Ed Hood *Screen Test* (ST149) shot

**July 9, 1966**  Susan Bottomly *Screen Test* (ST28) shot

**October 5, 1966**  Antoine *Screen Test* (ST8) shot

**October 10, 1966**  *Most Beautiful Women* shown at Cornell University, Ithaca, New York

**October 29, 1966**  *Screen Tests* of Nico projected during Exploding Plastic Inevitable performances in conjunction with the opening of Warhol's exhibition at the Institute of Contemporary Art, New England Life Hall, Boston

**November 3, 1966**  *Screen Tests* of Nico and Gerard Malanga projected during Velvet Underground performances at the Topper Club, Cincinnati

**November 12, 1966**  *Screen Tests* of Nico projected with orange filter during performance of the Exploding Plastic Inevitable, McMaster University, Hamilton, Ontario

**December 4, 1966**  Allen Ginsberg (ST115) and Peter Orlovsky (ST250) *Screen Tests* shot

**March 31–April 1, 1967**  *Screen Tests* of John Cale shown during the Velvet Underground performance at the Rhode Island School of Design, Providence

**February 14–16, 1968**  *The Thirteen Most Beautiful Women* included in Andy Warhol Film Festival, University of Minnesota, Minneapolis

**August 21, 1969**  Selections from *The Thirteen Most Beautiful Women in the World* (Vaughan version) licensed to the Third Programme of West Germany Television for a period of seven years, via Vaughan-Rogosin Films, Ltd., London

# The Preserved *Screen Tests*

Since 1995 the Museum of Modern Art in New York has been restoring and preserving the Warhol *Screen Tests* (as well as many of Warhol's other films, which will be covered in Volume 2 of the catalogue raisonné). By 2005, 279 *Screen Tests* have been preserved, out of a total of 472.

For the sake of convenience, the *Screen Tests* were assembled into reels for preservation and distribution, with ten *Screen Tests* per reel. (The only exception to this rule is MoMA *Screen Test* Reel 12, which has only seven *Screen Tests*.) The *Screen Tests* were assembled and preserved according to the numerical order in which they had been internally catalogued by MoMA; that is, the ordering of the *Screen Tests* on the reels is for the most part entirely random in relation to dates, content, stylistic considerations, or the order in which they were actually shot. One exception to this rule is a group of *Screen Tests* from *The Thirteen Most Beautiful Women* (ST365), which were found stored together in a box and were therefore catalogued in order by MoMA; they have been preserved together in Reel 25, rolls 5–10.

Another group of original *Screen Tests* was found spliced together in a reel titled *Original Salvador Dalí* (ST367); this reel has been preserved by MoMA under the title *Salvador Dalí*. In this book, *Salvador Dalí* has been catalogued in Chapter Five; the individual *Screen Tests* from this film have also been catalogued alphabetically under the names of the individual people in them. The *Screen Tests* found in *Salvador Dalí* are not included in the MoMA *Screen Test* reels listed below. Also not included in these MoMA reels are the two Bob Dylan *Screen Tests* preserved in 2005.

Four of the films preserved as *Screen Tests* by MoMA have not been catalogued as *Screen Tests* in this publication; entries for these titles can be found in Volume 2. As further information became available, it became apparent that *Alan Marlowe/Diane di Prima* (MoMA *Screen Test* Reel 13, no. 8) was not a *Screen Test* but a separate short film from 1964. Similarly, *Denis Deegan* (MoMA *Screen Test* Reel 13, no. 10) turned out to be part of a longer portrait film of Deegan from 1963. Although the 1964 double–portrait film *Philip and Gerard* (MoMA *Screen Test* Reel 19, no. 7) is as static as most *Screen Tests*, its complex visual and psychological content suggests that it should be considered a film in its own right. And *Steve Holden* (MoMA *Screen Test* Reel 22, no. 3) has been identified as one roll in a longer film from 1964 called *Steve Holden Drunk*.

During preservation, original *Screen Tests* were spliced together head-to-tail in groups of ten onto larger reels; to avoid confusion between similar films, the MoMA cataloguing numbers were written on the clear film at the head of each *Screen Test*. The assembled reels were then sent to the lab, where two negatives were generated for each 1,100' reel. The "release negative" is used to generate positive prints for exhibition. The "archival negative" is placed in climate–controlled storage and preserved as archival material. Once preservation was complete, the assembled *Screen Test* reels were disassembled, and each individual *Screen Test* was replaced in its original box and returned to climate–controlled storage for preservation as archival material. Many of the frame enlargements in this book were made from the preserved *Screen Tests* in MoMA Reels 1 through 23; unpreserved *Screen Tests* were photographed directly from the camera originals.

The *Screen Tests* have been preserved by The Museum of Modern Art with funding from The Andy Warhol Foundation for the Visual Arts, Inc. 16mm *Screen Test* reels may be rented from the Circulating Film Library, The Museum of Modern Art, 11 West 53rd Street, New York, N.Y. 10019. Tel: 212-708-9530; e-mail: circfilm@moma.org.

## Preserved *Screen Tests* Available from The Museum of Modern Art

**Reel 1**
1. *Charles Aberg*, 1966 (ST1)
2. *Roderick Clayton*, 1966 (ST59)
3. *Imu*, 1964 (ST160)
4. *Peter Hujar*, 1964 (ST156)
5. *Amy Taubin*, 1964 (ST334)
6. *Alicia Purchon Clark*, 1965 (ST55)
7. *Hal*, 1964 (ST125)
8. *Susanne De Maria*, 1964 (ST72)
9. *Danny Foster*, 1966 (ST109)
10. *Virginia Tusi*, 1965 (ST345)

**Reel 2**
1. *Amy Taubin*, 1964 (ST335)
2. *Bibbe Hansen*, 1965 (ST129)
3. *Nancy Fish*, 1964 (ST102)
4. *Jim Rosenquist*, 1964 (ST285)
5. *Donyale Luna*, 1965 (ST196)
6. *Steve Balkin*, 1964 (ST14)
7. *Marilynn Karp*, 1964 (ST173)
8. *Cathy James*, 1965 (ST163)
9. *Tina*, 1965 (ST341)
10. *Kellie*, 1965 (ST175)

**Reel 3**
1. *Henry Geldzahler*, 1965 (ST113)
2. *Twist Jim Rosenquist*, 1964 (ST284)
3. *Beverly Grant*, 1964 (ST122)
4. *Pat Hartley*, 1965 (ST130)
5. *Roderick Clayton*, 1966 (ST58)
6. *Tony Towle*, 1964 (ST342)
7. *Kyoko Kishida*, 1964 (ST183)
8. *Charles Aberg*, 1966 (ST3)
9. *Paul Thek*, 1964 (ST338)
10. *Gerard Malanga*, 1964 (ST198)

**Reel 4**
1. *Buffy Phelps*, 1965 (ST256)
2. *John Giorno*, 1964 (ST117)
3. *Paul Wittenborn*, 1965 (ST353)
4. *Kenneth King*, 1964 (ST179)
5. *Dennis Hopper*, 1964 (ST155)
6. *Kipp Stagg*, 1965 (ST326)
7. *Richard Markowitz*, 1964 (ST205)
8. *Dennis Hopper*, 1964 (ST154)
9. *Richard Schmidt*, 1965 (ST297)
10. *Gregory Battcock*, 1964 (ST18)

**Reel 5**
1. *Dennis Hopper*, 1964 (ST153)
2. *Peter Hujar*, 1964 (ST158)
3. *Bruce Rudow*, 1964 (ST287)
4. *François de Menil*, 1965 (ST214)
5. *Patrick Fleming*, 1966 (ST104)
6. *Helmut*, 1964 (ST136)
7. *Ivy Nicholson*, 1965 (ST232)
8. *Jane Holzer*, 1964 (ST146)
9. *Walter Dainwood*, 1964 (ST66)
10. *Paul Katz*, 1966 (ST174)

**Reel 6**
1. *Charles Rydell*, 1964 (ST290)
2. *Dan Cassidy*, 1965 (ST49)
3. *David Hallacy*, 1964 (ST127)
4. *François de Menil*, 1965 (ST213)
5. *Roderick Clayton*, 1966 (ST57)
6. *Gerard Malanga*, 1964 (ST199)
7. *Jean-Paul Germain*, 1965 (ST114)
8. *Kenneth King*, 1964 (ST180)
9. *Charles Aberg*, 1966 (ST2)
10. *Lawrence Casey*, 1964 (ST48)

**Reel 7**
1. *Paul Wittenborn*, 1965 (ST354)
2. *Barbara Rubin*, 1965 (ST286)
3. *Ondine*, 1966 (ST249)
4. *Bea Feitler*, 1964 (ST100)
5. *Imu*, 1964 (ST161)
6. *David Hallacy*, 1964 (ST126)
7. *Lucinda Childs*, 1964 (ST53)
8. *Timothy Baum*, 1966 (ST19)
9. *Marie Menken*, 1966 (ST215)
10. *Billy Linich*, 1964 (ST194)

**Reel 8**
1. *Marian Zazeela*, 1964 (ST362)
2. *Edie Sedgwick*, 1965 (ST306)
3. *Charles Henri Ford*, 1966 (ST105)
4. *Susan Sontag*, 1964 (ST318)
5. *Katha Dees*, 1964 (ST74)
6. *Mary Woronov*, 1966 (ST357)
7. *Debbie Caen*, 1965 (ST36)
8. *Willard Maas*, 1965 (ST197)
9. *Jane Holzer*, 1964 (ST141)
10. *Jane Holzer*, 1964 (ST139)

## Reel 9

1. *Brooke Hayward*, 1964 (ST131)
2. *Peter Hujar*, 1964 (ST157)
3. *Binghamton Birdie*, 1964 (ST25)
4. *Dan Cassidy*, 1965 (ST51)
5. *John Giorno*, 1964 (ST116)
6. *Charles Rydell*, 1964 (ST289)
7. *Kipp Stagg*, 1965 (ST325)
8. *Binghamton Birdie*, 1964 (ST24)
9. *Joe Campbell*, 1965 (ST45)
10. *Rufus Collins*, 1964 (ST62)

## Reel 10

1. *Ethel Scull*, 1964 (ST302)
2. *Barbara Rose*, 1964 (ST281)
3. *Robin*, 1965 (ST278)
4. *Jane Holzer*, 1964 (ST140)
5. *Lou Reed*, 1966 (ST263)
6. *Edie Sedgwick*, 1965 (ST308)
7. *John Ashbery*, 1966 (ST13)
8. *Jonas Mekas*, 1966 (ST211)
9. *Ann Buchanan*, 1964 (ST34)
10. *Paul Morrissey*, 1965 (ST226)

## Reel 11

1. *Kelly Edey*, 1964 (ST89)
2. *Walter Burn*, 1964 (ST35)
3. *Sophronus Mundy*, 1964 (ST227)
4. *Susan Sontag*, 1964 (ST321)
5. *Betty Lou*, 1964 (ST23)
6. *Denis Deegan*, 1964 (ST73)
7. *Rufus Collins*, 1964 (ST61)
8. *Ivy Nicholson*, 1965 (ST234)
9. *Donyale Luna*, 1965 (ST195)
10. *Edie Sedgwick*, 1965 (ST305)

## Reel 12

1. *Bibbe Hansen*, 1965 (ST128)
2. *Jane Wilson*, 1964 (ST352)
3. *Bea Feitler*, 1964 (ST98)
4. *Nico*, 1966 (ST238)
5. *Paul Thek*, 1964 (ST337)
6. *Francesco Scavullo*, 1966 (ST296)
7. *Sheila Oldham*, 1966 (ST247)

## Reel 13

1. *Dan Cassidy*, 1965 (ST50)
2. *Harry Smith*, 1964 (ST314)
3. *Larry Latreille*, 1965 (ST191)
4. *Taylor Mead*, 1964 (ST210)
5. *Rosalind Constable*, 1964 (ST63)
6. *Penelope Palmer*, 1966 (ST255)
7. *David Murray*, 1965 (ST228)
8. *Alan Marlowe/Diane di Prima*, 1964 (see Vol. 2)
9. *Susan Sontag*, 1964 (ST319)
10. *Denis Deegan*, 1964 (see Vol. 2)

## Reel 14

1. *Boy*, 1964 (ST31)
2. *Billy Linich*, 1964 (ST193)
3. *Cliff Jarr*, 1964 (ST166)
4. *DeVerne Bookwalter*, 1964 (ST27)
5. *Allen Midgette*, 1967 (ST217)
6. *Ethel Scull*, 1964 (ST301)
7. *Ivan Karp*, 1964 (ST171)
8. *George Millaway*, 1966 (ST218)
9. *Sandra Hochman (Lips)*, 1964 (ST138)
10. *Allen Ginsberg*, 1966 (ST115)

## Reel 15

1. *Ivan Karp*, 1964 (ST172)
2. *George Millaway*, 1966 (ST219)
3. *Eric Andersen and Debbie Green*, 1966 (ST7)
4. *Andrew Sarris*, 1964 (ST295)
5. *Cliff Jarr*, 1964 (ST168)
6. *John Cale (Lips)*, 1966 (ST41)
7. *Howard Kraushar*, 1964 (ST186)
8. *Walter Dainwood*, 1964 (ST65)
9. *Louis Martinez*, 1966 (ST207)
10. *David*, 1966 (ST70)

## Reel 16

1. *Paul America*, 1965 (ST4)
2. *Susan Sontag*, 1964 (ST324)
3. *Lou Reed*, 1966 (ST261)
4. *Ruth Ford*, 1964 (ST106)
5. *Harold Stevenson*, 1964 (ST328)
6. *Henry Rago*, 1965 (ST260)
7. *Nico (Beer)*, 1966 (ST243)
8. *Alan Solomon*, 1964 (ST316)
9. *Jack Smith*, 1964 (ST315)
10. *Ethel Scull*, 1964 (ST303)

## Reel 17

1. *Ingrid Superstar*, 1966 (ST333)
2. *Guy*, 1964 (ST124)
3. *Susan Sontag*, 1964 (ST320)
4. *Isabel Eberstadt*, 1964 (ST84)
5. *Peter Goldthwaite*, 1966 (ST119)
6. *Robert Pincus-Witten*, 1964 (ST258)
7. *Louis Martinez*, 1966 (ST206)
8. *Ed Sanders*, 1964 (ST293)
9. *Henry Romney*, 1964 (ST280)
10. *Irving Blum*, 1964 (ST26)

## Reel 18

1. *Nico (Hershey)*, 1966 (ST246)
2. *Rosebud*, 1964 (ST283)
3. *Chip Monck*, 1966 (ST221)
4. *Susan Sontag*, 1964 (ST322)
5. *John Palmer*, 1964 (ST254)
6. *Richard Markowitz*, 1964 (ST204)
7. *Isabel Eberstadt*, 1964 (ST87)
8. *John Cale (Eye)*, 1966 (ST39)
9. *Lou Reed (Hershey)*, 1966 (ST271)
10. *Star of the Bed*, 1965 (ST327)

**Reel 19**

1. *Ronald Tavel*, 1964 (ST336)
2. *Susanna Campbell*, 1966 (ST46)
3. *Ed Hood*, 1966 (ST151)
4. *Taylor Mead*, 1964 (ST209)
5. *Archie*, 1966 (ST9)
6. *Susan Sontag*, 1964 (ST323)
7. *Philip and Gerard*, 1964 (see Vol. 2)
8. *James Claire*, 1966 (ST54)
9. *Ondine*, 1966 (ST248)
10. *Ruth Ford*, 1964 (ST107)

**Reel 20**

1. *Ruth Ford (Laugh)*, 1964 (ST108)
2. *Jane Holzer*, 1965 (ST148)
3. *Nico*, 1966 (ST236)
4. *Peter Orlovsky*, 1966 (ST250)
5. *Lou Reed (Apple)*, 1966 (ST268)
6. *Lou Reed (Coke)*, 1966 (ST269)
7. *Debbie Caen and Gerard Malanga*, 1965 (ST37)
8. *Noboru Nakaya*, 1964 (ST229)
9. *Ingrid Superstar*, 1965 (ST332)
10. *Kelly Edey*, 1964 (ST90)

**Reel 21**

1. *Holly Solomon*, 1964 (ST317)
2. *Nico*, 1966 (ST239)
3. *Maureen Tucker*, 1966 (ST344)
4. *Jane Holzer*, 1964 (ST145)
5. *Roderick Clayton*, 1966 (ST60)
6. *Barbara Jannsen*, 1966 (ST165)
7. *Richard Rheem*, 1966 (ST272)
8. *Isabel Eberstadt*, 1964 (ST86)
9. *John Cale (Eye)*, 1966 (ST40)
10. *Sarah Dalton*, 1964 (ST69)

**Reel 22**

1. *Randy Bourscheidt*, 1966 (ST29)
2. *Ed Sanders*, 1964 (ST294)
3. *Steve Holden*, 1964 (see Vol. 2: *Steve Holden Drunk*)
4. *Brooke Hayward*, 1964 (ST133)
5. *Dino*, 1966 (ST77)
6. *Zachary Scott*, 1964 (ST298)
7. *Susanna Campbell*, 1966 (ST47)
8. *Fred*, 1964 (ST111)
9. *Joe Brainard*, 1965 (ST32)
10. *Steve Garonsky*, 1964 (ST112)

**Reel 23**

1. *Sterling Morrison*, 1966 (ST225)
2. *Salvador Dalí*, 1966 (ST67)
3. *Cass Elliot*, 1966 (ST92)
4. *Ed Hood*, 1965 (ST149)
5. *Clarice Rivers*, 1964 (ST277)
6. *Jane Holzer (Toothbrush)*, 1964 (ST147)
7. *Harry Fainlight*, 1964 (ST97)
8. *Kenneth Jay Lane*, 1966 (ST190)
9. *Piero Heliczer*, 1965 (ST135)
10. *King*, 1964 (ST177)

**Reel 24**

1. *Freddy Herko*, 1964 (ST137)
2. *Lucinda Childs*, 1964 (ST52)
3. *John Cale*, 1966 (ST38)
4. *Niki de Saint Phalle*, 1964 (ST292)
5. *Lou Reed (Eye)*, 1966 (ST265)
6. *Lou Reed (Lips)*, 1966 (ST264)
7. *Marcel Duchamp*, 1966 (ST80)
8. *Steve Stone*, 1964 (ST330)
9. *Grace Glueck*, 1964 (ST118)
10. *Lou Reed (Hershey)*, 1966 (ST270)

**Reel 25**

1. *Beverly Grant (Hair)*, 1964 (ST123)
2. *Chuck Wein*, 1965 (ST350)
3. *Peter Hujar*, 1964 (ST159)
4. *Ed Hood*, 1966 (ST150)
5. *Ivy Nicholson*, 1964 (ST230)
6. *Jane Holzer*, 1964 (ST142)
7. *Brooke Hayward*, 1964 (ST132)
8. *Sally Dennison*, 1964 (ST76)
9. *Susanne De Maria*, 1964 (ST71)
10. *Ann Buchanan*, 1964 (ST33)

**Reel 26**

1. *Isabel Eberstadt*, 1964 (ST85)
2. *Cass Elliot*, 1966 (ST91)
3. *Steve Stone*, 1964 (ST331)
4. *Arman*, 1964 (ST12)
5. *Richard Rheem*, 1966 (ST274)
6. *François de Menil*, 1965 (ST212)
7. *Nico (Hershey)*, 1966 (ST245)
8. *John Palmer*, 1964 (ST253)
9. *Archie*, 1966 (ST11)
10. *Susan Bottomly*, 1966 (ST28)

**Reel 27**

1. *Alicia Purchon Clark*, 1965 (ST56)
2. *Ultra Violet*, 1965 (ST347)
3. *Sally Kirkland*, 1964 (ST181)
4. *Cathy James*, 1965 (ST162)
5. *Beverly Grant (Hair)*, 1964 (ST121)
6. *Nico (Coke)*, 1966 (ST244)
7. *Ultra Violet*, 1965 (ST346)
8. *Steve America*, 1965 (ST5)
9. *Henry Romney*, 1964 (ST279)
10. *John D. McDermott*, 1965 (ST208)

**Reel 28**

1. *Mary Woronov*, 1966 (ST358)
2. *Olga Klüver*, 1964 (ST185)
3. *Michael*, n.d. (ST216)
4. *Antoine*, 1966 (ST8)
5. *Karen*, 1964 (ST170)
6. *Richard Rheem*, 1966 (ST275)
7. *Olga Klüver*, 1964 (ST184)
8. *Ron Padgett*, 1964 (ST251)
9. *Gino Piserchio*, 1965 (ST259)
10. *Eric Andersen*, 1965 (ST6)

## Appendix D
# Color Reproductions

ST94. *Philip Fagan*, 1964

ST164. *Cathy James*, 1965

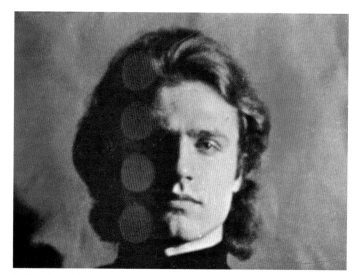

ST200. *Gerard Malanga*, 1965. From the cover of *Screen Tests/A Diary* by Gerard Malanga and Andy Warhol (New York: Kulchur Press, 1967).

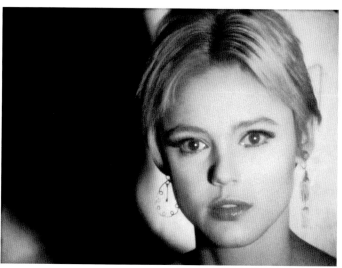

ST310. *Edie Sedgwick*, 1965

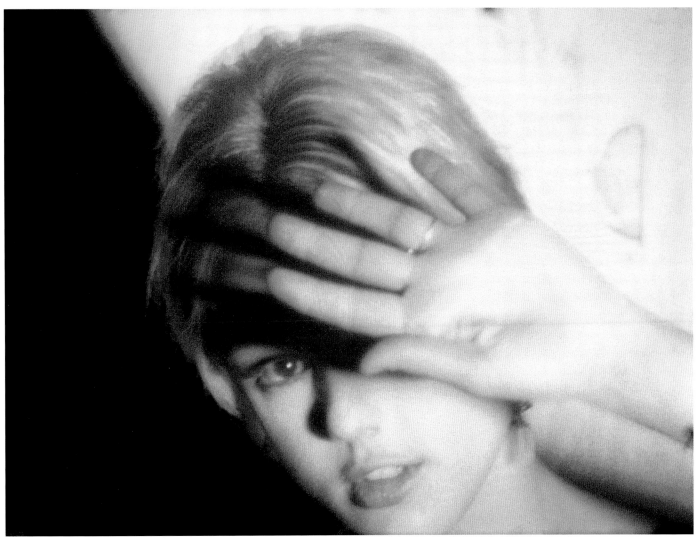

ST310. *Edie Sedgwick*, 1965

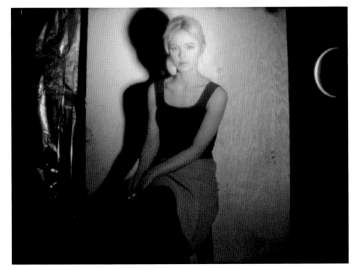

ST310. *Edie Sedgwick*, 1965

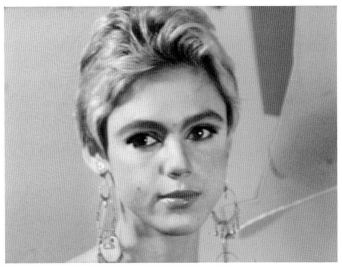

ST311. *Edie Sedgwick*, 1965

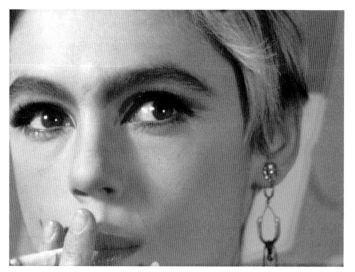

**ST312.** *Edie Sedgwick,* 1965

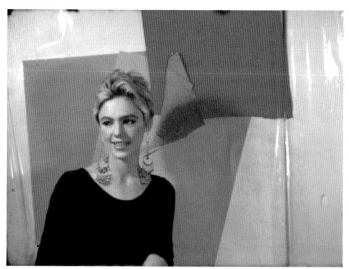

**ST312.** *Edie Sedgwick,* 1965

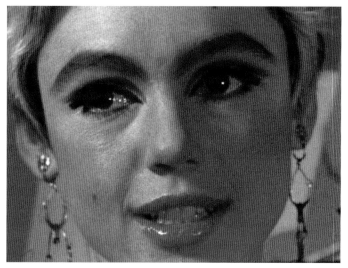

**ST313.** *Edie Sedgwick,* 1965

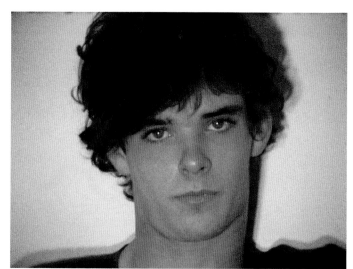

**ST339.** *Patrick Tilden-Close,* 1966

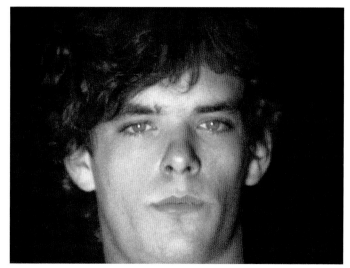

**ST340.** *Patrick Tilden-Close,* 1966

# Appendix E
# The Andy Warhol Film Project

The Andy Warhol Film Project has been a joint undertaking of the Whitney Museum of American Art, The Museum of Modern Art, The Andy Warhol Foundation for the Visual Arts, Inc., and The Andy Warhol Museum. The project originated in the early 1980s, when John G. Hanhardt, then curator and head of film and video at the Whitney, proposed an ambitious and unusually collaborative project in which the Whitney and MoMA would work together to preserve, restore, exhibit, distribute, and catalogue the entirety of Warhol's cinema. With the help of Tom Armstrong, director of the Whitney, and Fred Hughes and Vincent Fremont, two of the artist's closest colleagues, Warhol's cooperation was enlisted. In 1984, Warhol placed his original film materials on deposit with MoMA, where initial inspections and inventories were performed.

Warhol died in 1987; in 1988 the Whitney presented The Films of Andy Warhol: An Introduction, an exhibition of vintage prints from the Warhol Film Collection that was the inaugural event of the Andy Warhol Film Project. In 1989, The Museum of Modern Art restored the first group of thirteen Warhol films, putting them into distribution in 16mm through their Circulating Film Library. In 1990, The Andy Warhol Foundation for the Visual Arts, Inc. assumed ownership of Warhol's estate, including all the films. In 1991 the Warhol Foundation began providing major funding both to The Museum of Modern Art for the preservation of Warhol's cinema and to the Whitney for research on a catalogue raisonné of the films. Also in 1991, Callie Angell joined the Whitney as adjunct curator of the Andy Warhol Film Project; she also became consultant to MoMA on the preservation of the films.

In 1994, The Andy Warhol Museum opened in Pittsburgh as a joint venture of the Andy Warhol Foundation, the Dia Center for the Visual Arts, and the Carnegie Institute. Copies of the restored Warhol films were included in the Warhol Museum's collection. In 1997 the Warhol Foundation donated all of Warhol's film materials to The Museum of Modern Art, including the originals previously deposited at MoMA as well as the many remaining prints and originals found in storage at Warhol's studio. At the same time, the Warhol Foundation transferred the ownership of the film rights to the Warhol Museum in Pittsburgh.

Since 1991 the Whitney Museum has conducted major research for a catalogue raisonné of Warhol's films, and has also presented a number of premiere exhibitions, including The Films of Andy Warhol: An Introduction (1988), Andy Warhol's Video + Television (1991), The Films of Andy Warhol: Part II (1994), and Andy Warhol: Outer and Inner Space (1998).

The Museum of Modern Art has housed Warhol's original film materials since 1984 and now owns the entire Collection, which is maintained in state-of-the-art cold storage at MoMA's Celeste Bartos Film Preservation Center near Scranton, Pennsylvania. Since 1989 MoMA has restored more than ninety hours of Warhol's cinema, including 279 *Screen Tests* and fifty-three other titles; the restoration of the Warhol films by MoMA has been conducted in collaboration with both the Warhol Museum and the Whitney. The restored Warhol films are available for rental in 16mm from MoMA's Circulating Film Library; for more information, contact circfilm@moma.org. Study prints of the Warhol films are made available to scholars at MoMA's Celeste Bartos International Film Study Center by appointment only; for more information, contact charles_silver@moma.org.

The Andy Warhol Museum in Pittsburgh administers the rights for all the Warhol films, including copyright registrations, licensing, and reproduction fees. The Warhol Museum also holds a collection of all restored film titles, which are shown regularly in screenings at the Warhol Museum, and also made available to visiting scholars and researchers; for more information, visit http://www.warhol.org.

Prints of most of the preserved Warhol films have also been donated to the UCLA Film and Television Archive in Los Angeles, where they may be accessed by film scholars; for further information, contact the Archive Research and Study Center of the UCLA Film and Television Archive at 310-206-5388.

Since 1991, The Andy Warhol Foundation for the Visual Arts has generously supported both the restoration of the Warhol films by The Museum of Modern Art and the Whitney's research project. The Warhol Foundation also oversaw the large portion of the film collection that was initially stored at Warhol's Factory, and it administered all the films' rights up until the fall of 1997, when the film materials were donated to MoMA and the rights were transferred to The Andy Warhol Museum.

# Notes

Sources frequently cited are identified by the following abbreviations:

AWF     The Andy Warhol Foundation for the Visual Arts, Inc., New York
AWM     Archives Study Center, The Andy Warhol Museum, Pittsburgh
MoMA    The Museum of Modern Art, New York

## Introduction

**1.** Sally Banes, *Greenwich Village 1963: Avant-Garde Performance and the Effervescent Body* (Durham and London: Duke University Press, 1993), 2.

**2.** Friends, actors, and associates of Warhol's from 1964–66 who do not appear in the *Screen Tests* include, among many others, Brigid Berlin, David Bourdon, Dan Williams, Dorothy Dean, Sam Green, Buddy Wirtschafter, Roger Trudeau, Emile de Antonio, Danny Fields, Jill Johnston, Billy Klüver, David McCabe, Stephen Shore, Lester Persky, Donald Lyons, Jerry Benjamin, Robert Heide, David Whitney, and Tally Brown. The better-known stars from Warhol's later cinema such as Joe Dallesandro, Viva, Candy Darling, Jackie Curtis, and Holly Woodlawn do not appear in the *Screen Tests* because the production of *Screen Tests* had ceased by the time they arrived at the Factory.

**3.** Irving Blum interviewed by Patrick Smith in Patrick Smith, *Andy Warhol's Art and Films* (Ann Arbor, MI: UMI Research Press, 1981), 223–24. In the interview, Blum mistakenly identifies the kissers as Robert Indiana and Marisol; they are, actually, Harold Stevenson and Marisol.

**4.** Diary of Winthrop Kellogg Edey, January 17, 1964, The Frick Collection, New York. My thanks to Douglas Crimp and to Edgar Munhall, Barbara Roberts, Don Swanson, and Amy Genell at The Frick Collection for facilitating access to Edey's diary.

**5.** George Frei and Neil Printz, eds., *The Andy Warhol Catalogue Raisonné 01 : Paintings and Sculptures 1961–1963* (New York and London: Phaidon, 2002), cat. nos. 460–504.

**6.** Howard Junker, "Andy Warhol, Movie Maker," *The Nation*, February 22, 1965, 207.

**7.** See, for example, notes written on the boxes of *Ivy Nicholson* (ST234), *Ingrid Superstar* (ST332), and *Mary Woronov* (ST357). The *Screen Tests* should not be confused with *Screen Test No. 1* and *Screen Test No. 2*, two feature-length sound films from 1965 that were scripted by Ronald Tavel; the Tavel/Warhol films, on-screen interviews that are takeoffs on the conventional Hollywood screen test, are unrelated to Warhol's silent three-minute portraits.

**8.** Gerard Malanga interviewed by the author, June 15, 1995.

**9.** Malanga to the author, September 14, 1997. Malanga has also claimed that the idea for all the *Screen Tests* originated with him, beginning when he asked Warhol to film him in a "roll of movie film framed as a 'headshot' composition that I could then replicate as a publicity headshot." (Gerard Malanga, "The First Screen Test," *Archiving Warhol: An Illustrated History* [http://www.creationbooks.com: Creation Books, 2002], 65). It is possible that the origins of the *Screen Test* portrait films really were this overdetermined, simultaneously inspired by the photobooth photos, the mug shots in *The Thirteen Most Wanted* police brochure, and by Malanga's desire to reproduce frame sequences from a film as a publicity photo for himself. Nevertheless, the claims to the *Screen Tests* that Malanga has asserted seem to relate primarily to their reproduction as photographs, not to the actual films themselves, a confusion between media that has somehow turned into a confusion in credit.

**10.** Also, between fall 1965 and summer 1966, Warhol often loaned his Bolex to his assistant Dan Williams so that Williams could use it to make his own silent films; the Dan Williams films will be catalogued in an appendix to Vol. 2.

## Chapter One: Cataloguing and Methodology

**1.** Gerard Malanga interviewed by the author, June 15, 1995.

## Chapter Two: *Screen Tests* A–Z

**1.** Thanks to James Dowell for this information about Aberg.

**2.** See, for example, Andy Warhol and Pat Hackett, *POPism: The Warhol '60s* (New York: Harcourt Brace Jovanovich, 1980), 124–25; David Bourdon, *Warhol* (New York: Abrams, 1989), 211; Guy Flatley, "How to Become a Superstar—And Get Paid, Too." *New York Times*, December 31, 1967, D9.

**3.** Jean Stein, with George Plimpton, ed., *Edie: An American Biography* (New York: Knopf, 1982), 323–26.

**4.** Warhol and Hackett, *POPism*, 125.

**5.** Stein, *Edie*, 213.

**6.** See "America's Victory, Warhol Pays Off 'Hustler' Star," *Variety*, November 15, 1967; also Flatley, "How to Become a Superstar."

**7.** "'Ciao' Loses Leads: Warhol Alumni to Jail and Sanatorium," *Variety*, October 30, 1968.

**8.** Warhol and Hackett, *POPism*, 107.

**9.** AWM.

**10.** Angela Taylor, "A Hubbub at Paraphernalia," *New York Times*, October 6, 1966; Richard Goldstein, "If He Wasn't Antoine He'd Be So Ugly," *Village Voice*, October 13, 1966; "Ici Antoine," *Datebook*, February 1967. Thanks to Jay Reeg for discovery of the *Datebook* article.

**11.** *Screen Tests* of Paul Katz, Richard Rheem, and Ronna Page also demonstrate this same loss of registration, which suggests that all four people were probably filmed around the same time in October 1966.

**12.** Don Moser, "The Pied Piper of Tucson." *Life*, March 4, 1966, 18–24, 80–90.

**13.** Lot nos. 3409, 3414, 3417, *The Andy Warhol Collection: Contemporary Art* (New York: Sotheby's, 1988).

**14.** John Ashbery interviewed by Reva Wolf, in Reva Wolf, *Andy Warhol, Poetry, and Gossip in the 1960s* (Chicago: University of Chicago Press, 1997), 86.

**15.** "Andy Warhol in Paris," *New York Herald Tribune (International Edition)*, May 17, 1965, reprinted in John Ashbery, *Reported Sightings: Art Chronicles 1957–1987* (Cambridge, MA: Harvard University Press, 1991), 120–22. Quote, 120.

**16.** Stephen Shore (photographs) and Lynne Tillman (text), *The Velvet Years: Warhol's Factory 1965–67* (New York: Thunder's Mouth Press, 1995), 137.

**17.** See Chapter 4, "Artistic Appropriation and the Image of the Poet as Thief," in Wolf, *Warhol, Poetry, and Gossip*, 81–106, for a detailed discussion of Malanga's adaptations of and responses to Ashbery's work.

**18.** Tillman, *The Velvet Years*, 137.

**19.** A flyer for the World Theater dated October 1965 mentions works by a number of artists, including Dick Higgins, Al Hansen, Yoko Ono, Nam June Paik, Wolf Vostell, Andy Warhol, and Balkin himself; Time Capsule 14, AWM.

**20.** Steve Balkin, conversation with the author, August 13, 2004.

**21.** Cited by Gerard Malanga in "Figure of Benedetta," *Status and Diplomat*, March 1967, 38.

**22.** Ibid., 36–40.

**23.** "The Films of Gerard Malanga/Andy Warhol," a distribution brochure dated November 13, 1990, identified as "the first descriptive checklist of films

presently available for programming or museum purchase from ARCHIVES MALANGA"; copy courtesy Reva Wolf.

**24.** Malanga, *Archiving Warhol*, 48 (see intro., n. 9).

**25.** Gregory Battcock, ed., *The New Art: A Critical Anthology* (New York: E. P. Dutton & Co., 1966), 235–42.

**26.** For information about Battcock's death, see Bourdon, *Warhol*, 404 (see n. 2 above).

**27.** Interview by Patrick Smith, *Art and Films*, 213–14 (see intro., n. 3).

**28.** *Andy Warhol Photobooth Pictures*, exhibition catalogue (New York: Robert Miller Gallery, 1989), 99–100, 103.

**29.** Frank O'Hara quoted by Ron Padgett, conversation with the author, November 10, 2003.

**30.** Ted Berrigan, diaries, undated entry July 1963, Berrigan Collection, Rare Book and Manuscript Library, Columbia University, New York; cited in Wolf, *Warhol, Poetry, and Gossip*, 160, n. 25 (see n. 14 above).

**31.** *C: A Journal of Poetry* 1 (September 1963). For more details on this cover, see entry on Edwin Denby (ST75) and also Wolf, *Warhol, Poetry, and Gossip*, 15–33.

**32.** For a complete list of Berrigan's books of poetry, see "Publications by Ted Berrigan," http://epc.buffalo.edu/authors/berrigan/biblio.html.

**33.** David Ehrenstein, "An Interview with Andy Warhol," *Film Culture* 40 (Spring 1966): 41.

**34.** For a magical realist recollection of these experiences, see Mary Woronov's book *Swimming Underground: My Years in the Warhol Factory* (Boston: Journey Editions, 1995).

**35.** See Warhol and Hackett, *POPism*, 61–62 (see n. 2 above).

**36.** See Warhol and Hackett, *POPism*, 51; Andy Warhol and Pat Hackett, ed., *The Andy Warhol Diaries* (New York: Warner Books, 1989), December 12, 1984.

**37.** Misc. Box 124, AWM.

**38.** Thanks to Geralyn Huxley of The Andy Warhol Museum and to Irene J. Patrick for this identification.

**39.** See Susan Bottomly interviewed by Tillman, *The Velvet Years*, 107 (see n. 16 above).

**40.** Susan Bottomly appears in the following reels of ★★★★ *(Four Stars)*: *Susan and Allen*, Reel 3; *Ivy and Susan*, Reel 8; *Tally and Ondine*, Reel 9; *Susan and Allen Screaming*, Reel 15; *Susan—Screen Test*, Reel 16; *Allen and Apple*, Reel 19; and *Susan and David #1*, Reel 82. She also appears in various outtake reels from this period, including *Tiger Hop*, *Mary I*, and *Ivy, David, Susan*.

**41.** Interview by Mirra Bank Brockman, June 24, 1993, AWF.

**42.** Edey diary, January 17, 1964 (see intro., n. 4).

**43.** *Nancy*, 1961, cat. no. 019, Frei and Printz, *Warhol Catalogue Raisonné 01* (see intro., n. 5).

**44.** Roberta Smith, "Joe Brainard, Artist, Theater Set Designer and Poet, Dies at 52," *New York Times*, May 27, 1994; Roberta Smith, "Knitting Images and Words Into a Deft, Knowing Style," *New York Times*, November 9, 2001.

**45.** Ehrenstein, "Interview with Warhol," 41 (see n. 33 above).

**46.** From "Catfish McDarish Interviews Charles Plymell," in Charles Bové, ed. *Room Temperature*, Grist On-Line; http://www.thing.net/~grist/homebove.htm.

**47.** Allen Ginsberg, *Collected Poems 1947–1980* (New York: Harper and Row, 1984), 388–89.

**48.** P.T., "'13 Most Beautiful . . . ,'" *New York Herald Tribune*, January 10, 1965, sec. 10, 3.

**49.** I am indebted to Matt Wrbican at The Andy Warhol Museum for this observation.

**50.** Warren Sonbert, "A Letter," *Film Culture* 45 (Summer 1967).

**51.** Time Capsule 79, AWM.

**52.** According to Billy Name, Warhol attended this performance, the repetition of which seems to have had an influence on the editing of his film *Sleep*; Billy Name, conversation with the author, October 28, 1993.

**53.** John Cale and Victor Bockris, *The Autobiography of John Cale: What's Welsh for Zen* (London: Bloombury Publishing, 1999).

**54.** Joe Campbell, conversation with the author, Feb. 6, 1997. Harvey Milk would later become a leading gay politician and the mayor of San Francisco; he was murdered by Dan White in 1978.

**55.** Joe Campbell, conversation with the author, October 23, 2003.

**56.** Smith, *Art and Films*, 442 (see intro., n. 3).

**57.** Susanna Campbell, identified as "Tinkerbell," appears in a Stephen Shore photograph of the Velvet Underground entourage in Ann Arbor, Michigan, in March 1966; Victor Bockris and Gerard Malanga, *Up-Tight: The Velvet Underground Story* (New York: Omnibus Press, 1983), 28.

**58.** My thanks to Katha Dees Casey, Lawrence Casey, Melissa Casey, and Megan Dees Friedman for information about Casey's life.

**59.** Banes, *Greenwich Village 1963*, 59, 71 (see intro., n. 1).

**60.** Gerard Malanga, interview with the author, June 16, 1995.

**61.** From Roderick Clayton to Andy Warhol, June 25, 1966, Time Capsule 79, AWM.

**62.** See Patrick Smith's interview with Tom Lacey, in *Warhol: Conversations about the Artist* (Ann Arbor, MI: UMI Research Press, 1988), 151–52.

**63.** See, for example, Constable's 1963 memorandum to the editors of *Time* on the subject of "Underground Cinema," reproduced in Jonas Mekas, ed. *From the Archives, Volume I: New American Cinema Group and Film-Makers' Cooperative(s), The Early Years: Documents, Memos, Articles, Bulletins, Photos, Letters, Newspaper Clippings, etc.*, (New York: Anthology Film Archives, 1999), 144–47.

**64.** "Between the Lines," *New York*, December 16, 1968, quoted in Andrew Wilson, *Beautiful Shadow: A Life of Patricia Highsmith* (New York and London: Bloomsbury, 2003), 82.

**65.** Ibid., 81–83.

**66.** Harold Stevenson to the author, February 25, 1997.

**67.** Dale Joe, conversation with the author, March 11, 1999.

**68.** Walter Dainwood, "Digression of the Meaning of Willard Maas as Filmmaker and Poet," *Filmwise* no. 5–6 (1967): 46–50.

**69.** Advertisement, *Village Voice*, February 10, 1966, 22. The *Up-Tight* films will be catalogued in Vol. 2.

**70.** Sarah Dalton, conversation with the author, September 10, 1999.

**71.** Andy Warhol 1964 datebook, AWM.

**72.** Susanna De Maria Wilson, conversation with the author, July 7, 2003.

**73.** I am indebted to Susanna De Maria Wilson, Walter De Maria, and J. Hoberman for this information.

**74.** Warhol and Hackett, *POPism*, 44 (see n. 2 above).

**75.** Confusingly, one of these 1963 non-ST films was later selected for *The Thirteen Most Beautiful Boys* by Andy Warhol, and was also preserved in a *Screen Test* reel by MoMA.

**76.** Edey diary entry, January 17, 1964 (see intro., n. 4).

**77.** Gerard Malanga, "From *The Secret Diaries*," in *Out of This World: An Anthology of the St. Mark's Poetry Project, 1966–1991*, ed. Anne Waldman (New York: Crown Publishers, 1991), 287. The "still" that Malanga gave Deegan was probably a copy of the frame enlargement from Deegan's *Screen Test* that appears in *Screen Tests/A Diary* (see Appendix A), for which, as his diary mentions, Malanga was collecting signed permissions in September 1966.

**78.** My thanks to Katha Dees Casey, Lawrence Casey, Melissa Casey, and Megan Dees Friedman for this information about their family.

**79.** *C: A Journal of Poetry* 1 (September 1963). For a highly detailed discussion of the history and implications of this work see Wolf, *Warhol, Poetry, and Gossip*, 15–33 (see n. 14 above).

**80.** Thanks to Ron Padgett for this information. See Edwin Denby, "Four Plays by Edwin Denby," *The World* (St. Mark's Poetry Project) no. 12 (June 1968), unpaginated.

**81.** Ron Padgett, "Simon Smith and Ron Padgett: A Conversation about Edwin Denby," *Jacket* 21 (February 2003), http://jacketmagazine.com/21/denb-smith-padg.html.

**82.** See also ST85 for the original box for this film, with original notes in AW's hand: *13 Sally. Sam's Sally*.

**83.** I am indebted to Sam Green for identifying Sally Dennison, and for much of the following information.

**84.** Grace Glueck, "Warhol Unveils 25-Hour ★★★★ Film," *New York Times*, July 8, 1967, 15.

**85.** Rowland Koeford, "Antonioni Flick," interview with Sally Dennison, *Boston Free Press*, no. 5 (June 1968): 4; available online at http://www.trussel.com/lyman/bfp3.htm.

**86.** Dave O'Brian, "Mark Frechette: A Manipulated Life," *Boston Phoenix*, October 7, 1975, 9, 12; available online at http://www.trussel.com/lyman/frech4.htm. In 1973 Frechette was arrested in Boston during an armed bank robbery in which another commune member, Christopher Thien, was killed. Frechette died in prison in 1975, suffocated in a weight-lifting accident. For more information about Lyman's commune, see entry on Ronna Page (ST252).

**87.** Fiona Russell Powell, "The Face Interview," *Face* 59 (March 1985): 50; Warhol also discussed this project in his interview with Benjamin H. D. Buchloh, in "Three Conversations in 1985: Claes Oldenburg, Andy Warhol, Robert Morris," *October* 70 (Fall 1994): 33–54.

**88.** I am grateful to Neil Printz for identifying the occasion of this opening.

**89.** Ken Tyler Gemini G.E.L., to Andy Warhol, March 9, 1970, Time Capsule 22, AWM.

**90.** See photograph no. 104 in Nat Finkelstein, *Andy Warhol: The Factory Years 1964–1967* (New York: Powerhouse Books, 2000). I am grateful to Paul B. Franklin for identifying this painting; e-mail to the author, October 6, 2004.

**91.** Warhol and Hackett, *POPism*, 108 (see n. 2 above).

**92.** That this apocryphal-sounding story is true can be confirmed by Nat Finkelstein's photograph of Warhol and Dylan standing in front of the *Double Elvis* painting at the Factory, and by the provenance listed for this painting (cat. no. 407) in Frei and Printz, *Warhol Catalogue Raisonné 01*, 378 (see intro., n. 5). In 1978 Dylan ran into Warhol in London and promised him that if he ever gave him another painting, he'd never do it again; Warhol and Hackett, *Diaries*, June 20, 1978 (see n. 36 above).

**93.** In a filmed conversation shot in 1965, Warhol asked Henry Geldzahler: "Oh, Henry, do you think social imagery is going to come in? Like Bob Dylan singing all those funny songs? . . . Like rock and roll? . . . It seems it really should be the thing. . . . It's interesting, it's happening." Bruce Torbet, *Super Artist, Andy Warhol*, 1966, b&w and color, sound, 22 min.

**94.** *Andy Warhol's Index (Book)* (New York: Random House, 1967).

**95.** E-mail from Billy Name, May 15, 2003.

**96.** Ondine interviewed by John Hagen, "Arts Forum," WNYC-FM, taped April 4, 1978, airdate April 7, 1978.

**97.** Typescript, "Movie Party at the Factory: A Trip & a Half" by "Ingrid von Scheven (Superstar)," Time Capsule 7, AWM.

**98.** Marilyn Bender, *The Beautiful People* (New York: Coward-McCann, 1967), 96.

**99.** Ibid., 160–61.

**100.** Inge Reist, *Kelly Edey: In Life and In Memoriam, 1937–1999*, Frick Art Reference Library brochure, Fall 2001–Spring 2002.

**101.** *The Art of the Timekeeper: Masterpieces from the Winthrop Edey Bequest*, exhibition catalogue (New York: The Frick Collection, 2001); see also Robert McG. Thomas Jr., "Winthrop K. Edey, 61, Clock Enthusiast, Dies," *New York Times*, February 29, 1999.

**102.** Edey diary, January 20, 1964 (see intro., n. 4).

**103.** Danny Fields, "Andy Warhol and the Big Bird: Pop Pope Casts Cass," *Hullabaloo*, May 1967, 26–29, Time Capsule 47, AWM.

**104.** Ibid.

**105.** Gerard Malanga, interview with author, June 15, 1995.

**106.** Ugo Mulas and Alan R. Solomon, *New York: The New Art Scene* (New York: Holt, Rinehart and Winston, 1967); see photograph of Nancy Fish's *Screen Test* projected, 319. Information about Fish meeting Warhol is taken from an April 5, 1992, letter from Fish to the AWF.

**107.** Fish's 1992 letter also mentions that her *Screen Test* was nationally televised in 1966.

**108.** Charles Henri Ford interviewed by John Wilcock in *The Autobiography and Sex Life of Andy Warhol* (New York: Other Scenes, 1971), unpaginated.

Warhol's move into cinema was of course influenced by other friends as well, most notably Emile de Antonio.

**109.** Information taken from Roberta Smith, "Charles Henri Ford, 94, Prolific Poet, Artist and Editor," *New York Times*, September 30, 2002, B10.

**110.** Gerard Malanga, conversation with the author, June 16, 1995.

**111.** I am grateful to Fred Kraushar for identifying Steve Garonsky.

**112.** Henry Geldzahler interviewed by John Wilcock in *Autobiography and Sex Life* (see n. 108 above).

**113.** Ibid. In this interview, Geldzahler suggests that they also became less close because Geldzahler had started living with someone, and Warhol may have felt hurt by his unavailability.

**114.** Clarice Rivers recalls that when her *Screen Test* was shot in the fall of 1964, Henry Geldzahler was already in the chair, posing for his *Screen Test*, and they had to wait until that film was finished before Warhol could film her and Niki de Saint Phalle. Since the single Geldzahler *Screen Test* found in the Collection was shot on 1965 film stock with different lighting and a different background, this suggests that another earlier Geldzahler *Screen Test* may have existed at some point. Its current location is unknown. Clarice Rivers, conversations with the author, November 20–21, 2003.

**115.** Thanks to Billy Name for the identification of Germain as a friend of Lester Persky's.

**116.** Letter from Susan Pile, December 4, 1966; thanks to Steven Watson for this information.

**117.** See Jim Carroll, *Forced Entries: The Downtown Diaries, 1971–1973* (New York: Penguin, 1987), 26–27; Kent E. Carroll, "More Structured, Less Scandalized Warhol Aiming for Wider Play Off," *Variety*, May 7, 1968; "Walt Whitman as Male Nurse: Latest Warhol Homopeek," *Variety*, July 29, 1970.

**118.** Winston Leyland, "Interview with John Giorno," *Gay Sunshine* 24 (Spring 1975): 1–8.

**119.** In 1969, Giorno used another frame sequence from *Sleep* for the cover and illustrations of his book of poems, *Cunt* (Darmstadt, Germany: Marz Verlag, 1969); Time Capsule 19, AWM.

**120.** "Art Notes: Boom?" *New York Times*, May 10, 1964, 19; "Warhol Is Remembered by 2,000 at St. Patrick's," *New York Times*, April 2, 1987, B10; "Pittsburgh, Warhol's Hometown, To Get His Museum, Opening in '92," *New York Times*, October 3, 1989, C15–16.

**121.** "Art Notes: Popera," *New York Times*, July 5, 1964, 16.

**122.** Conversation with the author, September 28, 2004.

**123.** Glenway Wescott to Andy Warhol, October 3, 1964, Box B560, AWM.

**124.** Thanks to Sean Carrillo, Bibbe Hansen, and the bibbe.com Web page for this information; see also Bibbe Hansen interviewed by Vaginal Davis, *Index Magazine*, 1999, http://www.indexmagazine.com/interviews/bibbe_hansen.shtml.

**125.** Warhol and Hackett, *POPism*, 39–40 (see n. 2 above).

**126.** Information obtained from the Piero Heliczer Web page, http://mujweb.cz/www/heliczer.

**127.** See Warhol's films *Courtroom*, *Jail*, and *Allen in Jail* (1966). Information on Heliczer obtained from: Tom Raworth, "Piero Heliczer, 1937–1993," *The Poetry Project Newsletter* 153 (February/March 1994): 5.

**128.** Piero Heliczer, *Soap Opera* (London: Trigram Press, 1967), 31.

**129.** For various tellings of this story, see Victor Bockris, *Warhol* (New York: De Capo, 1997), 236; John Giorno, *You Got to Burn to Shine* (New York: High Risk Books, 1994), 147; and Bourdon, *Warhol*, 191 (see n. 2 above). In early 1965, Warhol made a color film called *Suicide*, in which a young man reminisces about his various suicide attempts.

**130.** Warhol and Hackett, *POPism*, 55 (see n. 2 above)

**131.** Most of the details of Herko's life are taken from Donald McDonagh, "The Incandescent Innocent," *Film Culture* 45 (Summer 1967): 55–60. The dedication of the white *Flowers* painting is mentioned in Bourdon, *Warhol*, 191.

**132.** James Stoller, "Beyond Cinema: Notes on Some Films by Andy Warhol," *Film Quarterly* 20, no. 1 (Fall 1966): 38.

**133.** Film-Makers' Cinematheque flyer, November 30–December 21, 1964, Time Capsule 74, AWM.

**134.** Warhol and Hackett, *Diaries*, 8 (see n. 36 above). Information about Hochman obtained from Chadwyck-Healey, Inc., http://www.dlxs.org/products/archive-by-CDRoM/6/TextClass/src/web/a/a.../am22212.bio.htm.

**135.** Bender, *Beautiful People*, 158–59 (see n. 98 above).

**136.** Tom Wolfe, "The Girl of the Year," *New York Herald Tribune*, Sunday Magazine, December 9, 1964.

**137.** Mirra Bank Brockman, unpublished interview, December 17, 1991, AWF.

**138.** "Saint Andrew," *Newsweek*, December 9, 1964, 103A.

**139.** Irving Blum quoted in Victor Bockris, *Warhol* (London: Penguin Books, 1990), 173. According to Blum, Hopper graciously returned the painting when Blum decided to keep all thirty-two paintings together as a set.

**140.** See Patrick Smith interview with Henry Geldzahler in Smith, *Conversations*, 184 (see n. 62 above). Although Geldzahler recalled that this visit was in 1962, according to Frei and Printz, *Warhol Catalogue Raisonné 01* (see intro., n. 5), *Double Mona Lisa* (cat. no. 332) was painted in January–February 1963.

**141.** Hopper quotation from Chuck Workman's 1990 documentary, *Superstar: The Life and Times of Andy Warhol* (1990), transcribed by the author.

**142.** Information on Hujar obtained from Urs Stahel and Hripsimé Visser, *Peter Hujar: A Retrospective* (Zurich: Scalo, 1994).

**143.** Stahel, "Foreword," in ibid., 8.

**144.** "Underground Clothes," photographs by Howell Conant, *Life*, March 19, 1965, 106–12. Imu is identified as "Imo" in this article.

**145.** John Burks and Jerry Hopkins, "Groupies and Other Girls," *Rolling Stone*, February 15, 1969, 19. Many thanks to Jay Reeg for locating this article.

**146.** Julie Finch, conversation with the author, June 17, 2003.

**147.** Bourdon, *Warhol*, 80–82, 84–86, 130–31, 186; Warhol and Hackett, *POPism* (see n. 2 above).

**148.** Ivan C. Karp, *Doobie Doo* (New York: Doubleday, 1965). Warhol's copy is inscribed by Karp, "For beautiful Andy, magic artist, friend and latter day saint, genius and pulse of our time, all my love and affection, Ivan." Time Capsule 30, AWM.

**149.** Lady Henriette Rous, ed., *The Ossie Clark Diaries* (London: Bloomsbury, 1998); thanks to Charles Griemsman for identifying these photographs. As this book was going to press, some last-minute information about Kellie, including her full name, was provided by Richard J. Powell. Kellie Wilson was originally from the small town of Dowagiac, Michigan; her modeling career was based in London, where she modeled for Mary Quant.

**150.** Banes, *Greenwich Village*, 71 (see intro., n. 1).

**151.** Information obtained from Kenneth King press release dated June 11, 1965, Time Capsule 30, AWM.

**152.** Kenneth King, "Toward a Trans-Literal and Trans-Technical Dance-Theater," in *The New Art: A Critical Anthology*, ed. Gregory Battcock (New York: E. P. Dutton & Co., 1966), 243–50.

**153.** Kenneth King, *Writing in Motion: Body—Language—Technology*, ed. Deborah Jowitt (Middletown, CT: Wesleyan University Press, October 2003).

**154.** "Underground Clothes" (see n. 144 above).

**155.** "13 Most Beautiful . . ." (see n. 48 above).

**156.** *The American Film Institute Catalogue: Feature Films, 1961–1970* (Berkeley: University of California Press, 1976), 1237.

**157.** My thanks to Douglas Crimp and Akiko Mizoguchi for these details.

**158.** Olga Adorno, conversation with the author, July 18, 2003.

**159.** "You Bought It, You Live with It," *Life*, July 16, 1965, Time Capsule 6, AWM; "Way Out, but Definitely 'In,'" *Protection* (Travelers Insurance Co.), August 1966, 4, Time Capsule 472, AWM.

**160.** Richard Polsky, "The Forgotten Legend of Leon Kraushar." *Artnet*, February 4, 2003, http://www.artnet.com/magazine/features/polsky/polsky2-4-03.asp.

**161.** Fred Kraushar, interview with the author, July 23, 2003; my thanks also to Ivan Karp and Richard Polsky.

**162.** Warren Sonbert, "Vivian," *Film Culture* 45 (Summer 1967): 33.

**163.** Tom Lacey, interviewed by Patrick Smith in *Conversations*, 151–52 (see n. 62 above).

**164.** AWF. For a color illustration of this portrait, see Richard Meyer, *Outlaw Representation: Censorship and Homosexuality in Twentieth-Century American Art* (Oxford: Oxford University Press, 2002), 116.

**165.** Christopher Mason, "Real Charm and Fake Jewels Society Ladies Can't Resist," *New York Times*, October 10, 1999, Sec. 9, 1.

**166.** In addition to the Mason article, additional information on Lane was obtained from Julie Hatfield, "When It Comes to Fakes, He's the Real Thing," *Boston Globe*, November 17, 1990, 17; Enid Nemy, "The King of Junque," *New York Times*, June 27, 1993, Sec. 9, 1; and Stein, *Edie*, 441 (see n. 3 above).

**167.** Kenneth Jay Lane, *Faking It* (New York: Harry N. Abrams, 1996), 28; the photograph of Sedgwick is reproduced in Stein, *Edie, 251*.

**168.** Lacy quoted by Smith in *Conversations*, 151–52 (see n. 62 above).

**169.** Kenneth Jay Lane, telephone conversation with the author, November 10, 2003.

**170.** Ronald Tavel, interviewed by the author, August 4, 1994; Bibbe Hansen, conversation with the author, October 2, 2003.

**171.** Howard Junker, "Movie Maker," 207 (see intro., n. 6).

**172.** "Joe" to Andy Warhol, January 13, 1965, Time Capsule 76, AWM.

**173.** Alan Marlowe to Andy Warhol, January 14, 1965, Time Capsule 59, AWM. Marlowe mentions the Diane di Prima section: "Diane and I have a section for the Leseur (sic) *Messy Lives* The two of us and five pounds of nice clear honey. If you were to call us and set a time we would be sure to come."

**174.** Frank O'Hara, *Amorous Nightmares of Delay: Selected Plays*, Reprint ed. (Baltimore: Johns Hopkins University Press, 1997). Thanks to Ron Padgett for this information. In Brad Gooch, *City Poet: The Life and Times of Frank O'Hara* (New York: Alfred A. Knopf, 1993), 397, the author recalls that the O'Hara/Lima collaboration was called "Love on the Hook."

**175.** Joe LeSueur, *Digressions on Some Poems by Frank O'Hara* (New York: Farrar, Straus and Giroux, 2003), 289–90.

**176.** Howard Junker, "Movie Maker," 208 (see intro., n. 6).

**177.** LeSueur, *Digressions*, 291.

**178.** Gooch, *City Poet*, 435.

**179.** Joseph LeSueur, "Theatre: Two Plays by Ronald Tavel," *Village Voice*, October 13, 1966, 25.

**180.** Reproduced in Warhol and Hackett, *POPism*, 300 (see n. 2 above).

**181.** Bender, *Beautiful People*, 21 (see n. 98 above). As this book was going to press, additional information was obtained from Richard J. Powell. According to Powell, Donyale Luna was discovered in 1964 at the age of eighteen in Detroit by the fashion photographer David McCabe. McCabe brought her to New York, introduced her to Warhol, and Warhol in turn introduced her to the editors of *Harper's Bazaar*; Donyale Luna appeared on the cover of *Harper's Bazaar* in January 1965. By 1966, she had moved to Europe and eventually settled in Italy, where she died from a drug overdose in 1979.

**182.** "Luna in Galanos," and "Frug That Fat Away: The Death of the Diet," *Harper's Bazaar*, April 1965, 190–93 and 184–85; http://www.rootstein.com/html/history/60s/content.htm.

**183.** Warhol and Hackett, *POPism*, p. 25–26 (see n. 2 above).

**184.** See Mel Gussow, *Edward Albee: A Singular Journey* (New York: Simon and Schuster, 1999), chap. 8.

**185.** Malanga, *Archiving Warhol*, 23 (see intro., n. 9).

**186.** Gerard Malanga, conversation with the author, June 15, 1995.

**187.** See entry on Menken; Maas's film *Andy Warhol's Silver Flotations* was shot at the Leo Castelli Gallery in 1966.

**188.** *Filmwise*, no. 5–6, 1967.

**189.** Note postmarked April 27, 1966, Time Capsule 30, AWM.

**190.** Jonas Mekas interviewed by the author, December 18, 1991.

**191.** Minimum wage became $1.15/hr. in September 1964, $1.25/hr. in September 1965 (U.S. Department of Labor, "History of Changes to the Minimum Wage Law," http://www.dol.gov/esa/minwage/coverage.html); Malanga's time sheets, on which he calculated his weekly salary in 1965 and 1966, show he was being paid $1.25/hour. Time sheets found in "B" Boxes 17 and 381, AWM.

**192.** Isabel Eberstadt and Danny Fields quoted in Stein, *Edie*, 161 (see n. 3 above).

**193.** Malanga appears in the following two reels of ★★★★ *(Four Stars)*: *Gerard Has His Hair Removed with Nair*, Reel 22, and *Barbara and Ivy*, Reel 26, as well as in *Donyale Luna* and *Mary and Richard II*.

**194.** A quantity of Malanga's correspondence concerning distribution of the Warhol films in 1969 has been found in "B" Box 12, AWM.

**195.** Flyer found in Time Capsule 11, AWM; advertisement in *Village Voice*, June 26, 1969, 48. According to the ad, the titles shown were *Male Amateur Striptease*, *Homo-Eroticus*, *Double Exposure*, *Charles Pierce Drag Camp '69*, *Summersex*, *Repairman*, *Santa Comes to California*, and *The Basket Boy of the Week*. See also: "Homo Films From Frisco Getting First 'Conventional' Theatre Dates in New York," *Variety*, David Curtis files, London; and Jonas Mekas, "Movie Journal," *Village Voice*, August 14, 1969.

**196.** "The First Screen Test," manuscript by Gerard Malanga mailed to author, July 14, 1997. In a later, published version of this essay, Malanga changed the dating of his first *Screen Test* to "Sometime in December 1963, a couple of months before our move to the 47th Street Factory"; Malanga, *Archiving Warhol*, 65 (see intro., n. 9). According to Warhol's 1964 datebook, the 47th Street Factory was acquired on January 28, 1964; AWM.

**197.** This film is also illustrated in Malanga, *Archiving Warhol*, 64, where it is dated 1965 (see intro., n. 9).

**198.** Warhol and Hackett, *POPism*, 34 (see n. 2 above).

**199.** Marisol herself was unable to identify this gentleman, and did not know where the film original might be. Marisol, conversation with the author, February 26, 2003.

**200.** I am grateful to Fred Kraushar for identifying Markowitz.

**201.** Painters of immensely popular "kitsch" images of sad-eyed children and animals.

**202.** Gerard Malanga, interview with the author, June 15, 1995.

**203.** Taylor Mead, *Son of Andy Warhol. Vol. IV: Excerpts from the Anonymous Diary of a New York Youth* (Madras and New York: Hanuman Books, 1986).

**204.** Warhol and Hackett, *POPism*, 35 (see n. 2 above).

**205.** David James, *New American Film and Video Series 68: Jonas Mekas*, program notes (New York: Whitney Museum of American Art, November 18–December 6, 1992).

**206.** A mention of the work-in-progress *Sleep* in Jonas Mekas, "Movie Journal," *Village Voice*, September 19, 1963. The earliest mention of Warhol as filmmaker appears mysteriously in a magazine called *American Girl* (May 1961) in a short section about the contributors titled "Behind Our By-Lines." The paragraph on Warhol, one of the illustrators in the issue, says: "At home in New York, now Andy is working on an experimental movie." Time Capsule 12, AWM.

**207.** *Film Culture* 33 (Summer 1964): 1.

**208.** This homage, produced on the occasion of *Film Culture*'s award to Warhol, was shot in the style of a Warhol film: a twelve-minute black-and-white film, optically printed to appear in slow motion and accompanied by a pop sound track, shows Mekas presenting a basket of fruit to Warhol and a group of his superstars, including Gerard Malanga, Philip Fagan, Jane Holzer, Ivy Nicholson and her two children, Darius and Sean, and dancer Kenneth King. Mekas and his cameraman Gregory Markopoulos also appear briefly in the film. The fruit is consumed by the entire cast in slow motion.

**209.** E-mail from François de Menil to the author, May 22, 2003.

**210.** Warhol and Hackett, *POPism*, 26 (see n. 2 above)

**211.** Gary McColgan, "The Superstar: An Interview with Mario Montez," *Film Culture* 45 (Summer 1967): 19.

**212.** Midgette appears in the following sequences shot for or included in ★★★★ *(Four Stars)*: *Allen in Restaurant*, *Orion #1*, *Orion #2*, *Allen and Dicken*, *Susan and Allen Screaming*, *Ultra*, *Sally Kirkland*, *Allen in Jail*, *Group #1*, *Allen and Apple*.

**213.** See, for example: Don Bishoff, "Film Maker Sends 'Double' on 4-Campus Hoax," *Los Angeles Times*, February 8, 1968, 3; also published as "Andy Warhol or Someone Gives a Non-Lecture Tour," *New York Post*, February 8, 1968. Midgette-as-Warhol first appeared at the University of Rochester, and later, in early October, at the University of Utah in Salt Lake City, at the University of Montana in Missoula, at Linfield College in McMinnville, Oregon, and at the University of Oregon in Eugene. In early 1968, inquiries from suspicious students at the University of Utah led to a confession by the Warhol organization and the uncovering of the hoax. The Warhol publication, *Andy Warhol's Index* (see n. 94 above), had already "revealed" the hoax on its back cover, which shows a large Billy Name photograph of Allen Midgette with the words "Andy Warhol" printed on his upper lip.

**214.** Warhol and Hackett, *POPism*, 248 (see n. 2 above).

**215.** "A Midgett (sic) Version of Andy Warhol," *New York Post*, March 24, 1988, 6.

**216.** See *Eric (Background)* and *3 Min. Mary Might* for the "background reels" from *The Chelsea Girls* (1966) in which Millaway appears.

**217.** Gary McColgen, "Superstar: An Interview with Mario Montez," *Film Culture* 45 (Summer 1967): 19.

**218.** Warhol and Hackett, *POPism*, 181 (see n. 2 above).

**219.** Archer Winston, "Rages and Outrages," *New York Post*, February 28, 1966.

**220.** John Gruen, "The Underground's M.M.—Mario Montez," *World Journal Tribune*, January 22, 1967; Rosalyn Regenson, "Where Are 'The Chelsea Girls' Taking Us?" *New York Times*, September 24, 1967.

**221.** Photographs by Mark Zane Safron of the shooting of Montez's *Screen Test* and the making of *More Milk Yvette* appeared in *Film Culture* 40 (Spring 1966).

**222.** Avery Willard, *Female Impersonation* (New York: Regiment Publications, 1971), 46. I am grateful to Marc Siegel for sending me a copy of this publication.

**223.** Details from Lawrence Van Gelder, "Sterling Morrison, 53, Rock Guitarist, Dies," *New York Times*, September 2, 1995, 32.

**224.** This meeting was possibly on June 19 or 20, 1965, when *Vinyl* and *Poor Little Rich Girl* were shown by the Film-Makers' Cinematheque at the Astor Place Playhouse on Lafayette Street; a program of Paul Morrissey's films was scheduled to be shown at the Cinematheque the next day, June 21. Film-Makers' Cinematheque schedule for June and July 1965, Time Capsule 41, AWM.

**225.** Warhol and Hackett, *POPism*, 119 (see n. 2 above).

**226.** Jonathan Rosenbaum, "Conversation with Paul Morrissey," *Oui*, March 1975, 72. While it is true that Warhol did not usually set up the lights or handle the details of organizing the film shoots, it should be noted that Chuck Wein, Dorothy Dean, Dan Williams, Billy Linich, and Ronald Tavel also made important contributions to the films.

**227.** I am grateful to Edgar Munhall and Richard Barsam for this information about Mundy.

**228.** David Murray, "From David Murray's Journal," *Intransit: The Andy Warhol-Gerard Malanga Monster Issue*, Warhol and Malanga, ed. (Eugene, OR: Toad Press, 1968), 60–66.

**229.** Ivy Nicholson on the cover of *Harper's Bazaar*, http://www.geocities.com/SunsetStrip/Mezzanine/3877/ivyhb.gif.

**230.** Darius de Poleon appears with Jane Holzer in *Jane and Darius* (1964); in addition to *John and Ivy* (1965), the children also appear in some rolls shot for *Batman Dracula* (1964) and can be seen in Jonas Mekas's 1964 film *Award Presentation to Andy Warhol*.

**231.** Nicholson herself reports that the twins were born on March 2, 1965, but her slim appearance in *John and Ivy* makes it seem highly unlikely that she was seven months pregnant with twins in January. The birth date of November 2, 1965, listed for Penelope Palmer seems much more likely. For a record of the birthdate, see http://us.imdb.com/name/nm0658421/bio.

**232.** Nicholson appears in the following reels of the final version ★★★★ *(Four Stars)*: *Ivy in Pool*, Reel 1; *Ivy*, Reel 4; *Ivy and Susan*, Reel 8; *Nico and Ivy*, Reel 10; *Group #1*, Reel 11A; *Ivy in Philadelphia*, Reel 13; *Katrina Dead*, Reel 23; *Ondine Dead*, Reel 24; *Barbara and Ivy*, Reel 26; *Waldo*, Reel 36; *Rolando*, Reel 37; *Ondine and Edie*, Reel 38; *Sally Kirkland*, Reel 39; *Ivy and Nico in Room*, Reel 44; and *Don McNeil*, Reel 45. She also appears in the following reels from late 1966 to early 1967: *Bufferin Commercial*, *The Bob Dylan Story*, *Since*, *Tiger*

*Hop, Courtroom, Ivy, David,* and *Susan, Ivy Swimming, Dentist—Nico, Ivy, Denis, Ivy #1, Ivy and Denis, Matilda and Françine, Barbara and Ivy I, Ivy and Don McNeil II, Ivy and Barbara II, Ivy and Nico #2,* and *Ivy.*

**233.** Time Capsule 47, AWM.

**234.** Frederick C. Castle, "Cab Ride with Andy Warhol," *Art News,* vol. 66, no. 10, February, 1968, 46. Castle was working as a cab driver when he happened to pick Warhol up outside Max's Kansas City and recorded their conversation; Warhol had hurriedly left Max's because Nicholson had just made a scene when he arrived.

**235.** Warhol and Hackett, *Diaries,* February 10, 1987 (see n. 36 above).

**236.** Junker, "Movie Maker," 208 (see intro., n. 6).

**237.** "Underground Clothes" (see n. 144 above).

**238.** See Richard Witts, *Nico: The Life and Lies of an Icon* (London: Virgin, 1993): 80–81 on Delon; 89–91 on Dylan.

**239.** Nico appears in the following reels of ★ ★ ★ ★ *(Four Stars): Nico and Ivy,* Reel 10; *Nico–Music,* Reel 20; *Nico and Katrina,* Reel 21; *Sally Kirkland,* Reel 39; *Nico and Ivy in Room,* Reel 44; *Ted O'Neil,* Reel 45; *The Castle,* Reel 48; *Tom Baker,* Reel 52, *Patrick and Nico,* Reel 59; *Pat and Nico,* Reel 60; *Sausalito,* Reel 75; *Haight Ashbury,* Reel 76. She also does the voice-over for *Sunset,* Reel 77. She also appears in the following outtake reels from ★ ★ ★ ★ *(Four Stars): Mary and Richard II, Tiger's Place, Dentist—Nico, Ivy, Denis, Nico and Music and Ivy,* and *Ivy and Nico II.*

**240.** Ari Boulogne appears in the *Nico in Kitchen* reel of *The Chelsea Girls, The Velvet Underground and Nico,* and *Ari and Mario.*

**241.** Witts, *Nico,* 160.

**242.** Ibid., 168.

**243.** See ibid.; also, James Young, *Nico: The End* (New York: Overlook Press, 1993).

**244.** See Nat Finkelstein's photograph of Warhol with Brian Jones at Paraphernalia in Bockris and Malanga, *Up-Tight,* 31 (see n. 57 above). A color roll called *Paraphernalia,* showing Susan Bottomly at the opening of this boutique, is dated 7/29/66.

**245.** Witts, *Nico,* 181.

**246.** Information about Sheila Oldham obtained from Andrew Loog Oldham, *Stoned: A Memoir of London in the 1960s* (New York: St. Martin's Press, 2001). A photograph of Sheila Klein appears on p. 70.

**247.** After Ondine, with twenty-five hours of footage, the next most frequently filmed star, with nearly eighteen hours of footage, is Edie Sedgwick, followed by Ivy Nicholson, with nearly seventeen hours.

**248.** Andy Warhol, *a a novel* (New York: Grove Press, 1968).

**249.** Ondine appears in the following reels of ★ ★ ★ ★ *(Four Stars): Ondine in Bathroom,* Reel 7; *Tally and Ondine,* Reel 9; *Allen in Jail,* Reel 17; *Katrina Dead,* Reel 23; *Ondine Dead,* Reel 24; *Christmas Carol,* Reel 27; *Emmanuel,* Reel 35; *Waldo,* Reel 36; *Rolando,* Reel 37; *Edie Sedgwick,* Reel 38; *Sunset Beach on Long Island,* Reel 40; *Edith and Ondine,* Reel 41; *East Hampton Beach,* Reel 43; *Ondine F.,* Reel 48; *Ondine G.,* Reel 49; *Pat and Brigid,* Reel 61; *Ondine and Ingrid,* Reel 68; *Ondine and Joe,* Reel 69; and *Haight Ashbury,* Reel 76. He also appears in several outtake reels: *Jail, Courtroom,* and *Philadelphia Stable.*

**250.** "Beloved Ondine's Advice to the Shopworn," *Kiss,* vol. 1, no. 12 (1969): 16, 19, Time Capsule 65, AWM.

**251.** Quoted in Nancy Steadman, "Andy's Gang," *New York Daily News,* October 31, 1968, 31.

**252.** Letter from Susan Pile, December 4, 1966; thanks to Steven Watson for this information.

**253.** Information about Orlovsky's life obtained from the Harry Ransom Humanities Research Center at the University of Texas at Austin, http://www.hrc.utexas.edu/research/fa/orlovsky.peter.html.

**254.** Ron Padgett, conversation with the author, November 10, 2003.

**255.** *Film Culture* 32 (Spring 1964): 13.

**256.** Ron Padgett, *Two Stories for Andy Warhol* (New York: C Press, 1965).

**257.** Published in Ron Padgett, *Great Balls of Fire* (Minneapolis: Coffee House Press, 1990).

**258.** Information about Padgett obtained from his Web site: http://www.ronpadgett.com.

**259.** Padgett recalls that when he and Berrigan visited the Factory, Berrigan's *Screen Test* had already been shot by Warhol. Since Berrigan's *Screen Test* was filmed on March 3, 1965 (see discussion of Ted Berrigan), Padgett's portrait film, shot on 1964 stock, was probably made later that same month.

**260.** Ron Padgett, conversation with the author, November 10, 2003.

**261.** Her name is spelled and pronounced "Ronna," although people often called her "Rona," which she disliked; Bruce Rudow, conversation with the author, October 23, 2003.

**262.** See Gordon Ball, *'66 Frames* (Minneapolis: Coffee House Press, 1999), 33, 79–81.

**263.** "Talk of the Town," *The Avatar* (October 27, 1976): 17.

**264.** "Ondine and Broughton: Graduate Seminar at the San Francisco Art Institute, Oct. 2," *Canyon Cinema News* (November–December, 1975): 6.

**265.** Reprinted in David Felton, ed., *Mindfuckers: A Source Book on the Rise of Acid Fascism in America (Including material on Charles Manson, Mel Lyman, Victor Baranco and their followers by David Felton, Robin Green, and David Dalton)* (San Francisco: Straight Arrow Books, 1972).

**266.** From Ronna Page to Andy Warhol, undated, Time Capsule 79, AWM.

**267.** My thanks to Eileen Clancy and Matthew Buckingham for this information.

**268.** John Palmer, conversation with the author, October 15, 2003. See also Steven Watson, *Factory Made: Warhol and the Sixties* (New York: Pantheon, 2003), 161.

**269.** Junker, "Movie Maker," 208 (see intro., n. 6).

**270.** From "Buffy" to Andy Warhol, undated, "B" Box B172, AWM.

**271.** Quoted in Smith, *Conversations,* 228 (see n. 62 above).

**272.** Robert Pincus-Witten, "Pre-Entry: Margins of Error: Saint Andy's Devotions," *Arts Magazine* (Summer 1989): 56–60.

**273.** Information on Piserchio obtained from: "Susy Says: Wedding Wows in Aspen," *New York Daily News,* February 9, 1972, Andy Warhol Scrapbooks, AWM; Holly Woodlawn to Andy Warhol, February 8, 1972, Time Capsule 7, AWM; Steina and Woody Vasulka, Studies, Electronic Arts Intermix NY, http://www.eai.org/eai/tape.jsp?itemID=6518. Thanks also to Lynne Tillman.

**274.** Julie, "The," *Night Owl* (February 1967): 36, Time Capsule 47, AWM.

**275.** From Richard Rheem to Andy Warhol, July 27 and September 4, 1966, Time Capsule 79, AWM.

**276.** Bockris, *Warhol* (1990), 315 (see n. 139 above).

**277.** Rheem signed a talent release dated November 7, 1966, using his full name, Richard S. Rheem II, and giving 1342 Lexington Avenue as his address; AWF.

**278.** Bockris, *Warhol* (1990), 314–15 (see n. 139 above).

**279.** Richard Rheem to Andy Warhol, 1968 and 1969, Time Capsules -12, 19, 10, AWM.

**280.** *Warhol Photobooth Pictures,* 133–47 (see n. 28 above). Rheem is unidentified in this catalogue.

**281.** Similar maneuvers can be seen in *Allen and Apple,* in which the camera repeatedly focuses on Allen Midgette holding a piece of fruit, such as an apple, then goes way out of focus, then focuses in again on Midgette holding a different kind of fruit, such as a banana.

**282.** Information on Ricard obtained from renericard.org: http://renericard.org/index.html.

**283.** See n. 114 above.

**284.** Clarice Rivers, conversations with the author, November 20–21, 2003. See also Larry Rivers and Arnold Weinstein, *What Did I Do?: The Unauthorized Autobiography* (New York: HarperCollins, 1992), 336–37, 376-77, 379, 410, 423–24, 469.

**285.** Gerard Malanga, conversation with the author, February 13, 1995.

**286.** Information about Romney provided by John Palmer in a telephone conversation with the author, October 15, 2003.

**287.** See, for example, Jonas Mekas, "Movie Journal: Warhol Shoots *Empire*," *Village Voice*, July 30, 1964; also, Gerard Malanga, "The Empire State Building Is a Star! *Harbinger*, vol. 1 (Austin, Texas: Cassandra Publications, July 1967), 6–9.

**288.** Thanks to John Palmer for this information. A still of Beverly Grant drinking Coke from *Batman Dracula* appeared in *Film Culture* 33 (Summer 1964), identified by the following caption: "A Rom Palm Hol Production, a lavender Filter throughout. A concatenation of Jack Smith by Andy Warhol in collaboration with Henry Romney and John Palmer."

**289.** Junker, "Movie Maker," 207 (see intro., n. 6).

**290.** Barbara Rose, *American Art Since 1900: A Critical History* (New York: F. A. Praeger, 1967); Barbara Rose, *Autocritique: Essays on Art and Anti-Art, 1963–1987* (New York: Weidenfeld and Nicolson, 1988).

**291.** Ad Reinhardt, *Art-As-Art: The Selected Writings of Ad Reinhardt*, ed. Barbara Rose (New York: Viking Press, 1975).

**292.** For more information about Rosebud's relationship with Smith, see Paola Igliori's interview with her in *American Magus: Harry Smith*, ed. Paola Igliori (New York: Inanout Press, 1996), 97–105.

**293.** Warhol and Hackett, *POPism*, 15 (see n. 2 above).

**294.** Rita Reif, "Rosenquist Painting Sells for Record Price," *New York Times*, November 12, 1986.

**295.** Lot 3354, *Untitled*, 1969; Lot 3365, *Ceiling*, 1979; Lot 3400, *Black Star with Pointer*, 1977; Lot 3401, *Leaky Neck*, 1978. *The Andy Warhol Collection: Contemporary Art* (New York: Sotheby's, 1988).

**296.** James Rosenquist, conversation with the author, October 3, 1994. I am grateful to Rosenquist for this information about the piano stool.

**297.** I am very grateful to Bill Horrigan, from whose wonderful program notes much of the information in this entry has been obtained. Bill Horrigan, "*Christmas on Earth*," 5th New York Lesbian and Experimental Film Festival, program notes (New York: Anthology Film Archives, September 11, 1991).

**298.** See also an undated twenty-three–page typed manuscript by Barbara Rubin, titled "Christmas On Earth Continued Again (a chatter on the movie)," signed "To Andy, love, Barbara," Time Capsule 41, AWM.

**299.** Quoted in Bockris and Malanga, *Up-Tight*, 8 (see n. 57 above).

**300.** A number of these 1966 *Up-Tight* films, many shot by Rubin, have been found in the Warhol Film Collection.

**301.** "Kreplach to Invade London," *East Village Other*, vol. 1, July 15–July 1, 1966, 6; on Caterpillar Changes, see Jonas Mekas, "Movie Journal," *Village Voice*, March 9, 1967.

**302.** See http://www.thefirstchurchofthelivingdead.com/tiavi/htm; Bruce Rudow, conversation with the author, October 28, 2003.

**303.** Gerard Malanga, interview with the author, June 15, 1995. In a letter dated July 10, 1966, Malanga thanked Warhol for the loan of his camera, which he promised to take good care of; Time Capsule -12, AWM.

**304.** Gerard Malanga, "From *The Secret Diaries*," 278 (see n. 77 above).

**305.** Warhol and Hackett, *POPism*, 46 (see n. 2 above).

**306.** Ibid., 50–51.

**307.** John G. Hanhardt, *Andy Warhol's Video & Television*, exhibition catalogue (New York: Whitney Museum of American Art, 1991), 13.

**308.** Warhol and Hackett, *POPism*, 46 (see n. 2 above).

**309.** Mentioned in Warhol and Hackett, *Diaries*, October 8, 1980 (see n. 36 above).

**310.** Information about Saint Phalle obtained from: "Niki de Saint Phalle Biography," http://stuartcollection.ucsd.edu/phalle/bio.html; "Niki de Saint Phalle, Sculptor, Is Dead at 71," *New York Times*, May 23, 2002, C14.

**311.** See "Ed Sanders Wins Obscenity Case," mimeographed flyer disseminated by Sanders announcing the court's decision and a "grand re-opening" party at the Peace Eye Bookstore on June 27, 1968; "B" Box 549, AWM.

**312.** See Wolf, *Warhol, Poetry, and Gossip*, 55–57 (see n. 14 above); a photograph of the interior of the Peace Eye bookstore showing Warhol's banner is reproduced on p. 56.

**313.** See Tandy Sturgeon, "An Interview with Ed Sanders," *Contemporary Literature*, vol. 31, no. 3 (1990); "Ed Sanders," New York State Writers Institute,

http://www.albany.edu/writers-inst/sanders.html; Ben Sisario, "Rock 'n' Roll Dissidents, Fearless for 4 Decades," *New York Times*, July 15, 2003, E1.

**314.** Andrew Sarris, "Notes on the *Auteur* Theory in 1962," *Film Culture* 27 (Winter 1962/63). For Mekas's relation to Sarris, see Gerald Barrett, "Andrew Sarris Interview, Part II," *Literature Film Quarterly*, vol. 2, no. 1 (Winter 1974): 9.

**315.** Andrew Sarris, "Films," *Village Voice*, December 6, 1965, 21.

**316.** Julian Bain, "Scavullo," http://www.scavullo.com/bio2/html.

**317.** Franceso Scavullo, *Scavullo on Beauty* (New York: Random House, Inc., 1976); *Scavullo Women* (New York: HarperCollins, 1982); David Leddick, ed., *Scavullo Nudes* (New York: Harry N. Abrams, 2000).

**318.** John Schott and Jeff Vaughn, *America's Pop Collector: Robert C. Scull–Contemporary Art at Auction* (1974), Circulating Film Library, MoMA.

**319.** Information about Ethel Scull obtained from Grace Glueck, "Ethel Scull, a Patron of Pop and Minimal Art, Dies at 79," *New York Times*, September 1, 2001, C15.

**320.** Frei and Printz, *Warhol Catalogue Raisonné 01*, 410 (see intro., n. 5).

**321.** "13 Most Beautiful . . . " (see n. 48 above).

**322.** Billy Name interviewed by Mirra Bank Brockman, December 17, 1991, unpublished manuscript, AWF.

**323.** Warhol and Hackett, *POPism*, 109 (see n. 2 above).

**324.** For press images of Warhol and Sedgwick together, see Douglas Sefton, "The Underground Movie: An Avant Garden of Eden," *New York Daily News*, August 6, 1965, 34; Angela Taylor, "What Audience Wears When It's on Camera," *New York Times*, August 18, 1965; "At the Party," *New York Journal-American*, August 18, 1965; Angela Taylor, "Over the Rainbow Room: Modness," *New York Times*, November 18, 1965; Leo Lerman, "Success," *Mademoiselle*, December 1965, 96; Arts and Leisure Section of *New York Times*, December 12, 1965 (a photo of Warhol "discussing underground movie-making with his star" on Channel 4's upcoming special program "Hollywood on the Hudson"); *New York World Telegram and Sun*, January 4, 1966. Major articles about Sedgwick include: Marilyn Bender, "Edie Pops Up as Newest Superstar," *New York Times*, July 26, 1965; "Edie & Andy," *Time*, August 27, 1965, 65–66; Nora Ephron, "Edie Sedgwick, Superstar," *New York Post*, September 5, 1965; "The Girl with the Black Tights," *Life*, November 26, 1965; and Virginia Palmer, "Goddess of the Underground," *New York Journal-American*, March 6, 1966, 4.

**325.** David Bourdon, "Help!" *Village Voice*, October 14, 1965. See also statement by Samuel Adams Green in *Andy Warhol: A Retrospective*, Kynaston McShine, ed. (New York: The Museum of Modern Art, 1989), 431.

**326.** Sedgwick can be seen performing with the Velvet Underground at their first Warhol-produced event, at the Annual Dinner of the New York Society for Clinical Psychiatry at Delmonico's Hotel, January 13, 1965; see Jonas Mekas's 16mm film, *Scenes from the Life of Andy Warhol*, 1990, and photography by Billy Name reproduced in Stein, *Edie*, 281 (see n. 3 above). She can also be seen in footage from the *Up-Tight* films, dancing on stage with Gerard Malanga, at the premiere of Andy Warhol Up-Tight with the Velvet Underground at the Film-Makers' Cinematheque on February 8, 1966.

**327.** Information about Smith obtained from "Harry Smith (1923–1991)," Harry Smith Archives, http://www.harrysmitharchives.com/1_bio/content.html; and J. Hoberman, "Wild About Harry," *Village Voice*, October 15, 1996, 45. Smith's life has also been commemorated in *American Magus Harry Smith: A Modern Alchemist*, ed. Paola Igliori (see n. 292 above).

**328.** P. Adams Sitney, "Harry Smith Interview," *The Film Culture Reader* (New York: Praeger, 1970), 275–76.

**329.** Francis Francine appears in *Lonesome Cowboys* (1967–68); Arnold Rockwood plays the plastic surgeon in *Hedy* (1966).

**330.** Ehrenstein, "Interview with Warhol," 41 (see n. 33 above).

**331.** Warhol and Hackett, *POPism*, 31 (see n. 2 above).

**332.** Gerard Malanga, "Interview with Jack Smith," *Film Culture* 45 (Summer 1967): 12.

**333.** Ronald Tavel, "The Theatre of the Ridiculous," *Tri-Quarterly* 6 (1966): 93–117.

**334.** Handwritten note exhibited in Flaming Creature: The Art and Times of Jack Smith, P.S. 1 Contemporary Art Center, 1997; transcribed by Branden W. Joseph.

**335.** Information on Jack Smith obtained from *Flaming Creature: Jack Smith, His Amazing Life and Times* (New York: P.S. 1 Contemporary Art Center and Serpent's Tail, 1997); and from J. Hoberman, *On Jack Smith's 'Flaming Creatures' (and Other Secret-Flix of Cinemaroc)* (New York: Granary Books, 2001).

**336.** Information on Solomon obtained from Grace Glueck, "Holly Solomon, Adventurous Art Dealer, Is Dead at 68," *New York Times*, June 10, 2002, B8.

**337.** Bob Morris, "15 Minutes of Fame Has Lasted 35 Years," *New York Times*, Arts Section, November 11, 2001, 6.

**338.** Reprinted in Susan Sontag, *Against Interpretation* (New York: Dell Laurel Edition, 1969), 277-93.

**339.** Henry Luhrman, "A Bored Susan Sontag: 'I Think Camp Should Be Retired'," *The Columbia Owl*, vol. 7, no. 22, (March 23, 1966): 8.

**340.** Thomas Meehan, "Not Good Taste, Not Bad Taste—It's 'Camp'," *New York Times Magazine*, March 21, 1965. Other examples included Tiffany lamps, Marlene Dietrich, Victor Mature, and the 1962 film *The Creation of the Humanoids*, reportedly Warhol's favorite movie.

**341.** See http://www.susansontag.com for more information. All of Sontag's books are published by Farrar, Straus and Giroux.

**342.** Warhol and Hackett, *POPism*, 88 (see n. 2 above).

**343.** Luhrman, "A Bored Susan Sontag" (see n. 339 above).

**344.** Dara Meyers Kingsley of the Warhol Foundation met Stagg in the audience during a Warhol panel discussion at the Los Angeles Filmforum in 1994. Stagg told her that he had felt terribly humiliated during the shooting of *Beauty #1* and hoped the film would never be shown; Kipp Stagg, conversation with Dara Meyers Kingsley, November 1994.

**345.** Some people, including Stevenson himself, have identified *The New Adam* as a source for Warhol's 1963 film *Sleep*. However, the painting was not shown in New York until November 1963, four months after Warhol first began filming Giorno.

**346.** The invitation, a photocopy of which was provided to the author by Harold Stevenson, reads: "You are cordially invited to a party for Harold Stevenson and a screening of Andy Warhol's 'Harold.' Sunday, January 5th, 1964. Feigen/Palmer Gallery, 515 North La Cienaga Blvd., Los Angeles."

**347.** Harold Stevenson to the author, February 25, 1997. Stevenson's recollection that the 16mm film was shown on video in January 1964 seems unlikely, given the technical limitations of the video medium at the time; perhaps the film was shown as an 8mm loop on a rear screen projector, like Warhol's *8mm Loops* installation of September 1964.

**348.** I am grateful to Fred Kraushar for identifying Steve Stone and his brother's other friends.

**349.** Stein, *Edie*, 218–19 (see n. 3 above).

**350.** Warhol and Hackett, *POPism*, 122 (see n. 2 above). Judy Holliday was the comedienne star of *Born Yesterday*; the 6'1" Verushka was one of the top fashion models of the late 1960s to early 1970s.

**351.** Ingrid Superstar appears in the following reels of *The Chelsea Girls*: Reel 2, *Ondine and Ingrid*; Reel 3, *Brigid Holds Court*; Reel 4, *Boys in Bed*; Reel 5, *Hanoi Hannah*; Reel 6, *Hanoi Hannah and Guests*; and Reel 10, *Colored Lights on Cast*. She also appeared in several outtake reels from *The Chelsea Girls: Toby Short*; *Eric—Chelsea Girls*; and *Eric (Chelsea Girls)*. Also during 1966, she appeared in the following "outtake" reels from ★★★★ *(Four Stars): Ingrid and Richard*; *Courtroom*; *Jail*; *Mary I*; *Tiger's Place*; *Mary and Richard II*; *The Bob Dylan Story*. Ingrid Superstar also can be seen in the following reels of ★★★★ *(Four Stars)* (1966–67): *Tally and Ondine*, Reel 9; *Group #1*, Reel 11A; *Katrina*, Reel 25; *Ingrid and Tom*, Reels 33 and 34; *Emmanuel*, Reel 35; *Waldo*, Reel 36; *Rolando*, Reel 37; *Rough Trade*, Reel 47; *Ondine G.*, Reel 49; *Viva #2 and #3*, Reel 73 and 74.

**352.** Ingrid Superstar's writings have been published in *Andy Warhol's Index* (see n. 94 above) and in Warhol and Malanga, *Intransit*: 1, 45 (see n. 228 above). Several other unpublished manuscripts were found among Warhol's papers in Time Capsule -7, AWM. Also see a flyer for "A Reading by Ingrid Super—Star of Andy Warhol Pop—Art Fame" at the Folklore Center in New York City, May 22, 1968, Time Capsule 14, AWM.

**353.** Warhol and Hackett, *POPism*, 122 (see n. 2 above).

**354.** Amy Pagnozzi, "Ex-Warhol Protegé Vanishes," *New York Post*, February 4, 1987. My thanks also to the Detectives Division, Police Department, Kingston, New York.

**355.** Amy Taubin, conversation with the author, October 29, 2003.

**356.** Taubin speaking in K. Griffiths's documentary film, *Warhol's Cinema 1963–1987: Mirror for the Sixties* (1989, color, sound, 64 min.).

**357.** Taubin, conversation with the author, October 29, 2003.

**358.** Warhol and Hackett, *POPism*, 90 (see n. 2 above).

**359.** Ronald Tavel, interview with the author, August 10, 1994.

**360.** Elenore Lester, "Theatre: Two by Tavel." *Village Voice*, August 5, 1965, 12.

**361.** Ronald Tavel, interview with the author, August 10, 1994.

**362.** Gregory Battcock, "Humanism and Reality—Thek and Warhol," in Battcock, *The New Art*, 235–42 (see n. 25 above). For more comparisons of Warhol and Thek, see Mike Kelley, "Death and Transfiguration," in *Foul Perfection: Essays and Criticism*, ed. John C. Welchman (Cambridge: MIT Press, 2002), 130–41.

**363.** Petronius, *New York Unexpurgated: An amoral guide for the jaded, tired, evil, non-conforming, corrupt, condemned and the curious, human and otherwise, to underground Manhattan* (New York: Matrix House, 1966), 223.

**364.** Pat Close appeared on *General Electric Theater* in episode no. 9.20, "Open House," aired on March 5, 1961, and on *The Twilight Zone* in episode no. 3.37, "The Changing of the Guard," aired on January 1, 1962, http://www.imdb.com/name/nm0167100.

**365.** The Velvet Underground was booked to play at the Trip from May 3 to May 20, 1966. On May 12, the club was temporarily closed when Virginia Greenhouse, the wife of one of the operators, sued to collect a $21,000 overdue promissory note, and a representative of the sheriff's office delivered a writ of attachment to the club. Warhol and the Velvet Underground filed a claim for their fee with the local musicians' union, and were forced to wait in Los Angeles for payment to arrive. "Strip's Trip Hit by 3G Pay Claim as Club Shutters," *Daily Variety*, vol. 131, no. 52, May 17, 1966.

**366.** There are only eight color *Screen Tests*. In addition to two films of Patrick Tilden-Close, there is one color *Screen Test* of Philip Fagan (ST94), one of Gerard Malanga (ST200), one of Cathy James (ST164), and four of Edie Sedgwick (ST310–313).

**367.** Tony Towle, *Memoir 1960–1963* (Cambridge: Faux Press, 2001), 79–80, 100.

**368.** Information on Towle available at http://jacketmagazine.com/10/towle.html.

**369.** Single page typescript, Time Capsule 15, AWM. Text reprinted with permission of the author.

**370.** Tony Towle, conversation with the author, January 16, 2004; typescript of poem provided by Towle.

**371.** For further information, see Moe Tucker's Taj Moe Hal, http://www.spearedpeanut.com/tajmoehal and The Velvet Underground Web Page, http://www.members.aol.com/olandem/tucker.html.

**372.** For further information about this period in her life, see *Ultra Violet, Famous for Fifteen Minutes: My Years with Andy Warhol* (New York: Harcourt Brace Jovanovich, 1988).

**373.** Warhol and Hackett, *POPism*, 211 (see n. 2 above).

**374.** Ultra Violet appears in the following reels of ★★★★ *(Four Stars): Nico and Ivy*, Reel 10; *Group #1*, Reel 11A; *Ivy and Isabelle*, Reel 4; *Ivy in Philadelphia*, Reel 13; *Ultra*, Reel 18; *Sally Kirkland*, Reel 39; *Tom Baker*, Reel 52; *Castle*, Reel 58; *Viva and Brigid*, Reel 71; *Haight Ashbury*, Reel 76. She also appears in the following reels, which were apparently shot for, but not included in, the final version of ★★★★ *(Four Stars): Isabelle and Staempfli*; *Matilda and Francene*; *Susan and David #1*; *Ivy and Barbara II*; *Ivy and Don McNeil II*; *Allen and Ultra*.

**375.** "Poetry Reading Review: Malanga Warhol Consistent," *The Cornell Daily Sun*, May 4, 1966; Andy Warhol Scrapbooks 9, AWM.

**376.** Reva Wolf, "Collaboration as Social Exchange: *Screen Tests/A Diary* by Gerard Malanga and Andy Warhol," *Art Journal*, vol. 52, no. 4 (Winter 1993): 65, 66, n33, n34.

**377.** Malanga, *Archiving Warhol*, 92 (see intro., n. 9).

**378.** "The Films of Gerard Malanga/Andy Warhol," a distribution brochure, dated November 13, 1990, identified as "the first descriptive checklist of films presently available for programming or museum purchase from ARCHIVES MALANGA"; copy obtained courtesy Reva Wolf.

**379.** Typed program notes for Warhol/Malanga film screening, NYU Fine Arts Club, May 12, 1979, Anthology Film Archives Library, New York.

**380.** Sterling McIlhenny and Peter Ray, "Inside Andy Warhol," *Cavalier*, vol. 16, no. 11 (September 1966): 89.

**381.** Chuck Wein, conversation with the author, July 20, 1999.

**382.** Ibid.

**383.** John Weiners, "Of Asphodel, In Hell's Despite," a one-act play for the Judson Poet's Theater, typescript with handwritten corrections, "B" Box 566, AWM.

**384.** For information about Wieners, see Christopher Hennessey, "The Man From Joy Street: John Wieners, 1943–2002," *James White Review*, vol. 19, no. 2/3 (Spring–Summer 2002): 13–14. Also, "In Memoriam John Wieners," http://tomraworth.com/wieners.html.

**385.** "Thirteen Most Beautiful . . . ," 3 (see n. 48 above).

**386.** My thanks to Celene Keller for identifying Paul Wittenborn and providing details about his life.

**387.** Woronov, *Swimming Underground*, 23 (see n. 34 above).

388. For example, Woronov is listed not under "W" but under "Might, Mary" in the index to Warhol and Hackett, *POPism* (see n. 2 above).

**389.** Woronov appears in four reels of *Since*, as well as *Richard and Mary*, *Mary I*, *Mary and Richard II*, *Tiger Hop*, *Barbara and Ivy I*, and *Ivy and Don McNeil*.

**390.** "Celebrity Closet: Mary Woronov Speaks," *Trash Compactor* 2, no. 7 (Spring 1995).

**391.** For more information about Mary Woronov, see The Mary Woronov Web site, http://www.maryworonov.com.

**392.** The original notations for these two missing films have been found on the boxes of two other *Screen Tests*: *Ondine* (ST249), which reads "*Print. Screen Test. Gerard and Mary I*"; and *James Claire* (ST54), which reads "*Print. Screen Test II. Gerard and Mary. Tri-XXX.*"

**393.** For more information about Zazeela, see the Mela Foundation Web site, http://www.melafoundation.org/narrabio.htm.

**394.** This piece was installed in the Grand Promenade of Philharmonic Hall at Lincoln Center for the opening of the New York Film Festival on September 14, 1964. When the Lincoln Center staff requested that the volume be lowered, Young reportedly withdrew his sound track, leaving the films to play silently. Eugene Archer, "Pop Artist Places Films in Festival," *New York Times*, September 11, 1964.

## Chapter Three: *Six Months*

**1.** Ronald Tavel, "The Banana Diary ('Harlot')" in *Film Culture* 40 (Spring 1966): 48.

**2.** Bockris, *Warhol* (1990), 247 (see chap. 2, n. 139).

**3.** For photobooth pictures of Fagan, see *Warhol Photobooth Pictures*, 94–98 (see chap. 2, n. 28). Fagan's September 1964 identity card from the U.S. Merchant Marines, which has been found in the Warhol Archives, identifies him as "ordinary seaman, wiper"; his birth date is listed as June 5, 1938, and his home address as Fort Worth, Texas. Time Capsule 85, AWM. For references to Fagan's foreign travels, see Tavel, "Banana Diary" (see n. 1 above).

**4.** This film was found inside a film mailer, postmarked January 14, 1965, which had been sent from Color Processing Labs in Stamford, Connecticut, to Philip Fagan at 1342 Lexington Avenue, Warhol's home address.

**5.** Tavel, "Banana Diary" (see n. 1 above). Tavel has more recently recalled another title for *Six Months*, *Philip Dying*; panel discussion, "Warhol Yesterday, Today and Tomorrow," Warhol Weekend, Filmforum, Hollywood, California, November 6, 1994; tape recording courtesy of David Ehrenstein.

## Chapter Four: Conceptual Series

**1.** Andy Warhol, *The Philosophy of Andy Warhol: From A to B and Back Again* (New York: Harcourt Brace Jovanovich, 1975), 61–62. Warhol is not actually referring to *The Thirteen Most Beautiful* films here, but to *L'Amour*, which was originally titled *The Beauties*. Nevertheless, as explained below, he faced many of the same issues with *The Thirteen Most Beautiful* films. See "Warhol Wraps 16m 'Beauties' in Paris," *Variety*, November 17, 1971. Time Capsule 7, AWM.

**2.** Billy Name, interview by Mirra Bank Brockman, December 17, 1991, AWF.

**3.** Ibid.

**4.** *The Thirteen Most Wanted*, New York Police Department, February 1, 1962, AWM. For a detailed discussion of Warhol's 1964 mural and its censorship, see Meyer, *Outlaw Representation*, 128–53 (see chap. 2, n. 164).

**5.** Billy Name, interview by Mirra Bank Brockman, December 17, 1991, AWF.

**6.** Edey diary, January 17, 1964 (see intro., n. 4).

**7.** Frei, George and Neil Printz, eds., *The Andy Warhol Catalogue Raisonné 02: Paintings and Sculpture 1964–1969* (London and New York: Phaidon Press Ltd., 2004): cat. nos. 547–67. The entry cites three receipts for the *Most Wanted Men* silkscreens found in the Warhol Archives, dated February 25, March 13, and March 16, 1964.

**8.** Both Douglas Crimp and Richard Meyer have pointed out how Warhol's mural cross-references homosexual desire and criminality with the criminalization of homosexuality, and have related the suppression of Warhol's mural to the police crackdown on gay culture that accompanied the opening of the New York World's Fair in 1964, a crackdown that also had its effects on Warhol's cinema. See Vol. 2 for relevant discussions of *Andy Warhol Films Jack Smith Filming 'Normal Love'* (1963) and *Blow Job* (1964). See also Douglas Crimp, "Getting the Warhol We Deserve: Cultural Studies and Queer Culture," *Invisible Culture* 1, no. 1 (1999), http://www.rochester.edu/in_visible_culture/issue1/crimp/crimp.html; and Richard Meyer, "Most Wanted Men: Homoeroticism and the Secret of Censorship in Early Warhol," in *Outlaw Representation*, 94–157 (see chap. 2, n. 164).

**9.** Richard Barr and Cyril Egan Jr., "Mural Is Something Yegg-Stra," *New York Journal—American*, April 15, 1964.

**10.** Emily Genauer, "Fair Mural Taken Off, Artist to Do Another," *New York Herald Tribune*, April 18, 1964.

**11.** Frei and Printz, *Warhol Catalogue Raisonné 02*, cat. nos. 547–67 (see n. 7 above).

**12.** Robert Pincus-Witten, interview by Patrick Smith in Smith, *Conversations*, 228 (see chap. 2, n. 62).

**13.** See *Film-Makers' Cooperative Catalogue No. 4*, 1967, 152–53. Also "Andy Warhol: Film-Maker's Income and Expense Balance Sheet," Film-Makers' Cooperative statement, Time Capsule 39, AWM.

**14.** "Sixth Independent Film Award," flyer for the Film-Makers' Cinematheque, December 7, 1964, Film Study Center, MoMA. See also Stoller, "Beyond Cinema," 37–38 (see chap. 2, n. 132); and Bourdon, *Warhol*, 193–94 (see chap. 2, n. 2).

**15.** Billy Name, interview by Mirra Bank Brockman, December 17, 1991, AWF.

**16.** Neil Printz, "*Other Voices, Other Rooms*: Between Andy Warhol and Truman Capote, 1945–1961" (UMI Dissertation Services, 2000): 17.

**17.** "13 Most Beautiful . . . " (see chap. 2, n. 48).

**18.** Jane Holzer, conversation with the author, May 8, 2003.

**19.** "Underground Clothes" (see chap. 2, n. 144).

**20.** On January 13, 1965, three days after the "13 Most Beautiful . . . " article about Kirkland's party appeared in the *New York Herald Tribune*, the Film-Makers' Cooperative rented *Eat*, *Henry Geldzahler*, *Batman*, and some unidentified *Screen Tests* to *Life* magazine for the "Underground Clothes" article, for

a total rental fee of $1,200; Film-Makers' Cooperative's "Andy Warhol: Film-Maker's Income and Expense Balance Sheet." Time Capsule 39, AWM.

**21.** "Pop Women," *New York Times*, February 28, 1965, Billy Rose Theatre Collection, New York Public Library for the Performing Arts.

**22.** Ed. R. Svigals, Cinemasters International Ltd., to Leslie Trumbull, Film-makers' Cooperative, March 8, 1965, in Mekas, *From the Archives*, 243 (see chap. 2, n. 63).

**23.** *Film-Makers' Cooperative Catalogue No. 4*, 152 (see n. 13 above).

**24.** The possibility that this reel was assembled for a television broadcast is raised by an undated letter that Warhol received from a fan in New Jersey, who reported having seen "Ann Worthington Fish" (sic) in *The Ten Most Beautiful Women* in a program about Warhol broadcast on Channel 13. Joe Roberts to Andy Warhol, Time Capsule 39, AWM.

**25.** Abstract of contract between Andy Warhol Films, Inc. and Vaughan-Rogosin Films, Ltd., May 15, 1969, "Contracts Book," AWF.

**26.** Peter Gidal, *Andy Warhol—Films and Paintings: The Factory Years* (New York: Da Capo Press, 1971), 95–96.

**27.** Jonas Mekas, "The Filmography of Andy Warhol," in John Coplans, *Andy Warhol* (New York: New York Graphic Society), 149.

### Chapter Five: Background Reels

**1.** "Andy Warhol, The Velvet Underground and Nico, Last performance, Sat. April 30," advertisement printed in an unidentified publication, Time Capsule -11, AWM. An earlier, similarly worded ad appeared in the *East Village Other*, April 15–March 1, 1966, Andy Warhol Scrapbooks, Reel 3, AWM.

**2.** These two "Whip Dance" rolls included in *EPI Background: Original Salvador Dalí* are not labeled, but the title *Whips*, which appears in the 1966 EPI ad (see n. 1 above), has been assigned to them. Prints of these two *Whips* rolls also can be found in *EPI Background: Gerard Begins* and *EPI Background: Velvet Underground*. Another S and M performance film starring Malanga and Woronov, *Kiss the Boot*, is catalogued separately in Vol. 2.

**3.** Western Union telegram from Philip Smith to Andy Warhol, June 2, 1966, Business files, AWF.

**4.** Julie, "The," *Night Owl* (February 1967): 36, Time Capsule 47, AWM.

**5.** Gerard Malanga and Andy Warhol, "Screen Test Poems," special issue, *Film Culture: Expanded Arts Bourse* 43 (Winter 1966): 8.

**6.** Although many of Warhol's lab bills have been found in the Time Capsules, a lab bill matching *Screen Test Poems* (approx. 3,100' of reversal release prints) has not been located.

**7.** "Poetry Reading Review: Malanga, Warhol Consistent," *Cornell Daily Sun*, May 4, 1966, Andy Warhol Scrapbooks, Book 9, AWM.

**8.** Malanga and Warhol, "Screen Test Poems," ibid.

**9.** Ibid.

**10.** The background reel titled *Eric Background: Toby Short* can be seen projected at a distorted angle behind Eric Emerson in *Eric Tells All*, Reel 9 of *The Chelsea Girls*. It can also be seen projected in the background of three outtake reels from *The Chelsea Girls: Toby Short*; *Eric—Reel 1*; and *Eric—First Day (Reel 2)*. The background reel titled *3 Min. Mary Might* can be seen projected in the background of *Eric—Reel 1* and in another *Chelsea Girls* outtake reel, *Eric (Chelsea Girls)*.

### Appendix A

**1.** Eighth Street Bookshop ad for *Screen Tests/A Diary*, *Village Voice*, April 20, 1967, Billy Rose Theatre Collection, The New York Public Library for the Performing Arts.

**2.** Eugenia Sheppard, "Pop Art, Poetry, and Fashion," *New York Herald Tribune*, Sunday Magazine, January 3, 1965, 10. Warhol's *Flowers* exhibition at Leo Castelli ran from November 21 through December 19, 1964.

**3.** Wolf, *Warhol, Poetry, and Gossip*, 68–69 (see chap. 2, n. 14). A reproduction of the flyer for the December 16 reading at Leo Castelli appears on p. 67.

**4.** Ibid., 70–74.

**5.** Reva Wolf has explored the uses of appropriation in Malanga's work more thoroughly in her chapter, "Artistic Appropriation and the Image of Poet as Thief," in ibid., 81–123.

**6.** See "Poems and Images of Death," in *Andy Warhol: Death and Disasters*, exhibition catalogue (Houston: The Menil Collection and Houston Fine Arts Press, 1988), 24. Although this catalogue attributes the Thermofax poems to Malanga and Warhol, and to Billy Linich, who made the Thermofax images, Wolf reports that Malanga told her that Warhol and Name had little to do with the Thermofaxes (see Wolf, *Warhol, Poetry, and Gossip*, 172, n. 44). Linich (now known as Billy Name) told this author that he was usually the one who operated the Thermofax machine at the Factory, but that Malanga may have used it in 1965 when Linich was not there; e-mail to author, March 9, 2004.

**7.** "Poetry Reading Review: Malanga, Warhol Consistent," *Cornell Daily Sun*, May 4, 1966, Andy Warhol Scrapbook No. 9, AWM.

**8.** Malanga, "From *The Secret Diaries*," 278, 287, 288 (see chap. 2, n. 77).

**9.** Wolf, "Collaboration," 59; and notes 6–7 (see chap. 2, n. 376).

**10.** Ibid., 65, 66, and note 30. According to Malanga, Geldzahler was "very insulted" by his exclusion from the book.

**11.** The other *Screen Tests* bearing Malanga's printing instructions are Paul America, John Ashbery, Ted Berrigan, Debbie Caen, Dan Cassidy, Denis Deegan, Harry Fainlight, Piero Heliczer, Freddy Herko, and David Murray.

**12.** *Screen Tests* bearing typed labels include: John Ashbery, Timothy Baum, Ann Buchanan, Debbie Caen, Ronnie Cutrone, Salvador Dalí, Denis Deegan, Donovan, Harry Fainlight, Charles Henri Ford, Allen Ginsberg, Piero Heliczer, Freddy Herko, Jane Holzer, Ed Hood, Paul Katz, Kenneth Jay Lane, Billy Linich, Willard Maas, Paul Morrissey, David Murray, Ivy Nicholson, Nico, Ondine, Ronna Page, John Palmer, Lou Reed, Barbara Rubin, Phoebe Russell, Francesco Scavullo, Edie Sedgwick, Chuck Wein, Mary Woronov. It is possible that all *Screen Tests* selected for *Screen Tests/A Diary* originally bore these typed labels, some of which have since been lost.

**13.** See Randy Bourscheidt (ST29), Dan Cassidy (ST49), Salvador Dalí (ST67), Bob Dylan (ST83), Sandra Hochman (ST138), Jane Holzer (ST148), Henry Rago (ST260), Ed Sanders (ST293), Edie Sedgwick (ST305), and Ingrid Superstar (ST332). The frame enlargement notated on *Debbie Caen and Gerard Malanga* (ST37) was reproduced on the flyer for Malanga's reading of his "Debbie High School Drop-Out Poems" on January 31, 1966.

**14.** Gerard Malanga, "Hustling for Army Health Razor Blades & Bomb Drop Yuk Yuk!" *Aspen* 1, no. 3 (December 1966). *Screen Test* images of the following people appear in this issue, identified with captions: John Ashbery, Gerard Malanga, Debbie Caen, Ted Berrigan, Dan Cassidy, Ingrid Superstar, David Murray, and Rene Ricard.

**15.** Wolf, "Collaborations", 66, note 34 (see chap. 2, n. 376).

### Appendix B

**1.** "Andy Warhol: Film-Maker's Income and Expense Balance Sheet," Film-Makers' Cooperative, New York, Time Capsule 39, AWM.

**2.** Edey diary, January 17, 1964 (see intro., n. 4).

**3.** Andy Warhol's 1964 date book, AWM.

**4.** Frei and Printz, *Warhol Catalogue Raisonné 02*, cat. nos. 547–67 (see chap. 4, n. 7). The entry cites three receipts for the *Most Wanted Men* silk screens found in the Warhol archives, dated February 25, March 13, and March 16, 1964.

# Photograph and Reproduction Credits

# Index

Individual *Screen Tests* are indexed under last name of subject.
Page numbers in **bold** refer to main entries on *Screen Test* subjects.
Page numbers in *italics* refer to illustrations.
Endnotes are denoted by lower case "n": for pages 300, 308–9,
further delineation occurs before the colon to indicate page section.

**Editor:** Deborah Aaronson
**Designer:** Miko McGinty
**Production Manager:** Maria Pia Gramaglia

The catalogue raisonné of the films of Andy Warhol has been funded by The Andy Warhol Foundation for the Visual Arts, Inc., New York.

**Library of Congress Cataloging-in-Publication Data**

Angell, Callie.
  Andy Warhol screen tests : the films of Andy Warhol : catalogue raisonné / by Callie Angell.
    p. cm.
  Includes bibliographical references and index.
  ISBN 0-8109-5539-3
  1. Warhol, Andy, 1928–87. Motion pictures—United States—Catalogs. I. Title.

  PN1998.3.W366A54 2006
  791.4302'33'092—dc22

                    2005020597

Printed and bound in China

10 9 8 7 6 5 4 3 2 1

**HNA** ■■■■■
**harry n. abrams, inc.**
a subsidiary of La Martinière Groupe

Harry N. Abrams, Inc.
115 West 18th Street
New York, NY 10011
www.hnabooks.com

Harry N. Abrams, Inc., is a subsidiary of  LA MARTINIÈRE

**WHITNEY**

Whitney Museum of American Art
945 Madison Avenue at 75th Street
New York, New York 10021
www.whitney.org

Outer case image: Andy Warhol filming Sterling Morrison's *Screen Test* (ST225) at the Factory, 1966. Photograph by Nat Finkelstein.

End papers: *Six Months*, 1964–65 (ST363.083).

P. 2: Edie Sedgwick posing for her *Screen Test* (ST310) at the Factory, 1965. Photograph by Billy Name.